D1156008

A HISTORY OF WESTERN ART

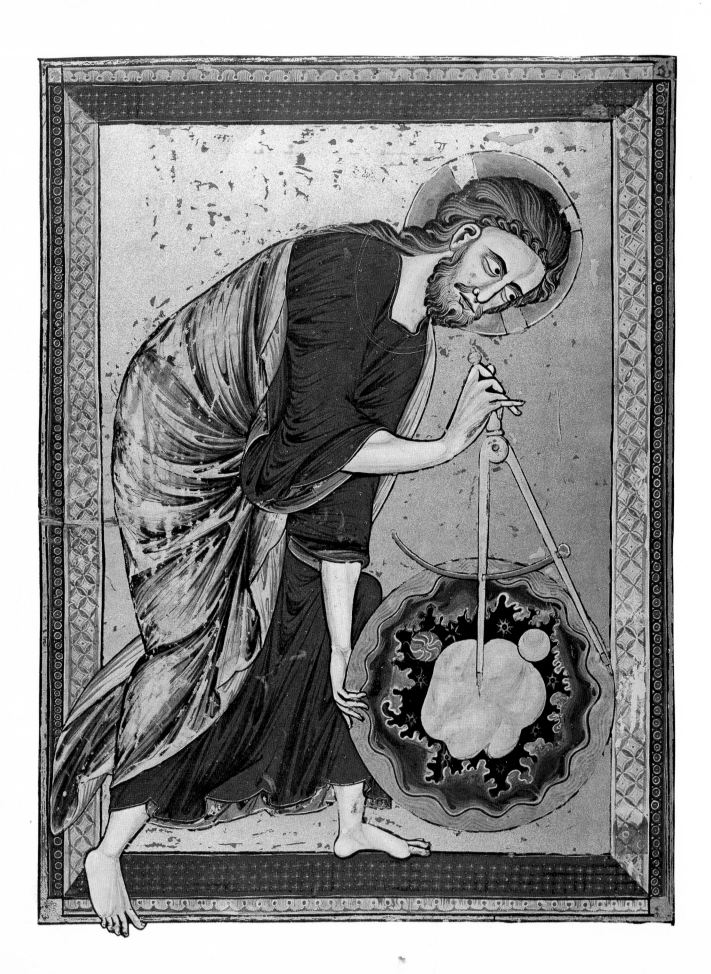

FINKELSTEIN MEMORIAL LIBRARY
SPRING VALLEY, N.Y. 10977

A HISTORY OF WESTERN ART

LAURIE SCHNEIDER ADAMS

Harry N. Abrams, Inc., Publishers

00479 6602

To John, Alexa, and Caroline

The credits section for this book begins on page 501
and is considered an extension of the copyright page.

Copyright © 1994 by Laurie Schneider Adams. All rights reserved

**Brown &
Benchmark**

A Division of Wm. C. Brown Communications, Inc.

Published in 1994 by Brown & Benchmark Publishers

Distributed in 1994 by Harry N. Abrams, Incorporated, New York

Both Brown & Benchmark Publishers and Harry N. Abrams, Inc.,
are Times Mirror Companies

Library of Congress Catalog Card Number: 93–70606

ISBN 0–8109–3425–6

No part of this publication may be reproduced, stored in a
retrieval system, or transmitted, in any form or by any means,
electronic, mechanical, photocopying, recording, or otherwise,
without the prior written permission of the publisher.

This book was designed and produced by
CALMANN & KING LTD, London

Designer: *Andrew Shoolbred*
Picture Researcher: *Prue Waller*

Printed in Hong Kong by South Sea International

FRONTISPIECE:
God as Architect, from the *Bible Moralisée*, Reims, France, fol.1v,
fig. **1.3**. Mid-13th century. Illumination, 8⅓ in (21.2 cm) wide.
Österreichische Nationalbibliothek, Vienna.

PART OPENERS:
p.11 Vincent van Gogh, detail of *Self-Portrait*, fig. **25.9**. 1889.
Oil on canvas, entire painting 25½ × 21¼ in (64.8 × 54 cm).
Musée d'Orsay, Paris. Cliché des Musées Nationaux, Paris.

p.33 Exekias, Attic black-figure *amphora, Achilles and Ajax Playing
a Board Game*, fig. **7.3**. 540–530 B.C. Terra cotta, 24 in (61 cm) high.
Musei Vaticani, Rome.

p.149 Detail of the ceiling of the choir, S. Vitale, Ravenna,
fig. **10.8**. C. A.D. 547. Mosaic. Scala, Florence.

p.209 Ambrogio Lorenzetti, detail of *Allegory of Good Government:
The Effects of Good Government in the City and the Country*, Sala
della Pace, Palazzo Pubblico, Siena, fig. **14.8**. 1338–9. Fresco, entire
wall 46 ft (14 m) long. Scala, Florence.

p.295 Paul Cézanne, detail of *Still Life with Apples*, fig. **25.3**.
c. 1875–7. Oil on canvas, 7½ × 10¾ in (19.1 × 27.3 cm).
By kind permission of the Provost and Fellows of King's College,
Cambridge, England (Keynes Collection).

p.409 Richard Rogers, detail of the Lloyd's Building, London,
fig. **31.11**. 1986. Arcaid, Kingston-upon-Thames, UK/Photo Richard
Bryant.

Contents

Preface

The object of this text is to introduce students to the history of western art and of its most important styles. Although works of art have a history, they lose much of their meaning if separated from their cultural context, from the personalities of their makers, or from the requirements of patronage. As far as possible given the limitations of space, therefore, I try to place works of art within their context of time and place. I also emphasize the evolution of artistic style, a bias that is reflected in chapter and section headings.

This book differs from most others in its focus on relatively fewer works in greater depth. As a result, certain key artists and works are given more attention than in some texts, while others have had to be omitted entirely. Also, since this is a history of *western* art, many cultures—African and Asian, for example—are left out except to the extent that they have significantly influenced western style. Nonwestern arts and cultures are so complex that they deserve their own texts, and I have resisted the politically correct, but intellectually incorrect, temptation to present nonwestern arts as ''chapters'' of western art.

Many people have assisted generously in this endeavor. Marlene Park was particularly helpful during its formative stages. In the course of its development, sections have been read by Paul Barolsky, James Beck, Larissa Bonfante, Ellen Davis, Jack Flam, Sidney Geist, Donna and Carroll Janis, Carla Lord, Oscar White Muscarella, Maria Grazia Pernis, and Leo Steinberg. Their suggestions have been immensely helpful. John Adams contributed in a number of ways at all stages of the process.

I would also like to thank Deborah Daniel Reinbold of the publisher, Brown & Benchmark, as well as a group of readers recruited by them: Edward Bryant of the University of New Mexico; Catheryn Leda Cheal of California State University, Northridge; Harvey A. Collins of Olivet Nazarene University; Laurinda S. Dixon of Syracuse University; Elisabeth L. Flynn of Longwood College; Larry Gleeson of the University of North Texas; Donna H. Goodman of Francis Marion College; Anthony Lacy Gully of Arizona State University; Nancy LaPaglia of Daley College; Anne H. Lisca of Santa Fe Community College; Charles S. Mayer of Indiana State University; Ronald D. Rarick of the University of Indianapolis; James T. Rocha; Nancy Serwint of Arizona State University; Laurel Covington Vogl of Fort Lewis College; Robert G. Ward of Northeast Louisiana University; and Salli Zimmerman of Nassau Community College.

Rosemary Bradley of Calmann & King provided valuable editorial advice. Ursula Sadie, my editor, spent many hours polishing the manuscript, and picture researcher Prue Waller and designer Andrew Shoolbred also lent much expertise to the final product.

For assistance with the illustrations, I have to thank, among others, ACA Galleries, Warren Adelson, Christo and Jeanne-Claude Christo, the Flavin Institute, William Gaddis, Duane Hanson, M. Knoedler & Co., Inc., Sidney Janis Gallery, Robert Miller Gallery, Muriel Oxenberg Murphy, the Pace Gallery, and Allan Stone Gallery.

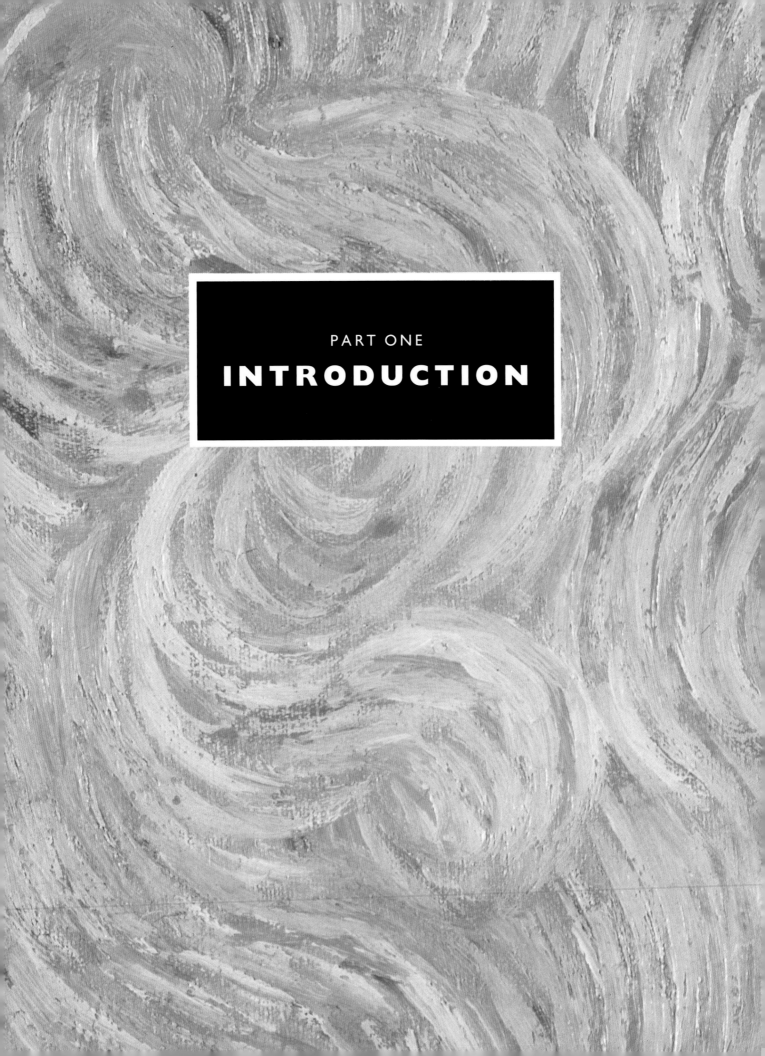

PART ONE

INTRODUCTION

Why Do We Study Art?

We study art because by doing so we learn about our own creative expressions and those of the past. The arts bridge the gap between past and present, and may even be the primary means of exploring a culture that never developed written documents. For example, the prehistoric cave paintings dating as far back as 30,000 B.C. reveal the importance for early societies of hunting. Their wish to reproduce and ensure the survival of the species is expressed in faceless prehistoric female figurines whose breasts and pelvis are disproportionately large. Prehistoric structures, whether oriented toward earth or sky, provide insights into the kinds of gods people worshiped. Without such objects, which have fortunately been preserved, we would know far less about ancient cultures than we now do.

We would also know less about ourselves, for art is a window on human thought and emotion. Certain themes, such as the wish to survive and to define oneself, persist in very different times and places. It is through the arts that the unique creative spirit of different peoples — as well as the similarities that bind them together — begins to emerge.

This book surveys the major periods and styles of western art. The arts of nonwestern cultures, such as those of Asia, Africa, and Pre-Columbian America, are so extensive that each requires its own text. Nonwestern examples are included here only when they influence western art. In the West, the major visual arts fall into three broad categories: pictures, sculpture, and architecture.

Pictures (from the Latin *pingo*, meaning "I paint") are two-dimensional images (from the Latin *imago*, meaning "likeness") with height and width, and are usually on a flat surface. But the discussion of pictures covers more than painting; it includes **mosaics**, **stained glass**, tapestry, some drawing and printing techniques, and photography.

A sculpture, unlike a picture, is a three-dimensional image — besides height and width, it has depth.

Architecture, literally meaning high (*archi*) building (*tecture*), is the most utilitarian of the three categories. Buildings are designed to enclose space for a specific purpose — worship, recreation, living, working — although they often contain pictures and sculptures as well, and

other forms of visual art. The pyramids of ancient Egypt, for example, were filled with statues of the pharaoh (king) who built them and their walls were painted with scenes from his life. Many churches are decorated with sculptures, paintings, mosaics, and stained glass windows illustrating stories of Christ and the saints. Likewise, the sumptuous palaces of western Europe would look bare without the decoration provided by paintings, sculptures, and tapestries.

The Artistic Impulse

Art is a vital and persistent aspect of everyday life. But where, one might ask, does the artistic impulse originate? We can see that it is inborn by observing children, who make pictures, sculptures, and buildings before learning to read or write. Children trace images in dirt or sand, and decorate just about anything from their own faces to the walls of their houses. They spontaneously make mud pies and snowmen. If given a pile of building blocks, they usually attempt to stack one on top of another to make a tower. All are efforts to create order from disorder and form from formlessness. While it may be difficult to relate a Greek temple or an Egyptian pyramid to a child's sandcastle, all three express the same natural impulse to build.

Chronology

The Christian chronological system, generally used in the West, is followed throughout this book. Other religions (for example, Islam and Judaism) have different calendars.

Dates before the birth of Christ are followed by the letters B.C., an acronym for "Before Christ." Dates after his birth are denoted by the letters A.D. — an acronym for *anno Domini*, Latin for "In the year of our Lord." There is no year 0, so A.D. I immediately follows I B.C. If neither B.C. nor A.D. accompanies a date, A.D. is understood. When dates are approximate or tentative, they are preceded by "c.", an abbreviation for the Latin *circa*, meaning "around."

In the adult world, creating art is a continuation and development of the child's inborn impulse. But now it takes on different meanings. One powerful motive for making art is the wish to leave behind after death a product of value by which to be remembered. The work of art symbolically prolongs the artist's existence. This parallels the pervasive feeling that, by having children, one is ensuring genealogical continuity into the future. Several artists have made such a connection. For example, according to Michelangelo's biographers, he said that he had no human children because his works were his children. Giotto, the great Italian painter of the early Renaissance (see p.213), expressed a similar idea in a fourteenth-century anecdote which begins as the poet Dante asks Giotto how it is that his children are so ugly and his paintings so beautiful. Giotto replies that he paints by the light of day and reproduces in the darkness of night. The twentieth-century artist Josef Albers (see p.448) also referred to this traditional connection between creation and procreation: he described a mixed color as the offspring of the two original colors and compared it to a child who combines the genes of two parents.

Related to the role of art as a memorial is the wish to preserve one's image after death. Artists have been commissioned to paint portraits, or representations of specific people; they have also made self-portraits. "Painting makes absent men present and the dead seem alive," wrote Leon Battista Alberti, the fifteenth-century Italian humanist (see p.238). "I paint to preserve the likeness of people after their death," wrote Albrecht Dürer, the sixteenth-century German artist (see p.291). Even as early as the Neolithic era (c. 8000–2000 B.C.; see p.46) skulls were modeled into faces with plaster, and shells were inserted into the eye sockets. In ancient Egypt (see Chapter 5), the pharaoh's features were painted on the outside of his mummy case so that his *ka*, or soul, could recognize him. And gold death masks of kings have been discovered from the Mycenaean civilization of ancient Greece (c. 1500 B.C.; see fig. **6.15**).

It is not only the features of an individual that are valued as an extension of self after death. **Patrons**, or people who commission works, may prefer to order more monumental tributes. For example, the Egyptian rulers (3000–1000 B.C.) spent years planning and overseeing the construction of pyramids, not only in the belief that such monumental tombs would guarantee their existence in the afterlife, but also as a statement of their power while on earth. The Athenians built the Parthenon (see p.105) in 448–432 B.C. to house the colossal sculpture of their patron goddess Athena and, at the same time, to embody the intellectual and creative achievements of their civilization and to preserve them for future generations. King Louis XIV (see p.303) built his magnificent palace at Versailles in the seventeenth century as a monument to his political power, his reign, and the glory of France.

The Value of Art

Works of art are valued not only by the artist or patron, but also by entire cultures. In fact, those periods of history that we tend to identify as the high points of human achievement are those in which the arts were most highly valued and vigorously encouraged. In ancient Egypt, the pharaohs initiated building activity on a grand scale. They presided over the construction of palaces and temples in addition to pyramids, and commissioned vast numbers of sculptures and paintings. In fifth-century-B.C. Athens, the cradle of modern democracy, artists created many important sculptures, paintings, and buildings; their crowning achievement was the Parthenon. During the Gothic era (c. A.D. 1200–1400; see Chapter 13), a major part of the economic activity of every cathedral town revolved around the construction of its cathedral, the production of cathedral sculpture, and the manufacture of stained glass windows. In fifteenth-century Renaissance Florence, Italian banking families such as the Medici spent enormous amounts of money on art to adorn public spaces, private palaces, churches, and chapels. Today, corporations as well as individuals have become patrons of the arts and there is a flourishing art market throughout the world. More people buy art than ever before — often as an investment — and the auctioning of art has become an international business.

The contribution of the arts to human civilization has many facets, a few of which we shall now explore.

Material Value

Works of art may be valuable simply because they are made of a precious material. Gold, for example, was used in Egyptian art to represent divinity and the sun. These associations recur in Christian art, which reserved gold for the background of religious icons and for **halos** on divine figures. Valuable materials have unfortunately inspired the theft and plunder of art objects down the centuries by thieves who disregard their cultural, religious, or artistic value and melt them down. Even the monumental cult statue of Athena in the Parthenon disappeared without a trace, presumably because of the value of the gold and ivory from which it was made.

Intrinsic Value

A work of art may contain valuable material but that is not the primary criterion by which its quality is judged. Its intrinsic value depends largely on people's assessment of the artist who created it and on its own **esthetic** character (that is, the degree to which the viewer experiences it as beautiful). The *Mona Lisa* (fig. **16.13**) is made of relatively modest materials — paint and wood — but it is a priceless object nonetheless, and arguably the western world's most famous image. Leonardo da Vinci, who painted it around A.D. 1500 in Italy, was an acknowledged genius in his own day and his work has stood the test of time. The

paintings of the late nineteenth-century Dutch painter Vincent van Gogh (see p.401) have also endured, although he was ignored in his lifetime. It was not until after his death that his esthetic quality and originality were recognized. Today, the intrinsic value of an oil painting by van Gogh is reflected by its market price, which has risen to as high as $80 million.

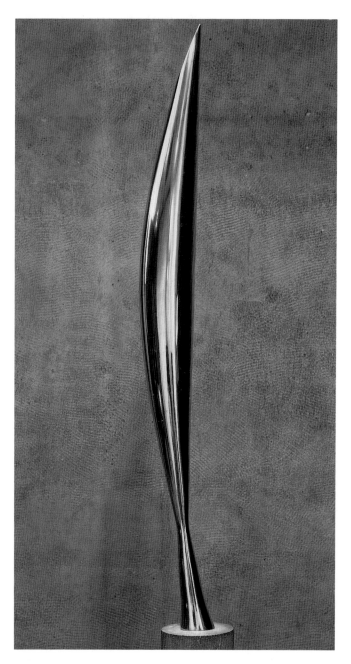

1.1 Constantin Brancusi, *Bird in Space*. 1928. Bronze, unique cast, 54 x 8½ x 6½ in (137.2 x 21.6 x 16.5 cm). Collection, The Museum of Modern Art, New York (Given anonymously). Brancusi objected to the view of his work as abstract. In a statement published shortly after his death in 1957, he declared: "They are imbeciles who call my work abstract; that which they call abstract is the most realist, because what is real is not the exterior form but the idea, the essence of things."[1]

Intrinsic value is not always apparent, as seen in the changing assessment of van Gogh's works. "Is it art?" is a familiar question, which expresses the difficulty of defining "art" and of recognizing the esthetic value of an object. One famous example of this dilemma is illustrated by a trial held in New York City in 1927. Edward Steichen, the prominent American photographer, had purchased a bronze sculpture entitled *Bird in Space* (fig. **1.1**) from the Romanian artist Constantin Brancusi, who was living in France. Steichen imported the sculpture to the United States, whose laws do not require payment of customs duty on original works of art as long as they are declared on entering the country. When the customs official saw the *Bird*, however, he balked. It was not art, he said; it was "manufactured metal." Steichen's protests fell on deaf ears. The sculpture was admitted into the United States under the category of "Kitchen Utensils and Hospital Supplies," which meant that Steichen had to pay $600 in import duty.

Later, with the financial backing of Gertrude Vanderbilt Whitney, the American sculptor and benefactor of the arts, Steichen appealed the ruling of the customs official. The ensuing trial received a great deal of publicity. Witnesses discussed whether the *Bird* was a bird at all, whether the artist could make it a bird by calling it one, whether it could be said to have certain characteristics of "birdness," and so on. The conservative witnesses refused to accept the work as a bird because it lacked certain biological attributes, such as wings and tail feathers. The more progressive witnesses pointed out that it had bird-like qualities — upward movement and a sense of spatial freedom. The final decision of the court was in favor of the plaintiff and Steichen got his money back. The *Bird* was declared a work of art. In today's market a Brancusi *Bird* would sell for millions of dollars.

Religious Value

One of the traditional ways in which art has been valued is in terms of its religious significance. From prehistory to the sixteenth-century Reformation, art was one of the most effective ways to express religious beliefs. Paintings and sculptures depicted gods and goddesses and thereby made their images accessible. Temples, churches, and mosques were symbolic dwelling places of gods and served to relate worshipers to their deity. Tombs expressed belief in the afterlife.

During the Middle Ages in western Europe, art often served an educational function. One important way of communicating Bible stories and legends of the saints to a largely illiterate population was through the sculptures, paintings, and stained glass windows in churches and cathedrals.

Beyond its teaching function, the religious significance of a work of art may be so great that entire groups of people identify with the object. The value of such a work is highlighted when it is taken away. In 1973, the Afo-a-Kom — a sacred figure embodying the soul of a village in

the Cameroon — disappeared. The villagers reportedly fell into a depression when they discovered that their statue was missing. The subsequent reappearance of the Afo-a-Kom in the window of a New York art dealer caused an international scandal that died down only after the statue was returned to its African home.

Patriotic Value

Works of art have patriotic value inasmuch as they express the pride and accomplishments of a particular culture. Patriotic sentiment was a primary aspect of the richly carved triumphal arches of ancient Rome (see p.142) because they were gateways for the return of victorious emperors and generals. Statues of national heroes stand in parks and public squares in most cities of the western world.

But a work need not represent a national figure or even a national theme to be an object of patriotic value. In 1945, at the end of World War II, the Dutch authorities arrested an art dealer, Han van Meegeren, for treason. They accused him of having sold a painting by the great seventeenth-century Dutch artist Vermeer to Hermann Goering, the Nazi Reichsmarschall and Hitler's most loyal supporter. When van Meegeren's case went to trial, he lashed out at the court. "Fools!" he cried, "I painted it myself." What he had sold to the Nazis was actually his own forgery, and he proved it by painting another "Vermeer" under supervision while in prison. Van Meegeren thus saved himself from conviction of treason by proving that he had been guilty of a lesser crime, namely forgery. It would have been treason to sell Vermeer's paintings, which were (and still are) considered national treasures, to Holland's enemies.

Another expression of the patriotic value of art can be seen in recent exhibitions made possible by shifts in world politics. Since détente between the Communist bloc and the West, Russia has been sending works of art from her museums for temporary exhibitions in the United States. In such circumstances, the traveling works of art become a kind of diplomatic currency and contribute to improved relations between nations.

The patriotic feeling that some cultures have about their works of art has contributed to their value as trophies, or spoils of war. When ancient Babylon was defeated by the Elamites in 1170 B.C., the victors stole the statue of Marduk, the chief Babylonian god, together with the law code of Hammurabi (see p.55). In the early nineteenth century, when Napoleon's armies marched through Europe, they plundered thousands of works of art. Napoleon's booty is now part of the French national art collection at the Louvre in Paris.

The patriotic value of art can be so great that nations whose works of art have been taken go to considerable lengths to recover them. Thus, at the end of World War II, the Allied army assigned a special division to recover the vast amounts of art stolen by the Nazis. A United States army task force discovered Hermann Goering's two personal caches of stolen art in Bavaria, one in a medieval castle, and the other in a bombproof tunnel in nearby mountains. The task force arrived just in time, for Goering had equipped an "art train" with thermostatic temperature control to take "his" collection to safety. At the Nuremberg trials, Goering claimed that his intentions were nothing if not honorable — he was protecting the art from air raids.

A contemporary example of the patriotic value of art can be seen in the case of the Elgin Marbles. In the early nineteenth century when Athens was under Turkish rule, Thomas Bruce, the seventh earl of Elgin, obtained permission from Turkey to remove sculptures from the Parthenon and other buildings on the Acropolis. At great personal expense (amounting to £75,000), Lord Elgin sent the sculptures to England by boat. The first shipment sank, but the remainder of the works reached their destination in 1816. The British Museum in London purchased the sculptures for just £35,000. Now referred to as the Elgin Marbles, they are still in the British Museum, where they are a tourist attraction and a source of study for scholars. For years, the Greeks have been pressuring England to return the sculptures and the British have refused to do so. This kind of situation is a product of historical circumstance. Although Lord Elgin broke no laws and probably saved the sculptures from considerable damage, he is seen by many Greeks as having looted their cultural heritage.

Since art continues to have patriotic value, modern legislation in many countries is designed to avoid similar problems by making it difficult, if not illegal, to export national treasures. International protocols, such as the Hague Convention of 1959, the UNESCO General Conferences of 1964 and 1970, and the European Convention of 1967, protect cultural property and archeological heritage.

Other Symbolic Values

There are other aspects of the symbolic value of art besides religious and patriotic significance. Art is valued for its ability to convey illusions with which we identify. This identification leads us to endow art with symbolic power and to create legends about the origins of art.

Reactions to the arts cover virtually the entire range of human emotion. They include pleasure, fright, amusement, outrage, even avoidance. People can become attached to a work of art and not want to part with it, as Leonardo did after he painted the *Mona Lisa*. Instead of delivering it to the person who had commissioned it, Leonardo kept the painting until he died. Conversely, one may wish to destroy certain works because they arouse anger. In London in the early twentieth century, a suffragette slashed Velázquez's *Rokeby Venus* (fig. **19.33**) because she was offended by what she considered to be its sexist representation of a woman. Such examples illustrate the intense responses to the symbolic power of art. The remainder of this chapter considers psychological responses to the symbolic nature of the arts.

Art and Illusion

Before considering illusion and the arts, it is necessary to point out that when we think of illusion in connection with an image, we usually assume that the image is lifelike, or **naturalistic**. This is often, but not always, the case. With certain exceptions, such as Judaic and Islamic art, western art was mainly representational until the twentieth century. **Figurative**, or **representational**, art depicts recognizable natural forms or created objects. When the subjects of painting and sculpture are so convincingly portrayed that they may be mistaken for the real thing, they are said to be **illusionistic**. Where the artist's purpose is to fool the eye, the effect is described by the French term, *trompe l'oeil*.

The deceptive nature of pictorial illusion was simply but eloquently stated by the Belgian Surrealist painter, René Magritte, in his painting *The Betrayal of Images* (fig. **1.2**). This work is a convincing (although not a *trompe l'oeil*) rendition of a pipe. Directly below the image, Magritte reminds the viewer that in fact it is not a pipe at all — "Ceci n'est pas une pipe" ("This is Not a Pipe") is Magritte's explicit message. To the extent that observers are convinced by the image, they have been betrayed. Even though Magritte was right and illusion does fall short of reality, however, the observer is nevertheless pleased by its effect.

The pleasure produced by *trompe l'oeil* images is reflected in many anecdotes, or stories which may not be literally true but illustrate an underlying truth. For example, the ancient Greek artist Zeuxis was said to have painted grapes so realistically that birds pecked at them. In the Renaissance, a favorite story recounted that a fellow artist was so fooled by Giotto's realism that he tried to brush off a fly that Giotto had painted on a figure's nose. The contemporary American sculptor Duane Hanson (see

p.471) is a master of *trompe l'oeil*. He uses synthetic materials to create statues which look so alive that it is not unusual for people to approach and ask them questions. When the unsuspecting observers realize that they have been fooled, they are embarrassed by their own mistake, but admire the artist's skill.

In these examples of illusion and *trompe l'oeil*, artists produce only a temporary deception. Such may not always be the case. For instance, the Latin poet Ovid relates the tale of the sculptor Pygmalion, who was not sure whether his own statue was real or not. Disappointed with the infidelities of real women, he turned to art and fashioned a beautiful girl, Galatea, out of ivory. He dressed her and brought her jewels and flowers. He undressed her and took her to bed. Finally, during a feast of Venus (the Roman goddess of love and beauty), Pygmalion prayed for a wife as lovely as his *Galatea*. Venus granted his wish by bringing the statue to life — something that only gods and goddesses can do. Human artists have to be satisfied with illusion.

Traditions Equating Artists with Gods

The fine line between illusion and reality, and the fact that gods are said to create reality while artists create illusion, has given rise to traditions equating artists with gods.

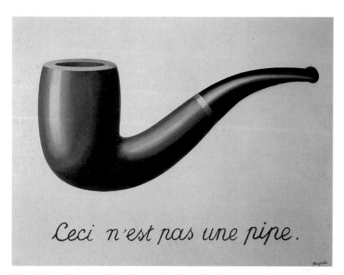

1.2 René Magritte, *The Betrayal of Images* ("This is Not a Pipe"). 1928. Oil on canvas, 23½ × 28½ in (55 × 72 cm). Los Angeles County Museum of Art, California.

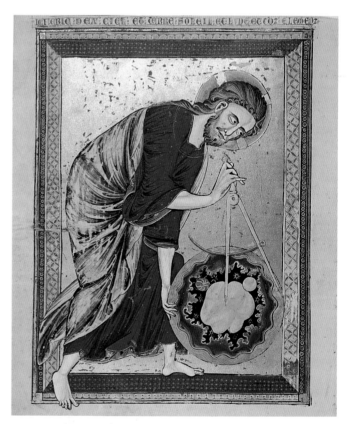

1.3 *God as Architect*, from the *Bible Moralisée*, Reims, France, fol. Iv. Mid-13th century. Illumination 8⅓ in (21.2 cm) wide. Österreichische Nationalbibliothek, Vienna.

Both are seen as creators, the former making replicas of nature and the latter making nature itself. Alberti referred to the artist as an *alter deus*, Latin for "other god," and Dürer said that artists create as God did. Leonardo wrote in his *Notebooks* that artists are God's grandsons and that painting, the grandchild of nature, is related to God. Giorgio Vasari, the Renaissance biographer of artists, called Michelangelo "divine," a reflection of the notion of divine inspiration. Even as recently as the nineteenth century, the American painter James McNeill Whistler put forward the theory that artists are "chosen by the gods."

Artists have been compared with gods, and gods have been represented as artists. In ancient Babylonian texts, God is described as the architect of the world. In the Middle Ages, God is sometimes represented as an architect drawing the universe with a compass (fig. **1.3**). Legends in the **Apocrypha**, the unofficial books of the Bible, describe Christ as a sculptor who made clay birds and then breathed life into them.

The comparison of artists with gods, especially when artists make lifelike work, has inspired legends of rivalry between these two creators. Even when the work itself is not lifelike, the artist may risk incurring divine anger. For example, the Old Testament story of the Tower of Babel describes the dangers of building too high and rivaling God by invading the heavens. God's reaction to the tower is illustrated in a sixteenth-century painting by the Dutch artist Pieter Brueghel the Elder (fig. **1.4**).

Some legends endow sculptors and painters with the power to create living figures. In Greek mythology the sculptor Daedalus was reputed to have made lifelike statues that could walk and talk. Prometheus, on the other hand, was not satisfied with merely lifelike works. Since the ancient Greeks believed that human beings were made of earth (the body) and fire (the soul), Prometheus knew he needed more than clay to create living figures. He stole fire from the gods, and they punished him with eternal torture. This story illustrates the fact that there is an ultimate difference between artists and gods: no matter how skilled artists are, they can only create illusions.

1.4 Pieter Brueghel the Elder, *The Tower of Babel*. 1563. Tempera on panel, 3 ft 9 in x 5ft 1 in (1.14 x 1.55 m). Kunsthistorisches Museum, Vienna.

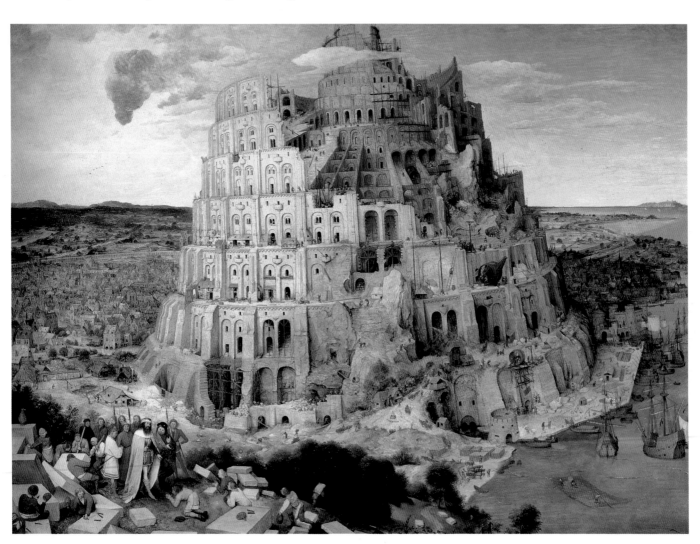

Art and Identification

Reflections and Shadows: Legends of How Art Began

Belief in the power of images extends beyond the work of human hands. In many societies, not only certain works of art, but also reflections and shadows are thought to embody the spirit of an animal or the soul of a person. These ideas appear in numerous superstitions throughout the world. For example, in some European countries, seeing oneself in a mirror that is in the same room as a dead person is read as a warning of death. In certain South Australian tribes, a man's shadow falling on his mother-in-law is cause for divorce on the grounds of incest. The shadow is taken for the man himself and embodies his sexual potency. In other cultures, the absence of a shadow can indicate sexual impotence or even impending death. The danger of losing one's shadow is evident in Peter Pan's anxiety at the loss of his, and the lengths to which he went to recover it.

Even though reflections and shadows are not art, ancient traditions trace the origin of painting and sculpture to drawing a line around a reflected image or a shadow. Alberti recalled the myth of Narcissus—the Greek youth who fell in love with his own image in a pool of water—and compared the art of painting to the reflected image. He also quoted the Roman writer Quintilian, who identified the first painting as a line traced around a shadow. An oriental tradition recounts that Buddha was unable to find an artist who could paint his portrait. As a last resort, he had an outline drawn around his shadow and filled it in with color himself. A Greek legend attributes the first sculpture to a woman who traced the shadow of the man she loved. Her father, a potter, used clay to fill the outline on the wall where the shadow had fallen, fired it, and the sculpture emerged. These legends indicate that works of art are inspired not only by the impulse to create form, but also by the discovery or recognition of forms that already exist and the wish to capture and preserve them.

Image Magic

The belief that a likeness substitutes for a real person (or animal), who will experience what is done to the image, is found in many different cultures. In sixteenth-century England, Queen Elizabeth I's advisors became alarmed when they discovered her wax effigy stuck through with pins. They immediately summoned the renowned astrologer, John Dee, to counteract the effects of witchcraft. During the French Revolution of 1789, mobs protesting the injustices of the royal family destroyed statues and paintings of earlier kings and queens because of their association with the *ancien régime*. Many nineteenth-century American Indians objected to having their portraits painted by the artist George Catlin, whose memoirs recorded their suspicious and violent reactions. In 1989

and 1990, when eastern Europe began to rebel against communism, the protestors tore down statues of the communist leaders.

Portraits are images which can create a particularly strong impression. The most famous portrait in the western world, the *Mona Lisa*, depicts a woman who is virtually unknown, and her personality is one of the most persistent riddles in the history of western art. Later artists have satirized her (fig. **28.1**) and incorporated her image into their own work. Thousands of articles, books, poems, and songs have been written about her. As a result of her image, she has become a household word.

In 1911, the *Mona Lisa* disappeared from the Louvre. Two years later, the police recovered her from under the bed of a house painter in Italy. She toured Europe by train and was accorded a heroine's welcome upon her return to France. In the 1960s the painting was loaned to New York's Metropolitan Museum. On this occasion, the *Mona Lisa* traveled from France by boat in a first-class stateroom accompanied at all times by an armed security guard. The painting has achieved the status of a world **icon**, demonstrating that an image can have as much meaning and appeal as a living celebrity.

On an individual level, some people have actually fallen in love with images. In the sixteenth century, King Henry VIII of England agreed for political reasons to take the German princess, Anne of Cleves, as his fourth wife without having met her. He commissioned the artist Hans Holbein (see p.294) to paint her portrait and was enchanted with the result. When Anne landed in England, Henry could not contain himself and traveled incognito to meet his bride. But, alas, in this case illusion proved better than reality. Henry was sorely disappointed by the real Anne; he went through with the marriage but reportedly never consummated it.

The nineteenth-century English art critic John Ruskin fell in love with an image on two separate occasions. He became so enamored with the marble tomb effigy of the young Ilaria del Caretto in Lucca, Italy, that he wrote letters home to his parents describing the statue as if it were a living girl. Later, when in a more delusional state, Ruskin persuaded the Accademia, a museum in Venice, to lend him the painting of the sleeping St. Ursula by the sixteenth-century Italian artist Carpaccio. He kept it in his room for six months and became convinced that he had been reunited with his former fiancée, a young Irish girl named Rose la Touche, who had merged in Ruskin's mind with the image of the young saint.

The ability to identify with images, and the sense that a replica may actually contain the soul of what it represents, has sometimes led to an avoidance of images. Certain religions prohibit their followers from making pictures and statues of their god(s) or of human figures. In Judaism, the making of graven images is expressly forbidden in the second commandment: "Thou shalt not make unto thee any graven image, or any likeness of any thing that is in heaven above, or that is in the earth beneath, or that is in the water under the earth" (Exodus 20:4, 5). When the

Israelites blatantly ignored this, Moses berated them for worshiping the golden calf they had made. Years later, the prophet Jeremiah declared both the pointlessness and the dangers of worshiping objects instead of the Creator God.

In Islam, as in Judaism, works of art are meant to avoid the human figure. Mohammed condemned those who would dare to imitate God's work by making figurative art. As a result, Islamic art is, for the most part, nonfigurative; its designs are typically geometric or floral (see p.166).

During the Iconoclastic Controversy in the eighth and ninth centuries, Christians argued vehemently over the potential dangers of creating any images of holy figures (see p.165). Those wishing to destroy existing images and to prohibit new ones believed that they would lead to idolatry, or worship of the image itself rather than what it stood for.

In the modern era, as societies have become increasingly technological, traditional imagery seems to have lost some of its magic power. But, no matter how sophisticated we become, we are still personally involved with images. For example, when complimented on the famous portrait of his mother, Whistler merged the real person with her picture: "Yes," he replied, "one does like to make one's mummy just as nice as possible" (fig. **1.5**). Other kinds of images evoke different responses. A peaceful landscape painting can provide respite from everyday tensions as we contemplate its rolling hills or distant horizon. A **still life** can remind us of the beauty inherent in objects we take for granted. Even works that contain no recognizable objects or figures — nonfigurative or abstract art — may engage our attention as we identify with the movement of their lines or the mood of their colors. Contemporary images, many in electronic media, exert power over us in subtle ways. Movies and television affect our tastes and esthetic judgments. Advertising images influence our decisions — what we buy and which candidates we vote for. These modern media use certain traditional techniques of image-making to convey their messages effectively.

Architecture

As is true of images, architecture evokes a response by identification. A building may seem inviting or forbidding, gracious or imposing, depending on its exterior form and structure. One might think of a country cottage as welcoming and picturesque, or a haunted house as endowed with the spirits of former inhabitants who could inflict mischief on trespassers.

Architecture is more functional, or utilitarian, than pictures and sculptures. Usually the very design of a building conforms to the purpose for which it was built. The criterion for a good building is not only whether it looks good, but also whether it fulfills its function well. For example, a hospital may be esthetically pleasing, but its ultimate test

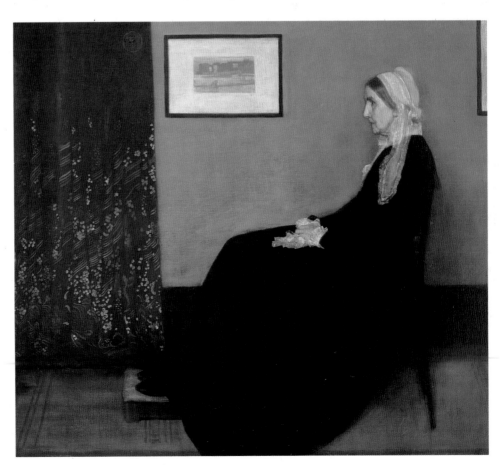

1.5 James Abbott McNeill Whistler, *Arrangement in Black and Gray (Portrait of the Artist's Mother)*. 1871. Oil on canvas, 4 ft 9 in x 5 ft 4½ in (1.45 x 1.64 m). Musée d'Orsay, Paris.

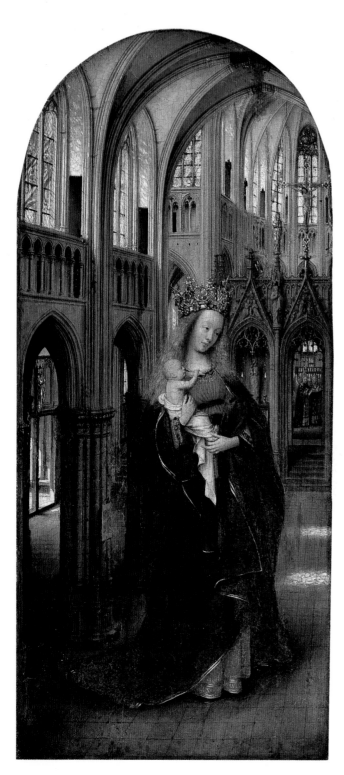

1.6 Jan van Eyck, *The Virgin in a Church*. c. 1410–25. Oil on panel, 12¼ x 5½ in (31 x 14 cm). Gemäldegalerie, Staatliche Museen, Berlin. It is thought that, given the narrowness of this picture, it may originally have been part of a **diptych** — a work of art consisting of two panels — in which case the other section is lost.

is whether it serves the patients and medical staff adequately. A medieval castle was not only a place to live; it was also a fortress requiring defensive features such as a moat, towers, and thick walls.

Beyond function, the next most important consideration is the use of space in architecture. The fact that a building is larger than a painting or sculpture and that, with very few exceptions, it can enclose us evokes our response to its interior space. Paintings, although flat, can have an illusion of space. Sculptures occupy real space, although the observer generally cannot appreciate this fact except from the outside. In the ancient world, many buildings, such as the Egyptian pyramids or the Greek temples, were intended to be experienced from the outside only. Nevertheless, certain people — priests, for example — had access to the interiors and everyone was aware of the existence of an interior. From both the esthetic and psychological point of view, therefore, our response to architecture is incomplete until we have been inside it and experienced it physically.

The degree to which we are inside or outside of architectural space appears in everyday language. We speak of "insiders" and "outsiders," of being "in on" something and of being "out of it." The importance of "in" and "out" recurs in certain traditional architectural arrangements. In the ancient world, for example, the innermost room or sanctuary was considered the most sacred part of the temple, the "holy of holies," which only the high priest or priestess could enter. Likewise, an audience with a highly placed personage or ruler, whether a king, queen, or pope, permits access to an inner room which is generally denied to the public at large. We gain access to an interior architectural space by following either a passageway or some other spatial sequence; often we have to go through a door or series of doors in order to reach our destination. In popular speech, therefore, we say of people who have influence that they can "open doors."

Our identification with the experience of being inside begins before birth. Unborn children exist in the enclosed space of their mother's womb where they are provided with shelter, protection, and warmth. This biological reality has resulted in a traditional association between women and architecture, particularly concerning homes and churches. In Christianity, for example, the relationship between the mother and architecture can be seen in the popular medieval metaphor equating the Virgin Mary as mother of Christ with the church building. This concept is given visual form in Jan van Eyck's fifteenth-century painting *The Virgin in a Church* (fig. **1.6**). Here Mary is enlarged in relation to the architecture so that she is identified with the church building as the House of God. Van Eyck portrays an intimacy between Mary and Christ that evokes both the natural closeness of mother and child and the spiritual union between God and humanity.

This union is an important aspect of the sense of space in religious architecture and is discussed in later chapters. Gothic cathedrals, such as the one in van Eyck's painting, contain several references to it. The vast interior space

creates an impression of awe and wonder at the smallness of humanity compared to an all-encompassing God. The upward movement of the interior space, together with the tall towers and spires on either side of the entrance, echo the Christian belief that paradise is up in the heavens. The rounded spaces of other places of worship, such as the domed ceilings of **mosques** (see p.166), symbolize the dome of Heaven. In a sense, then, these religious buildings stand as a kind of transitional space between ground and sky, between the limited time on earth and feelings about infinite time, or eternity.

Just as we respond emotionally and physically to the open and closed spaces of architecture, so our metaphors indicate that we like to have confidence in the structural security of our buildings. A "house of cards," or a "castle in the air," evokes instability and irrational thinking. Likewise, if we say that an argument "stands up," we mean that it seems logical and cannot easily be "knocked down." Since buildings are constructed from the bottom up, a house built on a firm foundation can symbolize stability, even rational thinking, forethought and advance planning. Thus, in the initial stages of a building's conception, the architect makes a plan. Sometimes called a **ground plan**, or floor plan, it is a drawing of the entire floor of the structure indicating where walls and other supports that begin at ground level are located. Although in everyday speech we use the term "to plan" in a figurative sense, the architect has to construct a literal and well-thought-out plan or the building, like a poor argument, will not stand up.

Identification with images and spaces is as old as the human race and it persists in everyday contemporary language. From the beginning of human history, pictures, sculptures, and buildings have been endowed with various kinds of literal and symbolic value related to personal experience, religious beliefs — even aspirations. For works of art are created and enjoyed as expressions of basic and universal human concerns. Artists communicate these concerns through a visual language which has pictorial, sculptural, and architectural rather than verbal elements. For example, an artist might use the color blue to suggest sadness or bright yellow to suggest happiness. A straight line might represent a road while a wavy line could evoke the ocean. A big space makes us feel small and a small space makes us feel large. These visual elements are the subject of the next chapter. Once we have covered the basic elements of the artist's language, we will be better prepared to explore the history of art.

The Language of the Visual Artist

The visual arts have their own language and the artist thinks in terms of that language, just as a musician thinks in sounds and rhythms, and a mathematician in numbers. The basic visual vocabulary consists of the so-called **formal elements** of style, which include line, shape, color, light, and dark. When artists combine these elements in a characteristic way, they are said to have a **style**. In order to describe and analyze a work of art it is helpful to be familiar with the artist's perceptual vocabulary.

Form

In its broadest sense, the **form** of a work of art — literary, musical, or visual — refers to its overall plan, composition, or structure. It denotes the relationship between component parts, whether chapters of a book, movements of a symphony, or lines and colors of a painting. The form of a work depends on how its formal elements are arranged or organized, and is distinct from its subject matter or **content**. In a narrower sense, the form of an object may refer to its shape, which can also be a component, or element, within its overall organization.

Balance

In a successful composition, the harmonious blending of the formal elements gives the work its **balance**. The most simple form of balance is **symmetry**. This is a term whose original meaning is that there is an exact correspondence of parts on either side of an axis or dividing line. In other words, the left side of a work is a mirror image of the right side. The human body is an example of this type of balance, as shown in Leonardo's *Vitruvian Man* (fig. **16.2**).

Balance can also be achieved when non-equivalent elements balance each other. In Bernini's *David* (fig. **19.15**), for example, the weight of the figure is not evenly distributed on either side of the central axis. However, although the parts are not in perfect symmetry, there is a balance or equilibrium between them which produces an esthetically satisfying result. This is known as **asymmetrical balance**.

Line

A line is the path traced by a moving point. For the artist, the moving point is the tip of the brush, pen, crayon, or whatever instrument is used to create an image on a surface. In geometry, a line has no width or volume; in fact it has no qualities at all except for location. In the language of art, however, a line can have many qualities, depending on how it is drawn (fig. **2.1**). A vertical line seems to stand stiffly at attention, a horizontal line lies down, and a diagonal seems to be falling over. Zigzags have an aggressive, sharp quality, whereas a wavy line is more graceful and, like a curve, more naturally associated with the outline of the human body. Parallel lines are balanced and harmonious, implying an endless, continuous movement, while perpendicular, converging, and intersecting lines meet and create a sense of force and counterforce. The thin line (a) seems delicate, unassertive, even weak. The thick one (b) seems aggressive, forceful, strong. The flat line (c) suggests calmness, like the surface of a calm sea, whereas the wavy line (d) implies the reverse. The angular line (e) climbs upwards like the edge of a rocky mountain. (Westerners understand (e) as going up and (f) as going down, as we read from left to right.)

Expressive Qualities of Line

Many of the lines in figure **2.1** are familiar from geometry and can therefore be described formally. But the formal qualities of line also convey an expressive character because we identify them with our bodies and our experience of nature. So, in math, a straight line is the shortest distance between two points and, likewise, a person who follows a straight, clear line in thought or action is believed to have a sense of purpose. "Straight" is associated with rightness, honesty, and truth, while "crooked" — whether referring to a line or a person's character — denotes the opposite qualities. We speak of a "line of work," a phrase adopted by the former television program "What's my Line?" When a baseball player hits a line drive, the bat connects firmly with the ball, and a "hardliner" takes a strong position on an issue.

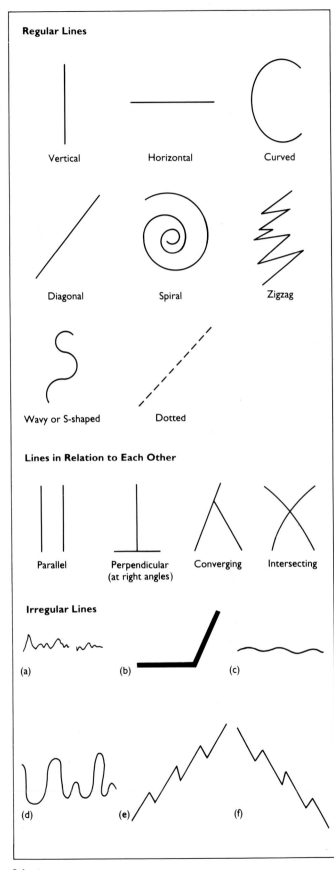

2.1 Lines

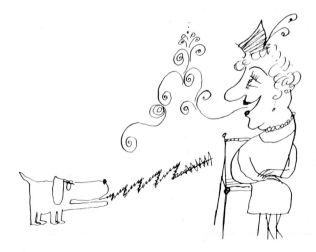

2.2 Lines used to create facial expressions.

In the configuration of the face, it is especially easy to see the expressive impact of lines (fig. **2.2**). In (a), the upward curves create a happy face, and the downward curves of (b) create a sad one. These characteristics of upward and downward curves actually correspond to the emotions as expressed in natural physiognomy. And they are reflected in language when we speak of people having "ups and downs" or of events being "uppers" or "downers."

Speeches (fig. **2.3**), drawn by Saul Steinberg (b. 1914), uses only line to convey the character of the two figures and their "dialogue." The enlarged **curvilinear** head and neck of the woman and the long horizontal of the dog's head correspond to their speech. The floral curlicues "spoken" by the woman seem mellifluous and demure like her pose, while the harsh zigzags coming from the dog's mouth suggest a sharp, rasping bark. Reinforcing this effect are the diagonals of its eyebrow and pointed tail, which are contrasted with the wide-eyed, open expression of the woman.

2.3 Saul Steinberg, *Speeches.* 1954. Steinberg was born in Romania and studied architecture in Milan before emigrating to the U.S.A. Since 1940 he has been a regular contributor to *The New Yorker*. He has described drawing as "a way of reasoning on paper"; to make a good drawing, he has said, "one has to tell the truth."

The importance of line in the artist's vocabulary is illustrated by an account of two ancient Greek painters, Apelles, who was Alexander the Great's personal artist, and his contemporary Protogenes. Apelles traveled to Rhodes to see Protogenes' work, but when he arrived at the studio, Protogenes was away. The old woman in charge of the studio asked Apelles to leave his name. Instead, Apelles took up a brush and painted a line of color on a panel prepared for painting. "Say it was this person," Apelles instructed the old woman.

When Protogenes returned and saw the line, he immediately recognized that only Apelles could have painted it so perfectly. In response, Protogenes painted a second, and finer, line on top of Apelles' line. Apelles returned and added a third line of color, leaving no more room on the original line. When Protogenes returned a second time, he admitted defeat and went to look for Apelles.

Protogenes decided to leave the panel to posterity as something for artists to marvel at. Later it was exhibited in Rome, where it impressed viewers for its nearly invisible lines on a vast surface. To many artists, the panel seemed a blank space, and for that it was esteemed over other masterpieces. After his encounter with Protogenes, it was said that Apelles never let a day go by without drawing at least one line. His experience was the origin of an ancient proverb, "No day without a line."

Lines Used for Modeling

Even though drawn lines have only two dimensions, height and width, they can be used by an artist to make an object appear three-dimensional (fig. **2.4**).

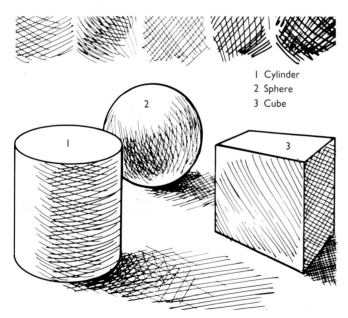

1 Cylinder
2 Sphere
3 Cube

2.4 The lines inside the sphere, cube, and cylinder create the illusion that these objects are solid. They also suggest that there is a source of light coming from the upper left and shining down on the objects. Such lines are called modeling lines.

The parallel **modeling** lines in the front surface of the cube are called **hatching**. If they intersect other parallel lines, as in the cylinder and the oblique surface of the cube, they are known as **cross-hatching**. The closer the lines are to each other, the darker their surface. They suggest shade or **shading**, which is gradation or transition from light to dark. Shading appears on the side of the object that is turned away from the light source. A shadow is seen as dark and denotes the absence of light; it is cast onto a surface when the source of light is blocked by another object.

Perspective

In some styles the artist wishes to create the illusion of three-dimensional depth on a two-dimensional surface. In addition to the use of modeling lines, other techniques include:

- depicting the nearer object as larger than the more distant
- making the nearer object overlap the more distant
- making the base of the more distant object closer to the horizon line and, conversely, the base of the nearer object closer to the lower edge of the picture.

Perspective, another technique for creating the illusion of three-dimensional space on a flat surface, is discussed on pages 226 and 228.

Shape

When lines enclose a space, they create a shape, and the line that outlines the shape is called its **contour**. Shapes are another basic unit, or formal element, used by artists. There are regular and irregular shapes. Regular ones are **geometric** and have specific names. Irregular shapes are also called "biomorphs," or **biomorphic** (from the Greek *bios*, meaning "life" and *morphe*, meaning "shape") because they seem to move like live, **organic** matter. Shapes can be two-dimensional (fig. **2.5**) or three-dimensional, in which case they are solid or have volume (fig. **2.4**).

Expressive Qualities of Shape

Like lines, shapes can be used by artists to convey ideas and emotions. Open shapes create a greater sense of movement than closed ones (fig. **2.5**). Likewise, we speak of open and closed minds; open minds allow for a flow of ideas, flexibility, and the willingness to entertain new possibilities. Closed minds, on the other hand, are inaccessible to new ideas.

Specific shapes can evoke associations with everyday experience. Squares, for example, are symbols of reliability, stability, and symmetry. To call people "foursquare" means that they are forthright and unequivocal, that they confront things "squarely." If something is "all square," a certain equity or evenness is implied; a "square meal" is

satisfying in both amount and content. When the term "brick" is applied to people, it means that they are good-natured and reliable. Too much rectangularity, on the other hand, may imply dullness or monotony—to call someone "a square" suggests overconservatism or conventionality.

The circle has had a special significance for artists since the Neolithic era (see p.41). In the Roman period, the circle was considered a divine shape and thus most suitable for temples. This view of the circle persisted in the Middle Ages and the Renaissance, when ideal church plans were also circular.

The appeal of the circle's perfection is illustrated by a Renaissance anecdote about Giotto. As the story goes, the pope's messengers scoured Italy to find the best living artist. When a messenger arrived at Giotto's studio and asked for a sample of his work, the artist took up a piece of paper and brush. He held out his arm stiffly as if to make a compass of his whole body and drew a circle. When the puzzled messenger asked the meaning of his action, Giotto told him to take the picture to the pope, who would understand. As soon as the pope saw Giotto's O, he recognized his genius and summoned him to Rome. From that anecdote came the expression, "You are more stupid than Giotto's O."

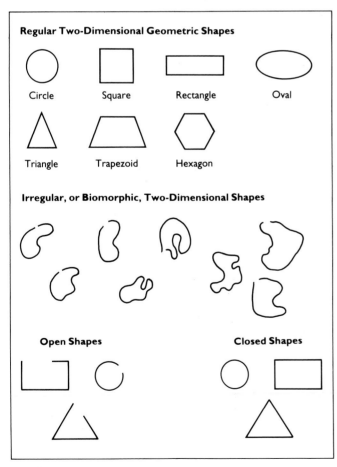

2.5 Shapes.

Light and Color

Light may be technically defined as electromagnetic energy of certain wavelengths which produces visual sensations when it strikes the retina of the eye. The opposite, or the absence, of light is darkness. Color, one of the most powerful elements at the artist's disposal, is derived from light. Rays of light emanating from the sun are composed of waves with various wavelengths (i.e. they vibrate at various frequencies), and these are perceived by the human brain as different colors. This can be examined scientifically by passing a beam of light through a prism (a triangular block of glass): each wavelength is refracted, or bent, at a different angle. Light can be reflected on to a screen as a continuous band composed of separate colors (fig. **2.6**) – basically the same phenomenon as a rainbow, when rays of light from the sun are refracted through falling raindrops.

Each beam of light contains all the colors of the spectrum; but objects look as though they have different colors because they have pigmentation which allows them to absorb certain color waves and reflect others. We see a tomato, for example, as red because its pigmentation absorbs every color of the spectrum except red, which it reflects. The coloring materials, or **pigments**, that artists use also absorb and reflect different waves. If applied to the surface of an object, the pigment transfers this quality to the object. The colors produced through the use of pigments are not as pure or intense as the colors in the spectrum. Either they reflect more than one color, or they reflect one color plus a certain amount of white light, which makes the basic color less intense. If all pigments were recombined, the result would not be pure white but, at best, a pale shade of gray (see p.29).

Objects that are white, gray, or black (known as **neutrals**) reflect all (or none) of the colors in a ray of light

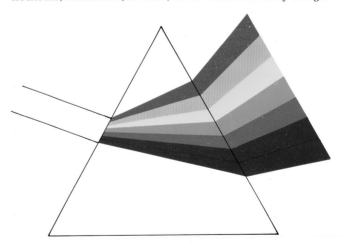

2.6 The **visible spectrum** has seven principal colors — red, orange, yellow, green, blue, indigo (or blue-violet), and violet — that blend together in a continuum. Beyond the ends is a range of other colors, starting with infrared and ultraviolet, which are invisible to the human eye. If all of the colors of the spectrum are recombined, white light is again produced.

and differ among themselves only in the amount of light that they reflect. Pure white reflects all color waves; absolute black (which is very rare) reflects no light at all; shades of gray reflect different amounts of light—the darker the gray, the less light is reflected.

Physical Properties of Color

There are seven principal colors in the spectrum. Each of the seven has many variations, which depend on the three physical properties of color: **hue, value,** and **intensity.**

Hue. This is virtually synonymous with color. Red is one hue, yellow is another. Each has a different wavelength. Mixing one color with another changes its wavelength and hence its hue. Red plus yellow, for example, produces orange; adding more red makes a reddish orange and adding yellow makes a yellowish orange.

Red, yellow, and blue are the **primary colors.** They cannot themselves be produced by combining any other colors. However, all of the other colors can be created by mixing the primary colors either in pairs or all together. A mixture of two primary colors produces a **secondary color:** yellow and blue produces green, blue and red produces violet, red and yellow produces orange. A **tertiary** or **intermediate color** can be formed by combining a primary with an associated secondary color. Thus mixing

green (which already contains blue) with more blue produces a blue-green; mixing violet (which also contains blue) with more blue produces a blue-violet. The number of intermediate colors is unlimited because the proportions of each mixture can be varied to an unlimited degree.

Hues containing a common color, although in different proportions, are known as **analogous hues** and their combination produces a feeling of color harmony in a work of art. If only a single hue is used, the work is said to be **monochromatic** (from the Greek *mono,* meaning "single" and *chroma,* meaning "color").

The **color wheel** (fig. **2.7**) illustrates the relationships between the various colors. The farther away hues are, the less they have in common, and the higher their contrast. Hues directly opposite each other on the wheel (red and green, for example) are thus the most contrasting and are known as **complementary colors.** They are often juxtaposed when a strong, eye-catching contrast is desired. Christmas colors, for example, are red and green, and Easter colors are commonly purple and yellow. Mixing two complementary hues, on the other hand, has a neutralizing effect and lessens the intensity of each. This can be seen in figure **2.7** as you look across the wheel from red to green. The red's intensity decreases, and the gray circle in the center represents a "stand-off" between all the complementary colors.

Value. The relative lightness or darkness of an image is known as its value, also referred to as brightness, shade, or tone. An object's value is a function of the amount of light reflected from its surface. Gray, for example, reflects more light than black but less than white, which makes gray lighter than black and darker than white. The **value scale** in figure **2.8** provides an absolute value for different shades. But, in fact, our visual perceptions are more relative than absolute and are "colored" by the context in which we perceive something. For example, in figure **2.9** the band across the center is of a uniform shade of medium gray (i.e. it has the same value throughout). However, when seen alongside the darker gray on the left it looks lighter, and vice versa on the right. Artists are constantly aware of the absolute values of the shades with which they are working and of the effect of juxtaposing different colors.

Value is characteristic of both **achromatic** works of art—those with no color, consisting of black, white, and shades of gray—and of **chromatic** ones (from the Greek **chroma,** meaning "color"). On a scale of color values (fig. **2.10**), yellow reflects a relatively large amount of light, approximately equivalent to "high light" on the neutral scale, whereas blue is equivalent to "high dark." The normal value of each color indicates the amount of light it reflects at its maximum intensity. The addition of white or black would alter its value (i.e. make it lighter or darker) but not its hue. The addition of one color to another would change not only the values of the two colors but also their hues.

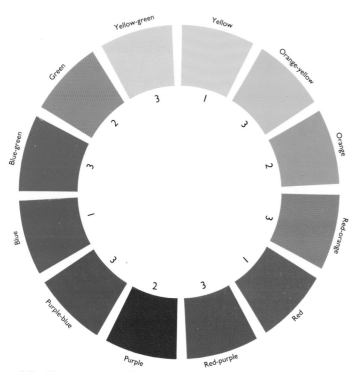

2.7 The color wheel. Note that the three primary colors — red, yellow and blue — are equally spaced around the circumference. They are separated by their secondary colors. Between each primary and its two secondaries are their related tertiaries, giving a total of twelve hues on the rim of the wheel.

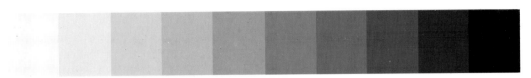

2.8 This ten-step value scale breaks the various shades from white to black into ten gradations. The choice of ten is somewhat arbitrary because there are many more values between pure white and pure black. Nevertheless it does illustrate the principle of value gradations.

2.9 (below) The juxtaposition of objects with different tonal values produces a **contrast**. Objects from opposite ends of the value scale create a very high or strong contrast — the simplest example is the juxtaposition of black and white.

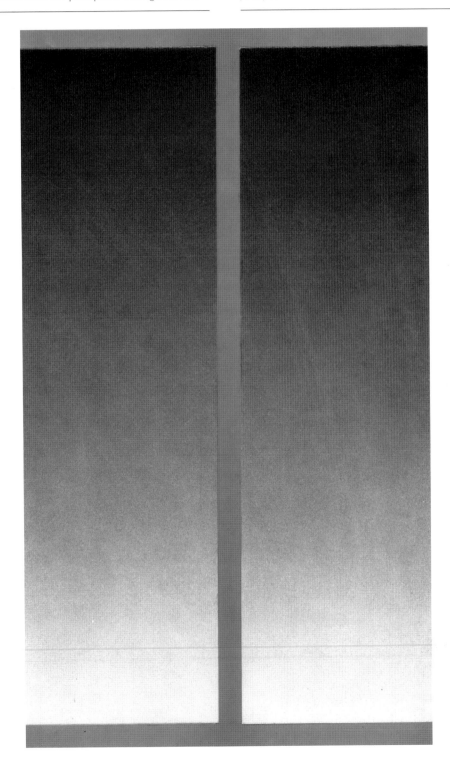

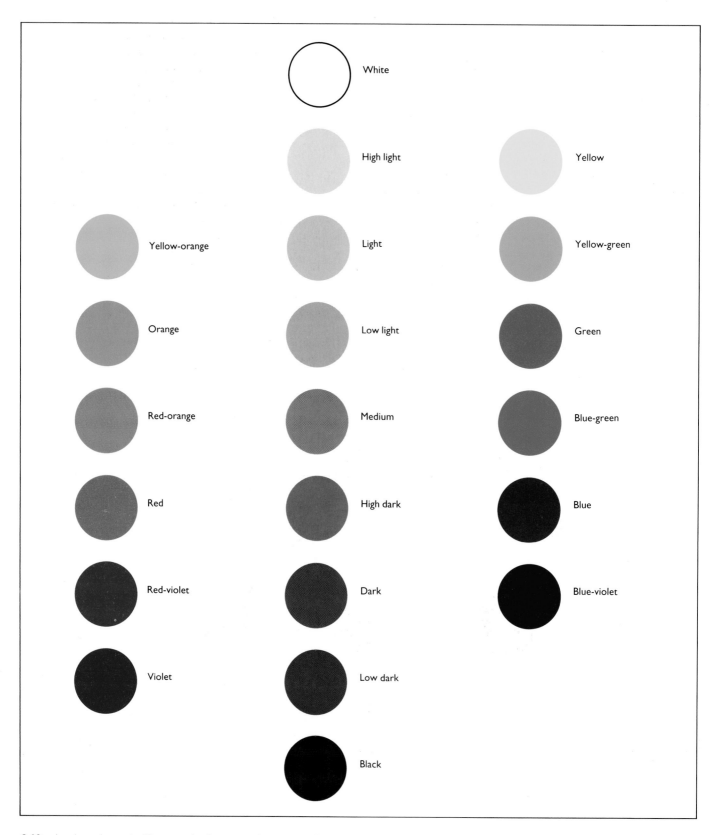

2.10 A color value scale. The central column contains a range of neutrals from white to black; the columns at the sides match the twelve colors from the color wheel with the neutrals in terms of the amount of light reflected by each.

Intensity. In darkness, colors are invisible; in dim light they are muted and difficult to distinguish; in bright light, color is at its most intense. Intensity (also known as **saturation** or chroma) refers to the brightness or dullness of a color. There are four methods of changing the intensity of colors. The first is to add white. Adding white to pure red creates light red or pink, which is lighter in value and less intense. If black is added, the result is darker in value and less intense. If gray of the same value as the red is added, the result is less intense but retains the same value. These three methods are illustrated in figure **2.11**. The fourth way of changing a color's intensity is to add its complementary hue. For example, when green (a secondary color composed of two primaries, yellow and blue) is added to red, gray is produced as a consequence of the balance between the three primaries. If red is the dominant color in the mixture, the result is a grayish red; if green is dominant, the product is a grayish green. In any event, the result is a color less intense and more neutral than the original.

Expressive Qualities of Color

Just as lines and shapes have expressive qualities, so too do colors. Artists select colors for their effect. Certain ones appear to have intrinsic qualities. Bright or warm colors convey a feeling of gaiety and happiness. Red, orange, and yellow are generally considered warm, perhaps because of their associations with fire and the sun. It has been verified by psychological tests that the color red tends to produce feelings of happiness. Blue and any other hue containing blue — green, violet, blue-green — is considered cool, possibly because of its association with the sky and water. It produces feelings of sadness and pessimism (see, for example, the discussion of Picasso's Blue Period on p.412).

Colors can also have symbolic significance and suggest abstract qualities. A single color, such as red, can have multiple meanings. It can symbolize danger, as when one waves a red flag in front of a bull. But to "roll out the red carpet" means to welcome someone in an extravagant way, and we speak of a "red letter day" when something particularly exciting has occurred. Yellow can be associated with cowardice, white with purity, and purple with luxury, wealth, and royalty. We might call people "green with envy," "purple with rage," or "in a brown study" if they are quietly gloomy. The great European plague of 1348 is referred to as the Black Death.

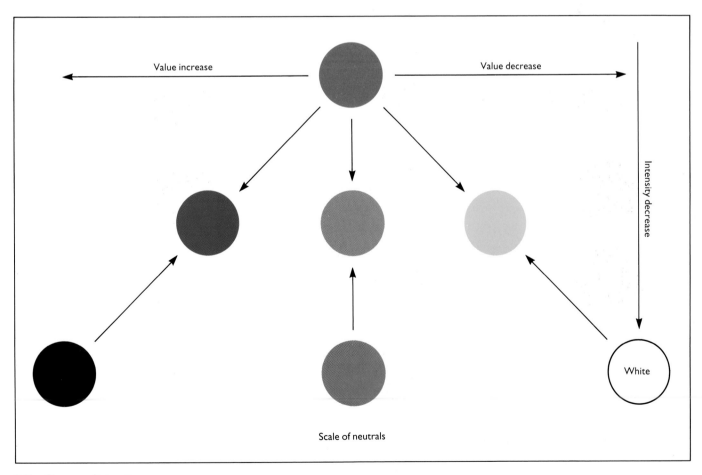

Value increase Value decrease

Intensity decrease

White

Scale of neutrals

2.11 Changes of intensity.

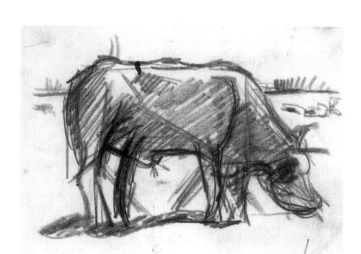

(a)

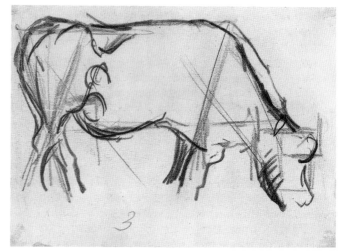

(b)

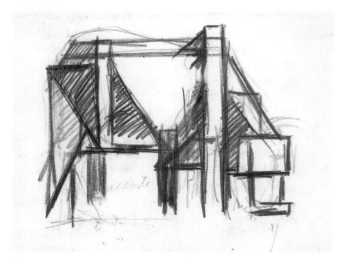

(c)

(d)

(e)

2.12 Theo van Doesburg, *Composition (The Cow)*. 1916–17. (a) and (b) pencil, 4⅝ × 6¼ in (11.7 x 15.9 cm); (c) pencil, 4⅛ × 5¾ in (10.4 × 14.6 cm); (d) tempera, oil, and charcoal on paper, 15⅝ × 22¾ in (39.7 × 57.8 cm); (e) oil on canvas, 14¾ × 25 in (37.5 x 63.5 cm). Collection, The Museum of Modern Art, New York ((a), (b), (d), (e) Purchase, (c) Gift of Nelly van Doesburg).

Texture

Texture (from the same word stem as the Latin *texo*, "I weave") is another expressive quality at the artist's disposal. It refers to the surface characteristics of an object or material. These are usually described by adjectives such as rough or polished, hard or soft, firm or fluffy, coarse or fine, cold (like steel) or warm (like wood), shiny or matte, stiff or pliable.

Texture is associated with the tactile sense (the sense of touch), and indirectly with vision. By touching or feeling an object, we experience its texture directly. But our eyes also have a role here. As soon as we see something, we either recognize its texture from experience or make an assumption based on how it looks. When we explore art, the senses of sight and touch interact. Thus, a sculpture of polished bronze will look and feel hard and smooth. Unpolished marble will look and feel rough.

It is necessary to distinguish between actual texture and simulated (or implied) texture. Actual texture is the surface quality of a real object — canvas, marble, paint — which is the artist's medium. When artists simulate texture, they create an illusion.

Until the latter part of the nineteenth century, it was customary for painters to use their medium to create illusions of texture. During the past 150 years, however, certain painters have begun to incorporate the literal, textural quality of their medium into the work's impact. Brushstrokes have intentionally been made visible so as to arouse the viewer's tactile sense. More recently — since the late 1940s — many artists have emphasized the medium to the point where its literal tactile character is a central aspect of the image.

All of the formal elements of art — whether line, shape, light, dark, color, or texture — are arranged by artists to create images. The final arrangement of the individual elements is called the **composition** of the work. It involves such matters as balance and harmony, the relationships of parts to each other and to the whole work, and the impact on the viewer.

Stylistic Terminology

Certain terms have become conventional in describing works of art, especially with reference to their styles and shapes. Since they are used throughout this book, the most important are set out here.

The word "naturalistic" describes a work whose forms represent figures and objects as they are perceived in nature. Related terms are as follows:
- figurative: representing the likeness of a recognizable human (or animal) figure.
- realistic: attempting to depict objects accurately, as they actually are. In the nineteenth-century style called Realism (see Chapter 23), artists consciously tried to depict everyday reality.

- representational: representing natural objects in recognizable form. Note that a work of art may be representational without being realistic.

All of these terms can be applied to a painting such as the *Mona Lisa*.

If an image is representational but falls short of absolute faithfulness to the original object, it may be that it is:
- **stylized**: emphasizing certain features, or distorted in accordance with certain artistic conventions. Examples of stylized forms can be found in ancient Near Eastern art. The eyebrows of Gudea (fig. **4.11**), for example, are identifiable by virtue of their position above the eyes, but they do not replicate the natural appearance of eyebrows.
- **romanticized**: emphasizing characteristics which show the subject matter in a "romantic" light. Chapter 22 considers the late eighteenth- and early nineteenth-century Romantic style.
- **idealized**: representing a figure or object according to an ideal of beauty or perfection accepted at that time. Perhaps the most idealized depictions of the human figure in western art come from Greece and date back to the fifth century B.C. They belong to the Classical style and are discussed in Chapter 7.

If the shapes within a work of art bear little or no relation to observable or natural objects, they may be called:
- **nonrepresentational**, or **nonobjective**: the opposite of representational and objective, implying that the art does not represent real objects or subject matter. Examples of such work appear in Chapters 26 to 29. Certain Abstract Expressionist works contain no recognizable figures or objects.
- **abstract**: used to describe forms that do not represent observable objects, but which the artist has derived or abstracted from real things. Often the artist is attempting to depict the essence, or the intrinsic qualities, of an object. Sometimes the result may be representational, in the sense that the viewer can still recognize the original object.

Figure **2.12** illustrates how the early twentieth-century Dutch artist Theo van Doesburg made the transition from the drawing of a cow to an abstract composition. He gradually changed the cow from image (a), which could be called naturalistic, figurative, or representational, to image (e), which is an abstract arrangement of flat squares and rectangles. In (a) and (b), the cow's form is recognizable as that of a cow — it is composed of curved outlines and a shaded surface that creates a three-dimensional illusion. In image (c), the cow form is still recognizable, especially as it follows (a) and (b). It is now devoid of curves, but still shaded — it has become a series of volumetric (solid, geometric) shapes. Even in image (d), the general form of the cow is recognizable in terms of squares, rectangles, and triangles, but there is no longer any shading. As a result, each distinct color area is flat. In image (e), however, the shapes can no longer be related to the original natural form. It is thus a pure abstraction, and is also nonobjective and nonrepresentational.

Subject Matter, Content, and Iconography

The subject matter of a painting refers, not surprisingly, to what is represented, such as figures, landscape, inanimate objects, or formal elements such as lines and shapes. The content refers to themes or ideas contained in a work and may include its subject matter. In western art there are certain standard categories of subject matter:

- human (or animal) figures, either in generalized form or as portraits of specific individuals. This category may in turn be divided into subcategories that include religious, historical, and mythological themes.
- landscape — scenes in which human figures are absent or minimal; subcategories are cityscapes and sea-scapes.
- still life, in which the artist arranges inanimate objects specifically to be the subjects of an image.
- **genre** (the French word for "kind" or "sort") — scenes of everyday life.

The word **iconography** is used to refer to the significance of what is represented, the literal and symbolic meanings of the imagery. In Leonardo da Vinci's *Mona Lisa* (fig. **16.13**), for example, the subject is a woman seated on a balcony in front of a landscape. The content includes the subject, but also encompasses the traditional idea of the woman in relation to the landscape, even the woman as a metaphor for landscape.

The iconography of the *Mona Lisa* has been the subject of numerous studies and is fraught with controversy. She has been seen as a symbolic mountain because her form echoes the distant rock formations. Certain landscape details, such as the aqueduct, merge into the lines of her drapery, and the spiral road repeats the undulating folds of her sleeves. Freud, the pioneer of psychoanalysis (see p.408), thought that she evoked Leonardo's childhood memory of his mother — particularly her smile — and that this explained Leonardo's attachment to the figure's mysterious expression. An American physician analyzed her smile as a reflection of the serene inner satisfaction of a pregnant woman, and a computer researcher identified her as Leonardo's self-portrait! Not all works of art are as elusive as the *Mona Lisa*, but her case illustrates the potential complexity of nailing down a precise iconographic interpretation. Most good images are quite complex and have multiple layers of meaning.

Following this brief survey of some of the major visual elements used by artists, we begin our historical sequence. Many important works of art are necessarily omitted from a book such as this. Nevertheless, what follows is an attempt to convey the remarkable range of western art and a sense of the artists who created it.

PART TWO

THE ANCIENT
WORLD

	Style/Period	Works of Art	Cultural/Historical Developments
40,000 B.C.	PALEOLITHIC 40,000–10,000 B.C.	Venus of Willendorf (p.36) Venus of Laussel (p.36) Lascaux cave paintings (p.39)	Hunting and gathering Evidence of recording time Use of stone tools Last Ice Age (18,000–15,000 B.C.)
	MESOLITHIC 10,000–8000 B.C.		Bow and arrow invented (c. 10,000 B.C.) Wheat and barley domesticated (9000 B.C.)
	NEOLITHIC 8000–2000 B.C.	Jericho skulls (p.46) Stonehenge (p.42)	Development of agriculture; domestication of sheep and goats Megalithic monuments
5000 B.C.	ANCIENT IRANIAN 5000–4000 B.C.	Susa beaker (p.59)	Copper smelting developed (c. 4500 B.C.)
	URUK 3600–2800 B.C.	Uruk vase (p.48) White Temple and Ziggurat (p.49)	Invention of the potter's wheel First bronze casting (c. 4000 B.C.)
	SUMERIAN Early Dynastic 2800–2300 B.C. Neo-Sumerian 2150–1800 B.C.	Lyre soundbox (p.51) Statues of Gudea (p.53)	First evidence of epic poetry (Gilgamesh)
2000 B.C.	AKKADIAN 2360–2180 B.C.	Bronze head of Sargon I (p.54) Stele of Naram-Sin (p.54)	
	EGYPTIAN Old Kingdom 2700–2100 B.C. Middle Kingdom 2100–1700 B.C. New Kingdom 1600–1000 B.C.	Palette of Narmer (p.64) Pyramids at Giza (p.66) Statue of Menkure and his queen (p.70) Funerary Temple of Hatshepsut (p.69) Bust of Nefretete (p.76) Coffin of Tutankhamen (p.77) *Book of the Dead* (p.74)	Hieroglyphic writing Hyksos invasion of Egypt First female ruler of Egypt
1500 B.C.	MINOAN 3000–1500 B.C.	Palace of Knossos (p.81)	Linear A used in Crete (c. 2000 B.C.) Linear B used in Crete and Greece (c. 1500 B.C.)
	CYCLADIC 3000–1200 B.C.	Idol (p.79)	
	ASSYRIAN 3000–612 B.C.	Lamassu (p.59)	
	OLD BABYLONIAN 1830–1550 B.C.	Law code of Hammurabi (p.55)	
1000 B.C.	MYCENAEAN 1600–1300 B.C.	*Tholos* tombs (p.87)	Greece invaded from north (c. 1300 B.C.) Trojan War; sack of Troy (c. 1200 B.C.)
	HITTITE 1450–1200 B.C.	Lion Gate (p.56)	Beginning of Judaism (c. 1200 B.C.) Phoenicians develop alphabetic script (c. 1100 B.C.)
	SCYTHIAN 800–550 B.C.	Gold stag (p.60)	
500 B.C.	ETRUSCAN 800–450 B.C.	*Apollo of Veii* (p.121) *Mater Matuta* (p.122)	Etruscan civilization starts (800–700 B.C.) Veii destroyed by Romans (396 B.C.)
	NEO-BABYLONIAN 612–539 B.C.	Ishtar Gate (p.57)	Birth of Buddha (c. 563 B.C.) Birth of Confucius (c. 550 B.C.)
	ACHAEMENID 539–331 B.C.	Apadana of Darius (p.60)	Birth of Herodotus, "Father of History" (485 B.C.)
400 B.C.	GREEK Geometric 900–700 B.C. Archaic 660–480 B.C. Early Classical 490–450 B.C. Classical 450–400 B.C. Late Classical 400–300 B.C. Hellenistic 323–31 B.C.	Vase painting (p.94) *New York Kouros* (p.98) Black-figure vase painting (p.95) *Peplos Kore* (p.98) Red-figure vase painting (p.96) *Critios Boy* (p.99) Parthenon (p.104) Polyclitus, *Doryphorus* (p.101) Praxiteles, *Hermes* (p.115) *Winged Nike* (p.116) *Laocoön and his Two Sons* (p.118)	Homer, *Iliad* and *Odyssey* Pythagoras (581–497 B.C.) Persians conquer Asia Minor (c. 546 B.C.) Lost-wax process (p.100) Persian Wars (490–449 B.C.) Age of Pericles (460–429 B.C.) Plato, *Republic* Death of Socrates (399 B.C.) Euclid, *Elements of Geometry* (323 B.C.) Death of Alexander the Great (323 B.C.)
300 B.C. **A.D. 400**	ROMAN Republic 509–27 B.C. Empire 27 B.C.–A.D. 476	Temple of Portunus (p.137) *Ara Pacis* (p.140) *Augustus of Prima Porta* (p.145) Colosseum (p.134) Trajan's Column (p.141) Pantheon (p.138) Statue of Marcus Aurelius (p.146) Head of Constantine (p.146)	Julius Caesar assassinated (44 B.C.) Augustus becomes emperor (27 B.C.) Crucifixion of Christ (c. A.D. 30) Founding of London (A.D. 43) Revolt of Jews; Romans sack Jerusalem (A.D. 70) Destruction of Pompeii and Herculaneum (A.D. 79) Roman Empire at its zenith (A.D. 98–117) Bishop of Rome becomes pope (c. A.D. 200) Edict of Milan: Christianity legalized (A.D. 313)

Prehistoric Western Europe

Who are we? Where do we come from? Where are we going? These are three of the most universal existential questions people ask themselves. They are about time — past, present, and future — as well as about the nature of the human condition.

Works of art help us to define ourselves in time and space. The more we know about our past, the better we understand our present. We shall begin our exploration of art by going back in time to the early history of the human race — to prehistory. Prehistory refers to the time before people learned to write and therefore before the existence of written records. In one sense, the term prehistory is a misnomer, because objects and images are actually documents of a sort. The challenge, for us, lies in discovering how to "read" the nonverbal information accurately.

Stone Age

The Stone Age is divided into three general phases: the Paleolithic (from the Greek *paleos*, meaning "old" and *lithos*, meaning "stone"), c. 40,000 to 10,000 B.C.; the Mesolithic ("middle stone"), c. 10,000 to 8000 B.C.; and the Neolithic ("new stone"), c. 8000 to 3000 B.C. (and continuing somewhat later in northwestern Europe). The designation of these early periods as Stone Age derives from the use of tools and weapons made of stone. Metals had not yet been discovered.

Paleolithic Era (c. 40,000–10,000 B.C.)

By the beginning of the Paleolithic era our own subspecies, *homo sapiens*, had supplanted the earlier Neanderthal people, who had left no traces of any works of art. But complex cultures had already developed. Because ideas cannot be fossilized, there is much that will never be known about Paleolithic society.

Very little is known about its religion, but inferences have been drawn from certain ritual burial practices. For example, red ocher — presumably symbolizing blood — was sprinkled on corpses, and various objects of personal adornment (such as necklaces) were buried with them.

The bodies were arranged in the fetal position, often oriented toward the east and the rising sun, which must have seemed reborn with every new day. Each of these practices has been interpreted as a sign of belief in life after death. They provide some insight into the way Paleolithic people might have answered the third question at the start of this chapter: Where are we going?

Paleolithic society was a culture of hunters and gatherers, who lived communally. They built shelters at cave entrances, under rocky overhangs. Their tents were made of animal skins and their huts of mud, stone, and bone. Fire had already been used for some 600,000 years, and there is evidence of hearths in Paleolithic homes.

Although the invention of writing was still far off, people had learned to make marks on hard surfaces, such as bone and stone, which suggests that they were keeping track of time. Language had been developed — the ability to communicate with words and tell stories — which in itself requires a sense of sequence and time. It is likely that groups of craft workers functioned independently.

The earliest examples of western art that have been preserved correspond roughly with the final stages of the Ice Age in Europe. As the huge glaciers that had covered the continent receded, it seems that people began making art, and some of it has survived. The first evidence dates back to about 30,000 B.C., which marks the beginning of the Late or Upper Paleolithic period. Before that time, the making of objects probably had a utilitarian, rather than artistic, purpose. It is important to remember, however, that our modern concept of art would have been alien to many of these earlier civilizations.

Sculpture. Perhaps the most famous Paleolithic sculpture is the small limestone statue of a woman, the Venus of Willendorf (fig. **3.1**), variously dated from 30,000 B.C. to 15,000 B.C. Although this figure can be held in the palm of one's hand, it is a **monumental** object with a sense of organic, if not entirely naturalistic, form. As a work of art, it is evidence of a well-developed esthetic sensibility and was probably carved by a trained artist. The rhythmic arrangement of bulbous oval shapes emphasizes the head, breasts, torso, and thighs. The scale of these parts of the

body in relation to the whole is quite large while the facial features, neck, and lower legs are virtually eliminated. The arms, resting on the breasts, are so undeveloped as to be hardly noticeable. The Venus of Willendorf is a strikingly expressive figure. But what does it "mean" and what were the intentions of the artist who carved it?

There are only partial answers to such questions. The artist apparently did not envisage a naturalistic representation of an obese woman or the figure would have had fat arms as well as a fat body. Furthermore, comparison of the front with the side and back shows that, although it is a sculpture in the round, the most attention has been lavished on the front. This suggests that it was intended to be seen frontally. Since the artist has emphasized those parts of the body related to reproduction and nursing, most scholars agree that the Venus of Willendorf is a fertility figure. But even so, the sculpture is symbolic. A literal representation of a pregnant woman would have had larger arms, some facial features, and a neck.

This little figure is called a Venus, after the Roman goddess of love and beauty, as a modern gloss — for there is no evidence as to whom (if anyone) it was meant to represent. It is, in fact, one of a number of prehistoric figurines named Venus by modern scholars. Many have been

Carving

Carving is a subtractive technique in which a sculptor uses a sharp instrument, such as a knife, gouge, or chisel, to remove material from a hard substance such as bone, wood, or stone to make an image. When the image is complete, it can be sanded, filed, or polished to create a smooth or shiny surface. The Venus of Willendorf was not polished, although other Paleolithic sculptures were. However, it was made of limestone, a substance that does not polish very well in comparison with other types of stone.

discovered throughout the European regions that were inhabited by family groups during the Stone Age. All of these figures exaggerate the breasts and pelvis, suggesting a cultural preoccupation with fertility and survival.

Most of the prehistoric Venuses are sculptures in the round, but Paleolithic artists also made relief sculpture. A good example of low relief is the so-called Venus of Laussel (fig. 3.2). Traces of red color on it might have represented the blood of childbirth, an association reinforced

3.1 Venus of Willendorf, from Willendorf, Austria. c. 30,000–15,000 B.C. Limestone, 4½ in (11.5 cm) high. Naturhistorisches Museum, Vienna.

3.2 Venus of Laussel, from Laussel (Dordogne), France. c. 30,000–15,000 B.C. Limestone, 17⅜ in (44 cm) high. Fouilles Lalanne, Musée d'Aquitaine, Bordeaux.

by the form itself. The pelvis and breasts are exaggerated and the face featureless, although the arms are slightly more prominent than those of the Venus of Willendorf. In her right hand, the Venus of Laussel holds an object, perhaps a **cornucopia,** or horn of plenty. The gesture of the left hand is unexplained but is remarkably similar to the gesture of later Venuses in western art (see fig. **15.14**).

In addition to female fertility sculptures and paintings of men either hunting, dancing, or wearing animal skins, Paleolithic artists produced many representations of animals. This reflects how vital success in hunting was to their survival. The animals most often represented are horses, bison, and oxen. Less frequently found are deer, mammoth, antelope, boar, rhinoceroses, foxes, wolves, and bears, plus a few fish and birds. A bison carved from reindeer horn (fig. **3.3**) illustrates the naturalism of Paleolithic animal art in contrast with the stylization and abstraction of human figures.

Cave Art. Carved and incised objects dating from the Late (or Upper) Paleolithic period have been found in an area extending from southern Europe to the former Soviet Union. Most extant Paleolithic art, however, is cave painting, which is largely confined to the limestone areas of southwest Europe. Particular concentrations are located in northern Spain, the Pyrenees, and the Périgord and Dordogne regions of France. The good state of their preservation is due mainly to the fact that the caves had been sealed up until their discovery in the past century. After exposure to the modern atmosphere, the rate of deterioration has been so great that some caves have been closed to the public.

Cave paintings are found primarily deep within cave systems, whose interiors are difficult to reach and uninhabitable. These areas seem to have served as religious sanctuaries where fertility and hunting rituals were performed. The proliferation of works of art in the inner sanctuaries of the caves points to an intimate relationship between art and religion. This persists in the western world until the seventeenth century A.D. and, to a lesser degree, to the present.

The most famous examples of cave art are the murals, or wall paintings (from the Latin *murus,* meaning "wall"), at Lascaux in the Dordogne (figs. **3.4** and **3.5**). They represent a wide range of animal species and a few human stick-figures.

Earth-colored pigments at Lascaux include brown, black, yellow, and red. They were ground from minerals such as ocher, hematite, and manganese and applied to the natural white limestone surface of the wall. The Lascaux artists created their figures by first drawing the outline and then filling it in with pigment. The pigment itself

3.3 Bison with turned head, from La Madeleine (Tarn), France. c. 11,000–9000 B.C. Reindeer horn, 4⅛ in (10.5 cm) long. Musée des Antiquités Nationales, St. Germain-en-Laye. The finely incised lines of the bison's mane and the sharp turn of the head reveal a keen observation of detail as well as the capacity to render the illusion of turning in space.

Categories of Sculpture

Sculpture in the round and **relief sculpture** are the two most basic categories of sculpture. Sculpture in the round is completely detached from its original material — one can go all the way around it. The Venus of Willendorf is an example, while the Venus of Laussel is a relief sculpture. It remains part of, or partly attached to, its original material — in this case limestone — so that there is at least one angle from which the image cannot be seen. Relief sculpture is more pictorial than sculpture in the round because the original material remains and forms a background **plane**.

There are different degrees of relief. In **high relief**, the image stands out farther from the background plane. In **low relief**, also called **bas-relief**, the image is closer to the background plane. When light strikes the image from an angle, it casts a larger shadow on high relief than on low relief and thus emphasizes the image more. Relief sculpture can also be **sunken** (**incised**), as in much ancient Egyptian carving (fig. **5.21**), in which case the image or its outline is slightly recessed into the surface plane.

Modeling

Modeling, unlike carving, is an additive process and its original materials, such as clay, are pliable rather than hard. The primary tools are the artist's hands — especially the thumbs — although various other tools can be used. Until the material dries and hardens, the work can still be revised. In later periods of western history, artists learned to **fire** clay (to heat it in a kiln or oven). Eventually they mastered the craft of **casting**, or reproducing, models in more durable materials such as bronze. These techniques are discussed more fully in later chapters.

Map of prehistoric Europe.

was stored in hollow bones plugged at one end, which may also have been used to blow the pigment onto the wall. Actual bone tubes, still bearing traces of pigment, have been found in the caves. These finds provide a good example of the way in which deductions about the use of objects in a prehistoric society are made. Perhaps if the bones containing pigment had been found out of context, far from the paintings, different conclusions about their use would have been drawn.

The Lascaux animals are among the best examples of the Paleolithic artists' ability to create the illusion of motion and capture the essence of each species by slightly exaggerating characteristic features. The diagonal plane of the long white bull (fig. **3.4**) and its outstretched legs create the impression that it is running downhill. One Lascaux painting that has given rise to various

interpretations is the so-called Chinese Horse (fig. **3.5**), whose sagging body suggests pregnancy and even imminent delivery of the foal. In this detail the two diagonal forms, one almost parallel to the horse's neck and the other overlapping its lower outline, have been variously identified. Some scholars think they are arrows, while others have identified them as phallic symbols related to a male–female polarity in the world view of Paleolithic society, or plant and branch forms associated with the seasonal cycles of animal reproduction. These interpretations are not necessarily mutually exclusive. Rather, they reveal the ability of Paleolithic artists to produce complex symbolic imagery and our own difficulty in reading it.

Scholars generally do agree that the inaccessible location and ritual associations of cave art indicate a religious and symbolic purpose. The fact that animals are painted on top of one another reinforces this view, for it suggests that the act of making the image was an end in itself and that the artist was not primarily concerned with decora-

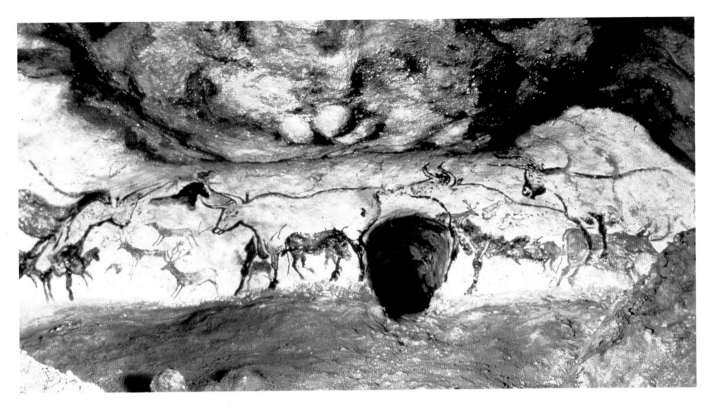

3.4 (above) Hall of Running Bulls, Lascaux (Dordogne), France. c. 14,000–10,000 B.C. Paint on limestone rock, individual bulls 13–16 ft (3.96–4.88 m) long. Note that the white bulls are superimposed over other animals. The cave artist did not cover up previous representations before applying new ones to the wall's surface, nor was a frame or outline used around the picture.

3.5 (right) Chinese Horse, Lascaux. c. 14,000–10,000 B.C. Paint on limestone rock, horse c. 5 ft 6 in (1.42 m) long.

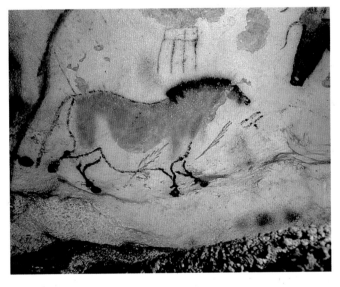

Pigment

Pigment (from the Italian *pingere*, meaning "to paint") is the basis of color, which is the most striking or eye-catching aspect of most painting. Pigments are colored powders made from organic substances, such as plant and animal matter, or inorganic substances, such as minerals and semi-precious stones. Cave artists either applied colored minerals directly to the wall, or mixed the pigments with a liquid — the **medium** or **binder** — before applying them.

Technically, a medium is a liquid in which pigments are suspended (but not dissolved). The term **vehicle** is often used interchangeably with "medium." If the liquid binds the pigment particles, it can be referred to as the binder or **binding medium**. Binders help paint to adhere to a surface, which increases the durability of the image. The cave painters used fats and oils as their binding media.

Pigment is applied to the surface of a painting, called its **support**. Supports vary widely in western art — paper, canvas, pottery, even faces. For the cave artist, the wall of the cave was the support.

tion. The traditional view is that cave paintings were a kind of picture magic in which capturing the image on a surface and immobilizing it stood for killing or capturing the real animal. Given the importance of successful hunting in Paleolithic society, it would not be surprising if magic rituals had surrounded such an essential activity.

Mesolithic Era (c. 10,000–8000 B.C.)

The Mesolithic era in western Europe was a period of transition more noteworthy for its important cultural and environmental changes than for its artistic legacy. It coincided with the end of the Ice Age and the development

of a more temperate climate in about 8000 B.C. Animals that had been hunted in the Paleolithic era died out or migrated. Communities started to settle around bodies of water, where fishing became a major source of food. Instead of gathering fruit and other forms of food, people began to cultivate cereals and vegetables. A more stable communal existence began to supplant the nomadic life of the Paleolithic era.

Neolithic Era (c. 8000–2000 B.C.)

In western Europe, the change from hunting and gathering to agriculture—and hence a less nomadic existence—contributed to the development of a new art form: monumental stone architecture. As was true of earlier art, the character of Neolithic stone structures was largely determined by religious beliefs. These buildings, or monuments, are referred to as **megaliths** (from the Greek *megas*, meaning "big") and are made of huge stones, assembled without the use of mortar.

Northern Europe (especially Britain and France), Spain, and Italy contain some of the most impressive megalithic architecture. Three distinctive stone structures regularly occur in these regions: **menhirs, dolmens,** and **cromlechs** (the terms are Celtic in origin). They are not only visually impressive and mysterious reminders of our ancient past, but are also imbued with fascinating symbolic associations. For megalithic builders, stone as a material was an integral part of an ancestral cult of the dead. Whereas Neolithic dwellings in western Europe were made of impermanent material such as wood, the "houses of the dead," or tombs, were erected in stone so that they would outlast mortal time. Even today we associate these qualities of durability and stability with stone. For example, we speak of things being "written in stone" when we mean that they are immutable and enduring, and to "stonewall" means to make a proceeding last as long as possible. One who is "stoned" is unable to move because of an excess of drugs or alcohol.

3.6 Alignment of menhirs, Carnac, France. c. 3000 B.C. Stone, 6–15 ft (1.83–4.57 m) high. A small village has grown up around the Carnac menhirs. They are arranged in parallel rows nearly 13,000 feet (4000 m) long, and the menhirs themselves number almost three thousand.

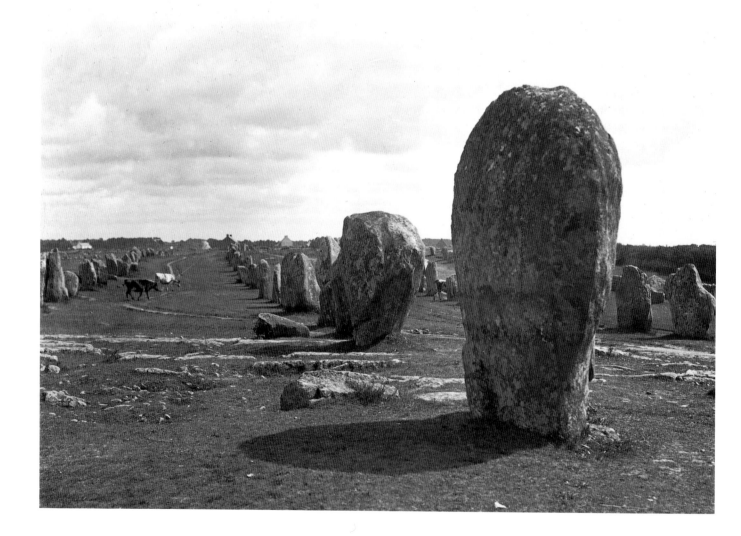

Menhirs. Menhirs (from two Celtic words, *men*, meaning "stone" and *hir*, meaning "long") are single, unhewn or slightly shaped single stones (**monoliths**), usually standing upright on the ground. They were erected individually, in clusters, or in rows as at Carnac in Brittany (fig. **3.6**). Carnac was probably an important Neolithic religious center in what is now northern France. Menhirs apparently symbolized the "body" or dwelling of the dead, and were endowed with a phallic character as fertilizers of the earth.

Dolmens. Dolmens (from the Celtic *dol*, meaning "table") are chambers or enclosures consisting of two or more vertical stones that support a large single stone, much as legs support a table (fig. **3.7**). The earliest dolmens were built as tombs — each enclosed a dead body. Later additions turned them into corridors or passageways. Some interior dolmen walls were decorated with sculptures and others were painted. Occasionally, a pillar stood in the center of the burial chamber. Dolmens, like menhirs, were imbued by Neolithic people with symbolic associations. Evidently this symbolism linked eternity with the durability of stone as material for the houses of the dead, in contrast to the impermanence of houses built for the living.

Cromlechs. Cromlechs (from the Celtic *crom*, meaning "circle" and *lech*, meaning "place") are megalithic structures in which groups of menhirs are arranged to form circles or semicircles. Britain has by far the greatest number of Neolithic stone circles. Even though the meaning of the circular shape in the Neolithic era is not definitively known, Neolithic builders evidently attributed a sacred quality to it.

The most famous Neolithic cromlech in western Europe

The Celts

The Celts were a group of peoples first identified in the basin of the upper Danube and southern Germany in the second millennium B.C. Although of mixed origins, they spoke related Indo-European languages. From around the beginning of the ninth century B.C., the Celts began to migrate throughout western Europe, occupying France, Spain, Portugal, northern Italy (they sacked Rome in 390 B.C.), the British Isles, and Greece. Gaelic-speaking Celts settled in Ireland, Scotland, England, and Wales. Celtic dialects are still spoken in parts of Britain and northern France.

The Celts had a rigidly organized social structure under the ultimate rule of a chief. They worshiped many gods and believed in the immortality of the soul. Celtic priests, called Druids, supervised education, religion, and the administration of justice. The rich Celtic oral tradition forms the basis of many European folk and fairy tales.

is Stonehenge (fig. **3.8**), which was built in several stages, from roughly 3000 to 1800 B.C. Rising dramatically from Salisbury Plain in southern England, Stonehenge has fascinated its visitors for centuries. The plan in figure **3.9** includes all stages of construction, with the dark sections showing the megalithic circles as they stand today. Many of the original stones have now fallen down. The aerial view in figure **3.8** shows the present disposition of the remaining stones — the inner circles — and the modern highway nearby.

This circular area of land on a gradually sloping ridge was a sacred site before 3000 B.C. Originally, barrows containing individual burials were surrounded by a ditch roughly 350 feet (107 m) in diameter. A mile-long "avenue" was hollowed out of the earth and ran in an

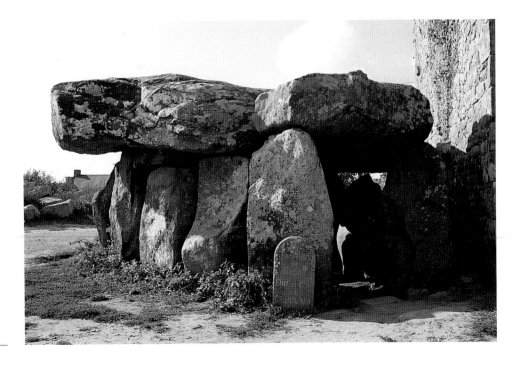

3.7 Dolmen, Crucuno, north of Carnac. Stone.

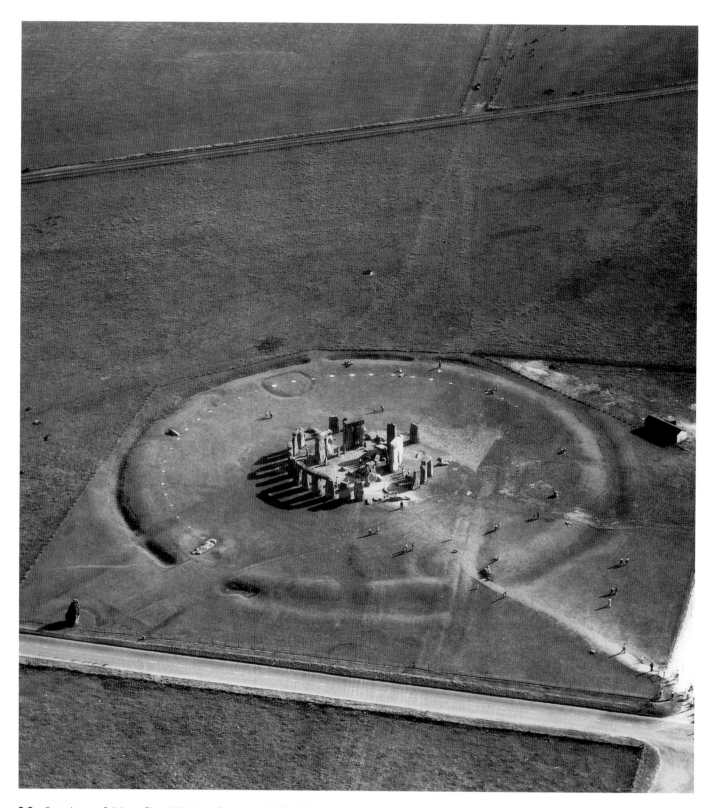

3.8 Stonehenge, Salisbury Plain, Wiltshire, England. c. 3000–1800 B.C.
Stone, diameter of circle 97 ft (29.57 m), height c. 13 ft 6 in (4 m).
Interpretations of this remarkable monument have ranged from the
possible — a kind of giant sundial, or a Druid ritual site — to the purely
fanciful — a form of architectural magic conjured by Merlin, King
Arthur's magician.

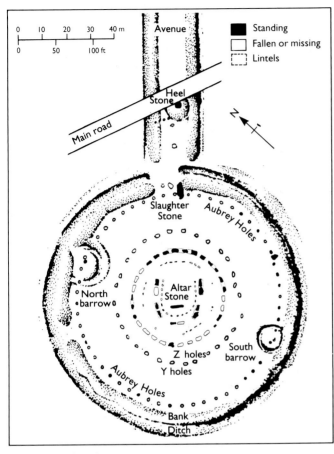

3.9 Plan of Stonehenge.

Post and Lintel Construction

Post and lintel construction is a system in which vertical uprights (posts) support a horizontal (the lintel). The most basic, single post and lintel form is the **trilithon** (fig. **3.10**).

In later eras, this simple post and lintel system was elaborated into highly complex structures (see p.108).

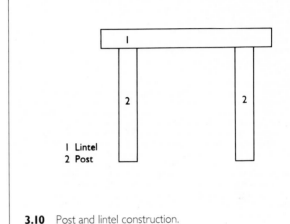

1 Lintel
2 Post

3.10 Post and lintel construction.

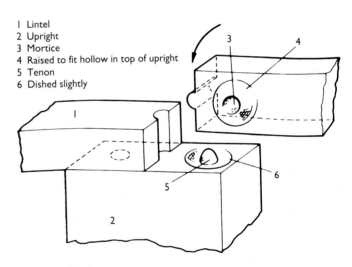

1 Lintel
2 Upright
3 Mortice
4 Raised to fit hollow in top of upright
5 Tenon
6 Dished slightly

3.11 Lintel and tenon.

east–west direction. Fifty-six pits (known as Aubrey Holes after their seventeenth-century discoverer) were added inside the circular ditch and filled with rubble or cremated human bones in about 2800 B.C. Around the same period, the Heel Stone was set in place outside the ditch in the entrance causeway to the northeast — this is a block of **sarsen** (a local sandstone) 16 feet (4.88 m) high. The first stone circle, consisting of smaller stones called bluestones and imported from Wales (over a hundred miles away), was constructed in about 2500 B.C.

Over the next 400 years, a new group of people settled in western Europe and was assimilated into the native population. The origins of these Beaker People, so-called after their beaker-shaped pottery, are still a matter of debate. They brought with them new building techniques, pottery, and a knowledge of metalworking. Partly as a consequence of these developments, the Stone Age gave way to the Bronze Age. Nevertheless, before the total disappearance of the Stone Age in western Europe, its most famous architectural monument was completed, apparently by the Beaker People themselves. In the final stages of the construction of Stonehenge, big sarsen blocks were brought to the site from Marlborough Downs, a distance of some twenty miles. From these larger monoliths, the outer circle and inner U-shape were constructed.

The final monument at Stonehenge is a series of concentric circles and horseshoe or U-shaped curves (fig. **3.9**). The outer circle is made of connected posts and lintels. Each post is a sarsen block 13 feet (3.96 m) high, and is rougher on the outside than on the inside, bulging at its center and then gradually tapering at the top. Projecting above the posts were **tenons** which fitted into holes carved out of the lintels (fig. **3.11**). The lintels were slightly curved to create a circle when attached end-to-end. They were more leveled and smoother than the posts, thereby creating a unified circular plane of movement.

From inside the ring (fig. **3.12**) one can see part of the outer ring (on the left) and an individual post and lintel (on the right). The second, inner circle consists entirely of single upright bluestones. Inside those are five gigantic trilithons (in which a pair of sarsen posts support a single lintel) arranged in a U shape. An even smaller U shape of bluestones parallels the arrangement of the five posts and lintels. We do not know how the bluestones weighing up to 40 tons (40,640 kg) and the sarsens weighing up to 50 tons (50,800 kg) were transported, or how the lintels were

raised above the posts. Within the U of bluestones one stone lies horizontally on the ground. This is referred to as the altar stone, although there is no evidence that it was ever used for sacrifice.

While continuing archeological activity steadily increases our knowledge of Stonehenge, we still cannot identify its purpose with certainty. Clearly the presence of circular stone rings throughout western Europe points to a common purpose. Some scholars think that rites, processions, and sacred dances were held in and around the megalithic structures. It is possible that such rites celebrated the resurgence of life with each coming of spring and summer. These practices correlate with what we know of early agricultural society — the timing of seasonal change was of crucial importance for survival. Also

3.12 The inside ring of Stonehenge.

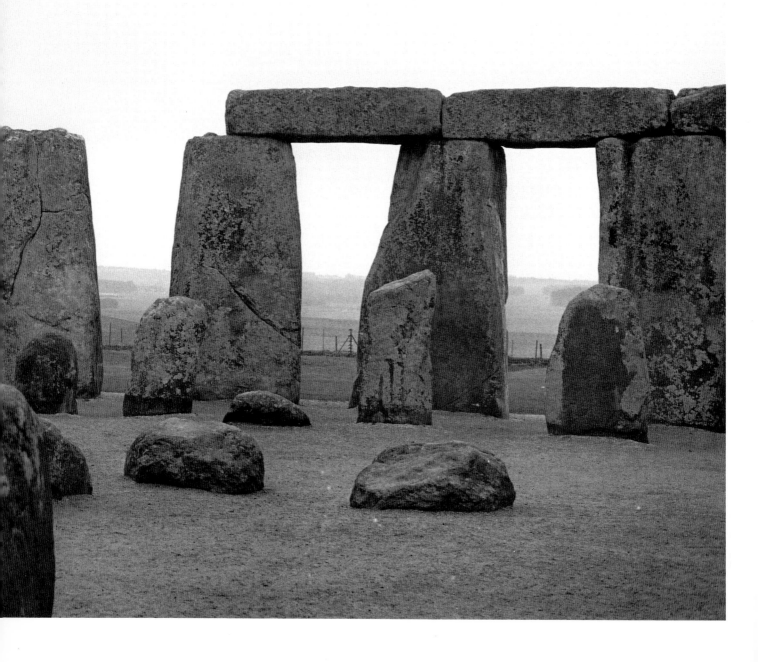

consistent with agricultural preoccupations are the interpretations of Stonehenge and other megalithic structures as astronomical observatories, used to predict lunar eclipses and to keep track of seasonal change. Carnac (fig. **3.6**) has been described as an observatory in which each stone functions as a point on a landscape graph. Elsewhere, direct evidence of astronomical markings on carved stones has been found. The circular monuments, in particular, are aligned according to the positions of the sun and moon at critical times of year. Earlier cromlechs were oriented toward sunrise at the winter solstice, and later the orientation was changed to summer. At Stonehenge, the avenue is aligned with the rising summer sun. An observer standing in the middle of the circle in about 1800 B.C. would have seen the sun rise over the Heel Stone

on 21 June, the summer solstice. Other stones are aligned with the northernmost and southernmost points of moonrise.

The greatest megalithic monument of the Neolithic era in western Europe was also the last. Around 2000 B.C., as the use of metal increased, the construction of large stone monuments declined. It is likely that there were also climatic reasons for this change. Stonehenge and the other megaliths of western Europe are roofless open-air structures, with the ground itself as the floor. The absence of a roof reinforces the relationship of the buildings with the sky and celestial phenomena. But this degree of openness required temperate conditions. By about 1500 B.C., the climate of northern and western Europe had changed to the damp, cool, cloudy conditions we know today.

The Ancient Near East

It is in the ancient Near East that people first learned to write—a momentous development in human history that cannot be overestimated. With the invention of writing, people could keep records and create a literature, whereas previously they had had to rely on images and oral tradition. The ancient Near East produced the first known epic poetry, written myths, and hymns. These works, which were based on even earlier traditions, provide insight into the origins of human thought and civilization. They shed light on the artistic products of ancient Near Eastern civilization in a way that was not possible in preliterate times. Before discussing the invention of writing and its relation to art history, however, we shall consider certain aspects of ancient Near Eastern Neolithic culture.

Neolithic Era (c. 8000–4000 B.C.)

As was true of Neolithic cultures in western Europe, those in the Near East emerged as a result of the transition from hunting and gathering to agriculture and the consequent domestication of animals. Agricultural rituals were developed to celebrate fertility and the vegetation cycles of birth–death–rebirth, and concern for the dead is evident from burial practices. Perhaps the most constant artistic and religious presence in the Neolithic religions of the Near East was the mother goddess and her male counterpart. Architecture of the period reflects increasingly elaborate concepts of sacred space—religious buildings represent the cosmic world of the gods. Masonry walls and town planning both date from the Neolithic era. And pottery with artistic as well as utilitarian importance began to be made.

Jericho

Dating back to about 8000 B.C. and located on the West Bank of the River Jordan in modern Israel, the Neolithic city of Jericho is one of the world's oldest fortified settlements. It was surrounded by a ditch and walls 5 to 12 feet (1.5–3.7 m) thick, from which rose a tower some 30 feet (9 m) high. Much later—in the biblical era—Joshua

attacked Jericho (Joshua 6), and his success lives on today in the refrain of the Spiritual: "Joshua fought the battle of Jericho, and the walls came tumbling down."

Jericho's walls protected a city of rectangular houses and public buildings made of mud brick and erected on stone foundations. The walls of the houses were plastered and painted with patterned designs. In addition to providing shelter for the living, dwellings in Jericho housed the dead. Corpses buried under the floors indicate an ancestor cult, a conclusion that is reinforced by one of the most intriguing of archeological finds, namely the Jericho skulls (fig. 4.1). These uncanny "portraits" are almost literal transitions between life and death. The dead person's skull served as a kind of armature on which to rebuild the

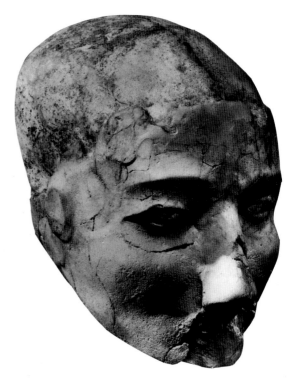

4.1 Neolithic plastered skull, from Jericho, Jordan. c. 7000 B.C. Lifesize. Archeological Museum, Amman, Jordan.

face in plaster and thus preserve the memory of the deceased. The hair was painted and cowrie shells were embedded in the eye sockets.

Çatal Hüyük

Evidence of ancestor cults is found throughout the ancient Near East. Similar burial practices occur at the fascinating Neolithic site of Çatal Hüyük in Anatolia (modern Turkey), which dates from around 6500 to 5500 B.C. To the best of our knowledge, it is the largest Neolithic site in the ancient Near East, and it is there that archeologists discovered ruins of one of the most advanced Neolithic cultures. Agriculture and trade were well established, and the organization of the town suggests town planning. However, there were no streets. Instead, one-story mud brick houses were connected to each other, with access apparently provided by ladders to the rooftops. Windows were small, and a ventilation shaft in each home allowed smoke from ovens and hearths to escape. The interiors of the houses were furnished with built-in benches that were used as seats and beds.

Little is known of the religious beliefs at Çatal Hüyük since it was a preliterate culture. However, the elaborate decorations of the shrines offer some clues that challenge us to read the meaning of their images. Representations of a mother goddess are very much in evidence (fig. **4.2**).

Map of the ancient Near East and Middle East.

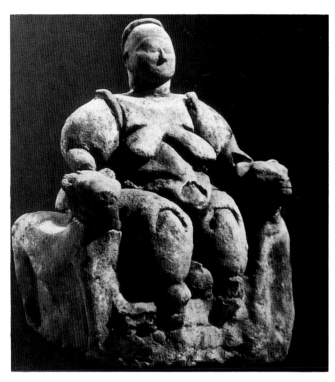

4.2 Mother goddess giving birth, from Çatal Hüyük, Turkey. c. 6500–5700 B.C. Baked clay, 8 in (20.3 cm) high. Archeological Museum, Ankara, Turkey. The seated mother goddess, depicted in relief, is giving birth. Her monumental form is reminiscent of the Venus of Willendorf (fig. **3.1**) and other prehistoric fertility figures.

Mesopotamia

Mesopotamia (in modern-day Iraq) is the focal area of ancient Near Eastern civilization. Its name is derived from the Greek *mesos* (meaning "middle") and *potamos* (meaning "river"). Mesopotamia is literally the "land between the rivers," bounded by the Tigris and Euphrates. Although the climate was harsh, the inhabitants learned irrigation and made the land fertile. The terrain was open and without natural protection. As a result, Mesopotamian cities were vulnerable to invasion, and their history is one of continuous warfare.

Chalcolithic Mesopotamia
(c. 4000–2800 B.C.)

The Neolithic period in Mesopotamia ended in about 4000 B.C. It was followed by the Chalcolithic ("copper stone") age, marking the development of metal technology. Hand-turned potter's wheels were introduced and the first known monumental temples were built. These temples were oriented with their corners toward the four cardinal points of the compass, which suggests religious beliefs relating earth (geography) and sky (astronomy) to ideas about sacred architecture. Reading back into the Chalcolithic era from historical documents, it is possible to discern the foundations of Mesopotamian religion.

Uruk Period (c. 3600–2800 B.C.)

The city of Uruk (biblical Erech and modern-day Warka) has given its name to a period that coincides with the last years of the Chalcolithic era in Mesopotamia, and is sometimes known as "Protoliterate."

It is thought that the New Year festival in honor of the goddess Inanna is the subject of the impressive alabaster vase (fig. **4.3**) found at Uruk. As tall as a medium-sized child, it is decorated with four horizontal bands (or **registers**) in low relief. At the top a goddess — possibly Inanna herself — receives a figure with a basket of fruit. In the next register, men bearing offerings walk from right to left. Below that, rams alternate with ewes and march around the vase in the opposite direction. Barley stalks alternate with date palms at the bottom.

Several conventions on this vase are retained in later ancient Near Eastern art. Though the figures are stocky and modeled **three-dimensionally**, they occupy a flat space, which is partly maintained by their pose. Legs and heads are in profile, the torso turns slightly, and the eye is frontal. There is no indication of three-dimensional space behind the figures, who walk as if on a thin ledge. In the top register, figures and objects seem suspended in midair.

Despite the flat space of the vase, and of much relief or pictorial art in ancient Mesopotamia, artists at Uruk were in command of three-dimensional form. This is demonstrated by the white marble head of a female (fig. **4.4**), a sculpture in the round. The face is organically modeled;

the cheeks bulge slightly, creating the natural line from the nose to the corners of the mouth, and the lower lip curves outward from the indentation above the chin. The asymmetry of the cheeks and the slight rise of the right side of the upper lip create the impression of an individual personality. The eyebrows would originally have been inlaid, and possibly other additions, such as hair or eyes, have also disappeared.

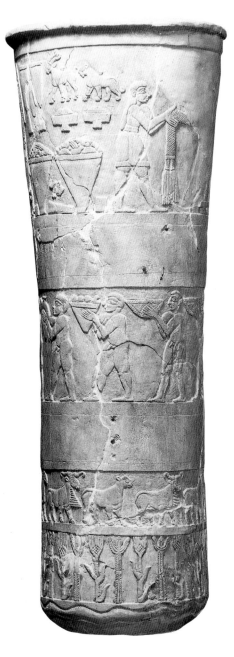

4.3 Sculpted vase, from Uruk, Iraq. c. 3500–3000 B.C. Alabaster, 36 in (91.4 cm) high. Iraq Museum, Baghdad. The abundance of vegetation in the iconography of this vase reinforces its relationship to festivals of seasonal renewal and rebirth. The association of these rites with Inanna, the goddess of love and fertility, is almost certainly derived from the role of the Neolithic mother goddess.

Mesopotamian Gods

In ancient Mesopotamian religion, the bull continued in its prehistoric role and was worshiped as the supreme male god under the name Anu. He was also the sky god and his roar was associated with the sound of thunder. Enlil was the thunder god, Ea (or Enki) the water god, Namar (or Sin) the moon god, Utu (later Shamash) the sun god, and Inanna (later Ishtar) the goddess of love and fertility.

Load-Bearing Construction

The ancient Near Eastern ziggurat is an example of **load-bearing construction**, which actually began in the Neolithic period. Ziggurats are built as thick masses with small openings, if any. They were usually solid, stepped structures, which tapered at the top and had greater support at the bottom.

Ziggurats

The **ziggurat**, derived from an Assyrian word and literally meaning "raised" or "high," is a uniquely Mesopotamian architectural form. Mesopotamians believed that each city was under the protection of a specific civic god who required an imitation mountain as a platform for a shrine.

The earliest extant structure believed to be a ziggurat is at Uruk (fig. **4.5**), and dates from between 3500 and 3000 B.C. It supported a shrine accessible by a stairway, and the ziggurat itself was a solid clay structure reinforced with brick and asphalt. As a symbolic mountain, the ziggurat satisfied one of the basic requirements of sacred architecture — namely, the creation of a transitional space between people and their gods.

4.5 The White Temple on its ziggurat, Uruk, c. 3500–3000 B.C. Stone and polished brick, temple c. 80 × 60 ft (24.38 × 18.29 m), Ziggurat c. 140 × 150 ft (42.7 × 45.7 m) at its base and 30 ft (9.1 m) high. It was called the "White Temple" because of the white paint on its outer walls.

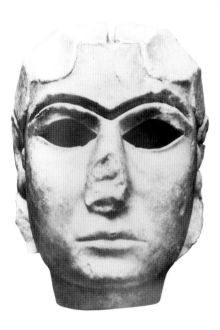

4.4 (above) Female head, from Uruk. c. 3500–3000 B.C. White marble, c. 8 in (20.3 cm) high. Iraq Museum, Baghdad.

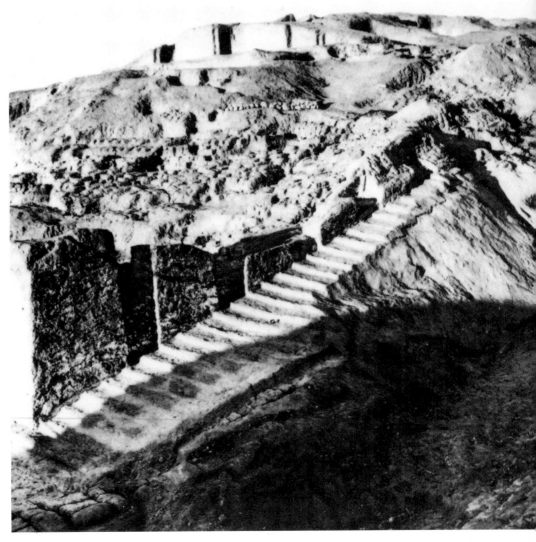

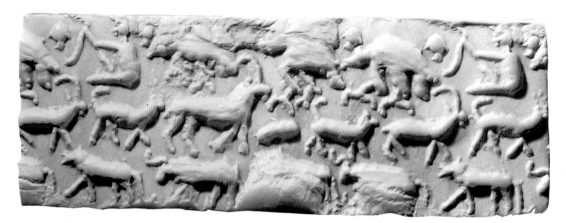

Cylinder Seals

The Uruk period also produced the earliest surviving examples of cylinder seals (fig. **4.6**), small stone cylinders engraved in **intaglio** with a design or a scene. Intaglio is a process where lines are carved into an object from which a print can be made. In the case of the cylinder seal, called **glyptic art** after the Greek word *glyptos* (meaning "carved"), the image was carved into the seal. When rolled across a pliable surface (such as a clay tablet or the sealing on a package of merchandise), it created an impression in relief. Seal impressions were used originally to designate ownership and keep inventories and accounts, and later to legalize documents. They offer a rich view of Mesopotamian iconography and of the development of pictorial style over a three-thousand-year period.

From Pictures to Words

The use of seal impressions to designate ownership contributed to the development of writing. Some time between about 3500 and 3000 B.C., abstract wedge-shaped characters began to appear on clay and stone tablets. To date, the earliest known written language is Sumerian. It is called **cuneiform** from the Latin word *cuneus*, meaning "wedge" (fig. **4.7**). Sumerian persisted as the language of the priestly and intellectual classes throughout Mesopotamian history. But after about 2000 B.C., the Semitic language Akkadian (which belonged to a people who may have come from the west) was more prevalent among the other levels of society. Sumerians and Akkadians coexisted for many centuries and the spread of their languages roughly corresponds to the two main geographical divisions of Mesopotamia, with Sumer in the south and Akkad in the north.

After the invention of writing by the Sumerians at Uruk, a Mesopotamian literature developed. The written word had begun in response to a practical need for record-keeping, but soon became a tool of creative expression. Much of the epic poetry of Mesopotamia deals with the origins of gods and human beings, the history of sovereignty, the founding of cities, and the development of civilization. These epic themes are also familiar in later

4.6 Cylinder impression and seal from Uruk c. 3500–3000 B.C. Iraq Museum, Baghdad.

western literature. The Sumerian flood myth, for example, describes an event much like the Old Testament Flood, which nearly destroyed the human race.

The gradual transition from preliteracy to full literacy occurred during the growth of powerful city-states ruled by dynasties, or families of kings. These rulers are recorded in the Sumerian king lists.

4.7 Clay tablet with cuneiform text, probably from Jemdet Nasr, Iraq. c. 3000 B.C. 3¼ × 3¼ in (8 × 8 cm). British Museum, London. This tablet is covered with cuneiform inscriptions, to be read from right to left. They were made by pressing a wedge-shaped stylus into the surface. In addition to the written word, the Sumerians used a numerical system with a base of sixty and a decimal system.

Gilgamesh

The *Epic of Gilgamesh* is the first known epic poem in western history and is preserved on cuneiform tablets from the second millennium B.C. It recounts Gilgamesh's search for immortality as he undertakes perilous journeys through forests and the Underworld, encounters gods, and struggles with moral conflict. The opening lines introduce Gilgamesh as the hero who saw and revealed the mysteries of life, even from primeval times:

> The one who saw the abyss . . .
> . . . he who knew everything, Gilgamesh,
> who saw things secret, opened the place hidden,
> and carried back work of the time before the Flood.[1]

Gilgamesh finally does attain immortality as the builder of Uruk's walls. He establishes urban civilization and lays the foundations of historical progress. The *Epic* says that he also "cut his works into a stone tablet." Just as the megalithic builders of Neolithic Europe revered stone as a permanent material, so Gilgamesh founded a city of stone walls and ensured that the record of his achievements was written in stone. This is consistent with the historical fact that the earliest writing and record-keeping was actually done on stone or clay tablets. It is thus literally as well as figuratively true that things written in stone and built in stone are intended to last.

Sumer: Early Dynastic Period

(c. 2800–2300 B.C.)

At the Sumerian site of Ur, the English archeologist Sir Leonard Woolley discovered evidence of a rich civilization that flourished in about 2500 B.C. The most impressive finds came from the "royal" cemetery, so-called because of the abundance of wealth in the tombs. The burial pits at Ur were filled with chariots, harps, headdresses, jewelry, and sculpture. An elegant lyre soundbox (fig. **4.8**) from Ur reflects not only the presence of music and musical instruments but also the superb craftsmanship of the early Sumerian artists.

The significance of the gold bearded bull's head and the inlay decoration at the front of the box (fig. **4.9**) is unknown, but it is likely that they served a ritual purpose and had mythological meaning. Certainly the image of the bull's head is known from 7000 B.C., when it apparently embodied the male god at Çatal Hüyük. At Ur, the head was combined with a stylized **lapis lazuli** human beard, which illustrates the typical ancient Near Eastern taste for combinations of species, or monsters.

4.8 Lyre soundbox, from the tomb of Queen Puabi, Ur, Iraq. c. 2685 B.C. Wood with inlaid gold, lapis lazuli, and shell. University Museum, University of Pennsylvania, Philadelphia.

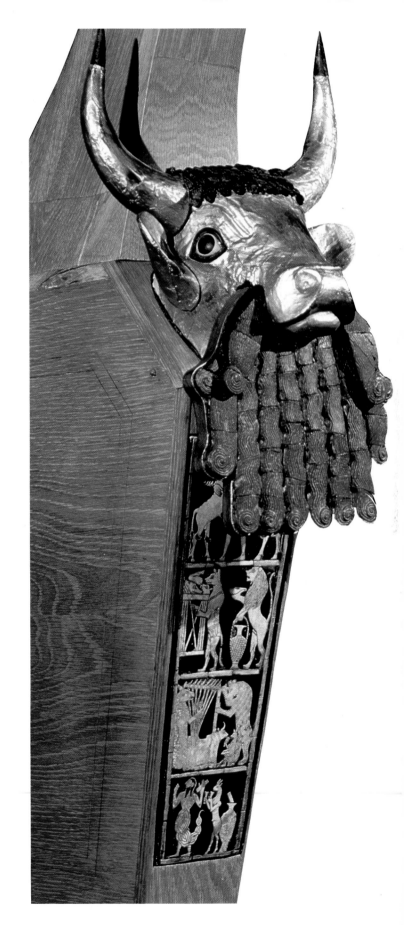

By the end of the Early Dynastic period, ancient literature was well established and epic poetry had become the medium for tales of gods and heroes. Records from the Early Dynastic city of Lagash (modern Telloh) refer to extensive architectural and political activity. Thereafter came a period of submission to the Akkadians in the north, followed by the Guti invasions.

Neo-Sumerian Culture (c. 2150–1800 B.C.)

After the worst of the turmoil, a revival of Sumerian culture, called Neo-Sumerian, occurred in the southern city-states. Gudea is the best-known king of Lagash from that period. He initiated an extensive construction program, including a number of temples. His building activities were facilitated by his ability to maintain peace in his own kingdom despite being surrounded by upheaval and warfare. As all Mesopotamian kings, Gudea was believed to embody the transition between gods and people. Just as the temple was seen to link earth with the heavens, so the Mesopotamian king was viewed as the gods' intermediary on earth. Such ideas form the basis for the belief in the divine right of kings.

Gudea's image is familiar from a series of similar statues made of **diorite**, a hard black stone that had to be imported. He either stands or sits, usually with hands folded in an attitude of prayer (figs. **4.10** and **4.11**). Standing or seated, Gudea wears a robe over his left shoulder, leaving his right shoulder bare, and the bottom of the robe flares out slightly into a bell shape. He is bald and sometimes wears a round cap (fig. **4.11**), which is decorated with rows of small circles formed by incised spiral lines. This insistence on circles in the hat is consistent with the general curvilinear character of all the Gudea statues.

The Gudea in figure 4.10 is compact; there is no space between arms and body, and the neck is short and thick. This contraction of space contributes to Gudea's monumentality, as does his controlled and dignified pose. The typical Mesopotamian combination of surface stylization with organic form can be seen in the juxtaposition of the incised eyebrows (fig. **4.11**) with the more naturalistically modeled nose, cheeks, and chin.

Akkad: Old Akkadian Period

(c. 2360–2180 B.C.)

When the Semitic civilization of Akkad merged with Sumerian culture, Akkadian became the dominant spoken language and the Akkadian god Marduk replaced the Sumerian god Enlil as the national god of Mesopotamia.

Sargon I. The first great Akkadian king, Sargon I, gained control of most of Mesopotamia and the lands beyond and established an important dynasty. The monumental bronze head of around 2250 B.C. (fig. **4.12**) is perhaps a portrait of him. Its power resides in its sense of

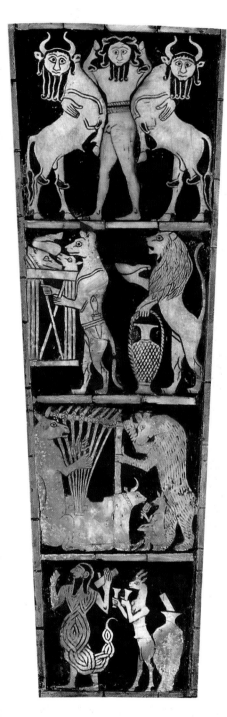

4.9 Inlay from front of lyre soundbox, detail of fig. **4.8**. Shell inlay set in bitumen, 13 in (33 cm) high.

4.8 and **4.9** The scorpion-man, who appears in the bottom scene on the front of the box, may be one of the fearsome guardians of the sun described in the *Epic of Gilgamesh*. In addition to monsters, ancient Near Eastern art is populated by animals that act like humans — for example, the goat holding a cup and walking upright. Such figures could represent mythological creatures or men dressed as animals.

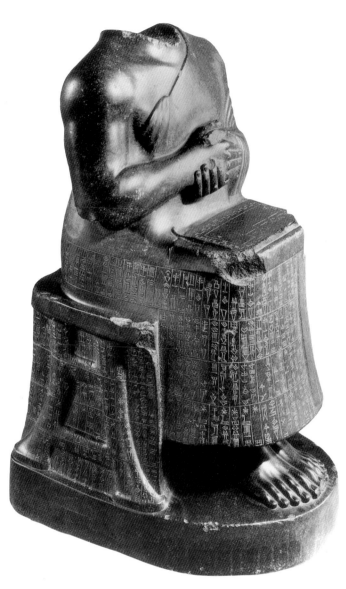

4.10 Gudea with temple plan, from Lagash, Iraq. c. 2150 B.C. Diorite, 29 in (73.7 cm) high. Louvre, Paris.

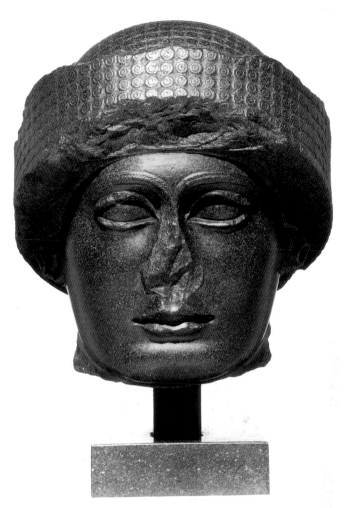

4.11 Head of Gudea, from Lagash. c. 2150 B.C. Diorite, 9 in (22.9 cm) high. Museum of Fine Arts, Boston.

4.10 and **4.11** Gudea left records of his accomplishments and ideas in his temples, and some of his statues incorporate inscriptions describing his building activity. His affinity with the Sumerian gods is revealed in his account of a dream in which a god instructed him to restore a temple. Gudea saw the radiant, joyful image of the god Ningirsu wearing a crown, and flanked by lions. He was accompanied by a black storm bird, while a storm raged beneath him. Ningirsu told Gudea to build his house, but Gudea did not understand until a second god, Nindub, appeared with the plan of a temple (fig. **4.10**) on a lapis lazuli tablet.

forthright self-confidence, as the facial features seem determined to emerge from a surrounding framework of stylized hair. The headdress consists of a dome resting on a circle and is decorated with incised triangular patterns.

At the back of the head, the hair is tied in a bun. Another ring of hair is visible below a band circling the forehead and directly under the hair. The large curved eyebrows meet on the strong, assertive nose. A striking V shape frames the lower face in the form of a beard made of energetic spiraling curves.

In this head, the energy and rhythm of the stylizations combine with an organic facial structure to produce an imposing air of regal determination.

Naram-Sin. Sargon's grandson, Naram-Sin, commemorated his victory over a mountain people, the Lullubians,

Sargon of Akkad

With Sargon, we encounter another "first" in western history — namely, the legendary birth story of one who is destined for greatness. These tales typically link humble origins to later fame. Sargon's story is inscribed on a tablet, and recounts his lowly illegitimate birth. His mother sends him down a river in a basket (which for us has echoes of the biblical account of Moses in the bulrushes). A man named Akki, who is drawing water, finds Sargon and raises him as his own son. Later Sargon rules in the city of Agade, or Akkad, whose inhabitants are called Akkadians.

4.12a and **b** (below) Head of an Akkadian ruler (Sargon I?), from Kuyunjik, Iraq. c. 2250 B.C. Bronze, 12 in (30 cm) high. Museum of Antiquities, Baghdad.

4.13 (right) Victory stele of Naram-Sin. c. 2300–2200 B.C. Pink sandstone, 6 ft 6 in (1.98 m) high. Louvre, Paris. This stele suffered an ironic twist of fate when it was taken as booty by invaders from the northeast. What had been created to mark an Akkadian victory was looted to mark their defeat.

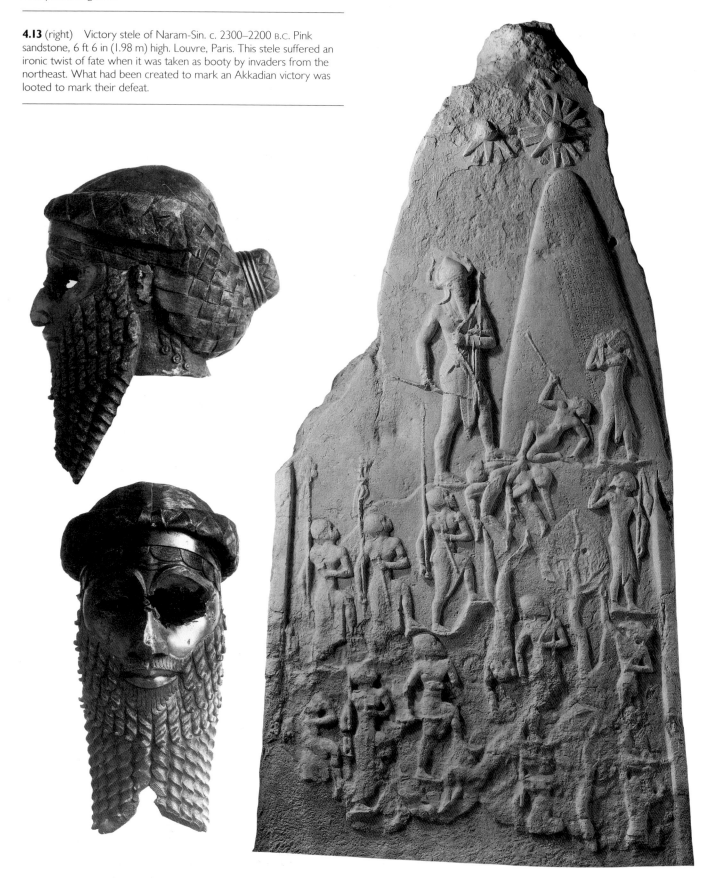

in the **stele** in figure **4.13**. The figures are set in a land-scape background, with stars shining over a triangular mountain at the top. Naram-Sin is depicted as a god by the horned cap of divinity, and he dominates the scene by virtue of his large size and central position above the other figures. Two defeated enemies are before him, one praying for mercy and the other trying to pull a spear from his neck. Naram-Sin's victorious followers march in relentless unison up the mountain while the defeated soldiers fall. This opposition exemplifies the convention in which going up denotes success and downward movement, or falling, denotes failure or death. In a related convention, Naram-Sin steps on a defeated foe, which indicates triumph or victory.

Babylon (c. 1830–539 B.C.)

Continuing warfare between Mesopotamian city-states led to the frequent rise and fall of different civilizations. Some two centuries into the second millennium B.C., the first dynasty of Babylon was established.

Old Babylonian Period (c. 1830–1550 B.C.)

Under the rule of King Hammurabi (c. 1792–1750 B.C.), Babylon gained control of Mesopotamia. Hammurabi is best known for his law code, inscribed on a black basalt stele (fig. **4.14**). The law code of Hammurabi stands as an important marker of legal history and of the relationship

The Law Code of Hammurabi

The text of Hammurabi's law code, comprising three hundred statutes, is written in Akkadian in fifty-one cunei-form columns. It provides a unique glimpse into the social and legal structure of ancient Mesopotamia. Although the stated purpose of Hammurabi's code was to protect the weak from the strong, it also maintained traditional class distinctions. Thus the lower classes were more severely punished for crimes committed against the upper classes than vice versa. There was no intention of creating social equality by protecting the weak, or by caring for orphans and widows. Rather, the aim was to maintain the continuity and stability of society.

Three types of punishment stand out in Hammurabi's law code. The talion law — the equivalent of the biblical "eye for an eye" — operated in a provision calling for the death of any builder whose house fell down and killed its owner. In some cases, the punishment fitted the crime. For example, if a surgical patient died, the doctor's hand was cut off. Perhaps the most illogical punishment was the ordeal in which the guilt or innocence of an accused adulte-ress depended on whether she sank or floated when thrown into water — floating indicated guilt! Although such punishments may seem harsh and irrational, they neverthe-less characterize the style of criminal justice practiced in western civilization until quite recently.

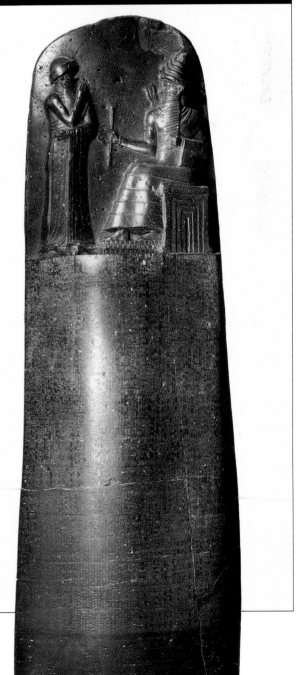

4.14 Stele inscribed with the law code of Hammurabi. c. 1792–1750 B.C. Basalt, height of stele c. 7 ft (2.13 m), height of relief 28 in (71.1 cm). Louvre, Paris. Hammurabi stands before the Akkadian sun god, Shamash, who is enthroned on a symbolic mountain. Shamash wears the horned cap of divinity and an ankle-length robe. He holds the ring and rod of divine power and justice, and rays emanate from his shoulders. Here the conventional relief pose of the god serves a double purpose: the torso's frontality communicates with the observer, while the profile head and legs turn to Hammurabi. Hammurabi receives Shamash's blessing on the law code, inscribed on the remainder of the stele. The god's power over Hammurabi is evident in his greater size — were Shamash to stand, he would tower over the mortal ruler.

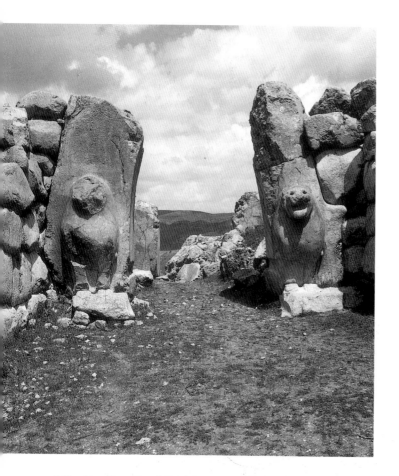

4.15 Lion Gate (Royal Gate), Boghazköy, Turkey. c. 1400 B.C. Stone, lions c. 7 ft (2.13 m) high. The visitor's direct confrontation with the lions, combined with their open, roaring mouths, served as a warning and symbolically protected the inhabitants against the forces of evil.

of law to the very fabric of society. Its cultural importance is reflected in its value as booty—Hammurabi's stele, as well as Naram-Sin's, was carried off to Susa by invading Elamite armies.

Hittite Empire (c. 1450–1200 B.C.)

In about 1500 B.C., Babylon was sacked by the Hittites, an Anatolian people whose capital city, Hattusas, was located in modern Boghazköy, in the northeast of central Turkey. Their greatest accomplishments in the arts occurred under their empire, which was as mighty as those of Babylon and Egypt (see Chapter 5). The Hittites, like the Mesopotamians, kept records in cuneiform on clay tablets. These were stored on shelves, as in modern libraries, according to a cataloguing and labeling system. Their archives comprise thousands of tablets, and are the first records in an Indo-European language known to date. Thanks to these documents, Hittite culture and art are fairly well understood.

The western entrance to the citadel at Hattusas (fig. **4.15**) is a good example of the monumental fortified walls constructed by the Hittites. Guardian lions are a traditional motif in ancient art, and one which continues to the present. They project forward from the stone wall, literally emerging from natural into sculpted form. Their heads and chests are in high relief and some surface body details, such as mane, fur, and eyes, are incised.

Neo-Babylonian Period (612–539 B.C.)

By about 850 B.C., the Assyrians had taken control of Babylon. They ruled until the early seventh century B.C., when Nebuchadnezzar restored some of its former splendor.

The only extant example of monumental architecture from the reign of Nebuchadnezzar is the Ishtar Gate (fig. **4.16**), one of eight gateways with round arches located inside the city. Named after the goddess of love and fertility, the Ishtar Gate covered a procession route through the city. It was faced with blue-glazed enamel bricks and edged with white and gold geometric designs. Set off against the blue background are rows of bulls and dragons in relief, walking in a horizontal plane either toward or away from the arched opening.

Round Arches

An **arch** may be thought of as a curved lintel connecting two vertical supports, or posts. The round arch, as used in the Ishtar Gate, is semicircular and stronger than a horizontal lintel. The Romans developed rounded arches for many other purposes besides gateways (see Chapter 9). Later still, in medieval Europe, round arches were revived in Romanesque churches and cathedrals (see Chapter 12).

Glazing

Glazing bricks and other objects—pottery, for example—is done by covering the surface with a thin layer of color. The object is then fired, which fuses the color into the surface, resulting in a hard, colored **facing**.

4.16 (opposite) Ishtar Gate (reconstructed), from Babylon, Iraq. c. 575 B.C. Glazed brick. Staatliche Museen, Berlin. The gate is now restored and preserved in Berlin, but the slow uniform pace of the animals remains as a visual echo of its purpose — namely, to frame and highlight a procession. The idea of a gateway with a round arch as a kind of processional marker is one that continues throughout western history — for example, in the arches of Imperial Rome (see p. 142) and the Arch of Triumph in Paris.

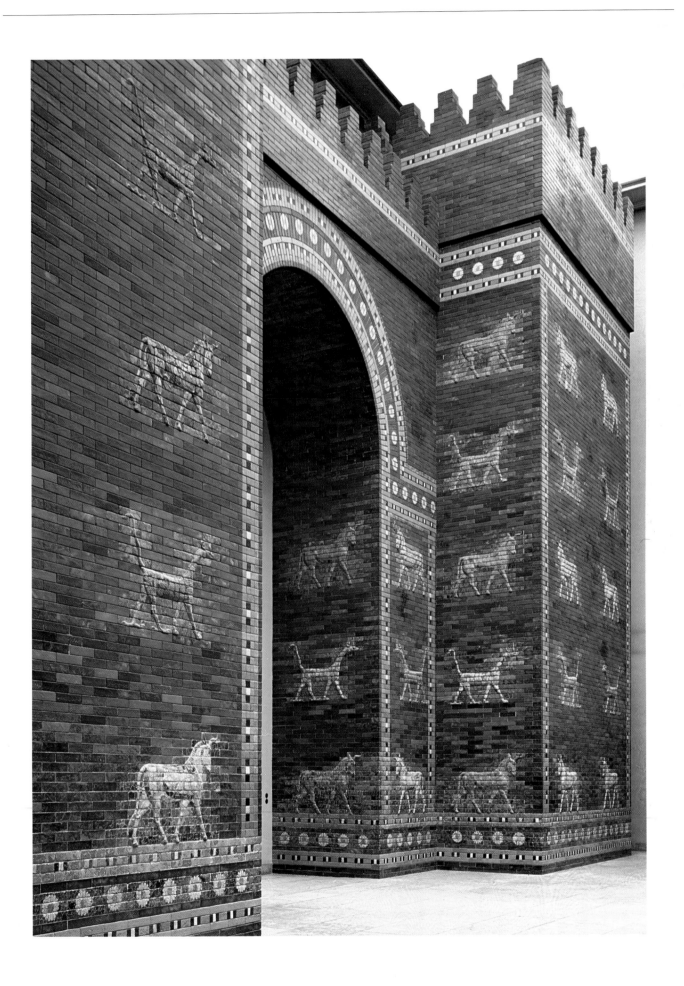

Assyria (c. 3000–612 B.C.)

The Assyrian civilization is named for Ashur, a city located by the Tigris River in northern Mesopotamia. Excavations carried out there in the early twentieth century uncovered a civilization dating back to 3000 B.C. Ashur was also the name of the national deity, roughly equivalent to the Babylonian Marduk and the Sumerian Enlil. By the end of Hammurabi's reign in around 1750 B.C., Ashur had become a prominent fortified city. By 1300 B.C., its rulers were in correspondence with the leaders of Egypt, which indicates that they had achieved international status.

Assyrian Kings

Under Assurnasirpal II, Assyria became a formidable military force. His records are filled with boastful claims detailing his cruelty. He says that he dyed the mountains red, like wool cloth, with the blood of his slaughtered enemies. From the heads of his decapitated enemies he erected a pillar, and he covered the city walls with their skins.

The last powerful king of Assyria, Assurbanipal II (668–633 B.C.), combined cruelty with culture. He established a great library, consisting of thousands of tablets recording the scientific, historical, literary, religious, and commercial pursuits of his time. Also included in his collection were the Mesopotamian Creation and Flood epics, which were not translated until the late nineteenth century. Today, most of Assurbanipal II's library is in the British Museum in London.

4.17 King Assurnasirpal II hunting lions, from Nimrud, Iraq. c. 883–859 B.C. Alabaster relief, 3 ft 3 in x 8 ft 4 in (99 cm x 2.54 m). British Museum, London.

Assyrian Empire (c. 1100–612 B.C.)

The Assyrian Empire is particularly well documented through texts and the remains of architectural and sculptural projects undertaken to reflect the glory and military might of its kings. The region in and around Assyria had a great deal more stone available than did the rest of Mesopotamia. As a result, the determination of the Assyrians to memorialize their accomplishments in stone could be satisfied without importing raw materials.

Reliefs

The best visual records of Assyrian might are the stone reliefs lining their palace walls. From the reign of Assurnasirpal II (c. 883–859 B.C.) — one of the most bloodthirsty Assyrian kings — comes a relief showing the king standing at the back of a horsedrawn chariot, aiming his bow and arrow at a rearing lion (fig. **4.17**). The king's dominance over the lions, a favorite motif in Assyrian art, is a metaphor for the subjugation of his people. The dynamic energy of the scene is reinforced by opposing diagonal planes and the accentuation of muscular tension. Overlapping creates the impression that the chariot is drawn by three horses.

Lamassu

The king's power was also symbolized by stone **lamassu** (fig. **4.18**), monumental guardians representing divine genii and guarding the palace entrances. Lamassu combine animal and human features — in this case, a bull's body and legs and a human head. Hair, beard, and eyebrows are stylized and each wears a cylindrical, three-horned crown of divinity.

Seen from the side, the relief aspect of the lamassu is more evident than it is from the front. The figure combines organic quality in the suggestion of bone and

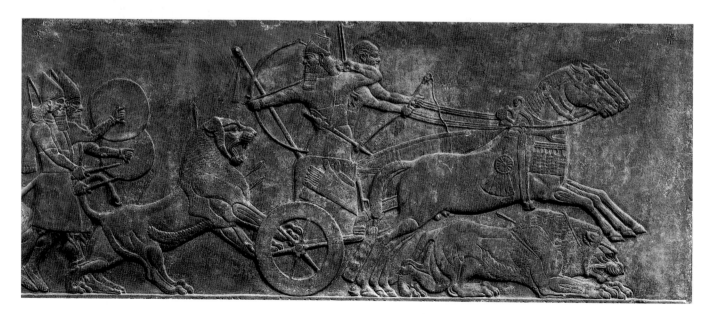

Ancient Iran (c. 5000–331 B.C.)

Present-day Iran (former Persia) is named after the Indo-European Aryans, a people of mixed background who are thought to have entered the Near East from the Russian steppes. Located between Mesopotamia and southern Russia, ancient Iran was the scene of numerous nomadic migrations. Many cultural and linguistic groups infiltrated the region and influenced its art.

As early as the fifth millennium B.C., a distinctive pottery style had emerged. A painted pottery beaker from Susa, the capital of Elam in the southwest, exemplifies the artistic sophistication of the Iranians at the very dawn of their history (fig. **4.19**). It combines elegant form with a preference for animal subjects. The central image is a geometric ibex, or wild goat, composed of two curved triangles. Its head and tail are smaller triangles with individual hairs on the tail and beard rendered as repeated diagonals. The ibex stands still and upright in contrast to the dogs, which race around the upper part of the beaker. A sense of slower movement is created by the repeated long-necked birds at the bottom.

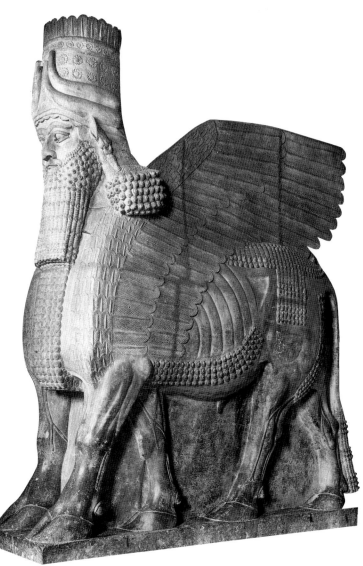

4.18 Lamassu, from the gateway, Palace of Sargon II, Khorsabad, Iraq. c. 720 B.C. Limestone, 14 ft (4.27 m) high. Louvre, Paris.

muscle under the skin with several patterns of surface stylization in the body hair. Rising from above the foreleg in a sweeping curve is a wing which fills up the limestone block. The head and crown are identical to those confronted on approaching the entrance. Thus, while the face itself is repeated, the crown is shared, thereby creating unity between front and side. Also unifying the transition from front to side is the fact that the side view of the lamassu has four legs and the front, two. In this unique arrangement, the lamassu conform to the architectural function of an entrance, which is to mark a point of access—they face the approaching visitor and seem to stride past as one enters.

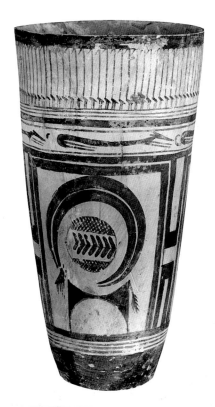

4.19 Painted beaker, from Susa, Iran. c. 5000–4000 B.C. Painted pottery, 11¼ in (28.6 cm) high. Louvre, Paris. By using the largest visible surface of the beaker for the standing ibex, and the top and bottom for the running and walking animals, the artist creates a unity between the painted images and the three-dimensional character of the object. The images make use of the fact that the viewer is more aware of the beaker's circularity at its rim and base than on the broader surface in between.

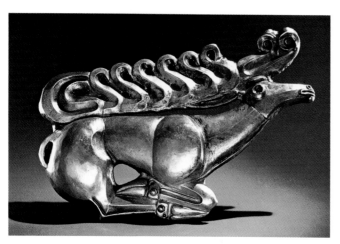

4.20 Stag, from Kostromskaya, Russia. 7th century B.C. Chased gold, 12½ in (31.7 cm) long. State Hermitage Museum, St. Petersburg. As with paleolithic cave paintings and carvings (see Chapter 3), this Scythian work is the product of artists familiar with the organic structure of animals that are important for their survival.

4.21 Apadana (Audience Hall) of Darius, Persepolis, Iran. c. 500 B.C. c. 250 sq ft (23.26 m²). The Apadana was decorated with a hundred columns each 40 feet (12.2 m) high. Originally painted, the shafts showed influence from other cultures, including Egypt and Greece, but the bull capitals were unique to Persia.

The Scythians

(8th Century B.C.–Early 6th Century B.C.)

The influence of Iranian art persists in the animal art of the Scythians, a migratory people from southern Russia. A stag from the seventh century B.C. (fig. **4.20**) is typical of Scythian gold objects. The artist has captured an organic likeness of the animal, while at the same time forming its antlers into an abstract repetition of curves and turning the legs into birds. Such visual metaphors are typical of the creative process. Although it is clear from the folded legs that the stag is not moving, the curvilinear pattern of circular antlers creates an illusion of motion.

Persian Empire (539–331 B.C.)

By the sixth century B.C., the Babylonians and the Medes had united against the Assyrians. Cyrus the Great led the Persians against Lydia, in Anatolia, in 546 B.C. and against Babylon in 539 B.C. Under Cyrus, the Medes and the Persians (who had been traditional enemies) united, and the Persians rose to dominance in the Near East. They created an empire that was even larger and more powerful than that of the Assyrians. The Assyrians influenced the Persians in several ways, most notably in their determination to celebrate kingship on a grand scale.

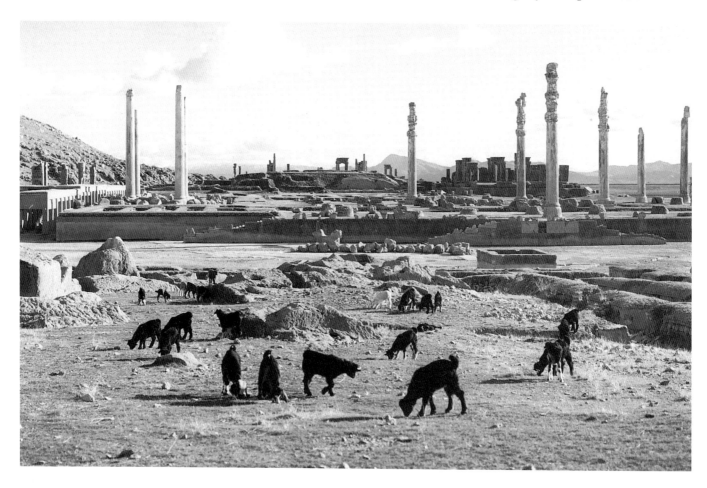

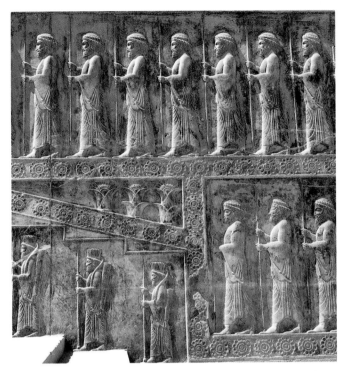

4.22 Subjects bringing gifts to the king, relief on the stairway to the Audience Hall of Darius, Persepolis.

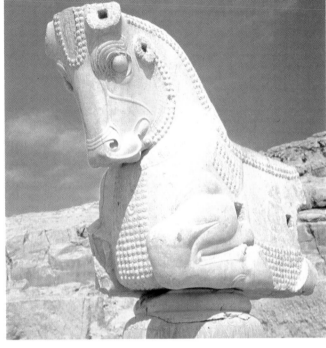

4.23 Bull capital, Persepolis. c. 500 B.C.

Both the culture and style of the Persians are referred to as Achaemenid, or Achaemenian, after Achemenes, the founder of the dynasty. There were no Achaemenid temples — religious rituals were held outdoors, where fires burned on altars. The Persians followed Zoroaster, who taught that the world's two central forces were light and dark. Ahuramazda was light and Ahirman, similar to the Christian concept of evil, was dark.

The most elaborate Achaemenid architectural works were palaces. The best example is at Persepolis (Greek for "city of the Persians"). Started in about 520 B.C. by Darius I, work continued over many years under his successors, especially Xerxes and Artaxerxes I. Persepolis was built on a stone platform and consisted of multistructured rooms. The most important structure was the Apadana, or Audience Hall (fig. **4.21**), a columned chamber where the king received foreign delegations. The capitals were constructed in the form of double bulls facing in opposite directions (fig. **4.23**). With its legs tucked under its body, this bull has a dynamic organic quality despite its stylized details. The choice of a bull as the capital parallels the animal's connotations of power and fertility with those of the king. It is also an architectural metaphor for the position of the king as head of state.

Further emphasizing the king's grandeur are the reliefs lining the walls and stairways of the palace at Persepolis. In contrast to the aggressive military scenes on Assyrian reliefs, Persian reliefs depict tributes and offerings presented to the ruler. This distinction is consistent with the political styles of the two civilizations — unlike the cruelly repressive Assyrian Empire, the Persian Empire was generally administered in an orderly and peaceful way. At Persepolis, sculpted groups of delegates to the palace proceed solemnly around the walls. The wall in figure **4.22**, for example, is covered with tribute bearers marching toward the king. The broad, slightly curved folds of their drapery contribute to the sense of slow, ceremonial movement. Their stylizations, particularly the curls of hair and beard, are classically Achaemenid. The vast numbers of these relief figures, like the repeated columns and their bull capitals, focus attention — both formal and iconographic — on the centrality and greatness of the king.

Persian domination of the Near East came to an end nearly 200 years after Darius I began the palace at Persepolis. In 331 B.C., Alexander the Great of Greece conquered the Persians and went on to create the largest empire the world had ever known.

Columns

A **column** is an elaborated post within the post and lintel system of construction. At Persepolis, it consists of three main parts: a **base**, a vertical **shaft**, and a **capital**, which is directly below the horizontal lintel. The term "capital" comes from the Latin word *caput*, meaning "head," and refers to its position at the top of the column.

Ancient Egypt

Egypt was the home of the most powerful and lasting civilization in the ancient Near East. Located in northeast Africa, it was bordered on the north by the Mediterranean Sea, on the east by the Red Sea, and by vast deserts to the south and west. Egypt was called "the Gift of the Nile" — the world's longest river — because its annual floods kept the land fertile. Some 900 miles (1450 km) long, it flows through Egypt from its source thousands of miles to the south at the Victoria Falls. Ancient Egypt was divided into Upper Egypt in the south and Lower Egypt in the north, where the Nile delta empties into the Mediterranean (see the map on p.63).

In the Neolithic period, from about 7000 B.C., farming communities settled along the Nile. They used stone tools and made ivory and bone objects and handbuilt pottery. As in other Near Eastern Neolithic cultures, Egyptian burials indicate the prevalence of ancestor cults and a belief in life after death.

The Pharaohs

From approximately 3000 B.C., Egypt was ruled by pharaohs (kings), whose control of the land and its people was virtually absolute. Egyptian monumental art on a vast scale began with pharaonic rule, when King Menes (also known as Narmer) united Upper and Lower Egypt and established the first of the historical dynasties, or royal families. Monumental art in Egypt was above all an art of kings, which is reflected in the terminology of Egyptian history. The period from Menes's unification until about 1000 B.C. is divided into three time sequences: the Old Kingdom (c. 2700–2100 B.C.), the Middle Kingdom (c. 2100–1700 B.C.), and the New Kingdom (c. 1600–1000 B.C.). Each kingdom, in turn, was subdivided into dynasties. The two thousand years or so under discussion mark the period of Egypt's greatest and most durable power. Artists worked for the state and its rulers, within the strict confines of a political and religious hierarchy.

The one-hundred-year interruption between the Middle and New Kingdoms resulted from a foreign invasion by the Hyksos people. They are known for having introduced horsedrawn chariots into Egypt. During the New Kingdom, several important changes occurred. The first known queen, Hatshepsut, came to power and ruled Egypt from 1501 to 1482 B.C. Then in about 1365 B.C., the pharaoh Akhenaten tried to establish a new religion. But from the end of the New Kingdom, Egypt's preeminent position as a powerful monarchy was weakened by infiltration from other cultures. In 525 B.C., the Persians conquered Egypt, and in 332 B.C. Alexander the Great added both Egypt and Persia to his empire. After the death of Alexander in 323 B.C., Ptolemy took control of Egypt and his descendants ruled until the Roman conquest in 30 B.C.

Writing and Religion

Ancient Egyptian culture is well known from hieroglyphic texts (fig. **5.1**) in manuscripts and on paintings, sculptures, and buildings. **Hieroglyphs** (from the two Greek words *hieros*, meaning "sacred" and *glypho*, meaning "I carve") are a form of picture writing, as opposed to the more abstract cuneiform writing of Mesopotamia. The hieroglyphic texts have revealed a great deal about Egyptian religion and its influence on art and culture. A thorough examination of the complexity of Egyptian beliefs would require several volumes, and would be inappropriate here. But some discussion is necessary for even a preliminary understanding of Egyptian art.

Polytheism — the belief in many (Greek: *poly*) gods (Greek: *theoi*) — was a basic tenet of ancient Egyptian religion. Gods were manifest in every aspect of nature. They influenced human lives, ordered the universe, and were identified with the pharaoh. They could appear in human or animal form, or as various human and animal combinations. The Old Kingdom sky goddess was Hathor, a great horned cow, and the sky god was Horus, a falcon identified with kingship whose eyes were the sun and moon. Ancient Egyptians worshiped the Nile as Hapi, represented as both male and female because it was the source of agricultural fertility. Osiris, usually depicted in human form, was also a fertility god, and from the end of the Old Kingdom he was believed to rule the dead.

Death, for the ancient Egyptians, was as much a part of existence as life itself. In order to ensure a good afterlife, the deceased had to be physically preserved along with earthly possessions and painted scenes of daily activities (fig. **5.17**). During the first dynasty of the Old Kingdom, servants were killed in order to accompany the pharaohs to the afterlife. But by the Middle Kingdom, statues or paintings were considered adequate substitutes. An image of the dead person was needed which the *ka*, meaning "soul" or "double," could identify and reenter before proceeding on its journey into the next world.

Kings and their families had the means and the power to build more elaborate tombs than anyone else and to fill them with the most valuable objects. Largely because of the Egyptian attitude toward the afterlife, most art was inspired by the need to worship gods and prepare for death.

The links between divine and earthly power noted in earlier civilizations reappear in a ritual object decorated on both sides in low relief. The so-called Palette of Narmer (fig. **5.2**) dates to the beginning of pharaonic rule.

The large scene on the left is depicted according to certain conventions found in Mesopotamian art and which lasted for over two thousand years in Egypt. For example, King Narmer (Menes) is the biggest figure — his size and central position denote his importance. His pose, in which head and legs are rendered in profile and eye and torso in frontal view, is an Egyptian convention. The trapezoidal tunic does not account for the naturalistic twist at the waist. The entire body is flat, with certain details such as the kneecaps rendered as surface design, rather than as representations of underlying organic structure. Hanging from behind Narmer's tunic is a ritual bull's tail, identifying the king with the bull as a figure of power and fertility. Narmer wears the tall conical crown of Upper Egypt and threatens a kneeling enemy with a mace. He holds his enemy by the hair — an act that symbolizes conquest and domination. Two more enemies, either fleeing or already dead, occupy the lowest register of the palette. Behind Narmer on a suspended horizontal line is a servant whose small size, like the enemy's lowered position, identifies him as less important than the king. The servant holds Narmer's sandals, indicating that the king is on holy ground (just as modern Moslems remove their shoes before entering a mosque). In front of Narmer, at the level of his head, is the falcon god of sky and kingship, Horus. He holds a human-headed figure at the end of a rope. From the back of the figure rise six papyrus plants, which represent Lower Egypt. The image of Horus dominating symbols of Lower Egypt thus parallels Narmer, as the king of Upper Egypt, subduing an enemy.

At the top center of each side of the palette, the symbol of the king's name is framed by a rectangle known as a serekh. To left and right, frontal heads of the cow goddess Hathor imply that she guards the king by flanking his name and facing all who approach.

5.1 Rosetta Stone. 196 B.C. Basalt, 3 ft 9 in (1.14 m) high. British Museum, London. In 1799, French scholars with Napoleon's army in Egypt found a slab of stone in the town of Rosetta at the Nile delta. The identical text in three languages — Greek, late Egyptian, and hieroglyphics — was inscribed on its surface. In 1821, the French scholar Jean-François Champollion used his knowledge of the first two languages to decipher hieroglyphics, and the mysteries of ancient Egyptian civilization were revealed to the world.

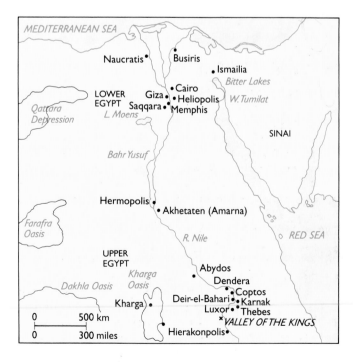

Map of ancient Egypt.

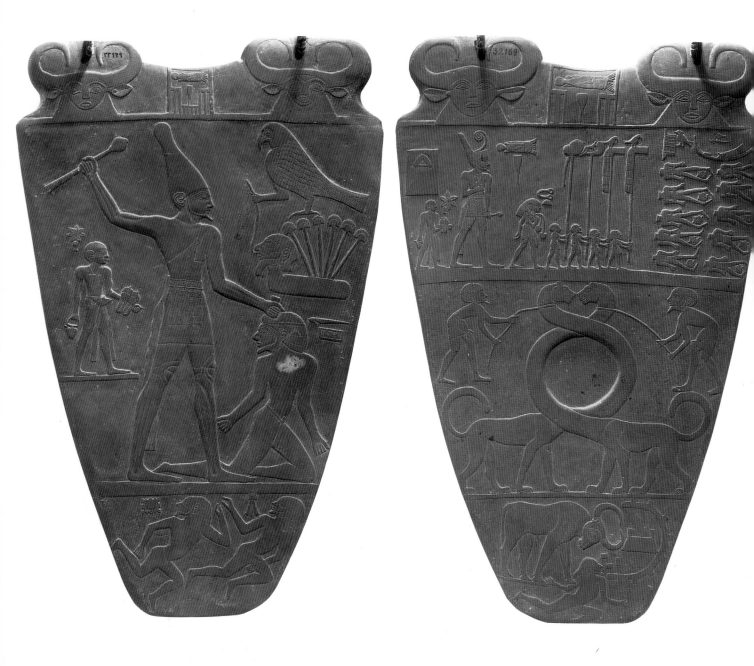

5.2a and **b** Palette of Narmer, from Hierakonpolis. c. 2700 B.C. Slate, 25 in (63.5 cm) high. Egyptian Museum, Cairo.

The reverse of the palette (fig. **5.2**) comprises three registers below the Hathor heads and the pharaoh's name. At the top, Narmer wears the crown of Lower Egypt. His sandal-bearer is behind him and he is preceded by warriors with upraised standards. On the far right, ten decapitated enemies lie with their heads between their feet. These figures are meant to be read from above, as a row of bodies arranged side by side. Such shifting viewpoints are characteristic of Egyptian pictorial style. The central register depicts two felines, roped by two bearded men. Their elongated necks form an

indented circle that may have been used for mixing pigments. It is not certain what these two animals mean, but their apparent act of union in the intertwining of their necks could refer to Narmer's unification of Egypt, as reflected in his two crowns. In the lowest register, a bull — probably a manifestation of Narmer himself — subdues another fallen enemy.

Every image on Narmer's palette enhances the king's importance in some way. He is protected by the gods. He is taller, more central, and more powerful than any other figure. He destroys his enemies and their cities. The iconographic message of this work is a political one. Like much Egyptian art of the following two thousand years, Narmer's palette celebrates the king's divine right to rule, and illustrates his ability to do so.

Monumental Architecture

Pyramids

The most monumental expression of the Egyptian pharaoh's power was the pyramid — his burial place and point of entry into the afterlife. Pyramids were preceded by smaller, trapezoidal structures called **mastabas**, from the Arabic word for "bench" (fig. **5.3**). During the Old Kingdom, King Zoser's architect Imhotep constructed a colossal pyramid at Saqqara as part of a sacred architectural precinct. Six mastabas of decreasing size were placed on top of each other over a tomb chamber some 90 feet (27.4 m) underground (fig. **5.4**).

About two centuries later, the three most famous pyramids (fig. **5.5**), wonders of the ancient world, were constructed at Giza, some 30 miles (48 km) north of Saqqara. These buildings are in pure pyramidal form: four triangular sides slant inward from a square base so that their top angles meet over the center of the square. Originally, the sides were smooth. A capstone, probably gilded, reflected the sun and the pharaoh's identification with it. These and other Egyptian tombs were located on the western side of the Nile with the sun rising to the east across the river.

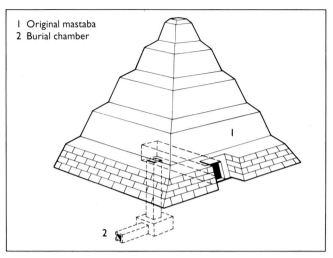

1 Original mastaba
2 Burial chamber

5.3 A mastaba.

5.4 Step pyramid, funerary complex of King Zoser, Saqqara. c. 2750 B.C. Limestone, 200 ft (61 m) high. Imhotep was a priest at Heliopolis and was reputed to have been the first Egyptian to have built monumental stone architecture. He became a legendary figure and was worshiped as a god. He is the only ancient Egyptian architect known by name.

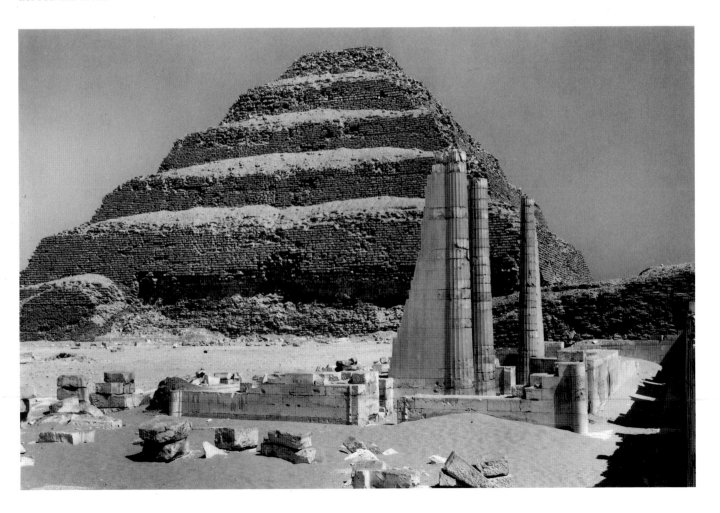

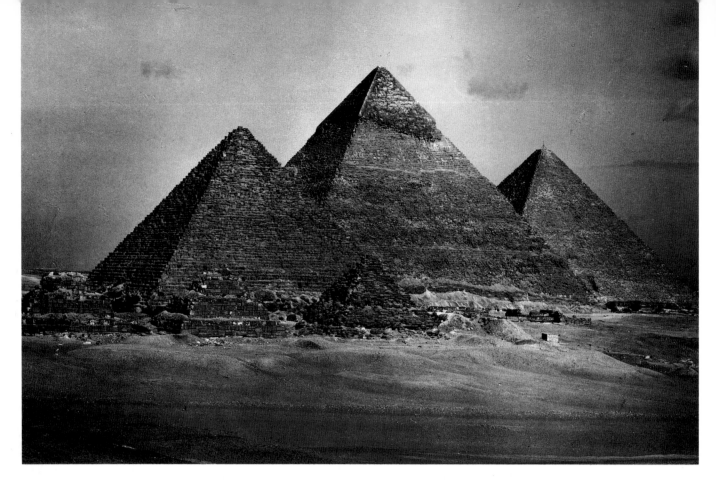

5.5 Pyramids of Menkure (Mycerinus), Khafre (Chephren), and Khufu (Cheops), Giza. 2570–2530 B.C. Limestone; Pyramid of Khufu c. 480 ft (146 m) high; base of each side 755 ft (230 m) long. The Giza pyramids were built for three Old Kingdom pharaohs of the fourth dynasty, Khufu (c. 2570 B.C.), Khafre (c. 2530 B.C.), and Menkure (c. 2500 B.C.). Khufu's pyramid — the largest of the three — was over twice as high as Zoser's step pyramid at Saqqara.

5.7 (below) Colossal statue of Khafre as the god Hu, later known as the Great Sphinx, Giza. c. 2500 B.C. Sandstone, 66 ft (20.12 m) high, 240 ft (73.15 m) long. In Egypt, as elsewhere in the Near East, lions guarded entrances, especially to temples and palaces. Lions were particularly appropriate as guardians because they were thought to be watchful and to sleep with their eyes open. They were also associated with the sun as the eye of Heaven.

5.6 Cross section of the Pyramid of Khufu.

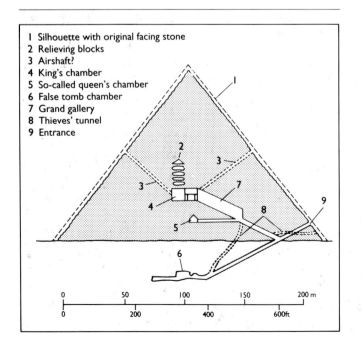

1 Silhouette with original facing stone
2 Relieving blocks
3 Airshaft?
4 King's chamber
5 So-called queen's chamber
6 False tomb chamber
7 Grand gallery
8 Thieves' tunnel
9 Entrance

The Giza pyramids were the most elaborate expression of the Egyptian need to ensure a continued existence after death. Constructed of limestone by thousands of laborers, they were begun early in the pharaoh's reign and took years to complete. Workers quarried stones and carried them by boat along the Nile to the construction site. Surveying techniques made it possible to orient the four corners of the square plan to the four directions of the compass. Plumb lines ensured that the angles were correct, and blocks were precisely measured and cut so as to fit together tightly. It is probable that the blocks were hauled up the sides of the structures by means of ramps which were later removed.

The interior contained false doors, false tomb chambers, and dead-end passages to confuse grave robbers. The actual burial chamber in Khufu's pyramid (fig. 5.6) is slightly less than halfway between the ground and the top. Its entrance was originally hidden from view but is now visible from the outside, and the chamber can be visited by tourists. Despite the builders' efforts to prevent entry once the final door was sealed, nearly all the pharaohs' tombs have been plundered.

From the Pyramid of Khafre, a road for ceremonial processions led to a valley temple guarded by a colossal sandstone **sphinx** (fig. 5.7). A human-headed creature with a lion's body, it is thought to have the facial features of Khafre himself. Surrounding the sphinx's head is the traditional trapezoidal Old Kingdom wig, which fills up the naturally open space above the shoulders and increases the sculpture's monumental effect.

Temples

As durable and impressive as the tombs, Egyptian temples provided another way of establishing the worshiper's relationship with the gods. The first known Egyptian temples in the Neolithic period took the form of a hut preceded by a forecourt. From the time of Menes, a courtyard, hallway, and inner **sanctuary** were added. The hallway, called a **hypostyle** (fig. 5.8), had two rows of central columns which were taller than the columns on either side. Post and lintel construction was used.

Egyptian Columns

The Egyptian column is articulated into three sections: a round base, a cylindrical shaft, and a capital. The capitals were usually carved in the shape of plants, hence the lotus, **papyrus**, and palm forms. As the top of the column corresponds to the top of the plant, flowers, buds, and rising fronds were common (fig. **5.9**).

Bud Foliated Palm leaf Papyrus blossom Reed bundle Lotus

5.9 Egyptian columns.

5.8 Model of the hypostyle hall, Temple of Amon-Ra, Karnak. c. 1290 B.C. Metropolitan Museum of Art, New York (Bequest of Levi Hale Willard, 1890). The central hypostyle columns have capitals that seem to grow upward and curve outward from the shaft like the branches of a palm tree. The shafts were covered with painted low-relief scenes and hieroglyphs. Their enormous scale is hard to imagine from a photograph — the base of each column would reach to the waist of an adult of average height.

5.10 The hypostyle hall, Temple of Amon-Mut-Khonsu, Luxor. Begun c. 1390 B.C. Sandstone, columns 30 ft (9 m) high. Here the capitals are constructed in the form of bundles of papyrus reeds, which grow along the Nile.

5.11 Plan of the Temple of Amon-Mut-Khonsu, Luxor. Reading the plan from right to left, number 1 refers to the **pylons**, flanking the entrance. From the entrance, one proceeded through three open-air colonnaded courtyards (2, 3, and 4). Then the worshiper was plunged into the darkened and mysterious realm of the hypostyle hall (5), beyond which lay the sanctuary complex (6).

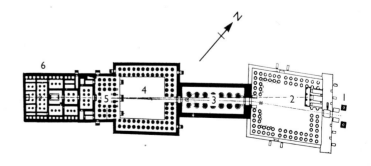

Ancient Egyptian temples were considered a microcosm of the universe, and as such they contained both earthly and celestial symbolism. Column designs were derived from the natural vegetation of Egypt, and represented the earth. In the New Kingdom temple at Luxor (fig. **5.10**), a short distance up the Nile from Karnak, the original ceiling would have been painted blue and decorated with birds and stars denoting its symbolic role as the heavenly realm.

It is clear from Egyptian temple architecture, as well as from the pyramids, that colossal size was important to the builders of ancient Egypt. The scale of these structures emphasized the enormous power of the gods and must have made the human worshipers feel small by comparison. Not only were the columns colossal, but there were many of them. Similarly, there were large and repeated statues of the pharaoh lining the temple courtyards, or rows of sphinxes preceding the entrances. This insistence on repetition was intended to impress worshipers with the king's immortality and the fertility of the Nile.

5.12 Funerary Temple of Queen Hatshepsut, Deir-el-Bahari. c. 1480 B.C. Sandstone and rock. Hatshepsut is the first documented queen in western history. She ruled Egypt from about 1501 to 1482 B.C. and dedicated her temple to the god Amon.

The plan of the Temple of Amon-Mut-Khonsu at Luxor (fig. **5.11**) indicates that the hut and courtyard layout of the Neolithic era was later elaborated to include numerous rooms. Altogether, three pharaohs contributed to the Luxor temple, each adding to its complexity. A stone roof closed in the hypostyle hall. Upper, or **clerestory**, windows—which are barely visible in the reconstructed model (fig. **5.8**)—let in small amounts of light, causing the huge columns to cast hundreds of shadows. Only a select few worshipers were allowed beyond the hypostyle into the sanctuary complex. At the far end was the "holy of holies" (the small central room with four columns at the far right of the plan). It was here that the image of the god was located, accessible only to certain priests and the pharaoh himself.

Mortuary Temples. The function of an Egyptian mortuary temple was to house the patron god of a dead ruler. The structure was literally built into the natural landscape, usually along the Nile. One of the greatest examples is Queen Hatshepsut's New Kingdom temple complex, cut into the rocky cliffs at Deir-el-Bahari (fig. **5.12**). Most of the projecting colonnades (constructed by the post and lintel system) have been restored. They adorn the three large terraces, which are connected to each other by ramps. The inner sanctuary is located inside the cliff.

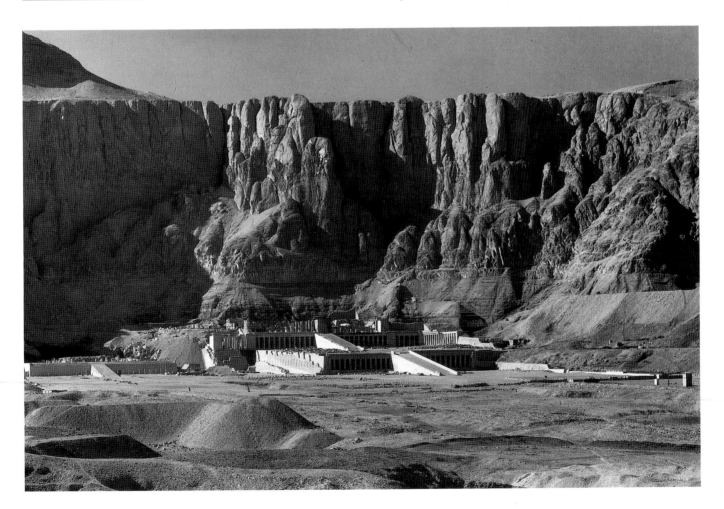

Sculpture and Painting

Nearly all of the Egyptian sculpture, painting, and painted relief that has been preserved was originally created for tombs or temples.

Egyptian artists followed certain canons and **conventions**, both for sculptures in the round and for relief. The more important the personage represented, the more rigorously were the conventions observed. A good example of Old Kingdom royal sculpture in the round is the standing couple, Menkure (Mycerinus) and his queen (fig. **5.13**). The artist began with a rectangular block set in a vertical plane, and the original block remains in the base and behind the figures. Menkure is portrayed frontally and stands as if at attention, arms at his sides and fists clenched. His left leg extends forward in an assertive stance indicative of his power. A trapezoidal wig closes up the space around the head as in the sphinx at Giza. Both the kneecap and the ceremonial beard are rectangular, echoing the form of the original block.

A comparison of Menkure with the queen illustrates certain conventional differences between the representation of male and female in Egyptian art. Even though a queen, she is below the king in rank within the rigorously hierarchic social organization of Egypt. This lower, or possibly supportive, position is indicated by her more naturalistic stance. Her left foot does not extend as far forward as her husband's, nor are her arms as rigidly positioned as his. In addition, her arms are bent, the right one reaching around the king's waist and the left one bent at the elbow and holding the king's left arm. The openness of her hands lacks the tension of the king's clenched fists. Her drapery, in contrast to Menkure's, outlines the form of her body and, like her wig, is more curvilinear.

An over-lifesize diorite statue of Khafre (fig. **5.14**) illustrates the Old Kingdom conventional representation of the seated king. It was found at Giza in the Valley Temple where it would have provided a material body for the pharaoh's *ka*. Khafre sits in an erect, regal posture with both hands on his lap, his right fist clenched and his left

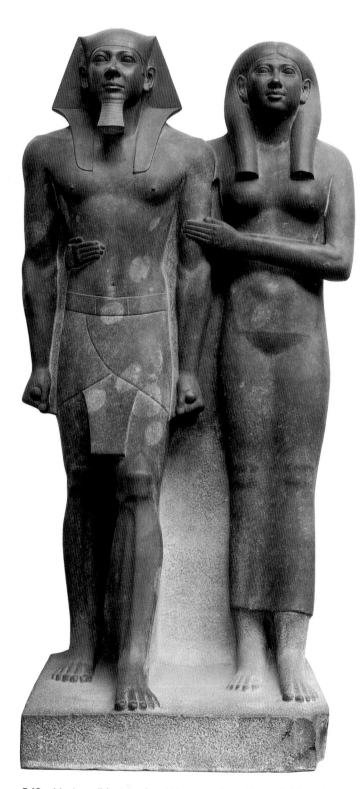

5.13 Menkure (Mycerinus) and his queen, from Giza. c. 2470 B.C. Slate, 4 ft 8 in (1.42 m) high. Courtesy, Museum of Fine Arts, Boston.

The Egyptian Canon of Proportion

Guiding the Egyptian painters in the representation of the human figure were so-called **canons**, which changed slightly from the Old to the New Kingdom. These were rules of proportion setting out ideal measurements for depicting human figures and the ideal relationships between parts. The artist constructed a grid in which each square measured one half of a unit. In the Middle Kingdom the distance from the bottom of the hair or wig to the shoulder was one unit, from the shoulder to the bottom of the tunic five units, and so forth. One purpose of this system was to arrive at a generally recognizable image of imposing royal power. The persistence of such *canons* contributed to the continuity of Egyptian style over a two-thousand-year period.

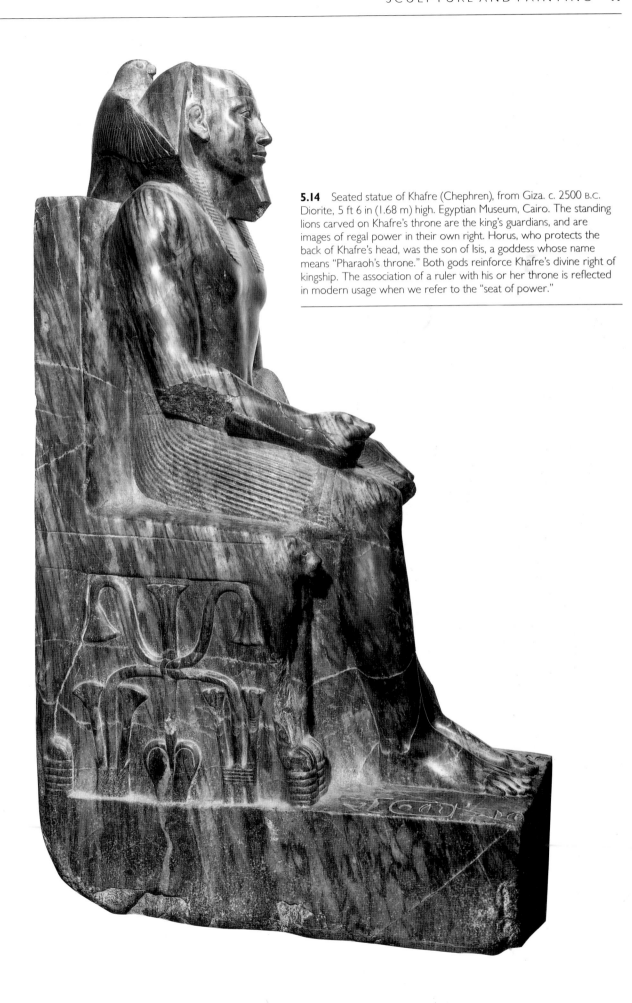

5.14 Seated statue of Khafre (Chephren), from Giza. c. 2500 B.C. Diorite, 5 ft 6 in (1.68 m) high. Egyptian Museum, Cairo. The standing lions carved on Khafre's throne are the king's guardians, and are images of regal power in their own right. Horus, who protects the back of Khafre's head, was the son of Isis, a goddess whose name means "Pharaoh's throne." Both gods reinforce Khafre's divine right of kingship. The association of a ruler with his or her throne is reflected in modern usage when we refer to the "seat of power."

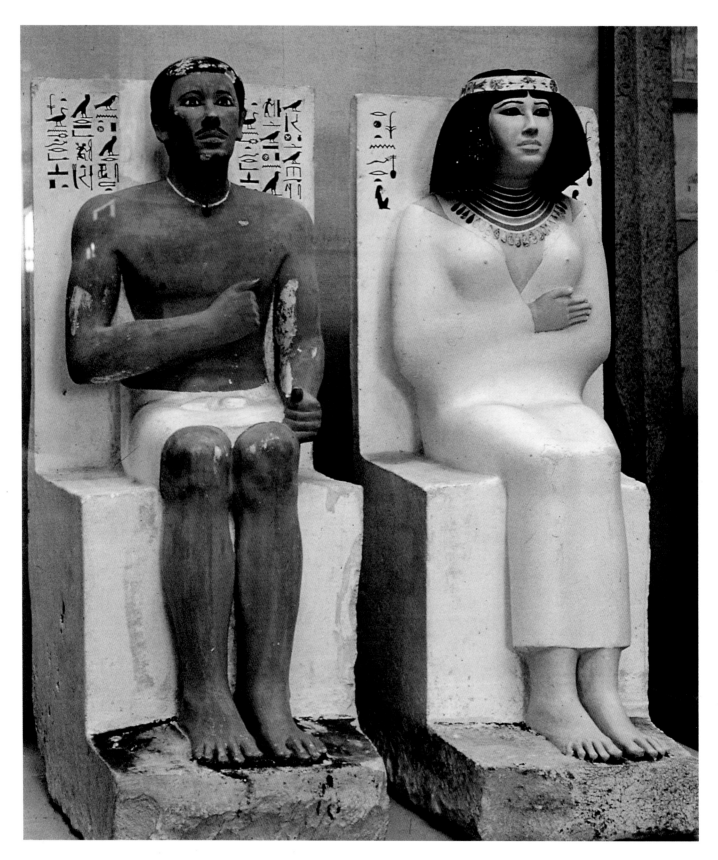

5.15 Prince Rahotep and his wife Nofret. c. 2610 B.C. Painted limestone, 3 ft 11¼ in (1.2 m) high. Egyptian Museum, Cairo. The eyes are inlaid with rock crystal; facial features and Nofret's headband and necklace are painted.

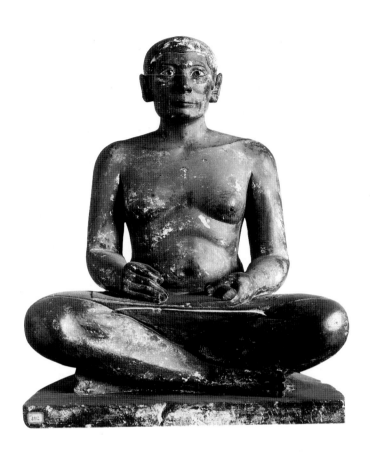

5.16 Seated scribe, from Saqqara. c. 2400 B.C. Limestone, 21 in (53.3 cm) high. Louvre, Paris. The scribe retains his original paint, which makes his eyes in particular seem lifelike. He holds his head slightly to one side, his neck muscles are tense, and he seems to look up, as if waiting to hear what he is to write down.

hand lying flat on his left knee. As in the standing figures of Menkure and his queen, this artist began with a rectangular block of stone to which the planes of the figure still conform. Khafre's throne and its base have a stepped arrangement with two verticals (corresponding to the back and lower legs of the king) meeting two horizontals (his thighs and feet) at right angles. Natural spaces between body and throne are eliminated because the original diorite remains, serving to unify the king and his throne. The symbolic identification of king and throne is thus formally enhanced by sculptors of this period.

The seated figures of Prince Rahotep and his wife Nofret (fig. **5.15**) are also united with their thrones. Both are rigid and frontal but, as in Menkure and his queen (fig. **5.13**), the female is more curvilinear than the male. Her right hand is also flattened instead of clenched into a fist and she is clothed above the waist. Because the paint has been well preserved, the convention of making the woman's skin a lighter color — yellow ocher — than the man's — brown — can easily be observed.

Compared with the sculptures of Khafre and Rahotep, the seated scribe (fig. **5.16**) is less monumental, though no less impressive. He sits with a papyrus scroll on his lap,

his right hand poised to write. In contrast to statues of the pharaoh, the scribe's cross-legged position, open spaces, and individual character are permissible because of his lower rank. The sculptor has cut away the limestone between the arms and body as well as around the head and neck, thereby reducing the monumentality of the piece. The depiction of the scribe is also more individualized than Khafre's — he has a roll of fat around his torso, a pot belly and sagging breasts. He appears to move more freely in space and is rendered more naturalistically than members of the royal family, in particular the pharaoh.

Egyptian painting, like sculpture, was used primarily in the service of the ruler. Walls of Egyptian tombs and temples were covered with sculpture and paintings — usually frescoes. Both provided the *ka* with scenes from the king's earthly existence, and they offer the modern viewer a wealth of information about life in ancient Egypt.

A New Kingdom painting from the *Book of the Dead*, a collection of funerary texts, provides evidence that the Egyptians also painted on papyrus (fig. **5.18**). At the top are several rows of hieroglyphs describing the ceremony as the "opening of the mouth" ritual. It was performed on the nineteenth-dynasty mummy of Hunefer, a private citizen rather than a king. Reading the scene from left to right, we see a priest in a leopard skin, a table, two priests in white tunics with upraised ritual objects, a hook, a bull's leg, and a knife. Two mourning women are directly in front of the standing mummy, and behind it is Anubis, the jackal-headed death god. The two architectural forms to his right are a stele covered with hieroglyphs and topped by a representation of Hunefer appearing before a god, and a stylized pyramid. Anubis was believed to embalm the bodies of the deceased and weigh their hearts before Osiris in the Underworld's Hall of Judgment. Each heart was placed on a scale and weighed against the Feather of Truth before an assembly of forty-two gods. Only if the heart passed the test was the deceased admitted into an afterlife of contentment.

In spite of the remarkable social, political, and artistic continuity of ancient Egypt, it is clear that certain changes occurred during the two thousand years between the beginning of the Old Kingdom and the creation of the New Kingdom fresco fragment in figure **5.17** and of Hunefer's papyrus. The most important cultural change, however, took place from about 1379 B.C., when a revolutionary pharaoh came to power.

Akhenaten's Style (c. 1379–1362 B.C.)

Generations of scholars have tried to answer the questions surrounding King Amenhotep IV, who challenged entrenched religious cults and threatened the very existence of the established priesthood that had reigned in Egypt for centuries. In the fifth dynasty of the New Kingdom, the sun god Ra had superseded Horus as the supreme deity. His cult was introduced north of Cairo at Heliopolis (from the Greek *polis*, meaning "city" and *helios*, meaning "sun"). In the twelfth dynasty, the god

Egyptian Fresco

Egyptian **frescoes** were *fresco secco*, or dry fresco. Pigments were mixed with water and applied to a dry plaster wall. As a result, the paintings were less durable than those produced by the later ***buon fresco*** technique described on page 81. Egyptians also used water paint on papyrus and on sculptures such as the scribe in figure **5.16**.

The New Kingdom *fresco secco* in figure **5.17** shows Nebamun enjoying a favorite sport, accompanied by his wife and daughter and surrounded by animal and landscape forms. He is not shaded, but depicted in silhouette. Following the conventional Egyptian pose, his head and legs are in profile, and his torso and left eye are frontal. The natural twist at the waist is masked by the diagonal line of the tunic. Nebamun's wife and daughter are small and curvilinear by comparison, continuing the Old Kingdom tradition of increasing naturalism for decreasing rank. The birds turn more freely in space than the human figures, and on the fish there is evidence of shading and a sense of volume. In contrast to the statues of Rahotep and Nofret (fig. **5.15**), these figures do not conform to the Egyptian convention according to which women are depicted as lighter-skinned than men.

5.17 Nebamun hunting birds, from the Tomb of Nebamun, Thebes. c. 1400 B.C. Fragment of a *fresco secco*. British Museum, London.

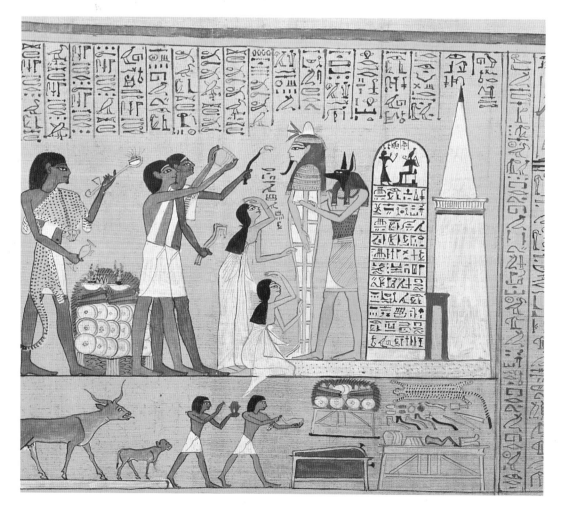

5.18 "Opening of the mouth ceremony," from *The Book of the Dead* of Hunefer. New Kingdom, 19th dynasty. Papyrus painting. British Museum, London. The object of this ceremony was to restore the dead body's ability to breathe, feel, hear, see, and speak. Interestingly, the ritual usually took place in a sculptor's workshop, thereby relating the Egyptian designation of their artists as the "givers of life" to the ceremony in which the deceased is "reborn."

Amon superseded Ra, and then in the eighteenth dynasty Amenhotep IV adopted a religious system that was more monotheistic (based on belief in a single god, from the Greek *mono* and *theos*). The primary god was Aten, the sun disk, and Amenhotep accordingly changed his name to Akhenaten. He moved Egypt's capital down the Nile from Thebes to Amarna, which is why his reign is re-ferred to as the Amarna period.

Nothing is known of Akhenaten's education or of the origin of his ideas, which greatly influenced artistic style in Egypt. Statues of Akhenaten (fig. **5.19**) differ from those of traditional pharaohs and imply that he had unusual, if not deformed, physical features. The fact that he does not appear in works of art from the reign of his father, Amen-hotep III, suggests that he was intentionally omitted, pos-sibly because of his odd appearance. Here Akhenaten holds the crook and flail which are typical attributes of Egyptian royalty. Rather than being represented as a powerful, assertive, and dominating king, he is elongated, thin, pot-bellied, and curvilinear. Some scholars believe that Akhenaten suffered from acromegaly — a condition caused by an overactive pituitary gland, resulting in en-larged hands, feet, and face. Others think these propor-tions simply reflect a change in artistic conventions.

The best-known sculpture from Akhenaten's reign is a painted limestone head of his wife, Nefretete (fig. **5.20**). The well-preserved paint adds to its naturalistic impres-sion. This is enhanced by the modeled features, the sense that taut muscles lie beneath the surface of the neck, and the open space created by the long elegant curves at the sides of the neck. Instead of the traditional queen's wig, Nefretete wears her own hair pulled up into a tall crown that creates an elegant upward motion.

A small relief in which Akhenaten and Nefretete play with their children illustrates some of the stylistic and iconographic changes during the Amarna period (fig. **5.21**). The king and queen sit as if on thrones, but there is a naturalism unprecedented in Egyptian royal figures. Their fluid, curved outlines — repeated in their drapery patterns — add a new sense of individual spatial motion to the composition. The children are represented in the un-natural proportions of miniature adults, but their behavior and relative freedom of movement endow them with con-vincing childlike character.

Hieroglyphs are carved at the top of the scene, and several **cartouches** are visible on the right. The car-touche — an oval ring that encloses the king's two most important names — is a descendant of the serekh on Narmer's palette. The ring itself, like the frame of the serekh, had apotropaic power — that is, it was a protective device against the evil eye. In the middle of the hiero-glyphs is the sun disk Aten, with radiating rays of light that end in hands which seem to reach out to Akhenaten and Nefretete. Unlike earlier representations of gods in Egyptian art, Aten was a pure shape — a circle — rather than a human or animal form.

Akhenaten's new cult posed a danger to the estab-lished priesthood and its traditions. At the close of his

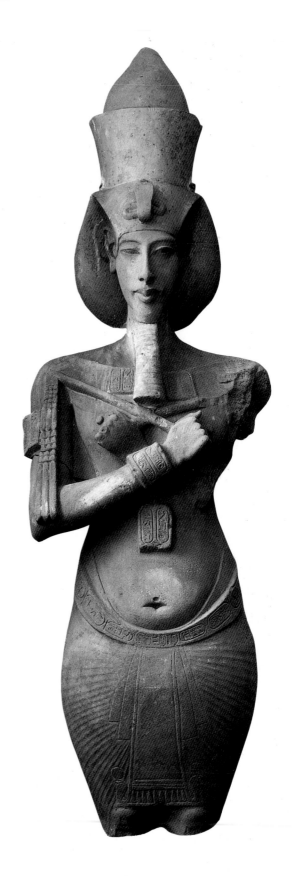

5.19 Akhenaten, colossal statue from Karnak, c. 1375 B.C. Sandstone, c. 13 ft (3.96 m) high. Egyptian Museum, Cairo.

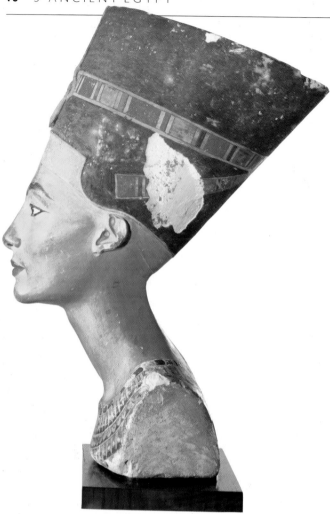

5.20 Bust of Nefretete. c. 1360 B.C. Painted limestone, c. 19 in (48 cm) high. Egyptian Museum, Berlin.

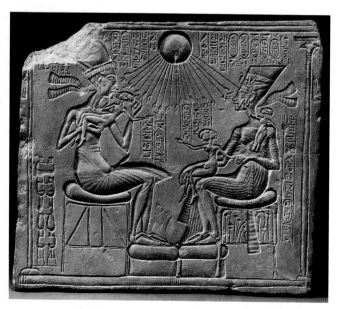

5.21 Akhenaten and Nefretete and their children. 1370–1353 B.C. Limestone relief, 13 × 15 in (33 × 38 cm). Staatliche Museen, Berlin.

seventeen-year reign, despite certain innovations, Egypt reverted to its previous beliefs and reinstated the priestly hierarchy. Akhenaten's tomb has never been found, and later Egyptian rulers did their best to eradicate any trace of his religion and its expression in art.

Tutankhamen's Tomb

Akhenaten's successor Tutankhamen returned to the worship of Amon, as his name indicates. He died at eighteen and his only claim to historical significance is the fact that his tomb, with its four burial chambers, was discovered intact. In 1922, the English Egyptologist Howard Carter was excavating in the Valley of the Kings, to the west of the Nile and the New Kingdom temples at Karnak and Luxor. To the delight of his benefactor, Lord Carnarvon, Carter found one tomb that had not yet been opened. It yielded some five thousand objects, including the mummy and coffin of the king himself. The coffin cover (fig. **5.22**) supports an effigy of Tutankhamen made of polished gold, decorated with inlaid semiprecious stones and pieces of enamel. The blue stone is lapis lazuli, considered sacred by the Egyptians. Because of its blue color, it was thought to have a celestial origin, relating the pharaoh to the sky and guaranteeing the protection of the sun.

Comparing the effigy to the images produced under Akhenaten, it is clear that the rigid, frontal pose has returned. The natural spaces are closed, for example, around the head and neck by the traditional wig, and around the body by virtue of the crossed arms and tight drapery. The king's outline, in fact, matches the rectangle of the coffin cover, and is reminiscent of the rectangularity of traditional royal sculpture. The conventional iconography of kingship is also restored. Tutankhamen holds the crook and flail as Akhenaten did, but the falcons of the Old Kingdom are again present, as if embroidered in red and blue and hanging from his forearms. The falcon recurs on the wig, next to the royal cobra, a solar deity which protected the pharaoh by spitting flames.

Over forty years after Carter's discovery, the contents of Tutankhamen's tomb were to become one of the world's most popular and widely traveled exhibitions, appearing in Paris, London, Russia, and the United States. But Lord Carnarvon did not live to see it. Just one year after Tutankhamen's tomb was opened, he died, rumored to have been the victim of a mummy's curse — a tribute to the continuing belief in the power of images.

5.22 (opposite) Cover of Tutankhamen's coffin. c. 1340 B.C. Gold inlaid with enamel and semiprecious stones, height of whole 6 ft ⅞ in (1.85 m). Egyptian Museum, Cairo. The Egyptians developed a seventy-two-day process called mummification to preserve and embalm the deceased. The internal organs were removed and placed in jars, but the brain was discarded as useless. Chemicals were used to dry out the body, which was wrapped in up to twenty layers of cloth. The mummy was then placed in a wooden coffin and lowered into a tomb, or sarcophagus (literally an eater, *phagos*, of flesh, *sarcos*). The cover of the coffin or sarcophagus contained an effigy of the deceased.

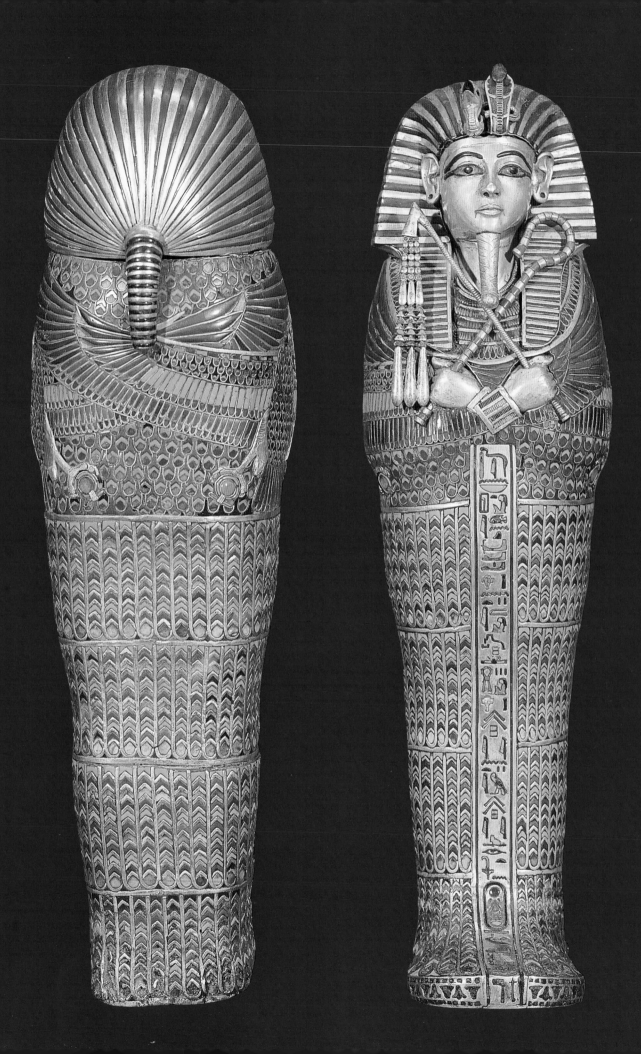

CHAPTER SIX

The Aegean

From about 3000 to 1200 B.C., three civilizations flourished on the islands of the Aegean Sea that lie between western Turkey and mainland Greece. These civilizations chronologically overlapped the Old, Middle, and New Kingdoms of Ancient Egypt, and there is evidence of trade between them. But before the late nineteenth and early twentieth centuries, Aegean culture was remembered only in myths and legends — most of the works of art discussed in this chapter have been discovered within the past 150 years.

Cycladic Civilization
(c. 3000–1200 B.C.)

The Cyclades, so-named because they form a circle (from the Greek *kuklos*), are a group of islands in the southern part of the Aegean Sea. Typical of many island populations, the inhabitants of the Cyclades were accomplished sailors, fishermen, and traders. Less is known of the Cycladic civilization than of ancient Egypt because there is no evidence of writing. But works of art including pottery, metalwork, and marble sculptures have been unearthed from Cycladic graves.

The most impressive examples of Cycladic art date from the early Bronze Age. These are marble sculptures ranging in height from nearly 5 feet (1.5 m) (fig. **6.1**) to only a few inches (fig. **6.2**). They are called idols because it is assumed that they were objects of worship.

The female figures, like the large example in figure **6.1**, have longer and thinner proportions than the usual Neolithic fertility idols or mother goddesses. Nevertheless the Cycladic artist has accented the breasts and the pubic triangle. This statue appears broader from the front than the side, and is composed mainly of geometric shapes. Note that the head is a slightly curving rectangle — its only articulated feature is the long, pyramidal nose. The neck is cylindrical, and the torso is divided into two squares by the horizontals of the lower arms. The right angles of the elbows create a three-sided frame around the upper torso, which the breasts seem to transform into a second face. Geometric as this figure is, certain features such as

breasts and knees have a convincingly organic quality, as if protruding naturally from beneath the exterior.

The male Cycladic figures are composed mainly of cylindrical shapes and are often depicted playing musical instruments. The man in figure **6.2** playing a double pipe, or flute, tilts his head so far back that it is nearly at a right angle to his neck. The area of greatest formal movement in this sculpture — namely the diagonals of arms and flute combined with the tilting head and long neck — is consistent with musical movement. Arms, legs, and torso are shorter and sturdier than those of the female. The relative solidity of the statue is reinforced by the horizontal plane of the feet and their little **pedestal**, which provide actual support.

Map of the ancient Aegean.

6.1 (left) Female cycladic idol, from Amorgos. 2700–2300 B.C. Marble, 4 ft 10½ in (1.49 m) high. National Archeological Museum, Athens.

6.2 (below) Male cycladic flute player, from Keros. Marble. National Archeological Museum, Athens.

Minoan Civilization

(c. 3000–1500 B.C.)

The modern Greek island of Crete, to the south of the Cyclades and northwest of the Nile delta in the Aegean Sea, was the home of another important Bronze Age civilization. It was destroyed twice, once in 1700 B.C. by an earthquake and again two or three centuries later, when Greeks from the mainland invaded and conquered its people. The civilization that flourished on Crete was all but forgotten until A.D. 1900, when the British archeologist Sir Arthur Evans decided to search for it. Inspired by his knowledge of later Greek myths about the pre-Greek Aegean, Evans initiated excavations that were to establish the historical basis of the myths.

1 West porch
2 Corridor of the Procession
3 South *propylon*
4 Central court

5 "Theater area"
6 North *propylon*
7 Pillar hall
8 Magazines
9 Throne room
10 Palace shrine and
 lower verandas
11 Stepped porch
12 Grand staircase
13 Light area
14 Hall of the
 Colonnade

15 Hall of the Double
 Axes (principal
 reception room)
16 Queen's *megaron*

Reconstruction

Earlier structures { Existing
 Reconstruction

0 10 20 30 m
0 50 100 ft

6.3 Plan of the Palace of Knossos, Crete. 1600–1400 B.C. Area c. 4 acres (1.6 hectares).

6.4 (opposite) Wooden columns and limestone bulls' horns near the south entrance, Palace of Knossos.

The Myth of the Minotaur

In Greek mythology, Crete was the home of the tyrant King Minos, son of Zeus and the mortal woman Europa. Minos broke an oath to Poseidon, who had guaranteed his kingship, and in revenge the sea god caused Minos's wife to fall in love with a bull. The offspring of their unnatural union was the Minotaur, a monstrous creature, part man and part bull, who lived at the center of a labyrinthine maze in the Palace of Minos at Knossos. Every year the Minotaur killed fourteen Athenians — seven girls and seven boys — exacted as annual tribute by Minos. Eventually, the Athenian hero Theseus killed the Minotaur and was rescued by Minos's daughter Ariadne from the labyrinth. But when Theseus sailed home to Athens, he forgot the prearranged signal to his father, King Aegeus, indicating that he was returning safely. Believing his son dead, Aegeus threw himself into the sea and drowned. The Aegean Sea is named after the unfortunate king.

The civilization he discovered is called Minoan, after Minos. This may be either a generic term for ruler, or the name of a particular ruler. The major Minoan site of Crete is at Knossos, whose palace was the mythical residence of Minos. The plan of the palace (fig. **6.3**), with its maze of irregular rooms, hallways, and staircases, clearly suggests the mythical labyrinth.

The palace itself (fig. **6.4**) was built over the remains of an earlier Neolithic settlement on a hilltop. Like other Minoan palaces, it was not fortified. The fact that Crete was an island was its main source of protection against invasion. Minoan palaces reveal a well-organized system for receiving and distributing local agricultural products, which were stored in large **terra cotta** jars. Records of these transactions were written on clay tablets in a still undeciphered script called Linear A. A later form of Linear A, known as Linear B, is an early version of Greek.

The Palace of Knossos used post and lintel construction with low ceilings, stone masonry walls, and short, wooden columns that taper slightly toward a thin square

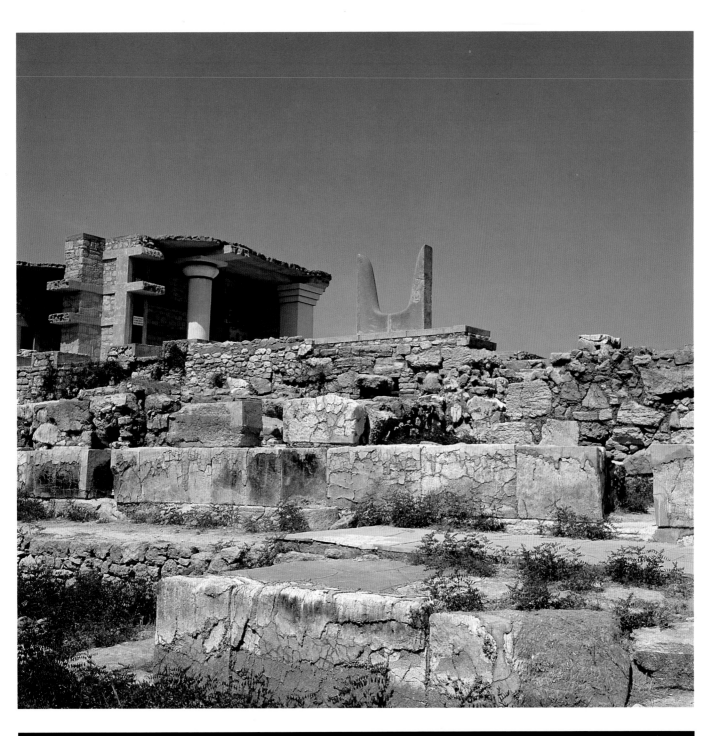

Minoan Fresco

Whereas Egyptian painting is definitely *fresco secco*, there is controversy among modern scholars over the technique of Minoan mural painting. Sir Arthur Evans, who discovered Knossos, believed that Minoan painting was *buon* (true) *fresco* — pigments were mixed with water and applied to wet lime plaster. As the plaster dried, the coloring was absorbed into the fabric of the wall. *Buon fresco* is durable because it actually becomes part of the wall, whereas *fresco secco* rubs or flakes off.

Although Minoan painters did not use exactly the same fresco technique as Roman, medieval, and Renaissance artists were to develop (see pp.147, 185, and 216), they did apply pigments to wet lime plaster. The main question is whether or not the Minoans used a binding medium such as limewater when preparing their pigments.

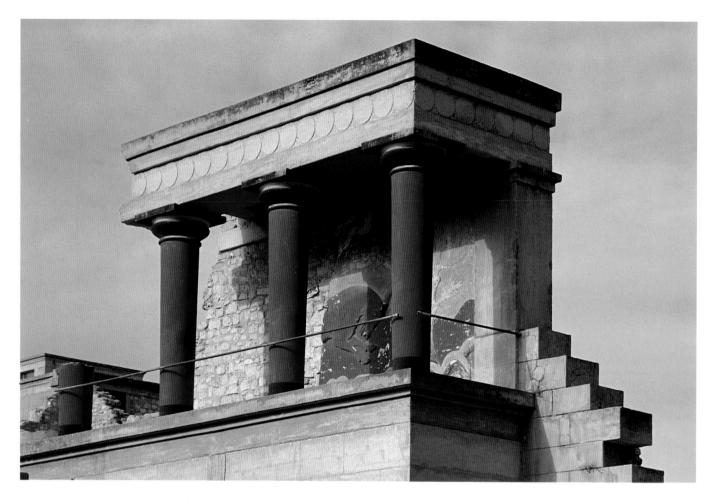

6.5 Partly restored west portico of the north entrance passage with a reconstructed relief fresco of a charging bull, Palace of Knossos.

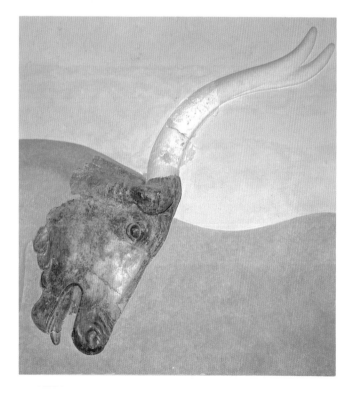

6.6 (left) Original bull's head, as reconstructed in fig. **6.5**. Relief fresco. Archeological Museum, Herakleion, Crete. Note the paler quality of the color of the original before reconstruction.

base. Their puffy capitals (fig. **6.5**) are called pillow capitals. Those shown here have been reconstructed on the basis of the fragments of fresco painting that originally decorated the interior palace walls. These three painted columns come from the western portico, or porch, at the north entrance to the palace.

The painted relief behind the columns, based on the original fragments shown in figure **6.6**, depicts a charging bull which recalls the myth of the Minotaur. The bull's ancient significance as a royal fertility **motif** recurs at Knossos — note the horns perched on the edge of the wall in figure **6.4**.

The so-called *Toreador Fresco* (fig. **6.7**) is perhaps the best-known wall painting from Knossos. It represents a charging bull with two girls and one boy. One person grabs the bull's horns, somersaults over its back, lands upright behind the bull, and catches the next jumper. As in Egyptian paintings (see p.73), females have lighter skin

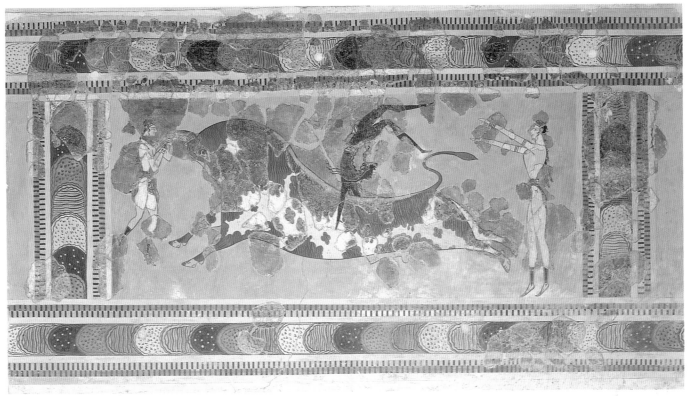

6.7 (above) *Toreador Fresco*, from Knossos. c. 1500 B.C. c. 32 in (81.3 cm) high (including border). Archeological Museum, Herakleion. This fresco was discovered in fragmentary condition and has been pieced back together. The darker areas belong to the original mural and the lighter sections are modern restorations.

6.8 Snake Goddess, from Knossos. c. 1600 B.C. Faïence, height 13½ in (34.3 cm). Archeological Museum, Herakleion. This frontal figure has a thin, round waist and wears a conical flounced skirt. Her breasts are exposed and a cat perches on top of her headdress.

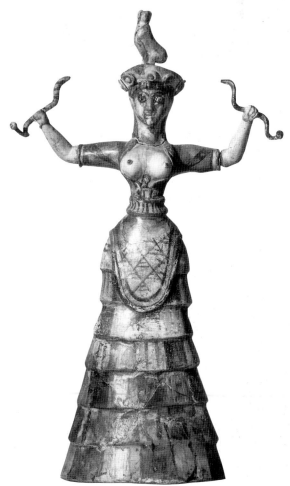

than males, and in each case a profile head is combined with a frontal eye. Although the skin tones demarcate three different human figures, they seem to be performing a unified sequence of movement. Bordering the scene are several rows of colored designs.

Little is known of Minoan religion. Shrines were small and located outdoors on hilltops or inside the palaces. Until such time as Minoan Linear A is deciphered, we can only guess at the religious beliefs and practices of ancient Crete. Besides bulls, religious images found in large numbers at Knossos include the double axe, trees, and other vertical forms such as pillars and poles. The meaning of the double axe is something of a mystery, but trees, pillars, and poles had been worshiped since the Stone Age. It is likely that rituals connected with these forms celebrated the annual rebirth of spring.

Another recurring motif in Minoan art is the goddess holding snakes. The precise significance of the small, well-preserved statue of the so-called Snake Goddess (fig. **6.8**)

6.9 Left section of the *Ship Fresco*, from Akrotiri, Thera. c. 1650–1500 B.C. 15¾ in (40 cm) high. National Archeological Museum, Athens. In this view of city walls and boats propelled by oars, the landscape is rendered with no sense of perspective and appears to "frame" the city.

is not known. However, the motif of a female goddess dominating animals — called a "mistress of the beasts" — occurred both earlier in ancient Near Eastern culture and later in Greek art. As creatures of the earth, snakes were associated with fertility and agriculture. They did not have the evil connotations with which they later became endowed. Scholars believe the Minoan statue to be a representation of a goddess or of a priestess in the guise of a goddess. As such, it would fall well within an iconographic tradition linking certain animals with divinity and associating an imposing frontal stance with worship.

Discoveries at Thera

Some thirty years ago, the Aegean yielded exciting new archeological evidence on the modern island of Santorini in the southern Cyclades. Formerly called Thera, Santorini is a volcanic island and parts of it are covered with ash and pumice. A Greek archeologist, Spyridon Marinatos, decided to pursue the hypothesis that the ash covered a lost civilization, and began to excavate near the modern town of Akrotiri in 1967.

His excavations have confirmed that a volcanic eruption buried a flourishing civilization with a well-developed artistic tradition. The date of this disaster has been placed as late as 1500 B.C. but the most recent redating is 1628 B.C. — in either case, it occurred during the heyday of Minoan civilization. Apparently the inhabitants had advance notice from tremors and were able to evacuate the island before the volcano erupted. No bodies have been found in the ashes, nor is it known where the inhabitants went. The geographical location of Thera, north of

Crete, places it squarely within the trading and seafaring routes of the time. Evidence of trade throughout the Aegean and as far away as Syria has been found, but the absence of writing forces archeologists to rely principally on works of art and other artifacts for information about ancient Thera.

To date, archeologists digging at Akrotiri have uncovered large portions of an ancient town. The paved, winding streets and houses of stone and mud brick reveal a high standard of living. Homes had basements for storage and workroom space and upper-story living quarters. Mills attached to the houses indicate an active farming as well as seafaring economy. Walls were reinforced with timber and straw to protect against earthquakes. Interior baths and toilets were connected by clay pipes to an extensive drainage and sewage system under the streets. Such elaborate attention to comfortable living conditions is not found again in the west until the rise of the Roman Empire over a thousand years later (see p.129).

Equally remarkable was the attention paid to works of art on Thera. The walls of many private houses were decorated with frescoes, which indicates the presence of a thriving artistic community. This unexpected discovery has revealed an important new body of paintings. They represent a wide range of subjects: landscapes, animals, human figures engaged in sports and rituals, boats, and warriors. When they were discovered, most of the frescoes were covered with volcanic ash which had to be carefully removed by brush. The paintings had fallen from the walls and had to be restored piece by piece to their original locations.

Theran pictures are characteristically framed at the top with painted borders, often created by abstract geometric patterns. The most significant painting discovered on Thera is the large *Ship Fresco*, a detail of which is reproduced in figure **6.9**. It depicts a naval battle, city walls, human figures, landscape, fish, and animals. A work such as this documents the types of boats used by the ancient

Therans and the sort of towns they built as well as their style and technique of **mural** painting.

The Thera fresco of *Boxing Children* (fig. **6.10**) offers a larger-scale depiction of human figures than the *Ship Fresco*. As is true of painted figures from Egypt and Crete, these stand on a thin line rather than in a naturalistic space. They also retain the frontal eye in a profile face. Like Minoan figures, and in contrast to Egyptian style, the curved outlines and shifting planes of movement create a sense of vigorous, sprightly energy.

When hitherto unknown cultures, such as this one on Thera, are uncovered for the first time, the modern view of history is necessarily modified. The precise role of Thera in the Minoan era still remains to be determined. Some people believe it is the lost Atlantis, described by Plato in fourth-century-B.C. Athens; others disagree. In any case, such archeological finds reveal the dynamic nature of history, the similarities as well as differences linking us to ancient history, and the continuing relevance of past to present.

6.10 *Boxing Children*, from Akrotiri, Thera. c. 1650–1500 B.C. Fresco. National Archeological Museum, Athens.

Mycenaean Civilization

(c. 1600–1300 B.C.)

In the late 1860s, at the age of thirty-six, a successful German businessman named Heinrich Schliemann decided to become an archeologist. Like Sir Arthur Evans, Schliemann was convinced that certain Greek legends were based on historical events. He focused his search on the legends of the Trojan War and its heroes as described by Homer. In 1870, Schliemann found the site of Troy on the

6.11 Plan of a Mycenaean **megaron**. The *megaron* was rectangular, with four columns enclosing a circular hearth in the center. It was preceded by an antechamber and a front porch with two columns — an arrangement that had pre-Mycenaean antecedents on the Greek mainland, and would be elaborated in later Greek temple architecture.

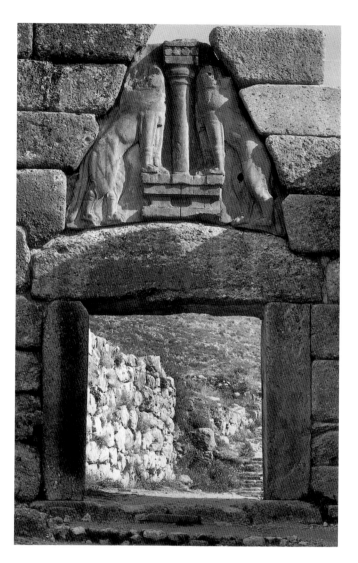

6.12 Lion Gate and Cyclopean wall, Mycenae. 1500–1300 B.C. Limestone relief, c. 9 ft 6 in (2.9 m) high. The presence of a Minoan column at Mycenae is an example of the kind of evidence used by archeologists to demonstrate trade and travel between the two civilizations. The column itself may be a more elaborated architectural version of the trees, poles, or pillars worshiped on Crete and elsewhere.

The Legend of Agamemnon

Mycenae was the legendary home of King Agamemnon, who led the Greek army against King Priam of Troy in the Trojan War. Agamemnon's brother, King Menelaus of Sparta, had married Helen, known to history as the beautiful and notorious Helen of Troy. When Priam's son Paris abducted Helen, Agamemnon was pledged to avenge the offense against his family. But as soon as the Greek fleet was ready to sail, the winds refused to blow, because Agamemnon had killed a stag sacred to the Greek moon goddess Artemis (see p.92). As recompense for the stag and in return for allowing the winds to blow, Artemis exacted the sacrifice of Agamemnon's daughter Iphigenia.

Ten years later the war ended and Agamemnon returned to Mycenae, where he was murdered by his wife Clytemnestra and her lover Aegisthus. They, in turn, were killed by Agamemnon's remaining children, Electra and Orestes, to avenge Agamemnon's death.

These tales were well known to the later Greeks — the Trojan War from Homer's eighth-century-B.C. epic the *Iliad*, and the tragedy of Agamemnon's family from the fifth-century-B.C. plays of Aeschylus and Euripides. Like the myths of Theseus and the Minotaur, however, the account of Agamemnon's family was the province of imagination and legend until the end of the nineteenth century.

Cyclopean Masonry

Cyclopean masonry is named for the mythological race of Giants, or Cyclopes, who were believed strong enough to lift the blocks of stone found at Mycenaean sites. The Cyclopes are described by Homer in the *Odyssey* as having a single round eye in the center of their foreheads (the name derives from the Greek *kuklos*, meaning "circle" and *ops*, meaning "eye"). In Book IX of the *Odyssey*, Odysseus escapes from the Cyclops Polyphemus by putting out his single eye with a stake and tying himself and his men to the undersides of a flock of sheep.

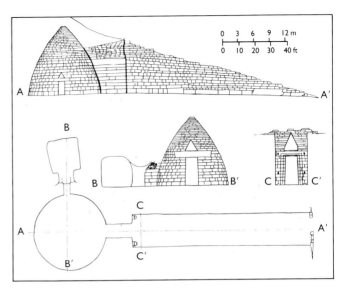

6.14 Plan and sections of a *tholos.*

6.13 *Tholos* tomb from exterior showing doorway. c. 1300 B.C. Doorway 17 ft 8 in x 8 ft 10 in (5.4 x 2.7 m). The so-called Treasury of Atreus is a huge circular chamber cut into an existing rock. The finely-cut rectangular stones of the sides contrast with the deliberate roughness of the fortifications. The interior is over 40 feet (12 m) high and about 43 feet (13 m) in diameter. It curves inward as the walls rise to form a corbeled roof, and resembles an enormous beehive.

west coast of Turkey. Six years later he located Mycenae in the northeast of the Peloponnese (the peninsula below the isthmus of Corinth which forms the southern part of Greece) and identified it as the city of Agamemnon. The discovery of several other similar sites on the Greek mainland led to the recognition of an entire Mycenaean civilization that flourished between 1600 and 1300 B.C.

Also called Helladic (after *Hellas*, the Greek name for Greece), the Mycenaean civilization takes its name from the site of Mycenae. Here, as elsewhere, citadels were built on hilltops and fortified with massive walls. It seems that the palaces were small, and each contained a throne room, or *megaron* (literally "big room" in Greek) (fig. **6.11**).

Like the Minoans, the Mycenaeans left no trace of monumental temple architecture, and the shrines that have been found are inside the palaces. Most of the citizens lived in small mud brick houses below the citadel and in times of siege sought refuge within its walls. The fortifications of the Mycenaean cities indicate a culture more oriented toward war than the Minoan, and more concerned with protection from invaders.

These concerns must have determined the choice of the thick, monumental walls surrounding Mycenaean citadels (fig. **6.12**). They were constructed of large, roughly cut and irregular blocks of stone. Because of the enormous weight of such stones, the Greeks called the walls Cyclopean (fig. **6.12**). At the Lion Gate entrance to the city of Mycenae, the masonry around the entrance opening reveals a post and lintel structure and the triangular section over the lintel forms a corbel arch. **Corbeling** consists of arranging layers, or courses, of stones so that each level projects over the lower one. When the stones meet at the top, they can be held in place by a **keystone** to create an arch. Decorating the space enclosed by the arch is a relief sculpture of two rampant lions, now headless, flanking a Minoan-style column set on Minoan altars. Clearly these lions are the descendants of the guardian lions on royal entrances throughout the ancient Near East and Egypt.

The most dramatic structure at Mycenae also exemplifies the culmination of Minoan–Mycenaean tomb architecture in the thirteenth century B.C. The largest beehive tomb, or *tholos* (Greek for "round building"), at Mycenae (fig. **6.13**) has been called both the Treasury of Atreus and the Tomb of Agamemnon, who was Atreus's son. In fact, it is not known who was buried there, but, because of its enormous size, scholars assume that it was the tomb of a king. It is likely that the construction of such large tombs was influenced by the design of smaller *tholoi* used earlier for communal burials on Crete. There is also some

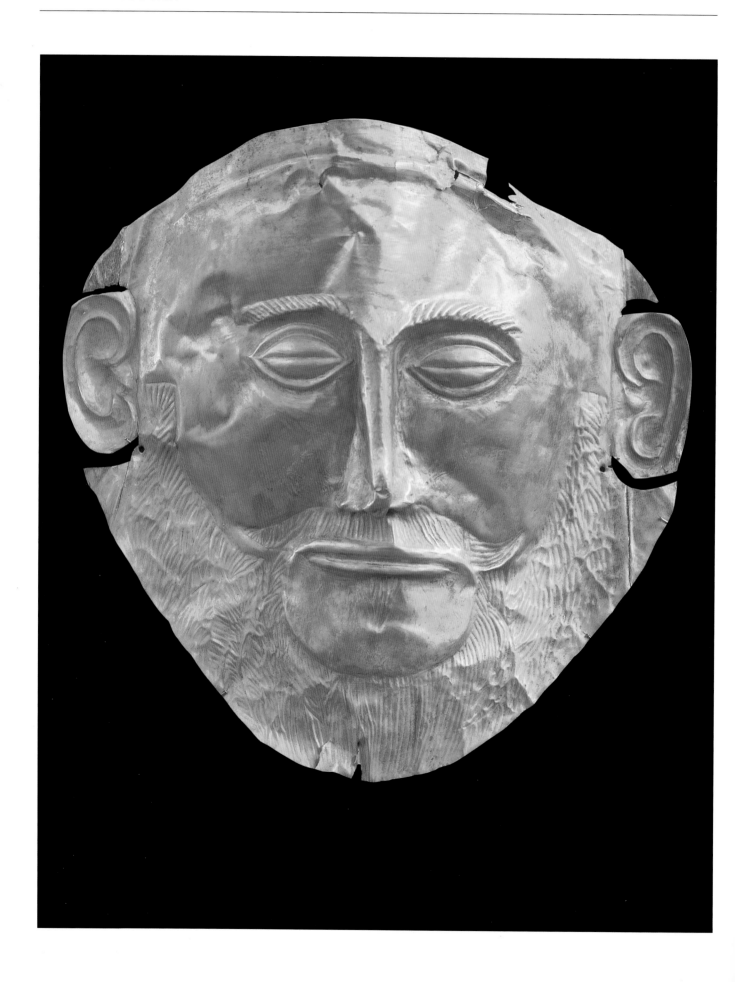

connection with the earlier Mycenaean shaft graves, which were set within circular walls.

The Mycenaeans approached the *tholos* along a *dromos*, or roadway, 118 feet (36 m) long, whose walls were faced with rectangular stone blocks (fig. **6.14**, section B). Above the rectangular entrance (fig. **6.13**) was a horizontal lintel approximately level with the original hillside into which the round chamber was cut. The lintel is equivalent in height to two stone courses and weighs over 100 tons (100,000 kg). It separates the doorway from a triangle that relieves the weight from the lintel (fig. **6.14**, sections C and D). The same kind of entrance leads from the main chamber into a side chamber. Like the triangle above the Lion Gate, those here were originally filled in with carved stone blocks of the type that also decorated the rest of the **façade**.

Once the body had been placed inside the *tholos*, the Mycenaeans walled up the entrance. All that would have

6.15 (opposite) Funeral mask, from Mycenae. c. 1500 B.C. Beaten gold, c. 12 in (30.5 cm) high. National Archeological Museum, Athens. Death masks such as this preserved the features of the deceased. Although little is known of Mycenaean religion, it is thought that such masks were probably intended to guarantee a dead person's identity in the afterlife.

been visible from the exterior of the closed tomb was the *dromos* and the mound of earth (fig. **6.14**, section A). Unfortunately, the Treasury of Atreus was plundered before its excavation. However, excavations of unplundered graves have yielded remarkable objects, many made of gold.

The gold mask in figure **6.15**, for a time mistakenly considered the mask of Agamemnon, is a good example of the goldwork found in royal Mycenaean graves. It probably belonged to a ruler and was almost certainly a death mask. Despite stylizations such as the scroll-shaped ears, its more distinctive features—the thin lips and curved mustache—are clearly those of a particular person.

The rediscovery of the Minoan–Mycenaean cultures in the late nineteenth and early twentieth centuries, and the more recent finds at Thera, have restored some missing links of western history. Minoan and Mycenaean cultures came to light unexpectedly as a result of the conviction of a few scholars that certain old legends and myths had a basis in fact. There remains, however, much to be learned, and archeologists continue to probe the earth for clues to the past. Although the fall of Mycenae was followed by several hundred years of "Dark Ages," about which very little is known, the Aegean civilizations provide a transition from Egypt and the ancient Near East to the art and culture of ancient Greece, which is the subject of the next chapter.

Ancient Greece

Unlike the Aegean civilizations, which were known only in myth and legend until the late nineteenth and early twentieth centuries, ancient Greece made an immediate and lasting impact on western culture. The decline of Mycenae and other Aegean civilizations around 1200 B.C. was followed by some 400 years of relative obscurity in Greek history. On mainland Greece, shifts in population occurred, with new migrations from northern and eastern Europe.

The exact origins of the Hellenes, as the Greeks called themselves, are unknown, but by about 800 B.C. two distinct groups of people had settled in Greece. For the most part the Dorians inhabited the mainland, while the Ionians occupied the easternmost strip of mainland (including Athens), the Aegean islands, and the west coast of Anatolia (modern Turkey). Later, the Greeks established colonies in southern Italy, Sicily, France, and Spain. As such colonizing activity suggests, the Greeks were accomplished sailors, and their economy depended primarily on maritime trade. They were also successful in cultivating their rocky terrain and in the manufacture of pottery and metal objects.

Cultural Identity

Greece was unified by a strong sense of its own cultural identity, although the mainland Greeks were geographically separate from those on the islands and, later, from their colonies. The Greeks as a whole viewed themselves as the most civilized culture in the world, and this self-perception is reflected in their attitude toward foreigners. The modern meaning of the word "barbarian" is "uncivilized" or "primitive," but for the ancient Greeks any foreigner was a barbarian (*barbaros*). The Greeks considered anyone who spoke a foreign language — unintelligible words sounding like "bar-bar" — to be less civilized than they were. The distinction between Greeks and barbarians had been established by about 800 B.C., around the time that the Greek alphabet developed. It was an adaptation of Phoenician, a Semitic language of the ancient Near East. The English word "alphabet," in fact, combines the first two letters of the Greek

alphabet — *alpha* and *beta* are equivalent to *A* and *B*.

Greece was not only the most civilized country in its own estimation, it was also the most central. The oracle on the mainland at Delphi, where futures were foretold, omens read, and dreams interpreted, was called the navel, or *omphalos*, of the world. Inscribed in stone at Delphi was the prescription "Know thyself," which expressed a new emphasis on individual psychology and insight.

There was also a new perception of history. Rather than marking the passing of time in terms of kings and dynasties as the Egyptians and the Mesopotamians had, the Greeks counted in Olympiads — four-year periods beginning with the first Olympic Games, held in 776 B.C. The Games contributed to the Greek sense of cultural unity. They were so important that all wars were halted so athletes could travel safely to Olympia to participate, and the honors for victory were great. In this way the destructive forces of battle were transformed into the more peaceful pursuit of athletic competition.

Government, Philosophy, and Science

The Athenians abhorred the rule of kings and pharaohs. When the so-called *tyrannicides*, or tyrant-killers, were put to death in the sixth century B.C., the Athenians honored them as champions of liberty. Tyranny, to the Greeks, was exemplified by the Assyrians and Persians. Their aversion to it is evident in their establishment of the independent city-state (*polis*), with citizen participation in government. Even though the Greeks kept slaves and did not allow women to participate in public affairs, the *polis* was to become an important foundation of modern democracy. The ideas embodied in the Athenian democracy of the second half of the fifth century B.C. inspired Thomas Jefferson when he wrote the Declaration of Independence and framed the American Constitution in the late eighteenth century. The very term "democracy" is a Greek word meaning "power" (*kratos*) of the "people" (*demos*).

Greek ideas of government and philosophy reinforced each other, especially in the dialogues of Plato, a philosopher of the fourth century B.C. In the *Republic* and the

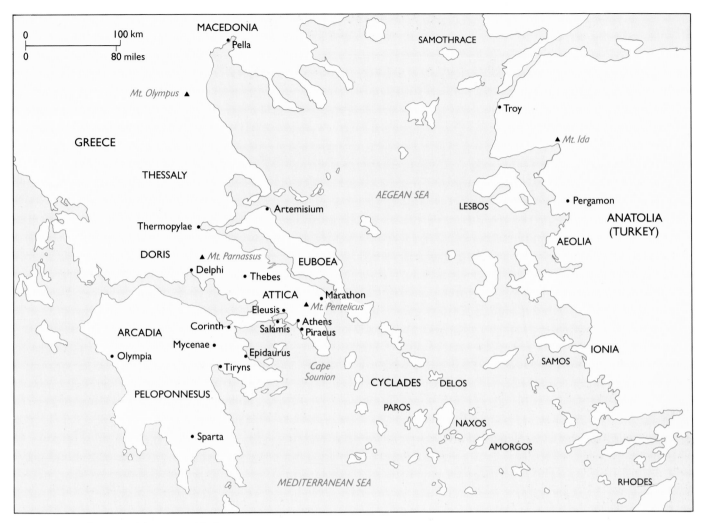

Map of ancient Greece and the eastern Mediterranean.

Laws, Plato takes his readers on a philosophical journey through his ideal state and describes the laws required for its proper functioning. As his spokesman he chooses Socrates, who had created the Socratic method of dialogue — that is, he elicited the truth of an argument from the student by a process of question and answer. The Socratic method demands close observation and consideration of nature and human character — it is a system that assumes a scientific view of the world.

There was no shortage of scientists or scientific thinking in ancient Greece. In the seventh century B.C., Thales of Miletus founded the first Greek school of philosophy. In the following century, the Pythagorean school on Samos recognized that the earth was a sphere some two thousand years before Columbus set out to prove it. Here the Pythagorean theorem was formulated: $A^2 + B^2 = C^2$ (the square of the hypotenuse of a right-angled triangle is equal to the sum of the squares of the other two sides). The same mathematical relationships determined the proportions of Classical Greek temples (see p.105) built some one hundred years after Pythagoras. In the fourth century B.C., Euclid developed number theory and the type of plane geometry which is still called Euclidian today. In medicine, too, the Greeks made major contributions to western civilization. Hippocrates, a doctor of the fifth century B.C. to whom over seventy works on medicine have been attributed, studied the effects of the environment on health. His name survives in the Hippocratic Oath, the pledge required of all western doctors before they are allowed to practice medicine.

Literature and Drama

Greece has left to western civilization one of its most remarkable literary legacies. Homer's *Iliad* and *Odyssey*, which would later inspire Schliemann to search for Troy, were originally recited and transmitted orally. These epics were written down between the eighth and sixth centuries B.C., although the exact date is disputed by scholars. A great deal of western theater originated in the tragedies of Aeschylus, Sophocles, and Euripides, and in the comedies of Aristophanes. It was Aeschylus, in the fifth century B.C., whose trilogy of plays, the *Oresteia*, dramatized the tragedy of Agamemnon's family after his return

The Greek Gods

Greek God	Function/Subject	Attribute	Roman Counterpart
Zeus (husband and brother of Hera)	King of the gods, sky	Thunderbolt, eagle	Jupiter
Hera (wife and sister of Zeus)	Queen of the gods, women, marriage, maternity	Veil, cuckoo, pomegranate, peacock	Juno
Athena (daughter of Zeus)	War in its strategic aspects, wisdom, weaving, protector of Athens	Armor, shield, Gorgon, Nike	Minerva
Ares (son of Zeus and Hera)	War, carnage, strife, blind courage	Armor	Mars
Aphrodite	Love, beauty	Eros (her son)	Venus
Apollo (son of Zeus and Leto)	Solar light, reason, prophecy, medicine, music	Lyre, bow, quiver, shepherd's crook	Phoebus
Helios (later identified with Apollo)	Sun		
Artemis (daughter of Zeus and Leto)	Lunar light, hunting, childbirth	Bow and arrow, nymphs, dogs	Diana
Selene (later identified with Artemis)	Moon		
Hermes (son of Zeus and Maia)	Male messenger of the gods, good luck, wealth, travel, dreams, eloquence	Winged sandals, winged cap, *caduceus* (winged staff entwined with two serpents)	Mercury
Hades (brother of Zeus, husband of Persephone)	Underworld	Cerberus (a monstrous dog)	Pluto
Dionysus (son of Zeus and Semele)	Wine	*Thyrsus* (staff), wine cup, grapes, panther skin	Bacchus
Hephaestus (son of Zeus and Hera)	Fire, the art of the blacksmith, crafts	Hammer, tongs	Vulcan
Hestia (sister of Zeus)	Hearth, domestic fire, the family	Hearth	Vesta
Demeter (sister of Zeus)	Agriculture, grain	Ears of wheat, scepter, torch	Ceres
Poseidon (brother of Zeus)	Sea	Trident, horse	Neptune
Heracles (son of Zeus and a mortal woman, the only hero admitted by the gods to Mount Olympus and granted immortality)	Strength	Lion skin, club	Hercules
Eros (son of Aphrodite)	Love	Bow and arrow, wings	Amor (Cupid)
Iris	Female messenger of the gods (especially Hera), rainbow	Wings	
Hebe (daughter of Zeus and Hera)	Cupbearer of the gods, youth	Cup	
Nike	Victory	Wings	
Persephone (daughter of Zeus and Demeter, wife of Hades)	Underworld	Bat, narcissus, pomegranate	

to Mycenae from the Trojan War (see p.86). And it was Sophocles who gave the world the Oedipus plays, from which Freud recognized that poets had understood human psychology long before the development of psychoanalysis. Aristotle, Plato's most distinguished student and tutor to Alexander the Great, stands out among the ancient Greeks for the diversity of his interests. In addition to natural sciences such as botany, physics, and physiology, Aristotle wrote on philosophy, metaphysics, ethics, politics, logic, rhetoric, and poetry. His *Poetics* established the basis for many subsequent discussions of tragedy, comedy, and epic poetry in western literary criticism.

"Man is the Measure of All Things"

The ancient Greek contributions to western civilization are inextricably linked to this famous maxim. It represents a kind of historical revolution when compared to the philosophies of other Mediterranean cultures of the period. This Greek orientation toward individual human potential strongly influenced science, history, philosophy, and literature, as well as the visual arts.

Ancient Greece developed the first known western religion whose gods were not only **anthropomorphic** (imagined to have human form and attributes), but also had human personalities and conflicts. These more humane gods of Mount Olympus had overthrown their primitive, cannibalistic forerunners, the Giants or Titans.

The Greeks also differed from previous Mediterranean cultures in their beliefs about death. Taking a spiritual rather than a material view of the afterlife, they believed that certain rituals were necessary for the "shade" to pass into the shadowy underworld of Hades. Without proper burial rituals, a spirit might be condemned to wander restlessly forever. It was important that the grave be marked in some way, but the markers were seen as memorials to the deceased rather than as offerings to the gods.

The works of art that survive from ancient Greece are a particularly powerful expression of the Greek emphasis on the human being. In contrast to the remarkable continuity of Egyptian art, Greek art evolved rapidly from stylization to naturalism. The treatment of nature and humanity's place in nature — ideal as well as actual — differentiated the Greek and Egyptian use of *canons* (see p.70). In Greek art, measurements were calculated in relation to human scale and organic form.

The Greek attitude to artists indicated a new interest in the relationship of creators to their work. As far as one can tell, the Greeks were the first western people to sign their work. They were also the first to write about female as well as male artists, indicating that — despite the restricted role of women in Greek society — a few exceptional women did achieve professional success. The Greeks gave their artists a new status which was consistent with their cultural view that people, rather than gods, were the "measure of all things."

Painting and Pottery

Geometric Style (c. 900–700 B.C.)

As all the monumental murals of ancient Greece have been lost, the development of painting styles is known only through the images on pottery. The earliest recognizable style in Greek art after the migrations of 1200–800 B.C. is called **Geometric**. The lively patterns arranged on the **amphora** (two-handled storage jar) in figure **7.1** are

Women in Ancient Greece

In the period of Greek history depicted by Homer, aristocratic women led lives of relative independence, as did the women of Sparta from the sixth century B.C. onward. In Athens and other parts of Greece during the Classical period, however, women lived under severe constraints. They rarely ventured outside the home except for religious processions, festivals restricted to women, or theatrical performances, and even then they had to be accompanied by a slave or other attendant. They could neither vote nor hold public office.

In the private sphere, they occupied segregated quarters of the house. The Greek family was monogamous. Marriage was an economic transaction arranged by the parents of the couple, generally within a circle of relatives so as to preserve property within the family. The woman was usually much younger than the man, and they often had no previous acquaintance. If an unmarried woman had no brothers, she was obliged upon the death of her father to marry his closest relative in order to carry on the family.

Once married, a woman became her husband's property. She had no independent status and her life was devoted to childbearing and looking after the family and household. In the words of the historian Thucydides (c. 460–400 B.C.), it was a woman's duty "to be spoken of as little as possible among men, whether for good or ill." Women could own nothing apart from personal possessions, and could not be party to any transaction worth more than a nominal amount. A husband could divorce his wife by declaration before witnesses, whereas a wife could do so only by taking her husband to court and proving serious offenses.

Ideas about female emancipation appear in literature from the end of the fifth century B.C., and some of the most memorable roles in Greek plays are female. From the fourth century B.C. onwards — and increasingly so in the Hellenistic period — education was accessible to some women, and there are reports of women studying philosophy, painting, and writing poetry. A few were made citizens of other than their native cities because of their accomplishments. But such women were rare, and the general attitude continued to be at once protective and patronizing. In the words of Aristotle, "The deliberative faculty is not present at all in the slave, in the female it is inoperative, in the child undeveloped."

7.1 Attic High Geometric *amphora*. Mid-8th century B.C. Terra cotta, 20 in (51 cm) high. Staatliche Antikensammlungen, Munich. The painted surface of this vase is essentially monochromatic — restricted to a dark brown on a buff ground. The patterns of diamonds, triangles, checkerboard, and meander that encircle the body, neck, and rim of the vase reinforce its rounded shape.

Greek Vase Media

Greek vases were made of terra cotta. On **black-figure** pieces, the artist painted the figures in **silhouette** with a **slip** made of clay and water. Details were added with a sharp tool by incising lines through the painted surface and exposing the orange clay below. The vase was then fired (baked in a kiln) in three stages. The final result was an oxidization process that turned the body of the vase reddish-orange and the painted areas black.

For **red-figure** vases, the process was reversed. Figures were left in red against a painted black background, and details were painted in black.

On **white-ground** vases, a wash of white clay formed the background. Figures were then applied in black and additional colors were sometimes added after the firing.

As early as the Archaic period, certain shapes became associated with specific uses (fig. **7.2**).

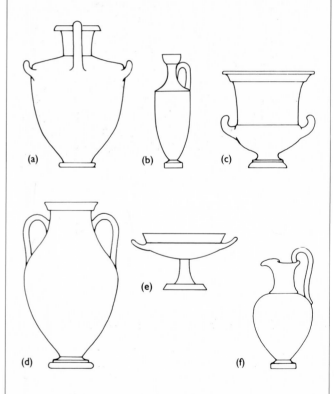

7.2 Greek vase shapes include (a) the **hydria**, a water jar with three handles; (b) the **lekythos**, a flask for storing and pouring oil; (c) the **krater**, a bowl for mixing wine and water (the Greeks drank their wine diluted); (d) the **amphora**, a vessel for storing honey, olive oil, water, or wine; (e) the **kylix**, a drinking cup; and (f) the **oenochoe**, a jug for pouring wine.

typical of Geometric pottery design. Each pattern is framed by circular horizontal borders that restate the shape of the pot. Three rows of animals — grazing deer under the rim or lip, crouching goats on the shoulder, and long-necked herons above the dark rings at the base — repeat the circular motion of the painted decoration. The deer and herons move from left to right, the direction in which our eyes naturally read an image. That movement is echoed in the diagonal planes of the goats' bodies, which are angled from upper left to lower right. The curves of their necks counterbalance this, shifting from right to left. Repeating the arrangement of the goats in abstract

form are the four **meander patterns**, two on the neck and two on the body of the vase. The spaces between the animals are decorated with individual geometric shapes, and this creates a satisfying unity of natural and geometric form.

7.3 *Achilles and Ajax Playing a Board Game*, detail of *amphora*. 540–530 B.C. Terra cotta, total height of vessel 24 in (61 cm). Musei Vaticani, Rome. This *amphora* was signed by Exekias as both potter and painter. He integrates form with psychology to convey the impression that Achilles, the younger warrior on the left, will win the game. On the right, Ajax leans farther forward than Achilles so that the level of his head is slightly lower than Achilles', and he has removed his helmet. Achilles' helmet and tall crest indicate his dominance.

Black-Figure Painting (c. 600–480 B.C.)

There are three main categories of Greek pottery decoration: black-figure, red-figure, and white-ground. In the black-figure painting of *Achilles and Ajax Playing a Board Game* (fig. **7.3**), geometric patterns have been subsumed into border devices. The central image is a narrative scene. Exekias, the most insightful black-figure artist, transforms the personal rivalry between the two Greek heroes of the Trojan War into a board game. He emphasizes their intense concentration by using the combined diagonals of their spears and their gaze to focus on the game board. Ajax and Achilles are identified by inscriptions. They wear elaborately patterned cloaks, arm and thigh armor enlivened with elegant spiral designs, and greaves (shin protectors). The stylized frontal eye persists from Aegean, Egyptian, and Mesopotamian art, but the shoulders are rendered more naturally in side view.

Encaustic: Luminous Painting

From the second half of the fifth century B.C., Greek artists colored their sculptures with **encaustic** — one of the oldest and most luminous painting media. It is made by mixing dry powder pigments with molten beeswax. Colors are applied with a brush or a spatula and then fused in with heat — hence the term "encaustic," which means "burnt in." Greek artists liked to refer to their "waxes" just as modern artists refer to their "oils."

Because of its luminosity, encaustic can create a particularly naturalistic impression. The sixth-century-B.C. poet Anacreon was reportedly so amazed by an encaustic likeness that he exclaimed, "Quickly, O wax, you will speak!" Unfortunately, Greek encaustic paintings are now known only from descriptions.

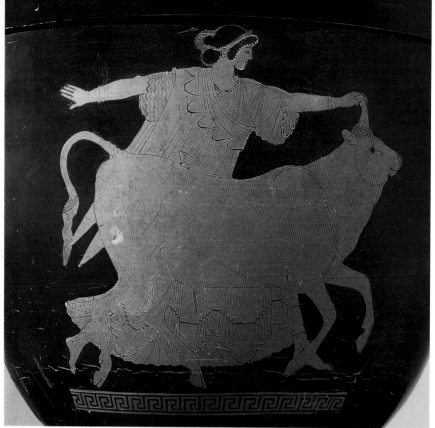

7.4 (left) Berlin Painter, *Abduction of Europa*, detail from bell *krater*. c. 490 B.C. Terra cotta, total height of vessel 13 in (33 cm). Museo Archeologico, Tarquinia. In this scene, Zeus takes the form of a bull and abducts the mortal Europa. The Greeks, who knew the myth, would have seen the irony in the way the unsuspecting Europa is fascinated by Zeus's horn and rushes to her fate.

Red-Figure Painting (c. 530–450 B.C.)

The scene on a bell *krater* of about 490 B.C. by the so-called Berlin Painter (fig. **7.4**) illustrates the stylistic development that accompanied the changes in technique in red-figure painting. The decorative surface patterns have decreased and more attention is given to natural form and movement. Black lines indicating the folds of Europa's dress appear three-dimensional in form and suggest the motion of her body — especially the large step that she takes with her left leg on the far side of the bull.

White-Ground Painting (c. 450–400 B.C.)

During the late fifth century B.C., white-ground *lekythoi* became popular as grave ornaments. The example in figure **7.5**, from about 410 B.C., shows a warrior sitting by a grave. He is rendered as if seated in a three-dimensional space — his body moves naturally, bending slightly at the waist, and his head inclines. The drapery falls over his legs as it would in reality, and his left thigh and shield are **foreshortened**.

Greek interest in naturalism is reflected in numerous accounts of artists' ability to create illusionistic images. As mentioned in Chapter 1, Zeuxis was reputed to have painted grapes that fooled birds into believing they were real. By the second half of the fifth century, Zeuxis was painting from live models and therefore directly from nature. Anecdotes relate that he died laughing while staring at his painting of an old woman, and that he painted Helen of Troy (see p.86) as a high-class prostitute, charging admission when the picture was exhibited. Such accounts convey the artist's personality and also express the Greek admiration for convincing depictions of the natural world.

7.5 Reed Painter, *Warrior by a Grave*, detail of white-ground *lekythos*. Late 5th century B.C. Terra cotta, total height of vessel 18⅞ in (48 cm). National Archeological Museum, Athens. The use of foreshortening, which depicts the round shield as an oval because it is partly turned, indicates the Greek artist's interest in rendering forms as they appear in natural, three-dimensional space.

Mosaic

The few monumental examples of Greek pictorial style that have survived date from the Hellenistic period (c. 323–31 B.C.). The pebble **mosaic** in figure **7.6** represents a stag hunt. The diagonal planes, the curved, shifting outlines, and the sharp contrast between the white figures and dark gray background animate the composition. This sense of animation is strongly reinforced by the elaborate floral border. Note also the suggestion of muscle tension rendered by shading, and the flowing cloaks of the hunters. The opposing diagonals of the figures enhance the impression of struggle between hunters and stag and between stag and dog. Because the artist conveys a sense of three-dimensional space, the two hunters and their dog appear to surround their prey.

7.6 *Stag Hunt*, from Pella. 3rd century B.C. Pebble mosaic, 10 ft 4 in x 10 ft 4 in (3.15 x 3.15 m). Archeological Museum, Pella. In floor mosaics, the image is created by embedding colored pebbles into a surface and defining the outlines with metal strips inlaid to keep the stones in place. The use of pebbles tends to make the colors dull. Despite the limitations of the medium, an illusion of organic figures moving freely in three-dimensional space is achieved here.

Sculpture

Greek sculpture parallels the development of painting toward increasing naturalism.

Archaic Style (c. 660–480 B.C.)

Monumental sculpture in Greece began in the Archaic period (the name is derived from the Greek *archaios*, meaning "old"). It is not known why the Greeks started to make monumental sculptures when they did, but it is clear that the early Archaic artists were influenced by Egyptian technique and convention. The Greeks learned from the Egyptians how to carve blocks of stone, but adapted the method to suit their own tastes.

A comparison of the *New York* **Kouros** (fig. **7.7**) with the sculpture of Menkure (fig. **5.13**) highlights the similarities and differences between Egyptian and Archaic Greek lifesize statues. The *kouros* maintains the standard Egyptian frontal pose. His left leg extends forward with no bend at knee, hips, or waist, and his arms are at his sides, fists clenched and elbows turned back. Nevertheless, the Greek artist has made changes to emphasize human scale and anatomy. The *kouros* is cut away from the original rectangular block of marble, leaving open spaces between arms and body and between the legs. This openness and the smaller shoulders decrease the tension and monumentality of the *kouros* when compared with Menkure.

Both figures are rendered with characteristic stylizations. In contrast to the rectangularity of Egyptian convention, various features of the *kouros* are curved—the round kneecaps topped by two arcs, the lower outline of the ribcage, the shoulder blades, and the double arc above the buttocks. The hair is composed of little circles arranged in parallel rows, ending in a bottom row of small cones. It falls over the back of the shoulders, but does not fill up as much space as Menkure's wig. The most obvious difference between Menkure and the *New York Kouros* is the nudity of the latter. The Greek convention of nudity for male statues from the Archaic period signals the Greek interest in human form.

Archaic statues of females were clothed for reasons of propriety. The fact that Greek women stayed at home may account for their greater modesty in monumental art before the fourth century B.C. Archaic sculptures of standing women are referred to as **korai** (singular **kore**, Greek for "girl"). In the **Peplos Kore** (fig. **7.8**) (*peplos* is Greek for "outer robe"), the figure's pose is similar to that of the

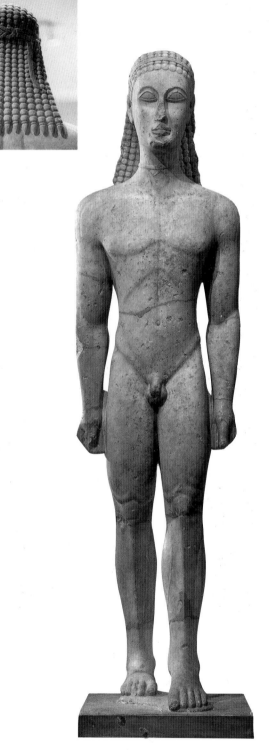

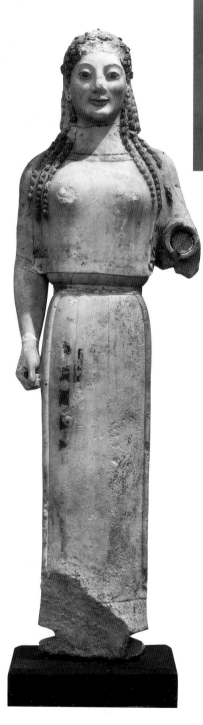

7.7a and **b** Dipylon Master, *New York Kouros*, from Attica. c. 620 B.C. Marble, 6 ft (1.84 m) high. Metropolitan Museum of Art, New York (Fletcher Fund, 1932). *Kouros*, the Greek word for "boy" (*kouroi* in the plural) is used to denote a type of standing male figure, typically carved from marble and usually commemorative in nature. This *kouros* is named for its present location. It is the earliest known lifesize sculpture of a standing male from the Archaic period.

7.8a and **b** *Peplos Kore*. c. 530 B.C. Parian marble, 3 ft 11⅔ in (1.21 m) high. Acropolis Museum, Athens. Although we have become used to white Greek sculptures, Greek artists originally used color to enliven the appearance of their figures. The *Peplos Kore* still retains traces of paint on her dress and in her eyes.

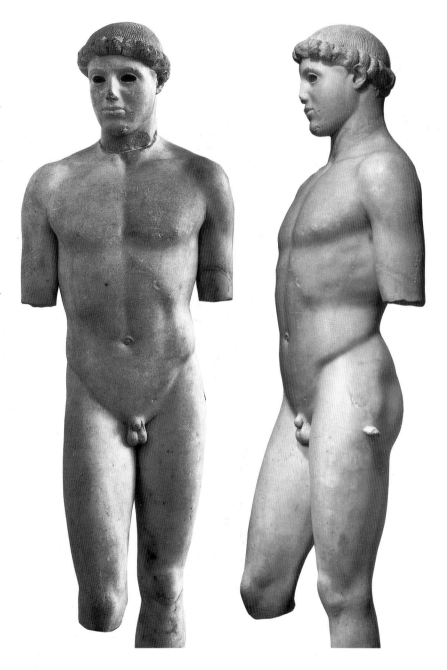

7.9a and **b** *Critios Boy*, from the Acropolis, Athens. c. 480 B.C. Parian marble, 33⅞ in (86 cm) high. Acropolis Museum, Athens.

kouros except for the bent left arm and the lack of extension of the left leg.

Unlike the earlier Archaic figures, the *Peplos Kore* has the so-called ''Archaic smile,'' the first clear and recognizable facial expression in western art. The smile is a uniquely human phenomenon (animals don't smile), and reflects the Greek interest in human form and character. Here the artist has handled the face organically by curving the lips upward and raising the cheekbones in response to the smile.

Early Classical Style (c. 490–450 B.C.)

In 499 to 494 B.C. Athens gave aid to the Ionian cities in their unsuccessful revolt against Persia. This provoked Darius the Great, King of Persia, to invade mainland Greece in 490, only to be defeated by the Athenians at the Battle of Marathon. Another invasion a few years later by Darius's son, Xerxes, was finally turned back in 479 B.C.; this marked the end of Persian attempts to conquer Greece. A change in artistic style seems to have coincided with the Persians' final departure from Greek soil. The Early Classical style, sometimes called Severe or Transitional (because it bridges the gap between Archaic and Classical), produced radical changes in the approach to the human figure.

The best example of the new developments can be seen in the marble *Critios Boy*, attributed to the sculptor Critios (fig. **7.9**). Stylization has decreased, remaining primarily in the smooth wavy hair and the perfect circle of curves

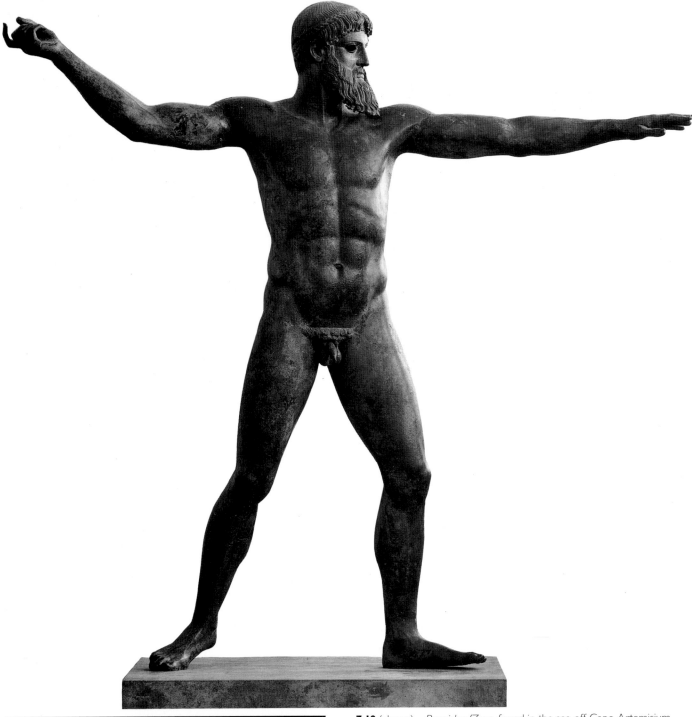

The Lost-Wax Process

In casting bronze by the **lost-wax** method (also known by the French term *cire-perdue*), the artist begins by molding a soft, pliable material such as clay or plaster into the desired shape and covering it with wax. A second coat of soft material is superimposed on the wax and attached with pins or other supports. The wax is then melted and allowed to flow away, leaving a hollow space between the two layers of soft material. The artist pours molten bronze into the mold, the bronze hardens as it cools, and the mold is removed. The bronze is now in the shape originally formed by the "lost" wax. It is ready for tooling, polishing, and the addition of features such as glass or stone eyes and ivory teeth to heighten the organic appearance of the figure.

7.10 (above) *Poseidon/Zeus*, found in the sea off Cape Artemisium. c. 450 B.C. Bronze, 6 ft 10¼ in (2.09 m) high. National Archeological Museum, Athens. Dating from about thirty years after the *Critios Boy*, the Poseidon/Zeus reflects the Greek interest in athletics. Greek artists studied athletes practicing in the gymnasia in order to create figures in action.

7.11 (opposite) Polyclitus, *Doryphorus* (*Spearbearer*). c. 440 B.C. Marble copy of bronze original, 6 ft 11½ in (2.12 m) high. Museo Nazionale Archeologico, Naples. This is known to be a Roman copy from ancient records indicating that the original was bronze. Typical of Roman copies is the "tree trunk" supporting the back of the right leg, and the block of marble connecting the hip with the right wrist. Since bronze is a stronger medium than marble, it can stand on its own more readily and needs no such additional supports.

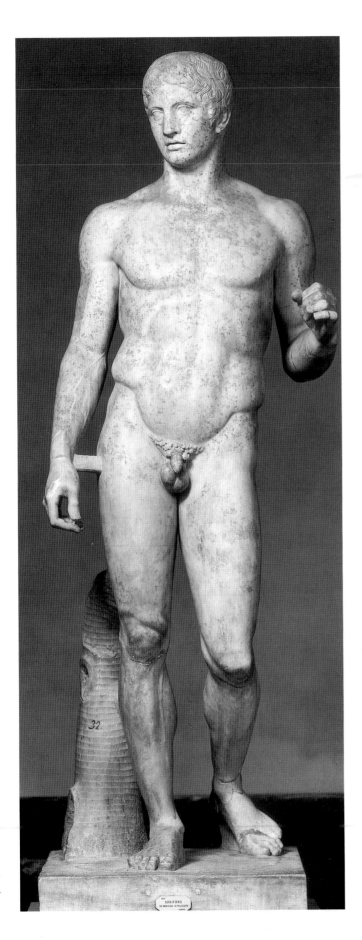

forming the hemisphere of the head. The flesh now seems to cover an organic structure of bone and muscle. The Archaic smile has disappeared and the face has become neutral in expression and, like the body, idealized. But perhaps the most important development is that the head is turned slightly and the right leg, which is forward, bends at the knee. In response, the weight of the torso shifts so that the right hip and shoulder are lowered. This pose is referred to as **contrapposto** (from the Latin *positus*, meaning "positioned" and *contra*, meaning "against"). As a result of the *contrapposto*, the *Critios Boy* seems relaxed and the frontality and rigid stance of the Archaic *kouros* have been modified.

Another Early Classical development was the introduction of bronze as a medium for large-scale sculptures, which were cast by the "lost-wax" process. Of the few Greek bronzes that have survived, the over-lifesize bronze statue representing either Zeus hurling his thunderbolt or Poseidon his trident (fig. **7.10**) is one of the most impressive. By virtue of his pose, the god seems to command space. He focuses his aim, tensing his body and positioning himself for an instantaneous shift from his right forefoot to his left heel. His slightly bent knees create the impression that he will spring at any moment. The intensity of his concentration and the force of an imminent thrust extend beyond the sculpture to the weapon's destination.

Fifth-Century Classical Style

(c. 450–400 B.C.)

The fifty-year span of Greek history from about 450 to 400 B.C. is known as the Classical period. The modern term "classical," which has multiple meanings, including "traditional," "lasting," and "of high quality," referred originally to the Greek achievements of the second half of the fifth century B.C. The works of art produced during this period not only reflect the cultural and intellectual advances of ancient Greece itself; they have also had a far-reaching influence on subsequent western art and culture. It is virtually impossible to understand any aspect of western development fully without some familiarity with Classical Greece. In particular, Classical Greek artists brought the representation of human figures to what is considered one of the high points of western style.

Polyclitus of Argos. Polyclitus was esteemed by his contemporaries, and his work is still thought of as the embodiment of Classical style. He is known to have recorded a *canon* (see p.70) which is no longer extant. Most of his sculptures were cast in bronze and do not survive — they are known today only through later Roman copies in marble. The *Doryphorus*, or *Spearbearer* (fig. **7.11**), who originally held a spear in his left hand, stands like the *Critios Boy* (fig. **7.9**) although with a slight increase in *contrapposto* and in the inclination of the head. The gradual S motion of the body is more pronounced and there is a greater sense of conviction in the body's underlying organic structure — notably the bulging kneecaps,

ribcage, and veins in the arms. The proportions of the head have changed so that the ears are lower in relation to the eyes, the nose is straighter, and the chin narrower. The head is dome-shaped, as in the *Critios Boy*, but the circle of curls has been eliminated and the short, wavy hair lies flat on the surface of the head and face.

Another marble replica of a bronze attributed to Polyclitus is the *Wounded Amazon* of around 430 B.C. (fig. **7.12**). Compared with the Archaic *Peplos Kore* (fig. **7.8**), the figure is relaxed — her body turns somewhat languidly, and she inclines her head and twists at the waist. The Archaic stylizations have disappeared, as has the smile. The hair is parted in the middle and seems to grow from the scalp. Whereas Archaic drapery has a columnar, architectural quality, Classical drapery follows the form and movement of the body.

Another important Classical characteristic is the idealization of the human form. Figures are usually young, with no trace of physical defect. They are nicely proportioned and symmetrical, but lack personality and facial expression. These qualities are evident in the *Amazon*, who turns toward a wound in her right side without indicating any pain or discomfort. Polyclitus's preference for idealization thus overrides the narrative content. Such conventions of Classical taste can be seen in Greek theater of the fifth century B.C. as well as in sculpture. No violence or impropriety occurred on stage — when the plot demanded such events, they were not performed but rather were described by a messenger.

Classical Architecture

Athens: The Acropolis

Athens is the capital of modern Greece, and is located on the Saronic Gulf, just inland from the port of Piraeus. In the second half of the fifth century B.C., Athens was the site of the full flowering of the Classical style in the arts. This section considers that culmination as it was embodied in the buildings on the Acropolis — particularly the Parthenon. The Acropolis (from the Greek *acros*, meaning "high" or "upper" and *polis*, meaning "city") (figs. **7.13** and **7.14**) is a fortified rock supporting several temples, precincts, and other buildings. Its steep walls meant that it could not be scaled by invaders. Like the Mycenaean citadel (see p.87), the Acropolis provided sanctuary for citizens in times of siege.

The Classical period in Athens is also called the Age of Pericles, after the Greek general and statesman (c. 500–429 B.C.) who initiated the architectural projects for the Acropolis. He planned a vast rebuilding campaign to celebrate Athenian art and civilization after the devastation of the Persian Wars. The **Propylaea** and the Parthenon (fig. **7.15**) were completed during his lifetime, but work on the Temple of Athena Nike (fig. **7.28**) and the **Erechtheum** (fig. **7.30**) was not begun until after his death.

7.12 Polyclitus, *Wounded Amazon*. c. 430 B.C. Marble copy of bronze original, 6 ft 7½ in (2.02 m) high. Museo Capitolino, Rome. Amazons were female warriors from the east who helped defend Troy against the Greeks. The dress of the Amazon has numerous folds, creating an additional surface movement that interrupts the smooth skin of the body. The repeated bunches of short curves just below the waist can be related to the waves of the hair, creating a visual unity between parts that also conform to the organic logic of the whole. This kind of unity, integrating the visual and the intellectual, is one of the predominant characteristics of the Classical style.

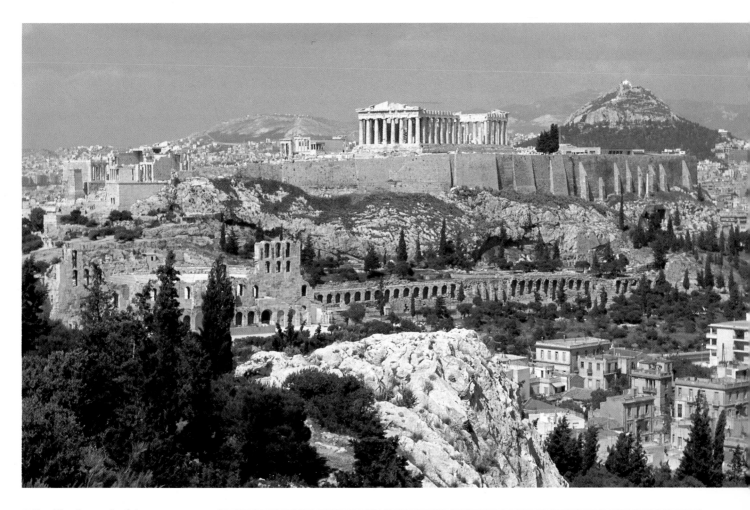

7.13 The Acropolis, Athens.

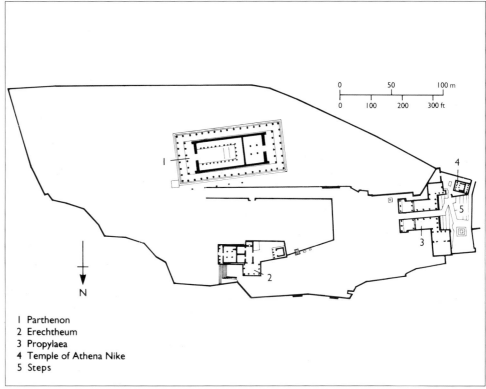

7.14 Plan of the Acropolis. This plan includes only the four Classical buildings that were rebuilt after the destruction of the Acropolis at the end of the Persian Wars (c. 480 B.C.). Like most Greek temples, they were made of marble. It was a favorite construction material of the Greeks, and was available in large quantities from quarries in the mainland and on the islands.

1 Parthenon
2 Erechtheum
3 Propylaea
4 Temple of Athena Nike
5 Steps

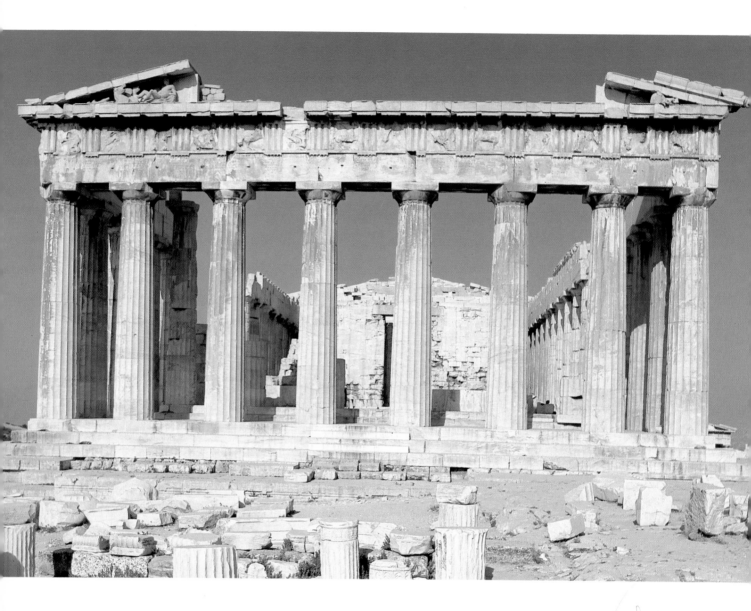

7.15 West end of the Parthenon, Athens. 448–432 B.C. Pentelic marble, 111 x 237 ft (33.8 x 72.2 m) at base. Once through the Propylaea at the western edge of the Acropolis, the viewer emerges facing east. Ahead and a little to the right are the remains of the western wall of the Parthenon. Its damaged state reflects centuries of neglect and misuse. In the fifth century A.D., the Parthenon became a church, and 900 years later the Turks conquered Athens and converted the temple into a mosque. They stored gunpowder in the building! When it was shelled in the seventeenth century, most of the interior and many sculptures were destroyed. Centuries of vandalism and looting, plus modern air pollution, have further contributed to the deterioration of the Parthenon.

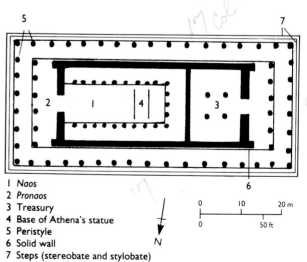

1 *Naos*
2 *Pronaos*
3 Treasury
4 Base of Athena's statue
5 Peristyle
6 Solid wall
7 Steps (stereobate and stylobate)

7.16 Plan of the Parthenon.

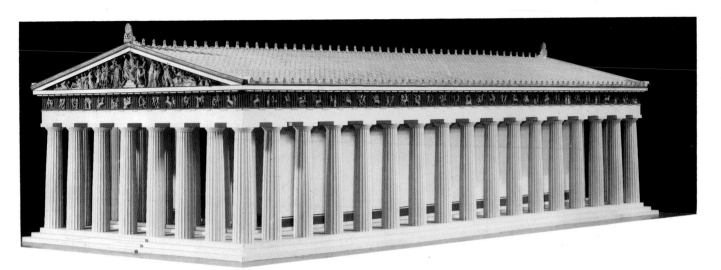

7.17 Reconstruction of the Parthenon. Metropolitan Museum of Art, New York (Purchase, Bequest of Levi Hale Willard, 1890). This view is from the northeast corner — the eastern pediment and the long north side are visible.

Plan of the Parthenon

The Parthenon (fig. **7.16**) is constructed as a rectangle, which is itself divided into two smaller rectangular rooms. A front and back porch and a **peristyle (colonnade)**, supported by the three steps of the Doric order, complete the structure. The temple was made entirely of marble, which was cut and fitted without the use of mortar.

The three lines on the perimeter of the plan represent the steps. The black circles indicate columns — those comprising the peristyle number eight on the short sides (east and west) and seventeen on the long sides (north and south), counting the corner columns twice. Each corner column serves a short and a long side, making a smooth visual transition between them.

The inside wall of the Parthenon, supported by two steps, consists of six columns on a front and back porch leading to a solid wall with a doorway to an inner room. The walls are indicated by thick black lines.

The western entrance leads to the smaller room, which served as a treasury. The eastern entrance leads to the **naos,** or inner sanctuary. It was originally dominated by a monumental gold and ivory statue of Athena — its base is indicated on the plan by the rectangle inside the *naos.* An inner rectangle of Doric columns repeats the shape of the room and surrounds the statue on three sides.

Although constructed primarily in the Doric order, the Parthenon had two features that were Ionic. Firstly, there were four Ionic columns inside the treasury. And secondly, a continuous Ionic frieze ran around the top of the inside wall (this cannot be seen on the plan). Such inclusion of Ionic elements in the Parthenon expresses the Athenian interest in harmonizing the architectural and sculptural achievements of eastern and western Greece.

The Parthenon

The Parthenon was designed by the architects Ictinus and Callicrates. Phidias, the leading Athenian artist of his generation, supervised the sculptural decorations. Completed in 432 B.C. as a temple to Athena, the patron goddess of Athens, the Parthenon celebrates her in her aspect as a virgin goddess. *Parthenos,* Greek for "virgin" and the root of the word "parthenogenesis" (virgin birth), was one of Athena's epithets.

The Parthenon stands within a continuum of Doric temples. Earlier examples are found at Olympia in the western Peloponnese and at Paestum in southern Italy. However, no previous Greek temple expresses Classical balance, **proportion**, and unity to the same extent as the Parthenon. Its exceptional esthetic impact is enhanced by its so-called refinements, which are slight architectural adjustments to improve the visual impression of the building. For example, lines that are perceived as horizontals actually curve upward in the middle. The original rationale for this is not known for certain, but it serves to correct the tendency of the human eye to perceive a long horizontal as curving downward in the middle. Other refinements involve the columns: all columns are tilted inward slightly, and are placed closer together toward the corners of the building. This creates a sense of stability and accentuates the corners, resulting in an almost imperceptible frame on each of the four sides.

The Parthenon sculptures were located in four sections of the building and integrated harmoniously with the architecture. Their narrative content proclaimed the greatness of Classical Athens.

Pediments. Drawings made in the seventeenth century by the Frenchman Jacques Carrey illustrate the condition of the pediments of the Parthenon three hundred years ago. Carrey's rendering of the east pediment sculptures (fig. **7.18**) shows them still in a relatively good state of preservation, although the central figures had disappeared.

The three goddesses on the left half of the east pediment

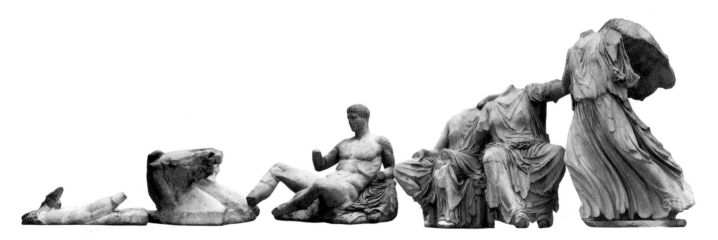

The Golden Section

The **Golden Section** is the name given in the nineteenth century to the proportion produced when a line segment is divided into two parts such that the ratio of the longer part *a* to the shorter part *b* is equal to the ratio of the entire segment *a* + *b* to the longer part *a*. This ratio — the **Golden Ratio** — can be expressed mathematically as

$$\frac{a}{b} = \frac{(a + b)}{a}.$$

Its value is approximately 1.618:1 or 8:5. A **Golden Rectangle** is a rectangle that has adjacent sides with lengths in the Golden Ratio (fig. **7.20**).

These concepts are important in the history of art and architecture, for it has traditionally been thought that any form (including the human figure) is most esthetically pleasing when it is divided in Golden Sections. In the fifth century B.C., the ancient Greeks felt that the Golden Rectangle was the most beautiful of all possible rectangles and they planned many of their temples — including the Parthenon — accordingly. For a more modern use of the Golden Rectangle, see the geometric pictures of Piet Mondrian (fig. **27.13**).

In the Renaissance, the Golden Section was credited with mystical, even divine, properties. And in the twentieth century, it has been claimed that statistical studies show that people naturally prefer proportions based on the Golden Section.

7.20 Diagram of Golden Sections and Golden Rectangles. The lines on the right are divided into Golden Sections, which correspond to the sides of the Golden Rectangles on the left.

7.18a and **b** (opposite) *The East Pediment of the Parthenon in 1674*, from a drawing by Jacques Carrey. Bibliothèque Nationale, Paris. Greek temple sculptures and their background areas were originally painted. The sculptures in the broken center section of this pediment used to represent Athena's birth on Mount Olympus: Zeus is in the middle and a Nike is crowning Athena with a laurel wreath. According to the myth, Hephaestus struck Zeus on the head with an ax and Athena emerged fully grown and armed. As the goddess of wisdom, as well as of war, she was born like an idea from the head of the supreme god.

7.19a, b, and **c** (opposite, below) Sculptures from the left side of the east pediment of the Parthenon. Pentelic marble, left figure 5 ft 8 in (1.73 m) high. British Museum, London. The pediments are almost 100 feet (30.5 m) wide at the base and 11 feet (3.35 m) high at the central peak. The depth of the pediment bases is, however, only 36 inches (91.4 cm), thus restricting the space available for the sculptures. Since the sides of the pediments slope toward the corner angles, Phidias had to solve the problem of fitting the sculptures into a diminishing triangular space.

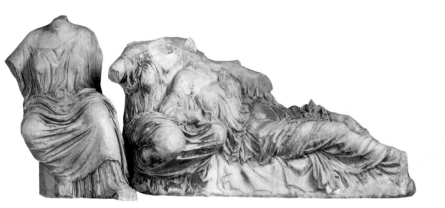

(fig. **7.19**) — possibly Iris or Hebe, Demeter, and Persephone, reading from the viewer's right to the left — are posed so that they fit logically into the triangular space. Their repeated diagonal planes relate to the two diagonals of the pediment, while the graceful curves of their garments harmonize with the architectural curves of the Doric order below. The reclining male nude to the left could be either Heracles or Dionysus. His limbs, like those of the goddesses, form a series of zigzag planes. His torso outlines a gentle curve, which is repeated in the domed head and organic muscle structure beneath the skin. Despite the naturalism of his pose and organic form, however, this figure is idealized — like those of Polyclitus (figs. **7.11** and **7.12**), it has no facial expression or personality.

Mirroring the two seated females and the male on the left of the pediment is the group of three goddesses on the right (fig. **7.21**). Their identity has been disputed by scholars because they have no attributes. Though posed slightly differently than their counterparts on the left, they match them closely. The reclining goddess relates to Dionysus/Heracles, and the two seated figures match Demeter and Persephone in the way they turn and wear curvilinear garments outlining their bodies.

The most dramatic correspondence between the two sides of the east pediment occurs at the angles. On the far left are the marble remnants of Helios's horses, pulling the chariot of the sun. They rise, beginning their daily journey

7.21a and **b** Sculptures from the right side of the east pediment of the Parthenon. Pentelic marble, left figure 4 ft 5 in (1.35 m) high. British Museum, London. At the left corner Helios's horses mark the rising of the sun, because Athena was born in the east at dawn. The horse of the moon descends at the right corner. The location of the scene on the eastern pediment also corresponds with the sunrise in the east. Thus in this arrangement, the artist has formally integrated sculpture and architecture with iconography, time, and place.

across the sky. On the far right, a single horse's head descends, echoing the triangular shape of the pediment. This is a horse from the chariot of Selene, a moon goddess. Its form shows a remarkable understanding of anatomy, and the Classical genius for relating it to an esthetic purpose. Phidias has created the illusion of a triangular cheek plate with one curved side, blood vessels, and muscles pushing against the inside of the skin. The right eye bulges from its socket, and the ear and clipped mane emerge convincingly from beneath the surface. The open mouth produces another triangular space, echoing the head, cheek plate, and the pediment itself.

The Doric Metopes. The Parthenon metopes illustrate four mythological battles. The best preserved were originally located on the south wall and represented the battle between Lapiths, a Greek tribe, and Centaurs, who

The Orders of Greek Architecture

The Doric and Ionic **orders** of Greek architecture had been established by about 600 B.C. and were an elaboration of the post and lintel system of elevation (see p.43). Ancient Greek buildings, like their sculptures, were more human in scale and proportion than those in Egypt. And unlike the animal-based forms of ancient Iran, the Greek orders were composed of geometric sections with individual meaning and logic. Each part was related to the others and to the whole structure in a harmonious, unified way.

The oldest order, the Doric, is named for the Dorians, who lived on the mainland. Ionic — after Ionia, which includes the Ionian islands and the coast of Anatolia — is an eastern order. Its greater elegance results from taller, thinner curvilinear elements and surface decoration. The Corinthian capital is most easily distinguished by its **acanthus** leaf design, and is never found on the exterior of Greek buildings.

Doric Order. The Doric order begins with three steps up from the ground. Its shaft rises directly from the top step (the **stylobate**), generally to a height about 5½ times its diameter at the foot. The shaft is composed of individual sections — **drums** — cut horizontally and held together in the middle by a metal dowel (peg) encased in lead. Shallow, concave grooves known as **flutes** are carved out of the exterior of the shaft. Doric shafts do not stand in an exact vertical plane, but taper slightly from about a quarter of the way up. The resulting bulge, or **entasis** (Greek for "stretching"), indicates that the Classical Greeks thought of their architecture as having an inner organic structure, with a capacity for muscular tension.

At the top of the shaft, three elements make up the Doric capital, which forms both the head of the column and the transition to the horizontal lintel. The **necking** is a snug band at the top of the shaft. Above it is the **echinus** (Greek for "hedgehog" or "sea urchin") — a flat, curved element, like a plate, with rounded sides. The *echinus* forms a transition between the curved shaft and the flat, square **abacus** (Greek for "tablet") above. The *abacus* in turn creates a transition to the **architrave** — literally, a "high beam."

The architrave is the first element of the **entablature** (note the "tabl" related to "table"), which forms the lintel of this complex post and lintel system. The **frieze** on it is divided into alternating sections — square **metopes** and sets of three vertical grooves, or **triglyphs** (Greek *tri*, meaning "three" and *glyphos*, meaning "carving"). Finally, projecting over the frieze is the top element of the entablature — the thin, horizontal **cornice**. In Greek temples, a triangular element known as a **pediment** rested on the cornice, crowning the front and back of the building.

The harmonious relationship between the parts of the Doric order is achieved by formal repetitions and logical transitions. The steps, sides of the abacus, architrave,

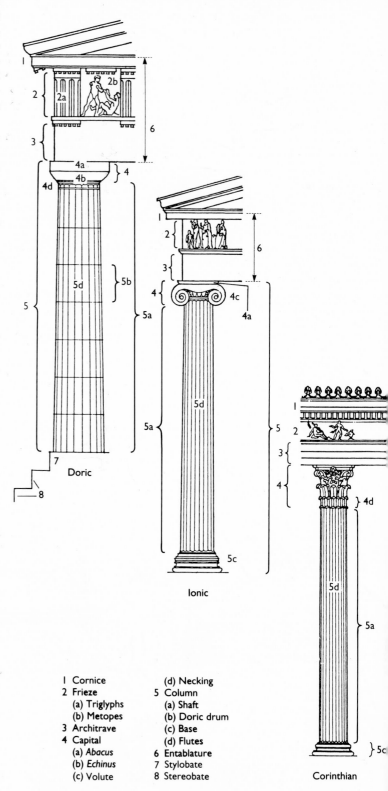

1 Cornice	(d) Necking
2 Frieze	5 Column
(a) Triglyphs	(a) Shaft
(b) Metopes	(b) Doric drum
3 Architrave	(c) Base
4 Capital	(d) Flutes
(a) *Abacus*	6 Entablature
(b) *Echinus*	7 Stylobate
(c) Volute	8 Stereobate

7.22 Doric, Ionic, and Corinthian orders.

metopes, frieze, and cornice are rectangles lying in a horizontal plane. The columns, spaces between columns, flutes, and triglyphs are all vertical. The outline of the three steps, the *echinus*, and each individual drum is a trapezoid (a quadrilateral with two parallel sides).

Groups of three predominate: three steps; a capital consisting of necking, *echinus*, and *abacus*; triglyphs; and the entablature, which is made up of architrave, frieze, and cornice. The sudden shift from the horizontal steps to the vertical shaft is followed by a gradual transition via the capital to the entablature. The pediment may be read as a logical, triangular crown completing the trapezoid formed by the outline of the steps.

Ionic Order.

The more graceful Ionic order has a round base with an alternating convex and concave profile. The shaft is taller in relation to its diameter (height is about nine times the diameter at the foot). The fluting is narrower and deeper. Elegant **volutes**, or **scroll** shapes, replace the Doric *echinus* at each corner, and virtually eclipse the thin *abacus*. In the Ionic frieze, the absence of triglyphs and metopes permits a continuous narrative extending its entire length.

Corinthian Order.

There is no evidence of the existence of the Corinthian order earlier than the latter part of the fifth century B.C. The origin of the term Corinthian is obscure, but it suggests that the acanthus-leaf capital was first designed by the metalworkers of Corinth and later transferred to marble. Unlike Doric and Ionic columns, Corinthian columns were used only in interiors by the Greeks — they were associated with luxury, and therefore with "feminine" character.

Doric drum

7.23 *Lapith and Centaur*, from South Metope XXVII of the Parthenon. Pentelic marble, 4 ft 5 in (1.35 m) high. British Museum, London. Each metope is approximately 4 feet square (0.37 m^2) and contains high relief sculptures. There were fourteen metopes on the short east and west sides, and thirty-two on the long north and south sides. Most of them showed scenes of single combat.

were part human and part horse. According to this myth, the Lapiths invited the Centaurs to a wedding, but the Centaurs got drunk and tried to rape the Lapith boys and girls. The violent energy of the battle (fig. **7.23**) contrasts dramatically with the relaxing gods on the east pediment. The strong diagonals of the Lapith, the repeated curved folds of his cloak, and the backward thrust of the Centaur's *contrapposto* enliven the metope.

The three other metope battles depicted Greeks against Amazons on the west, the Trojan War on the north, and Olympians overthrowing Giants on the east. Each set of metopes expressed one aspect of the Greek sense of superiority. The Lapiths and Centaurs symbolized the universal human conflict between animal instinct or lust — exemplified by the drunken Centaurs — and rational self-control — embodied by the Lapiths. The Greek victory over the Amazons symbolized the triumph of Greek patriarchal culture over an earlier matriarchy. In the Trojan War, west triumphed over east, and in the clash between Giants and Olympians, the more human Greek gods wrested control of the universe from the primitive and cannibalistic pre-Greek Titans. According to the Parthenon metopes therefore, the civilization of Classical Greece was rational, patriarchal, and western, with an established human-based religion.

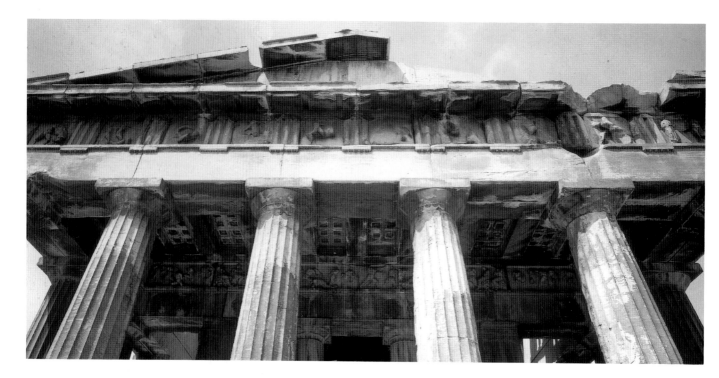

7.24 The Parthenon, looking up through the outer Doric peristyle at the Ionic frieze.

7.25 (below) Cutaway perspective drawing of the Parthenon showing the Doric and Ionic friezes, metopes and a pediment (after G. Niemann).

The Ionic Frieze. Over the outside of the inner wall of the Parthenon (figs. **7.24** and **7.25**), a 525 foot (160 m) Ionic frieze illustrated the Greater Panathenaic procession (fig. **7.26**). This was held every four years, and the entire city participated and presented a sacred robe to Athena. The continuous nature of the Ionic frieze, uninterrupted by triglyphs, is consistent with its content. Thus the shape of the frieze corresponds with the form of a procession. In order to maintain the horizontal plane of the figures, Phidias adopted the sculptural convention of **isocephaly** (from the Greek *isos*, meaning "equal" and *kephalos*, meaning "head"). When a work is isocephalic, the heads are set at approximately the same level.

Naos. The purpose of temples in antiquity was generally to house the statue of a god. Accordingly, the Parthenon *naos* contained the great statue of Athena herself. In the reconstruction in figure **7.27**, she is armed and represented in her aspect as the goddess of war. She stands and confronts her viewers directly, wearing Medusa's head on her breastplate and holding a Nike in her right hand and a shield in her left. Both shield and pedestal were decorated with reliefs by Phidias. This colossal statue — an exception to the human scale of Classical art — embodied Athena's importance as the patron goddess of Athens. Her central position in the pediments and the offering of the *peplos* in the frieze reflected her wisdom and power as well as the Athenians' devotion to her.

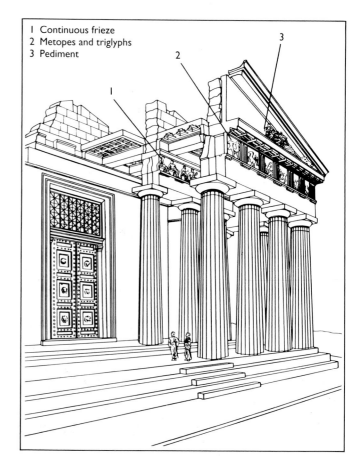

1 Continuous frieze
2 Metopes and triglyphs
3 Pediment

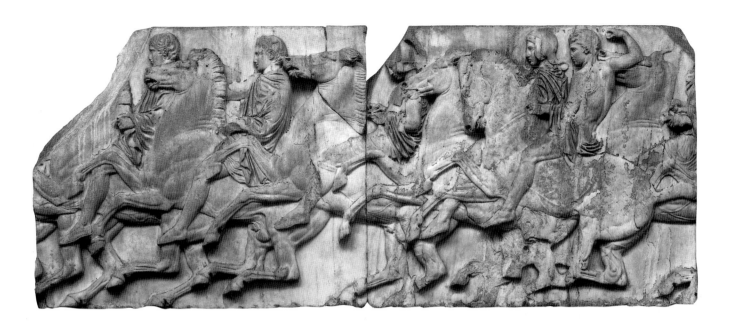

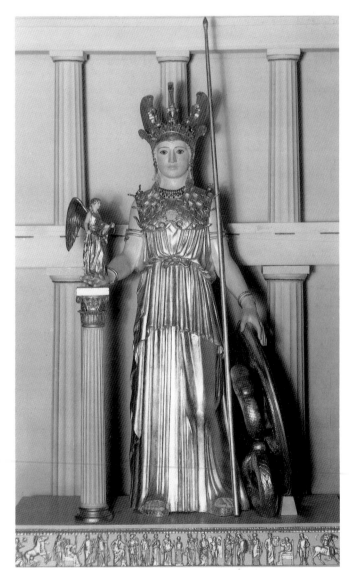

7.26 (above) Equestrian group from the north frieze of the Parthenon. c. 442–439 B.C. Pentelic marble, 3 ft 5¾ in (1.06 m) high. British Museum, London. The riders illustrate Phidias's technique of making the horses small in relation to the riders. He carved the horses' legs in higher relief than their bodies and heads. The effect is to cast heavier shadows on the lower part of the frieze which, together with the multiple zigzags, increase the illusion of movement.

7.27 (left) Reconstruction of Phidias's *Athena*, from the **cella** of the Parthenon. Original c. 438–432 B.C. Wood covered with gold and ivory plating, model c. 4 ft (1.22 m) high. Royal Ontario Museum, Toronto. Like many cult statues, that of Athena was over-lifesize, standing 40 feet (12 m) high on a pedestal. Phidias constructed the statue around a wooden frame, covering the skin area with ivory and the armor and drapery with gold. This combination of media is called **chryselephantine**, from the Greek *chrysos*, meaning "gold" and *elephantinos*, meaning "made of ivory." The original statue has long since disappeared and has been reconstructed from descriptions, small copies, and images on coins.

Medusa

Medusa, the only mortal of the three Gorgon sisters in Greek mythology, turned any man who looked at her to stone. She had snaky hair, glaring eyes, fanged teeth, and emitted a loud roar. Following the wise advice of Athena to look at her only in the reflection of his shield, the hero Perseus decapitated Medusa. He took her head to Athena, who adopted it as her shield device. The Medusa, or Gorgon head, subsequently became a popular armor decoration in the West, symbolically petrifying — i.e. killing — one's enemies.

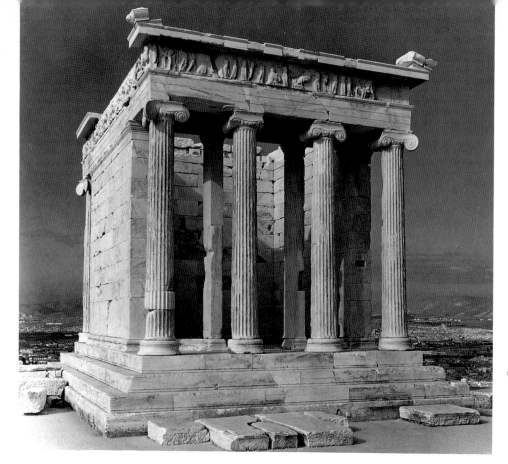

The Temple of Athena Nike

Athena was honored as the goddess of victory in the small Temple of Athena Nike which crowns the southern edge of the Acropolis (fig. **7.28**). It has a square *naos* and a front and back porch, each with four Ionic columns and four steps. This repetition reflects the Classical insistence on unifying the parts within the whole. The small size and graceful Ionic order of the Nike temple form a contrast with the heavier proportions of the Doric columns in the Parthenon.

The best example of relief sculpture from the Nike temple is *Nike Adjusting her Sandal* (fig. **7.29**), originally located on a **balustrade** of the parapet. This figure combines a graceful curved torso with diagonal planes in her legs. The sheer, almost transparent drapery — called "wet drapery" because it appears to cling to the body — falls in a pattern of elegant repeated folds. Behind the Nike is the remnant of an open wing. Its smooth surface contrasts with the activated drapery, and at the same time echoes and frames the torso's curve.

The Erechtheum

The Erechtheum (figs. **7.30** and **7.31**) is on the northern side of the Acropolis, opposite the Parthenon. A more complex Ionic building than the Nike temple, the Erechtheum is built on an uneven site. The eastern room was dedicated to Athena in her aspect as patron of the city.

The small southern porch (fig. **7.31**) is distinctive for its six **caryatids** — sculptured females performing the architectural function of columns. Each stands in a relaxed *contrapposto* pose, with drapery that defines the body,

7.28 (above, left) Temple of Athena Nike from the east, Acropolis, Athens. 427–424 B.C. Pentelic marble.

7.29 (above, right) *Nike Adjusting her Sandal*, from the balustrade of the Temple of Athena Nike. 410–409 B.C. Pentelic marble, 3 ft 5¾ in (1.06 m) high. Acropolis Museum, Athens.

and the ideal form characteristic of Classical style. A perfect symmetry is maintained within the ensemble so that each set of three, right and left, is a mirror image of the other. The two corner caryatids, like the corner columns of the Parthenon, are perceived as aligned with the four front figures when viewed from the front, and with the two back figures when viewed from the sides. Again, a smooth visual transition between front and side is achieved.

In the metaphorical transformation of columns into human form, several features are necessarily adapted. For example, the vertical drapery folds covering the support leg recall the flutes of columns. In the capital over the caryatid's head, the *echinus* has been replaced by a kind of headdress which creates a transition from the head to the *abacus*. At the same time, the headdress is an abstract geometric form, related to organic human form only by its proximity to the head. Whereas the Doric *echinus* effects a transition from vertical to horizontal and from curved elements to straight, the headdress satisfies the additional transition from human and organic to geometric and abstract. These caryatids thus illustrate the harmonious metaphorical relationship between ideal and organic, human and abstract, that characterizes Classical style.

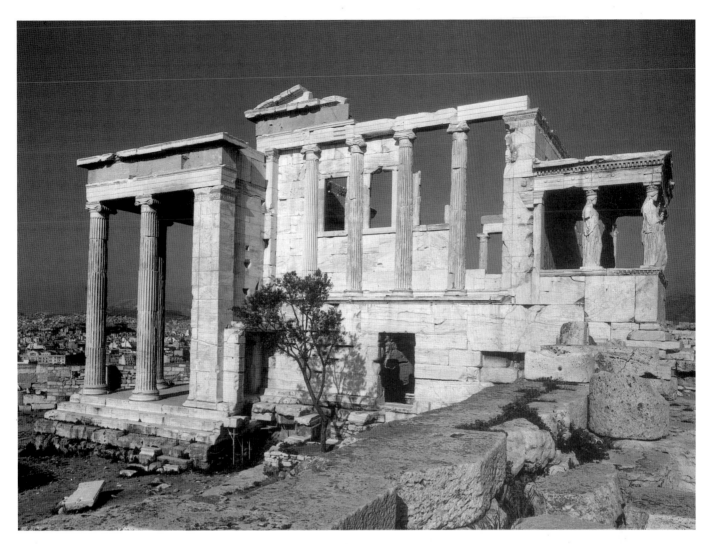

7.30 (above) The Erechtheum, Acropolis, Athens. 421–405 B.C. Porch figures c. 8 ft (2.44 m) high. This temple was named for Erechtheus, a legendary king of Athens who was worshiped with Athena and various other gods and ancestors in this building. As a result of this large number of dedicatees, the building itself is unusually complex for a Classical Greek temple.

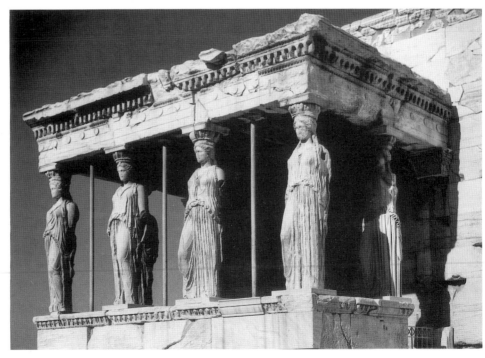

7.31 The caryatid porch of the Erechtheum.

Late Classical Style

(400–300 B.C.)

By the end of the fifth century B.C., Athens had lost its supremacy. Other Greek city-states began to exert political and military power over Greece — especially Sparta. In the fourth century B.C., Philip II of Macedonia (in northeastern Greece) conquered the Greek mainland, and his son Alexander the Great later extended the empire to the limits of the known world. Nevertheless, the intellectual leaders of the period — notably Plato and Aristotle — continued to flourish in Athens.

In architecture, after the fifth century B.C. the outdoor theater came into its own. The best example is the theater at Epidaurus (fig. 7.32). It had a slightly more than semicircular seating area, with radiating stairways and a walkway a little more than halfway up — not unlike a modern sports arena. The auditorium was built around the *orchestra* (literally, a place for dancing), a round space for the chorus where the action of the play took place; this was about 80 feet (24.5 m) in diameter, with an altar to Dionysus in its center (fig. 7.33).

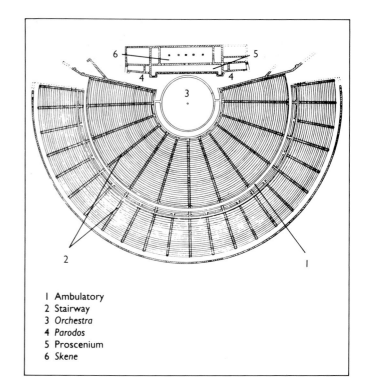

1 Ambulatory
2 Stairway
3 *Orchestra*
4 *Parodos*
5 *Proscenium*
6 *Skene*

7.32 Theater at Epidaurus. c. 350 B.C. Stone, diameter 373 ft (114 m). Curved rows of stone seats formed an inverted conical space in these impressive structures. Behind the *orchestra* was the rectangular stone backdrop, or **skene** (from which the modern English word "scene" is derived), and actors entered from the sides.

7.33 Plan of the theater at Epidaurus.

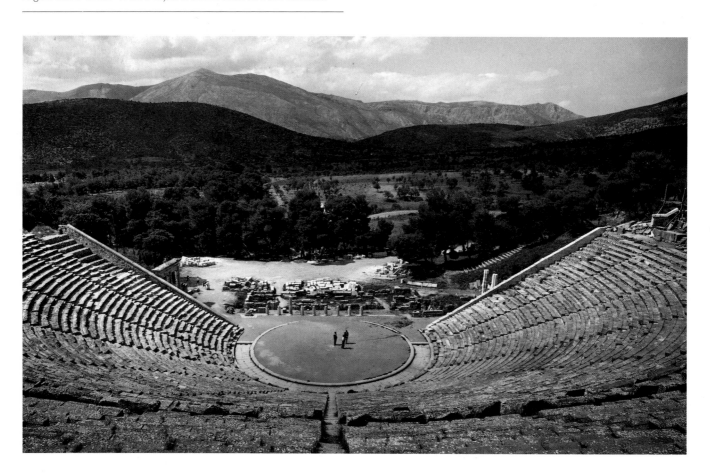

Greek Theater-in-the-Round

Greek theater originally grew out of rituals performed in honor of the wine god, Dionysus. The early theaters were hollow spaces in the hills, and in the fifth century B.C. these were developed to incorporate wooden benches arranged around an opening in a rock. Literally embedded in nature, these theaters harmonized drama with landscape. It was in such theaters — one was located below the Acropolis in Athens — that the great dramas by Aeschylus, Sophocles, and Euripides were performed. Greek theater began with a chorus of actors who sang and danced, and gradually individual roles performed by separate players emerged.

The leading Athenian sculptor of the Late Classical style was Praxiteles. An S shape, sometimes called the "Praxitelean curve," defines the stance of *Hermes and Dionysus* (fig. **7.34**). It is thought that Hermes originally dangled a bunch of grapes toward which the infant reaches. When compared with Classical sculptures (figs. **7.11** and **7.12**), the Hermes has slightly fleshier proportions and appears to have softer skin. Hermes's hair is more deeply carved, his forehead is creased, and his cheeks are fuller. Overall, his facial features are less distinct.

The Late Classical style formed a transition between the idealized canonical sculptures of the second half of the fifth century B.C. and the Hellenistic style. In Hellenistic art, idealism was to give way to increasing melodrama, and new types of representation would be developed.

Hellenistic Period (323–31 B.C.)

The Hellenistic period extended from the death of Alexander the Great (323 B.C.) to the rise of the Roman Empire under the emperor Augustus, who became emperor in 31 B.C. When Philip II of Macedonia died in 336 B.C., his monarchy had already begun to dominate mainland Greece. Within eleven years, his son Alexander had subjugated the rest of Greece and conquered Egypt, Phoenicia, Syria, and Persia (the latter in revenge for Xerxes' invasion of Greece). In 325 B.C. he pushed the limits of his kingdom to the Punjab, but rebellious troops forced his return westward. Wherever Alexander went, the process of Hellenization followed, until it encompassed virtually the entire Middle East. Even though Greek culture was dominant at this period, however, it was exposed to diverse languages and customs and was therefore enriched by cross-fertilization.

In 323 B.C. Alexander died, at the age of thirty-two. No single successor emerged after his death and his kingdom was broken up into independent monarchies. During the second century B.C., European tribes invaded Greece from the north and the Romans began to exert their influence in Europe and the Mediterranean (see p.127).

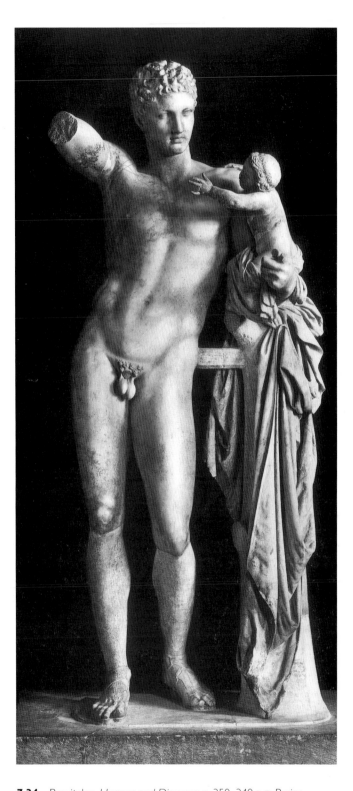

7.34 Praxiteles, *Hermes and Dionysus*. c. 350–340 B.C. Parian marble, 7 ft ⅓ in (2.15 m) high. Olympia Museum. Praxiteles (active 375–330 B.C.) was one of the foremost Athenian sculptors. His subjects were primarily youths and women (or goddesses). The famous nude Aphrodite, bought by the city of Cnidus in Anatolia, has survived only in Roman copies. *Hermes* is the only extant work by Praxiteles that is widely believed to be original. Today it stands in Olympia, set in a bed of sand as protection against earthquakes.

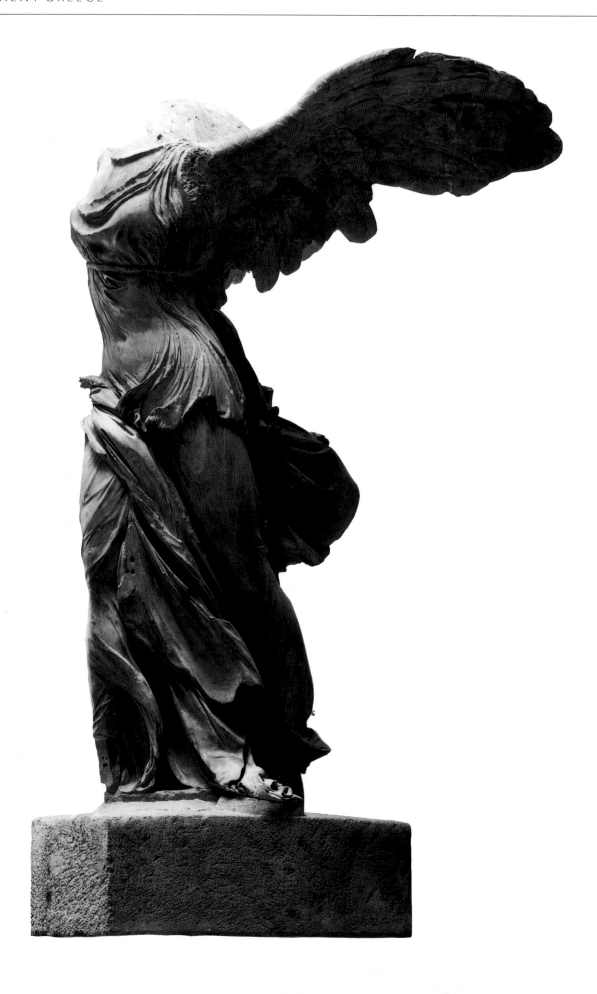

Sculpture

The large marble head of Alexander (fig. **7.36**) reflects the developing Hellenistic interest in naturalistic portraiture. Departing as it does from Classical and Late Classical idealization, the sculpture shows Alexander with somewhat dishevelled hair, a thick, fleshy face and neck, and a wrinkled forehead. The deep grooves carved in the hair, the modeled cheeks, and indentations by the corners of the mouth and above the chin create an expression of anxious energy.

In the *Winged Nike* from Samothrace (fig. **7.35**), drapery movement becomes more activated than it had been in Classical sculpture. The Nike is represented as if on the prow of a ship to commemorate a naval victory. The wind whips her clothing and her wings are outspread in triumph. The forward diagonal of her torso seems forced against the elements, and the position of her wings suggests that they have not yet settled. Adding to the sense of movement are the drapery masses sweeping across the front of the body. They contrast with the seemingly transparent fabric at the torso, which reveals a crease at the waist produced by the Nike's slight *contrapposto*. The more deeply cut folds also increase the areas of shadow in the skirt swirling around her legs, making it appear darker as well as heavier than the drapery covering the torso. From the side, the diagonal planes of the body and the outspread wings come into view.

In contrast to the Nike's billowing draperies energized by flight, those of the *Old Market Woman* (fig. **7.37**)

7.36 (above) Head of Alexander, from Pergamon. 1st half of 2nd century B.C. Marble, 16⅛ in (41 cm) high. Archeological Museum, Istanbul. This over-lifesize head was originally part of a full-length statue of Alexander the Great. It was found at Pergamon, an important Greek center on the west coast of Turkey. Alexander has been credited with founding over seventy cities (the number may be exaggerated) which were largely Greek in their political institutions and customs.

7.35 (opposite) *Winged Nike* (*Winged Victory*) from Samothrace. c. 190 B.C. Marble, c. 8 ft (2.44 m) high. Louvre, Paris. The shifting spatial thrusts of the Nike are characteristic of the new Hellenistic command of form and motion in space.

7.37 (right) *Old Market Woman.* 2nd century B.C. Marble, 4 ft 1½ in (1.26 m) high. Metropolitan Museum of Art, New York (Rogers Fund, 1909).

express the weight of old age. This peasant figure's garment hangs loosely as she bends forward, laden with her basket. For the first time in Greek art, artists had started to depict the qualities of old age that are apparent here—a bent and bony frame, wrinkled skin, sunken cheeks, and sagging breasts.

Another aspect of Hellenistic style is the interest in melodramatic pathos, for example in the sculptural group of *Laocoön and his Two Sons* (fig. **7.38**). It depicts an incident from the end of the Trojan War in which Laocoön and his sons are devoured by a pair of serpents. The choice of such a moment lends itself to the Hellenistic taste for violent movement. The zigzags and strenuous *contrapposto* of the human figures are bound by the snakes winding around them.

In the *Laocoön*, Classical restraint and the symmetry of the Parthenon sculptures have been abandoned. There is extra weight on the left as Laocoön's powerful frame pulls away from the serpent biting his right hip. A counter-balancing diagonal is produced by the sharp turn of his head, and is repeated by the leg, torso, and head of the boy on the right. In contrast to the Classical *Wounded Amazon* of Polyclitus (fig. **7.12**), Laocoön and his children express pain through facial contortion and physical struggle—bulging muscles, veins, flesh pulled taut against the ribcage.

7.38 (above) *Laocoön and his Two Sons*. Marble, 7 ft (2.13 m) high. Musei Vaticani, Rome. Estimates of the date of this work vary widely — from the second century B.C. to the first century A.D. — and there is debate over whether it is a later copy of an earlier original or a later original in an earlier style.

7.39 (below) Altar of Zeus, west front, reconstructed and restored, from Pergamon. c. 175 B.C. Marble. Pergamonmuseum, Berlin. The great frieze on the exterior base of the colonnade was over 36 feet (11 m) long. The altar originally stood within the elaborate enclosure, in the open air, reminding the viewer of Zeus's role as supreme ruler of the sky.

7.40 *Athena Battling with Alkyoneus*, from the great frieze of the Pergamon Altar, east section. Marble, 7 ft 6 in (2.29 m) high. Pergamonmuseum, Berlin.

The great altar erected at Pergamon (fig. **7.39**) shows how the Hellenistic taste for emotion, energetic movement, and exaggerated musculature could be translated into relief sculpture. The two friezes on the altar celebrated the city and its superiority over the Gauls. Inside the structure, a small frieze depicted the legendary founding of Pergamon.

In a detail illustrating Athena's destruction of a son of Gaia, the Titan earth goddess, the energy of the juxtaposed diagonal planes seems barely contained (fig. **7.40**). This mythical battle between pre-Greek Giants and Greek Olympians recurs in Hellenistic art partly as a result of renewed threats to Greek supremacy. Unlike the Classical version, however, Pergamon's reveled in melodrama, frenzy, and pathos. King Attalus I defeated the invading Gauls in 238 B.C., making Pergamon a major political power. Later, under the rule of Eumenes II (197–c. 160 B.C.), the monumental altar dedicated to Zeus was built to proclaim the victory of civilization over the barbarians. Greece was trying to reassert its superiority, as Athens had done in building the Parthenon following the Persian Wars. But Hellenistic art, especially in its late phase, reflects the uncertainty and turmoil of the period. By the end of the first century B.C. the Romans were in complete control of the Mediterranean world and, with the ascendancy of Augustus in 31 B.C., the scene was set for the beginning of the Roman Empire.

The Trojan Horse

According to Homer's description in the *Odyssey* (*iv*, 271; *viii*, 492; *xi*, 523), the Greeks constructed a colossal wooden horse and filled it with armed soldiers. They tricked the Trojans into believing it was an offering to Athena that they should take inside their city walls. Laocoön, a Trojan seer, told the Trojans that he did not trust the Greeks, "even bearing gifts." Thereupon Athena sent two serpents to kill the seer and his children. The Trojans took this as a sign that Laocoön was not to be believed, and accordingly opened their gates and pulled in the horse. The Greek soldiers emerged, let in the rest of the Greek army—and sacked Troy.

The Etruscans

The Etruscan civilization, which flourished from about 1000 B.C. to about 100 B.C., was contemporary with the Greek developments discussed in the previous chapter. The Etruscans are important in western history both in terms of their own art and culture and because of the significant links they provided between ancient Greece and Rome. Their homeland, Etruria (modern Tuscany), occupied a large part of the Italian peninsula. It was bordered on the south by the River Tiber, which runs through Rome, and on the north by the Arno.

The Greeks called the Etruscans Tyrrhenians after the sea of that name, and the Romans called them Tusci or Etrusci. Like the Greeks, the Etruscans never unified into a single nation, but coexisted as separate city-states with their own rulers. Unlike the Romans, they never established an empire.

Although the ancient Greek historian Herodotus thought that the Etruscans had come from Lydia, many Italian scholars believe that they were indigenous to Italy. They lived as a separate and distinctive group of people whose culture contributed to, and benefited from, the larger Mediterranean world. From the seventh to the fifth centuries B.C. — the period of their greatest power — the Etruscans controlled the western Mediterranean with their fleet, and were an important trading nation. They rivaled the Greeks and the Phoenicians and established trading links throughout the Aegean, the Near East, and northern Africa.

For centuries, the Etruscans were considered a decadent, bloodthirsty people with a predilection for piracy, superstition, and magic. The evidence of vase paintings indicates that they practiced human sacrifice. Their reputation, which is only partly justified, comes from ancient Greek and Roman accounts. It is mainly as a result of the development of modern archeology during the past 150 years that the study of the Etruscans has become more balanced and their positive achievements appreciated.

Map of Etruscan and Roman Italy.

Language

The Etruscan language resembles none other that is presently known, and its origin is uncertain. The alphabet was taken from the Greeks in the seventh century B.C. But unlike Greek script, Etruscan is written from right to left. The entire Etruscan literature — which, according to Roman sources, was rich and extensive — has disappeared. The writing that has survived is mostly in the form of epitaphs on graves or religious texts. Even though

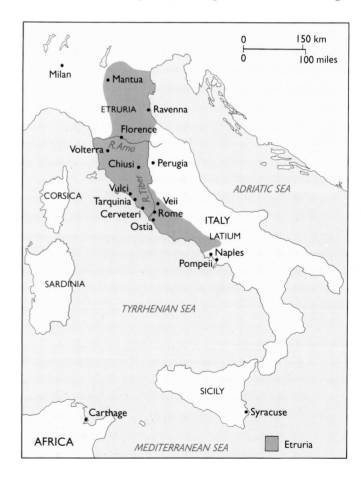

scholars can read some Etruscan words, they have not yet deciphered the content of much more than names and inscriptions.

Our major source of information about the Etruscans comes from the discovery of tombs and groups of tombs called **necropoleis** (from the Greek *polis*, meaning "city" and *necros*, meaning "dead"), which the Romans left undisturbed. Most of these were carved out of rocky ground, especially in the south. Etruscans used wood, mud, and tufa as building materials. However, most of their buildings have not survived, or are buried under modern Italian towns. Consequently, Etruscan tombs and their contents provide the richest examples of Etruscan painting, sculpture, and architecture.

Greek Influences

The evidence of the objects indicates that the Etruscans took more than their alphabet from Greece. Greece was the inspiration for large-scale architecture in Etruria. Etruscans also imported Greek olives and adopted Greek agricultural techniques for growing them. Customs such as the *symposium*, or drinking party, and the practice of banqueting in a reclining position came from Greece. Scenes and characters from Greek mythology liberally populated Etruscan imagery. The engravings on the backs of mirrors are a particularly rich source of these images. In addition, Etruscan tombs have yielded hundreds of imported Greek black- and red-figure vases, which were clearly an important source of Greek figure style in Italy.

In the development of style, the Etruscans paralleled Greece, although with strong preferences of their own. For instance, a lifesize terra cotta statue of Apollo which originally decorated the roof of a temple has many

8.1 *Apollo of Veii*, from Veii. c. 515–490 B.C. Painted terra cotta, c. 5 ft 10 in (1.78 m) high. Museo Nazionale di Villa Giulia, Rome. Terra cotta was a favorite Etruscan material for sculpture. It was modeled while still wet and the smaller details were added with hand tools. In this statue, Apollo's energetic forward stride reflects the Etruscan interest in gesture, motion, and posture.

Etruscan Materials

Unlike Greek architecture, that of the Etruscans was constructed primarily of mud brick. Columns were made of wood and decorative details of terra cotta or **tufa**, a soft, porous, volcanic rock that was easy to work.

Statues were typically made of terra cotta or bronze, and the Etruscans were justly renowned for them in Classical Athens. They were skilled in bronze casting and engraved mythological scenes on the backs of bronze mirrors. For jewelry, gold was the preferred material.

The earliest Etruscan paintings were on tufa ground, and later ones were applied to clay plaster. Most surviving Etruscan examples are fresco, but some have been discovered in **tempera**, a combination of pigment with water and egg yolk. The egg yolk makes the mixture thicker than fresco, and thus tempera paintings can be richer in color. The term derives from the French word *temper*, meaning "to bring to a desired consistency." It is not known when tempera was first used (see p.215), but it became progressively more popular in Italy during the fifteenth century A.D.

features of the Greek late Archaic style (fig. **8.1**). Although the sculpture has some organic form reminiscent of Greek Early Classicism (around the chest, for example), the curvilinear stylizations and flat surface patterns of the drapery folds are more characteristic of the Archaic period. The same can be said of the diagonal calf muscles fanning out from below the knees, and the lines on top of the feet suggest that the toes continue to the ankles. The stylized, braided hair and slight smile also belong to the Greek Archaic convention.

Women in Etruscan Art

One respect in which the Etruscans seem to have differed from the Greeks is in their attitude to women. Judging from Etruscan art, women were more literate, publicly more visible, and held higher positions than in ancient Greece — a state of affairs of which the patriarchal Greeks heartily disapproved. Wealthy Etruscan women were unusually fashion-conscious and wore elaborate jewelery commensurate with their rank. This greater emphasis on women in Etruscan society is consistent with the prominence in the arts of the mother goddess and other female deities well beyond the Bronze Age. Etruscan artists frequently depicted myths in which women dominate men by being older, more powerful, or more divine. For example, scenes of the adult Heracles being breastfed by the goddess Uni (probably the Etruscan equivalent of Hera) are not uncommon.

Funerary Art

The Etruscans clearly believed in an afterlife that was closer to the Egyptian notion than to the Greek, but it is not known what their concept of the afterlife was. It seems to have resembled the material view of ancient Egypt, since items used in real life such as women's mirrors, jewelry, men's weapons, and banquet ware accompanied the deceased.

An unusual lifesize cinerary statue represents a particularly monumental female with a child lying across her lap (fig. **8.3**). The woman's facial expression reveals a hint of mourning as the corners of the mouth turn down slightly and the forehead is creased. She is frontal and conforms to the planes of her chair. On either side of the chair is a sphinx, here with a woman's head and a lion's body. The identity of these figures is unknown, but the woman could be a mortal or a goddess, sitting on a chair or a throne. In Egypt, the Near East, and the Aegean, however, leonine guardians were generally associated with royalty and divinity.

Before the seventh century B.C., the Etruscans cremated their dead and buried the ashes in individual tombs or cinerary urns. These urns often had lids in the form of human heads and the vessels themselves sometimes had body markings. In figure **8.2** both the urn itself and the wide-backed chair on which it stands are made of bronze, but the head is terra cotta. Its individualized features suggest that it was intended to convey at least a general likeness of the deceased.

Other cinerary urns took the form of houses, and provide us with a glimpse of Etruscan domestic architecture (fig. **8.4**). Here the building has an elegant, symmetrical façade with an arched doorway, rectangular Corinthian pilasters, and a second story gallery. The lid corresponds to the roof, with a curved pediment over the entrance and a ***fleur-de-lys*** relief in the center.

These urns provide clues to the general physiognomy of the Etruscans, the development of their sculptural style, and their architectural taste. They also reflect Etruscan views of death. The effigies indicate both a wish to preserve the likeness of the deceased, and the importance of ancestors who were considered divine in the afterlife. The urn-as-house expresses a metaphor in which the tomb or burial place is a "house for the dead." In certain Neolithic cultures, people had buried their dead underneath their homes (see p.46). The little Etruscan architectural urns actually reverse the metaphor: instead of the house being the tomb, the tomb is the house.

8.2 Cinerary urn, from Chiusi. 7th century B.C. Hammered bronze and terra cotta, c. 33 in (83.8 cm) high. Museo Etrusco, Chiusi. The metaphorical nature of this object, in which the body, base, and handles of the urn are equated with the corresponding human anatomy, surely had religious significance. Thus the very container of the ashes assumes a transitional character, as if symbolically reversing the process of cremation and keeping the dead person alive through his image.

Pilasters

A **pilaster** is a flat vertical element resembling a rect-
angular pillar. It typically projects from (or, more techni-
cally, is engaged in) a wall and serves a decorative rather
than an essential structural function.

8.3 *Mater Matuta*, from Chiusi. 460–440 B.C. Limestone, lifesize.
Museo Archeologico, Florence. This figure corresponds chronologically
to the beginning of the Greek Classical style. Although the woman is
organically sculpted and the drapery outlines her body, she
nonetheless retains the stylized hair of the Early Classical period.

8.4 Cinerary urn in the form of a house, from Chiusi. 2nd half of 7th
century B.C. Laminated bronze with terra cotta head, 33½ in (85.1 cm)
high. Museo Archeologico, Florence.

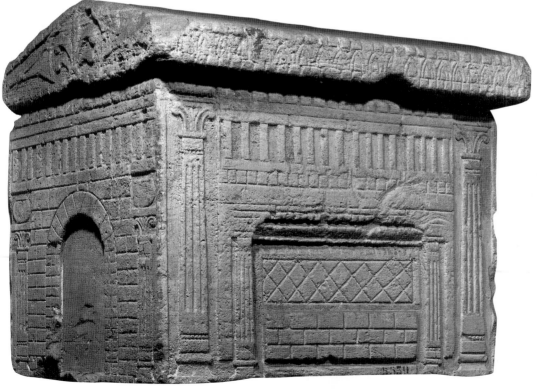

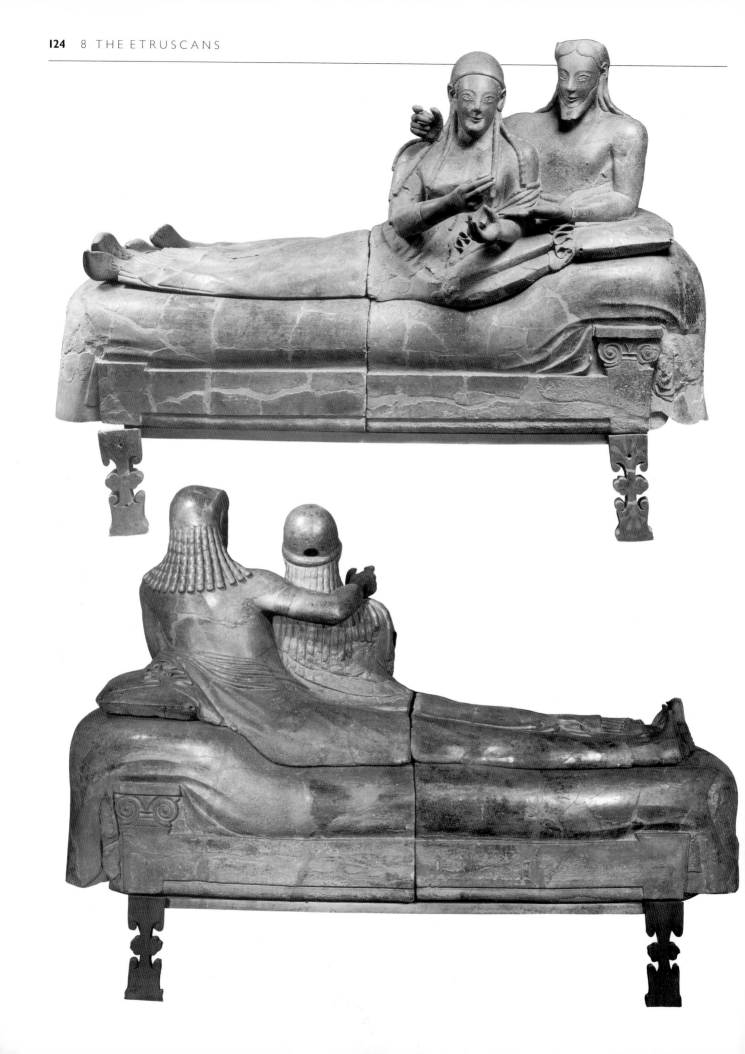

Tombs

The attitudes to death reflected by objects such as the urns recur in the Etruscan custom of building larger scale architectural tombs to "house" their families. In the early period tombs were individual, but from the seventh century B.C. they were grouped to replicate cities. They were rock-cut chambers covered by earth mounds called *tumuli* (**tumulus** in the singular). In fact, it is from the Etruscan *necropoleis* that scholars have been able to reconstruct entire city and town plans and to derive information about their urban architecture, since only a few temples have survived.

Etruscan artists developed a new funerary iconography, which they translated into monumental sculpture on the tombs of wealthy individuals. For example, a painted terra cotta **sarcophagus** from Cerveteri is in the form of a dining couch (fig. **8.5**). The figures represent a married couple — the basic family unit — which was an important subject in Etruscan art and society. The wife and husband are given equal status, reflecting the important position of women in the Etruscan social order. They are rendered with Archaic stylizations — braided hair, smiles with corresponding raised cheekbones and upwardly slanting eyes, a circular cap for the woman and neatly parted hair for the man. At the same time, however, the sharp bend at the waists and the animated gestures create the illusion of lively, sociable dinner companions, arranged according to the banqueting style adopted from the Greeks. The couple reclines as if in defiance of death.

Another type of Etruscan sarcophagus represents individual figures or couples in bed on the lid. In a later sarcophagus lid from Vulci (fig. **8.6**), husband and wife again have equal status and embrace beneath a sheet. The folds echo the curves of the arms, fluttering in shorter curves and diagonals over the zigzags of legs and feet.

Tomb Paintings. Etruscans used painted images as well as architecture and sculpture in the service of the dead. Hundreds of paintings have been discovered in the underground city of Tarquinia, a site northwest of Rome which has yielded rich archeological finds. Tomb paintings were usually frescoes, although occasionally tempera was applied to dry plaster. It is thought that similar paintings

8.5a (opposite) Sarcophagus, from Cerveteri. c. 520 B.C. Painted terra cotta, 6 ft 7 in (2 m) long. Museo Nazionale di Villa Giulia, Rome. **8.5b** Back view of fig. **8.5a**.

8.6 (right) Sarcophagus of Ramtha Visnai, from Vulci. c. 300 B.C. Limestone, 7ft 1¾ in × 2 ft 6¾ in (2.18 × 0.78 m). Courtesy, Museum of Fine Arts, Boston (Gift of Mr. and Mrs. Cornelius Vermeule III). This restful scene expresses the ancient identification of sleep with death. The correlation is virtually universal — in Greek mythology, for example, Sleep and Death were twins — but in Etruscan tomb iconography the metaphor is rendered literally.

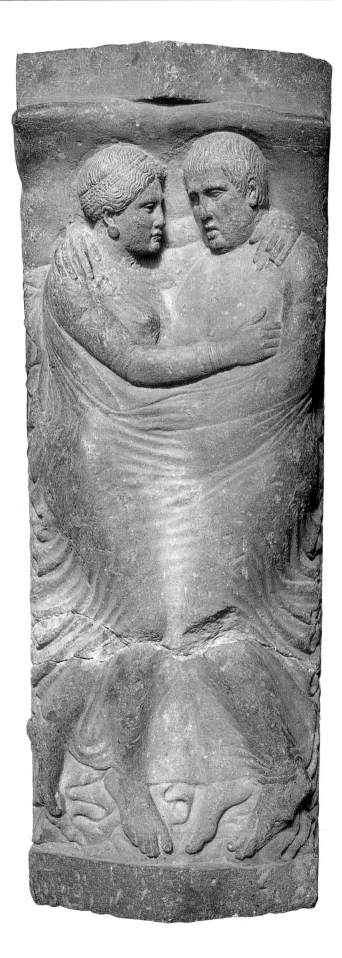

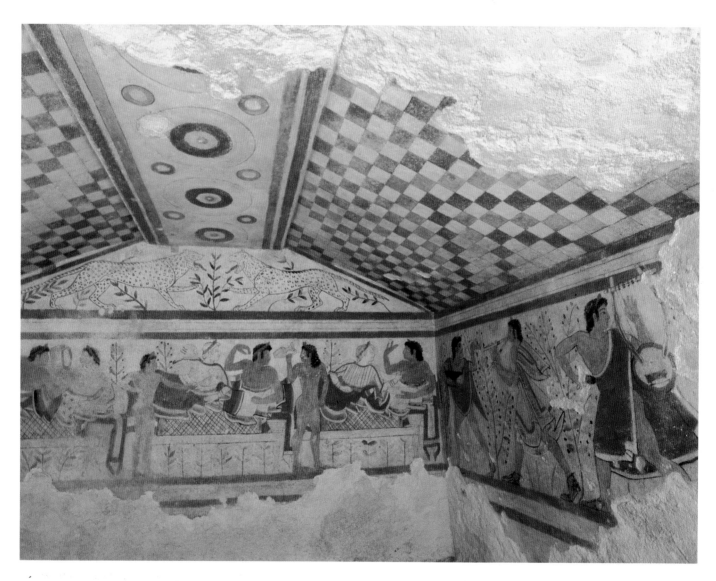

probably adorned public and private buildings, although there are no surviving examples (see p.121).

Until the fourth century B.C. the most frequently represented subjects in Etruscan tomb paintings were funeral rites or optimistic scenes of aristocratic pleasures — banquets, sports, dances, and music-making. A typical example is the scene in the Tomb of the Leopards which shows men and women reclining on banqueting couches while servers wait on them (fig. 8.7). The seated banqueters have the same bend at the waist and animated gestures as the couple in the Cerveteri sarcophagus (fig. 8.5), but their heads are in profile rather than facing toward the observer. Colors are mainly terra cotta tones of brown on an ocher background with drapery patterns, wreaths, plants, and other details in blues, greens, and yellows. Above this particular scene, two leopards flank a plant and protect the tomb from evil influences.

After the fourth century B.C., a quality of pessimism appeared in Etruscan painting, with more emphasis on the shadowy mysteries of the afterlife and a new taste for bloodthirsty scenes.

8.7 Banquet scene, Tomb of the Leopards, Tarquinia. 480–470 B.C. Fresco. Here the influence of Egyptian and Aegean painting is quite evident. Women are lighter skinned than men, profile heads contain a frontal eye, and figures are outlined in black and dark brown.

Despite Greek influence, the Etruscans remained a culturally distinct group for nearly a millennium. Occupying a large section of Italy for much of the Roman Republic, they were also independent of the Romans in language and religious belief. Yet they taught the Romans about engineering, building, drainage, irrigation, and the art of augury — how to read the will of the gods from the entrails of animals and the flight of birds. In matters of fashion and jewelry, the Etruscans were the envy of Greek and Roman women alike.

Etruscan kings ruled Rome until the establishment of the Roman Republic in 510 B.C. By the early third century B.C., Etruria had become part of Rome's political organization, and two centuries later it had succumbed to full Romanization.

Ancient Rome

The political supremacy of Athens had lasted for only about fifty years; Rome's endured for nearly 500. Greece had been unified culturally, but Rome was a melting pot of cultures and ideas. Despite Greece's belief in its own superiority over the rest of the world, it had never achieved long-term political unity. The political genius of Rome lay in the ability to encompass, govern, and assimilate cultures very different from its own. As time went on, Roman law made it increasingly easy for people from distant regions to attain citizenship, even if they had never been to Rome. Nevertheless, there was no doubt that the city itself was the center of a great empire. Rome's designation as *caput mundi*, or "head of the world," signified its position as a hub of world power.

Origins of the Roman Empire

From the death of Alexander the Great in 323 B.C., Rome began its rise to power in the Mediterranean. By the first century A.D., the Roman Empire extended from Armenia and Mesopotamia in the east to Spain in the west, from Egypt in the south to the British Isles in the north. Everywhere the Roman legions went, they took their culture with them — particularly their laws, their religion, and the Latin language. Only Greece and the Hellenized world kept Greek, rather than Latin, as their official language.

The Roman view of history was less mythical than the Greek. Whereas the Greeks had principally recorded the genealogy of the gods, from Chaos and the Titans to the Olympians, Rome traced its ancestry back to the human hero Aeneas. Aeneas's descendants included Romulus, who was said to have killed his twin brother Remus in a dispute and then built Rome on the Palatine Hill. He ruled until the late eighth century B.C., and was followed by six kings, including several Etruscans. In 510 B.C. the last of them was overthrown, and the Republic began. It lasted until about 30 B.C., when Octavian (who later took the title of Emperor Augustus) came to power. For the next three hundred years, Rome was ruled by a succession of emperors. In A.D. 330 Constantine established an eastern capital of the Roman Empire in Byzantium, and renamed the city Constantinople (Istanbul, in modern Turkey). After this period, the Empire fell into decline.

Greek Influence on Roman Art

The difference between the Greek and Roman approaches to history and politics in some sense parallels the differences in their views of art. Greek art had followed a clear line of stylistic development from Archaic to Hellenistic, and the Greeks had written about their artists and given them a historical identity. In Rome, however, styles changed under successive rulers, and virtually no artist — male or female — is identifiable by name. The Romans were nevertheless greatly influenced by Greek sculptures, and copied, imported, and collected them by the thousand, just as they had borrowed the Greek gods and Romanized them. Although no Greek monumental paintings have survived, it is known that they also

Women in Ancient Rome

Roman women enjoyed a more dignified status than the women of ancient Athens (see p.93). Instead of being confined to women's quarters, they ate with their husbands and were free to go out. Some women were involved in law, literature, and politics, but there are no references to women who excelled in the arts.

Before the second century B.C., marriage took the form of transfer of control of the woman from her father to her husband. To some degree, this required the bride's consent. If a woman lived with a man for a year without being absent for more than two nights, the couple were considered legally married.

From the second century B.C. onward, the pace of emancipation accelerated. Married women now retained their own legal identity. They controlled their property, managed their own affairs, and could become independently rich. Divorce became more common. Under the rule of the emperors, marriage itself became so unpopular that laws were passed to encourage it and to increase the birthrate.

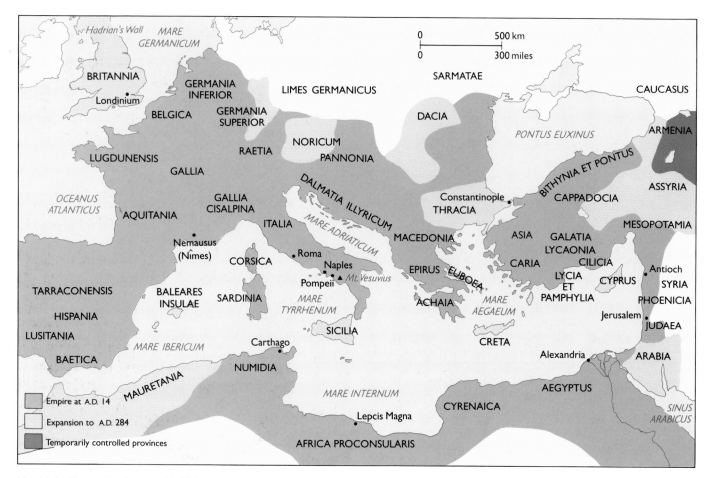

Map of the Roman Empire, A.D. 14–284.

Empire at A.D. 14
Expansion to A.D. 284
Temporarily controlled provinces

Virgil's *Aeneid*

During the reign of Rome's first emperor, Augustus, Virgil wrote a Latin epic entitled the *Aeneid* to celebrate the legendary founder of Rome. Composed in twelve books like Homer's *Iliad* and *Odyssey* (see p.91), the *Aeneid* opens with the fall of Troy. The Trojan Aeneas carries his aged father Anchises and the household gods as he leads his young son Ascanius from the burning city of Troy. Like Odysseus and Gilgamesh before him, Aeneas travels far and wide, even visiting the Underworld. Virgil's frequent references to "pius Aeneas" evoke his hero's sense of duty and destiny. The implication for the readers of first-century Augustan Rome was clearly that the founding of Rome and Roman domination of the world had been the will of the gods.

Roman Emperors

The principal Roman emperors, with the dates of their reigns, are as follows:

27 B.C.–A.D. 14	Augustus
A.D. 14–37	Tiberius
A.D. 37–41	Gaius (Caligula)
A.D. 41–54	Claudius
A.D. 54–68	Nero
A.D. 69–79	Vespasian
A.D. 79–81	Titus
A.D. 81–96	Domitian
A.D. 98–117	Trajan
A.D. 117–138	Hadrian
A.D. 138–161	Antoninus Pius
A.D. 161–180	Marcus Aurelius
A.D. 193–211	Septimius Severus
A.D. 211–217	Caracalla
A.D. 284–305	Diocletian
A.D. 286–305	Maximian
A.D. 305–311	Galerius
A.D. 306–312	Maxentius
A.D. 306–337	Constantine I, the Great
A.D. 379–395	Theodosius I

influenced Roman painters, especially in the Hellenistic period.

While Greek art had tended toward idealization, Roman art was generally commemorative, narrative, and based on history rather than myth. As in the Hellenistic style, Roman portraitists sought to preserve the features of their subjects. They went even further in the pursuit of specific likenesses, making wax death masks and copying them in marble.

One purpose of Roman portraiture was genealogical. As a family record, it connected present with past, just as Aeneas connected Roman descent with the fall of Troy and, through his mother Venus, with the gods. Roman interest in preserving family lineage also extended to names. The typical Roman family was grouped into a clan, called a *gens*, through which individuals traced their descent. Portraits, whether sculptures or paintings, thus had a twofold function: they both preserved the person's image and contributed to the history of the family. Likewise, Roman relief sculpture usually depicted historical narrative, commemorating the actions of a particular individual rather than mythical events. Most commemorative reliefs adorned architectural works, and it was in architecture that the Romans were most innovative.

Architectural Types

The Romans carried out extensive building programs, partly to accommodate their ever expanding territory and its growing population, and partly to glorify the state and the emperor. In so doing, the Romans assimilated and developed engineering techniques from the Near East and Etruria. They also recognized the potential of certain building materials, which allowed them to construct the monumental public buildings that are such an important part of the Roman legacy.

Domestic Architecture

Roman interest in the material comforts of living conditions led to the development of quite sophisticated domestic architecture. Many examples were preserved as a result of the eruption of Mount Vesuvius in A.D. 79. Volcanic ash covered the towns of Pompeii and Herculaneum (near modern Naples), creating a time capsule of a section of Roman civilization. Herculaneum had been a seaside resort and Pompeii, located at the foot of the volcano, a leading port, noted for its agriculture and commerce. Although an eyewitness, Pliny the Younger, had written an account of the entire eruption from a safe distance across the Bay of Naples, both towns were forgotten until A.D. 1592, when a Roman architect digging a canal discovered some ancient ruins. Serious archeological work on Pompeii and Herculaneum did not begin until the eighteenth century, and the excavations are still continuing today.

Roman domestic architecture (from the Latin *domus*,

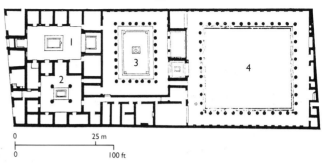

9.1 Plan of the House of the Faun, Pompeii. 2nd century B.C. (1) *atrium*, (2) *atrium tetrastylum*, (3) and (4) courtyards surrounded by peristyles.

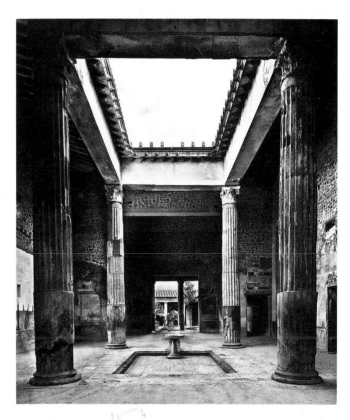

9.2 *Atrium* and peristyle, House of the Silver Wedding, Pompeii. Early 1st century A.D. Standing with our backs to the entrance, we can see the *compluvium* in the roof, which is supported by four Corinthian columns. The *impluvium* is in the center of the floor. Visible on the other side of the *atrium* is the *tablinium*, probably used for entertaining and for storing family documents and images of ancestors.

meaning "house") was derived from both Etruscan and Greek antecedents, yet maintained its distinctiveness. The main feature of the early Roman *domus* was the **atrium** (figs. **9.1** and **9.2**), a large hall entered through a corridor from the street. The *atrium* roof usually sloped inward and a rectangular opening, called a *compluvium*, allowed rainwater to collect in an *impluvium* (a sunken basin in the floor). From the *impluvium* the water was chaneled into a

Roman Building Materials

Marble had been the favorite building material of the Greeks, but was less available, and therefore a luxury, to the Romans. They mainly used it as a final decorative facing, or outer layer, over a core of other material. Today, much ancient Roman marble facing has disappeared because of subsequent looting. The Romans also used **travertine** — a hard, durable limestone that had decorative qualities as well — and tufa, which had been popular with the Etruscans (see p.121).

Above all, the Romans built with concrete, which made large-scale public structures possible. Their concrete was a rough mixture of mortar, gravel, rubble, and water. It was shaped by wooden frames, and often wedge-shaped stones, bricks, or tiles were inserted into it before it had hardened, for reinforcement and decoration. Alternatively, a facing of plaster, stucco, marble, or other stone was added.

Arches, Domes, and Vaults

Just as the Romans recognized the potential of concrete, which had been invented in the ancient Near East, so too they greatly developed the arch and the **vault** (fig. **9.3**), which had previously been used in Egypt, Babylon, and Etruria.

The round arch (see p.56) may be thought of as a curved lintel used to span an opening. A true arch is constructed of tapered (wedge-shaped) bricks or stones, called **voussoirs**, with a keystone at the center. The point at which the arch begins to curve from its vertical support is called the **springing**, because it seems to spring away from it. The arch creates an outward pressure, or **thrust**, which must be countered by a supporting **buttress** of masonry.

The arch is the basis of the vault — an arched roof made by a continuous series of arches forming a passageway. A row of round arches produces a **barrel** or **tunnel vault**, so-called because it looks like the inside of half a barrel or the curved roof of a tunnel. It requires continuous buttressing and is a difficult structure in which to make openings for windows. Vaults formed by a right-angled intersection of two identical barrel vaults are called **groin** or **cross vaults**.

Arches and vaults have to be supported during the process of construction. This is usually done by building over wooden frames known as **centerings**, which are removed when the keystone is in place and the mortar has set.

A **dome** is made by rotating a round arch through 180 degrees on its **axis**. In its most basic form, it is a semicircular section resembling one half of an orange skin. As is true of arches and vaults, domes must be buttressed, but in this case from all directions. They can be erected on circular or square bases. Ancient Roman domes, such as the Pantheon's (fig. **9.15**), were generally set on round bases. Domes on square bases are discussed in Chapter 10.

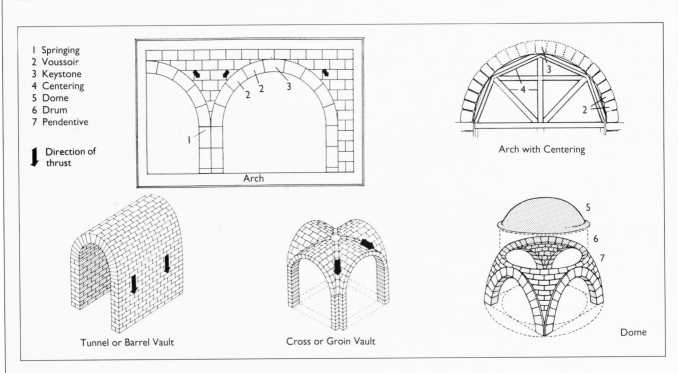

1 Springing
2 Voussoir
3 Keystone
4 Centering
5 Dome
6 Drum
7 Pendentive

↓ Direction of thrust

Arch

Arch with Centering

Tunnel or Barrel Vault

Cross or Groin Vault

Dome

9.3 Round arch, barrel vault, cross vault, and a dome on a drum.

separate cistern. But by the end of the first century B.C., the peristyle had become the focal point of the *domus* and the *atrium* was little more than a foyer, or entrance hall. Additional rooms surrounded the peristyle, and were used as slave quarters, wine cellars, and storage space.

These houses had plain exteriors without windows. Rooms fronting on the street functioned as shops, or *tabernae* (from which we get the English word "tavern"). Behind the unassuming façades were interiors that were often quite luxurious—decorated with floor and wall mosaics, paintings, and sculptures. The typical professional or upper-class Roman house also had running water and sewage pipes.

For the middle and lower classes, especially in cities, the Romans built concrete apartment blocks or tenements, called *insulae* (Latin for "islands") (fig. **9.4**). As early as the first century A.D., most of Rome's urban population lived in such *insulae*. According to Roman building codes, they could be as high as five stories. On the ground floor, shops and other commercial premises opened onto the street. The upper floors were occupied by families, who lived separately but shared certain facilities.

In addition to urban domestic architecture, the Romans invented the concept of the country **villa** as an escape from the city. Villas varied according to the tastes and means of their owners and, naturally, the most elaborate belonged to the emperors. In A.D. 64–68, for example, the Emperor Nero (who ruled from A.D. 54 to 68) had a villa built called the *Domus Aurea*, or Golden House. The

Emperor Hadrian's elaborate villa near Tivoli (fig. **9.5**), 15 miles (24 km) outside modern Rome, dates from around A.D. 125 to 135. (He was in power from A.D. 117 to 138.) His villa consisted of so many buildings that it occupied several square miles—libraries containing works in Greek and Latin, baths, courtyards, temples, plazas, and a theater occupied its grounds. When Hadrian traveled, he collected further ideas for the villa, and later had several monuments reproduced in its grounds.

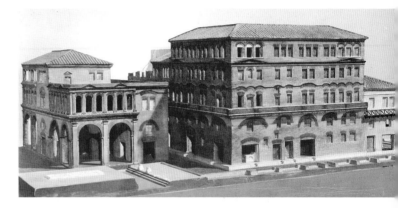

9.4 *Insula*, Ostia, reconstruction. 2nd century A.D. Brick and concrete.
9.5 (below) The Great Baths, Hadrian's Villa, Tivoli, etching by Piranesi, from *Views of Rome*, 1770. 18 in (45.7 cm) high. Istituto Nazionale per la Grafica, Rome.

Public Buildings

As life in Rome and its provinces became increasingly complex, a need emerged for spaces in which citizens could gather and for public administrative buildings. This led to the development of two characteristic architectural types, the **forum** and the **basilica**.

Forums. The forum was typically a square or rectangular open space, bounded on three sides by colonnades and on the fourth by a basilica (see below). Originally the forum was a marketplace. Its prototype was the Greek *agora*, which had never attained the size or complexity of a Roman forum. The first known forum in Rome, the *Forum Romanum*, dates from the sixth century B.C. but was repeatedly expanded throughout the period of the Republic and the Empire. In the first century B.C., the *Forum Julium* became the prototype for all later imperial forums. Conceived by Julius Caesar (who lived c. 102–44 B.C.) and completed by Augustus, it must have presented a magnificent architectural spectacle (it is now in ruins). A reconstruction showing how Rome's Republican and imperial forums would have looked in the early fourth century A.D. (fig. **9.6**) illustrates their architectural complexity, and this is borne out by the plan in figure **9.7**.

As a commercial center, the forum was a regular feature of most Roman town plans. Gradually, however, the shops were transferred elsewhere and the forum remained a focal point only for civic and social activity. It was a more or less enclosed space, usually restricted to pedestrian traffic. Important temples and meeting places for the town council (*curia*) and the popular assembly (*comitium*) were integrated into the forum.

Basilicas. A basilica (from the Greek *basilikos*, meaning "royal") was a large roofed building, usually at one end of a forum. It was used for commercial transactions and also served as a municipal hall and law court. Basilicas were typically divided into three **aisles** — a large central aisle was flanked by a smaller one on each side, supported by columns. The extra height of the center aisle, or **nave** (from the Latin *navis*, meaning "ship," derived from the idea of an inverted boat), permitted the construction of a second story wall above the colonnades separating the nave from the aisles. Clerestory windows were built into the additional wall space to let light into the building.

Public Baths. Another type of public building popular in ancient Rome was the bath. Besides bathing and swimming, the public bath provided low-cost facilities for playing ball, running, wrestling, and exercising. Romans attended the baths for health, hygiene, relaxation, and socializing. Amenities included a cold room (*frigidarium*), a warm room (*tepidarium*), a hot room (*caldarium*), steam rooms, changing rooms, libraries, and gardens.

Although there were baths throughout the Empire, the most impressive were the imperial ones in Rome. Particularly magnificent were the baths of the Emperor Caracalla, who ruled between A.D. 211 and 217 (figs. **9.8** and **9.9**).

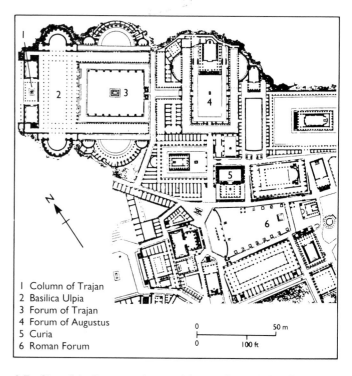

1 Column of Trajan
2 Basilica Ulpia
3 Forum of Trajan
4 Forum of Augustus
5 Curia
6 Roman Forum

0 50 m
0 100 ft

9.7 Plan of the Roman and imperial forums, Rome. When Roman civic leaders wished to address the populace, they entered the forum. Today a forum means a place or opportunity for addressing groups of people — candidates for political office are said to have a forum for their views if they can arrange a time and place for the voters to hear them speak.

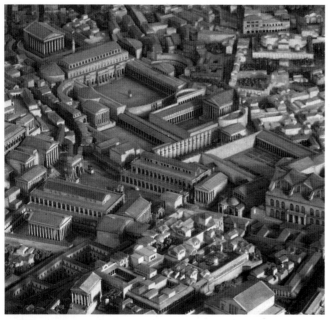

9.6 Reconstruction of the Roman and imperial forums, Rome, c. A.D. 310. Museo della Civiltà Romana, Rome.

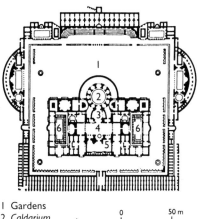

1 Gardens
2 *Caldarium*
3 *Tepidarium*
4 *Frigidarium*
5 *Natatio*
6 *Gymnasium*

9.8 Plan of the Baths of Caracalla, Rome. A.D. 211–217. The total complex occupied more than 50 acres (80,000 m²) and could accommodate over 1500 people at one time. It was constructed on two axes with the *frigidarium* at their intersection. As in the typical basilica construction, light entered the baths through clerestory windows and illuminated the myriad surface patterns created by marble, glass, painted decoration, and water.

9.9 Restoration drawing of the Baths of Caracalla. The plan in fig. **9.8** shows the enormous Corinthian columns that supported the groin vaults of the ceiling in this central hall.

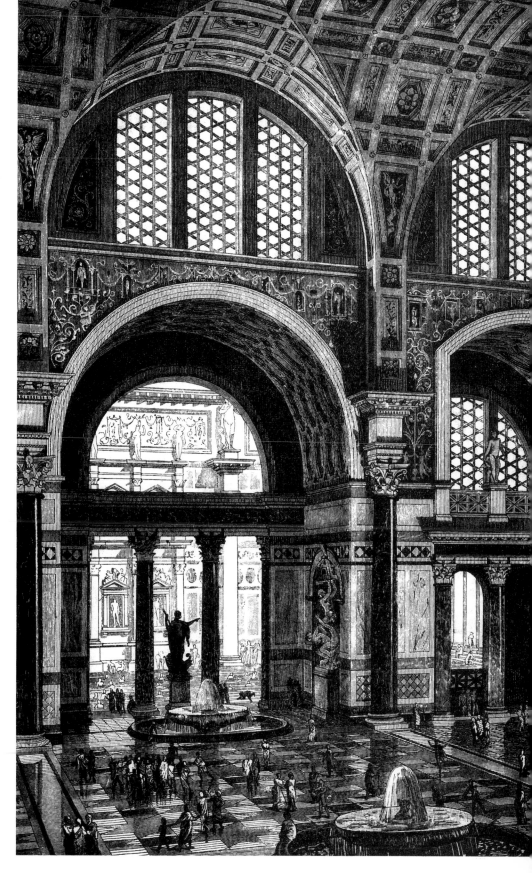

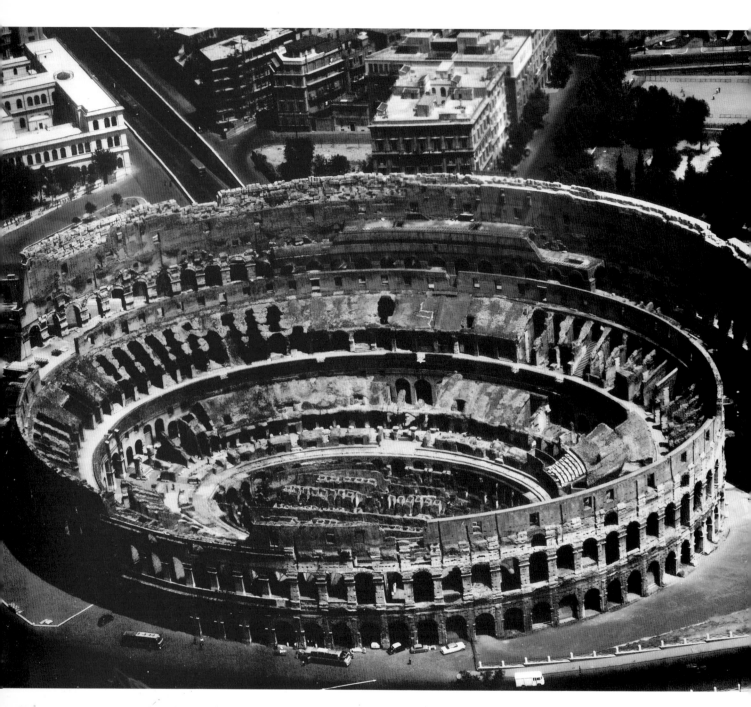

The Colosseum. Buildings such as the Colosseum (figs. 9.10 and 9.11) were primarily used for public spectacles. Their Greek antecedent was the outdoor theater (fig. 7.32). Similar to a modern sports arena, the Colosseum is actually an enormous **amphitheater** (from the Greek *amphi*, meaning "around" and *theatron*, meaning "theater"). Its exterior consists of **arcades** made of round arches framed by entablatures and **engaged columns**. The ground-floor columns are Tuscan (a later development of Doric), the second-floor columns are Ionic, and those on the third floor are Corinthian. This system arranges the columns in order of strength, with the "heaviest" Doric type at the bottom.

9.10 Aerial view of the Colosseum, Rome. A.D. 72–80. Concrete, travertine, tufa, brick, and marble; c. 615 × 510 ft (187.5 × 155.5 m). Construction of the Colosseum started in A.D. 72 under the Emperor Vespasian, who had come to power in A.D. 69, and the inaugural games were held in A.D. 80, one year after his death. More than 50,000 spectators proceeded along corridors and stairways through numbered gates to their seats. The concrete foundations were 25 feet (7.6 m) deep. Travertine was used for the framework of the piers, and tufa and brick-faced concrete for the walls between the piers. Originally there was marble on the interior, but it has completely disappeared.

9.11 Reconstruction model of the Colosseum. Museo della Civiltà Romana, Rome.

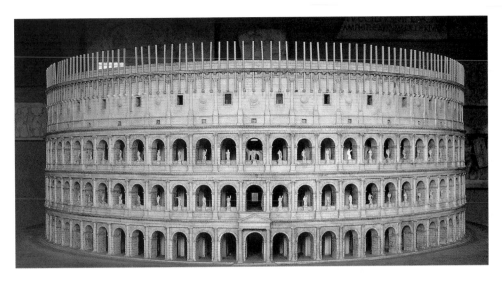

Above the Corinthian story was a wall fitted with sockets. Poles were inserted into them as supports for awnings that were stretched across the open top of the arena to protect spectators from inclement weather. The Colosseum was designed for gladiatorial contests and combats between men and animals or between animals alone, and it contained a built-in drainage system for washing away the blood and gore of combat. It remains a monument to one of the paradoxes of imperial Roman culture — catering to the popular taste for cruelty and violence, while at the same time showing a practical concern for creature comforts.

Circuses. A less bloodthirsty form of public entertainment in ancient Rome took place in the **circus**. Principally designed for chariot races, the circus could accommodate up to a dozen four-horse chariots. The resulting structures ranged in length from 1300 to 1970 feet (400–600 m). It has been estimated that the *Circus Maximus*, or Largest Circus, in Rome could hold more than 200,000 spectators. A more typical Roman circus (fig. **9.12**) was located at Lepcis Magna, in present-day Libya in northern Africa, at the southern extreme of the Roman Empire.

Circus races began from the starting gates and consisted of seven circuits in a counterclockwise direction. As the racers completed each lap, a marker indicated the number of laps that remained.

The Greek forerunners of the circus were the *hippodrome* for horseracing, and the *stadium* for footracing. Greek tastes, however, were different and altogether less violent, and the need for public spectacles was much more limited. The Roman populace craved entertainment, and the impetus for the huge imperial Roman building projects was as much to satisfy this craving as to express the power inherent in the emperor's ability to do so.

9.12 Plan of the circus at Lepcis Magna, Libya. Early 3rd century A.D. The two long sides and the semicircular eastern end were flanked by seats. A low dividing wall, or *spina* (as in "spine"), ran up the middle of the **arena** (the sandy running surface). It was decorated with statues, fountains, and other ornaments. Conical pillars marked the ends of the wall where the contestants had to turn.

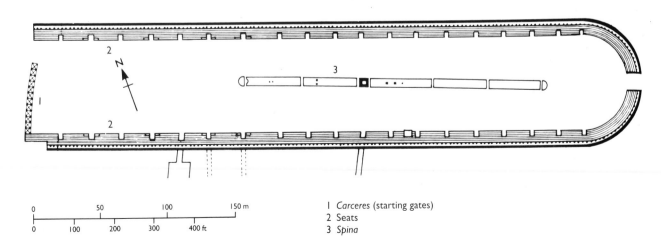

0	50	100	150 m	
0	100	200	300	400 ft

1 *Carceres* (starting gates)
2 Seats
3 *Spina*

Functional Architecture

Aqueducts. An example of the Roman ability to turn necessity into practical reality was the development of the **aqueduct** (from the Latin *ducere*, meaning "to lead" and *aqua*, meaning "water"). The most impressive example of a section of a Roman aqueduct is the Pont du Gard (fig. **9.13**), located at Nîmes in the south of France. Between 20 and 16 B.C. Marcus Agrippa (a friend and advisor to the Emperor Augustus) commissioned an aqueduct system to bring water to Nîmes from natural springs some 30 miles (48 km) away. Much of the aqueduct was built below ground or on a low wall, but when it had to cross the gorge of the River Gardon, it was necessary to build a stone bridge to carry it.

The Pont du Gard was constructed in three tiers, each with narrow barrel vaults. Those on the first two tiers are of the same size, while the third story vaults — which actually carried the channel containing the water — were smaller. The voussoirs that make up the arches weigh up to 6 tons (6000 kg) each. They were precisely cut to standard measurements, **dressed** (shaped and smoothed), and then fitted into place with no mortar or clamps.

The vault system of construction was well suited to a massive engineering project such as the Pont du Gard bridge and aqueduct. With the tunnel vaults in a continuous series side by side, the lateral thrust of each vault is counteracted by its neighbor, so that only the end vaults need to be buttressed. The placement of larger vaults below and smaller ones above serves a structural purpose — support — as well as an esthetic one. The repeated arches not only carry water, but also formally lead our vision across the river. Thus, in addition to the utilitarian virtues of the Pont du Gard, the repetition and arrangement of the arches create a formal rhythm that is consistent with its structural logic.

Religious Architecture

Temples. The Roman temple is derived from both Greek and Etruscan antecedents. From the Etruscans came various features, including the **podium** (base). From Greece came the columns, the *cella* (equivalent to the Greek *naos*), the porch (**pronaos**), the orders, and the pediment. Many Greek architects worked in Rome and its provinces from the middle of the second century B.C., after the Roman conquest of Greece, and their activity led to a gradual shift toward the use of marble.

The Roman Temple of Portunus (fig. **9.14**), the god of harbors, was formerly known as the Temple of Fortuna Virilis. Etruscan influence is evident in the raised podium and the steps, which are restricted to the front porch. Greek temples had been **peripteral** — their steps went all the way around the building, thereby avoiding the disjunction of steps and podium, and maintaining both esthetic and structural unity. Roman temples had a more

9.13 (opposite) Pont du Gard, near Nîmes, France. Late 1st century B.C. Stone, 854 ft (260 m) long; 162 ft (49 m) high. The aqueduct system maintains a constant decline of 1 in 3000, resulting in a total drop of only 54 feet (16.5 m) over its whole length.

9.14 (right) Temple of Portunus (formerly known as the Temple of Fortuna Virilis), Rome. Late 2nd century B.C. Stone. The Romans had moved beyond the Greek use of the column as the primary means of support and the colonnade as the principal tool for organizing architectural space. In this temple, the wall is the supporting element. The columns are engaged in the *cella* wall on the sides and at the back of the building, and serve a purely decorative purpose.

frontal aspect. But here the influence of the Greek peripteral temple is still evident in the Ionic columns, which continue on all four sides of the building. The corner columns serve on both the long and short sides, as in the Parthenon (fig. **7.16**).

The Pantheon. The most monumental Roman temple is the circular Pantheon (figs. **9.15** and **9.16**). It consists of two main parts—a traditional rectangular **portico** supported by massive granite Corinthian columns and a huge concrete **rotunda** faced on the exterior with brick. Inscribed on the pediment of the portico is the name of Augustus's friend Marcus Agrippa, who had dedicated an earlier temple on the same site. The entire Pantheon stands on a podium with steps leading up to the portico entrance. Worshipers originally approached the building through a colonnaded forecourt, which has since been destroyed. It masked the absence of symmetry between front and back, and the lack of harmony between the portico and the huge cylindrical rotunda. The dome and the drum are in perfect proportion—the distance from the top of the dome to the floor is identical to the diameter of the drum (see the **section** in fig. **9.16**).

Once inside the rotunda (fig. **9.17**), the visitor is in a huge domed space illuminated only from the open *oculus*

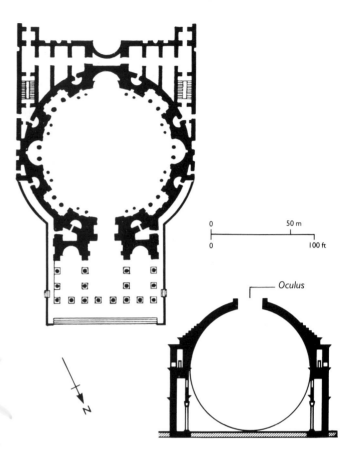

9.16 Plan and section of the Pantheon. The section shows how the thickness of the dome tapers toward the top, from approximately 20 to 6 feet (6–1.8 m). Note the stepped buttresses on the lower half of the dome.

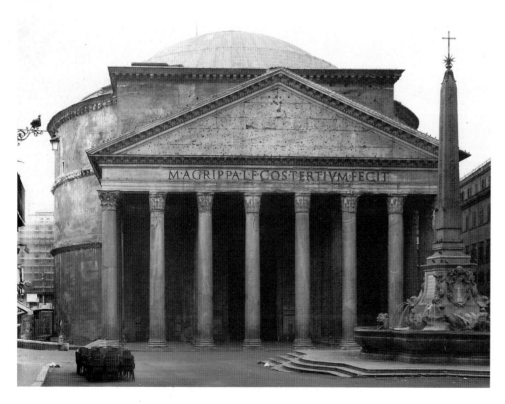

9.15 Exterior view of the Pantheon, Rome. A.D. 117–125. Marble, brick, and concrete. The Pantheon was built under Hadrian's rule and was dedicated in a literal sense to all (*pan*) the gods (*theoi*)—actually to the seven planetary deities Mercury, Venus, Mars, Saturn, Pluto, Neptune, and Jupiter. Uranus had not yet been discovered.

9.17 (opposite) Giovanni Paolo Pannini, *The Interior of the Pantheon.* c. 1740. Oil on canvas, 4 ft 2½ in (1.28 m) high; 3 ft 3 in (0.99 m) wide. National Gallery of Art, Washington (Samuel H. Kress Collection). The coffers were originally painted blue and each had a gold rosette in the middle, enhancing the dome's role as a symbol of the sky, or the Dome of Heaven. The blue paint repeated the blue sky that was visible through the *oculus*. It in turn cast a circle of light inside the building, reminding the ancient Roman visitors of the symbolic equation between the sun and the eye of Jupiter, the supreme celestial deity of Rome.

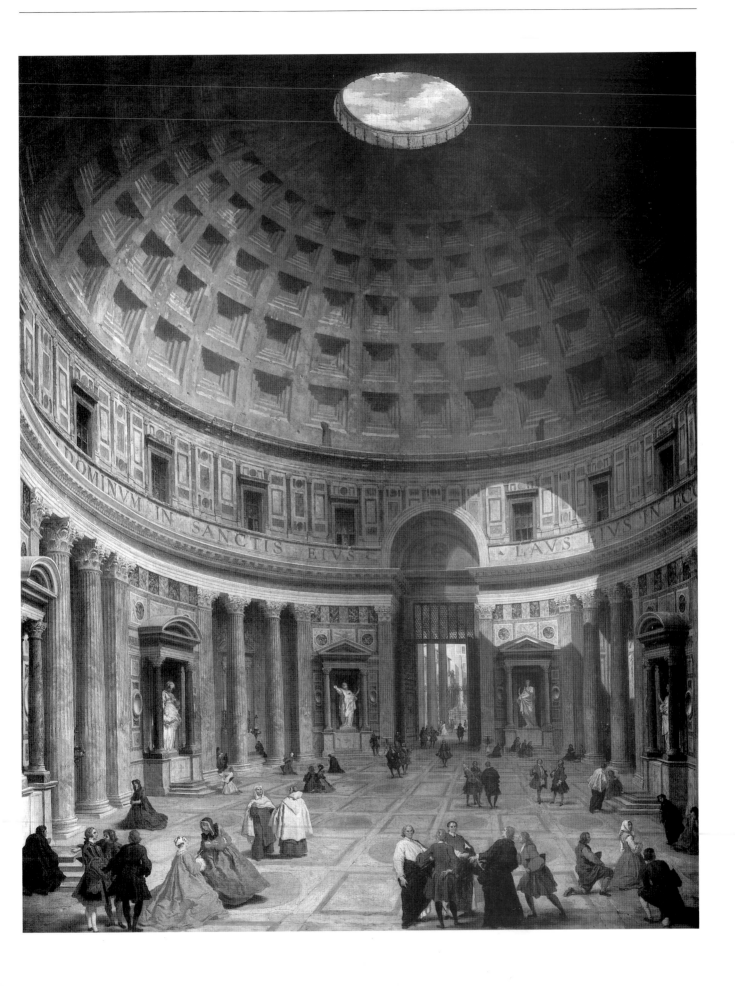

9.18 Western side of the *Ara Pacis* (*Altar of Peace*), Rome. 13–9 B.C. Marble, outer wall c. 34 ft 5 in x 38 ft x 23 ft (10.5 x 11.6 x 7 m). Its purpose was to celebrate the *pax Romana* (Roman peace), or *pax Augusta* (Augustan peace), considered by the emperor to be one of his most important accomplishments.

9.19 Detail of frieze of senators and officials on the northern side of the *Ara Pacis*. c. 5 ft. 3 in. (1.6 m) high.

9.20 Detail of frieze, *Ara Pacis*. This detail of a little child tugging at an adult's toga reflects the artist's careful observation of nature. The child is chubby, with fat rolls around his ankles and dimpled elbows and knees. He is tired of walking and wants to be picked up and carried. Such accurate psychological characterization of specific age-related behavior is consistent with the Roman interest in portraiture and observation of human nature.

(Latin for "eye") in the center of the dome. The marble floor consists of patterns of circles and squares, and the walls contain niches (each one for a different deity) with Corinthian columns supporting alternating triangular and rounded pediments. Between each niche is an opening in the wall, with two huge columns flanked by two corner pilasters. The columns and pilasters support a circular entablature which forms the base of a short "second story"; this, in turn, bears the whole weight of the dome. The dome itself has five **coffered** rings, which serve the practical function of reducing the weight of the structure as well as their more obvious decorative function.

Commemorative Architecture

An important category of Roman architecture specifically celebrated the actions of individuals — usually an emperor or a general.

The *Ara Pacis*. The Emperor Augustus took pride in the marble buildings constructed during his reign. One of his great marble monuments, the *Ara Pacis (Altar of Peace)* (fig. **9.18**), was located with deliberate irony on Rome's *Campus Martius* (literally "the field dedicated to Mars," the god of war).

The altar itself (visible here through the opening) stood on a podium and was enclosed by a large rectangular marble frame. Magistrates, priests, and Vestal Virgins (virgins consecrated to the service of Vesta, goddess of the hearth) made yearly sacrifices on it. They ascended the western stairs, entered the sacred space, and performed sacrifices while facing east — in the direction of the sunrise.

The exterior of the marble frame is decorated with relief sculptures. Elegant vinescroll **traceries** are carved on the lower half of the frame, and the procession in honor of the founding of the altar is represented on the upper half. On the south side, Augustus leads members of the imperial family toward the entrance. On the north, magistrates, senators, members of religious fraternities, women, and children proceed to the entrance. Other parts of the frame illustrate allegorical scenes.

There is good reason to believe that Augustus was inspired by the Ionic frieze of the Parthenon (fig. **7.24**) as a stylistic source. However, the *Ara Pacis* is carved in higher relief than the Panathenaic Procession. Variations in depth are suggested by changes in the degree of relief. The higher is reserved for the more prominent **foreground** figures, while the lower is used for figures that appear to be in the background (fig. **9.19**). As in the Parthenon frieze, there is some variety of pose among the figures so that the potential monotony of the procession is avoided. The Roman figures also have a greater range of facial expression and age — children as well as adults are represented (fig. **9.20**). Although the sculptor of the *Ara Pacis* idealized the figures to some extent, there are recognizable portraits, especially of the imperial family.

The Column of Trajan. Single, freestanding, colossal columns had been used as commemorative monuments from the Hellenistic period onward. The unique Roman contribution was the addition of a documentary, ribbon-like frieze, best exemplified in Trajan's Column (fig. **9.21**). Trajan was emperor from A.D. 98 to 117, and his Column was erected in honor of his victories over the Dacians, the inhabitants of modern-day Romania. The exterior of the

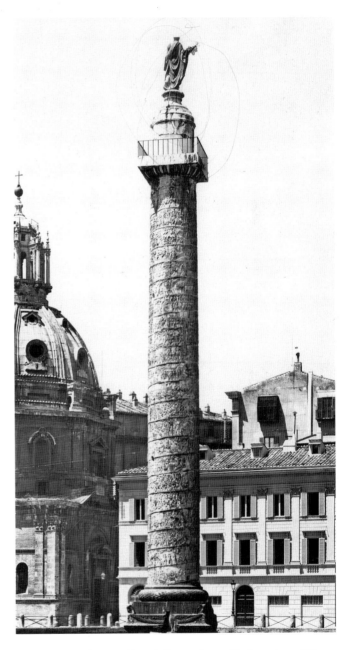

9.21 Trajan's Column, Trajan's Forum, Rome. Dedicated A.D. 113. Marble, 125 ft (38 m) high including base; frieze 625 ft (190 m) long. Although the upper scenes could not have been seen from the ground, they would have been visible from the balconies of nearby buildings. A gilded bronze statue of Trajan, since destroyed, originally stood at the top of the column. It has been replaced by a statue of St. Peter.

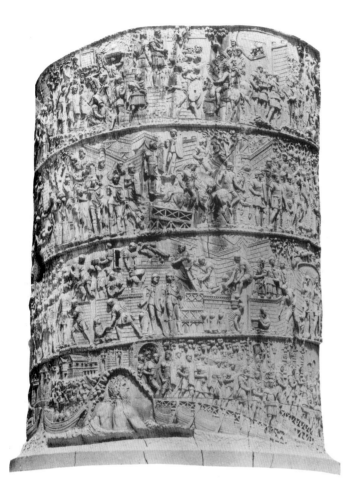

9.22 Detail of four lowest bands of Trajan's Column. Marble relief, each band 36 in (91.4 cm) high.

shaft is covered with a continuous low-relief spiral sculpture over 600 feet (180 m) long and containing some 2500 figures.

The column consists of marble drums cut horizontally and imperceptibly joined together. Supporting it is a podium decorated with relief sculptures illustrating the spoils of war) and containing a repository for Trajan's ashes. Inside the column shaft, a spiral staircase is illuminated by holes cut into the marble.

In the first four bands of the spiral, at the beginning of the narrative (fig. **9.22**), the Roman army prepares its campaign. On the first level, a giant bearded god of the Danube River appears under the arch of a cave. He watches as Trajan leads the Roman army out of a walled city. Boats and soldiers fill the river. The second level contains army camps, war councils, reconnaissance missions, and the capture of a spy. Background figures are raised into the area above foreground figures, virtually eliminating any unfilled space. Zigzagging buildings faced with brickwork patterns and the diagonals of the boats add to the sense of movement. The formal crowding conveys the bustling activity of armies preparing for war. In addition to its power as a commemorative statement, Trajan's

Column is one of the most informative historical records of life in the Roman army by virtue of its relief sculptures.

Trajan's Column and other monumental Roman columns were commemorative markers in vertical form. Their height and sculptural decorations symbolized the emperor's achievements. Thus they express the association of height with success and accomplishment.

Triumphal Arches. The triumphal arch was another Roman innovation that commemorated the military exploits of a victorious general or emperor. Rather than rising skyward, however, arches marked a place of earthly passage by framing a space. The act of passing through the arch symbolized the emperor's triumphant entry or reentry, into a city.

Since many Roman cities, including Rome itself, were walled, the Romans cut arches into the walls. These were often in sets of three, and served as entrances for the general populace. The earliest surviving examples of the triumphal arch, as distinct from public entrances in a long city wall, predate the reign of the first emperor, Augustus, by a century. They typically consisted of a rectangular block enclosing one or more round arches, and a short barrel vault like those on the Pont du Gard (fig. **9.13**). Most had one or three openings — two were quite rare. Pilasters framed the opening(s) and supported an entablature, which was surmounted by a rectangular section, or **attic**. This usually bore an inscription and supported chariots drawn by sculpted horses or, occasionally, by elephants. In ancient Rome, elephants were owned only by emperors and, because of their bulk and strength, became another symbol of the emperor's power.

One of the finest examples of an arch with a single opening is the Arch of Titus (fig. **9.23**), erected to commemorate that emperor's capture of Jerusalem and his suppression of a Jewish rebellion that had taken place in A.D. 70 to 71. Its columns are of the Composite order, a Roman order combining elements of the Greek orders — in this case, Ionic and Corinthian. On the curved triangular spaces between the arch and the frame, winged Victories hold laurel wreaths. Reliefs on either side of the **piers** (large rectangular supports) which form the passageway depict scenes of Titus's triumphs. In the center of the vault, which is not visible in figure **9.23**, Titus is carried up to Heaven on the back of an eagle. This scene represents the Apotheosis (deification, or being made a god) of Titus.

In the passageway (fig. **9.24**), Titus's soldiers can be seen carrying their booty from the Jewish Wars. Proceeding across the relief space in a horizontal line, the army holds up its trophy, the *menorah* (the sacred Jewish candelabrum with seven candlesticks). The artist has conveyed a sense of the *menorah*'s weight by showing the physical effort required to carry it. The trophy's heaviness and position enhance the visible symbolism of Roman victory. The base of the *menorah* is carved with some attempt at perspective, as is the diagonal of the triumphal arch on the right of the scene.

9.23 Arch of Titus, Rome. A.D. 81. Marble over concrete core, c. 50 ft (15 m) high; c. 40 ft (12 m) wide. The arch stands on the *Via Sacra*, or Holy Way, in Rome. The Latin inscription on the attic proclaims that "the senate and people of Rome (SPQR) [dedicate the arch] to divine Titus, Vespasian Augustus, son of divine Vespasian."

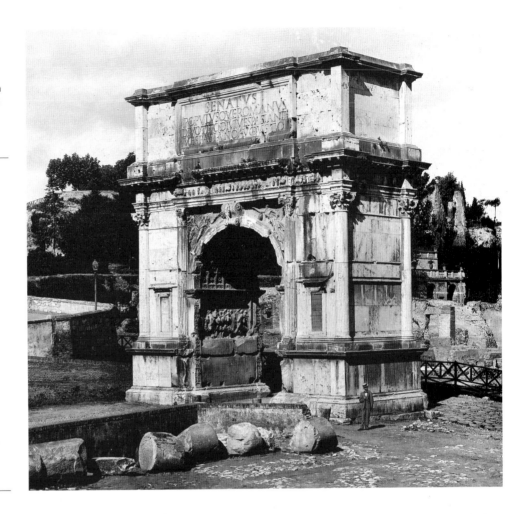

9.24 *The Spoils of the Temple at Jerusalem Exhibited at Rome*, detail of relief from the Arch of Titus. Marble, 6 ft 7 in (2 m) high.

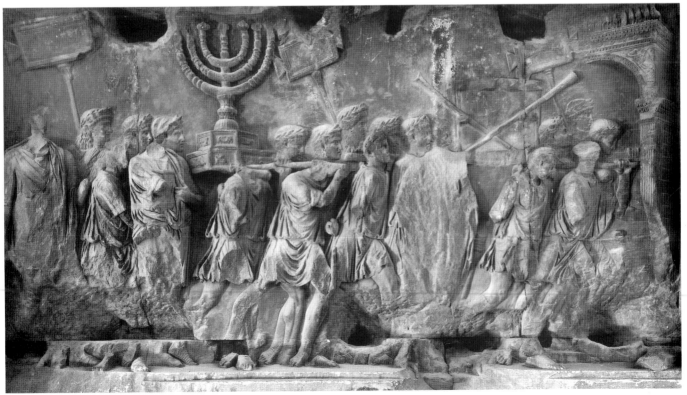

Sculptural Types

Sarcophagi

The Romans had three basic types of funerary art. They used cinerary urns for cremation — possibly the result of Etruscan influence. Graves were marked in the Greek style by stelae or tombstones with inscriptions and/or relief sculpture. But the most typical item of funerary art for the Romans was the sarcophagus.

The so-called Prometheus Sarcophagus (fig. **9.25**) is decorated with reliefs illustrating the Greek myth of Prometheus (see p.17). He is shown as a bearded man making humans from clay in the center, and Minerva gives each of his figures a soul in the form of a butterfly. On the right are personifications of Night and the Moon. A Cupid stands over a dead body holding a torch upside-down — its extinguished flame is a symbol of death. Hercules leads Prometheus before Jupiter, while Atropos (the Fate of the forces of death) records the life of the deceased. On the left are Clotho and Lachesis (the Fates of the life forces) with the gods of Earth, Ocean, and Wind. The Sun appears above in a horsedrawn chariot. Although the crowded imagery on this sarcophagus deals with a range of subjects, they are all related in one way or another to creation, life, and death.

Portraits

Just as tomb effigies are a metaphorical way of making the dead seem alive, so portraiture keeps alive in memory the features of the deceased.

9.25 Prometheus Sarcophagus. Marble. Museo Capitolino, Rome. The effigy of a sleeping child on the lid originally belonged to another sarcophagus. His head rests on a pillow and he holds poppies in his right hand. Poppies (well known for their narcotic quality) were an attribute of sleep in the ancient world, and in this context are a reminder of the traditional association of sleep and death.

One of the portrait types most characteristic of Rome was the head detached from the body, or **bust**. It had never been part of Greek tradition, but was common among the Etruscans. Busts were usually carved in marble, often from a wax death mask, so that even the most specific physiognomic details were preserved. The portrait of Julius Caesar is clearly a likeness (fig. **9.26**). His small but penetrating eyes contrast with the deep spaces under his eyebrows. Indentations are carved out under his cheekbones and creases spread from the sides of his nose. His right ear is slightly higher than the left one. These facial details create the impression of a specific personality, confident and self-assured, as one would expect of a great general and statesman.

One of the most important subjects of Roman sculpture in the round was naturally the emperor himself. In the *Augustus of Prima Porta* (fig. **9.27**), the emperor is

9.26 Bust of Julius Caesar, from Tusculum. Marble, 13 in (33 cm) high; head 8⅔ in (22 cm) high. Museo di Antichità, Turin.

9.27 (opposite) *Augustus of Prima Porta.* Early 1st century A.D. Marble, 6 ft 8 in (2.03 m) high. Musei Vaticani, Rome. The back is unfinished, indicating that the statue was intended for a niche. Augustus is armed but raises his right hand in a gesture characteristic of orators. The fact that he is barefoot is probably a reference to his divinity. The Roman deification of Augustus after his death harks back to the traditional equation of god and ruler that persisted throughout the ancient Mediterranean world.

MVNIF.PT.IX.P.M.
AN.XVIII

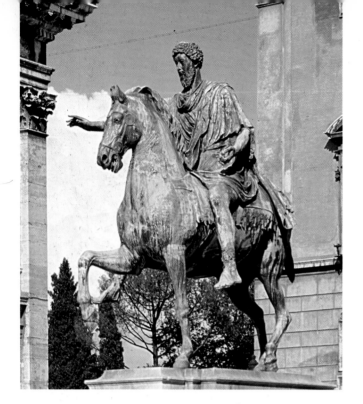

9.28 Equestrian statue of Marcus Aurelius (before restoration). A.D. 161–180. Bronze, over-lifesize. Piazza del Campidoglio, Rome. Marcus Aurelius, who ruled from A.D. 161 to 180, was a stoic philosopher and the author of the *Meditations*, which he wrote in Greek. In this statue he is unarmed and his right arm is extended in the conventional oratorical gesture. But domination and conquest are implied by equestrian iconography. Documents indicate that a conquered enemy originally cowered under the horse's raised foreleg. This harks back to Egyptian and Near Eastern motifs in which a small size and lowly position denote defeat.

portrayed as both orator and general. Even though the head is a likeness, it is idealized. Augustus was seventy-six when he died after a long principate (the term of a Roman *princeps* or emperor) — he had reigned from 27 B.C. to A.D. 14. But this statue represents a self-confident, dominating, and above all youthful figure. A possible source for this idealization is the *Doryphorus* of Polyclitus (fig. **7.11**). The similar stance suggests that the artist who made the Augustus was familiar with the Greek statue, probably from Roman copies, if not from the original.

The iconography of this statue, as well as its character, emphasizes the power of Rome that is embodied in Augustus as emperor. By his right leg, Cupid (Venus's son) rides a dolphin and serves as a reminder that Augustus traced his lineage to Aeneas (also the son of Venus). He was thus descended from the gods. Among the little reliefs carved on Augustus's armor is Mother Earth with a cornucopia, indicating the emperor's identification with the land as a source of plenty. The association of Augustus with the earth also refers by implication to Roman territorial conquests. Another scene depicts the Parthians, members of a Near Eastern culture whose army had looted military standards from the Romans in battle. Here they are returning the stolen property to the victors.

Another type of imperial portrait invented by the Romans is the equestrian monument. The only surviving

example is a bronze statue of the Emperor Marcus Aurelius (fig. **9.28**), who ruled from A.D. 161 to 180. His beard reflects a fashion set by Hadrian, which in turn indicates Greek influence. Also suggesting Greek influence is the artist's representation of convincing organic form in both emperor and horse. Veins, muscles, and skin folds of the horse are visible as he raises his right foreleg, turns his head, and lifts his left hind leg so that only the toe of his hoof touches the ground. His apparent eagerness to set out is controlled and counteracted by the more sedate emperor, who originally held his reins (now disappeared).

The last great Roman emperor, Constantine I (who ruled from A.D. 306 to 337), is depicted in a colossal marble head which has been broken off from the rest of the statue (fig. **9.29**). It is clearly a portrait, as evidenced by such specific features as a long nose, a cleft chin, and a thick neck. Nevertheless, despite the portrait quality of this sculpture, its size, staring eyes, and dominant character express Constantine's exalted power. The Classical approach of previous imperial sculpture has disappeared, giving way to a new style. The scale of the statue makes the emperor more imposing and more psychologically removed from his subjects.

9.29 Monumental head of Constantine, from the Basilica of Constantine, Rome. A.D. 313. Marble, 8 ft 6 in (2.59 m) high. Palazzo dei Conservatori, Rome. The statue's original location on the throne in the apse of Constantine's basilica reflected the emperor's power over the Roman people.

Mural Painting

Roman murals are among the most significant legacies of the eruption of Mount Vesuvius (see p.129). Hundreds of wall paintings have been discovered among the ruins of Pompeii and Herculaneum. They were executed in *buon fresco* — pigments mixed with a binder of limewater were applied to the walls before the plaster had dried. As a result of this durable technique, and because of their covering of volcanic ash, the murals have survived in relatively good condition and provide a remarkable panorama of Roman painting.

Portraiture was as popular a subject for paintings as for sculpture. Commissioned family portraits typically appear on the walls of private houses, serving the double function of genealogical record and decoration. An example of Roman portrait painting is the *Young Woman with a Stylus* (fig. **9.30**), whose bust-length figure is enclosed by a circular frame called a **tondo**. The formal aspects of this picture indicates that the Roman painters, like the sculptors, had command of three-dimensional space and organic structure. For example, the artist has used shading to create the cylindrical roundness of the neck and the changing planes of the drapery folds. The dome-shaped head is ringed by curls, echoing the circular frame. Formal unity is maintained between figure and frame, and yet an impression is created of a specific person frozen in a moment of thought.

Roman artists also painted still lifes, in which objects are removed from their usual or natural surroundings and arranged for purposes of representation. The objects in figure **9.31** are set on steps or shelves, whose spatial projection is indicated by abrupt shifts from light to dark. The spherical character of the peaches is indicated by their gradually shaded surfaces. But on the glass jar on the lower level, patches of white paint suggest that light bounces off its shiny, transparent surface. There is a suggestion that the source of light comes from the left, since the jar and the peaches cast shadows to the right. The light **highlights** and shading serve to create an illusion of three-dimensionality on the flat surface of the wall.

A more complex narrative mural painting, from the House of the Vettii in Pompeii, represents the Greek myth in which the infant Hercules (Heracles) strangles a pair of snakes (fig. **9.32**). Heracles was the son of Zeus and the mortal Alcmene. Hera was made jealous by her husband's infidelity, and tried to kill the infant by sending two snakes to his nursery. Her plot failed when Heracles killed the snakes instead. In this painting, Hercules is the focus of attention. On the right, Alcmene's mortal husband Amphitryon (who believes himself to be Hercules's father) watches with paternal pride. A frightened Alcmene cowers behind Amphitryon, knowing that Hercules is safe but afraid that her own guilty secret will be revealed. Both figures wear draperies whose folds define the structure and movement of their bodies. Amphitryon and Hercules are depicted in *contrapposto*, but reversed in relation to each other. The play of shading across their torsos defines

9.30 *Young Woman with a Stylus* (sometimes called *Sappho*), from Pompeii. 1st century A.D. Fresco, diameter 11⅜ in (28.9 cm). Museo Nazionale Archeologico, Naples. The subject holds wax writing tablets in her left hand and a **stylus** in her right. Her contemplative expression suggests that she is pondering what to write next.

9.31 Still life from Herculaneum. c. A.D. 50. Fresco, 14 × 13½ in (35.6 × 34.3 cm). Museo Nazionale Archeologico, Naples.

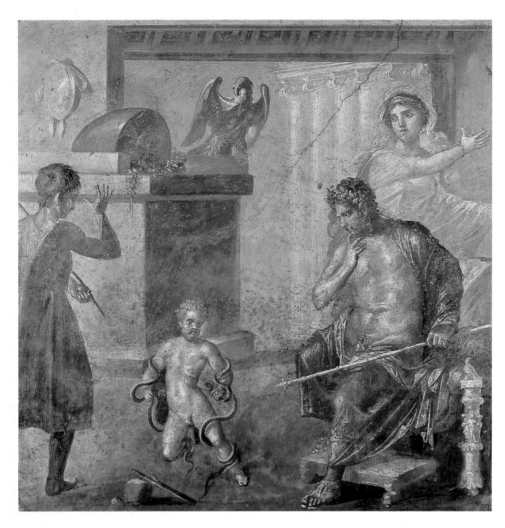

9.32 *Hercules Strangling the Serpents*, from the House of the Vettii, Pompeii. A.D. 63–79. Fresco.

the natural structure of their bodies as well as their spatial positions. The young boy on the left is rendered from the back, as if he, like the observer, has just happened on the scene. His placement creates the impression that the viewer looks through the **picture plane** onto an event taking place beyond the wall.

The architectural elements within the picture add to this effect of depth. The slightly receding row of Ionic columns, for example, is an attempt at perspective. The floor of the room is rendered as a horizontal, enabling the viewer to determine the locations of the figures and objects in space. Amphitryon's footstool and the altar behind Hercules are placed so that a corner faces the picture plane. By shading one side of the altar, the artist creates the illusion that both sides recede. The entire scene thus seems to occupy a convincing, if not mathematically precise, three-dimensional space.

Although the painting represents a Greek myth, certain iconographic details refer to the imperial concerns of Rome. Amphitryon is clearly a ruler, wearing a laurel wreath, enthroned, and holding a scepter. Perched on the altar is an eagle, which is at once a reference to the Roman army and to Zeus and his Roman counterpart Jupiter. The fate of Hercules — the only mortal in Greek

myth to have been granted immortality and access to Mount Olympus — evokes the late Roman custom of deifying its emperors. Likewise, his divine origins recall the Roman legends tracing the origins of Rome to Aeneas and ultimately to the Greek gods.

Roman and Greek pictorial art, sculpture, architecture, religion, and even certain ideas about citizen participation in government had much in common with each other. But the Romans translated what they borrowed from Greece into their own idiom. Greek and Roman culture have had an enormous impact on the foundation and development of western civilization. Since Greece was itself subject to Egyptian and oriental influences, and Rome had a remarkable ability to assimilate other foreign cultures, the entire Mediterranean world may be said to have contributed to western culture.

During the course of the Roman Empire, a new religion was born. Christianity was legally sanctioned by Constantine the Great in A.D. 313, and he may himself have been a convert. It was to dominate western art and culture for well over a thousand years. New conventions of style would develop to express Christianity's new message.

PART THREE

THE CHRISTIAN WORLD

	Style/Period	Works of Art	Cultural/Historical Developments
A.D. 300	EARLY CHRISTIAN 2nd to 5th century A.D.	Old St. Peter's (p.154)	Catacombs (2nd century A.D.) Constantine emperor (306–337) Edict of Milan: Christianity legalized (313) Books begin to replace scrolls (c. 360) Sack of Rome by Visigoths (410) St. Augustine, *City of God* (426) Sack of Rome by Goths; fall of Western Roman Empire (476)
500	BYZANTINE 5th to 14th century	Hagia Sophia (p.162) S. Vitale (p.156) Sutton Hoo purse cover (p.172)	Development of Gregorian chants (6th century) Monastery of St. Gall founded (612)
800	EARLY ISLAMIC 7th to 14th century	Dome of the Rock (p.168) Book of Durrow (p.173) Book of Kells (p.174) Great Mosque, Córdoba (p.169)	Death of Mohammed (632) Charlemagne becomes Holy Roman Emperor (800) Text of Koran completed (935) Beginning of Ottonian architecture (936) Omar Khayyam, *Rubaiyat* (c. 1100)
1100 **1200**	ROMANESQUE 11th to 12th century	Bayeux Tapestry (p.188) Sainte-Foy (p.180) Castel Appiano murals (p.186)	Norman conquest of England (1066) Building of Tower of London begins (1078) First Crusade (1095–99) *Chanson de Roland* (c. 1100) Oxford University founded (1167) Murder of Thomas à Becket (1170) Campanile (Leaning Tower) of Pisa built (1174) Francis of Assisi founds Franciscan Order (1209)
1300	GOTHIC Mid-12th to 14th century	Saint-Denis (p.190) Chartres Cathedral (p.195) Reims Cathedral (p.206) Salisbury Cathedral (p.208)	Signing of Magna Carta (1215) Dominican Order founded (1216) Marco Polo travels to China (1271–95) Fall of Acre (1291); end of Christian rule in the East Death of Kublai Khan (1294)

Early Christian and Byzantine Art

A New Religion

Jesus Christ died in about A.D. 33, during the reign of the Emperor Tiberius, who ruled from A.D. 14 to 37. He was crucified outside the city of Jerusalem, then part of the vast Roman Empire. The teachings of Christ and his followers led to the establishment of the Christian religion, whose impact on western art after the fall of the Empire cannot be overestimated.

Christianity began as one of many eastern cults current in the Mediterranean world and in Rome itself during the first century A.D. The roots of Christianity were based in Judaism, since Christ himself was a Jew. Like Judaism, Christianity was founded on written texts, was monotheistic, and taught a code of ethics to its adherents. As in certain other eastern cults, Christianity offered a promise of eternal salvation for the faithful. But Christianity differed from these cults in two crucial respects.

First, Christian rituals did not include animal or blood sacrifices, except in symbolic form. Christ's own sacrifice was recreated in the Last Supper, when the bread stood for his body and red wine for his blood. This celebration was originally performed by Christ and his followers as part of the Jewish Passover, shortly before his death. He asked his followers to repeat it in his memory, and at first they did so in private dining rooms. It consisted of breaking bread, drinking wine, singing hymns, praying, and reading from the Bible. By the third century A.D., this recreation of the Last Supper had become established as the liturgy of the Mass, conducted by a bishop. In the performance of the Mass, also called the Holy Communion, the Lord's Supper, or the **Eucharist** (Greek for "thanksgiving"), bread and wine are ritually substituted for the body and blood of Christ.

Second, Christians differed from followers of other eastern religions by refusing to worship the emperor as the embodiment of the state. Christian monotheism rejected the Roman and Greek pantheons and the Near Eastern and Egyptian gods. These attitudes set Christianity at odds with the imperial Roman establishment and made its followers subject to persecution by Rome. As a result, despite the rapid growth of Christianity, its special appeal to the lower classes of society, and the fervor of its adherents, it remained an underground movement for nearly the first 300 years of its existence. Rome was not entirely safe for Christians before A.D. 313. In that year, the Emperor Constantine issued the Edict of Milan, which granted tolerance to all religions, and especially mentioned Christianity.

Constantine and Christianity

Constantine's precise relationship to Christianity is not known. He clearly took a personal interest in the new religion. Although he moved his capital from Rome to Byzantium at least in part because the eastern regions of the Roman Empire were gaining in political importance, it was also there that Christianity had established the firmest foundations by the early years of the fourth century.

Apart from Constantine's own letters, his edicts, and what can be surmised from his actions, the primary source for his life is the biography by Eusebius (A.D. 265–340). The Bishop of Caesarea and a historian, Eusebius describes Constantine's defeat of the pagan Maxentius at the Milvian Bridge in Rome. According to Eusebius, Constantine saw two visions before the battle. In one, the cross appeared against a light with the words "In this sign you conquer." In the other, he was told to place the Chi-Rho — the first two letters of Christ's Greek name — on the shields of his soldiers. It was after this victory that Constantine issued the Edict of Milan because, according to Eusebius, he recognized the power of the cross and the Christian god. Eusebius also says that Constantine was baptized a Christian before his death.

The Divergence of East and West

These events and the controversies surrounding them reflect the political and religious turmoil of the centuries immediately following the birth of Christ. The title of this chapter is also a reflection of those uncertain times. "Early Christian" is a historical more than a stylistic designation. It refers roughly to the first four centuries A.D. and to Christian works of art made during that period.

Christianity and the Scriptures

Scriptures are literally "what has been written." For Judaism and Christianity, the most authoritative scriptures are collected in the Bible (which is derived from the Greek *biblos*, meaning "book"). The Jewish Bible consists of the Old Testament, to which Christians have added the New Testament. The Apocrypha (Greek for "secret" or "hidden") are Old and New Testament writings whose authenticity is questioned.

Established by the fourth century A.D., the New Testament was organized into three sections: the **Gospels** and Acts, the Epistles, and the **Apocalypse** (or Revelation). The four Gospels are essentially biographies of Christ, written in about A.D. 70 to 80 by Sts. Matthew, Mark, Luke, and John. The authors are called the four evangelists (from the Greek *euangelistes*, meaning "bearer of good news").

The Acts relate the works of Christ's twelve **apostles** in spreading his teachings. The Epistles, or Letters, contain further doctrine, and advice on how to live as a Christian. The Apocalypse describes the end of the world and Christ's Second Coming as the final judge. Although these are the basic Christian scriptures, other legends and traditions about Christ and his followers grew rapidly and developed into an enormous body of literature.

The most important figures in Christian art are the Holy Family, saints, and martyrs. The Holy Family consists of Mary (Christ's mother), Joseph (her husband), and Christ himself. A saint is any person noted for piety and faith who has been canonized by the Catholic Church. Martyr, from the Greek word *martus*, originally meant "witness" and specifically a witness to Christ's works. Subsequently martyr came to mean one who dies for a belief — in this case, Christianity. In western art, saints, martyrs, and members of the Holy Family are usually depicted with a halo — a circle of light around their heads — to indicate their holiness.

An important distinction between Christian and Roman art can be seen in their respective approaches to history. Romans used works of art to record the past — particularly the exploits and triumphs of their rulers. Christian art focused more on the future as determined by the Christian faith. It was important, therefore, for Christians to encompass as much of the past as possible into present and future.

One way in which they did this was by a method of historical revision called **typology** (from the Greek word *tupos*, meaning "example" or "figure"), which paired figures and events from the Old Testament (the Old Dispensation) with those of the New Testament (the New Dispensation). The purpose of typology was to reveal that history before Christ had foreshadowed or prefigured the Christian era. Christ, for example, calls himself greater than Solomon, the Old Testament king known for his wise judgments and temple-building. Christ is referred to as the new Adam, together with Mary, the new Eve. As Christianity developed, this typological view of history was expanded to include pagan antiquity and contemporary events as well as the Old and New Testaments.

Christian Symbolism

Christ means the Anointed, Messiah, Savior, Deliverer, and is written in Greek as ΧΡΙΣΤΟΣ. The two letters *X* and *P* (*Chi* and *Rho*) are equivalent to the English *Chr* and, as Constantine's symbol, were superimposed and written as

Ichthus, the Greek word for "fish," is an acronym for "Jesus Christ, Son of God, Savior." The *I* is the Greek equivalent of the English *J* (for "Jesus"), *Ch* stands for "Christ," *Th* for *theou* (Greek for "of God"), *U* for [h]*uios* (Greek for "son"), and *S* for *soter* (Greek for "savior"). The *ichthus* and other cryptic signs and symbols were used by Christians to maintain secrecy during the Roman persecutions. Much of early Christian imagery is symbolic in nature and often takes the form of pictorial puzzles known as **rebuses**. Even after Christianity had become the official religion of Rome and secrecy was no longer necessary, certain images such as the fish, the cross, the Lamb of God, and the Good Shepherd continued to have symbolic importance in art and liturgy.

"Byzantine," derived from the city of Byzantium, is the name of a style that originated in the Eastern Roman Empire. It is also used to include works made in Italy under Byzantine influence. At first the two terms overlap. However, as Rome and the Western Empire were overrun by northern European tribes and the east rose to prominence under Justinian, the distinction between the Eastern and Western Empires became more pronounced, and Early Christian and Byzantine started to diverge.

The geographical separation and political divergence of east and west was paralleled by a schism within the Church itself. In Rome and the Western Empire, the pope was the undisputed head of the Church. The eastern branch of the Church was led by a patriarch, whose power was bestowed on him by the Byzantine emperor.

Corresponding to the east–west division were the artistic styles produced by each branch of the Church. In the west, artists worked in the tradition of Hellenistic and Roman antiquity. This led to a proliferation of medieval styles from the seventh to the thirteenth centuries. Eastern artists were more influenced by Greece and the orient, and remained so. As a result, the Byzantine style persisted in the east. Byzantine art also infiltrated the west — especially Italy — and continued to influence artists there until the late thirteenth century. Just as Republican and imperial Rome had been able to assimilate other cultures, so Christianity and Christian art absorbed aspects of previous religions and their artistic expression. Greek and Roman myths were endowed with Christian meaning and interpreted in a Christian light.

Early Christian Art

Sarcophagi

A good example of continuing Roman imagery in Early Christian art can be seen on a marble sarcophagus in the Church of Santa Maria Antiqua in Rome (fig. **10.1a**). The side visible here includes Old and New Testament scenes as well as figures combining Roman with Christian meaning. Reading from left to right, the first character is the Old Testament figure of Jonah, who has emerged from the whale. Jonah's form (fig. **10.1b**) is based on the idealized, organic Classical reclining nude, while the whale is represented as a fantastic fish. This story was well suited to a Christian sarcophagus, since Christians interpreted it as a typological prefiguration of the New Testament Resurrection of Christ. Just as Jonah spent three days inside the whale, so Christ was entombed for three days before his Resurrection. An Early Christian viewer would have recognized the implications of this iconography as a metaphor for the salvation of the person buried in the sarcophagus.

To the right of Jonah on the sarcophagus are two Christian transformations of a Greco-Roman poet and his muse (see p.158). The seated poet wears a Roman toga but is shown as a Christian poring over a religious text. The muse is also in Classical dress. She stands with her arms raised in a gesture that combines prayer and mourning with a visual reference to Christ's cross. Spreading out from behind her palms are leafy branches of a tree — a reminder that the cross was made of wood. Indeed, trees have replaced columns as architectural dividers between scenes. Because of their relationship to the wood of the cross, trees were to become a central motif in Christian art.

Next on the right is the Good Shepherd, who carries a sheep on his shoulders. This figure was one of many antique images assimilated into the Christian repertory, and tallies with one of Christ's self-proclaimed roles. On the far right, a large, bearded John the Baptist stands on the banks of the River Jordan — indicated by wavy lines — and baptizes a small, nude Christ. In the upper left corner of the scene hovers the dove of the Holy Spirit, a traditional element in the iconography of Christ's Baptism. This is another appropriate scene for a sarcophagus because baptism signifies rebirth into the Christian faith, and thus salvation.

The opposition of the Baptism on the right of the sarcophagus and Jonah and the whale on the left demonstrates what was to become a traditional pairing of left and right. This associates the old, or pre-Christian, era with the left, and the new, Christian era with the right. Such pairing extended beyond the Old and New Testaments to include good and evil, light and dark, and so forth. (The negative implications of the Latin word *sinister*, meaning "left," survive in English.)

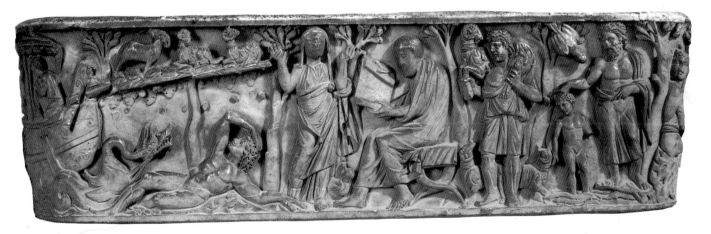

10.1a Early Christian sarcophagus, S. Maria Antiqua, Rome. 4th century A.D. Marble. Although the Christians continued to decorate their sarcophagi with relief sculptures, as the Greeks, Etruscans, and Romans had done, they omitted the effigy of the deceased from the cover of the tomb. They also eliminated cremation, because they believed in bodily resurrection.

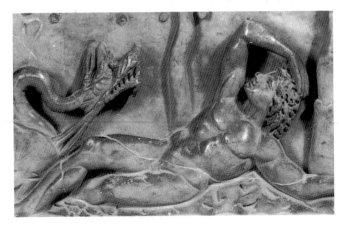

10.1b Detail of fig. **10.1a** showing Jonah as an idealized Classical reclining nude.

Basilicas

The Early Christians worshiped in private homes until the early fourth century A.D. But when Constantine issued the Edict of Milan in A.D. 313, they were suddenly free to construct places of worship. From that point on, Christianity was legally protected from persecution, and it soon became the official religion of the Roman Empire. New buildings were needed to accommodate the large and ever-growing Christian community. Unlike Greek and Roman temples, whose main purpose was to house the statue of a god, Christian churches were built so that crowds of believers could gather together for worship. With the active support of Constantine, many churches were constructed in very few years — in Constantinople (the new name Constantine had given to Byzantium — it is now known as Istanbul), in Italy, in the Holy Land, and elsewhere in the Roman Empire. Churches were modeled on the Roman basilica (see p.132) because of the need for space. The Early Christian basilica was to become the basis for church architecture throughout western Europe.

None of the Early Christian basilicas has survived in its original form, but an accurate floor plan of Old St. Peter's Basilica (figs. **10.2** and **10.3**) still exists. The architectural design of the Christian basilica conformed to the requirements of Christian ritual and especially to the role of the **altar**, where the Mass was performed, as its focal point. The movable communion table used in Christian meeting places before A.D. 313 was replaced by a fixed altar that was both visible and accessible to the worshipers. Both altar and **apse** were at the eastern end, and the **narthex** (vestibule) at the western entrance became standard in later churches.

The altar's location at the eastern end of the basilica served a symbolic as well as a practical function. It generally supported a crucifix with the image of Christ on the cross turned to face the congregation. Just as Christ's actual Crucifixion took place in the east (in Jerusalem), so the Christian basilica and most later churches are oriented with the altar in the east. According to tradition, Christ was crucified facing west, and therefore the altar

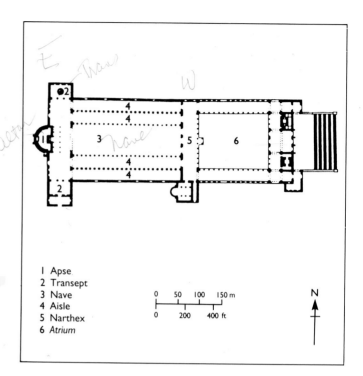

10.2 Plan of Old St. Peter's Basilica, Rome. A.D. 333–390. Interior c. 368 ft (112 m) long. Old St. Peter's was the largest Constantinian church and became the prototype for later churches. Besides being a place of worship, it was the saint's **martyrium** (a building over the grave of a martyr) — his grave was under a marble canopy in the apse.

1 Apse
2 Transept
3 Nave
4 Aisle
5 Narthex
6 Atrium

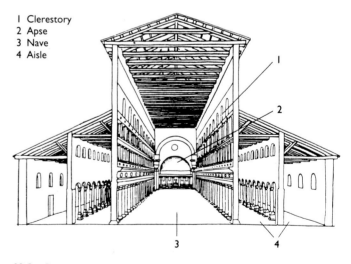

1 Clerestory
2 Apse
3 Nave
4 Aisle

10.3 Reconstruction diagram of the nave of Old St. Peter's Basilica. Old St. Peter's is similar to the pagan or secular basilica of pre-Christian Rome in having a long nave flanked by side aisles, clerestory windows on each side, an apse, and a wooden **gable** roof. Unlike pagan basilicas, which typically had an apse at each end, Old St. Peter's had a single one opposite the entrance. The whole building was demolished in the sixteenth century when work on the New St. Peter's began (see p.256).

The Catacombs

Christians were relatively safe from Roman persecution when hiding or holding services in the **catacombs** (narrow underground passages used for burials). Niches cut out of rock contained bodies which were closed in by slabs or tiles. According to Roman law, burial grounds were sacrosanct, so the Romans rarely pursued Christians into the catacombs. The earliest examples of Christian painting can be found on the catacomb walls.

After the sixth century A.D. the catacombs fell into disuse and were forgotten until their accidental discovery in 1578.

The Cross

The cross is the main symbol of the Christian religion (fig. **10.4**). Its principal representations are: (1) the *crux immissa*, known as the **Latin** (or Long) **cross**, whose base arm is longer than the other three (the one most familiar to western Christians); (2) the *crux quadrata*, or **Greek cross**, with four arms of equal length; (3) the *crux commissa*, known as St. Anthony's cross or the Tau cross (after the Greek letter); and (4) the *crux decussata* (named after the **decussis**, or Latin numeral ten), known as St. Andrew's cross. It is generally believed that Christ was crucified on a Latin cross, although some think it was a Tau cross.

Derivations from these types are (5) the Russian cross, (6) the Papal cross, and (7) the Celtic cross. The pre-Christian *crux ansata* (8), or *Ankh* cross — originally an Egyptian hieroglyphic symbol of life — was also adapted in the Christian era.

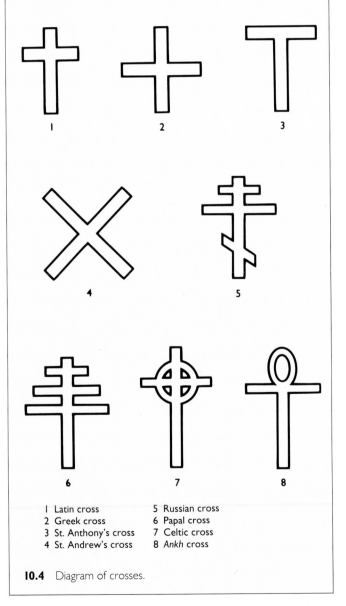

1 Latin cross	5 Russian cross
2 Greek cross	6 Papal cross
3 St. Anthony's cross	7 Celtic cross
4 St. Andrew's cross	8 *Ankh* cross

10.4 Diagram of crosses.

cross usually faces the main western entrance of the church building.

Another symbolic aspect of church design was the new use of the apse. In Roman basilicas apses had often contained statues of the emperors, and they were also the location of legal proceedings. In Early Christian apses, therefore, the image of Christ as Judge was particularly appropriate. It referred both to the Roman law courts and to the Christian belief in a Last Judgment when Christ will determine the eternal fate of each human soul.

An important new feature in Old St. Peter's was the addition of a **transept** to the Roman basilica. It consisted of two transverse spaces, or crossarms, placed at right angles to the nave, and separated the apse from the nave. The transept provided extra space for the congregation and isolated the clergy from the main body of the church. With the transept, the building forms the shape of a cross, hence the adjective **cruciform** to describe basilicas with this feature.

The altar and apse at Old St. Peter's were framed by a huge triumphal arch — a regular architectural element of Early Christian basilicas. The architects thus assimilated the Roman triumphal arch and transformed its meaning to refer to the triumph of Christ rather than the emperor.

The exterior of Old St. Peter's, and of similar churches, was plain brick. The interior, on the other hand, was richly decorated with mosaics, frescoes, and marble columns. Their purpose was not only to exalt the deity, but also to teach and inspire the worshipers. Unlike Classical Greek temples, which were designed to be seen mainly from outdoors, Early Christian churches were meant to be seen from both inside and outside.

Saint Peter

St. Peter was Christ's first apostle. In Matthew 16: 13–20, Christ gives Peter the keys to Heaven with the words, "On this rock will I build my Church." That statement became the basis for the pope's authority, although it is unclear grammatically whether "rock" refers to Peter or to his faith. The name Peter comes from the Greek *petros* (meaning "rock"), from which comes the English word "petrify," meaning "turn to stone." Rock is also a metaphor for something strong and lasting, as in "solid as a rock" or "Rock of Ages," and here denotes the solid and enduring character of faith.

St. Peter was the first bishop of Rome. Since that office later became the papacy, he is considered to have been the first pope. The basilica of Old St. Peter's became the prototypical papal church, although it was in fact an exception to the traditional Christian orientation of churches toward the east. During the Renaissance, St. Peter's was rebuilt by several architects (see p.256), and it is still the seat of papal power today.

Centrally Planned Churches

Another type of structure favored by the Early Christians was the **centrally planned** round or polygonal building. It radiated from a central point and was surmounted by a dome, and it was often attached to a larger structure. Less suitable for big congregations, such buildings were used mainly as *martyria*, **baptisteries** (for performing baptisms), or **mausolea** (large architectural tombs). Centrally planned churches included a central altar or tomb and a cylindrical core with clerestory windows. A circular barrel-vaulted passage, or **ambulatory** (from the Latin *ambulare*, meaning "to walk"), ran between the central space and the exterior walls.

Justinian and the Byzantine Style

During the fifth century A.D., the western part of the Roman Empire was overrun by Germanic tribes from northern Europe. The Ostrogoths occupied the strategic Italian city of Ravenna until it was recaptured during the reign of the Byzantine Emperor Justinian in A.D. 540. Under Justinian, the Eastern Empire rose to political and artistic prominence.

San Vitale. Situated on the Adriatic coast, Ravenna was an essential port for controlling trade between the east and the west. Because of its strategic location, it became the Italian center of Justinian's empire and the focus of his artistic patronage in Italy. He was striving to restore unity to Christendom, and one expression of that effort can be seen in his building programs. Ravenna was the site of interesting developments in the centrally planned church during the sixth century A.D. The city's most important Justinian church (figs. **10.5** and **10.6**) was dedicated to St. Vitalus (San Vitale in Italian). He was a Roman slave and Christian martyr who became the object of a growing cult from the end of the fourth century A.D.

The exterior of San Vitale (fig. **10.5**) is faced with plain brick, unbroken except by buttresses and windows, and the interior is richly decorated with mosaics and marble. In both respects, it is thus like the Early Christian basilica. Looking eastward toward the apse and the altar, the large rectangular piers that support the main arches and the columns at the base of the smaller arches are visible (fig. **10.7**). The interior is suffused with a glow of yellow light, resulting from the prevalence of gold in San Vitale's mosaic decoration. The subjects of the mosaics are Christian, and stylistically they are among the best examples of Byzantine mural decoration.

The vaulted **choir** ceiling (fig. **10.8**) creates a natural architectural division into four curved triangles. Each is decorated with elaborate floral and animal designs. At the center, a circular wreath frames a haloed lamb standing in a star-studded blue sky. It symbolizes Christ as the Lamb

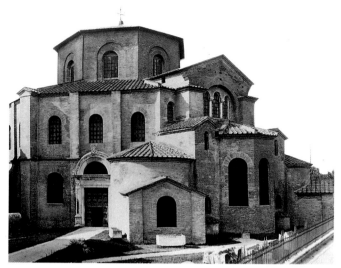

10.5 Exterior of S. Vitale, Ravenna. A.D. 540–547. Brick facing.

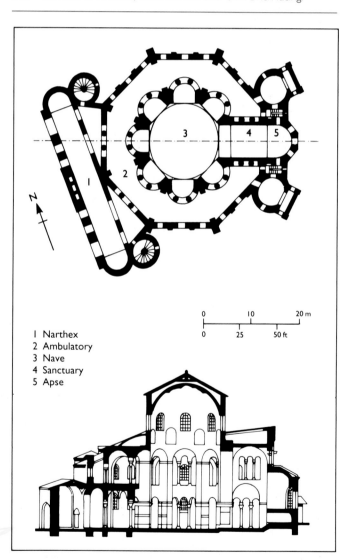

1 Narthex
2 Ambulatory
3 Nave
4 Sanctuary
5 Apse

10.6 Plan and section of S. Vitale.

10.5 and **10.6** (opposite) The domed central core and octagonal plan of San Vitale diverge from the architecture of western Christendom. Instead of having an east–west orientation along a longitudinal axis with the altar in the east and the entrance in the west, San Vitale is centrally planned. This eastern style of church architecture is less well suited to the requirements of Christian ritual. The narthex is placed on the western side of San Vitale at an angle to the axis of the apse. The circular central space is equivalent to the nave of western churches and is ringed by eight large piers supporting eight arches. Beyond the arches are seven semicircular niches and the cross vault containing the altar. Each niche is surrounded by an ambulatory on the floor level and a **gallery** (reserved for women) on the second story. All three levels — ground, gallery, and clerestory — have arched windows that admit light into the church.

10.7 Interior of S. Vitale looking east towards the apse. A.D. 540–547.

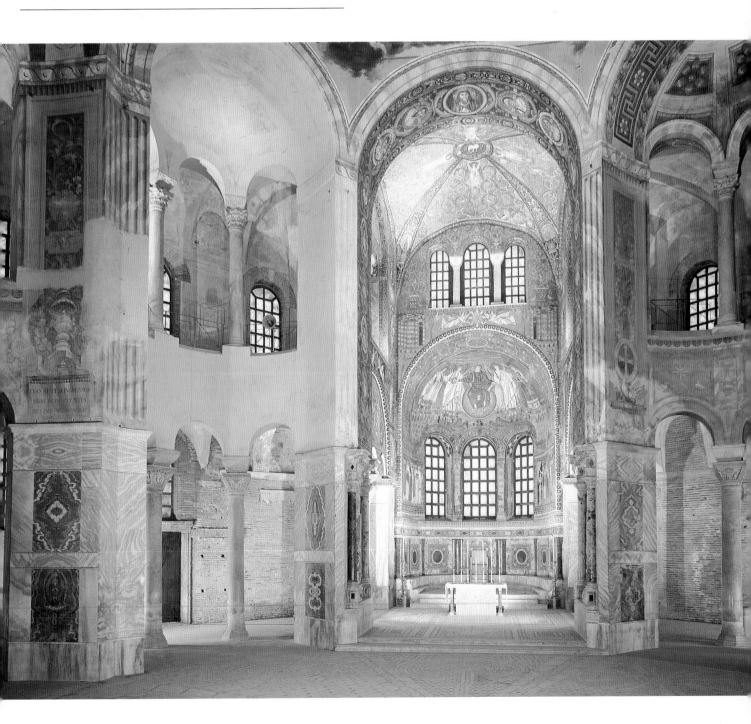

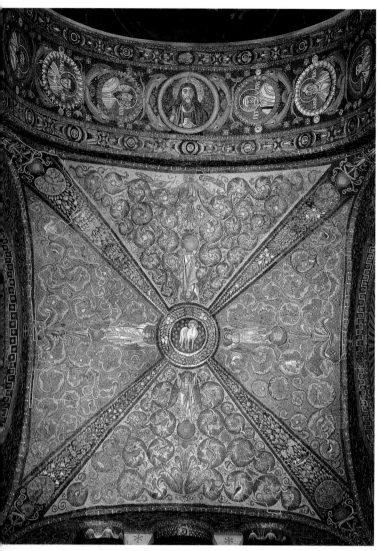

10.8 Ceiling of the choir, S. Vitale. c. A.D. 547. Mosaic.

10.9 Detail of a capital, S. Vitale. c. A.D. 540. Marble.

Mosaic Technique

Unlike Hellenistic mosaic, made by arranging pebbles on the floor, Christian mosaic was made by adapting the Roman method of embedding **tesserae** into wet cement or plaster. *Tesserae* (from the Greek word meaning "squares" or "groupings of four") are more or less regular small squares and rectangles cut from colored stone or glass. Sometimes rounded shapes were used. The gold *tesserae* characteristic of the Byzantine style were made by pressing a square of gold leaf between two pieces of cut glass.

The term "mosaic" comes from the same word stem as "museum," a place to house works of art, and "muse," someone — usually a woman — who inspires an artist to create. When we muse about something, we ponder it in order to open our minds to new sources of inspiration. Music, another art form, is also from the same word stem as mosaic.

of God. Four angels in white wearing Roman-style draperies stand on blue spheres and hold up the lamb's circle. Directly across from the lamb, on the arched entrance to the choir, is Christ in another guise. Again framed by a circle, the bust-length figure is frontal, dark-haired, and bearded. This is his traditional eastern, or Byzantine, representation. His central position on the arch and his frontality compared with the apostles around him reinforce his role as center of the Church.

The capitals no longer conform to the Greek or Roman orders (fig. **10.9**). Instead, the architect arrived at another kind of unity by virtue of geometric repetition. Both parts of the capital are trapezoidal, as is the curved section between the springing of the two arches. The large lower trapezoid is covered with vinescroll, a popular Christian motif in this period. It symbolizes the body of the Church, because Christ had said, "I am the vine; you are the branches." Note that the four yellow flowers in the center are arranged to form a cross, which echoes the actual

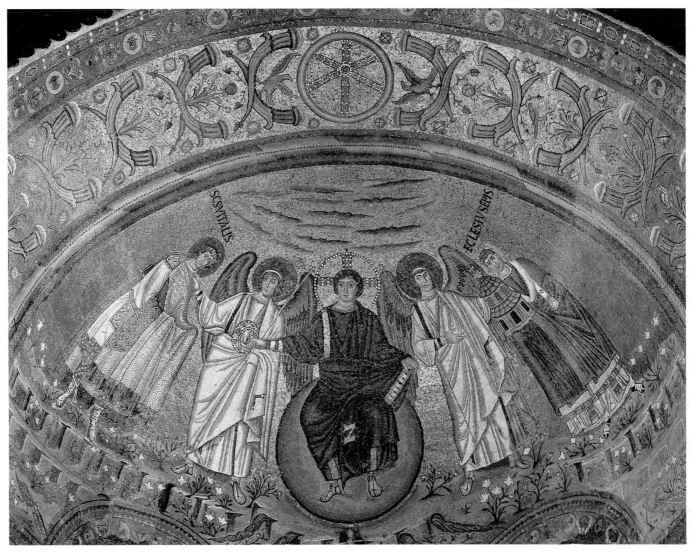

10.10 Apse mosaic, S. Vitale. c. A.D. 547.

yellow cross in the trapezoid above. The cross is flanked by horses (probably a Near Eastern motif), each in front of a green tree, recalling the Christian connection between tree and cross.

The large apse mosaic inside San Vitale (fig. **10.10**) depicts a young, beardless Christ, based on western Apollonian prototypes. His halo contains an image of the cross and he wears the purple robe of royalty. He sits on a globe, flanked by two angels, and hands a jeweled crown to San Vitale. On the right, Bishop Ecclesius holds up a model of the church. Although there are still traces of Hellenistic and Roman naturalism, for example in the landscaped terrain and suggestions of shading in figures and draperies, the representation is more conceptual than natural. The draperies do not convey a sense of organic bodily movement in space and the figures are essentially, if not exactly, frontal. The absence of perspective is evident in Christ's seated pose — he is not logically supported by the globe and hovers as if in midair.

On the two side walls of the apse are mosaics representing the court of Justinian and his empress Theodora. On the viewer's left, and Christ's right, is Justinian's mosaic (fig. **10.11**). The central figure of the emperor wears the same royal purple as Christ in the apse. On Justinian's left (the viewer's right) Archbishop Maximian wears a gold cloak and holds a jeweled cross. He is identified by an inscription and surrounded by three other members of the clergy. On Justinian's right are two court officials and his military guard. The large green shield is decorated with Constantine's *Chi-Rho*. The intention of this mosaic was clearly to depict Justinian as Christ's representative on earth and to show him as a worthy successor to Constantine — to express his power as head of both Church and state.

Opposite Justinian's mosaic, Theodora stands in an abbreviated apse with her court ladies on the right and two churchmen on the left (figs. **10.12** and **10.13**). Like her husband, she wears a royal purple robe and her head is

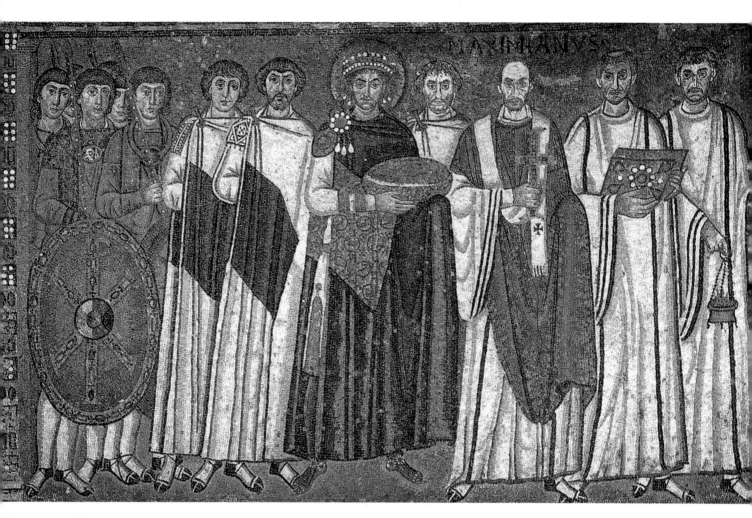

framed by a halo. She offers a golden chalice, and her gesture is echoed by the three **Magi** bearing gifts that are embroidered in gold at the bottom of her robe. The figures in this mosaic, like those in Justinian's, stand in vertical, frontal poses. Their diagonal feet indicate that they are not naturally supported by a horizontal, three-dimensional floor. An illusion of movement is created by repetition and elaborate, colorful patterns, rather than by figures turning freely in space. A good example of this typical Byzantine disregard of perspective appears in the baptismal fountain on top of a Corinthian column at the left of the scene. The bowl tilts forward, which in a natural setting would cause the water to spill out. But the water itself forms an oval, thereby creating some degree of three-dimensional illusion. In contrast, Theodora's completely flat halo is a perfect circle.

The importance of light in Christian art is expressed in Byzantine mosaics such as these by the predominance of gold backgrounds and the reflective surfaces of the *tesserae*. Christ's self-proclaimed role as "light of the world" provided the textual basis for such light symbolism in Christian art. The concept can be seen to carry echoes of various eastern sun cults of that and earlier periods. Constantine, too, used the designation *Sol Invictus*, or Invincible Sun, for himself. So when the Byzantine artist

depicted Justinian's and Theodora with halos, it was to emphasize their combined roles as earthly and spiritual leaders.

The style of Justinian's and Theodora's heads is far removed from the type of Roman portraiture that preserved the features of its subjects. However, the stylistic distinction and positioning of people according to their status has been retained. For example, the prominent position of Theodora's mosaic is a function of her status as co-regent with her husband. It is subordinate to Justinian's only by virtue of being on Christ's left — traditionally a less exalted position than his right. The emphasis on rank and hierarchy rather than on personality or portraiture reflects the highly structured nature of Byzantine society.

The symbolic nature of these images is evident not only in their style and iconography, but also in the virtual absence of any reference to the biographies of the emperor and empress. Justinian had never been to Ravenna, so his mosaic had great political importance. It served both as his substitute and as a visual reminder of his power.

Hagia Sophia. The undisputed architectural master-piece of Justinian's reign is the Basilica of Hagia Sophia (fig. **10.14**) in Constantinople. It was dedicated to Christ as

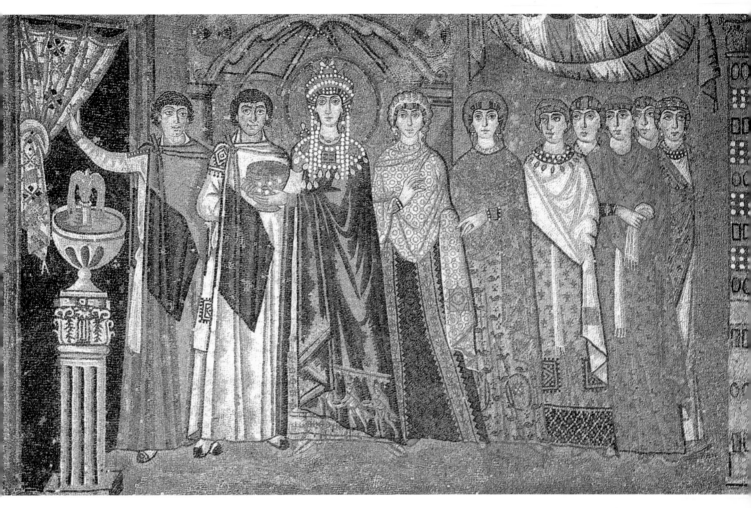

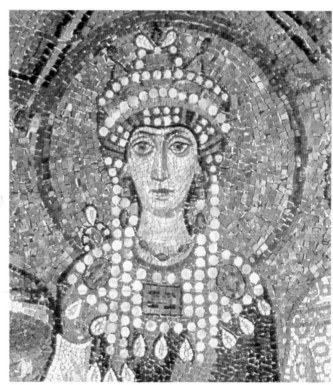

10.11 (opposite) *The Court of Justinian*, apse mosaic, S. Vitale. The gold background removes the scene from nature, thereby aiming to transport the viewer into a spiritual realm.

10.12 (above) *The Court of Theodora*, apse mosaic, S. Vitale. c. A.D. 547. Theodora had lived a dissolute life as a courtesan before her notorious romance with Justinian. They were married in A.D. 523, and became co-regents of the Eastern Empire four years later. Theodora was a woman of great intelligence. Once in power, she devoted herself to a campaign of moral reform and advised Justinian on political and religious policy.

10.13 Detail of fig. **10.12**. Here there is still an attempt at shading on the side of the nose and under the chin. Removing the image from the illusion of naturalism, however, is the black outline. The tilted, irregular placement of the *tesserae* creates thousands of small, shifting planes which reflect the outdoor light entering the church.

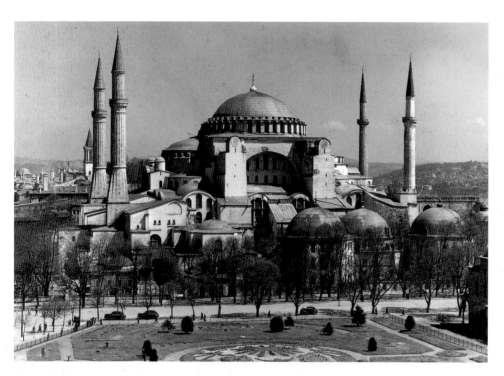

10.14 Hagia Sophia, Constantinople (now Istanbul). Completed A.D. 537. The four tall **minarets**, or slender towers, were added when the Turks captured Constantinople in 1453 and Hagia Sophia was converted into a mosque. The Christian mosaics in the interior were largely covered over and replaced by Islamic decorations. Today Hagia Sophia is a state museum.

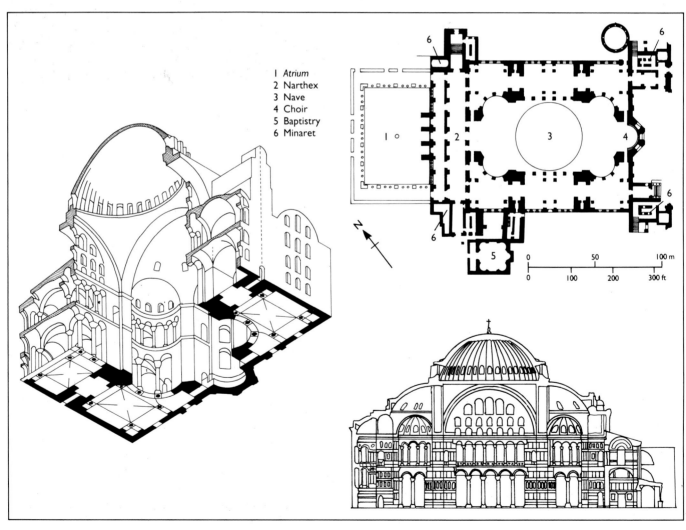

1 *Atrium*
2 Narthex
3 Nave
4 Choir
5 Baptistry
6 Minaret

the personification of Holy (*hagia*) Wisdom (*sophia*). As part of a massive rebuilding campaign following the suppression of a revolt in A.D. 532, Justinian commissioned two Greek mathematicians, Anthemius of Tralles and Isidorus of Miletus, to plan Hagia Sophia. In their design they successfully combined elements of the basilica with enormous rising vaults (fig. **10.15**).

Certain features of Hagia Sophia deserve special attention. The central dome is placed above four arches at right angles to each other. The arches are supported by four huge piers which are barely noticeable from the inside because the arches meet at the corners. The piers themselves are supported by buttresses which can be seen clearly both in the plan (fig. **10.15**) and in the exterior view (fig. **10.14**).

Whereas in Roman buildings domes were placed on drums (fig. **9.16**), the dome of Hagia Sophia rests on **pendentives**. These are four triangular segments with concave sides. Their appearance of suspension or hanging gives them their name (from the Latin *pendere*, meaning "to hang"). They provide the transition from a square or polygonal plan to the round base of a dome or intervening drum, and allow the architect to design larger and lighter domes. They are the principal Byzantine contribution to monumental architecture. Hagia Sophia's dome was constructed of a single layer of brick — a relatively thin shell that minimized the weight born by the pendentives. Nevertheless, the very size of the dome demanded buttressing. The exterior view (fig. **10.14**) shows that each of the forty small windows at the base of the dome is flanked by a small buttress, strengthening from the outside the interior juncture of dome and pendentives.

On the north and south sides of the nave there are walls below the arches. As their load-bearing function has been assumed by the four piers, they can be pierced with arcades and windows (fig. **10.16**). (Non-supporting walls, which usually have large expanses of windows or other openings, are called **screen walls**.) The extensive use of

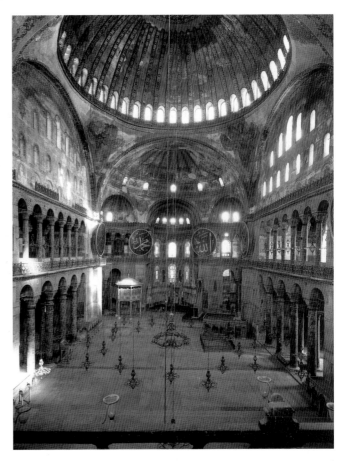

10.16 Interior of Hagia Sophia. The original effect would have been even more dazzling — window space was decreased when Hagia Sophia was rebuilt after earthquake damage. The destroyed mosaics would also have contributed color and reflected light. Justinian's court historian described the dome as "a sphere of gold suspended in the sky."

10.15 (opposite) **Axonometric projection,** plan, and section of Hagia Sophia. In the sixth century, one entered Hagia Sophia from the west, through an *atrium* that no longer survives (1 on the plan). The double narthex (2) was covered by a row of nine groin vaults. Passing through the narthex, one stood opposite the apse at the far eastern end. The path from narthex to apse, along a longitudinal axis, is reminiscent of an Early Christian basilica. However, instead of a long symmetrical nave surmounted by a gable roof, Hagia Sophia has a huge central square supporting an enormous dome (3). At the eastern and western ends of the square, two semicircles are topped by smaller half-domes. Surrounding each half-dome are three semicircular apses with open arcades surmounted by even smaller half-domes. Running from east to west along the axis are colonnaded side aisles on the first level and colonnaded galleries on the second level. Both are covered by groin vaults. Were it not for the central square, Hagia Sophia would resemble the typical centrally planned church, albeit on a massive scale. Note the impressive effect created by the open space of the nave, the high central dome, and the smaller half-domes. The central dome of Hagia Sophia is the earliest example of the use of pendentives on such a grand scale.

windows and arcades at Hagia Sophia creates an overwhelming impression of light and space. At the floor level, five arches connect the side aisles with the nave. At the second level, the galleries contain seven arches. The **lunettes** — the semicircular wall surfaces just below the top of the arches — have two rows of windows, five over seven. In each of the half-domes, there are five windows. Finally, a series of small windows encircling the bottom edge of the dome permits rays of light to enter from all directions.

Hagia Sophia was essentially an imperial building. Unlike San Vitale, it was the personal church of the emperor and his court rather than a place of worship for the whole community. The clergy occupied one half of the central space and the emperor and his attendants the other. Lay people were restricted to the aisles and galleries. Despite these differences between San Vitale and Hagia Sophia, however, both buildings served Justinian's desire to unite Christendom under his leadership, to build churches, and to commission works of art that would express his mission as Christ's representative on earth.

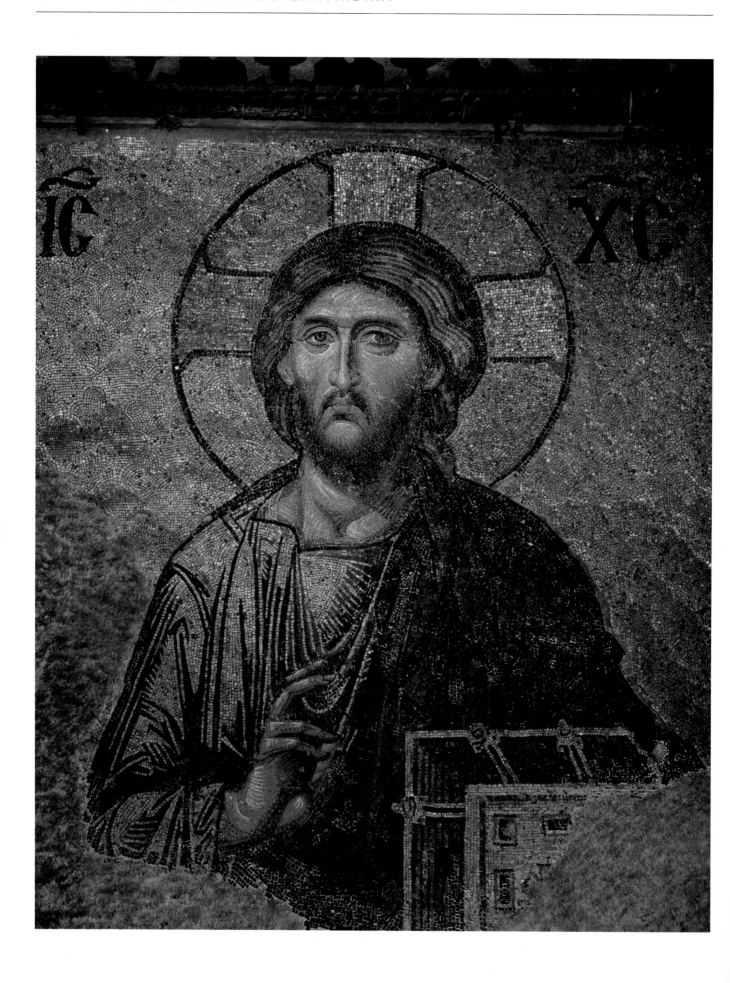

Later Byzantine Developments

The Byzantine style continued in both eastern and western Christendom for several centuries following the age of Justinian. It even survived the Iconoclastic Controversy of the eighth and ninth centuries concerning the virtues and dangers of religious imagery. The Iconoclasts, centered in eastern Christendom, followed the biblical injunction against worshiping graven images. They argued that images of holy figures in human form would lead to idolatry — worship of the image itself, rather than what it represented. According to the Iconoclasts, it was permissible for religious art to depict designs, patterns, and animal or vegetable forms, but not human figures. The Iconophiles (those in favor of images) were centered in the west. They pointed to the tradition that St. Luke had painted an image of the Virgin and Child. In A.D. 726, the Iconoclasts gained the support of the emperor and succeeded in having an edict issued against graven images. This was to contribute to the relatively minor role of sculpture in Byzantine art. Finally, in 843, the edict was lifted, and the Iconophile victory led to a revival of image-making and renewed artistic activity.

A mosaic detail of the thirteenth century from Hagia Sophia (fig. **10.17**) is a good example of later developments in Byzantine style. Compared with the San Vitale mosaics of Justinian and Theodora, this image of Christ has undergone a revival of Classical interest in organic form. Whereas Justinian and Theodora were portrayed frontally, outlined in black, and without personality, Christ turns his head slightly and has a facial expression. At the same time, however, the mosaic still has clear Byzantine elements. Although the drapery folds on the right are somewhat shaded, those on the left are rendered by dark blue lines. The background is gold and the halo is entirely flat. The inscription, *IC* on the left and *XC* on the right, is a shortened version of the Early Christian acronym ICHTHUS (see p.152).

This mosaic detail illustrates both the persistence of artistic style and its accessibility to change. Although created by an artist in the Eastern Empire and located in the world's greatest Byzantine church, it contains elements of pre-Christian, Hellenistic, and Roman styles. The eastern and western traditions would continue to exist side by side in the west for several centuries, but eventually Greco-Roman influences were to triumph.

10.17 (opposite) *Christ,* detail of a **deësis** mosaic, Hagia Sophia. 13th century. Shading is evident in the cheeks, neck, and right hand. The edges of Christ's form are indicated by slight shading rather than a black outline. The deep eye sockets, the bags under the eyes, and the downward curve around the mouth endow him with a rather melancholy character.

The Early Middle Ages

In western Europe, the term Middle Ages generally designates the period following the decline of the Roman Empire through the thirteenth century A.D. Early Middle Ages, as used here, covers the time from the seventh to the end of the tenth century A.D., when the Romanesque style began to take shape.

As the Roman Empire declined, various Germanic tribes overran western Europe. This affected artistic developments and produced radical changes in social and political organization. In addition to the Germanic invasions, a powerful new influence from the Middle East entered Europe—namely, Islam.

Spain had been part of the Roman Empire until A.D. 414, when it was overrun by the Visigoths. They ruled until A.D. 711, the date of the invasion of the Moors, who came from the Roman province of Mauretania in northwest Africa. The Moors had in turn been conquered during the seventh century A.D. by Arabs, who converted them to Islam. The Moorish occupation of Spain lasted until the thirteenth century, by which time Christians had reclaimed all but the kingdom of Granada. The final unification of Spain under Christian rule took place in 1492.

Islamic Art

Mohammed's teaching forbade idolatry, and the Koran explicitly condemns the figurative representation of Allah or any of his prophets. In fact, no Islamic religious building contains the image of any living creature. Islamic religious painting consists mainly of abstract geometric and floral patterns. Sculpture was considered evil—the work of Satan—and is thus virtually nonexistent in Islamic art. Monumental architecture and architectural decoration, on the other hand, flourished under Islam.

Mosques

The primary architectural expression of Islamic religion is the mosque, a place where Moslems gather to pray and kneel facing Mecca. In the early days of Islam, the faithful prayed in any available building or space, providing it was oriented toward Mecca. The main features that all mosques have in common are a *sahn*, or enclosed courtyard, and a *qibla*, or prayer wall. The *qibla* frequently has a *mihrab* (small niche) set into it indicating the direction of Mecca. By the end of the seventh century, Moslem

Islam

Islam literally means "submission [to God's will]," and the term refers equally to the religion, its adherents (Moslems or Muslims), and the countries in which they live. One of the world's great religions, Islam was founded by the prophet Mohammed, who was born in Mecca in western Saudi Arabia in around A.D. 570. At the time of his death in A.D. 632, Islam was established only in Arabia. But within a generation, Moslems controlled large areas of the Middle East. As a result of aggressive campaigns of conquest and conversion, Islam one century later stretched from Afghanistan in the east to Portugal, Spain, and southwestern France in the west, where it rivaled Christianity.

The organization of Islam differs from Christianity in the absence of a priesthood, religious hierarchy, sacraments, and liturgical requirements. It does, however, include caliphs (rulers) and imams (teachers). Islam carries a relatively simple and straightforward message, namely the "brotherhood of man" and equality before Allah (God). The precepts of Allah were revealed to his prophet Mohammed and are set out in the Koran, the holy book of Islam. They include the fundamental doctrine of the one true God, and instructions on how the Islamic faithful are to conduct their daily lives. Moslems are instructed to circumcise their male infants, pray to Allah five times a day facing Mecca, and worship in the mosque on Fridays. They should give alms to the poor, fast, and abstain from sex in the daylight hours during the holy period of Ramadan. At least one pilgrimage to Mecca (the *hadj*) is required of every Moslem. Women are subordinate to men, who are allowed many wives and concubines. As the most recent of the great world religions, Islam regards the others—Judaism, Buddhism, and Christianity, for example—as its forerunners.

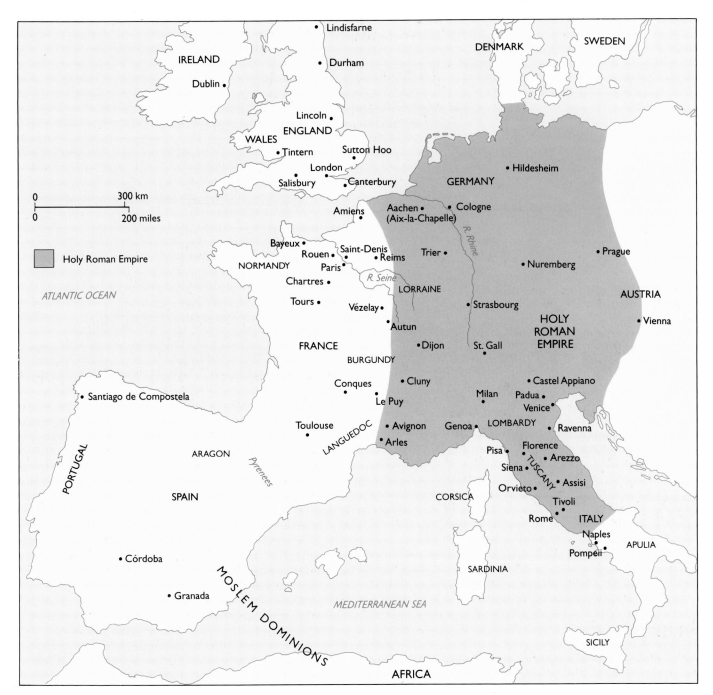

Map of western Europe in the Middle Ages.

gilded dome crowned the center. Unlike most mosques, the Dome of the Rock is a centrally planned octagon. (Its form was inspired by the round Christian *martyria*.) Nevertheless, it has the rich and complex abstract patterned surface decorations that are typically found on Islamic walls, and the golden dome makes a dazzling impression.

As Islam spread to the west and won more converts, new mosques were needed. In the eighth century A.D., the first Moslem ruler of Spain had one built in his capital at Córdoba. Abdu'r-Rahman I's mosque is one of the most striking examples of Islamic architecture in the western style. After its original construction, it was enlarged

rulers were beginning to build larger and more elaborate structures. The exterior of a typical mosque includes tall minarets, such as those added to Hagia Sophia when it was changed from a church to a mosque (fig. **10.14**). From these towers, a *muezzin*, or crier, calls the faithful to prayer at certain times each day.

The earliest mosque still surviving is the great Dome of the Rock in Jerusalem (fig. **11.1**). Much of what exists today is the result of later additions. Originally the exterior was faced with mosaics and marble, and a huge

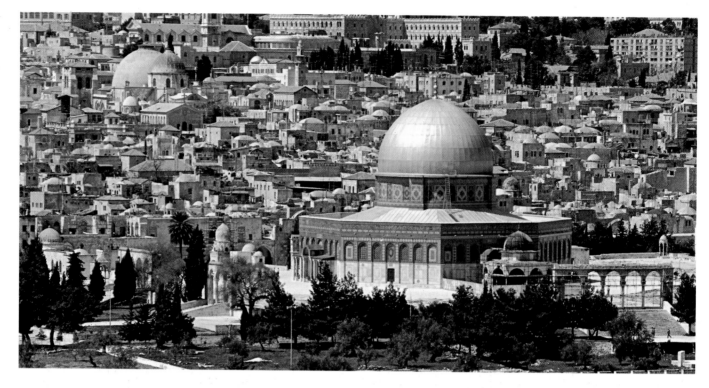

II.I (above) Dome of the Rock, Jerusalem. Late 7th century A.D. The Dome of the Rock, also known as the Mosque of Omar, was constructed on a 35 acre (140,000 m²) plateau in east Jerusalem. Moslems traditionally regard it as the site of Mohammed's ascent to Heaven. Jews know the plateau as the Temple Mount — the location of Abraham's sacrifice of Isaac and of the first Jewish temple, built by King Solomon in the tenth century B.C.

1 *Mihrab* niche
2 *Qibla* wall
3 Hypostyle hall

| 0 | 10 | 20 | 30 m |
| 0 | 50 | | 100 ft |

II.2 (left) Plan of the Great Mosque, Córdoba, Spain. Originally built A.D. 786–787; additions 832–848 and 961. The additions of A.D. 832 to 848 and 961 are shown, but not the final enlargement of 987. The mosque is a rectangular enclosure with its main axis pointing south, toward Mecca. Because Spain lies west of Mecca, this orientation is symbolic rather than exact.

several times (fig. **11.2**). In the thirteenth century, Christians took it over and turned it into a church.

The system of double arches devised by the mosque's original architect is unique, and it was used in each later addition. Filling the interior are numerous columns either derived or salvaged from Roman and Early Christian buildings (fig. **11.3**). These columns were relatively short — just 9 feet 9 inches (2.97 m) high. If they had supported the arches and vaults at that height, the interior illumination would have been inadequate. Instead, therefore, the architect constructed a horseshoe-shaped series of red and white striped arches (using voussoirs of alternating red and white stone bricks). To this he added a second series of arches springing from piers and also supported by the Roman columns. A wooden roof rested on the second set of arches. (It was replaced by vaulting in the sixteenth century.) The vast numbers of columns have

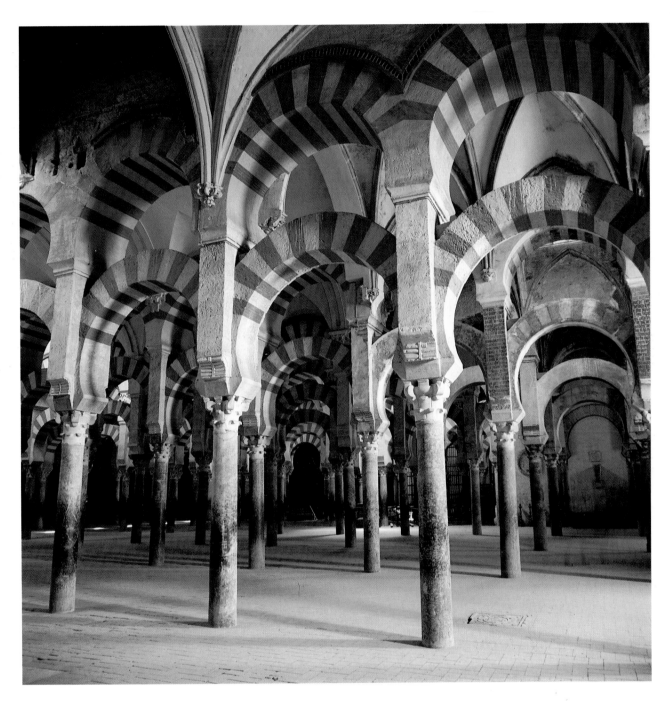

11.3 Arches of the Great Mosque, Córdoba. c. A.D. 961–76. Columns 9 ft 9 in (2.97 m) high. The large interior space is at present bigger than any other Christian church.

been likened to a forest, and the colored arches create an impression of continual motion that enlivens the interior.

As part of the second expansion phase in A.D. 961, the caliph ruling at Córdoba built a magnificent *mihrab* adjacent to the *qibla* wall. To its north was the Capilla de Villaviciosa, an area reserved for the caliph and his retinue. This consisted of three domed chambers entered through three tiers of arches (fig. **11.5**). They crisscross each other to form an interlaced screen. The domes themselves are built in an intricate geometric pattern on eight intersecting arches or **ribs**. The central dome, added in the tenth century A.D., has an elaborate mosaic pattern on a gold background (fig. **11.4**).

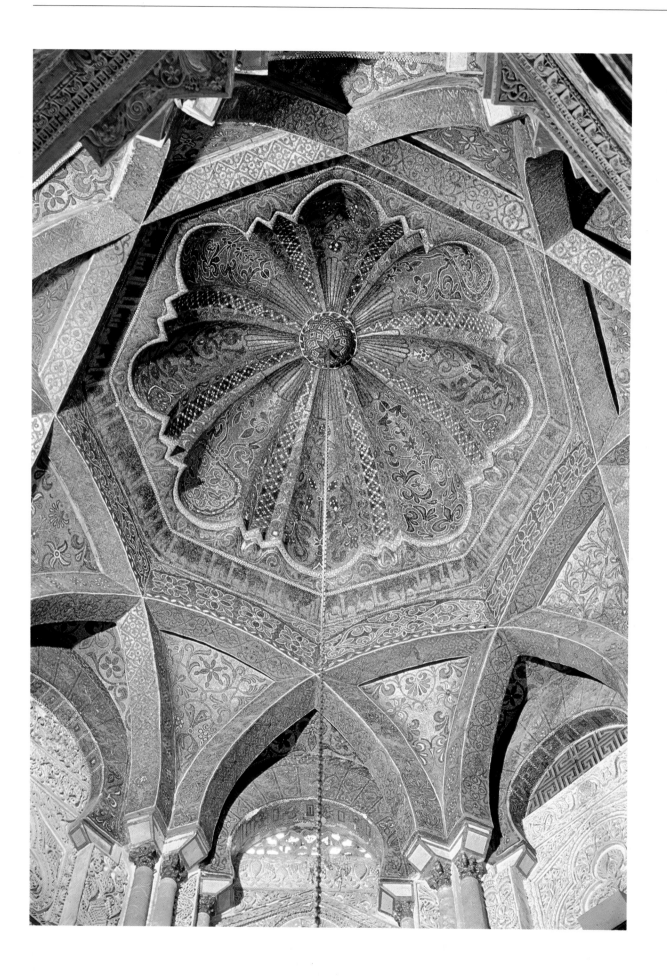

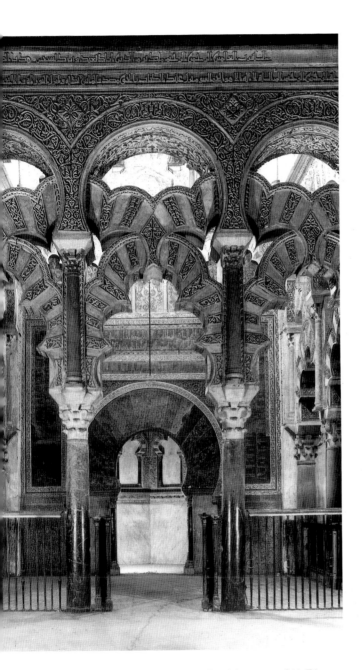

11.5 *Mihrab* bay in the Great Mosque, Córdoba. c. A.D. 961–76.

11.4 (opposite) Dome above the *mihrab*, Great Mosque, Córdoba. c. A.D. 961–76. Mosaic.

In the thirteenth century, Christians gained control of the mosque and turned it to their own use. Three centuries later it was badly damaged when they built a **cathedral** inside it. King Charles I of Spain had unwittingly given his consent to its construction, but expressed his displeasure when he saw the result. Fortunately, however, enough of the original mosque survives to convey the magnificence of its design and the beauty of the original Islamic ornamentation.

Northern European Art

To all intents and purposes, the early medieval Islamic influence on western Europe and its art remained in the south, for the Frankish ruler Charles Martel had halted the Moslem invasion of Europe at Tours, in central France. The north became a new focus of political and artistic activity. It was more influenced by the Germanic tribes than by either Islam or Hellenistic–Roman tradition. The Germanic Angles and Saxons had invaded the British Isles in the fifth century A.D. and the Franks had invaded Gaul (hence the name France). Because of these continual waves of invasion, no monumental architecture, painting, or sculpture was produced. Instead, a new craft was developed around the metalwork brought by the invaders. Some of it is reminiscent of the nomadic Scythians and their Animal style (fig. **4.20**).

Anglo-Saxon Metalwork

A good example of Anglo-Saxon metalwork is the seventh-century purse cover from Sutton Hoo in East Anglia on the southeast coast of England (fig. **11.6**). It was discovered among the treasures of a pagan ship burial — a practice indicating the belief that boats carried the souls of the dead to their afterlife. The circumstances of the burial suggest that the deceased was a royal personage, for the ship contained an abundance of treasures. The folk epic *Beowulf* describes the lavish burials of Anglo-Saxon kings with armor and other valuable objects.

The purse's decoration is of gold, *cloisonné* **enamel**, and dark red garnets. It combines Early Christian **interlace** designs (fig. **10.9**) with aspects of the Scythian Animal style and other ancient Near Eastern motifs. The taste for flat, crowded, interlaced patterns became an undercurrent in western Europe that continued through the Middle Ages. Organic form was practically eliminated.

The arrangement of the decorative sections on the purse cover is symmetrical, as is each individual section or pair of sections. At the top, two geometric shapes filled with gold tracery flank a centerpiece containing two fight-

Beowulf
Beowulf is the earliest European epic composed in the vernacular. Although clearly in the tradition of Germanic folklore, it is written in Old English and imbued with Christianity. It is thought that it was written in the eighth century A.D. However, the events it describes took place in the sixth century. *Beowulf* is divided into two main parts. The hero is Beowulf, a Swedish prince. In the first part, he offers his services to the king of Denmark, whose palace is being ravaged by the monster Grendel. Beowulf destroys Grendel and takes its head to the Danish king. In Part Two, Beowulf has become king. But as fate would have it, he is mortally wounded in old age in a battle with another dragon.

II.6 Sutton Hoo purse cover, from East Anglia, England. c. A.D. 630. Gold with garnets and *cloisonné* enamel, originally on ivory or bone (since lost), 8 in (20.3 cm) long. British Museum, London. In the *cloisonné* technique, liquid enamel of different colors is poured into *cloisons*, or compartments formed by a network of thin metal strips, to create surface decoration. The top of the metal remains exposed.

II.7 Irish stone cross, Ahenny, Tipperary, Ireland. Late 8th century A.D. Granite. The use of interlace designs for stone carving was probably derived from their previous use in metalwork, as in the Sutton Hoo purse cover.

ing animals intertwined in the tracery. This technique, in which animals merge into a design or into each other, had also been characteristic of the much earlier Scythian gold objects. Below, in the center of the purse cover, are two sets of animals. The eagle and duck face each other and are symmetrically framed by a pair of frontal men flanked by animals in profile. This latter motif derives from ancient Near Eastern iconography. The merging animal forms suggest that waves of invaders from the fifth century A.D. onward brought their artistic styles with them.

Hiberno-Saxon Art

During the Middle Ages there was a sudden flowering of Christian art in Ireland and various other islands off the coasts of northern Britain. Its style has been given a number of labels, including Insular and Hiberno-Saxon (*Hibernia* is Latin for "Ireland").

Stone Crosses. From the early seventh century to A.D. 800, pagan interlace patterns were incorporated into Christian art. They were carved in relief on the large stone crosses that still dot the Irish countryside. Three types of interlace adorn the vertical and arms of a cross from Tipperary (fig. **11.7**). At the bottom, a single row of scrolls is repeated in the broken circle. The pedestal design has largely worn away with time. Generally, these Irish monumental crosses mark graves or sacred places on roads.

Manuscript Illumination. Another typical use of the pagan interlace in Christian iconography occurs in the illuminated manuscripts produced by monks in Irish and English monasteries (see p.175). The main impetus for their style may have originated in Ireland, and from there it infiltrated England and other parts of western Europe.

The page in figure **11.8** is a relatively early example of medieval manuscript illumination. The lion is in profile, its mouth open and teeth bared as if growling or roaring. Note the dense patterning of the surface of its body with red and green diamond shapes. They are accentuated by a yellow outline that merges into stylized muscle, yellow feet, and tail. These colors, as well as the dot pattern on the face, are repeated in the interlace inside the border. The artist has created a strict unity of color and form on this page. On the border, for example, the reds are reserved for the upper and lower sections, thereby repeating the horizontal of the lion's body as well as its color arrangement. The edges are crisp and clear, the colors contrasting, and the surfaces flat. Design-driven optical

II.8 (opposite) *Lion Symbol of St. John*, from the Book of Durrow, fol.191v. After A.D. 650. Illuminated manuscript, 9⅔ x 5¾ in (24.5 x 14.5 cm). Library of Trinity College, Dublin. This manuscript originally came from either Ireland or Northumbria in England. It represents St. John the Evangelist as a lion surrounded by a rectangular border filled with interlace. Later, St. John's symbol was changed to an eagle.

illusions are created in the interlace, as if a ribbon has been threaded and rethreaded through itself. This kind of illusory mazelike play was to become more complex in the course of the Middle Ages. Such early medieval illuminated manuscripts from northern Europe create a world of images that seems totally independent of the humanistic tastes of Greco-Roman tradition.

Perhaps the most famous early medieval Hiberno-Saxon illuminated manuscript is the Book of Kells. Its text consists of the four Gospels, written in Latin in 680 pages. The manuscript dates from the late eighth or early ninth century A.D. By this period, the color and form of the illuminations have become more complex (fig. **11.9**). Figures literally emit letters and shapes from their mouths. In the *T* of *Tunc*, for example, the two arms of the letter stretch into the legs and claws of a lion or dragon. Its head is part of the left border, and its gaping jaws eject a series of colorful ribbonlike forms — probably a stylized representation of flames. The inside of the curve of the *T* contains more interlacing — notably fishlike creatures with prominent eyes. The large white fish emerging from the lower curl of the *T* bites the thick red interlace. This in turn metamorphoses into the ears of the little green fish on the upper right. Human forms have also been added to the repertory. Three sets of small human heads appear in rectangular spaces, two on the right of the page and one on the left. The attention that this artist has given to the painting — especially to the open mouths of the lion/dragon and the white fish — is actually quite common in manuscript illumination. It was to continue in border imagery throughout the Middle Ages.

In addition to the obvious visual pleasure these designs gave their artists as well as their viewers, their purpose was to illuminate the "Word of God." We have seen that the fish is an early symbol of Christ, so we can surmise that its presence on a page of text describing the Crucifixion symbolizes Christ's role as the Savior. The illumination of Christ with two thieves on the lower half of the page is fitted within a large *Chi* (written as *X*). This repeats the beginning of Christ's Greek name, and is also a visual reference to the cross. The formal interlacing that characterizes these manuscripts is thus echoed in the integration of the iconography into the more abstract letters.

Carolingian Period

The era of the Book of Kells corresponds with an important historical landmark in western Europe. In A.D. 800, the pope crowned Charlemagne (Charles the Great) Roman Emperor at St. Peter's in Rome. When he came to power,

11.9 (opposite) *Tunc Crucifixerant XPI*, from the Book of Kells, fol.124r. Late 8th or early 9th century A.D. Illuminated manuscript, 9½ x 13 in (24 x 33 cm). Library of Trinity College, Dublin. This is a page from the Gospel of Matthew (27:38). The scribe has written "Tunc cruxifixerant *XPI* cum eo duo latrones" ("Then they crucified Christ and, with him, two thieves").

Manuscript Illumination

Illuminated manuscripts are hand-decorated pages of text. Great numbers of these texts were needed because of the importance of the Bible, and especially the Gospels, for the study and spread of Christianity. Most were made during the Middle Ages in western Europe, before the invention of the printing press. (The Chinese are thought to have used movable type from the eleventh century A.D., but printing was not known in Europe before the fifteenth century.) Medieval manuscripts were copied in monastery *scriptoria* (Latin for "writing places"). Good medieval scribes had to know Latin, have good penmanship, excellent eyesight, and the ability to read the writing of other scribes whose manuscripts they were copying.

It is not known what tools the scribes had for illuminating the manuscripts, although it is obvious that compasses and rulers were used for the geometric designs. The magnifying glass had not yet been invented. The scribes' pigments consisted of minerals and animal or vegetable extracts. These were mixed with water and bound with egg whites to thicken the consistency. The paint was applied to **vellum**, which is high quality calfskin **parchment**, specially prepared and dried for manuscripts.

he ruled a large part of western Europe, including France, Germany, Belgium, Holland, northern Spain, and Italy to the south of Rome. Although this territory was to be the subject of extensive political and religious controversy between the popes in Rome and the German emperors right up until the nineteenth century, it was named the Holy Roman Empire in the thirteenth century and lasted as such for over 600 years. Charlemagne was also King of the Franks from A.D. 771 to 814. His court was located at Aachen (known as Aix-la-Chapelle in French), near the northwestern border of modern Germany.

During his reign, Charlemagne presided over a cultural revival that had a major impact on artistic style. The term used to describe this period — Carolingian — derives from the name of Charlemagne's grandfather, Charles Martel (*Carolus* is Latin for "Charles"). Under Charlemagne, the monasteries had created a network of learning throughout Europe in which Latin, as the language of the manuscript texts, had been kept alive. Besides the Latin language, Charlemagne wanted to revive other aspects of the Roman past, and he was responsible for the reinstatement of the political organization of ancient Rome, the establishment of a unified code of laws, the creation of libraries, and educational reforms. In his pursuit of the last of these, Charlemagne hired the English scholar Alcuin and brought him to his court at Aachen. Alcuin organized cathedral and monastic schools to emphasize Latin learning and culture as well as the language itself. He adopted from Aelius Donatus, a Latin grammarian and rhetorician of the fourth century A.D., a curriculum and grammar book which set the standard in western European schools until the end of the Middle Ages. The curriculum was

II.10 *St. John*, from the Coronation Gospels, fol.178v. Late 8th century A.D. Parchment, 12¾ x 10 in (32.4 x 24.9 cm). Kunsthistorisches Museum, Vienna. Tradition has it that this **codex** (manuscript book) was discovered in Charlemagne's tomb, opened in the year 1000 by Emperor Otto III. It gained its name through the practice of German emperors who swore their coronation oaths on it.

divided into two sets of disciplines based on the Seven Liberal Arts. The *trivium* consisted of Grammar, Rhetoric, and Dialectic, and the *quadrivium* of Geometry, Arithmetic, Astronomy, and Music.

Manuscripts. Because books were an important aspect of Charlemagne's Roman revival, manuscripts played a significant role in his endeavors to bring back the learning and culture of Roman antiquity. Charlemagne's court at Aachen was the hub of his empire, but the books and manuscripts were portable, and thus an important form of artistic and educational communication. Manuscript painting continued to flourish. All trace of the pre-Christian Roman styles, however, gave way to flat, abstract design. Some of the effects of Charlemagne's revival on artistic style can be seen in a manuscript page from the Coronation Gospels (fig. **11.10**).

This Carolingian St. John, painted by an artist at Charlemagne's court, is very different from anything in the Hiberno-Saxon style. The evangelist is seated in an architectural niche set in a natural landscape. His pen is poised to write and he holds a manuscript in his left hand. His

drapery seems to combine a taste for surface pattern with an interest in its relationship to the organic form of his body. Shading defines the contours of his face and hands and he inclines his head slightly, but his halo is flat. The position of the footstool—both inside and outside the frame—heightens the suggestion that the artist was struggling with two traditions, Classical and medieval, at the same time.

Monasteries. Of all the institutions in western Europe during the Middle Ages, none was more essential to Charlemagne's plan for controlling conquered territory and directing the reforms in art and education than the **monastery**. Each monastery included a school, and this created a network through which artists and educators could communicate with each other. The monastery was also a religious and administrative center, and performed an economic function through agricultural production.

Charlemagne decided that monasteries should follow the Benedictine Rule, a series of regulations devised by St. Benedict in the sixth century A.D. The monks were to live in a community under the supervision of an abbot, devoting themselves to a strict routine of work, study, and prayer. In A.D. 816 to 817, Charlemagne convened a council of abbots at Aachen to discuss the Rule and draw up a standard plan for Benedictine abbeys (fig. **11.11**). The council sent this plan to the abbot who was rebuilding the St. Gall monastery in Switzerland.

Figure **11.12** is a model constructed from the plan. About a hundred people were to form a self-sufficient community—almost a small town—occupying an area some 500 by 700 feet (150 × 210 m). Entrance to the monastery was from the west, through a passage between a hostel and stables. From there a gate led to a semicircular arcade flanked by two cylindrical towers, and into the vestibule at the western end of a church. This combination of towers with an entrance, chapels, and galleries at the west of a Carolingian church is known as a **westwork** (from the German word *Westwerk*). The

Monasticism: Chastity, Obedience, and Poverty

Monasticism is a way of religious life in which the individual takes vows of chastity, obedience, and poverty and serves God in relative seclusion. Monasticism began in the pre-Christian era among Middle Eastern Jews. The first Christian monks date from the third century A.D. Some chose to live as hermits, isolating themselves individually from society and devoting themselves to prayer. Others withdrew into communal groups that formed the basis of the monastic tradition.

Many monks became expert in a particular art or craft, and the monasteries played an important role in medieval cultural life and education. Works of literature, science, and philosophy, in addition to religious texts, have survived in copies handwritten in the *scriptoria* of the monasteries.

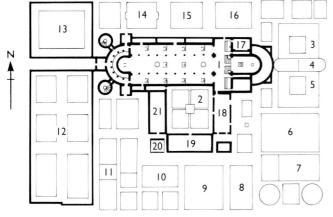

1 Church
2 Cloister
3 Infirmary
4 Chapel
5 Novitiate
6 Orchard/Cemetery
7 Garden
8 Barn
9 Workshops
10 Brewery and bakery
11 Stables
12 Animal pens
13 Hostel
14 Guesthouse
15 School
16 Abbot's house
17 Scriptorium and library
18 Dormitory
19 Refectory
20 Kitchens
21 Cellars

11.11 Plan of the Monastery of St. Gall, Switzerland. c. A.D. 820. This plan has been drawn from a tracing on five pieces of parchment, itself taken from an earlier document. It has been used by scholars to draw various conclusions about monastic life and architectural practice during the Carolingian period.

11.12 (below) Reconstruction of the Monastery of St. Gall. c. A.D. 820. The design of the monastery placed the church at the center and the buildings adjacent to it in approximate order of importance. The library and *scriptorium* were attached to the church, not far from the main altar. To the north were the abbot's house (connected to the transept by a private passage), a guest house, and a school. The latter fulfilled Charlemagne's mandate that monasteries should provide education even for those not intending to take holy orders.

church is designed along the lines of a basilica — at the eastern end are a transept, choir, apse, and altar (approached by seven steps). Another apse was located at the west. The nave and aisles are screened off from each other. They contain additional altars to make it possible for each priest to say Mass every day.

To the east of the church was a novitiate (a building to house novices) and an infirmary. Next to the infirmary stood the physicians' houses and a medicinal herb garden. Conveniently close was the cemetery, which doubled as an orchard. To the south, in the sunniest spot, was a square **cloister** surrounded by a covered portico where the monks could walk. The cloister was flanked by the dormitory, with a bath house and lavatory, a **refectory** (dining hall), and a cellar. Outbuildings included a bakery, a brewhouse, and barns for farm animals. The plan of St. Gall lays out the entire ideal monastery in meticulous, practical detail, right down to the shed for pregnant mares and foals.

Carolingian art and architecture were closely associated with Charlemagne's Classical revival. It flourished from approximately A.D. 800 to 900, and was succeeded by a century of Ottonian rule. Named for five emperors called Otto, the Ottonian period dates from about A.D. 920 to 1000. Manuscript painting continued to thrive, but most monumental Ottonian art has been destroyed. After the year A.D. 1000, monumental architecture, sculpture, and painting underwent a revival and reemerged as the Romanesque style.

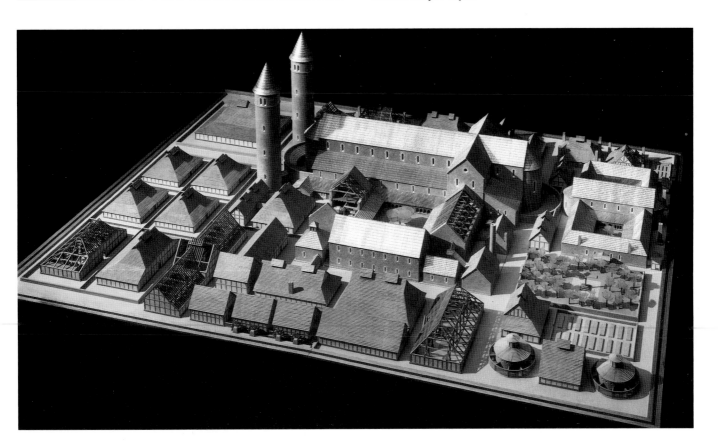

Romanesque Art

The term "Romanesque" (or "Roman-like") refers to the style that flourished in western Europe in the eleventh and twelfth centuries. It is a stylistic rather than a historical term, intended to describe medieval art that shared certain characteristics with the ancient Roman architectural style. Similar features included rounded arches, stone vaults, thick, solid walls, and exterior relief sculpture. Romanesque is something of a catch-all term because it embraces many regional styles. Scholars tend to distinguish these styles according to their geographical origins. In western Europe, the Romanesque period was marked by an enormous surge in building activity, especially of cathedrals, churches, and monasteries. This led to a revival of architectural sculpture through the ornamentation of Christian exteriors. Hundreds of examples of Romanesque art survive, especially in France, where the most innovative works were created.

Manuscript illumination continued throughout the Middle Ages and well into the Renaissance (Chapters 14–16). In both Romanesque and Gothic art (see Chapter 13), surviving paintings and stained glass provide examples of the monumental pictorial styles. The mosaic tradition is largely absent north of Italy, where stained glass predominates, especially in the Gothic period.

Historical Background

During the late ninth century A.D., Europe had been in turmoil. It was vulnerable from many directions. From the south, the Moslems continued their expansion, and, from the east, the Magyars advanced in search of a permanent home. From the north came the Vikings. These pagan Scandinavian sea-warriors, who had been raiding the British coasts since the eighth century, now set their sights on northern France.

By the second half of the eleventh century, the threat of invasion had decreased, largely because the barbarians had been assimilated and converted to Christianity. The Magyars had settled in present-day Hungary. The Vikings, having occupied Normandy on the north coast of France, had become Christians. Their leaders were recognized as

dukes by the French king, and in 1066 William of Normandy invaded England, becoming its first Norman king. In the early twelfth century, the Normans expelled the Arabs from Sicily, and wrested control of much of southern Italy from the Byzantines. Moslem dominance of Spain was in decline, and the Christians, maintaining their resistance from the mountains in the north, were poised to recapture most of the Spanish peninsula.

The social and political structure of western Europe was feudal. It was ruled by kings, dukes, and counts, to whom lesser barons and lords owed their allegiance. There was no centralized political order, and the only unifying

Feudalism

Feudalism (from the Latin word *foedus*, meaning "oath") was the prevailing socioeconomic system of the Middle Ages. Under the feudal system, the nobility had hereditary tenure of land. In theory, all land belonged to the emperor, who granted the use of certain portions of it to a king, in return for an oath of loyalty and other obligations. The king, in turn, granted the use of land (including the right to levy taxes and administer justice locally) to a nobleman. He granted an even smaller portion to a local lord, and so on down to the peasants. At each level of dependency, the vassal owed his loyalty to his lord and had to render military service on demand. In practice, however, these obligations were fulfilled only when the king or lord had the power to enforce them.

The principal unit of feudalism was the manor. The land was cultivated by serfs, or peasants, who were bound to their lord's service. They provided unpaid labor and tribute to their lord, who allowed them in return to cultivate a part of his manor for their own benefit. Feudalism and serfdom declined from the thirteenth century onward, partly because of a growing cash economy, and partly because of peasant revolts. In France, however, these social systems lingered on until the Revolution of 1783. In Russia and certain other European countries feudalism continued well into the nineteenth century.

Map of pilgrimage roads to Santiago de Compostela, Spain.

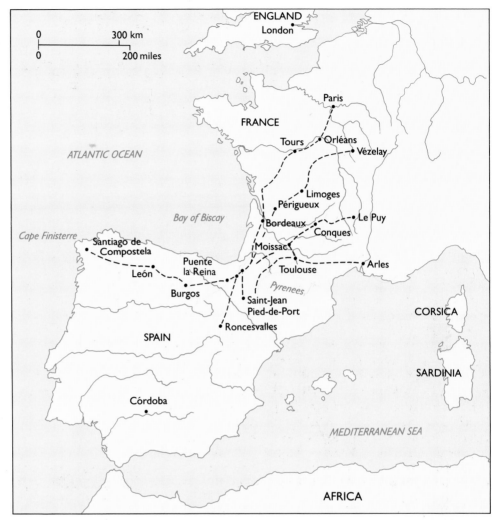

authority resided with the pope in Rome. Nevertheless, a degree of military and political equilibrium was achieved, which led to economic growth. Mediterranean trade routes were reopened, and several Italian sea-ports (such as Naples, Genoa, Venice) became hubs of renewed commercial activity. Manufacturing and banking flourished, and a new middle class of craftsmen and merchants arose. Cities and towns that had declined during the early Middle Ages revived, and new ones were founded. Gradually, towns began to assert their independence from their feudal lords. They demanded, and received, charters setting out their legal rights and obligations. Some even established republican governments.

Pilgrimage Roads

By the first half of the eleventh century, Christianity was in the ascendant almost everywhere in western Europe. There was a spirit of religious vitality in the air. On the military side, this spirit manifested itself in the Crusades — a series of military campaigns undertaken between 1095 and 1291 to recover the Holy Land from the Moslems.

Earlier in the Middle Ages, it was only penitent Christians who had made pilgrimages to atone for their sins. From the eleventh century, however, it became customary for all devout Christians to make pilgrimages. The pilgrims were particularly attracted to churches containing sacred relics. These might be the physical remains of the saints or remnants of their clothing, and were believed capable of performing miracles and curing the sick.

The two most sacred pilgrimage sites were Jerusalem and Rome. But journeys to these cities could be dangerous — especially to Jerusalem, where Moslems were often fighting the Crusaders. A third choice, which became popular in the eleventh century, was the shrine of St. James (Santiago in Spanish) in Compostela, Galicia (a region of northwest Spain). St. James was the first apostle to be martyred. According to Spanish tradition, his body was buried in Compostela, which was the center of Christian resistance to the Moslem occupation of Spain.

Pilgrims followed four main routes across France to the Pyrenees, and then westward to Compostela. Along these roads, an extensive network of churches, hospices (or lodging places), and monasteries was constructed. Their design and location were a direct response to the ever-growing crowds of pilgrims.

Architecture

Scholars have noted that Romanesque architects had to construct churches that were big enough to accommodate the pilgrims. At the same time, churches had to be structurally sound and adequately illuminated. The availability of materials often presented problems because of the great increase in building activity. More subjective considerations, such as esthetic appeal, also had to be taken into account. These might be influenced by the wishes of a local religious order or wealthy patron.

Sainte-Foy at Conques

Communication along the pilgrimage routes must have been constant, with pilgrims, masons, and other craftsmen continually moving back and forth. It is thus not surprising that many Romanesque churches had similar features. The earliest surviving example of the pilgrimage church (figs. **12.1**, **12.2**, and **12.3**) is dedicated to Sainte-Foy, a third-century virgin martyr known in English as St. Faith. It stands in Conques, a remote village on the route from Le Puy in southeastern France.

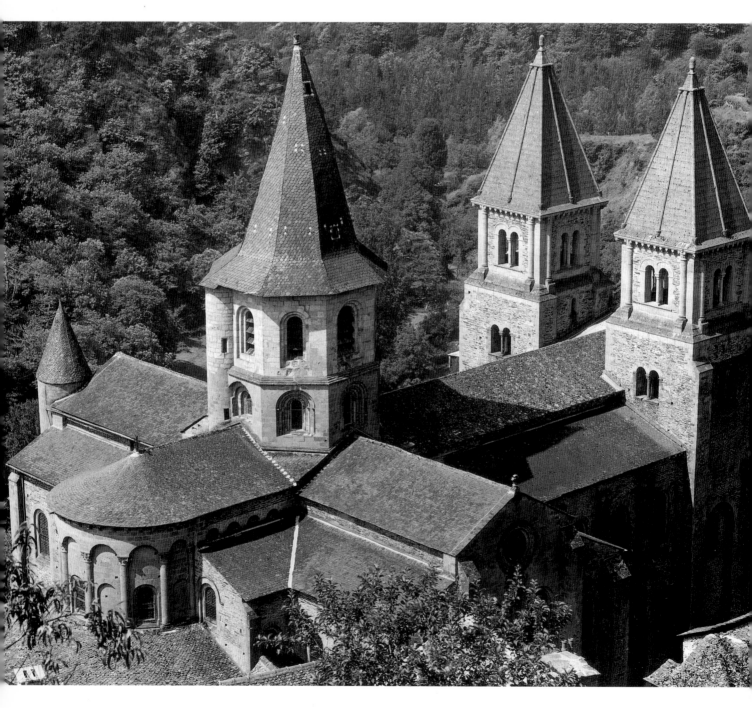

The builders of Sainte-Foy, and indeed of all pilgrimage churches, had to solve the problem of accommodating large crowds without interfering with the duties of the clergy. The monks, for example, required undisturbed access to the altar and the area surrounding it. The plan in figure **12.3** shows how the traditional basilica was modified by extending the side aisles around the transept and the apse to form an ambulatory, or continuous walkway. Three smaller apses, or **radiating chapels**, protrude from the main apse, and two chapels of unequal size have been added at the east side of the transept arms. The continuous ambulatory allowed pilgrims to circulate throughout the church, stopping to venerate relics in the radiating chapels, without disturbing the monks.

An important new architectural development in Romanesque churches was the replacement of wooden roofs by stone barrel vaults (fig. **12.2**). This change provided better safeguards against fire and improved the acoustics. Music, particularly Gregorian chants, had become an indispensable feature of the Christian service. Better acoustics also improved communication with the worshipers. The stone vaults required extra support, or buttressing, to counteract the lateral thrust, or sideways force, they exerted against the walls. At Sainte-Foy, diaphragm, or transverse, arches cross the underside of the vault. They are supported by piers, which mark the corner of the groinvaulted bays of the side aisles.

Those who designed the churches had another way of improving communication with the worshipers. Most of the population of medieval Europe was illiterate and had to rely on stories or images for their knowledge of the Bible and other Christian texts. Romanesque artists conveyed the Christian message to the faithful mainly through the sculptural programs that adorned architectural elements of the church, and by large mural paintings. Tapestries, most of which are now lost, often hung along the aisles, adding color and warmth to the interior.

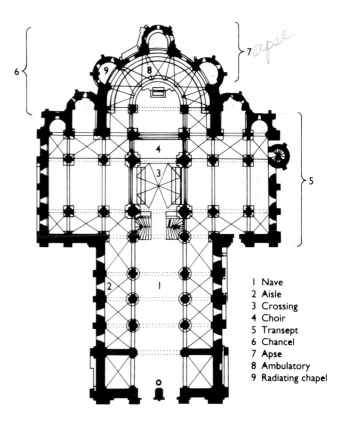

12.3 (above) Plan of Sainte-Foy, Conques. c. 1050–1120.

1 Nave
2 Aisle
3 Crossing
4 Choir
5 Transept
6 Chancel
7 Apse
8 Ambulatory
9 Radiating chapel

12.1 (opposite) Aerial view of Sainte-Foy, Conques, France. c. 1050–1120. Apart from two nineteenth-century towers on the west façade, Sainte-Foy, begun in about 1050 and finally completed around 1120, stands today as it did in the twelfth century. It has a relatively short nave, side aisles built to the full height of the nave (so that there is no clerestory lighting), and a transept. The **belfry**, or bell tower, rises above the roof of the **crossing**.

12.2 (above, left) **Tribune** and nave vaults, Sainte-Foy, Conques. c. 1050–1120. Romanesque builders solved the problem of supporting the extra weight of the stone by constructing a second-story gallery, or tribune, over the side aisles as an **abutment**. Structurally, the gallery diverted the thrust from the side walls back onto the piers of the nave. It also provided an extra interior space for the pilgrims.

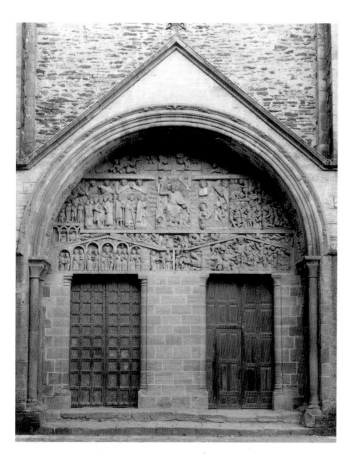

Sculpture

Perhaps the greatest impact on the Christian worshiper was created by the images carved in relief at the church entrance. The primary purpose of such images was to attract attention and encourage worshipers to enter. The area immediately around the doorways, or **portals**, would have contained the first images encountered by the worshipers as they approached the church. The layout of the architectural sections around the portals is fairly consistent in medieval churches, and is diagramed and labeled in figure **12.6**. What varies from building to building is the **program**, or arrangement and meaning, of the subjects depicted on each section.

At Conques, the relief sculpture on the western portal (fig. **12.4**) is confined to the **tympanum** and the lintel. The scene is the *Last Judgment* (fig. **12.5**), in which Christ the

12.4 (left) West portal with tympanum, Sainte-Foy, Conques. c. 1130. Stone, c. 12 × 22 ft (3.66 × 6.71 m).

12.5 (below) *Last Judgment*, tympanum of west portal, Sainte-Foy, Conques. Christ is both the central and the largest figure. He is surrounded by a **mandorla**, an oval of light (an eastern motif), and his halo contains the cross. He raises his right hand, reminding the viewer that the souls on his right will be received in Heaven — a visual rendition of the advantages of being "on the right hand of God."

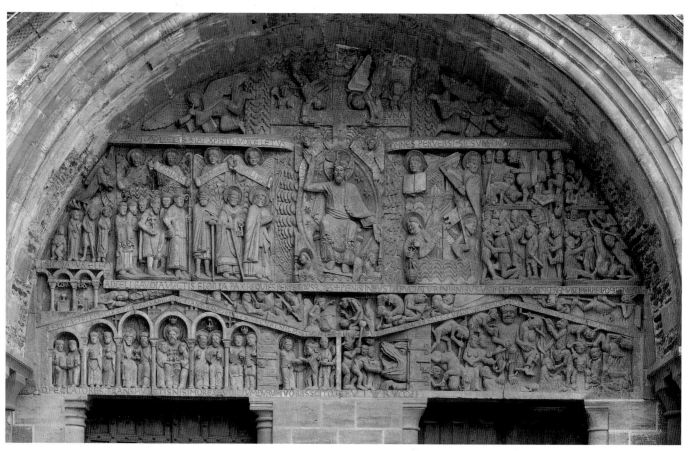

Judge (fig. **12.7**) determines whether souls will spend eternity in Heaven or Hell. It conforms to the iconographic norm in its overall arrangement. The figures on Christ's right (the viewer's left) and on his level are saints and churchmen. Above them, angels hold arches made of scrolls. Below, also on Christ's right, are figures framed by round arches. Christ's left hand is lowered, toward Hell, which lies even lower down. His gesture directs the viewer's attention to the damned souls falling and being tortured by devils. In the center of Hell, on the viewer's right, is the crowned figure of Satan. He and his company of devils, together with the damned, are entwined by snakes. They are symmetrically opposite the figures under round arches on the left side of the lintel. Note that the saved souls on Christ's right are neatly arranged under framing devices, whereas the damned, on Christ's left, appear jumbled and disordered.

At the center of the lintel, directly below Christ, the traditional right–left Christian symbolism prevails. Two individual scenes are divided by a vertical. On Christ's right, angels welcome saved souls into Heaven. On Christ's left, a grotesque devil with spiked hair and a long nose brandishes a club at a damned soul. The latter bends over as if to enter the gaping jaws of a monster, which pokes its head through a doorway. This image combines two traditional Christian metaphors: the "Gate of Hell" and the "Jaws of Death."

Images of Heaven and Hell vary as Christian art develops. The basic arrangement of the *Last Judgment*, however, is fairly constant. It is intended to act as a reminder of the passage of time. The world, it warns, as well as individual human existence, is finite. Ultimately, there will be an accounting and a judgment.

A unique development in Romanesque architecture is the use of the capital as a new surface for sculptural decorations. These might include abstract ornament, narrative scenes, or individual figures. A famous Romanesque capital — from the French Cathedral in Autun, Burgundy — represents a scene from Christ's childhood: the *Flight into Egypt* (fig. **12.8**). In this image the Holy Family (see p.152) flees the edict of King Herod, which decreed the death of all male infants under the age of two. Joseph leads a lively, high-stepping donkey which is carrying Mary and Christ out of Bethlehem into Egypt. On the Autun capital, decorative foliage covers the background, and design-filled circles support the figures. The open and closed circle designs are repeated in the borders of the draperies, on Joseph's hat, on the halos, and in the donkey's trappings. This taste for elegant surface design is a characteristic of Romanesque sculpture. Also typical are the repeated curves representing folds. These are carved into the draperies more for their patterned effect than to define the organic quality of the figures. In Joseph's tunic, the surface curves enhance the impression of backward motion, as if the cloth had been blown by a sudden gust of wind.

The Romanesque artist's disregard of gravity is evident in the figure of Christ. Facing front, with his right hand resting on a sphere held by Mary, he is suspended between Mary's knees, with no rational support for his weight. He is depicted as a *homunculus* ("little man"), babylike only in size, having neither the physique nor the personality of an infant. This depiction of Christ as a child-man, partly a reference to his miraculous character, is a convention of Christian art before 1300.

12.7 *Christ the Judge*, detail of tympanum of west portal, Sainte-Foy, Conques.

1 Voussoir
2 Archivolts
3 Tympanum
4 Lintel
5 Door jamb
6 Trumeau

12.6 Diagram of a portal.

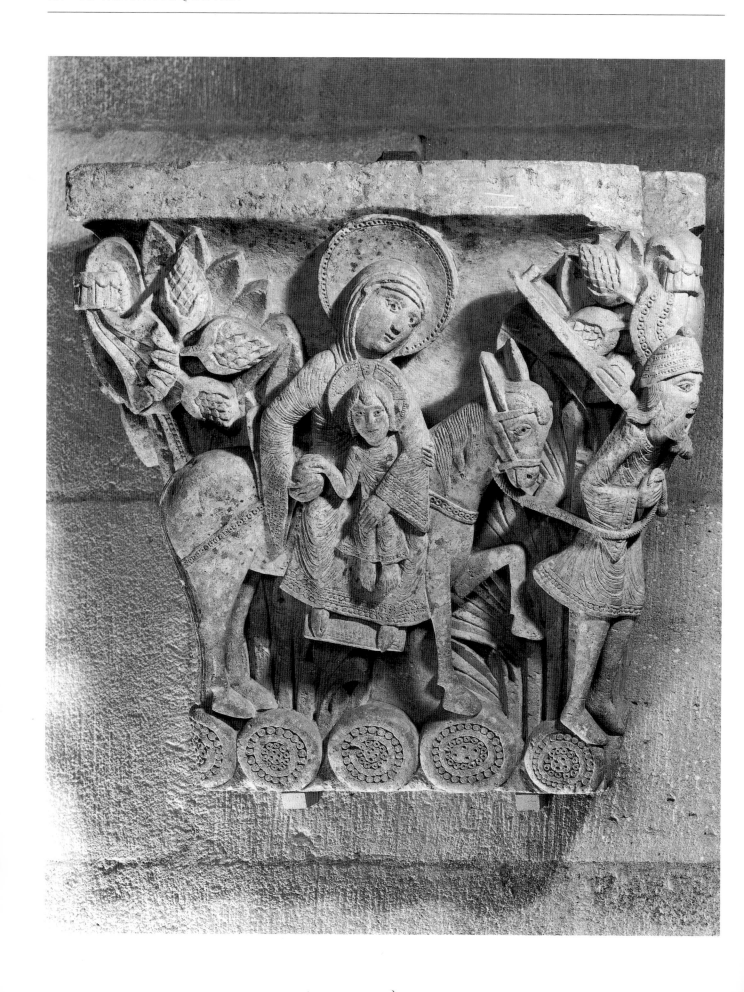

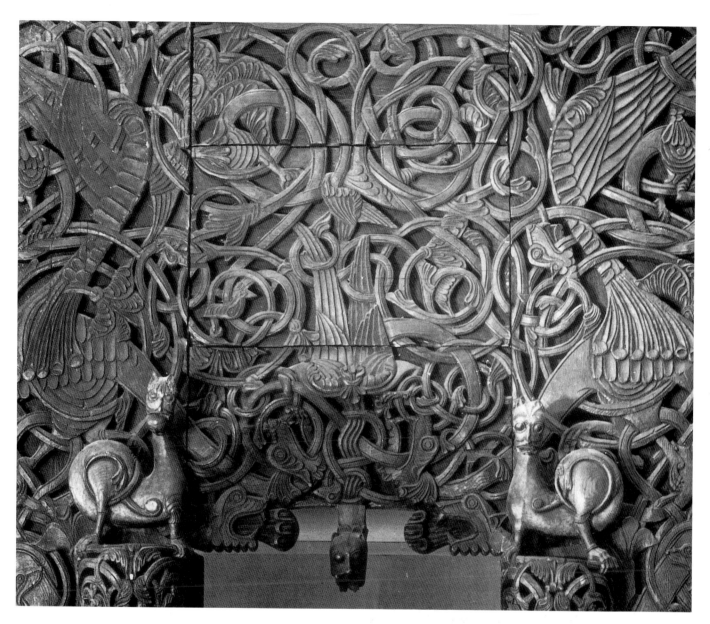

12.9 (above) Decorative detail of interlace sculpture from right jamb of west portal, Al Cathedral, Norway. 12th century.

12.8 (opposite) Gislebertus, Capital with *Flight into Egypt*, from Autun Cathedral, France. c. 1130. At Autun we encounter the only sculptor to inscribe his name in the tympanum of a Romanesque church. Little is known about Gislebertus, but his distinctive artistic personality influenced other sculptors considerably.

Another development in Romanesque art is the translation of Early Medieval manuscript interlaces (see p.172) into stone relief sculpture. A good example is the Romanesque church door **jamb** from Norway (fig. **12.9**), in which several elements of Early Medieval manuscript art are combined. The elaborate curvilinear interlace merges into floral and leaf designs, and is also transformed into animal forms.

Mural Painting

In contrast to those of the early Middle Ages, Romanesque churches and chapels still contain some well-preserved examples of monumental mural painting. As is true of Romanesque sculpture, the paintings had both a decorative and a didactic, or teaching, function.

Documents indicate that the Romanesque artists traveled from place to place. Often, more than one painter at a time would work on a particular series of murals. An artist's style might respond to various influences, including his personal training, the style of his co-workers, or the demands of a patron. The artist either planned the program and its arrangement on the walls and ceiling by himself, or followed the instructions of a member of the clergy, or other patron. He then made a preliminary drawing in *buon fresco*, consisting of outlines and details. A compass was often used for repeated curvilinear

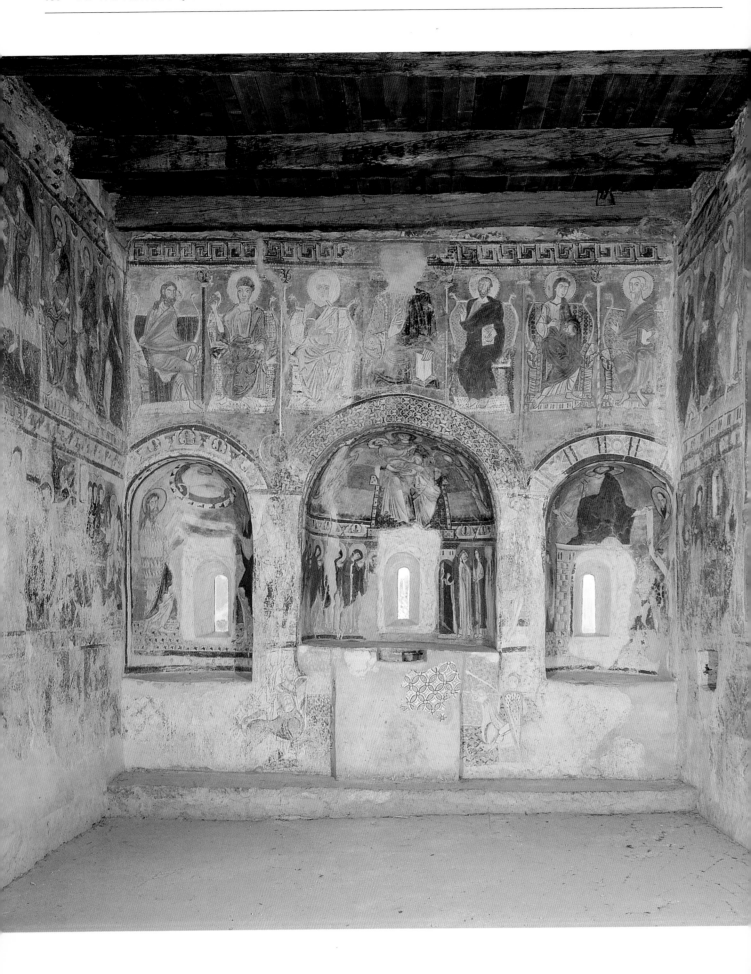

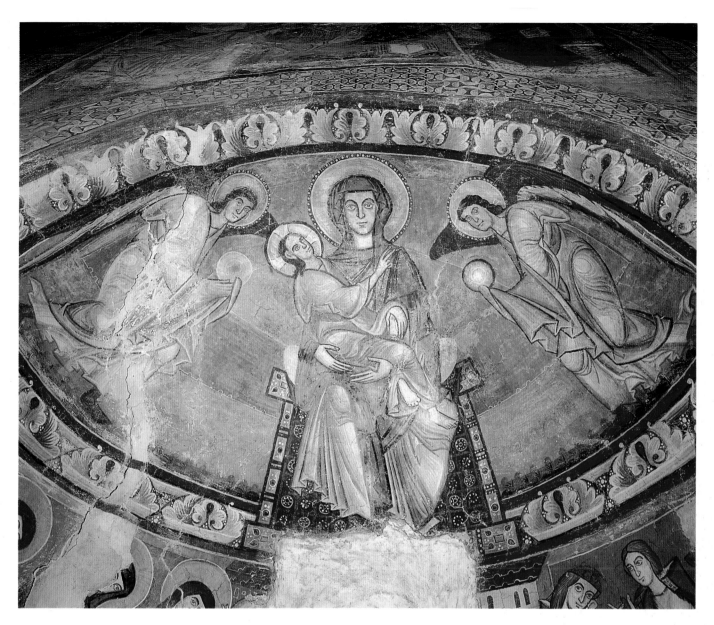

designs. The painting itself was usually *fresco secco*, possibly redampened so the plaster would absorb the paint. Sometimes, however, tempera was applied as well. Generally, the darker areas were painted before the highlights. In the final stage, the artist outlined the forms in black or brown. As in Byzantine mosaics (figs. **10.11** and **10.12**), this emphasized the figures, but decreased the realistic relation of the figures to three-dimensional space.

Figure **12.10**, a view of the chapel in Castel Appiano in northern Italy, illustrates the use of rich colors — blues, greens, browns, and yellows — and lively forms. These

would have been even more striking before they became damaged. In the detail of the semi-dome in the central apse, Mary and Christ are enthroned between two angels (fig. **12.11**). A floral border frames the scene. It is interrupted by the jeweled golden throne, which suggests Byzantine influence. A formal unity is created, as the background green repeats the shape of the border, while the blue repeats the pointed oval of the apse itself. Mary is frontal, staring directly at the viewer. Her draperies echo the background blue and green, and her flat halo repeats the color and beaded designs of the throne. Although this example is from Italy, and the *Flight* capital in figure **12.8** is French, they share stylistic similarities. As in the Autun *Flight*, although differing in proportions, Christ is a small man held in Mary's lap. His right hand extends to the right in a gesture of benediction. The draperies also reflect a taste for elegant, curvilinear surface patterns that are unrelated to organic form.

12.11 (above) *Mary and Christ with Two Angels*, detail of the apse, Chapel of Castel Appiano. c. 1200. Fresco.

12.10 (opposite) View of the Chapel of Castel Appiano, Italy. c. 1200.

Bayeux Tapestry

One of the most intriguing works made by Romanesque artists is the Bayeux Tapestry, which depicts the Norman invasion of England in A.D. 1066 (fig. **12.12**). The Bayeux Tapestry is over 230 feet (70 m) long and contains 626 human figures, 731 animals, 376 boats, and 70 buildings and trees. Such an undertaking probably involved several artists, technicians, and a general designer working together with a historian. It is actually an embroidery, rather than a tapestry, made by stitching colored wool on to bleached linen. We have no records of who the artists were, but most medieval embroidery was done by women, especially at the courts. This particular example is unique in having been preserved, but it is likely that there were once many others.

The Bayeux Tapestry was created for the cathedral of Bayeux in Normandy, near the northern coast of France. It was probably commissioned by Bishop Odo of Bayeux, half-brother of William the Conqueror. The events depicted on it unfold from left to right and are accompanied by

12.12 Battle detail showing Bishop Odo with a mace, from the Bayeux Tapestry. c. 1070–80. Wool embroidery on linen, 20 in (50.8 cm) high. Musée de l'Evêché, Bayeux. Note how the smooth texture of the linen contrasts with the rougher texture of the raised wool threads. Single threads were used for waves, ropes, strands of hair on the horses' foreheads, and the outlines of each section of color.

Latin inscriptions describing them. A detail is shown in figure **12.12**.

All the riders are helmeted and armed. The chain mail is indicated by circular patterns within the outlines of the figures. Odo holds a mace, and the nobles carry banners, shields, and lances. The weapons, held on a diagonal, increase the illusion of forward movement, while Odo seems to clash with an enemy riding against him. The ground line is indicated by a wavy line on a horizontal plane, but, aside from the overlapping of certain groups of figures, there is little attempt to depict three-dimensional space. Above and below the narrative events are borders containing human figures (note the decapitated figure below), natural and fantastic animals, and stylized plant forms. This iconography is reminiscent of the manuscript interlaces intertwining with animal and floral forms.

Unlike the other Romanesque works of art in this chapter, the Bayeux Tapestry is secular in subject. Even though it was probably commissioned by a bishop, and was possibly exhibited in Bayeux Cathedral, the events depicted in it are purely historical. They are, of course, shown from the Norman point of view, and so may be considered biased. Nevertheless, the Bayeux Tapestry is an excellent example of the potential importance of imagery as documentation. The Column of Trajan, some 900 years earlier (see p.141), performed a similar political function, though in the Tapestry, unlike the Column, Latin inscriptions explain the images.

Gothic Art

Gothic cathedrals are among the greatest and most elaborate monuments in stone. The term "Gothic" is applied primarily to the architecture, and also to the painting and sculpture, produced in western Europe immediately following Romanesque. The word was first used by Italians in the sixteenth century to denigrate the art preceding their own Renaissance style (see p.224). Literally, Gothic refers to the Goths, the Germanic tribes who invaded Greece and Italy, and sacked Rome in A.D. 410. They were blamed for destroying what remained of the Classical style. In fact, however, the origins of Gothic art in the middle of the twelfth century had nothing to do with what had happened 700 years earlier. By the nineteenth century, when scholars realized the source of the confusion, it was too late. Gothic remains the accepted name for the style discussed in this chapter.

Origins of the Gothic Style

The Gothic style dates from 1137–44. It originated in the Ile-de-France, the region in northern France that was the personal domain of the French royal family. The credit for its invention goes to one remarkable man, Abbot Suger of the French royal monastery at Saint-Denis, which is about 6 miles (10 km) north of Paris.

Abbot Suger was born in 1084 and educated in the monastery school of Saint-Denis along with the future French king Louis VI. Suger later became a close political and religious advisor to both Louis VI and Louis VII. He was a successful mediator between the Church and the royal family. While Louis VII was away on the Second Crusade of 1147, Suger was appointed regent, or ruler, of France.

In 1122 Suger was named Abbot of Saint-Denis. The monastery had a special place in French history. Not only was Denis, the first bishop of Paris and the patron saint of France, buried there, but it was also the site of Charlemagne's coronation and the burial place of the French royal family. Suger conceived a plan to rebuild and

enlarge the eighth-century Carolingian church at Saint-Denis. He intended to make it the spiritual center of France, and searched for a new kind of architecture that would reinforce the divine nature of the king's authority to rule and enhance the spirituality of his church. The rebuilding program did not start until 1137, and in the meantime Suger made extensive preparations. He studied the biblical account of the construction of Solomon's Temple and immersed himself in what he thought were the writings of St. Denis. Scholars now believe that Suger was actually reading the works of Dionysius (who may have been either a fifth-century Greek theologian or an Athenian follower of St. Paul).

Regardless of the identity of the source, Suger was inspired by the author's emphasis on the mathematical harmony that should exist between the parts of a building and on the mystical, even miraculous, effect of light. This was later elaborated into a theory based on musical ratios. The result was a system that expressed complex symbolism based on mathematical ratios. The fact that these theories about light and the mathematical symbolism of architecture could be attributed to St. Denis made them all the more appealing to Abbot Suger. In his preoccupation with light, Suger was thinking within a traditional Christian framework, for the formal qualities of light had been associated with Christ and divinity since the Early Christian period. In his reconstruction of Saint-Denis, Suger rearranged the elements of medieval architecture to express the relationship between light and God's presence in a new way.

Early Gothic Architecture: Saint-Denis

Suger's additions to Saint-Denis consisted of a new narthex and west façade with twin towers and three portals. Most of the original sculptural decoration on the portals has since been lost. On the interior, Suger kept the basic elements of the Romanesque pilgrimage choir—a colonnaded apse flanked by a semicircular

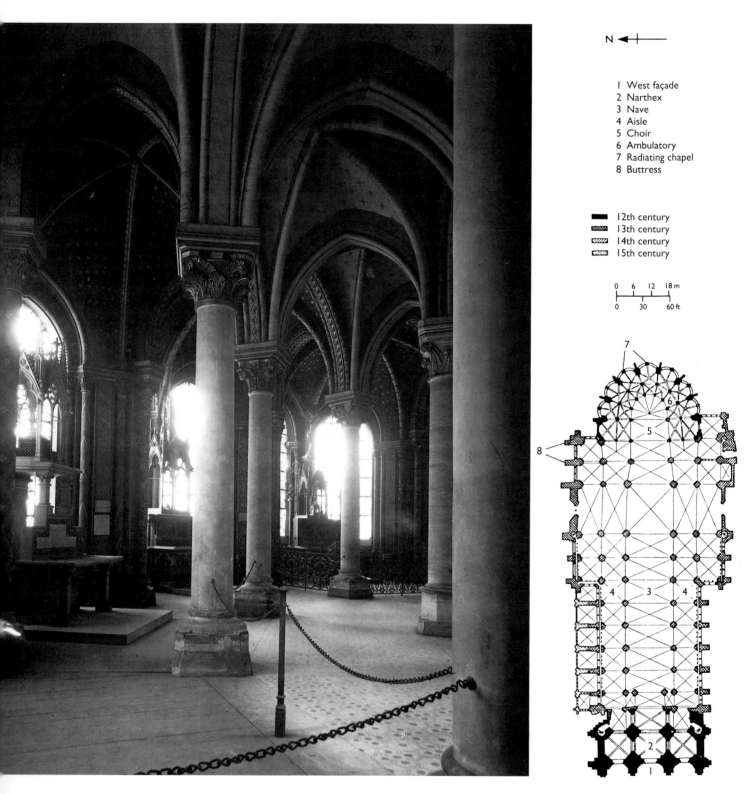

N ⟵┼

1 West façade
2 Narthex
3 Nave
4 Aisle
5 Choir
6 Ambulatory
7 Radiating chapel
8 Buttress

▄▄ 12th century
▨▨ 13th century
▧▧ 14th century
▨▨ 15th century

0 6 12 18 m
0 30 60 ft

13.1 Interior of Saint-Denis. Each chapel bay has a pair of large stained glass windows, delicate columns, and pointed vaults. The ambulatory and chapels have become a series of large windows supported by a masonry frame. Suger described the new effect as "a circular string of chapels, by virtue of which the whole [sanctuary] would shine with the miraculous and uninterrupted light of the most luminous windows"

13.2 Plan of Saint-Denis, France, showing the *chevet*. 1140–4. The chapels are connected shallow bays, which form a second ambulatory parallel to the first. This arrangement creates seven wedge-shaped compartments radiating out from the apse. Each wedge is a trapezoidal unit (in the area of the traditional ambulatory) and a pentagonal unit (in the radiating chapel). The old nave and the choir were rebuilt in the High Gothic style between 1231 and 1281.

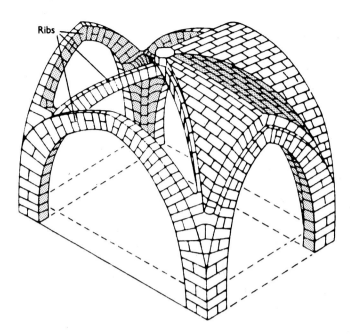

Ribs

13.3 Diagram of a ribbed groin vault. A groin vault is created by the intersection at right angles of two barrel vaults, thus forming four bays.

ambulatory with radiating chapels — but combined them in an original way (figs. **13.1** and **13.2**).

Under Suger's revision, the *chevet* (the east end of the church, comprising the choir, ambulatory, and apse) emphasized the integration of light with lightness. The entire area was covered with **ribbed** groin **vaults** (fig. **13.3**). These used the pointed arch (see below) as their basis and were supported by slender columns. On the exterior, thin buttresses were placed between the chapels (fig. **13.2**), to strengthen the walls. Suger's new approach attracted immediate attention, because the effect was so different from the dark interiors and thick, massive walls of Romanesque architecture. The new style was particularly popular in northern and central France, where royal influence was strongest. Notwithstanding its close association with France (it was soon dubbed **opus francigenum**, or "French work"), the style migrated north to England and south to Spain. There was also an Italian Gothic period, although Italy was the country that welcomed the style least and rejected it soonest.

Elements of Gothic Architecture

None of the individual architectural devices that Abbot Suger and his builders used was new. They can all be found in the various regional Romanesque styles of the preceding centuries. It was Suger's revolutionary synthesis of these elements that created the Gothic style.

Ribbed Groin Vaults

In Gothic architecture, the ribbed groin vault (fig. **13.3**) supersedes the earlier barrel vaults. The advantage of the groin vault is that it requires less buttressing. The barrel vault exerts pressure along its entire length and so needs strong buttressing. The weight of the groin vault, however, is concentrated only at the four corners of the bay. As a result, the structure can be buttressed at intervals, freeing up more space for windows. The addition of ribs also enabled Gothic builders to reinforce groin vaults and to distribute their weight more efficiently. The ribs could be built before the intervening space (usually triangular or rectangular) was filled in. Because of the weight-bearing capacity of the ribs, the vault's surfaces (the **web**, or infilling) could be made of a lighter material.

Piers

As the vaults became more complex, so did their supports. One such support is the **compound**, or **cluster**, **pier** (fig. **13.4**). Although compound piers had been used in Romanesque buildings, they became a standard feature of the Gothic repertory. The ribs of the vaults formed a series of lines which were continued down to the floor by **colonnettes** (thin columns) resting on compound piers.

With this system of support, the Gothic builders created a vertical unity that led the observer's gaze upward to the windows, the architectural source of interior light. The pier supports, with their attached colonnettes branching off into arches and vaults, have been compared with the organic upward growth of a tree.

Flying Buttresses

In Romanesque architecture walls performed the function of buttressing (see p.181). This reduced the amount of available window space and therefore light. In the Gothic period, builders developed the **flying buttress**, an exterior structure composed of thin half-arches, or flyers. This supported the wall at the point where the thrust of an interior arch or vault was greatest (fig. **13.5**).

Pointed Arches

The pointed arch, which is a characteristic and essential feature of Gothic architecture, can be thought of as the intersection of two arcs of non-concentric circles. Examples are found in Romanesque, but in a much more tentative form. In figures **13.4** and **13.5** all the arches are pointed. Dynamically and visually, their thrust is far more vertical than that of a round arch. The piers channel the downward thrust of the pointed arch, minimizing the lateral thrust against the wall. Unlike round (semicircular) arches, pointed arches can theoretically be raised to any height, regardless of the distance between their supports. The pointed arch is thus a more flexible building tool, with more potential for increased height.

The Skeleton

The features described above combined to form what is called a "skeletal" structure. The main architectural supports (buttresses, piers, ribs) form a "skeleton" to which non-supporting features, such as walls, are attached. The Gothic builders had, in effect, invented a structure that biologists would describe as exo-skeletal. An exo-skeletal creature is one, such as an armadillo or a crab, whose skeleton is on the outside of its body.

Stained Glass Windows

Finally, the light that had so inspired Abbot Suger required an architectural solution. That solution was the stained glass window. Suger was not seeking natural daylight, but rather light that had been filtered through colored fragments of glass. Light and color were diffused throughout the interior of the cathedral, producing a quite different effect from Early Christian and Byzantine buildings (see p.160). The predominant colors of Gothic tend to be blue and red, which are more subdued than the brilliant gold of mosaics.

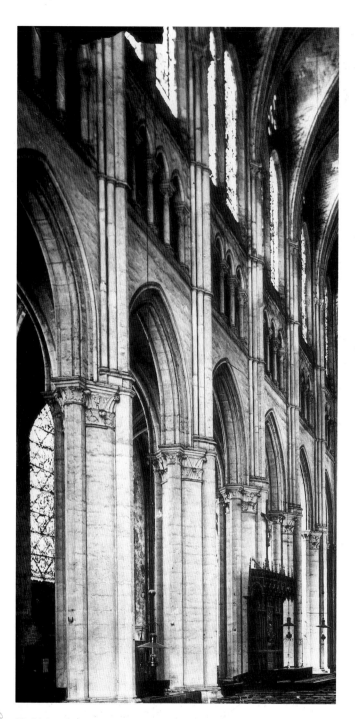

13.4 (above) View of piers in the nave arcade, Chartres Cathedral, France. 13th century. The compound piers along the two sides of the nave are massive columnar supports to which clusters of colonnettes, or pilaster shafts, are attached. The clusters usually correspond to arches or vault ribs above them.

13.5 (right) Section diagram of a Gothic cathedral (after E. Viollet-le-Duc). The **elevation** of the Gothic cathedral illustrates the flyers, which transfer interior thrusts to a pier or exterior buttress. Since the wall spaces between the buttresses were no longer necessary for structural support, they could be pierced by large windows to achieve the desired increase in light.

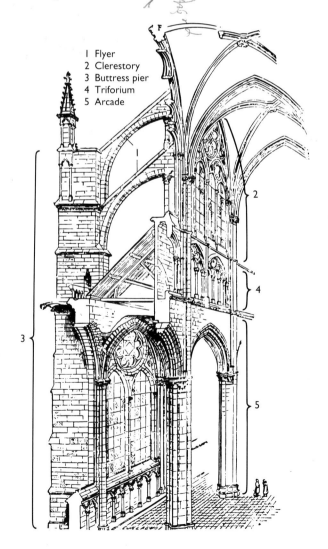

1 Flyer
2 Clerestory
3 Buttress pier
4 Triforium
5 Arcade

13.6 *Carpenters' Guild Signature Window*, detail of a stained glass window, Chartres Cathedral. Early 13th century. This signature scene depicts two carpenters at work on a plank of wood lying across three saw horses.

Stained Glass Windows

Stained glass is translucent colored glass cut to form a window design. Compositions are made from pieces of colored glass formed by mixing metallic oxides with molten glass or fusing colored glass with clear glass. The artist cuts the individual pieces as closely as possible to the shape of the face or other individual feature to be represented. The pieces are then fitted to a model drawn on wood or paper, and details are added in black enamel.

The dark pigments are hardened and fused with the glass through firing, or baking in a kiln. The pieces of fired glass are then arranged on the model and joined by strips of lead. Figure **13.7** is a detail of a stained glass window from Chartres Cathedral. Jeroboam, an Old Testament king, is shown praying before two golden calves. The red background is broken up, seemingly at random, into numerous sections. In the figures, however, the lead is arranged to conform either to an outline or to a logical location within the forms. Lead strips frame the head of the first calf and outline Jeroboam's crown. Once the pieces of stained glass are joined together, the units are framed by an iron **armature** and fastened within the tracery, or ornamental stonework, of the window.

Stained glass windows were made occasionally for Early Christian and Byzantine churches and more often in the Romanesque period. In the Gothic period, stained glass became an integral part of religious architecture and an artistic medium in its own right.

13.7 *Jeroboam Worshiping Golden Calves*, detail of a **lancet** under the north **rose window** (fig. **13.19**), Chartres Cathedral. Early 13th century.

The Age of Cathedrals: Chartres

By the time that the choir and west façade of Saint-Denis were completed in about 1144, and even before Abbot Suger turned his attention to the rest of the church, other towns in northern France were competing to build cathedrals in the new Gothic style. A cathedral is, by definition, the seat of a bishop (from the Greek word *kathedra*, meaning "seat" or "throne") and belongs to the city or town in which it is located.

The construction of cathedrals was the largest economic enterprise of the era. It had a significant effect on neighboring communities, as well as on the city or town itself. Jobs were created for hundreds of masons, carpenters, sculptors, stonecutters, and other craftsmen. When the cathedral was finished, it attracted thousands of pilgrims and other visitors, and this continual traffic stimulated the local economy. Cathedrals also provided a focus for community activities — secular as well as religious. Above all, they generated an enormous sense of civic pride, which united the townspeople.

The cult of the Virgin Mary became important in the Gothic period. Most of the great French cathedrals were dedicated to the Virgin, "Our Lady," or "Notre Dame" in French. As a result, to avoid confusion, it is customary to refer to cathedrals by the names of the towns in which they are located.

The town of Chartres is approximately 40 miles (64 km)

Guilds

Medieval **guilds**, or gilds, were associations formed for the aid and protection of their members and the pursuit of common religious or economic goals. The earliest form of economic guild was the Guild Merchant, which was responsible for organizing and supervising trade in the towns. Efforts by merchants to exclude craftsmen from the guilds led in the twelfth and thirteenth centuries to the formation of the craft guilds. These comprised all practitioners of a single craft or profession in a town. Craftsmen had to be members of the guild before they could ply their trade.

The functions of the craft guilds included regulating wages and prices, overseeing working conditions, and maintaining high standards of workmanship. Their effect, especially early on, was to ensure an adequate supply of trained workers and to enhance the status of craftsmen. They also provided charity to members in need, and pensions to their widows.

The guilds had three grades of membership — masters, journeymen (or paid assistants, *compagnons* in French), and apprentices. A precise set of rules governed the terms of apprenticeship and advancement to other grades. For promotion to the rank of master, a craftsman had to present to his guild a piece of work to be judged by masters. This is the origin of the term "masterpiece."

southwest of Paris. Its cathedral combines the best-preserved Early Gothic architecture with High Gothic, as well as demonstrating the transitional developments that took place in between. For a town like Chartres, with only about 10,000 inhabitants, the building of a cathedral dominated the economy just as the structure itself dominated the landscape. At Chartres, the construction continued off and on for more than a century, from around 1134 to 1220. The most intensive work, however, followed a fire in 1194, when the nave and choir had to be rebuilt.

The bishop and chapter (governing body) of the cathedral were in charge of contracting out the work. The funds, however, came from a much broader cross-section of medieval French society. The church itself usually contributed by setting aside revenues from its estates. At Chartres, the canons, or resident clergy, agreed in 1194 to give up their stipends (salaries) for three years so that the rebuilding program could begin. When the royal family or members of the nobility had a connection with a particular project, they also helped. At Chartres, Blanche, the mother of King Louis IX, donated funds for the entire north transept façade, including the sculptures and windows. The duke of Brittany contributed to the southern transept. Other wealthy families of the region gave windows, and their donations were recorded by depicting their coats of arms in the stained glass.

Guilds representing specific groups of craftsmen or tradesmen donated windows illustrating their professional activities (fig. **13.6**). Pilgrims and less wealthy local inhabitants gave money in proportion to their means. These donations went toward general costs rather than to a designated use. There were thus economic and social distinctions not only in the size and nature of the contributions, but also in the degree to which they were recognized. Noble families were recognized with coats of arms, and guilds with identifying images of their work. In the Gothic period, artists did not sign their works, as they would today. Instead, those who donated enough money for the creation of works of art were rewarded with a "signature" image.

Exterior Architecture

Chartres (figs. **13.8** to **13.11**) was constructed on a high site to enhance its visibility. The vertical plane of its towers seems to reach toward the sky, while the horizontal of the side walls carries the observer's gaze east toward the apse, where the altar is located. In figure **13.8**, we are standing opposite the west façade (no. 11 on the plan, fig. **13.10**). This façade illustrates clearly the dynamic, changing nature of the Gothic style. The southern tower,

13.8 (opposite) West façade, Chartres Cathedral. c. 1140–50. Symmetry in the Classical sense was not a requirement of the Gothic designers. Gothic cathedrals are structurally, but not formally, symmetrical. That is, a tower is opposite a tower, but the towers need not be identical in size or shape.

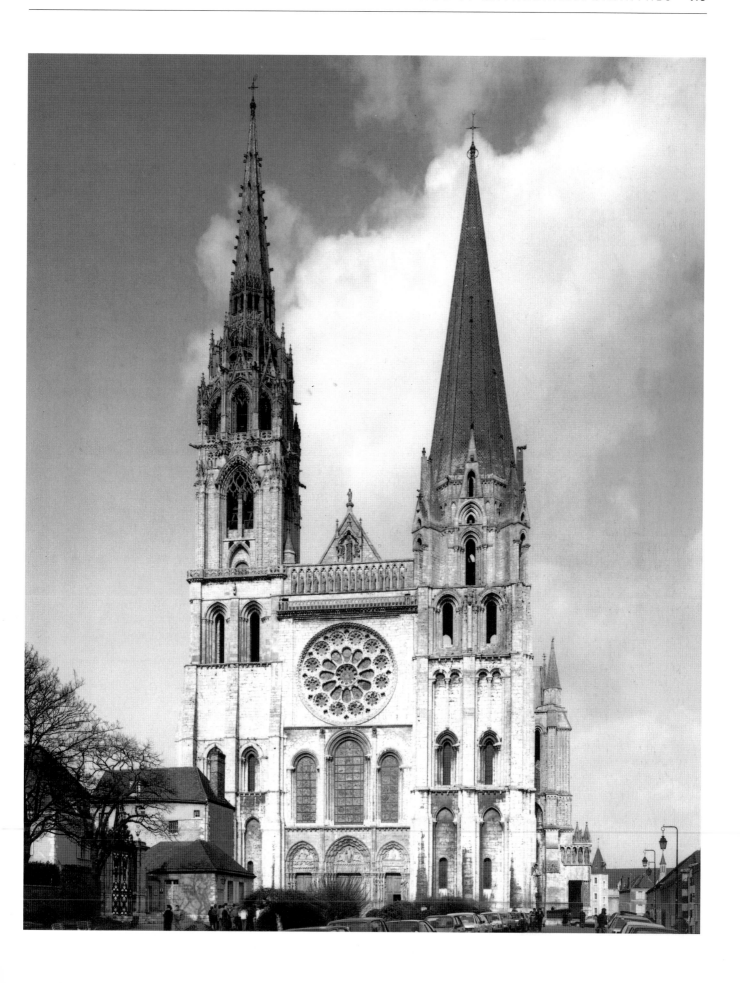

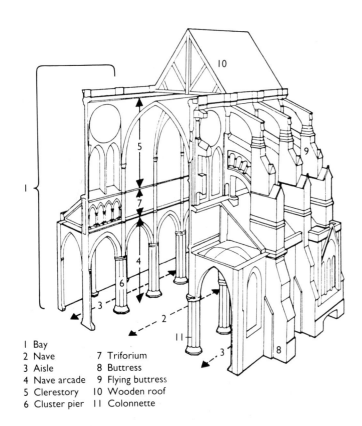

1 Bay
2 Nave
3 Aisle
4 Nave arcade
5 Clerestory
6 Cluster pier
7 Triforium
8 Buttress
9 Flying buttress
10 Wooden roof
11 Colonnette

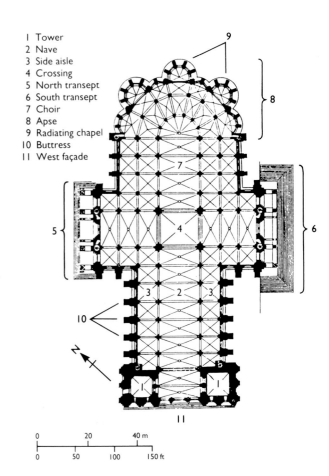

1 Tower
2 Nave
3 Side aisle
4 Crossing
5 North transept
6 South transept
7 Choir
8 Apse
9 Radiating chapel
10 Buttress
11 West façade

0	20	40 m	
0	50	100	150 ft

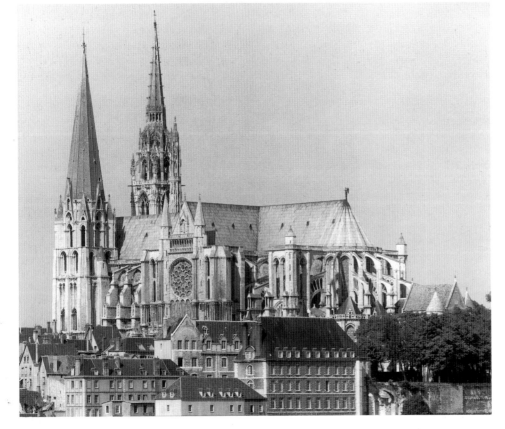

13.9 (above, left) **Isometric projection** and cross-section of Chartres Cathedral.

13.10 (above) Plan of Chartres Cathedral. Although the plan is quite symmetrical, the number of steps leading to each of the three entrances increases from west to north, and from north to south. This increase parallels the building sequence, for Gothic architecture became more detailed and complex as the style developed.

13.11 South wall of Chartres Cathedral.

13.12 The apse of Chartres Cathedral, with radiating chapels and flying buttresses. Visible in this view are two projecting, semicircular radiating chapels, the flying buttresses above them, and, at the top, the curved end of the roof.

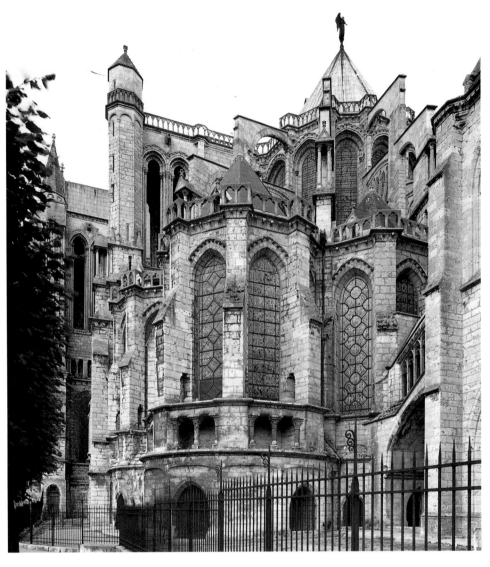

on the right, dates from before 1194. It marks the transition from Late Romanesque to Early Gothic. The High Gothic northern tower, started in 1507, is taller, thinner, and more elaborate than the southern tower.

The organization of Chartres's west façade is characteristic of most Gothic cathedrals. It is divided into three sections. Towers containing a belfry flank a central section, which is further subdivided. The three portals consist of the same elements as the Romanesque cathedral at Conques (fig. **12.4**). Above each portal is a tall, arched, stained glass window called a lancet. Inscribed in the rectangle over the lancets is the round rose window that appears over virtually all Gothic cathedral portals. Above the rose window, a gallery of niche figures representing saints stretches between the two towers. Finally, the gallery is topped by a triangular gable containing a niche statue of Mary and Christ. The repetition of triple elements (portals, lancets), the three horizontal divisions, and the triangular gable all suggest a numerical association with the Trinity (or Father, Son, and Holy Spirit)—a central tenet of Church dogma.

In the rose window, too, there is a symbolic Christian significance in the arrangement of the geometric shapes. Three groups of twelve elements surround the small central circle. These refer to Christ's twelve apostles. The very fact that the rose window is a circle could symbolize Christ, God, and the universal aspect of the Church itself.

Proceeding counterclockwise around the southern tower, the visitor confronts the view in figure **13.11**. This is one of two long, horizontal sides of the cathedral, parts of which are labeled in figure **13.9**. Visible in the photograph are the roof (no. 10 in the diagram), the buttresses between the tower and the transept entrance (no. 8), and the flying buttresses, or flyers (no. 9), over the buttresses and, at the eastern end, behind the apse. This transept, which is the south one, has five lancet windows, a larger rose window than the west façade, and a similar gallery and triangular gable with niche statues.

Continuing east to the end of the cathedral, turning around and facing west, the visitor sees the view of the apse in figure **13.12**.

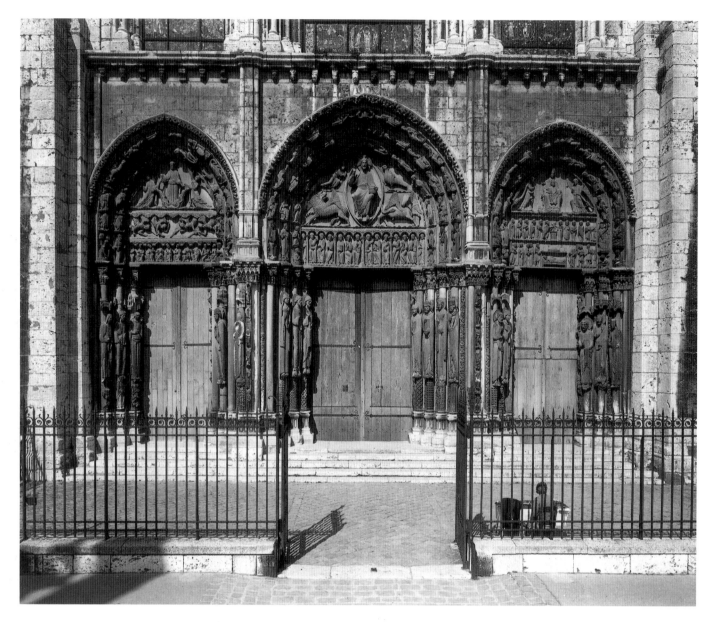

Exterior Sculpture

On the exterior there are so many sculptural details that it would take several volumes to consider them thoroughly. We shall therefore concentrate on a few of the most characteristic pieces on the west and south.

Royal Portal (West Façade). There are three portals, together known as the Royal Portal, at the western entrance to Chartres. The central portal is slightly larger than those at either side. This triple arrangement was derived from the Roman triumphal arches (see p.142). The parallel between Roman arches, which were often city entrances, and cathedral portals highlights the symbolic parallel between the interior of the church and the heavenly city of Jerusalem. Throughout the Middle Ages, entering a church was thought of as an earthly prefiguration of one's ultimate entry into Heaven.

13.13 The three portals of the west façade, Chartres Cathedral. c. 1140–50. The door jamb sculptures are slender, columnar figures of Old Testament kings and queens. This explains why the portals are called "royal." Above the doors are New Testament scenes and figures. This arrangement is an architectural metaphor for the way in which the New Testament is built on the Old Testament foundation.

At the sides of each individual doorway are relief sculptures, which, like those on the Romanesque cathedrals, had a didactic function. Figure **13.13** is a view of the three portals, which were built from about 1140 to 1150 during the earliest Gothic period. Their decoration is part of an iconographic program intended to convey a particular set of messages.

In the most general sense, these portals remind the observer of the typological view of history (see p.152), which was a characteristic of Christian thought from its

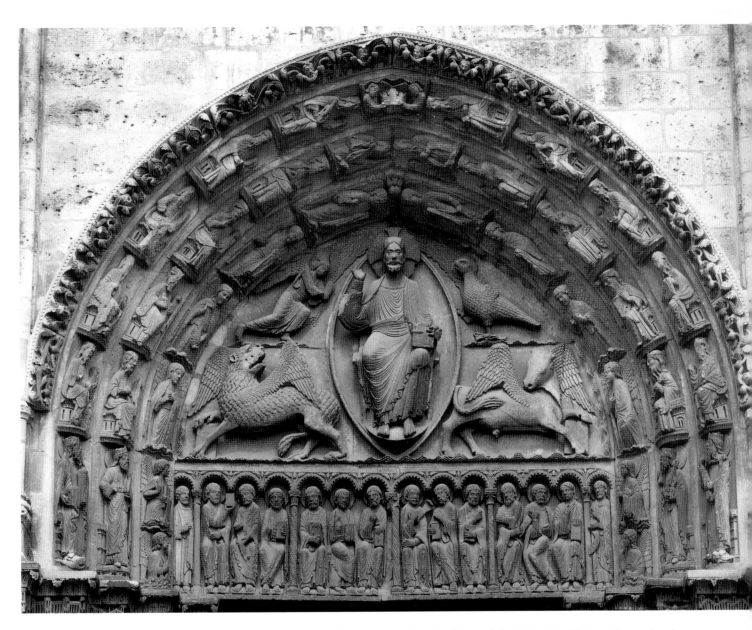

13.14 Detail of tympanum, lintel, and archivolts, central door, west façade, Chartres Cathedral. c. 1145–70. The eagle stands for John, the angel for Matthew, the lion for Mark, and the bull for Luke. The surface patterns on all of the tympanum figures are stylized — for example, Christ's drapery folds, and the wings, drapery, and fur of the Evangelists' symbols. Christ is frontal, directly facing the visitors to the cathedral, as if reminding them of their future destiny.

beginnings. The right, or southern, portal contains scenes of Christ's Nativity and childhood on a double lintel. An enthroned Virgin holding the Christ child occupies the tympanum, which is surrounded by the Seven Liberal Arts (see p.176) in the archivolts. On the left, or northern, tympanum and lintel are scenes of the Ascension. The archivolts contain the signs of the Zodiac and symbols of the seasonal labors of the twelve calendar months.

The central portal contrasts the Old Testament kings and queens on the door jambs (fig. **13.15**) with the

apocalyptic vision of St. John the Divine above the door. The door jamb statues are good examples of Early Gothic. Each figure is slim and vertical, as if a human counterpart to the colonnette behind. Separating each statue and each colonnette is a space decorated with floral relief patterns, which acts as a framing device.

As in the Early Christian mosaics, the Old Testament kings and queens are frontal. Their arms are contained within their vertical planes, and their halos are vertical. Their feet slant downward on a diagonal, indicating that they are not supported as in nature. The drapery folds reveal the artist's delight in surface patterns. Zigzags along the hems and circles at the elbows, for example, are repeated for their own sake rather than to identify organic form. Hair and beards are stylized and do not appear to be growing naturally from beneath the surface of the skin.

The New Testament event represented over the central door (fig. **13.14**) is the Second Coming of Christ, as

described by St. John the Divine in the Revelation, the last book of the Bible. On the tympanum, a seated Christ is surrounded by an oval mandorla, and the four traditional symbols of the Evangelists. Beneath the tympanum on the lintel, the twelve apostles are arranged in four groups of three. Each group is separated by a colonnette supporting round arches, which function visually as halo-like forms. At either end of the lintel stands a single prophet, holding a scroll. The prophets are Old Testament counterparts of the apostles. Of the three archivolts, the outer two contain the twenty-four Elders of the Apocalypse, described by St. John the Divine. The inner archivolt contains twelve angels. The two in the center hold a crown over Christ's head, referring to his role as King of Heaven.

Considered as an iconographic totality, the Royal Portal of Chartres confronts the worshiper with a Christian view of history. The beginning and end of Christ's earthly life are over the right and left doors, respectively. The Old Testament kings and queens on the door jambs are typological precursors of Christ and Mary. The end of the world, when Christ judges humanity for the last time, dominates the central portal.

Sculpture on the Southern Façade. A comparison of the Royal Portal on the west façade with the southern door jambs reveals the stylistic changes that occurred between about 1194 and about 1220. The saints on the left portal (fig. **13.16**) conform less rigidly to their background colonnettes, and their feet rest naturalistically on

13.15a (above) Door jambs, west façade, Chartres Cathedral. c. 1145–70.

13.15b (left) Detail of stylized drapery.

13.16 (opposite) *Saints Theodore, Stephen, Clement, and Lawrence,* detail of door jamb figures, south transept, Chartres Cathedral. 13th century. In the St. Theodore on the far left, there is the suggestion of a twist at the waist, as his heavy sword pulls down on his belt.

a horizontal plane. They are no longer strictly frontal. Their heads turn slightly, and there is more variety in their poses, gestures, and costumes. They have facial expressions, and are of different heights. A general increase in spatial depth is created by the more deeply carved folds and facial features, as well as by the crownlike architectural elements over their heads. The proportions have also changed. They are no longer as tall and thin as the figures on the west door jambs. Instead, they are wider, and seem as if they might step down from their supports into the real world of the observer.

Between the two doors of the central southern portal is the trumeau, a stone pier dividing a double doorway. This is a common feature of Romanesque and Gothic cathedrals. At Chartres, the trumeau on the southern entrance is decorated with a statue of the Teaching Christ. He stands on two monsters, which represent the Devil and the Antichrist (fig. **13.17**). Still frontal and strictly vertical, Christ's pose makes him seem more aloof than the door jamb saints, with whom one begins to identify.

Interior

The overwhelming sensation on entering Chartres Cathedral from the western entrance is one of height. In figure **13.18**, the visitor has just entered and is looking down the nave towards the curved apse at the opposite (eastern) end of the building. The ceiling vaults of the nave rise nearly 120 feet (37 m) and are only about 45 feet (14 m) wide.

The new height achieved by Gothic builders was made possible by the buttressing system. The effect of the buttress can be seen in the clerestory (fig. **13.18**), which is supported at two points by flyers (fig. **13.5**). These supporting flyers allowed more space to be used for windows. In each bay, the clerestory windows consist of two lancets under a small round window. At the far end, in the apse, the clerestory lancets are taller, but there are no round windows.

Proceeding down the nave, from west to east, one comes to the crossing (fig. **13.10**) and the two transept entrances. Figure **13.19** shows the north rose window illuminated by outside light filtering through the stained glass.

13.17 (right) *Teaching Christ*, trumeau figure, Chartres Cathedral. 13th century. Christ's earthly role as a teacher is reflected by the book in his left hand, and his divinity by his gesture of blessing. The act of standing on the Devil and Antichrist symbolizes the triumph of Christ's teaching over the forces of evil.

13.18 (opposite) View of the nave of Chartres Cathedral, looking east. The three stories of Gothic elevation rise on either side of the nave. The lowest story, or nave arcade, is defined by a series of large arches on heavy piers. These separate the nave from the side aisles (fig. **13.10**). The second story, or **triforium**, is a narrow passageway above the side aisle. At the top is the clerestory, whose windows are the main source of light in the nave.

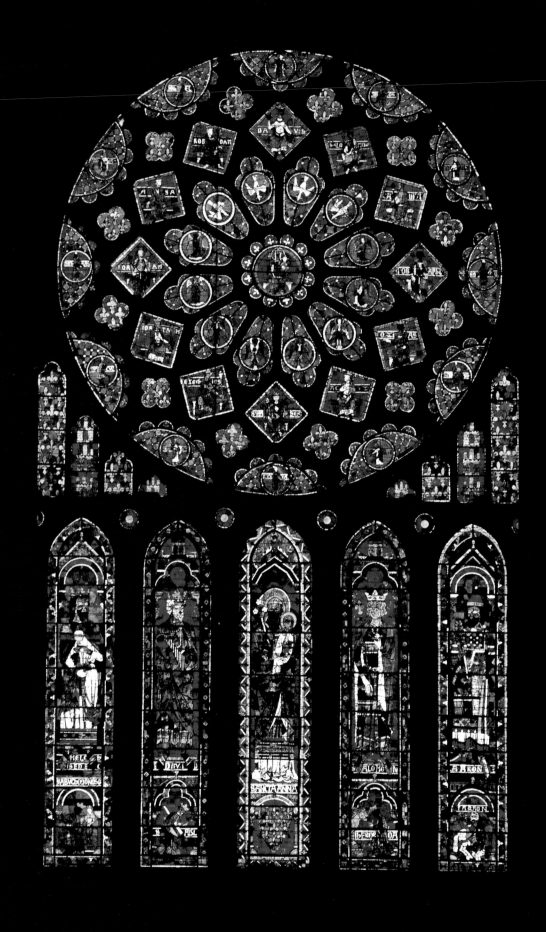

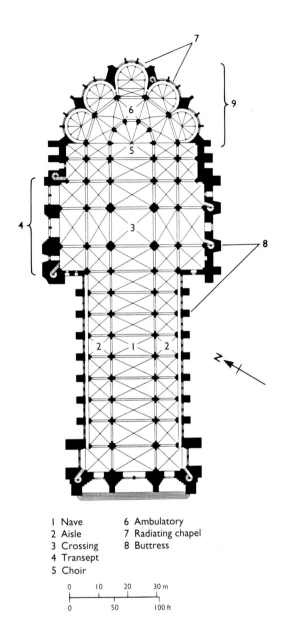

1 Nave	6 Ambulatory
2 Aisle	7 Radiating chapel
3 Crossing	8 Buttress
4 Transept	
5 Choir	

13.20 Plan of Reims Cathedral, France (after W. Blaser). Note that the plan of Reims is longer and thinner than that of Chartres (fig. **13.10**), and the five radiating chapels are deeper. The transepts of Reims are somewhat stubby and seem to merge into the choir with virtually no break.

13.19 (opposite) Rose window and lancets, north transept, Chartres Cathedral. 13th century. Note that the north windows are larger and more elaborate than the earlier west façade windows. The north lancets are taller and thinner than those on the west. The north rose window is larger, and has a greater variety of geometric shapes within it. Additional windows have also been inserted between the lancets and rose window. The rose window measures over 42 feet (12.8 m) in diameter. The windows between the rose window and the lancets are decorated with royal coats of arms, which proclaim the divine right of French kings. They also serve as a signature recording the donation of the north transept by Blanche, the queen mother.

Dominating the interior entrance walls, these window arrangements are like colossal paintings in light. Their intensity varies according to weather conditions and the time of day. At the center of the rose window, a small circle contains an image of Mary and the infant Christ, surrounded by twelve even smaller circles. Each series of geometric shapes around the center of the rose window numbers twelve—an implicit reference to the twelve apostles who surrounded Christ during his lifetime. The first series after the tiny circles contains four doves and eight angels. Twelve Old Testament kings, typological precursors of Christ, occupy the squares. The twelve quatrefoils contain gold lilies on a blue field, symbols of the French kings. Finally, the twelve outer semicircles represent Old Testament prophets, who are types for the New Testament apostles.

The lancets depict St. Anne and the infant Mary in the center, two Old Testament priests on the left, and King David and King Solomon on the right. In these windows, as in the west façade sculptures, the lower images act as visual and symbolic supports for the upper images. The New Dispensation is built on the Old. Here, the additional genealogical link between Christ and St. Anne is arranged vertically, with Mary as an infant in the lancet below and as the Virgin Mother above, at the center of the rose window.

Wherever possible and appropriate, Gothic artists integrated the dogma of Christianity into the cathedrals. The Gothic cathedral was designed as a total religious and esthetic experience, a unified expression of the skills of the architects, sculptors, artists, and other craftsmen who contributed to it. Works of theater, usually Christian mystery plays, were performed outside the entrances to the cathedrals, while music, in the form of chants and hymns, filled their interiors during services. Each art form thus conveyed the message of Christianity according to its own particular conventions.

Later Developments of the Gothic Style

Reims Cathedral

Chartres, completed in 1220, set the standard for other great French cathedrals built in the High Gothic style. Height and luminosity were the criteria by which they were measured. The cathedral at Reims, northeast of Paris, was the next to be built, from 1211 to about 1290. Its nave was 125 feet (38.1 m) high (fig. **13.20**). Amiens, also to the north, was begun in 1220, and its nave reached a height of 144 feet (43.89 m). Each was wider than the last, but the ratio of height to width continued to increase. A comparison of the west façade at Reims (fig. **13.21**) with that of Chartres reveals a more vertical thrust at Reims. The proportions of the arches at Reims are also taller and

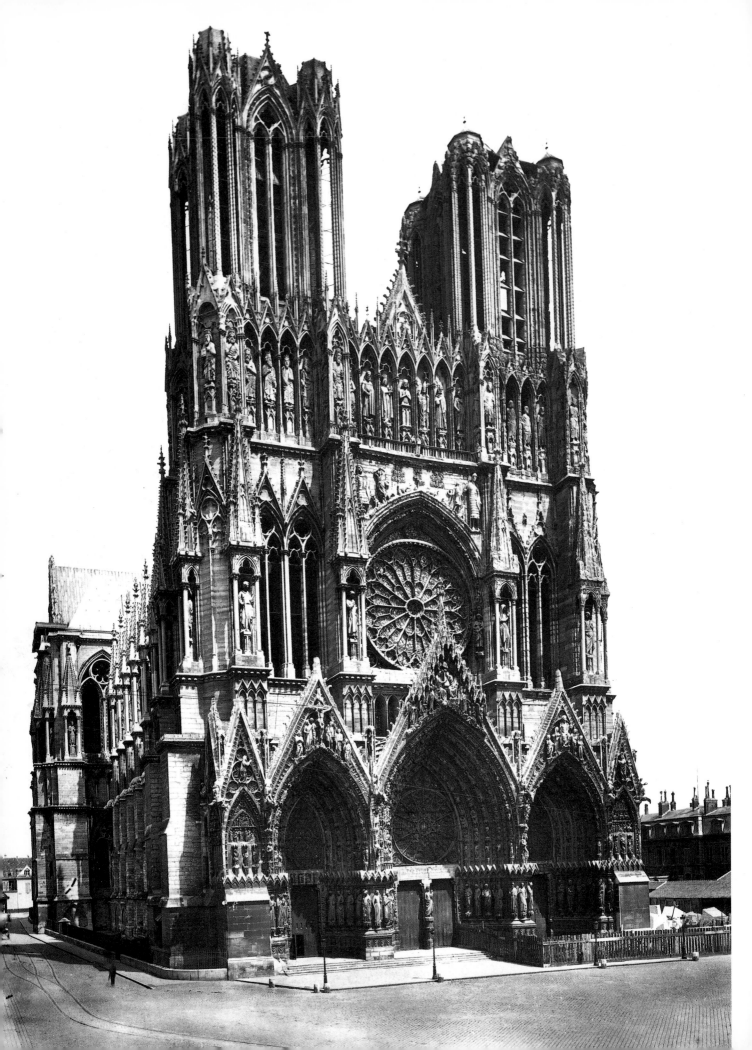

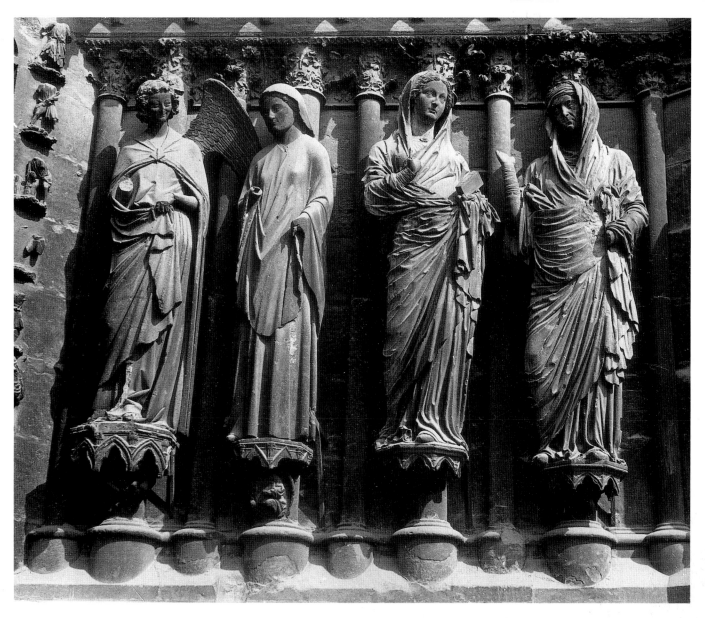

13.22 *Annunciation and Visitation*, door jambs, Reims Cathedral. c. 1225–45. The two figures on the left are the angel Gabriel and Mary. They enact the scene of the Annunciation, in which Gabriel announces Christ's birth to Mary. On the right, in the Visitation scene, Mary visits her cousin Elizabeth and tells her that she is three months pregnant. Elizabeth informs Mary that she herself is six months pregnant. Her son will be John the Baptist, Christ's second cousin and childhood playmate.

13.21 (opposite) West façade, Reims Cathedral. Begun 1211. The window space has been dramatically increased at Reims, as a result of continual improvements in the buttressing system. The tympanums on the façade, for example, are filled with glass rather than stone. At Reims the portals are no longer recessed into the façade, but are built outward from it.

thinner. Virtually every feature of the Gothic façade becomes increasingly elongated as the style develops.

Even more so than at Chartres, the exterior surfaces at Reims are filled with sculptures. But while the architectural proportions of Gothic become more vertical, the sculptures become less vertical and more naturalistic. This is clear from a comparison of door jamb statues from the west façade at Reims (fig. 13.22) with those from Chartres. Rather than being lined up vertically, as they are at Chartres, the Reims figures turn to face each other, thereby engaging the spaces between them. The drapery folds begin to respond to human anatomy, poses, and gestures. Gothic sculpture thus develops in the direction of greater naturalism, three-dimensional spatial movement, and more convincing organic form. This is the first appearance in the monumental Christian art of western Europe of an interest in the organic relationship between drapery and the human body it covers.

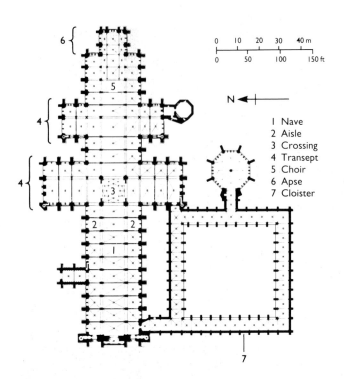

13.23 Plan of Salisbury Cathedral, England. The large square is a cloister attached to the south side of the cathedral. Aside from the cloister and a small porch on the north side of the nave, the plan is relatively symmetrical. The double transept and the square apse differ from the corresponding parts of a typical French Gothic cathedral.

1 Nave
2 Aisle
3 Crossing
4 Transept
5 Choir
6 Apse
7 Cloister

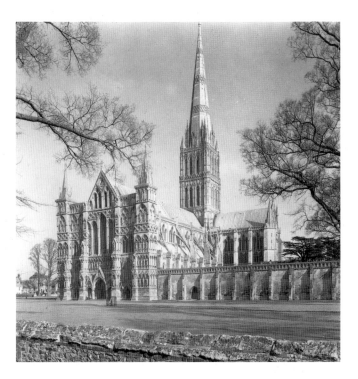

13.24 Exterior of Salisbury Cathedral. Begun 1220. The magnificent tower and spire, indicated on the plan and visible in the photograph, are Salisbury's most striking exterior feature. They were not added until the fourteenth century.

English Gothic Cathedrals

Within a generation of the new choir at Saint-Denis, the Gothic style had spread throughout France and to other countries in western Europe. Among the first to adopt the new style was England. Since its defeat by the Normans in 1066 (see p.188), there had been commercial, cultural, and political contacts between the two countries. The best example of Early Gothic style in England is Salisbury Cathedral, located in the southwest, not far from Stonehenge (fig. **3.8**).

Salisbury Cathedral (figs. **13.23** and **13.24**) was built from 1220 onward in a relatively homogeneous style. The English cathedral designers adopted the cloister, one of the main architectural features recommended for a monastic community (see p.177), as part of their own building plan. Unlike the French cathedrals, but characteristic of those in England, Salisbury is set in a cathedral **close**, a precinct of lawns and trees. Whereas the French cathedrals usually rise directly from the streets and squares of a town, emphasizing vertical movement, Salisbury is more related to the natural landscape. Its planar thrusts are horizontal. It has fewer stained glass windows and therefore less need for exterior buttressing.

Gothic cathedrals are found throughout western Europe. They are a testimony to a great age of building, inspired by the thought and determination of Abbot Suger at Saint-Denis. They express the strivings of Christianity to embrace the entire universe, and to reveal the Christian message to as many people as possible through works of art.

PART FOUR
THE RENAISSANCE

	Style/Period	Works of Art	Cultural/Historical Developments
1300	**PRECURSORS OF THE RENAISSANCE** Mid-13th to 14th century		
	Nicola Pisano	Pisa Baptistry (p.211)	Thomas Aquinas, *Summa theologica* (1273)
	Cimabue	*Madonna Enthroned* (p.215)	Invention of glass mirror (1278)
	Giotto	Arena Chapel (p.217)	Dante, *The Divine Comedy* (c. 1309–20)
		Madonna Enthroned (p.214)	Seat of papacy moves to Avignon (1309)
	Lorenzetti	*Allegory of Good Government* (p.222)	Black Death (1347–51)
			Boccaccio, *Decameron* (1353)
			Chaucer, *Canterbury Tales* (1387–1400)
1400	**EARLY RENAISSANCE** 15th century		
	Ghiberti	*Sacrifice of Isaac* (p.226)	
		Gates of Paradise (p.231)	
	Brunelleschi	*Sacrifice of Isaac* (p.226)	Invention of scientific perspective (c. 1400)
		Dome of Florence Cathedral (p.227)	England defeats France at Agincourt (1415)
		S. Spirito (p.230)	
	Masaccio	*Holy Trinity* (p.233)	
		Brancacci Chapel frescoes (p.235)	
	Gentile da Fabriano	*Adoration of the Magi* (p.236)	
	Campin	*Mérode Altarpiece* (p.247)	
	Uccello	Perspective drawing of a chalice (p.229)	Joan of Arc burned at the stake (1431)
	van Eyck	*Arnolfini Wedding Portrait* (p.250)	Cosimo de' Medici rules Florence (1434–64)
	van der Weyden	*St. Luke Painting the Virgin* (p.251)	
1450	Donatello	*David* (p.237)	
	Fra Angelico	*Annunciation* (p.243)	Platonic Academy founded in Florence (1440)
	Donatello	*Gattamelata monument* (p.238)	Francesco Sforza becomes duke of Milan (1450)
	Piero della Francesca	*Legend of the True Cross* (p.242)	Gutenberg Bible printed (1453–5)
		Portraits of Federico and Battista (p.241)	Erasmus of Rotterdam, humanist (1465–1536)
	Alberti	Rucellai Palace (p.239)	First printed music (1465)
	Mantegna	*Camera degli Sposi* (p.244)	Lorenzo de' Medici rules Florence (1469–92)
	van der Goes	*Portinari Altarpiece* (p.252)	William Caxton prints first book in English (1474)
	Botticelli	*Birth of Venus* (p.246)	Revival of Inquisition in Spain (1478)
1500	**HIGH RENAISSANCE** Late 15th to early 16th century		
	Leonardo	Plan of a church like the Holy Sepulchre (p.254)	Alberti, *On Painting* (c. 1435), *On Architecture* (1485)
		Vitruvian Man (p.254)	Columbus sets sail (1492)
		Last Supper (p.261)	
	Dürer	*Four Horsemen of the Apocalypse* (p.291)	Execution of Savonarola (1498)
			Vasco da Gama discovers sea route to India (1498)
	Michelangelo	*David* (p.263)	Julius II elected Pope (1503)
	Bramante	Tempietto (p.255)	
		Plan for New St. Peter's (p.259)	
	Raphael	*Betrothal of the Virgin* (p.257)	
	Leonardo	*Mona Lisa* (p.262)	
	Raphael	*School of Athens* (p.270)	
		Portrait of Pope Julius II (p.269)	
	Michelangelo	Sistine Chapel Ceiling (p.264)	Beginnings of slave trade (1509)
	Grünewald	*Isenheim Altarpiece* (p.293)	Immortality of the soul pronounced Church dogma (1512)
	Bosch	*Garden of Earthly Delights* (p.288)	Sir Thomas More, *Utopia* (1516)
	Dürer	*Melencolia I* (p.292)	Charles V elected Holy Roman Emperor (1519)
			Martin Luther excommunicated (1520)
1550	**MANNERISM** 16th century		
	Parmigianino	*Self-Portrait in a Convex Mirror* (p.276)	Castiglione, *Book of the Courtier* (1527)
		Madonna of the Long Neck (p.277)	Niccolò Machiavelli, *The Prince* (pub. 1532)
			Henry VIII of England rejects papal authority (1534)
	Michelangelo	*Last Judgment* (p.267)	Founding of Jesuit order by Ignatius Loyola (1534)
	Titian	*Venus of Urbino* (p.273)	Beheading of Thomas More (1535)
	Holbein	*Portrait of Henry VIII* (p.294)	Beheading of Anne Boleyn (1536)
	Cellini	Saltcellar of Francis I (p.279)	
	Bronzino	*Venus, Cupid, Folly, and Time* (p.278)	
	Titian	*Charles V at Mühlberg* (p.274)	Council of Trent (1545–63)
	Brueghel	*Landscape with the Fall of Icarus* (p.289)	Elizabeth I Queen of England (1558)
	Palladio	Villa Rotonda (p.283)	
	Veronese	*Last Supper* (p.280)	
1600	Tintoretto	*Last Supper* (p.280)	Edict of Nantes (1598)
	El Greco	*Resurrection of Christ* (p.282)	Shakespeare, *Hamlet* (1600)

Precursors of the Renaissance

Thirteenth-Century Italy

During the eleventh and twelfth centuries, Italy continued to be accessible to Byzantine influences originating in Greece and Turkey through its eastern ports, particularly Venice and Ravenna. Around the turn of the thirteenth century, however, momentous developments in Italy, inspired by imperial Roman traditions, laid the foundations for a major shift in western European art.

The name given to this period of Italian history, from the thirteenth through the sixteenth centuries, is the Renaissance — the French word for "rebirth," or *la rinascita* in Italian. It denotes a revival of interest in ancient Greek and Roman texts and culture, and Italy was the logical place for such a revival, since the model of imperial Rome was part of her own history and territory.

Nicola Pisano

A good example of the Roman heritage in Italian medieval art is the relief of around 1260 (fig. **14.1**) by the late Gothic sculptor Nicola Pisano (c. 1220–84). It is a detail of his marble **pulpit** from the Baptistery in Pisa, on the west coast of Italy. The scene represents Christ's Nativity, or birth. It is crowded with figures, including, from left to right at the bottom, a bearded Joseph, two midwives washing the infant in a basin, and sheep and goats. The largest figure, showing the influence of Etruscan and Roman tomb effigies, is Mary, whose monumentality and central position evoke her connections with the fertile earth goddesses of antiquity. Although the subject of the *Nativity* is entirely Christian and the scene contains traditional Christian symbolism, such as sheep, goats, and

14.1 Nicola Pisano, *Nativity*, detail of pulpit from the Pisa Baptistery. 1259–60. Marble, c. 34 in (86.4 cm) high. Nicola probably came from southern Italy and trained at the court of Frederick II. When Frederick died in about 1250, Nicola went north to Tuscany. He and his son Giovanni settled in Pisa, where they worked mainly in marble.

Map of leading art centers in Renaissance Italy.

trees, the forms are reminiscent of imperial Roman reliefs. Most clearly related to the Roman past is the artist's rendition of draperies, which define the organic, three-dimensional movements of figures in space.

Nicola Pisano had worked for Frederick II, the German Holy Roman Emperor, in the first half of the thirteenth century. Frederick controlled territories in southern Italy, where his patronage brought French and German artists, as well as Italians, to Capua. At his court, imported and local elements were combined with Frederick's personal taste for ancient Roman styles. Like many rulers before and after him, Frederick used the revival of Classical antiquity for his own political purposes, relating his accomplishments to those of imperial Rome.

Cimabue

The continuing production of Byzantine painting in Italy can be seen in the monumental *Madonna Enthroned* (fig. **14.3**) of around 1280 by Cimabue (c. 1240–1302). The gold background, the flecks of gold in Mary's drapery, the long, thin figures, and the elaborate throne are all characteristics of Byzantine style. The throne has no visible support at the back, but seems instead to rise upwards, denying the material reality of its weight. As in the Middle Ages, the Christ child is depicted with the proportions and gestures of an adult. Four elderly men at the foot of the throne hold scrolls, attributes of Old Testament prophets. Mary and Christ are thus represented according to the typological reading of history (see p.152), by which they embody the New Dispensation in fulfillment of Old Testament prophecy.

Roman Revival in Padua

Padua is a small town about 25 miles (40 km) southwest of Venice. In the second half of the thirteenth century, under a republican form of government, a group of Paduan lawyers developed an interest in Roman law, which led to an enthusiasm for Classical thought and literature in general. Roman theater was revived, along with Classical poetry and rhetoric. As the site of an old and distinguished university, Padua was a logical center for this humanist revival, which acknowledged the primacy of individual intellect, character, and talent. At the end of the thirteenth century, however, it fell under the domination of Milan, and its importance as a humanist center declined.

Fourteenth-Century Italy

Awareness of the Classical revival began to be reflected in the works of several Italian writers, including Petrarch, Dante, and Boccaccio, who began to discuss artists in a new way. For example, Petrarch, an ardent admirer of ancient Roman culture, described Giotto as having brought the art of painting out of medieval darkness into daylight. The Renaissance prided itself, with justification,

on being more literate than the Middle Ages. Literacy among the general population increased dramatically, and works of literature dealt more and more with art and artists, bringing their achievements to the attention of a wider public. Another important feature of the Renaissance in Italy was a new attitude to individual fame. In contrast to the Middle Ages, in which very few artists were known by name, Renaissance artists regularly signed their works. The very fact that the names of so many more Italian artists of the thirteenth and fourteenth centuries are known to us than in the Roman, Early Christian, and medieval periods anywhere in Europe attests the artists' wish to record their identity.

In art, the individual who exemplified, and in large part created, the new developments was Giotto di Bondone (c. 1267–1337). He was born in the Mugello valley near Florence, and in the course of his lifetime became the most famous Italian painter. He lived mainly in Florence, which was to be the early center of the new Renaissance. But his fame was such that he was summoned all over Italy, and possibly also to France, to work on various commissions.

Giotto became the subject of a number of the anecdotes about artists that became increasingly popular from the fourteenth century onward. These were stories which, although not literally true, contained a kernel of psychological truth. The renewal of the anecdotal tradition is itself indicative of the Classical revival, as it derives from fifth-century-B.C. Greece (see pp.24 and 96). Dante's comparison of Cimabue and Giotto (fig. **14.2**) was reflected in a popular anecdote describing Giotto as a boy tending sheep. According to Dante, Giotto was drawing the image of a sheep on a rock when Cimabue happened by.

Dante: The Poet of Heaven and Hell

The Florentine poet Dante Alighieri (1265–1321) wrote the *Divine Comedy*, a long poem divided into three parts: *Inferno* (Hell), *Purgatorio* (Purgatory), and *Paradiso* (Paradise). Dante describes a week's journey in the year 1300 down through the circles of Hell to Satan's realm. From there he climbs up the mountain of Purgatory, with its seven terraces, and finally ascends the spheres of Heaven.

The Roman poet Virgil, author of the *Aeneid*, guides Dante through Hell and Purgatory. The very fact that Dante chooses Virgil as his guide is evidence of the growing interest in Roman antiquity. But because Virgil lived in a pre-Christian era, according to Dante, he cannot continue past Purgatory into Paradise. Instead, it is Beatrice, Dante's dead beloved, who guides him through Heaven and presents him to the Virgin Mary.

Aside from its literary value, Dante's poem is an invaluable source for medieval and early Renaissance history. In the course of his journey, Dante encounters many historical figures to whom he metes out various punishments or rewards, according to his opinion of them.

14.3 Cimabue, *Madonna Enthroned.* c. 1280–90. Tempera on wood, 12 ft 7 in x 7 ft 4 in (3.84 x 2.24 m). Galleria degli Uffizi, Florence. Dante refers to Cimabue in the *Inferno* (see p.213) as an example of "transient glory" because, in spite of the artist's fame during his lifetime, he was overshadowed a generation later by Giotto.

Tempera: Painstaking Preparation and Delicate Detail

Tempera did not originate in the Middle Ages or the Renaissance. Examples are found as early as ancient Egypt. From the medieval period through the fifteenth century, however, tempera was the preferred technique for wooden panel paintings, especially in Italy. For large panels, such as those illustrated in figures **14.2** and **14.3**, elaborate preparations were required before painting could begin. Generally, a carpenter made the panel from poplar, which was glued and braced on the back with strips of wood. He also made and attached the frame. Apprentices then prepared the panel, under the artist's supervision, by sanding the wood until it was smooth. They sealed it with several layers of **size**, a glutinous material used to fill in the pores of the panel and to make a stable surface for later layers. Strips of linen reinforced the wood to prevent warping. The last step in the preparation of the panel was the addition of several layers of **gesso**, a water-based paint thickened with chalk and size. Once each layer of gesso had dried, the surface was again sanded, smoothed, and scraped. The gesso thus became the support for the artwork.

At this point, painting could begin. Using a brush, the artist lightly outlined the figures and forms in charcoal before reinforcing the outline with ink. The decorative gold designs, halos, and gold background were applied next, and were polished so that they would glow in the dark of the churches.

Apprentices made the paint by grinding pigments from mineral or vegetable extracts to a paste and suspending them in a mixture of water and egg. The artist then applied the paint with small brushes made of animal hair. Because tempera dries fairly quickly, only a limited area could be painted at one time. The tempera medium lends itself to precise details and clear edges. Once the artist had completed the finishing touches, the painting was left to dry — a year was the recommended time — and then it was varnished.

Instantly recognizing the artistic genius of the young shepherd, the older artist was said to have obtained permission from Giotto's father to train his son as a painter.

A comparison of Giotto's *Madonna Enthroned* (fig. **14.2**) of c. 1300 with Cimabue's (fig. **14.3**) illustrates their different approaches to space and to the relationship between space and form. Both pictures are tempera on panel and were intended as **altarpieces**. Giotto's is surrounded by an architectural frame that cuts off parts of

14.2 (opposite) Giotto, *Madonna Enthroned* (Ognissanti Madonna). c. 1310. Tempera on wood, 10 ft 8 in x 6 ft 8 in (3.25 x 2.03 m). Galleria degli Uffizi, Florence. Despite Giotto's fame, few of his works are undisputed. This is the only panel painting unanimously attributed to him. It was commissioned for the Church of Ognissanti (All Saints) in Florence.

the angels around the throne. In the Cimabue, there is no such framework. Both have elaborate thrones (Giotto's with Gothic pointed arches), Byzantine gold backgrounds, and flat, round halos that do not turn illusionistically with the heads. Whereas Cimabue's throne rises in an irrational, unknown space (there is no floor), Giotto creates a rational horizontal support with steps approaching the throne. Unlike Cimabue's long, thin, elegant figures, Giotto's are bulky. Their draperies correspond convincingly to organic form, and they appear to obey the laws of gravity. Giotto has thus created an illusion of three-dimensional space — his figures seem to turn and move as in nature.

Whereas Cimabue uses flecks of gold to emphasize Mary's drapery folds, Giotto's folds are rendered by shading. Giotto's V-shaped folds between Mary's knees identify both their solidity and the void between them, while the curving folds above her waist impart a suggestion of

Training in the Master's Workshop

In the Middle Ages and Renaissance, artists learned their trade by undertaking a prolonged period of technical training in the shop of a master artist. Young men became apprentices (there are no records of women apprentices) in their early teens, either because they had already shown talent or because their families wanted them to be artists. Artists usually came from the middle classes, often from families of artists. Quite a few married into such families and went into business with their relatives.

The term of apprenticeship varied. Cennino Cennini, the fourteenth-century author of a book on painting technique, recommended six years. Apprentices began learning their trade at the most menial level. They mixed paints, prepared pigments and the painting surface, and occasionally worked on less important border areas or painted the minor figures of a master's composition. By the time an apprentice was ready to start his own shop, he had a thorough grounding in techniques and media. He would probably also have assimilated elements of his master's style.

Art was in demand in the Renaissance, and artists were a large professional group in relation to the general population. The demand for art was the result of an increase in the sources of patronage. During the Middle Ages, most of the patronage had been ecclesiastic, or from the Church authorities. In the Renaissance, art was also commissioned by civic or corporate groups, and even by wealthy individuals. The commissions were generally sealed by legal contact between artist and patron, and these contracts have become an important documentary source for modern art historians.

Fresco: A Medium for Speed and Confidence

From the thirteenth to the sixteenth centuries, there was a significant increase in the number of monumental fresco cycles, especially in Italy.

Fresco cycles were typically located on plaster walls in churches or private palaces, and large scaffolds were erected for such projects. First, the wall was covered with a coarse plaster, called the *arriccio*, which was rough enough to hold the final layer of plaster. When the first layer had dried, the artist found his bearings by establishing the exact center of the surface to be painted, and by locating the vertical and horizontal axes. He blocked out the composition with charcoal, and made a brush drawing in red ocher pigment mixed with water. These drawings are called *sinopie* (*sinopia* in the singular) after Sinope, a town on the Black Sea known for the red color of its earth.

Once the artist had completed the *sinopia*, he added the final layer of smooth plaster, or *intonaco*, to the walls one patch at a time. The artist applied the colors to the *intonaco* while it was still damp and able to absorb them. Thus when the plaster dried and hardened, the colors became integrated with it. Each patch was what the artist planned to paint in a single day, and so it was called the *giornata*, the Italian word for a day's work. Because each *giornata* had to be painted in a day, fresco technique encouraged advance planning, speed of execution, broad brushstrokes, and monumental forms. Sometimes small details were added in tempera, and certain colors, such as blue, were applied *secco* (dry). They have been largely lost or turned black by chemical reaction.

contrapposto and also direct the viewer's attention to Christ.

A comparison of the two figures of Christ reveals at once that Giotto was more interested in the reality of childhood than Cimabue. The latter's Christ retains aspects of the medieval *homunculus*, or little man. He has a small head and thin proportions, and he is not logically supported on Mary's lap. Giotto's Christ, on the other hand, has chubby proportions and rolls of baby fat around his neck and wrists; he sits firmly on the horizontal surface of Mary's leg. Although Giotto's Christ is in a regal and frontal position, his right hand raised in a gesture of blessing — not at all the pose that a normal baby would adopt — his proportions are more natural than those of Cimabue's Christ.

It was precisely in the rendition of nature that Giotto seemed to his contemporaries to have surpassed Cimabue and to have revived the forms of antiquity. This represented a breakthrough in style — the pupil outstripping his teacher — and heralded the emergence of a new generation of artists. Giotto's success also exemplifies the benefits of the master–apprentice relationship in medieval and Renaissance artistic training.

The Arena Chapel

The best preserved examples of Giotto's work are the paintings in the Arena Chapel in Padua. The Arena Chapel, which derives its name from the old Roman arena adjacent to it, was funded by Enrico Scrovegni, Padua's wealthiest citizen. Having inherited his fortune from his father Reginaldo, whom Dante had consigned to the seventh circle of Hell for usury, or moneylending, Scrovegni commissioned the chapel and its decoration as an act of atonement.

The Arena Chapel is a simple, barrel-vaulted, rectangular building, faced on the exterior with brick and plain pilasters. The interior is decorated with one of the most remarkable fresco cycles in western art (fig. **14.4**).

14.4 (opposite) Interior view of the Arena Chapel (Cappella Scrovegni), Padua, toward the choir. In this illustration, we face east toward the round chancel arch, which is reminiscent of Roman triumphal arches. At the very top of the arch, in a tempera panel set into the plaster wall, God the Father is depicted enthroned. He summons the angel Gabriel and entrusts him with the Annunciation of Christ's birth to Mary.

Cardinal Virtues and Deadly Sins

The seven Christian Virtues and Vices, or Deadly Sins, are commonly personified in Christian art. The seven Virtues are divided into four Cardinal Virtues — Prudence, Temperance, Fortitude, and Justice — and three Theological Virtues — Faith, Hope, and Charity.

The seven Vices vary slightly, but generally consist of Pride, Covetousness, Lust, Envy, Gluttony, Anger, and Sloth.

14.5 Giotto, *Crucifixion*, Arena Chapel, Padua. c. 1305. Fresco. The raised ground beneath the cross represents the hill of Calvary (from the Latin *calvaria*, meaning "skull"). According to tradition, Christ was crucified on the Hill of the Skulls just outside Jerusalem. The skull that appears in the opening of the rock is Adam's — a reminder of the tradition that Christ was crucified on the site of Adam's burial. Both that tradition and its visual reference here are typological in character (see p.152), for Christ was considered the new Adam and the redeemer of Adam's sins.

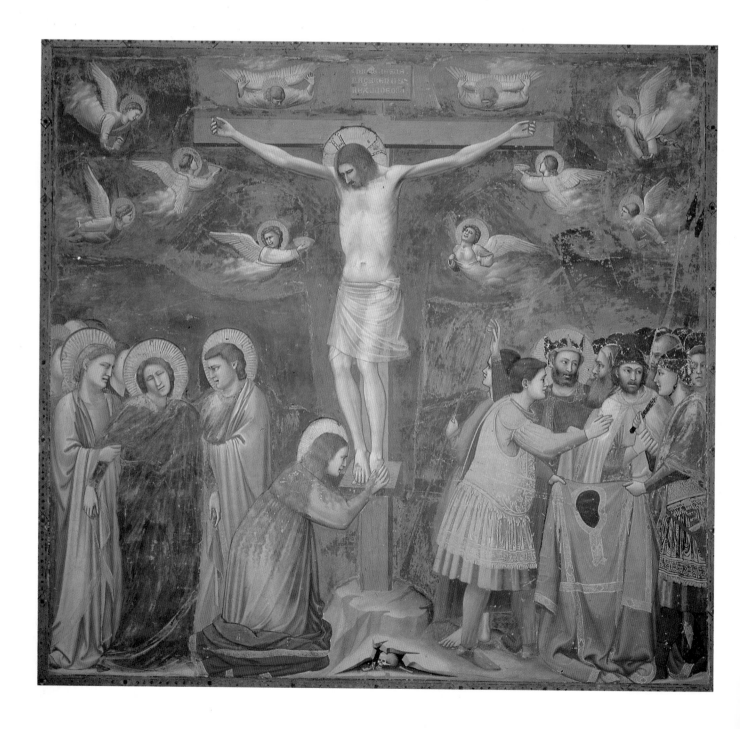

Architectural elements are kept to a minimum: the south wall has six windows and the north wall is solid, making it an ideal surface for fresco painting. The western entrance wall, which has one window divided into three lancets, is covered with an enormous *Last Judgment*.

On the north and south walls, three levels of rectangular narrative scenes illustrate the lives of Mary, her parents Anna and Joachim, and Christ. Below the narrative scenes on the north and south walls are Virtues and Vices disposed according to traditional left–right symbolism. As the viewer enters the chapel, the Virtues are on the right and the Vices on the left. Facing the observer is the chancel arch, containing *Gabriel's Mission* at the top, other events from Christ's life, and two illusionistic chapels.

Immediately below *Gabriel's Mission*, separated into two images on either side of the arch, is the *Annunciation*. Its setting is a rectangular architectural space with projecting balconies that seem to confirm the anecdotes praising Giotto's ability to deceive the viewer with illusionism. Equally illusionistic are the painted curtains, which appear to hang outside the architecture and swing in toward the windows.

Illusion is an important aspect of theater, and in the Arena Chapel the space in which the sacred drama unfolds has been compared to a stage. In the *Annunciation* (fig. **14.4**), for example, the painted space is three-dimensional but narrow — more like stage space than real space. The architecture, likewise, is relatively small in comparison to the figures in a manner akin to stage sets. Gabriel and Mary face each other across the span of the arch, concentrating on their own drama, while the viewer observes them as if through the "fourth wall" of a stage. The combination of Classical restraint and psychological insight in Giotto's frescoes may also be related to the contemporary revival of Classical drama in Padua. It is likely, although it cannot be documented except by the evidence of the pictures themselves, that in creating the most dramatic fresco cycles of his generation Giotto was influenced by the revival of Roman theater and by the traditional Christian mystery plays performed in front of churches. This combination of influences may also explain Giotto's psychological depictions of pose and gesture.

In the *Annunciation*, both Mary and Gabriel are rendered as solid, sculpturesque figures, their poses identified mainly by their drapery folds. Gabriel raises his right hand in a gesture of greeting. Mary holds a book, signifying that Gabriel has interrupted her reading. The source for this conventional detail in Annunciation scenes is the Apocrypha (see p.152). As Gabriel makes his announcement, diagonal rays of light enter Mary's room. Since there is no logical or natural source for this light, one must assume that it is divine light, emanating from Heaven. As such, it is prophetic of the symbolic light, or en*light*enment, that Christ will bring to the world. Equally prophetic is Mary's gesture, for her crossed arms refer forward in time to Christ's Crucifixion. According to Christian doctrine, this is the means by which salvation is achieved.

The events leading up to and including Christ's Crucifixion are referred to as the Passion of Christ. In the Arena Chapel, the *Crucifixion* is located on the north wall. In contrast to the *Annunciation*, the *Crucifixion* (fig. **14.5**) takes place outdoors, on a narrow, rocky piece of ground. Christ hangs from the cross, his body pulled down by the force of gravity, his neck and shoulders forced below the level of his hands. His arms are elongated, his muscles are stretched, and his ribcage is visible beneath his flesh. Transparent drapery reveals the organic form of his body. Family and friends are gathered to Christ's right. Mary, dressed in blue, slumps in a faint, her weight supported by St. John and an unidentified woman. Forming a diagonal bridge from Mary and John to the cross is the kneeling figure of Mary Magdalen, traditionally understood to have been a prostitute before she became one of Christ's most devoted followers. In this painting, she wears her hair long, an iconographic attribute denoting penance.

In contrast to the formal and psychological link between Christ and his followers on his right, there is a void immediately to the left of the cross. The symbolic distance between Christ and his executioners is reinforced by the diagonal bulk of the Roman soldier leaning to the right. The group of soldiers haggles over Christ's cloak, which one soldier prepares to divide up with a knife. (It was customary in western Europe to pay the executioner in part by giving him the clothes worn by the victim. Possibly this custom became merged with the conventional iconography of the Crucifixion.) Framing the head of a Roman soldier in the background is a halo, which sets him apart from the others and identifies him as Longinus, who later converted to Christianity.

The sky is filled with two symmetrical groups of mourning angels. Like a Greek chorus, they echo and enhance the human emotions of Christ's followers. The different spatial positions of the angels are indicated by varying degrees of foreshortening, the two above the arms of the cross being the most radically foreshortened. Two angels extend cups to catch Christ's blood flowing from his **stigmata**, or wounds. The greater formal activity and melodrama of the angels act as a foil to the Classical restraint of the human figures.

Chronologically, the last scene in the chapel is the *Last Judgment* (fig. **14.6**), which fulfills the Christian prophecy of Christ's Second Coming. The finality of that event corresponds to its location on the western wall of the Arena Chapel, where it is the last image to confront viewers on the way out. The sheer size of Giotto's *Last Judgment*, which takes up the entire wall, adds a monumental dimension to its impact and reinforces the sense of finality. A similar quality can still be found in modern theatrical productions, in which the so-called grand finale assembles the whole cast on stage at the end of a performance. Similarly, Giotto has assembled the host of Heaven, consisting of military angels, on either side of the window. Above the angels, two figures roll up the sky, to reveal the golden vaults of Heaven, just as two stagehands might roll up a curtain or strike the sets.

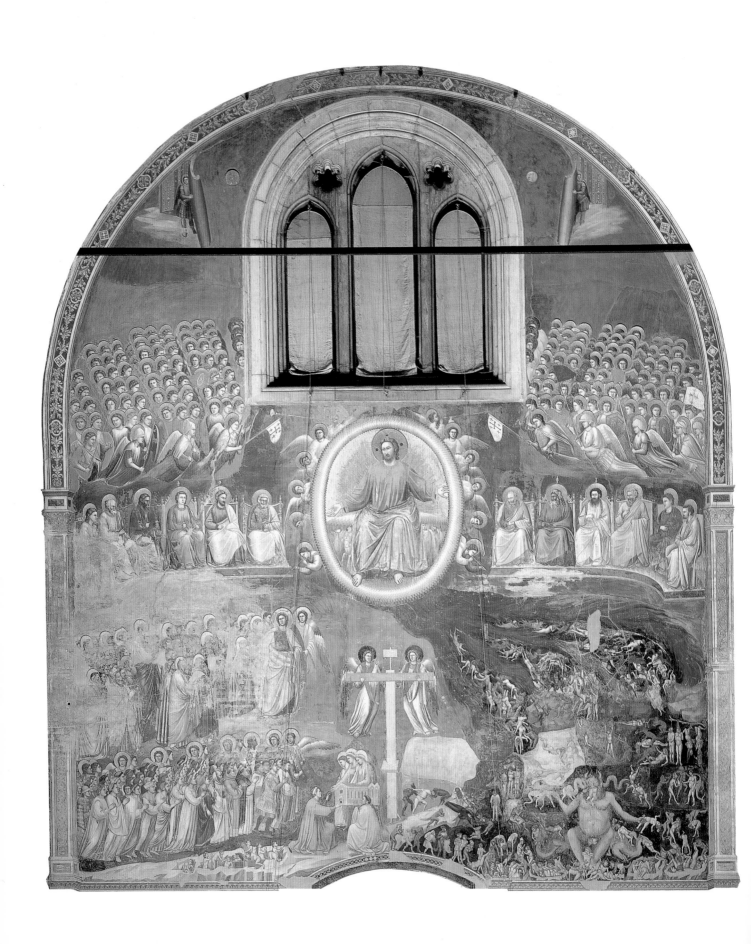

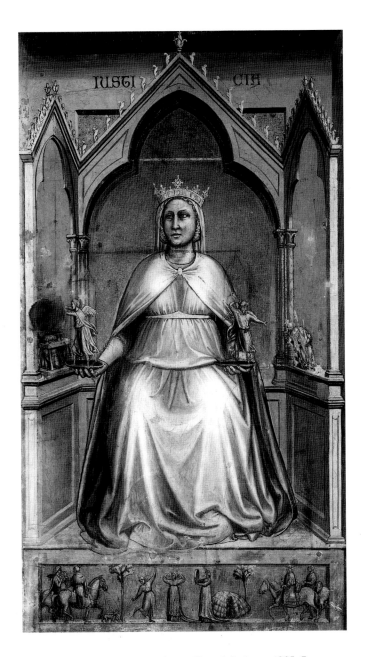

14.7 (above) Giotto, *Justice*, Arena Chapel, Padua. c. 1305. Fresco. Justice is personified as an enthroned queen in a Gothic architectural setting. She holds a Nike in her right hand, as did Phidias's Athena in the Parthenon *naos*, indicating that justice brings victory. Justice also leads to good government and a well-run state, with all the benefits that this implies. Painted as an imitation relief in the rectangle at the bottom of the picture are images of dancing, travel (men on horseback), and agriculture.

14.6 (opposite) Giotto, *Last Judgment*, Arena Chapel, Padua. c. 1305. Fresco, c. 33 ft × 27 ft 6 in (10.06 × 8.38 m). Enrico Scrovegni, assisted by a monk, lifts up a model of the Arena Chapel and presents it to three female saints. As he holds the model, Scrovegni faces the exterior of the entrance wall — the wall on which the *Last Judgment* is painted. The illusionistic detail of the monk's cloak, painted to look as if falling out of the picture plane over the doorway arch, is another illustration of Classical taste.

Immediately below the window, Christ sits in a circle of light, surrounded by angels. Seated on a curved horizontal platform on either side of Christ are the twelve apostles. Christ's right hand summons the saved souls, while his left rejects the damned, and he inclines his head to the lower left of the fresco (his right), where two levels of saved souls rise upward. At the head of the upper group stands the Virgin Mary, who appears in her role as intercessor with Christ on behalf of humanity.

Giotto's Hell, placed, according to convention, below Heaven and on Christ's left, is the most medieval of the Arena Chapel frescoes. It is surrounded by flames emanating from the circle around Christ. In contrast to the orderly rows of saved souls, those in Hell are disordered — as in the Romanesque example from Conques (fig. **12.5**). The elaborate visual descriptions of the tortures inflicted on the damned by the blue and red devils, and their contorted poses, are reminiscent of medieval border figures, whether on manuscripts or church sculptures.

The large blue-gray Satan in the depths of Hell is typical of the medieval taste for monstrous forms merging with each other. The characteristic oral aggression of many medieval manuscripts recurs in Giotto's Hell — Satan swallows one soul while the serpentine creatures who emerge from his ears bite into other souls. Dragons on either side of Satan's rear also swallow souls, and from the ear of one of the dragons rises a ratlike creature biting into a soul, who falls backwards in despair. The falling and tumbling figures emphasize the Christian conception of Hell as disorderly and violent.

Directly under Christ, two angels hold the cross, which divides the lower section of the fresco into the areas populated by the saved and the damned. Behind the cross, a little soul exemplifies Giotto's anecdotal reputation for humor by trying to sneak by and escape from Hell to the side of the saved. Toward the bottom of Hell, a bishop, recognizable by his miter, is approached by a damned soul holding a bag of money, possibly hoping to buy an indulgence (see p.276). Besides being a criticism of corruption in the Church, this detail may be an implied reference to the financial sin of Enrico's father, which was the prime cause for the dedication of the chapel. Not surprisingly, Giotto placed his patron, Enrico Scrovegni, on the side of the saved. As Scrovegni kneels, his drapery falls on the ground in soft folds, suggesting the weight of real fabric. Such individualization of the patron, or donor, within the work of art was to become characteristic of the Renaissance.

Before leaving the Arena Chapel, we consider the virtue, *Justice* (fig. **14.7**), which illustrates the contemporary Italian concern with government. Two forms of government prevailed in Italy as the Renaissance dawned. Popes and princes led the more authoritarian systems, while republics and communes were more democratic. Although the latter were, in practice, more often oligarchies (governments controlled by a few aristocrats) than democracies in the modern sense, republican government was nevertheless based on the Classical ideal.

Ambrogio Lorenzetti and the Effects of Good Government

Some thirty years after Giotto had completed the Arena Chapel frescoes, the innovative Sienese artist Ambrogio Lorenzetti painted *Allegories of Good and Bad Government* in the Palazzo Pubblico (town hall) of Siena. Figure **14.8**, like Giotto's *Justice*, illustrates the effect of good government on a city—in this case Siena. It depicts a broad civic panorama with remarkable realism, given the limited knowledge of perspective at the time. In the foreground, women wearing the latest fashions dance and sing in celebration of the joys of good government. People ride on horseback among the buildings, whose open archways reveal a school, a shoe store, and a tavern. A detail on the right depicts country life, as farmers are shown entering the city to sell their produce. On top of the central building in the background, workers carry baskets and lay masonry. Lorenzetti suggests that both agricultural prosperity and architectural construction are among the advantages of good government.

Just outside the city walls, people are shown riding off to the country. Below, a group of peasants tills the soil, and the cultivated landscape visible in the distance draws the viewer into a degree of spatial depth unknown since the decline of the Roman Empire. Floating above this tranquil scene, an allegorical figure of Security holds a scroll with an inscription reminding the viewer that peace reigns under her aegis. And should one fail to read the inscription, she provides a pictorial message in the form of a gallows. Swinging from the rope is a criminal executed for violating the laws of good government. Accompanying Ambrogio's vision of prosperity and tranquility, therefore, is a clear warning of the consequences of social disruption.

Ambrogio Lorenzetti's monumental secular painting is one of the first of its kind in western art since Christianity had become the official religion of Rome. It reflects the shift that had occurred in patronage, which was no longer exclusively tied to the church.

As Lorenzetti's work reveals, the new cultural and intellectual concerns of the early fourteenth century had resulted in a revolutionary development in style. Giotto had created a new approach to painted space, influenced as he was by the sculpture of Nicola Pisano and his son Giovanni, and by a revival of Classical culture. For the first time since Greco-Roman antiquity, human figures occupy three-dimensional settings. They turn and move freely in

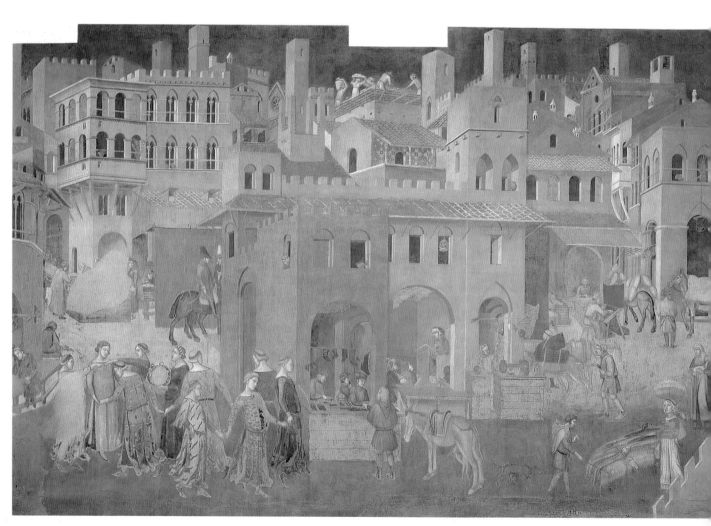

that space, obeying the laws of gravity. Backgrounds are no longer gold, but rather defined by natural blue skies or landscape. Architecture is set at an oblique angle to the picture plane, creating an illusion of spatial recession.

We shall never know how the next generations of fourteenth-century Italian artists might have advanced the new developments introduced by Giotto had one of the great disasters of western European history not intervened. A series of economic and agricultural crises hit Tuscany — especially Florence and Siena — in the 1340s, including the Black Death (a bubonic plague) of 1348. Between fifty and seventy-five percent of the residents of Florence and Siena died of the plague, resulting in major population shifts and radical changes in artistic patronage and style.

Contemporary sermons document a resurgence of religious fervor following the Black Death. In the visual arts there was a reversion to the Byzantine style. The increasing humanism of the first half of the century yielded to a more pessimistic view of the world, with greater emphasis on death and damnation. The innovations of Giotto and other early fourteenth-century artists remained in abeyance until taken up by the first generation of painters, sculptors, and architects of the fifteenth century.

14.8 Ambrogio Lorenzetti, *Allegory of Good Government: The Effects of Good Government in the City and the Country*, Sala della Pace, Palazzo Pubblico, Siena. 1338–9. Fresco, entire wall 46 ft (14 m) long. Ambrogio was the younger of two artist-brothers who were active in the first half of the fourteenth century. Both were born and worked in Siena, and they are believed to have died from the Black Death, since nothing is heard of them after 1348. Ambrogio also worked in Florence, where he was exposed to Giotto's style. The *Allegory of Good Government*, which has considerable documentary value as well as artistic merit, is considered his greatest surviving work.

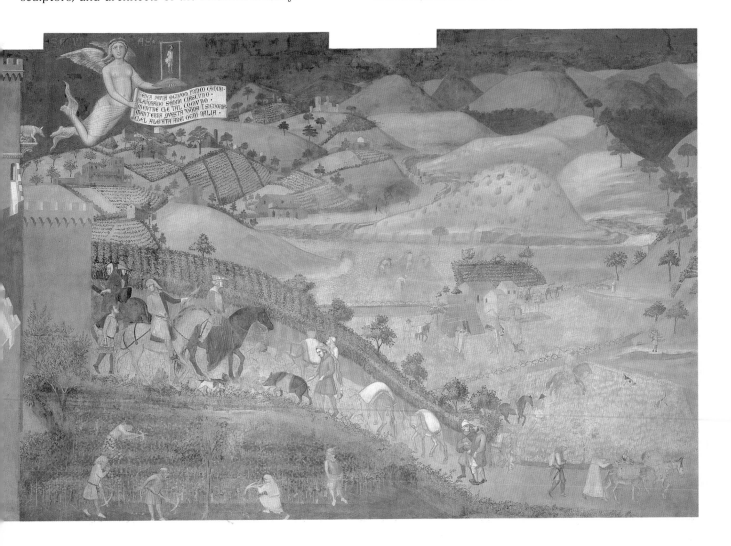

The Early Renaissance

Fifteenth-Century Italy

For most of the Quattrocento (or 1400s), the city of Florence in Tuscany was the intellectual, financial, and artistic center of Renaissance Italy. Florence followed the lead of the fourteenth-century poet Petrarch in its pursuit of humanism and the Classical revival, and fifteenth-century writers, such as Leonardo Bruni, extolled Florence as the new Athens. A chair of Greek studies had been established in Florence during the 1390s, thereby making available translations of Plato and other Greek authors.

The dominant Florentine banking family in the fifteenth century, the Medici, were among the leading humanists. They, and other powerful families, backed humanism both financially and philosophically. They encouraged the study of Plato and of Neoplatonism — the goal of which was to reconcile Christianity with Platonic philosophy. They collected ancient Greek and Roman sculpture, and gave contemporary artists access to it. Humanist patrons also commissioned works by the most progressive fifteenth-century artists, particularly those who were humanists themselves.

The new Renaissance interest in individual fame was associated not only with territorial, financial, and political power, but also with the arts. Renaissance patrons understood the power of imagery and used it to extend their fame and influence beyond the borders of their own states. Art became a symbol of status and power. Just as artists and writers competed for patronage, so too patrons competed among themselves, considering those who worked for them as a reflection of their own importance.

Courts throughout Italy thus became thriving centers of artistic activity and vied with each other for the leading humanists of the day. They employed scientists, writers, architects, painters, and sculptors, and established libraries as collections of Classical and Christian manuscripts expanded. The courts also became centers of humanist education. Some, such as the Gonzaga court at Mantua, founded innovative schools where promising students from less wealthy families were educated alongside the children of the nobility. In the most enlightened families, girls were taught together with boys, and both learned Latin and Greek, as well as other humanist subjects. The humanist schools also stressed physical education, discipline, and intellectual pursuits. Girls and boys learned sports, including swimming, ball games, and horse-riding, but boys were more likely than girls to study the martial arts.

By the time these students became princes, dukes, and duchesses themselves, they were skilled in politics, diplomacy, and rhetoric, and were knowledgeable in the classics. In many cases, women were sufficiently well educated to run the state while their husbands were away — either fighting as *condottieri* or engaged on diplomatic missions. Women as well as men became important patrons of the arts, for they too were involved in the design of palaces, churches, and other buildings. Painters and sculptors made portraits of their patrons, or, as in the Arena Chapel (see p.221), included their portraits in monumental fresco cycles. The humanist writers praised their patrons in works of literature, which were generally based on the models of ancient Greece and Rome.

Artists gained stature as they too became classically educated. Leon Battista Alberti (see p.238), for example, the great humanist theoretician and critic of the arts, and later an architect himself, recommended a humanist education for all artists and advised them to befriend poets, orators, and princes. Lorenzo Ghiberti, the goldsmith and sculptor whose *Commentarii* of around 1450 combined art theory with history, biography, and autobiography, also insisted that artists should be well educated.

Inspired by their studies, artists and others who admired antiquity traveled to Rome to draw ancient ruins, while antiquarians went to Greece to collect Classical texts and original Greek statuary. This search for the Classical past was combined during the Renaissance with an interest in empirical experience and a taste for intellectual and geographical discovery. In the second half of the fifteenth century, for example, Leonardo da Vinci pursued science as well as art, dissecting bodies and producing detailed anatomical drawings (fig. **16.11**). The invention of printing and the use of movable type in the fifteenth

Soldiers of Fortune

Condottiere (*condottieri* in the plural) is the Italian word for a soldier of fortune. During the Renaissance, Italy was divided into separate states, and individual mercenaries led armies of one state against another, according to their loyalties, their pay, or both. A *condottiere* could be a ruler earning money for his state, as was Federico da Montefeltro (fig. 15.22), or a private citizen, such as Gattamelata (fig. 15.19), who had trained as a soldier. Training to be a *condottiere* took place under a kind of apprentice system, usually through the tutelage of an experienced "master" *condottiere*. In the course of the fifteenth century, several *condottieri* were honored with portraits commissioned by the states for which they had fought.

century made books more available to the general population. At the end of the century, financed by Spain, Columbus sailed to America in Medici ships, thereby heralding the great age of world exploration in the sixteenth century.

One of the most energizing features of the Renaissance was its interdisciplinary nature. New combinations of subjects led to new areas of synthesis. The most pervasive effects derived from the integration of antiquity, and therefore history and ancient art, with the ideas and attitudes of the Quattrocento. The medieval scholastic tradition had integrated Aristotelian thought with Christianity. The Renaissance added Plato and a revival of Platonic ideas. Far from treating this "pagan" influence as threatening, the most enlightened Renaissance popes encouraged the humanist assimilation of ancient Greek and Roman philosophy into their own Christian faith.

Architecture

The Competition for the Baptistery Doors. During the Renaissance, there was an increase in the range of patronage. A good example of this expansion can be seen in the 1401 competition to design a set of doors for the Florence Baptistery. A fourteenth-century pair of doors was already in place, but two more were needed. Each was to be decorated with gilded bronze reliefs illustrating Old and New Testament scenes. Members of the wool-refiners' guild supervised the contest, and clerics, artists, and businessmen comprised the jury. The subject chosen for the competition was the Old Testament sacrifice of Isaac. Isaac's father, Abraham, obeys God's command to sacrifice his only son as an act of faith. At the last moment, an angel intervenes, and Abraham, having proved his obedience to God, substitutes a ram for Isaac.

Of the seven contestants, the most important were two young men in their twenties: Filippo Brunelleschi (1377–1446) and Lorenzo Ghiberti (born c. 1381). Ghiberti won the competition, despite, or perhaps because of, his less monumental, more graceful style. Brunelleschi's figures (fig. **15.1**) are more direct and forceful. His

Abraham, for example, grasps Isaac by the throat and has to be physically restrained by the angel. The thrust of Brunelleschi's Abraham, emphasized by his drapery folds, is more energetic than Ghiberti's (fig. 15.2), whose body leans away from his intended victim. The implied ambivalence of Ghiberti's figure is reinforced by the way in which the left knee turns away from Isaac and the draperies curve toward the left.

There are no known records explaining the decision of the judges. From the perspective of hindsight, however, it is clear that both reliefs are indebted to the new synthesis of Classical and Christian thought. The depiction of nature in both reliefs continues Giotto's early fourteenth-century interests. Landscape forms provide a narrow, but convincing, three-dimensional surface that rationally supports the figures. The cubic altars on which both Isaacs kneel are set at oblique angles to the relief surfaces, so that, as in the case of Giotto's architecture, their sides imply recession into space. Examples of radical foreshortening in certain figures, such as Ghiberti's angel and the man leaning forward on the lower right of the Brunelleschi, also enhance the impression of three-dimensional space.

Political and civic levels of meaning can be discerned in the very fact of the competition. Florence had recently been ravaged by plague, which had killed some 30,000 citizens. The survivors probably identified with Isaac. Danger had also come from the powerful and tyrannical duke of Milan, who threatened the Florentine republic. With the duke's death in 1402, Florence must have felt that she, like Isaac, had been granted a reprieve.

Brunelleschi and Architecture. Brunelleschi was the seminal figure in Renaissance architecture. After losing the Baptistery competition to Ghiberti, he was said to have given up sculpture. He moved for a few years to Rome, where he studied ancient buildings and monuments. The sixteenth-century biographer of the artists, Giorgio Vasari, records the effect of Rome on Brunelleschi: "Through the studies and diligence of Filippo Brunelleschi, architecture rediscovered the proportions and measurements of the antique. . . . Then it carefully distinguished the various orders, leaving no doubt about the difference between them; care was taken to follow the Classical rules and orders and the correct architectural proportions. . . . "

The roots of Brunelleschi's early architecture can be traced to Classical precedents. In contrast to the complexity of Abbot Suger's search for perfect mathematical ratios based on musical harmonies (see p.189), Brunelleschi's concept of architectural beauty lay in strict, but simple, proportions. Shapes such as the circle and square and simple ratios formed the basis of his designs. He constructed round, rather than pointed, arches, which were supported by Classical columns instead of Gothic piers. In introducing these systems, Brunelleschi contributed to the Renaissance revival of Classical forms and to the rejection of the Gothic.

15.1 Filippo Brunelleschi, *The Sacrifice of Isaac*, competition panel for the east doors of the Florence Baptistery. 1401–2. Gilt bronze relief, 21 × 17 in (53.3 × 43.2 cm). Museo Nazionale del Bargello, Florence.
15.2 Lorenzo Ghiberti, *The Sacrifice of Isaac*, competition panel for the east doors of the Florence Baptistery. 1401–2. Gilt bronze relief, 21 × 17 in (53.3 × 43.2 cm). Museo Nazionale del Bargello, Florence.

15.1 and **15.2** Both artists were born in Florence — Brunelleschi, the son of a lawyer, trained as a gold- and silversmith, while Ghiberti was the son of a goldsmith. The scenes are framed by a **quatrefoil**, or four-leaf clover shape, and depict the moment when the angel appears just in time to prevent Abraham from cutting his son's throat.

The Dome of Florence Cathedral. On returning to Florence about 1410, Brunelleschi became actively involved in the design and execution of the dome of Florence Cathedral (fig. **15.3**), across the way from the Baptistery. The dome of the cathedral had been a perennial problem for the Florentines. In 1294 they had decided to rebuild their old cathedral and in the course of the fourteenth century they had enlarged the original design. By the fifteenth century the cathedral required a dome to surmount an octagonal drum (already in place) measuring 138 feet (42 m) across.

In Rome, Brunelleschi had learned from the Pantheon — whose hemispherical dome was 142 feet (43.28 m) in diameter — that it was theoretically possibly to span an opening of this width. However, the design of Florence Cathedral did not lend itself to Roman building techniques. The octagonal drum in Florence was too weak to support a heavy concrete dome, and it was also too wide to be built with wooden centering, as in the Middle Ages (see p.130). Between 1417 and 1420, Brunelleschi developed his proposal for a horizontal construction plan based on a system of vertical ribs to strengthen the dome (fig. **15.4**). He reduced the weight of the structure by building two thin shells, comprising a single dome and connected with horizontal ties placed at intervals. He also constructed the walls of the dome at a steep angle, so that

they rose 58 feet (17.68 m) before needing support from below. Brunelleschi's plan was accepted. This undertaking was to last until 1436, and Brunelleschi died before the **cupola**, which he also designed, could be completed. The end result was nevertheless a triumphant success, and figure **15.3** shows the cathedral dominating central Florence today.

Brunelleschi and Scientific Perspective. In addition to establishing the basis for Renaissance architecture, Brunelleschi is credited with the invention of linear perspective. Giotto and other fourteenth-century painters had already used oblique views of architecture and natural settings to create an illusion of spatial recession on a flat surface. But their empirical system had not provided an objective way to determine the relative sizes of figures and objects on a picture plane or the surface of a relief. Brunelleschi's invention gave artists a mathematical technique that would enable them to pursue the Renaissance ideal of creating a space that would appear to replicate nature. Although the paintings Brunelleschi produced to illustrate his new discovery are lost, they have been described by Leon Battista Alberti (see p.238) in *On Painting*, written in about 1435. The technique was immediately taken up by the most progressive artists of the fifteenth century.

15.3 (above) Exterior of Florence Cathedral. According to Vasari, Brunelleschi's rivalry with Ghiberti did not end with the Baptistery doors. Ghiberti's political connections won him a commission to work with Brunelleschi on the dome of Florence Cathedral for equal credit and equal pay. Brunelleschi found fault with Ghiberti's work and ideas, but his protests fell on deaf ears. It was not until he took to his bed, feigning illness and refusing to advise on the project, that Ghiberti was removed — although he was allowed to keep his salary.

Vasari's *Lives*

Giorgio Vasari (1511–74) was a Mannerist architect and painter (see p.275). Born in Arezzo, he lived and worked in Florence for the Medici family. Cosimo I commissioned him to design the Uffizi Palace. This was originally a building for the government judiciary, but is now the most important art museum in Florence.

Vasari's architecture and painting are overshadowed by his writings. His major work, *The Lives of the Most Eminent Italian Architects, Painters, and Sculptors*, is the first full account of Renaissance art. The first edition of 1550 began with Cimabue and ended with Michelangelo, a friend and contemporary of Vasari. A second edition gave more prominence to painting, and included Vasari's own autobiography. Although Vasari's facts are not always accurate, he is a major source of information about art and artists in the fourteenth, fifteenth, and sixteenth centuries. Vasari believed that medieval art was an inferior product of the Dark Ages, which were no more than an unfortunate interlude between Classical antiquity and the Italian Renaissance.

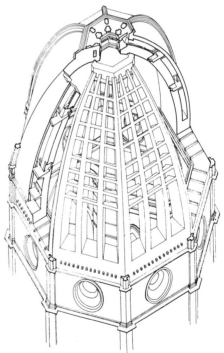

15.4 Axonometric section of the dome of Florence Cathedral. The dome has a total of twenty-four ribs. Eight primary ribs, approximately 11 by 7 feet (3.35 × 2.13 m), taper upward, one from each of the corners of the octagonal drum. These are visible from the outside, but the two secondary vertical ribs that lie between each pair of primary ribs are not. The overall height of the dome is slightly over 100 feet (30.48 m), compared with a radius of less than 70 feet (21.34 m), making the dome pointed rather than perfectly hemispherical.

Lines of Vision

The observed fact that distant objects seem smaller than closer ones, and that the far edge of uniformly shaped objects appear shorter than the near edges, determined the Renaissance theory of **linear**, or geometric, **perspective**. This provided artists with a mathematical method for depicting figures and objects as if they were at increasing or decreasing distances from the viewer.

Brunelleschi conceived of the picture plane (the surface of a painting or relief structure) as a window. The frame of the painting acts as the window frame. The contour lines of rectilinear objects (e.g. architectural features such as roofs, walls, or rows of columns, are extended along imaginary "lines of sight," which are perpendicular to the picture plane. Such lines are called **orthogonals** (from the Greek *orthos*, meaning "right" or "straight" and *gonia*, meaning "angle"). They converge at a single point, known as the **vanishing point**. This point usually lies on the horizon, corresponding to the viewer's eye-level. However, it can be anywhere inside the composition or even outside it, depending on the artist's organization of the picture space and content. Such a system is known as one-point perspective.

Artists using Brunelleschi's system usually made perspective studies in the planning stages of their work. Most were on paper and are now lost. Leonardo da Vinci's study, or preliminary drawing, for the *Adoration of the Magi* (fig. **15.5**) allows us a rare look at an artist's working plans laid out in schematic form.

Linear perspective permitted Renaissance artists to fulfill their ideal of creating the illusion of nature on a flat surface. In Mantegna's *Dead Christ* (fig. **15.6**), for example, the radical foreshortening is made possible by the perspective construc-tion — even though the figure is idealized compared to a real corpse.

Another fifteenth-century painter who delighted in solving perspectival problems was Paolo Uccello (1397–1475). In his drawing of a chalice in figure **15.7**, Uccello uses geometric shapes, mainly squares and rectangles, to create the illusion of spinning motion in a rounded, transparent object.

15.5 Leonardo da Vinci, Perspective study for the *Adoration of the Magi*. c. 1481. Pen, **bistre**, and wash, 6½ × 11½ in (16.5 x 29.2 cm). Galleria degli Uffizi, Florence. Leonardo created a perspective grid by drawing a series of horizontal lines parallel to the picture plane. Then he drew a series of lines perpendicular to the horizontals and converging at the vanishing point, which is just to the left of the figure on a rearing horse. All architectural forms in the study are aligned with the grid, so that the sides of the buildings are either parallel or perpendicular to the picture plane.

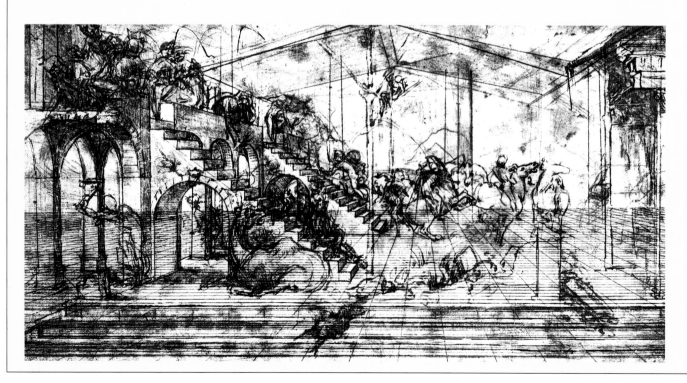

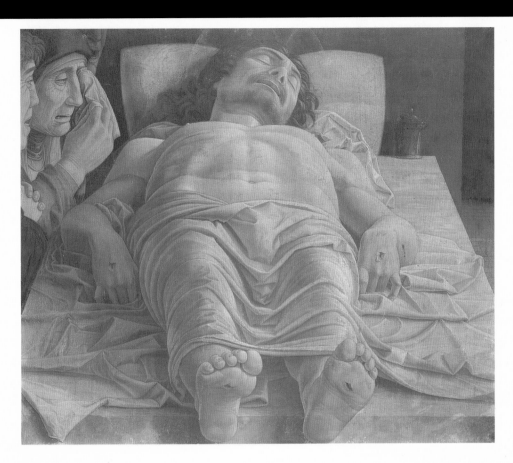

15.6 (above) Andrea Mantegna,
Dead Christ. c. 1500. Tempera on
canvas, 26¾ × 31⅞ in (67.9 × 81 cm).
Pinacoteca di Brera, Milan.

15.7 (left) Paolo Uccello, Perspective
drawing of a chalice. c. 1430–40. Pen
and ink on paper, 13⅜ × 9½ in
(34 × 24 cm). Gabinetto dei Disegni e
Stampe, Galleria degli Uffizi, Florence.
Vasari criticized Uccello for his
obsession with mathematics and
perspective, which, he said, interfered
with his art. According to a popular
anecdote, they also interfered with his
marital life. On being called to bed by
his wife, Uccello allegedly extolled the
beauty of "*la prospettiva*"
(perspective) — a feminine noun in
Italian.

15.8 (above) Filippo Brunelleschi, Plan of S. Spirito, Florence (after R. Sturgis). The depths of the choir and transept arms are equal. The perimeter forms a continuous ambulatory, which, apart from the western end, is ringed with semicircular chapels — forty in all.

1 Nave
2 Aisle
3 Transept
4 Choir
5 Crossing

0 15 30 m
0 100 ft

Santo Spirito, Florence. In his church architecture, Brunelleschi rejected medieval, and especially Gothic, style and reverted to the relative simplicity of the Early Christian basilica. The Church of Santo Spirito, begun in 1445, one year before Brunelleschi's death, illustrates the basic principles of his architecture—simplicity, proportion, and symmetry. Spatial units are based on the square **module** formed by each **bay** of the side aisles, and the whole geometry of the structure is based on a series of interrelated circles and squares.

The plan (fig. **15.8**) is a Latin cross whose four arms are similar in size, except for the greater length of the nave. The semicircular arches in the nave and the side aisles, supported by Corinthian columns (fig. **15.9**) reduce the size and height of the church to humanistic proportions. As a result, there is much less space in the structure for stained glass or the luminous quality characteristic of Gothic cathedrals.

Ghiberti's East Door. A good example of the one-point perspective system in a relief can be seen in Ghiberti's two commissions for the Baptistery in Florence. Between 1425 and 1452 he made reliefs for the east door (fig. **15.10**). The lowest scene on the right depicts the *Meeting of Solomon and Sheba* (fig. **15.11**) on the steps of Solomon's temple.

As was true of the competition reliefs, the *Solomon and Sheba*, in the context of fifteenth-century Florence, had political as well as Christian implications. Typologically,

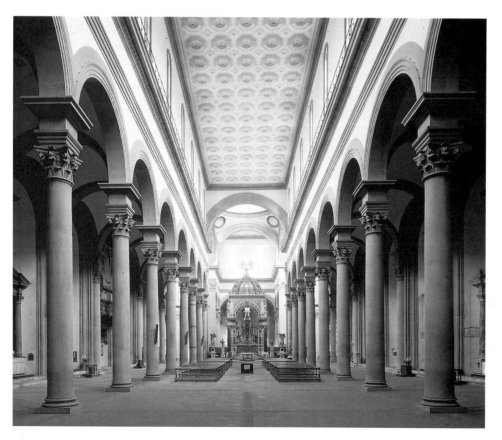

15.9 Filippo Brunelleschi, Interior of S. Spirito, Florence, facing east. Begun 1436. Each double bay of the nave forms a large square equivalent to four modular squares. The larger square is repeated in the crossing bays, the transept arms, and the choir. The semicircle of each chapel is one half the size of a circle that would fit exactly into the square module. If the larger squares were cubed and placed one on top of another, they would exactly match the height of the nave. The height of the side aisle is exactly half that of the nave.

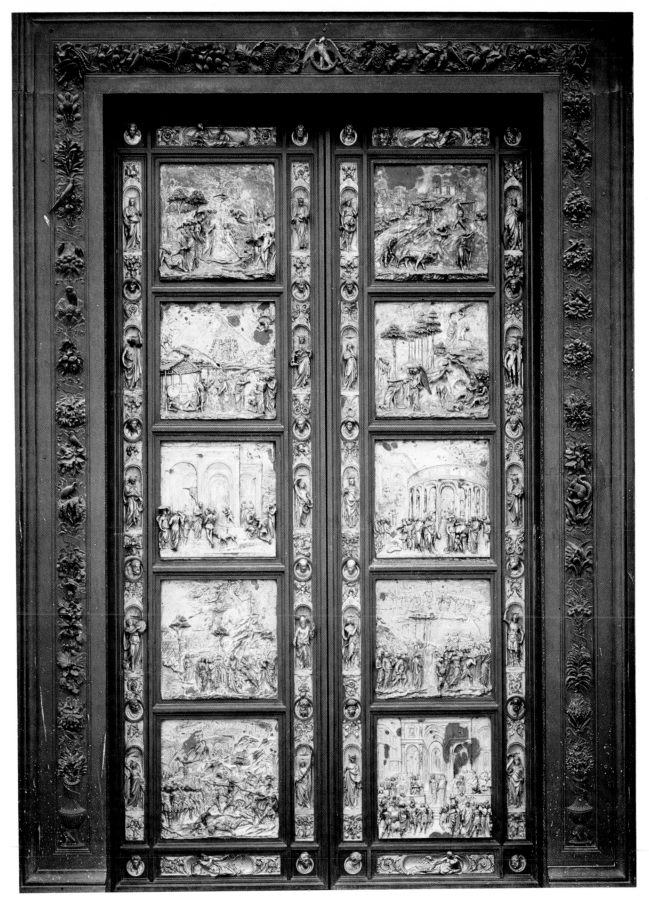

15.10 Lorenzo Ghiberti, *The Gates of Paradise*, east door, Florence Baptistery. 1424–52. Gilt bronze relief, c. 17 ft (5.18 m) high. Here Ghiberti has eliminated the medieval quatrefoil frame and uses the square, which is more suited to the new perspective system. The door is divided into two sets of five Old Testament scenes, which were modeled in wax, cast in bronze, and faced with gold. The east door was nicknamed the *Gates of Paradise*, because the space between a cathedral and its baptistery is called a *paradiso*.

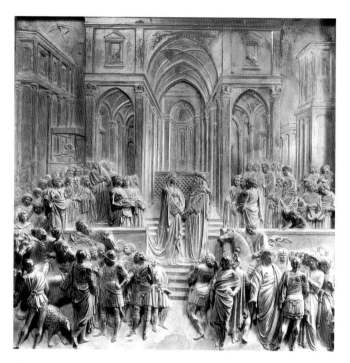

15.11 Lorenzo Ghiberti, *Meeting of Solomon and Sheba* (single panel of fig. **15.10**). Gilt bronze relief, 31½ x 31½ in (80 x 80 cm). This relief illustrates two techniques used by Ghiberti to create the illusion of depth. One is Brunelleschi's system of one-point perspective. The vanishing point is located at the meeting of Solomon and Sheba, at the center. The other combines the diminishing size of figures and objects with a decrease in the degree of relief. What is in lower relief appears more distant than what is in higher relief.

their meeting was paired with the Adoration of the Magi, for in both cases eastern personages (the Queen of Sheba and the Magi, respectively) traveled westward to honor a king (namely, Solomon and Christ). The biblical meeting of east and west was also related to political efforts in the fifteenth century to unite the eastern (or Byzantine) branch of the church with the western branch in Rome.

Early Fifteenth-Century Painting

Masaccio. Of the first generation of fifteenth-century painters, it was Masaccio who most clearly assimilated the innovations of Giotto and synthesized them into a new monumental style. His fresco of the *Holy Trinity* (fig. **15.12**) in the Church of Santa Maria Novella in Florence uses not only the new perspective system, but also the new architectural forms established by Brunelleschi. Its single vanishing point is located at the foot of the cross, corresponding to the eye-level of the observer. Orthogonals, provided by the receding lines of the barrel-vaulted ceiling, create the illusion of an actual space extending beyond the nave wall. This pictorial space is defined on

the outside by two Corinthian pilasters supporting a lintel, above which is a projecting cornice. The pilasters frame a round arch supported by composite columns.

The interior is a rectangular room with a barrel-vaulted ceiling and a ledge on the back wall. Below the illusionistic interior, a projecting step is supported by a ledge held up by Corinthian columns. Framed by the columns, a skeleton lies on a sarcophagus. The inscription above reads: "I was once what you are. You will be what I am." This kind of warning to the living from the dead, called a **memento mori**, or "reminder of death," had been popular in the Middle Ages and continued in the Renaissance. One purpose of the warning was to remind viewers that their time on earth was finite and that belief in Christ offered the route to salvation.

The spatial arrangement of the figures in the *Holy Trinity* is pyramidal, so that the geometric organization of the image reflects its meaning. The three persons of the Trinity — Father, Son, and Holy Spirit — occupy the higher space. God stands on the foreshortened ledge, his head corresponding to the top of the pyramid. He faces the observer and stretches out his hands to support the arms of the cross. Between God's head and that of Christ there floats the dove, symbol of the Holy Spirit. As in Giotto's *Crucifixion* (fig. **14.5**), Masaccio has emphasized the pull of gravity on Christ's arms, which are stretched by the weight of his torso, causing his head to slump forward. His body is rendered organically, and his nearly transparent drapery defines his form. Above and below the cross, triangular spaces geometrically reinforce the triple aspect of the Trinity.

Standing on the floor, but still inside the sacred space of the barrel-vaulted chamber, are Mary — who looks out at the viewer and gestures toward Christ — and St. John, in an attitude of adoration. Outside the sacred space, on the illusionistic step, kneel two donors, members of the Lenzi family who commissioned the fresco. They form the base of the figural pyramid.

The Renaissance convention of including donors in Christian scenes served a twofold purpose. In paying for the work, the donors hoped for intercession with God or Christ on their behalf. Their presence was a visual record of their donation, which expressed their alliance with the holy figures in a sacred space. In the *Holy Trinity*, the donors occupy a transitional space between the natural, historical world of the observer, and the spiritual, timeless space of Christ's sacrifice.

Masaccio's other major commission in Florence is the fresco cycle illustrating the life of St. Peter in the Brancacci Chapel, in the Church of Santa Maria del Carmine (fig. **15.13**). Masaccio used a new lighting technique called **chiaroscuro** (from the Italian *chiaro*, or "light" and *scuro*, or "dark"). This is the use of light and shade, rather than line, to model forms and create the illusion of mass and volume.

In Adam and Eve, Masaccio created the two most powerful painted nudes since antiquity. Eve's pose is derived from the type of Greek Venus illustrated in figure

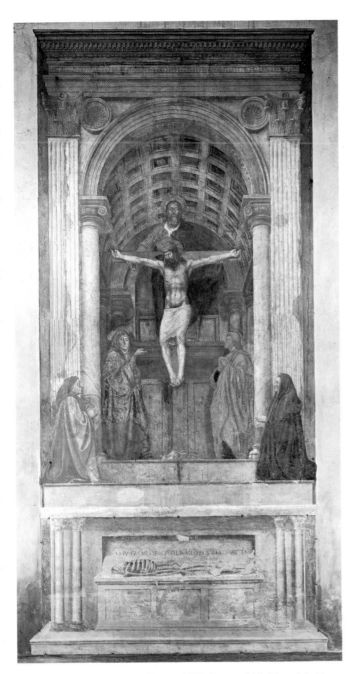

15.12 Masaccio, *The Holy Trinity*. 1425. Fresco, 21 ft 9 in x 9 ft 4 in (6.63 x 2.85 m). S. Maria Novella, Florence. Tommaso di Ser Giovanni di Mone (1401–28) was nicknamed Masaccio ("Sloppy Tom") because he seemed to neglect everything, including his own appearance, in favor of his art. In 1422 he enrolled in the painters' guild of Florence, and in 1424 joined the Company of St. Luke, a lay confraternity consisting mostly of artists. By his death at age twenty-seven or twenty-eight, Masaccio had become the most powerful and innovative painter of his generation.

15.14. The artist has transformed the figure of the modest goddess after her bath into an extroverted, wailing Eve, who realizes what she has lost and covers her nakedness in shame.

The more introverted Adam covers his face and hunches forward. His exaggerated right shoulder and the extended backward curve of his right leg emphasize his reluctance to face his destiny. Adam and Eve leave the gateway to Paradise behind them at the command of the foreshortened, swordbearing archangel Michael.

Masaccio's characteristic use of massive draperies can be seen in the large, horizontal fresco of the *Tribute Money* (fig. **15.15**), immediately to the right of the *Expulsion*. The fresco is divided into three events. Occupying the largest, central section, is Christ. He faces the viewer, surrounded by a semicircle of apostles. They wear plain, heavy drapery, whose folds and surface gradations are rendered in *chiaroscuro*. Seen from the back, wearing a short tunic, and formally continuing the circular group around Christ, is the Roman tax collector. Horizontal unity in the central group is maintained by strict isocephaly (see p.110). The foreshortened halos conform to the geometric harmony of Christ and his circle of followers. They both repeat the circular arrangement of figures and match their convincing three-dimensional quality.

The psychology of this painting is as convincing as its forms. Christ has no money with which to pay the tax. He tells St. Peter (the elderly, bearded disciple in yellow and green on his right) to go to the Sea of Galilee, where he will find the money in the mouth of a fish. St. Peter's not unreasonable skepticism is masterfully conveyed by his expression and gesture. A close look at his face reveals his displeasure with Christ's instructions. The corners of his mouth turn down, his jaw juts forward, and his left eyebrow is raised in doubt. His gesture—echoing Christ's outstretched arm and pointing finger with his right hand, while drawing his left arm back in protest—expresses his emotional conflict and crisis of faith.

On the far left, separated by space and distance from the central group, is the radically foreshortened figure of St. Peter retrieving a coin from the fish. At the right, St. Peter, framed by an arch, pays the tax collector. Masaccio has thus organized the narrative so that the point of greatest dramatic conflict—between Christ and St. Peter—occupies the largest and most central space, while the dénouement takes place on either side.

Masaccio uses both linear and aerial, or atmospheric, perspective in the Brancacci Chapel frescoes. That he has set his figures in a boxlike, cubic space is clear from the horizontal ground and the architecture at the right of the *Tribute Money*. To find the vanishing point of the painting, extend the orthogonals of the buildings at the right, and the receding line of the entrance to Paradise in the *Expulsion*. The orthogonals meet at the head of Christ, who is also at the mathematical center of the combined scenes. Rather than provide the vanishing point within a single

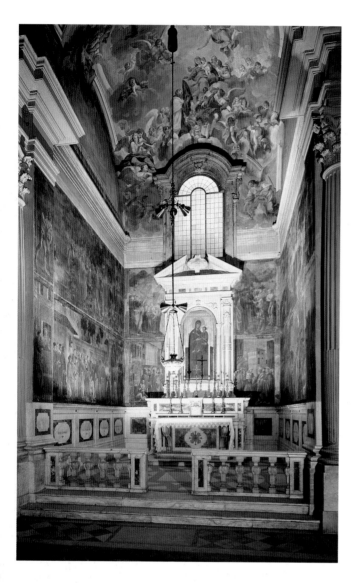

15.13 View of the Brancacci Chapel (before restoration), looking toward the altar. S. Maria del Carmine, Florence. Masaccio worked on the Brancacci Chapel in the 1420s. He received the commission only when the older artist Masolino, whose *Temptation of Adam and Eve* is on the right pilaster, left Italy to work in Hungary. After Masaccio's untimely death, the frescoes were completed by a third artist, Filippino Lippi. Lippi completed most of *St. Peter in Prison* and the large lower fresco on the left wall (see fig. **15.15**).

15.14 The *Medici Venus*. 1st century A.D. Marble, 5 ft ¼ in (1.53 m). Galleria degli Uffizi, Florence.

15.15 Left side of the Brancacci Chapel, S. Maria del Carmine, Florence (after restoration 1989). The scene on the upper left of the pilaster is *The Expulsion from Eden* (1425), and below is *St. Peter in Prison*. The large scene to the right of the *Expulsion* is from the New Testament book of Matthew (17:24–7), in which Christ arrives at the Roman colony of Capernaum, in modern Israel, with his twelve apostles. A Roman tax collector asks Christ to pay a tribute to Rome. This biblical event was topical in Florence in the 1420s because taxation was being considered as a way of financing the struggle against the imperialistic dukes of Milan. Below, St. Peter preaches and raises a boy from the dead. The two scenes on the altar wall (far right) show *St. Peter Baptizing* (above) and *St. Peter Curing by the Fall of his Shadow* (below). All the frescoes are illuminated as if from the window behind the altar. As a result, the light consistently hits the forms from the right, gradually increasing the shading toward the left. So monumental were the forms created by Masaccio in these frescoes that Michelangelo (see p.262) practiced drawing them in order to learn the style of his great Florentine predecessor.

frame, as he had done in the *Holy Trinity*, in the Brancacci Chapel Masaccio unified several scenes through a shared perspective construction. The diminished figure of St. Peter on the left and the gradually decreasing size of the trees indicate the use of linear perspective to create the illusion of a spatial recession far into the distance, beyond the Sea of Galilee. The shaded contours and slightly blurred mountains and clouds are partly the result of damage caused by centuries of burning candles and incense in the chapel. They also, however, exemplify Masaccio's use of aerial perspective to suggest their distance in relation to the monumental figures in the foreground.

Masaccio's frescoes are the true heirs of Giotto's Arena Chapel. For both artists, landscape and architecture are secondary to the monumental and dramatic character of the figures. But Masaccio has increased the depth of his painted spaces to create the impression of a natural landscape, rather than the narrow, stagelike space of Giotto. With his use of one-point perspective, Masaccio laid the foundations of Renaissance painting.

International Style: Gentile da Fabriano. Masaccio's originality as a painter can be seen by comparing him with an older contemporary, Gentile da Fabriano (c. 1370–1427). Gentile's greatest extant work is the large altarpiece in figure **15.16**, in which the *Adoration of the Magi* occupies the main panel.

In contrast to Masaccio's taste for simplicity, Gentile's frame is elaborately Gothic, and his gold sky continues Byzantine convention. Gentile's crowds wind their way from distant fortified hill towns down to the foreground, where the three Magi worship Christ. The crowded

15.16 Gentile da Fabriano, *The Adoration of the Magi*, altarpiece. 1423. Tempera on wood panel, c. 9 ft 11 in x 9 ft 3 in (3.02 x 2.82 m). Galleria degli Uffizi, Florence. Gentile was born in Fabriano, in the Marches (a region of central Italy bordering on the Adriatic coast). He trained in Lombardy, and established himself as a leading painter of the International Gothic style in northern Italy. The *Adoration of the Magi* was commissioned in 1423 by a wealthy Florentine, Palla Strozzi, to decorate his family chapel in the sacristy of Santa Trinità.

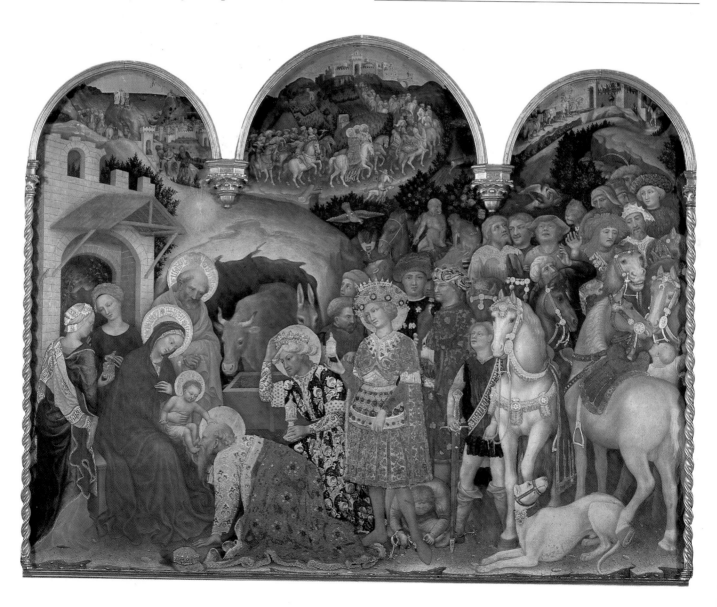

A Distant Haze

Aerial, or **atmospheric**, **perspective** is a painting technique based on the fact that objects in the distance appear to be less distinct and vivid than nearby objects. This is because of the presence of dust, moisture, and other impurities in the atmosphere. The artist may therefore use fainter, thinner lines and less detail for distant objects, while depicting foreground objects with bolder, darker lines and in greater detail. The artist may also create the illusion of distance by subduing the colors in order to imitate the bluish haze that tends to infuse distant views. In his advice to painters, Leonardo da Vinci (see p.259) recommended that all horizons be blue, as his were. Masaccio also used atmospheric perspective. In the *Tribute Money* (fig. **15.15**), for example, although the distant mountains are larger than the figures, they are less clearly defined.

composition, elaborate gold drapery patterns, the exotic animals — birds and monkeys, for example — are all typical features of the International Gothic style.

International Gothic resulted from a combination of Gothic qualities with some of the new Renaissance perspective innovations and interest in nature. In the foreground, though Gentile's use of linear perspective is not consistent, he has radically foreshortened the horses and the kneeling page removing the spurs from the youngest Magus. Gentile's elegance, like Ghiberti's, appealed more to popular, conservative tastes than the unadorned monumentality of Brunelleschi and Masaccio.

Early Renaissance Sculpture

Donatello's Early Years. The most important sculptor of early fifteenth-century Florence was Donatello (1386–1466). He outlived Masaccio by nearly forty years, continuing to develop his style well into the next generation.

His bronze *David* (fig. **15.17**), commissioned by the Medici family for a pedestal in their palace courtyard, is a revolutionary depiction of the nude. David stands over Goliath's head, which he has severed with the giant's own sword. In his left hand, David holds the stone thrown from his slingshot. He wears a shepherd's hat ringed with laurel, the ancient Greek and Roman symbol of victory, and boots. His facial expression is one of satisfaction at having conquered so formidable an enemy.

The genius of this statue lies not only in its revival of antique forms, but also in its enigmatic character and complex meaning. David and Goliath, whose encounter is described in the Old Testament (1 Samuel 17:28–51), were traditional Christian types (see p.152) for Christ and Satan, respectively, and David's victory over Goliath could refer to the moral triumph of Christ over the Devil. David was also an important symbol of the Florentine republic in its resistance against Milan, for he represented the success of the apparent underdog against a more powerful aggressor.

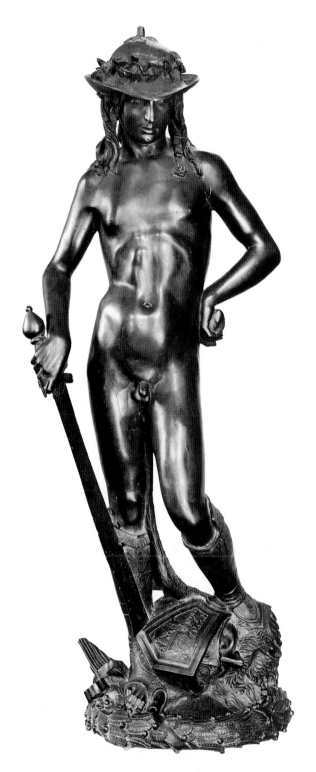

15.17 Donatello, *David*. c. 1430–40. Bronze, 5 ft 2¼ in (1.58 m) high. Museo Nazionale del Bargello, Florence. The *David* is the first large, naturalistic nude sculpture that we know of since antiquity. By 1430 to 1440, fragments of original Greek statues had been added to the collections of wealthy Florentine humanists, particularly the Medici. Like Masaccio and Brunelleschi, Donatello studied those works and also went to Rome to study ancient ruins. The pose of his *David* is influenced by the Classical statues that he had seen.

The erotic aspect of David is revealed by the large, life-like wing sprouting from the giant's helmet and rising up the inside of David's leg. The elegance of the polished bronze, together with David's smug expression, effete pose, and slim, graceful, adolescent form, enhances the narcissistic, homosexual character of the statue. This aspect of the *David*'s iconography probably reflects a Platonic version of the ideal warrior, who fights to impress and protect his male lover. In an unusually personal Renaissance synthesis, Donatello has combined the adolescent friendship of David and King Saul's son Jonathan, as described in the Bible, with Plato's philosophy. (Plato argues that homosexuality is tolerated more under republican forms of government than under tyrants.) It is also possible that Donatello drew on his own homosexuality —for such was his reputation in fifteenth-century Florence—in his interpretation of the *David*.

Second-Generation Developments

Once Donatello, Masaccio, and Brunelleschi had created the foundations of the new Renaissance style, subsequent generations of fifteenth-century artists developed and elaborated their innovations.

Alberti. In his treatise *On Painting* (c. 1345), Leon Battista Alberti (c. 1402–72) summed up the contribution that Brunelleschi, Masaccio, Ghiberti, and Donatello had made to the visual arts. He thus codified the principles of Early Renaissance style and the ideas on which it was based. Although primarily a humanist writer, from the 1440s Alberti worked as an architect. His influential treatise *De Re Aedificatoria* was based on the Roman architectural treatise of Vitruvius (p.254). In contrast to the more structural preoccupations of Brunelleschi, Alberti emphasized the esthetic importance of harmonious proportions.

From 1446 to 1450, Alberti designed the Rucellai Palace in Florence (fig. **15.20**), which belonged to the wealthy merchant Giovanni Rucellai. The diagram of the façade (fig. **15.18**), which is symmetrical and composed of Classical details, illustrates Alberti's interest in harmonious surface design. The second- and third-story windows, for example, contain round arches subdivided by two smaller arches on either side of a colonnette. Alberti has blended the large window arches with the rest of the wall by leaving visible the stone wedges of which they are composed. In so doing, he retains the surface pattern of the individual stones, setting them in curves around the windows and in horizontals elsewhere. In contrast, the pilasters framing each bay on all three stories (the Tuscan order for the first story, Ionic or modified Ionic for the second, and Corinthian for the third) have a smooth surface and serve as vertical accents. The vertical progression follows the order of the Colosseum (see p.134). Crowning the third story is a projecting cornice, which echoes the horizontal courses separating the lower stories and reinforces the unity of the façade.

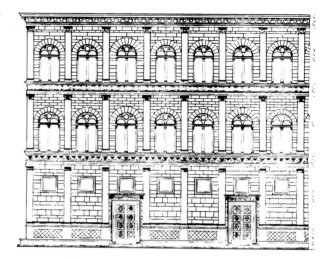

15.18 Diagram of the Rucellai Palace façade (after A. Gradjean de Montigny and A. Famin).

Equestrian Portraits. Donatello's monumental bronze equestrian portrait of Gattamelata stands on a high pedestal in front of the Church of Sant'Antonio in Padua (fig. **15.19**). It was inspired by the statue of Marcus Aurelius (see fig. **9.28**), which Donatello would certainly have seen in Rome. Both horses raise one foreleg, and their massive forms are rendered with a sense of weight and power. Donatello's rider, like Marcus Aurelius, is assertive. He holds his baton on a forward diagonal, conveying a sense of determined self-confidence. Gattamelata's armor is also inspired by ancient Roman models and is decorated with

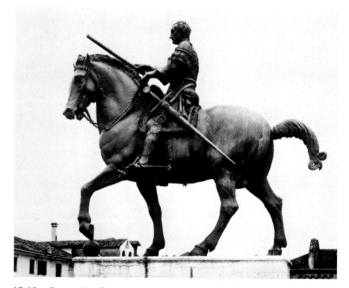

15.19 Donatello, Equestrian monument to Gattamelata. 1445–50. Bronze c. 11 × 13 ft (3.35 × 3.96 m). Piazza del Santo, Padua. Gattamelata, meaning "honeyed cat," is the nickname of the *condottiere* Erasmo da Narni. He had led the army of Venice, which at that time controlled Padua. Even though the *condottiere*'s family had, according to the terms of his will, financed the sculpture, its prominent location would have needed approval from the Venetian government.

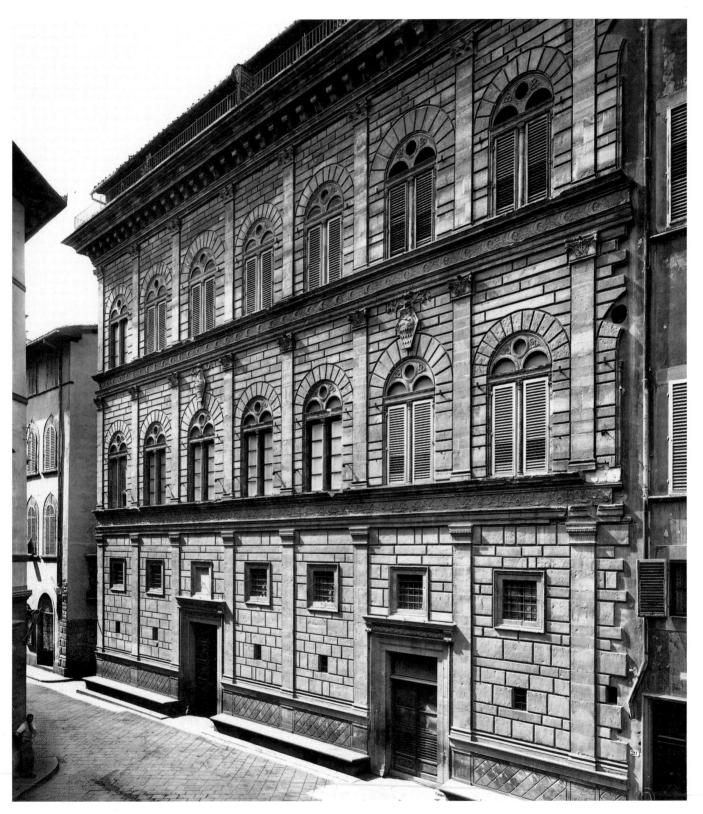

15.20 Leon Battista Alberti, Rucellai Palace, Florence. c. 1550s. By way of a family signature, the Rucellai coat of arms appears above each second-story window that is over a ground-floor door. An upward glance from either of the main entrances would therefore have identified the owner of the palace.

figures from Greek and Roman mythology. In combining these elements, Donatello's statue expresses the Renaissance synthesis of earthly fame and power, in a Christian site (in front of a church), with themes and motifs of Classical antiquity.

State Portraits. Another image of authority that became popular in fifteenth-century Italy was the official, or state, portrait of an individual ruler. Portrait busts, also revived from ancient Rome, had been commissioned from the earliest years of the Renaissance, and Donatello was reputed to have cast portraits from death masks, just as the Romans had done.

The Umbrian artist Piero della Francesca painted a double portrait of the duke and duchess of Urbino (figs. **15.21** and **15.22**) in oil and tempera on wood panels, with images of their triumphs on the back of each. Their iconography is inspired by imperial Roman portraits, particularly by profile busts on ancient coins. Duke Federico's coat and hat, for example, are painted in the red that had been conventional for Roman emperors.

The duke and duchess are in strict profile (concealing the loss in battle of Federico's right eye). They dominate the landscape backgrounds and are also formally connected to them. Figures and landscapes are bathed in the white light that is characteristic of Piero's style. Battista's pearls repeat the diagonal of the white buildings in the distance, while the diamond shapes in her necklace and brocade sleeve echo the rolling hills and distant mountains. The moles on Federico's face and the curls overlapping his ear create patterns of dark on light, just as

the trees do against his landscape. The triangle of his neck and under his chin repeat the triangular mountains. Such formal parallels between rulers and landscape signified the ultimate relationship between them and their territory. Piero's perspective construction, which makes the background forms radically smaller than the figures, implies the greatness of the ruler and the extent of his lands.

Monumental versus Spiritual in Fifteenth-Century Painting. Piero della Francesca was interested in the mathematical and geometric possibilities of painting—note Federico's perfectly round, foreshortened hat in figure **15.22**. Piero had, in fact, written two books, one on geometry and one on perspective, in Latin. A comparison of Piero's *Annunciation* (fig. **15.23**) with a painting of the same subject by Fra Angelico (fig. **15.24**) illustrates the most prominent trends in mid-fifteenth-century Italian Renaissance painting.

Both pictures are part of a series—Piero's of a fresco cycle in the Church of San Francesco (St. Francis) in Arezzo, while Fra Angelico's is one of many pictures decorating the Dominican monastery of San Marco (St. Mark) in Florence. The paintings are therefore set in different contexts and were commissioned by patrons (Franciscans and Dominicans—the latter being an order of which Fra Angelico was himself a member) with different attitudes to Christian imagery and church decoration. Nevertheless, both works are consistent with the general styles of Piero and Fra Angelico.

Piero's *Annunciation* is a good example of the artist's interest in combining geometry with Christian iconography and the Classical revival. The scene takes place in a white marble Classical building, whose entablature is supported by composite Corinthian and Ionic columns. Mary holds a book, Gabriel enters from the left, and God the Father hovers over a cloud in the upper left. Mary is related to the Classical architecture both as a form and a symbol. She fills the space of the portico, evoking the Christian

Oil Painting

In oil painting, pigments are ground to a powder and mixed to a paste with oil, usually linseed or walnut. In Italy, oil first came into use as part of tempera paintings and was applied to panels coated with a gesso support. Although oil had been known and occasionally used in Italy since the fourteenth century, it was not prevalent before about 1500. In northern Europe, on the other hand, oil was the most popular medium for painters from the early 1400s.

There are several advantages to using **oil paint**. It can be applied more thickly than fresco or tempera, because the brush will hold more paint. Oil dries very slowly, which allows artists time to revise their work as they go along. Oil also increases the possibilities for blending and mixing colors, opening up a much wider color range. Modeling in light and dark became easier, because oil enabled artists to blend their shades more subtly. As the oil paint tended to retain the marks made by the brush, artists began to emphasize their brushstrokes, so that they became a kind of personal signature. Tempera, a brittle medium, required a rigid support. Oil, on the other hand, was very flexible, so canvas became popular as a painting surface. This meant that artists did not have to worry as much about warping. The woven texture also held the paint better than wood.

15.21 (opposite, left) Piero della Francesca, *Battista Sforza, duchess of Urbino*. After 1475. Oil and tempera on panel, 18½ × 13 in (47 × 33 cm). Galleria degli Uffizi, Florence.

15.22 (opposite, right) Piero della Francesca, *Federico da Montefeltro, duke of Urbino*. After 1474. Oil and tempera on panel, 18½ × 13 in (47 × 33 cm). Galleria degli Uffizi, Florence.

15.21 and **15.22** Federico da Montefeltro, a successful *condottiere*, and his wife were leading patrons of the arts, and presided over one of the most enlightened humanist courts in fifteenth-century Italy. Artists, scientists, and writers (including Alberti) came from various parts of Europe to work for Federico. The fact that Piero used oil in his painting was probably a result of his contacts with Flemish painters working at the court of Urbino. Note the difference between the top pair of paintings and the panels below. The lower pair shows the diptych after a recent cleaning which restored the blue sky and intensified the colors throughout.

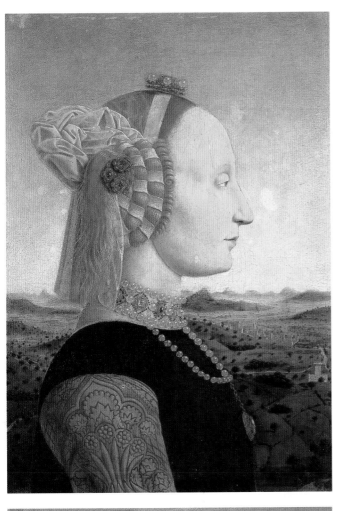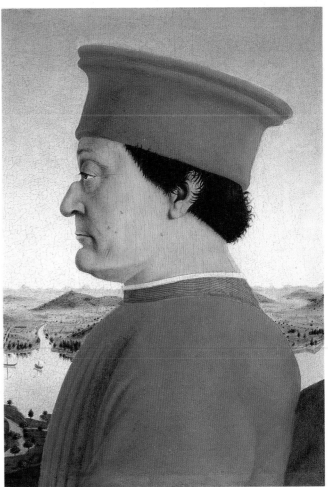

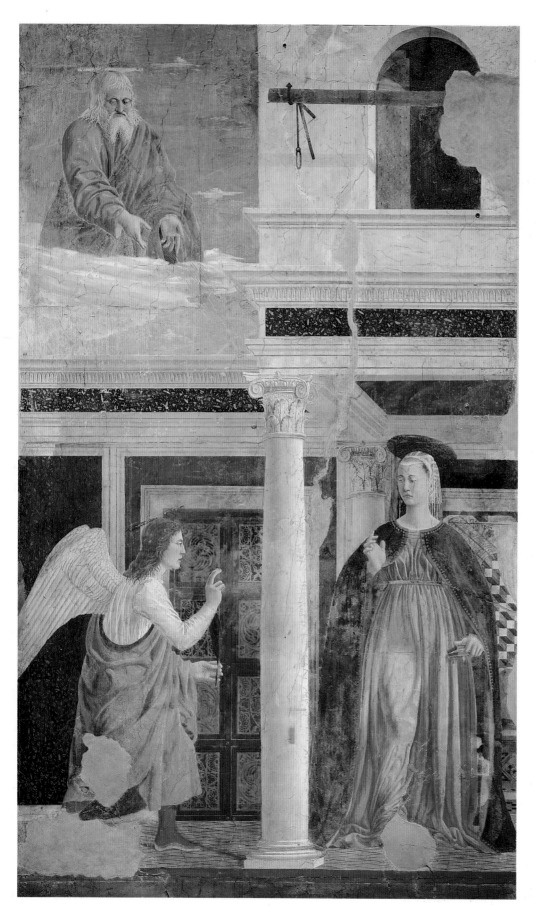

15.23 Piero della Francesca, *Annunciation*, from the *Legend of the True Cross*. c. 1450. Fresco. S. Francesco, Arezzo.

convention that equates Mary's monumental volume with the Church itself. The column swells slightly, even though it is not Doric and should not exhibit entasis (see p.108), and is thus an architectural metaphor for Mary's pregnancy. Mary's formal relationship with the architecture confirms her symbolic role as the "House of God."

Piero's *Annunciation* contains several allusions to the miraculous nature of Mary's impregnation. In the liturgy, Mary can be the "closed door," or *porta clausa*, behind Gabriel because she is a virgin. But she also stands before an open door, which represents Mary herself, because she is receptive, or "open," to God's word. The rays of light that God emits toward Mary signify Christ, who refers to himself in the Bible as the "light of the world."

The opposite of light — in nature, in painting, and in metaphor — is shadow. Piero uses shadow to create another allusion to impregnation in the *Annunciation*. The horizontal wooden bar that crosses the upper-story window casts a shadow that seems to pierce the loop hanging from it, to turn the corner, and enter the window. Because in the west we read pictures from left to right, the shadow, like the light, may be read as coming from God. Both shadow and light enter the building and therefore, in a metaphor for conception, symbolically enter Mary. The maternal significance of these images is implicit in the figure of Mary herself. Her monumental presence allies her with Piero's classicizing architecture, with Christian liturgy, and with the mother goddesses of antiquity.

Fra Angelico's fresco of the *Annunciation* (fig. **15.24**), dating from about 1440, offers an instructive contrast to Piero's. Although Fra Angelico was a Dominican friar who painted only Christian subjects, his style to some extent reflects the new fifteenth-century painting techniques. His *Annunciation* takes place in a cubic space, and orthogonals indicate the presence of a vanishing point. However, compared with those in Piero's *Annunciation*,

15.24 Fra Angelico, *Annunciation*. c. 1440. Fresco, 6 ft 1½ in × 5 ft 1½ in (1.87 × 1.56 m). S. Marco, Florence. The purpose of Fra Angelico's *Annunciation* is related to its location — in the cell of a Dominican monk in the monastery of San Marco. On the far left, just outside the sacred space of the Annunciation, stands the thirteenth-century Dominican saint Peter Martyr, who devoted his life to converting heretics to orthodox Christianity. A member of the Dominican order who had evoked visions of the Annunciation through prayer and meditation, he was a daily inspiration to the monks of San Marco.

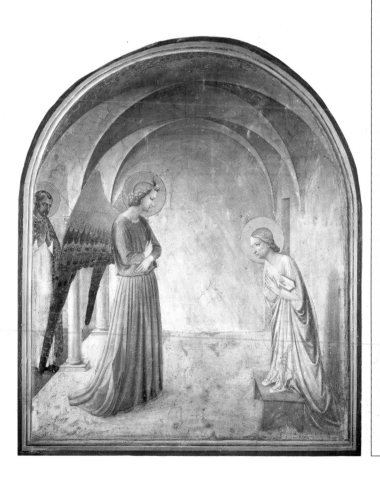

Mendicant Monks

The Franciscans and the Dominicans were orders of friars, or monks, who aspired to the ideals and simplicity of early Christianity. They devoted themselves to preaching and helping the poor. At first they made a virtue of poverty and supported themselves by work and begging for alms — hence the term "mendicants" by which they were known (from the Latin *mendicare*, meaning "to beg").

The Franciscan Order was founded by St. Francis of Assisi (1182–1226). The son of a rich cloth merchant, Francis rejected his father's wealth and preached a simple form of the Christian Gospel. In 1209 he received the pope's permission to found an order of friars. It expanded and was subdivided into different groups (including an order of nuns, the Poor Clares, named after St. Clare).

Members of the other great mendicant order, the Dominicans, were also known as Black Friars from the black mantle they wore. The order was founded by St. Dominic (1170–1221), a native of Old Castile in Spain. The original mission of St. Dominic and the Dominicans was to defend the official Church and convert heretics.

As these orders accumulated property and established abbeys and churches, they began to commission artists to decorate them. By the fourteenth and fifteenth centuries in Italy, the Franciscan and Dominican orders were active patrons of the arts. Works created for Dominican churches and monasteries tended to emphasize the spiritual qualities of Christian subject matter. Artists such as Giotto and Piero della Francesca, who were more attracted by the new humanist ideals than the Dominicans were, tended to work for the Franciscan Order.

Fra Angelico's figures are thin and delicate. Their gently curving draperies echo the curve of the ceiling vaults above them. The halos, rather than being radically fore-shortened, as on Piero's God the Father, are flat circles placed on the far side of their heads. The patterned rays in Gabriel's halo and the design on his wings reveal a taste for surface decoration more compatible with International Gothic than with the monumental artistic trends of fifteenth-century Italy.

Fra Angelico uses light to convey a sense of spiritual value. Like Gabriel himself, the light enters from the left and falls on Mary's bowed form. More striking is the fact that the vanishing point lies on the plain back wall of the porch, where the light is at its most intense. In contemplating this event, therefore, one's vision is directed to pure light, which in the context of the Annunciation signifies the miraculous presence of Christ.

Mantegna's Illusionism. In northern Italy, the leading painter from the middle of the Quattrocento was Andrea Mantegna (1431–1506). From about 1465 to 1474, Mantegna worked for Ludovico Gonzaga, the duke of Mantua,

15.26 (opposite) Andrea Mantegna, Ceiling tondo of the *Camera degli Sposi*, Ducal Palace, Mantua. 1474. Fresco, diameter of balcony 5 ft (1.52 m). Mantegna's humor is given full rein in this tondo. A potted plant balances precariously on the edge of the wall. Three leering women lean over and stare, while two more engage in conversation. A group of playful **putti** is up to various pranks. One prepares to drop an apple over the ledge, while three others have got their heads stuck in the round spaces in the parapet. In this scene of surreptitious looking, Mantegna plays upon the dangers that await the observers as well as the observed.

15.25 Andrea Mantegna, *Camera degli Sposi*, Ducal Palace, Mantua. 1474. Room c. 26 ft 6 in x 26 ft 6 in (8 x 8 m). Two walls are covered with frescoes depicting members of the Gonzaga family, their court, horses, and dogs, together with decorative motifs, and a distant landscape. The landscape view to the left of the door exemplifies the Renaissance idea of a painting as a window.

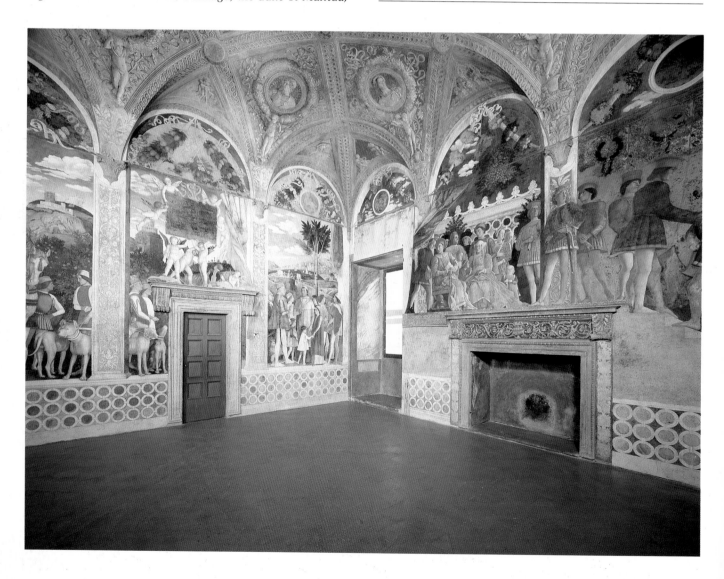

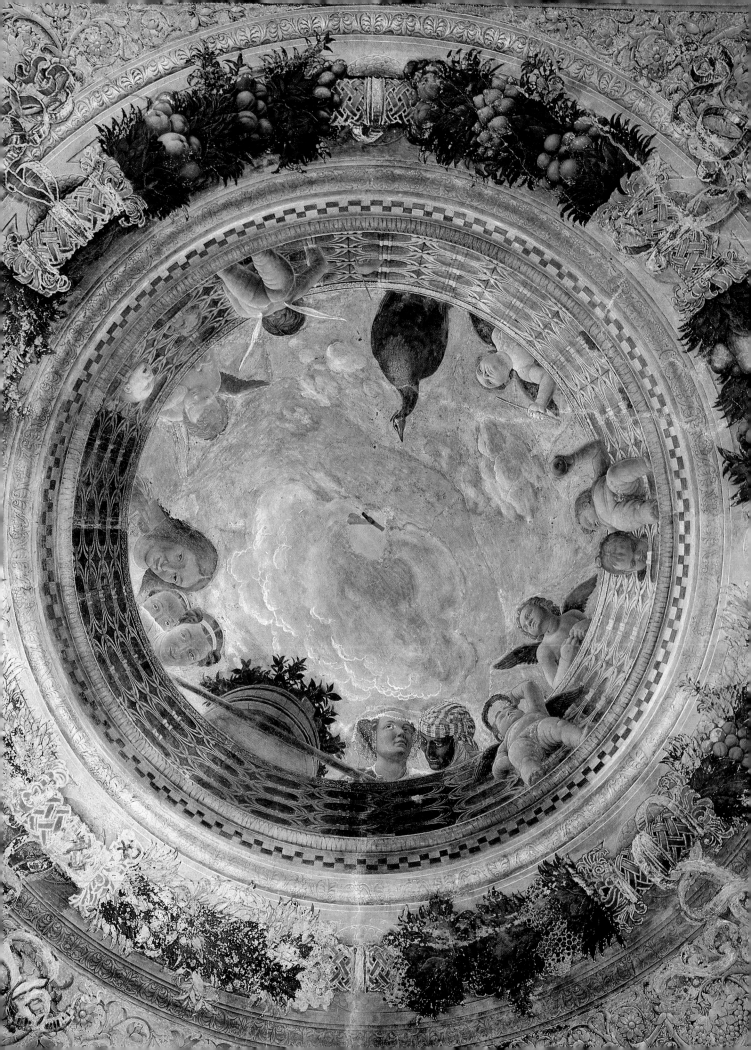

who, like Federico da Montefeltro, ruled a court that attracted leading contemporary humanists. Mantegna decorated what is presumed to have been the bedroom of the Ducal Palace in Mantua, using the new perspective techniques to create an illusionistic environment (figs. **15.25** and **15.26**).

The most dramatic instance of Mantegna's illusionism at the Ducal Palace is the ceiling tondo, painted to resemble an oculus (see p.138). Visually, it is integrated with the ceiling architecture, so that it is difficult for the casual observer to identify the border between reality and illusion. In figure **15.25** the portrait busts of Roman rulers around the tondo, painted to imitate relief sculpture, associate the duke of Mantua with imperial Rome. The tondo itself simulates a cloudy sky above a round parapet, with figures peering down as if into the real space. Mantegna's taste for radical foreshortening, also evident in the *Dead Christ* (fig. **15.6**), can be seen here in the spatial compression of the parapet and the extreme point of view from which the figures are depicted. Such illusionistic painted environments, which elaborate on the fourteenth-century spatial innovations of Giotto, could not have developed without the invention of perspective.

Botticelli and Mythological Subject Matter. Slightly later than Mantegna's illusionistic tour de force at Mantua are the mythological paintings of Sandro Botticelli (1445–1510), which exemplify the Renaissance interest in pagan subject matter. The *Birth of Venus* (fig. **15.27**) is one of a series of mythological pictures executed for an unknown patron, who was probably a member of the Medici family. It was the Medici interest in Classical themes and the revival of Plato's philosophy that had led to the founding of the Platonic Academy in Florence in 1469.

Botticelli's nude Venus, like Masaccio's Eve (fig. **15.15**), is derived from the type of the *Medici Venus* (fig. **15.14**). Unlike the Masaccio, however, Botticelli's Venus is somewhat elongated, elegant, even languid — as if just waking up. Her flowing hair, echoing the elegant drapery curves and translucent waves, conveys a linear quality characteristic of Botticelli's distinctive personal style.

15.27 Sandro Botticelli, *The Birth of Venus*. c. 1482. Tempera on canvas, c. 5 ft 8 in x 9 ft 1 in (1.73 x 2.77 m). Galleria degli Uffizi, Florence. According to Classical myth, Venus was born when the severed genitals of Uranos were cast into the sea. Botticelli's Venus floats ashore on a scallop shell, gently blown by the wind god Zephyr (also the English word for a light breeze). He is clad in blue drapery, suggesting a cool wind, and is embraced by an unidentified female. On the right, a mortal woman rushes to cover Venus with a pink floral cloak. As a goddess of love and fertility, it is appropriate that Venus should be surrounded by flowers.

Fifteenth-Century Flanders

In fourteenth- and fifteenth-century Flanders (roughly equivalent to modern Belgium, parts of northern France, and Holland), economic changes took place that were similar to those in Italy. Medieval feudalism gradually gave way to a merchant economy, based mainly on wool-trading and banking. Business travel between Italy and Flanders was not uncommon in the fifteenth century. Flemish artists worked in Italian courts, and Italian princes and wealthy businessmen commissioned works of art from Flanders.

Painting

For the most part, Flemish Renaissance art is restricted to painting. Neither the sculptors nor the architects of Flanders matched the significant contributions of Italy. Flemish painters preferred oil paint to tempera (see p.240). They refined the oil technique for altarpieces, which in Italy were mainly executed in tempera until the sixteenth century. Oil satisfied the Flemish taste for meticulous, decorative, and naturalistic detail, which characterizes much fifteenth-century northern painting.

Although the northern artists shared the Italian preference for the representation of three-dimensional space and lifelike figures, northern artists were less directly involved than Italians in the Classical revival. They continued to work in a Gothic tradition, which they nevertheless integrated into the new Renaissance style.

Campin's *Annunciation*. A good example of a Flemish altarpiece is the **triptych**, or three-part painting (fig. **15.28**), by Robert Campin, also called the Master of Flémalle (c. 1375–1444). The largest, central panel shows the Annunciation. In the right wing, Joseph makes mouse-traps in his carpentry workshop, and in the left, two donors kneel by an open door. As in contemporary Italian paintings, Campin's figures occupy a three-dimensional, cubic space and are modeled in light and dark. The light source itself is consistent and unified.

In contrast to Italian art, however, the Flemish preferred sharp, precise details. Some details are so small that magnification is necessary to see them clearly. Campin does not use one-point perspective in the triptych. Instead, each panel is seen from a different view-point. The Annunciation takes place entirely indoors, whereas in the side panels a distant medieval town is visible. Unlike those in Italian perspective constructions, Campin's floors appear to rise slightly, even though the ceilings are horizontal. The slight upward tilt of the painted space, together with the attention to elaborate detail, has been

15.28 Robert Campin (Master of Flémalle), *The Mérode Altarpiece* (open). c. 1425–30. Tempera and oil on wood, central panel c. 25 x 25 in (63.5 x 63.5 cm). Metropolitan Museum of Art, New York (Cloisters Collection, Purchase). Campin was a master painter in the painters' guild in Tournai, Flanders, from 1406, as well as being active in local government. A married man, he was convicted of living openly with a mistress and banished from Tournai, though his punishment was later commuted to a fine. This triptych is called the *Mérode Altarpiece* after the nineteenth-century family that owned it.

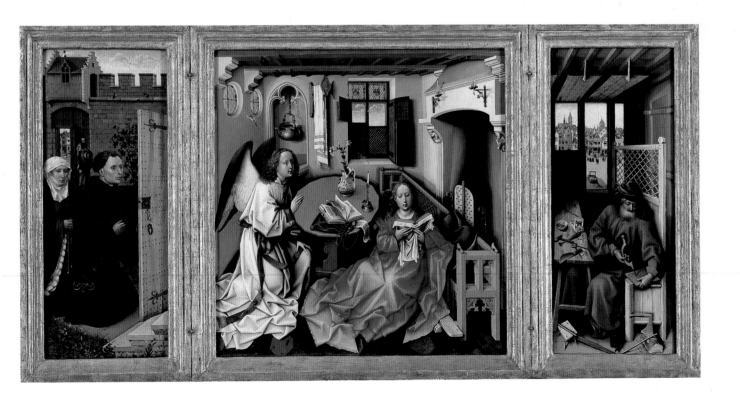

15.29 Detail of fig. **15.28**. Here Christ enters the sacred, though domestic, space of the Annunciation. He carries a small cross, referring forward in time to his Crucifixion. Christ and the cross leave the glass intact, illustrating the popular Christian metaphor that equates the entry of light through a window with the Virgin's Immaculate Conception.

Jan van Eyck. The most prominent painter of the early fifteenth century in Flanders was Jan van Eyck (c. 1390– 1441), whose work synthesizes Flemish interest in natural detail and tactile sensibility with Christian symbolism.

Van Eyck's *Man in a Red Turban* (fig. **15.30**) of 1433 is believed to represent himself—one of the first individual self-portraits of the Renaissance. His depiction of the red turban reveals his delight in the angular folds and their rich red color. In contrast to the expansive flourishes of the turban, van Eyck's own meticulously defined features betray the strain of an artist concentrating on his work. His lips are thin and drawn, while the corners of his piercing eyes are covered with slight wrinkles. An inscription on the frame, "*Als ich kan*," meaning "All I can" or, more colloquially, "This is the best I can do," reveals the sense of purpose that van Eyck must have felt in creating his own image.

attributed by some scholars to Gothic influence. The long, angular draperies also combine the Gothic taste for elegant surface design with the new Renaissance understanding of organic form.

This altarpiece contains a wealth of complex Christian symbols, but no references to Greek or Roman antiquity. Unlike Italian Annunciations, Campin's takes place in a bourgeois home, whose everyday, secular objects are endowed with symbolic Christian meaning. The lilies have the same meaning here as in Italian art. They represent the purity of the Virgin, and their triple aspect refers to the three persons of the Trinity. The copper basin and the towel, however, are more specific to the Flemish taste for depicting household objects and may refer to Christ cleansing the sins of the world. The candle, which on a naturalistic level has been blown out by the draft from the open door in the left panel, also represents Christ's incarnation. Entering the room through the round window on the left wall, a tiny Christ carrying his cross slides down rays of light (fig. **15.29**).

In the right panel, the attention to detail and the convincing variety of surface textures—for example, the wood, the metal tools, Joseph's fluffy beard, and his heavy, simple drapery—reflect Campin's careful study of the natural world. The image of Joseph making mousetraps signifies Joseph's symbolic role as a trap for the Devil. His marriage to Mary was interpreted as a divine plan to fool Satan into believing that Christ's father was mortal. Joseph thus protects Mary and Christ, and so guards the sanctity of the central panel. In working alone, isolated from the miraculous Annunciation, Joseph is both part of, and separate from, the central drama.

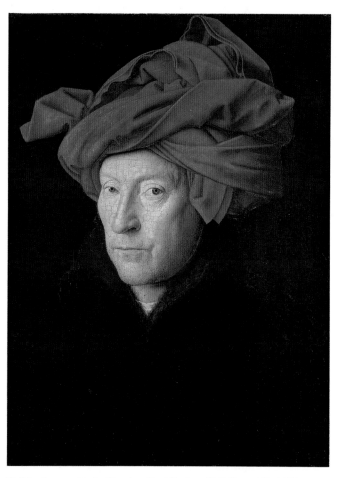

15.30 Jan van Eyck, *Man in a Red Turban* (*Self-Portrait?*). 1433. Tempera and oil on wood, c. 10¼ x 7½ in (26 x 19 cm). National Gallery, London. Van Eyck worked in The Hague as painter to John of Bavaria, and in Bruges for Philip the Good, duke of Burgundy. He also received commissions from private individuals, often in collaboration with his brother Hubert until the latter's death in 1426. Jan was a master of the oil medium. He used alternating layers of transparent glaze and opaque tempera to produce his characteristic effects of light and shade.

Van Eyck's *Arnolfini Wedding Portrait* of 1434 (fig. **15.31**) is unique in the history of western European art. A great deal has been written about this picture, and scholars have proposed numerous interpretations of it. There is, however, general agreement about the basic elements of the painting, if not about the overall intentions of the patron and artist.

The bride and groom stand in their bedroom, holding hands, in formalized poses. In their costume, each individual fabric and texture — for example, the fur, the lace, the gold and leather belt — is convincingly portrayed. The two pairs of shoes on the floor indicate that, while this is a bedroom, it is also a sacred space. (Compare this with the removal of the king's shoes on holy ground in the Egyptian Palette of Narmer, fig. **5.2**.) At the same time, the scene contains several references to the bride's potential fertility. She holds her drapery in a way that suggests her future pregnancy. The seemingly casual positioning of pieces of fruit on the chest and windowsill denotes natural abundance, and the little wooden statue by the bed represents St. Margaret, patron of women in childbirth. The dog, whose prominence in the foreground is surely meaningful, signifies fidelity, though it can also have erotic associations.

As in Campin's *Annunciation*, many of the household details in the *Arnolfini Wedding* also have Christian significance. The burning candle on the chandelier, for example, can refer to Christ's presence. The most controversial detail in this painting is the convex mirror on the back wall of the bedroom (fig. **15.32**). It is surrounded by ten small circles, each of which contains a scene of Christ's Passion. Reflected in the mirror are figures observing the ceremony from a door in front of the couple — the human witnesses. One of the figures is Jan van Eyck himself. He has, in fact, documented his own presence twice, both as a reflection and by his signature. Above the mirror he has written on the wall in Latin "*Johannes de eyck fuit hic,*" or, "Jan van Eyck was here," and added the date, 1434. Van Eyck's presence as both witness and artist recalls the traditional parallel between God, as creator of the universe, and the mortal artist, who imitates God's creations in making works of art.

Van der Weyden. The third great Flemish painter of the first half of the fifteenth century was Rogier van der Weyden (c. 1399–1464), the official city painter of Brussels. In his *St. Luke Painting the Virgin* (fig. **15.33**), he sets figures with specific personalities in a perspective architectural setting. Through the open wall of the room, the observer joins the two Flemish figures, seen in back view, in looking beyond the distant city toward the horizon. Figures, landscape, and architecture diminish abruptly in size, creating the illusion of great distance. At the same time, the elaborate patterns on the draperies continue the tradition of International Gothic in Flanders.

Mary and Christ, whose proportions depart more from the Classical ideal than their Italian counterparts, constitute a remarkable psychological depiction of the mother–child relationship. Christ is contained within Mary's voluminous form. He is framed by the white cloth underneath him, which links him with Mary's proffered breast and its white cloth. As Mary looks down at Christ, Christ gazes up at her. His physical pleasure in breastfeeding is suggested by his upturned toes and extended fingers.

A pervasive subtext of this painting is the psychology of the gaze and its relationship to the artist's eye. In the same way that the observer's eye is drawn to the river flowing toward the horizon, so St. Luke gazes at Mary and Christ, and Mary and Christ gaze at each other. Symbolically looking back at the viewer from the wall over the open space between the columns is the "eye of God," implied by the round window. In contrast to the open space in the wall, which is uninterrupted by glass, the round window is somewhat opaque, as if "returning our gaze," and watching the watchers in the painted room.

The specific physiognomy of St. Luke has led to the suggestion that he is a self-portrait of Rogier. His slightly wrinkled forehead, intense gaze, poised stylus, and posture reveal a physical tension that could well be autobiographical. There are no records of this painting's commission. However, it may have been painted for an artists' guild, since St. Luke was the patron saint of artists (tradition had it that he had actually drawn the Virgin during her lifetime). The identification of himself with the patron saint of his own profession would have been a logical one for Rogier to make.

Later Developments. The *Portinari Altarpiece* of c. 1746 by Hugo van der Goes (c. 1435/40–82) is an example of later fifteenth-century painting in Flanders (fig. **15.34**). Like the *Arnolfini Wedding* (fig. **15.31**), it was commissioned for the Church of Sant'Egidio in Florence by the Italian Tommaso Portinari, who was the Medici bank's representative in Bruges. It represents Mary, Joseph, shepherds, and angels adoring the newborn Christ, who lies on the ground surrounded by a glow of light. In the distance, at upper right, an angel announces Christ's birth to the shepherds.

Hugo's colors are deep and richer than those of van Eyck. Certain details, such as the vases of flowers in the foreground, which symbolize Christ's Passion, express the typical Flemish taste for endowing everyday objects with Christian meaning. In the background, David's harp on the building refers to Mary's descent from the "House of David." In the shed, the ox looks up and observes the event taking place before him, while the ass keeps on munching. This indifference to the birth of Christ on the part of the ass became associated with heretics and nonbelievers who did not recognize Christ as the Savior.

Compared to van Eyck, Hugo's style, at least in this altarpiece, conveys a sense of tension and anxiety. This is particularly true of the shepherds at the right of the central panel, whose grimacing faces and frantic gestures reflect their eagerness and wonder before Christ. They form part of a circle of figures whose excitement is revealed by the great variety of praying gestures and

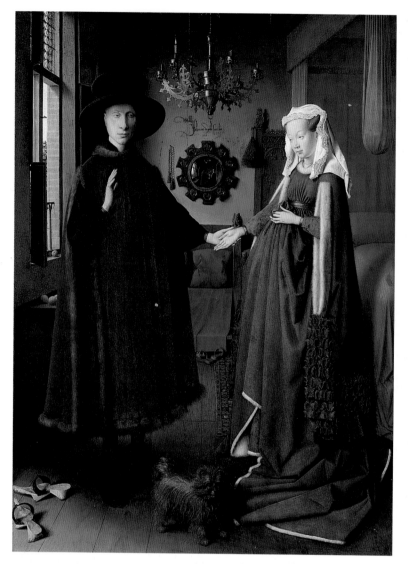

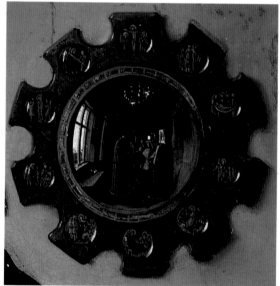

15.31 Jan van Eyck, *The Arnolfini Wedding Portrait*. 1434. Oil on wood, 32¼ × 23½ in (81.9 × 59.7 cm). National Gallery, London. Giovanni Arnolfini, a rich Italian merchant who lived in Flanders, exemplifies the cultural and economic ties that existed between Italy and northern Europe. He commissioned van Eyck to make a visual record of his marriage to Giovanna Cenami.

15.32 Detail of the mirror in fig. **15.31**. Convex mirrors were popular in homes before the development of full-length mirrors in Europe around 1500. Because they reflect a large area, they were used by shopkeepers (as they are today) to detect pilfering. As such, they were the "eyes" of owners who wanted to guard their possessions. Van Eyck's mirror has therefore been interpreted, in Christian terms, as God's eye witnessing the marriage ceremony.

15.33 (opposite) Rogier van der Weyden, *St. Luke Painting the Virgin*. c. 1400–64. Oil and tempera on panel; panel 4 ft 6⅛ in × 3 ft 7⅝ in (1.38 × 1.11 m), design 4 ft 5⅛ in × 3 ft 6 ⅝ in (1.35 × 1.08 m). Courtesy, Museum of Fine Arts, Boston (Gift of Mr. and Mrs. Henry Lee Higginson).

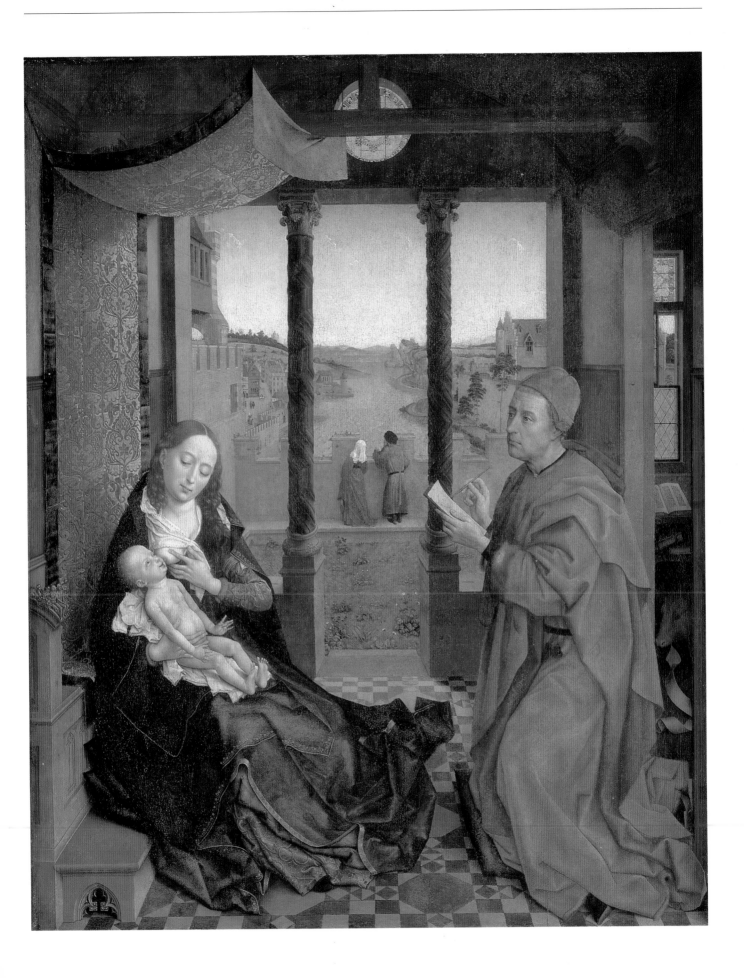

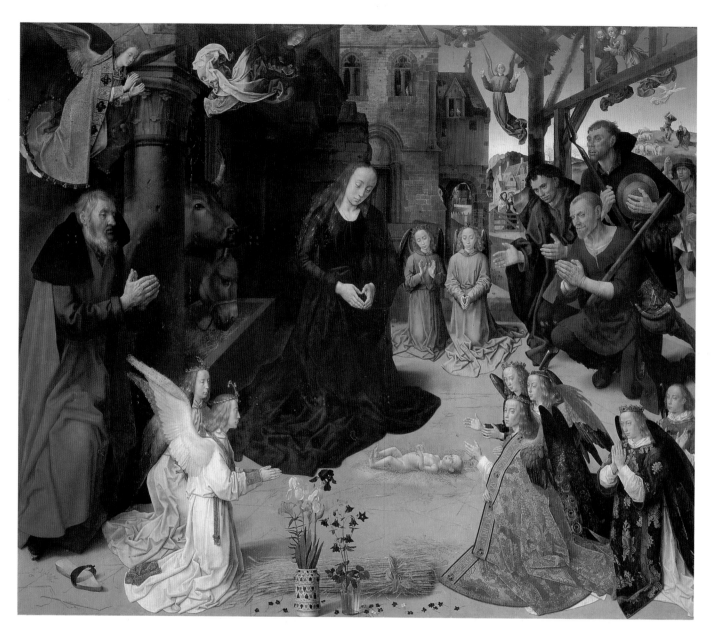

15.34 Hugo van der Goes, *The Portinari Altarpiece* (open). c. 1476. Oil on wood, central panel 8 ft 3½ in × 10 ft (2.53 × 3.05 m). Galleria degli Uffizi, Florence. This is Hugo van der Goes's only documented picture. In 1475 Hugo entered the monastery of the Red Cloister near Brussels as a lay brother. But his fellow monks accused him of being too worldly, because of his artistic success. He suffered several episodes of depression, and in 1481 tried to commit suicide. Contemporary rumor attributed his depression to disappointment because he had failed to produce works as good as van Eyck's Ghent Altarpiece.

angular, animated draperies. The tension is somewhat muted in the wings, where members of the donor's family kneel in front of their patron saints. The children in the family group are the first in Flemish art to have facial features suitable for their age. By depicting the family members as so much smaller in scale than the saints, however, Hugo creates an oddly irrational juxtaposition.

Whether the tensions in this painting are a result of the artist's personal conflicts or a reflection of contemporary stylistic developments is difficult to determine. Most likely, a combination of factors was at work. In any case, it is the only extant work by which to judge Hugo's style. After the death of its patron in about 1480, the painting went to Florence, where it was greatly admired. Its influence on Italian artists during the latter part of the fifteenth century was considerable, and it is to Italy that we now return, to consider the Italian artists of the High Renaissance.

The High Renaissance in Italy

The High Renaissance in Italy refers to the age of great accomplishment in western art that coincided with the late fifteenth century and the first half of the sixteenth. The term "High" that is used to designate this period indicates the esteem in which it is generally held.

Politically, the High Renaissance was a period of tension and turbulence. Foreign invasions produced upheaval and instability. The French invaded northern Italy and sacked Milan. The Medici were expelled from Florence, which was tyrannized by Savonarola. And though the Medici were reinstated in 1512, their style of rule had by then become autocratic.

Even though it was still an important artistic center, Florence no longer provided the main impetus for creative activity. Rome, meanwhile, under the control of ambitious popes, succeeded Florence as the artistic hub of Italy. Pope Julius II, determined to expand his political and military power, was also an enlightened humanist. In terms of patronage of the arts, Julius made perhaps the greatest contribution to the High Renaissance. The artistic achievements of this period, however, were not matched by political success. In 1527 the Holy Roman Emperor Charles V invaded Italy and sacked Rome.

Visual Arts

Although many important artists helped to lay the foundations of the High Renaissance in the first three-quarters of the fifteenth century, the period itself is dominated by a relatively small number of powerful artistic personalities. Those considered in this chapter are Leonardo da Vinci, Bramante, Raphael, Titian, and Michelangelo.

Leonardo (1452–1519) was the successor to Alberti (see p.238) as the embodiment of the "Universal Renaissance Man," or *uomo universale*. He painted only a small number of pictures, but also worked as a sculptor and architect, and wrote on nearly every aspect of human endeavor, including the arts and sciences. Although Leonardo worked in Milan as the Sforzas' military engineer and died in France at the court of Francis I, he is thought of as a Florentine artist. Bramante, Raphael, and Michelangelo,

all of whom were influenced by Leonardo, received their training in Milan, Umbria, and Florence respectively, but achieved their greatest success in Rome. In Venice, the High Renaissance was dominated by Titian, whose life was long and productive. Of these five artists, only Titian and Michelangelo lived beyond the year 1520, when new artistic styles began to emerge.

Architecture

The Ideal of the Circle

An important architectural ideal that preoccupied many artists and writers on art from the fifteenth century through the High Renaissance was the centralized church building. This was not an entirely new idea, as is evident from the Neolithic cromlechs (see p.41), such as Stonehenge in England, which reveal the sacred significance of circular architecture from an early date (see figs. **3.8** and **3.12**). Plato, writing in the fourth century B.C., associated God with the circle, which was considered the perfect geometric shape. In the Near Eastern cultures and Byzantium, the divinity of the circle was reflected in the churches and mosques, the domed ceilings of which symbolized Heaven. The domed shape for buildings had multiple celestial, royal, and mortuary associations. For

Savonarola: Fifteenth-Century Fanatic

Savonarola (1452–98) was a fanatical Dominican monk who led a program of moral reform against the Medici and denounced their interest in Plato and Neoplatonism (see p.224). At first, Savonarola was a popular demagogue, who established a more democratic form of government than that of the Medici. Later, however, he had an inhibiting effect on artists who were interested in Neoplatonism and mythological subject matter. In 1498 the tide turned against Savonarola and he was burned at the stake.

16.1 Leonardo da Vinci, Church like the Holy Sepulchre in Milan, MS 2184 fol.4r. Pen and ink. Institut de France, Paris. The octagonal plan in this drawing is composed of eight geometric shapes arranged in a circle. Leonardo left thousands of notebook pages with such drawings accompanied by explanatory text.

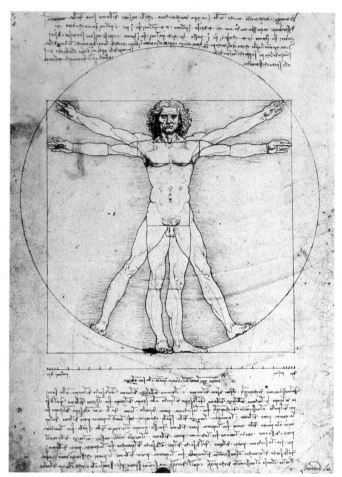

16.2 Leonardo da Vinci, *Vitruvian Man.* c. 1485–90. Pen and ink, 13½ × 9⅝ in (34.3 × 24.5 cm). Galleria dell'Accademia, Venice. This drawing illustrates the observation made by Vitruvius that, if a man extends his four limbs so that his hands and feet touch the circumference of a circle, his navel will correspond to the center of that circle. Vitruvius also drew a square whose sides were touched by the head, feet, and outstretched arms of a man.

example, there were the early *tholos* tombs of the Aegean (see p.87), and the round plan typically used for *martyria* in Greek, Early Christian, and Byzantine architecture (see p.154). Churches whose plans are based on the Greek Cross (see p.155) are also centralized, in contrast to the longitudinal layout of the Latin Cross and the basilican plan. God's connection with the circle persisted through the European Middle Ages, where it recurs in the great rose windows of the Gothic cathedrals (fig. **13.19**).

In fifteenth-century Italy, the circular ideal was an aspect of the humanist synthesis of Classical with Christian thought. It also reflected the new interest in the direct observation of nature. Alberti noted that in antiquity temples dedicated to certain gods were round. He wrote in his treatise on architecture that "Nature delights primarily in the circle," as well as in other centrally planned shapes such as the hexagon. In support of this assertion, Alberti observed that all insects created their living quarters in hexagonal shapes (the cells of bees are an example).

Vitruvius

Marcus Vitruvius Pollio, known as Vitruvius, was a Roman architect and engineer. During the Augustan period (30 B.C. –A.D. 14), Vitruvius wrote the *De Architectura*, a treatise on architecture in ten books that influenced the humanist architects of the Renaissance.

De Architectura was based on Vitruvius's own experience and on earlier works by Greek architects. It covered city planning and urban building, including the choice of site, materials, and construction types. Although the treatise has no particular literary merit, it is a good source of information on the ideas and practices of antiquity. Alberti's own architectural treatise, the *De Re Aedificatoria* (see p.238), uses Vitruvius as a model.

16.3 Donato Bramante, Tempietto, S. Pietro in Montorio, Rome. c. 1502–3. The Tempietto ("Little Temple" in Italian) was a small *martyrium* commissioned by King Ferdinand and Queen Isabella of Spain and erected in Montorio, Rome, shortly after 1500. It stood on the purported site of St. Peter's crucifixion. The hole in which St. Peter's cross supposedly stood marked the center of a chamber below the round *cella*. In the *cella* itself, just above the hole, stood a single altar.

16.4 (below, right) Donato Bramante, Plan of the Tempietto with projected courtyard, after sixteenth-century engraving by Sebastiano Serlio. From the geometrical center of the *cella*, equidistant lines can be drawn to each column of the peristyle, just as they can from the navel of Leonardo's *Vitruvian Man*, which lies at the center of a circle.

Centrally Planned Churches

Leonardo da Vinci apparently followed Alberti's preferences when devising his own projects for churches. From the 1480s, during his stay in Milan, Leonardo drew domed, centrally planned churches (fig. **16.1**).

Belief in the perfection of the circle was derived from the Roman writer Vitruvius (see p.254), who had related architectural harmony to human symmetry. Temples, according to Vitruvius, required symmetry and proportion in order to achieve the proper relation between parts that is found in a well-shaped man (fig. **16.2**). Leonardo influenced the older architect Donato Bramante (c. 1444–1514), who moved from Milan to Rome when the French invaded in 1499. Leonardo's designs for circular churches were never executed, but Bramante's Tempietto of San Pietro fulfills the ideal of the round building (fig. **16.3**).

The exterior, sixteen-column Doric peristyle of the Tempietto supports a Doric frieze (see p.108) and a shallow balustrade. Above the peristyle is a drum surmounted by

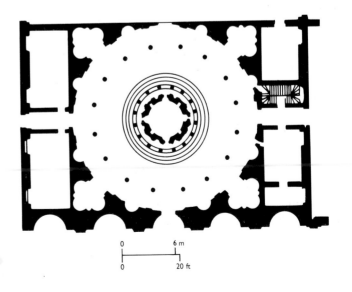

```
0          6 m
|——|——|——|
0              20 ft
```

a ribbed, hemispherical dome. In selecting Doric columns and a Doric frieze, Bramante conformed to Vitruvius's view that the order should correspond to the god to whom the temple was dedicated. Doric, according to Vitruvius, was suitable for the active male gods—a characterization consistent with St. Peter's hot-tempered nature. Finally, Bramante adopted the practice, also dating back to antiquity, of treating a building as one massive block of stone with openings and spaces carved out of it. This has been referred to as the **sculptured wall motif**.

The relatively small size of the Tempietto meant that very few people could enter it at once, so it was probably intended to be seen from the outside. The building now stands in a rather constricted space, but Bramante's original ground plan, as recorded in a sixteenth-century engraving (fig. **16.4**), placed it in the middle of a circular arcaded enclosure. The round enclosure was itself inscribed in a square with a tiny chapel in each corner.

In adhering to symmetry and the rules of geometry, the Tempietto satisfies the desire for abstract perfection, as laid down by Vitruvius in Augustan Rome and revived in the fifteenth century by Alberti and Leonardo. Centrally planned buildings were clearly regarded as key elements in Renaissance urban architecture, as can be seen in the *Painting of an Ideal City* (fig. **16.5**) by an anonymous fifteenth-century artist. The exact relationship between Bramante's Tempietto and the circular building in Raphael's *Betrothal of the Virgin* (fig. **16.6**) is not known. Both have steps leading to a round *cella,* round arches on Ionic columns, and a pediment over the door. A drum supporting a dome and **lantern** are the crowning features of both buildings.

Raphael has emphasized the geometric symmetry of his structure by placing it in the center of the top half of the picture plane. Because the compositional space is symmetrical and constructed according to a one-point perspective system, the vanishing point can be readily located by extending the short sides of the pavement tiles into the central space of the open door. The fact that Raphael's vanishing point is directly above the ring that Joseph is about to place on Mary's finger integrates the painting's geometry with its iconography.

St. Peter's and the Central Plan

Bramante and Raphael arrived in Rome within a few years of each other. The Tempietto established Bramante as Rome's leading architect, a position from which he acted as Raphael's mentor. In 1503 Julius II became pope and immediately set about recreating the ancient glory of imperial Rome. As part of his plan, Julius decided that the old basilica of St. Peter's (see pp.154–5), by then over a thousand years old and in bad condition, would have to be rebuilt. He gave the commission to Bramante, who by 1506 had designed a complex plan (fig. **16.8**). Bramante's design for the New St. Peter's was notable for its size. It was 550 feet (167.64 m) long, making it the largest church in history. A sizable church could be accommodated in each of its four wings.

In 1506 the foundation stone of the New St. Peter's was laid. In 1513 Pope Julius II died, followed in 1514 by Bramante, who had arranged for Raphael to succeed him as the new architect of St. Peter's. By the time Raphael died in 1520, little had been achieved beyond the

16.5 Circle of Piero della Francesco, *Painting of an Ideal City*. Mid-fifteenth century. Panel painting, 79 × 23½ in (200.7 × 59.7 cm). Galleria Nazionale delle Marche, Urbino. A circular building occupies the center of the composition. By implication, it is the navel of the ideal city. The rectangular buildings surrounding it differ in size and type, but all have the symmetrical, geometrical quality that is a feature of Renaissance architecture.

16.6 (opposite) Raphael, *Betrothal of the Virgin*. 1504. Oil on wood, 5 ft 7 in × 3 ft 10½ in (1.70 × 1.18 m). Pinacoteca di Brera, Milan. This painting is signed "Raphael of Urbino" and dated "1504," when the artist was twenty-one. The prominence and location of both date and signature probably had special biographical significance. Their connection with the ideal, classicizing architecture suggests Raphael's ambition to achieve fame in Rome. Ten years later, he was appointed chief architect of St. Peter's and overseer of Roman antiquities.

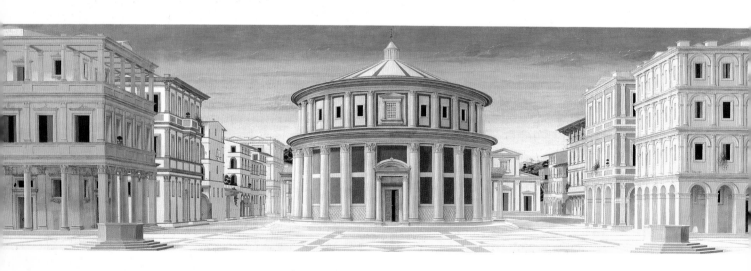

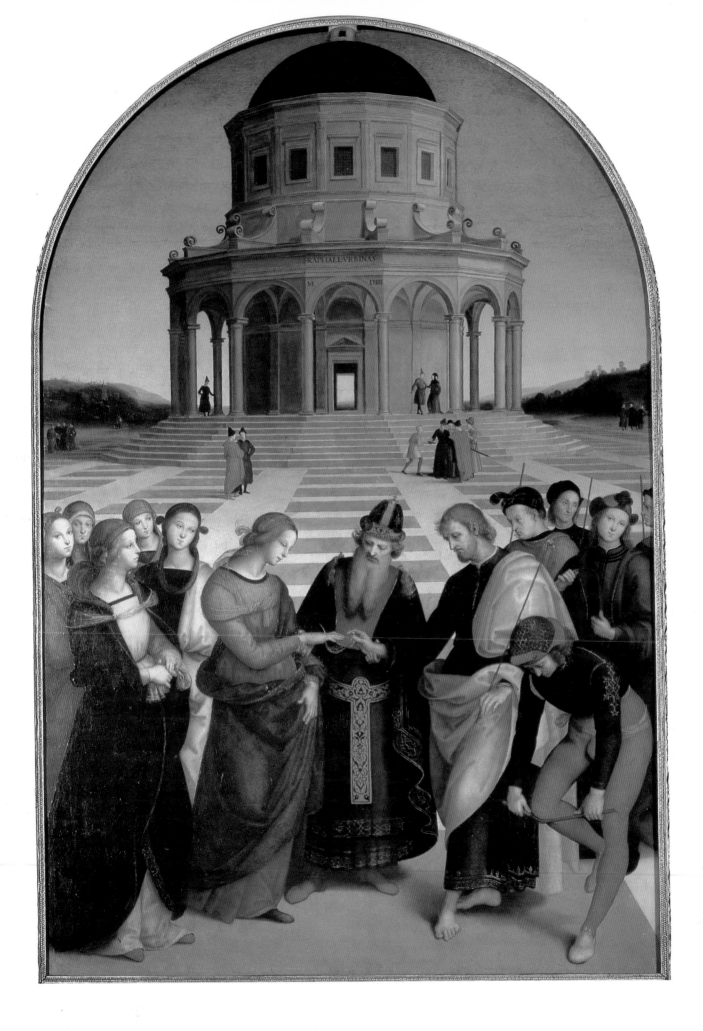

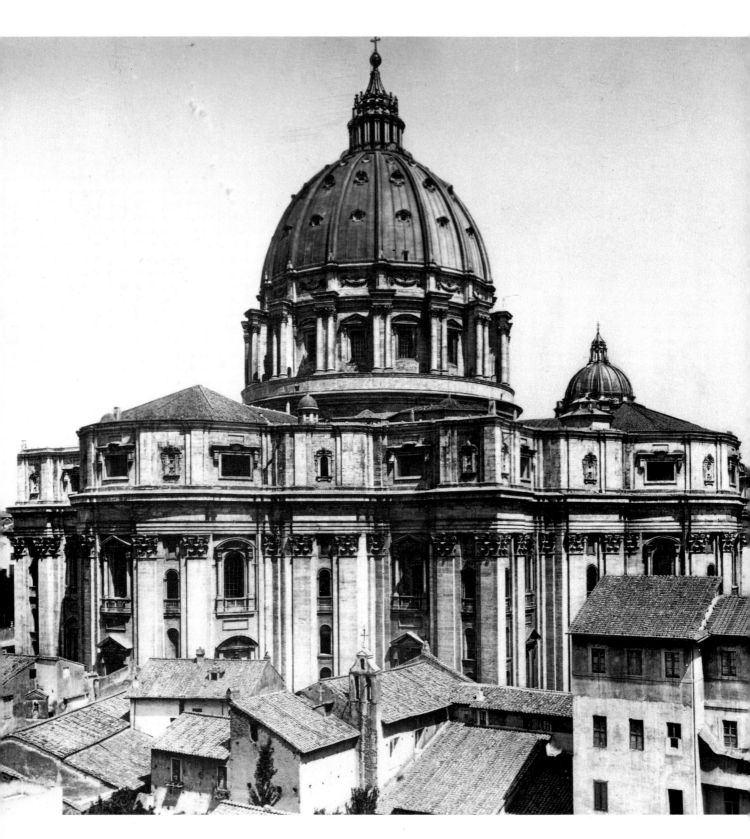

16.7 St. Peter's, Vatican, Rome, view from the west.

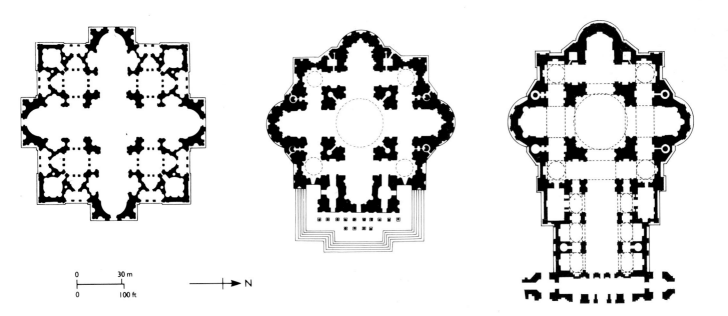

0 30 m
0 100 ft
→ N

16.8 (left) Donato Bramante, Plan for the New St. Peter's, Vatican, Rome. 1505. Bramante's plan is centrally planned, with four arms of a Greek cross ending in semicircular apses. A central, semicircular dome, larger than that of the Pantheon, would cover the central crossing. Between the arms of the cross would be four smaller, cross-shaped units, surmounted by smaller domes, and four tall towers. This plan is strictly symmetrical and follows the "sculptured wall" concept.

16.9 (center) Michelangelo, Plan for the New St. Peter's, Vatican, Rome. c. 1537–50. Michelangelo reduced the area of the floor by eliminating the smaller cruciform units (except for their domes), the corner towers, and the individual ambulatories of the apses. He also simplified Bramante's proposed exterior by introducing a colossal order of pilasters topped by a cornice, and an attic high enough to conceal the smaller interior cupolas.

16.10 (right) Plan for the New St. Peter's as built to Michelangelo's design with additions by Carlo Maderno, 1606–15 (see also fig. **19.4**).

demolition of the old basilica and the construction of the four great piers at the crossing.

In 1546 the task was entrusted to Michelangelo, then aged seventy-two. He decided to retain the underlying concept of a huge dome resting on four piers, but simplified Bramante's complex spatial arrangements (fig. **16.9**). As a result of Michelangelo's changes, work proceeded quickly. At his death in 1564, St. Peter's was nearly finished except for the dome. Despite the succession of architects who contributed to the New St. Peter's, the final result (fig. **16.10**) was based on Bramante's original central Greek cross plan, with the addition of a nave to form a Latin cross. The dome's profile (fig. **16.7**) is slightly pointed and small double columns soften the projection of the buttresses. Vertical ribs and a high lantern create a greater degree of verticality than Bramante's original design.

Painting and Sculpture

Leonardo da Vinci

Leonardo's numerous anatomical drawings illustrate the Renaissance synthesis of art and science. Among the most intriguing are the studies of fetuses in the womb (fig. **16.11**). In the larger image, Leonardo depicts an opened uterus, a fetus in the breech position, and the umbilical cord. A smaller drawing to the right depicts the fetus as seen through the amniotic membrane. Other drawings on the same page illustrate the systems by which the fetus is linked to the mother's blood supply.

Such drawings reflect Leonardo's obsessive interest in the origins of life and in discovering scientific explanations for natural phenomena. They also demonstrate his superb draftsmanship. The thousands of studies, covering virtually every aspect of scientific and artistic endeavor, contrast strikingly with the unusually small number of finished paintings by his hand. Leonardo's artistic nature may thus be characterized as investigative, preliminary, and experimental. Only rarely did he actually complete a work and deliver it to the patron.

Leonardo's single most important painting is his great mural of the *Last Supper* (fig. **16.12**), of 1495–8. Despite its poor condition, the *Last Supper* has become an icon of Christian painting and one of the most widely recognized images in western art. Its success as an image comes from Leonardo's genius in conveying character, capturing a significant narrative moment, and integrating these qualities with an imposing and unified architectural setting.

The painting fills a short wall of what was the refectory, or monastery dining room, of Santa Maria delle Grazie in Milan. The opposite wall had previously been decorated with a fresco of the Crucifixion, to remind the monks of the connection between the Eucharist and Christ's Passion. Like Masaccio's *Holy Trinity* (fig. **15.12**),

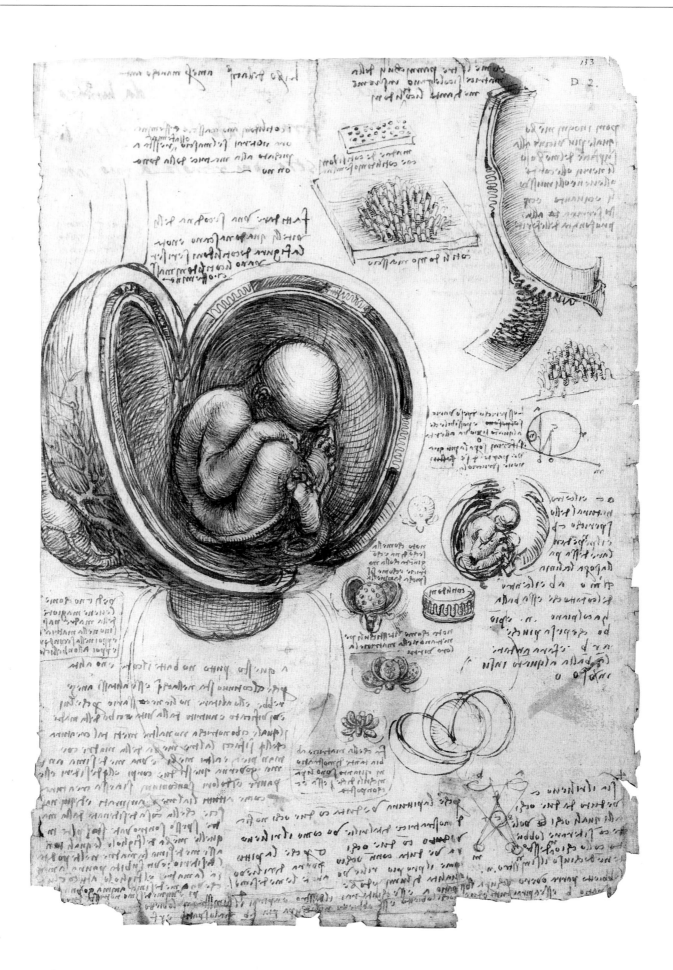

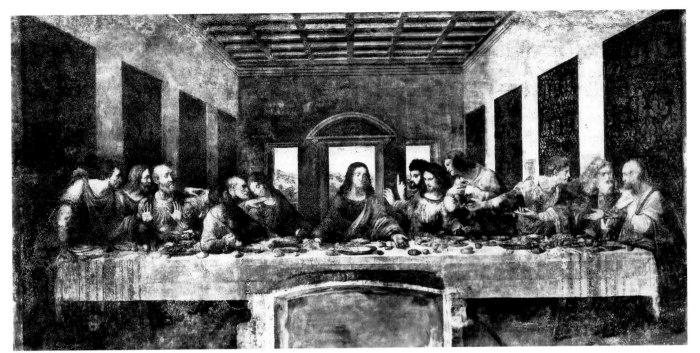

16.11 (opposite) Leonardo da Vinci, *Embryo in the Womb*. c. 1510. Pen and brown ink, 11¾ × 8½ in (29.8 × 21.6 cm). Royal Collection, Windsor Castle, Royal Library, copyright 1990 Her Majesty Queen Elizabeth II. Many Renaissance artists studied human anatomy by dissecting corpses. Leonardo went far beyond the artistic concern with musculature, and studied the digestive, reproductive, and respiratory systems. He apparently intended to collect his anatomical drawings into a treatise, but never completed the project. His script runs from left to right and must be read in a mirror. To date there is no generally accepted explanation for his curious "mirror writing."

16.12 (above) Leonardo da Vinci, *The Last Supper*, refectory of S. Maria della Grazie, Milan. c. 1495–8. Fresco (oil and tempera on plaster), 15 ft 1⅛ in × 28 ft 10½ in (4.6 × 8.56 m). Leonardo's experimentation had negative as well as positive results. Because of his slow, deliberate working methods, he could not keep pace with the rapidity required by the *buon fresco* technique. He seems to have applied a mixture of oil and tempera to the dry plaster. Sadly, the fusion between pigment and plaster was imperfect, and the paint soon began to flake off the wall. What we see today is a badly damaged painting, which has undergone several stages of restoration.

Leonardo's *Last Supper* is set within an illusionistic room receding beyond the space of the existing wall. But the *Last Supper* is above the eye-level of the observer, and on a loftier plane — physically as well as spiritually — than the monastery itself.

Leonardo has represented the moment of Christ's announcement that one of his twelve apostles will betray him. Each apostle reacts according to his biblical personality. St. Peter, whose head is fifth from the left, angrily grasps the knife with which he will later cut off the ear of a Roman soldier arresting Christ. John, the youngest disciple and future evangelist, slumps toward St. Peter in a faint. Thomas the doubter, on Christ's left, points upward, his gesture accented by the dark wall behind his hand. Judas, to the left of St. Peter, is the villain of the piece. He leans back, forming the most vigorous diagonal away from Christ. In placing Judas on the same side of the table as Christ and the other apostles, Leonardo departs from the traditional scenes of the Last Supper, in which Judas is distinguished by location, rather than simply by pose and gesture. Judas is the only apostle whose face is in darkness — a symbol of the evil that comes from ignorance and sin, or the absence of enlightenment.

The figures echo the geometric aspects of the composi-tion. The apostles are in four groups of three, echoing the four wall hangings on each side of the room and the three windows on the wall behind Christ. Christ forms a triangle, as he extends his arms forward across the table. His triangular form corresponds to the triple windows. The curved pediment over the central window functions as an architectural halo. Combined with the light background behind Christ's head, it acts as a formal reminder that Christ is the "light of the world." This aspect of Christ is reinforced in the perspective construction. The orthogonals radiate outward from his head, so Christ becomes the sun, or literal "light of the world," extending his "rays" into the world outside the picture.

The small area of landscape in the distance links Christ with nature, and connects the natural space with the architecture. Nature, as well as geometry, is an important aspect of Leonardo's paintings. The painting that epitomizes his synthesis of nature, architecture, human form, geometry, and character is the *Mona Lisa* (fig. **16.13**). Vasari says that the portrait depicts the wife of Francesco del Giocondo (hence its appellation *La Gioconda*, meaning "the smiling one"). The figure forms a pyramidal shape in three-quarter view, set within the cubic space of a balcony. The observer's point of view is made to shift from

Sfumato

Sfumato, an Italian word meaning "toned down" or, literally, "vanished in smoke," is a technique — used with particular success by Leonardo — for defining form by delicate gradations of light and shade. It is achieved in oil painting through the use of glazes, and produces a misty, dreamlike effect.

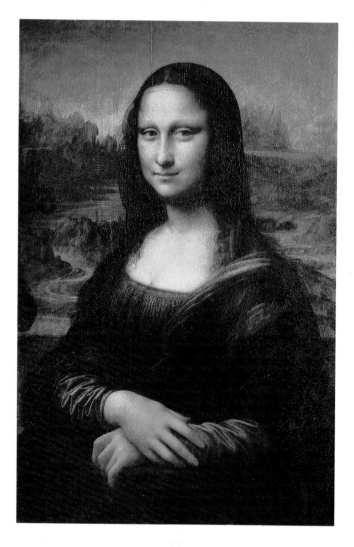

16.13 Leonardo da Vinci, *Mona Lisa*. c. 1503–5. Oil on wood, 30¼ x 21 in (76.8 x 53.3 cm). Louvre, Paris. The enigmatic smile of the *Mona Lisa* is the subject of volumes of scholarly interpretation. Vasari says that Leonardo hired singers and jesters to keep the smile on her face while he painted. According to Freud, the smile evoked the dimly remembered smile of Leonardo's mother. Leonardo was unwilling to part with the picture, and took it with him to the court of Francis I of France, where he died in 1519. It then became part of the French royal collection and was later trimmed by about an inch on either side.

figure to landscape. The figure is seen from the same level as the observer, but the viewpoint shifts upwards in the landscape. The light also shifts, bathing the figure in soft, subdued yellow tones and the landscape in a blue-gray sfumato. As a result, the rocky background, which is imaginary, has a hazy, misty atmosphere.

These contrasts serve to distinguish the landscape from the figure. At the same time, however, Leonardo has created formal parallels between figure and landscape that indicate their oneness. For example, the form of the sitter repeats the triangular mountains, and her transparent veil echoes the filtered light of the *sfumato* mists. The curved aqueduct continues into the highlighted drapery fold over her left shoulder, and the spiral road on her right is repeated in the short curves on her sleeves. These, in turn, correspond to the line of her fingers.

Such formal parallels do not explain the mystery of the figure, whose expression has been the subject of songs, stories, poems, even other works of art (fig. **28.1**). They do, however, illustrate Leonardo's own description, found in his notebooks, of the human body as a metaphor for the earth. He compares flesh to the soil, bones to rocks, and blood to waterways. This metaphorical style of thinking, which recurs in visual form throughout his paintings and drawings, is characteristic of Leonardo's genius.

Michelangelo

Michelangelo (Michelangelo di Buonarroti Simoni), born near Arezzo, lived to be eighty-nine (1475–1564), and his life is well known from contemporary biographies, comments on his personality and work, and from his own letters and sonnets. Like Leonardo, Michelangelo was an architect, painter, and writer, although he thought of himself primarily as a sculptor.

Michelangelo's father vigorously opposed his wish to become a sculptor, but, when he was thirteen, apprenticed him to the Florentine painter Domenico Ghirlandaio. Michelangelo's talent was recognized before the age of sixteen by Lorenzo de' Medici, under whose patronage he learned sculpture and was exposed to Classical art and humanist thought. His style was formed in Florence well before he went to Rome to work for Julius II. His attraction to the most monumental of his Florentine predecessors is evident from his habit of visiting the Brancacci Chapel to make drawings of Masaccio's frescoes (see p.232).

Michelangelo's first great work of sculpture is the marble *Pietà* (fig. **16.14**) in St. Peter's for the tomb chapel of a French cardinal. A youthful Mary mourns the dead Christ, and both are contained within a pyramidal space set on a circular base, reflecting the Renaissance synthesis of geometry and nature. Mary and Christ are formally and psychologically interrelated, so that one hardly notices Christ's relatively small size compared with Mary's massive form. The zigzag of Christ's body blends harmoniously with Mary's legs and her voluminous drapery folds. Mary's left hand repeats the movement of Christ's

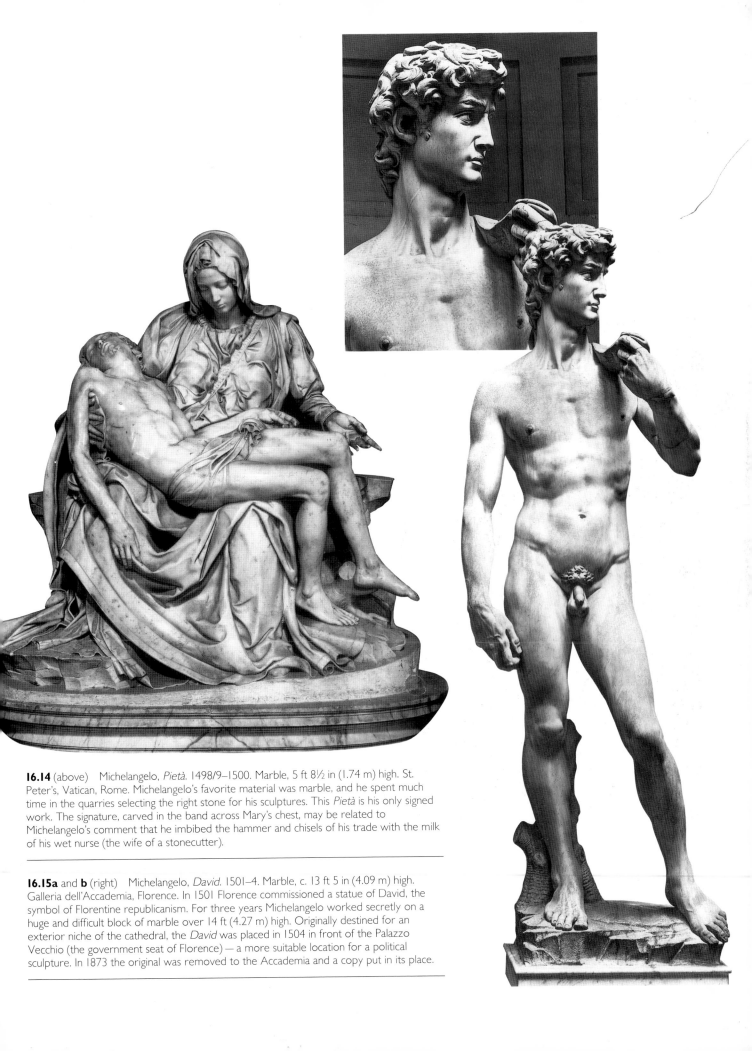

16.14 (above) Michelangelo, *Pietà*. 1498/9–1500. Marble, 5 ft 8½ in (1.74 m) high. St. Peter's, Vatican, Rome. Michelangelo's favorite material was marble, and he spent much time in the quarries selecting the right stone for his sculptures. This *Pietà* is his only signed work. The signature, carved in the band across Mary's chest, may be related to Michelangelo's comment that he imbibed the hammer and chisels of his trade with the milk of his wet nurse (the wife of a stonecutter).

16.15a and **b** (right) Michelangelo, *David*. 1501–4. Marble, c. 13 ft 5 in (4.09 m) high. Galleria dell'Accademia, Florence. In 1501 Florence commissioned a statue of David, the symbol of Florentine republicanism. For three years Michelangelo worked secretly on a huge and difficult block of marble over 14 ft (4.27 m) high. Originally destined for an exterior niche of the cathedral, the *David* was placed in 1504 in front of the Palazzo Vecchio (the government seat of Florence) — a more suitable location for a political sculpture. In 1873 the original was removed to the Accademia and a copy put in its place.

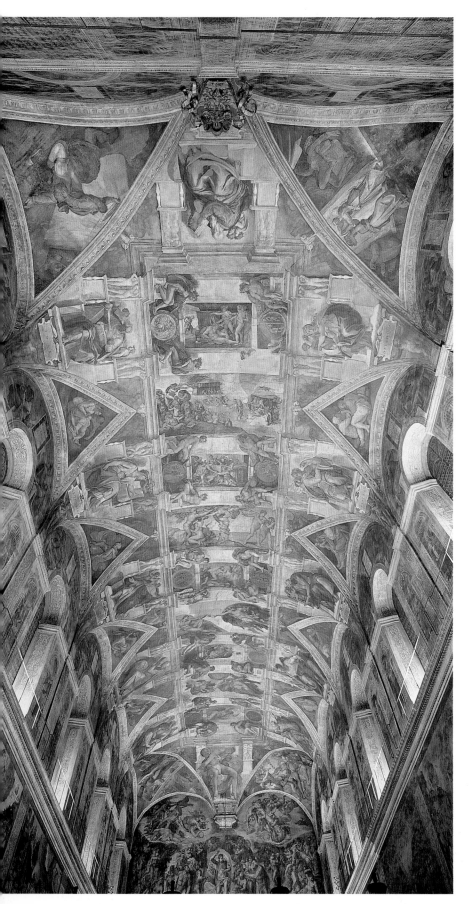

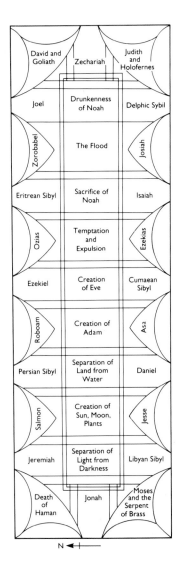

16.16 (left) Michelangelo, Ceiling of the Sistine Chapel, Vatican, Rome (before cleaning). 1508–12. Fresco, 5800 sq ft (538 m²). The Sistine Chapel was built in 1473 by Pope Sixtus IV, after whom it is named. It was the pope's personal chapel and the site of the conclave that elected new popes. Its proportions are exactly the same as the Temple of Solomon — twice as long as its height and three times as long as its width.

16.17 (below) Diagram of scenes from the ceiling of the Sistine Chapel. The first three scenes represent God's creation of the universe, the second three, Adam and Eve, and the last three, Noah and the Flood. Each small scene is surrounded by four nudes (called **ignudi**) in radically twisted poses. In each corner of the ceiling, the **spandrels** (curved triangular sections) contain an additional Old Testament scene.

David and Goliath	Zechariah	Judith and Holofernes
Joel	Drunkenness of Noah	Delphic Sybil
Zorobabel	The Flood	Josiah
Eritrean Sibyl	Sacrifice of Noah	Isaiah
Ozias	Temptation and Expulsion	Ezekias
Ezekiel	Creation of Eve	Cumaean Sibyl
Roboam	Creation of Adam	Asa
Persian Sibyl	Separation of Land from Water	Daniel
Salmon	Creation of Sun, Moon, Plants	Jesse
Jeremiah	Separation of Light from Darkness	Libyan Sibyl
Death of Haman	Jonah	Moses and the Serpent of Brass

N ◄—

left leg. She inclines her head forward as Christ's tilts back, and the slow curve of her drapery on the left is repeated by Christ's limp right arm. His right hand falls so that his fingers enclose and continue the prominent drapery curve between Mary's legs. In addition to the formal rhythms uniting Mary and Christ, Michelangelo makes them about the same age. He thus creates a powerful emotional and formal bond between the two figures who, though separated by death, will eventually be reunited, according to Christian tradition, as king and queen of Heaven.

The other great statue of Michelangelo's youth is the marble *David* (fig. **16.15a**). The little treetrunk supporting the statue is a reminder of the ancient Roman copies of Greek statuary and evokes the Classical past. There, however, the similarity ends. In contrast to the relaxed pose of Donatello's *David* (fig. **15.17**), Michelangelo's figure is tense (fig. **16.15b**). He is represented at a moment before the battle, and so does not stand on the head of the slain Goliath. His creased forehead, his strained neck and torso muscles betray apprehension as he sights his adversary. Although Michelangelo's *David* is the most monumental marble nude since antiquity, its proportions are not Classical. David's hands, in particular, are large in relation to his overall size, and his veins and muscles seem to bulge from beneath his skin.

Shortly after completing the *David*, Michelangelo was summoned to Rome by Pope Julius II to work on his tomb. Before its completion, however, the pope commissioned Michelangelo to paint the ceiling of the Sistine Chapel in the Vatican. The side walls had already been painted by fifteenth-century artists, according to typological left–right pairing, with Old and New Testament scenes on the left and right, respectively (see p.152). Michelangelo considered himself a sculptor rather than a painter and was initially reluctant to undertake the project. He finally relented, however, and worked on the ceiling and the window lunettes from 1508 to 1512. Michelangelo's descriptions of the work dwell on the physical discomfort of having to contort his body in order to paint the ceiling. Over twenty years later, from 1534 to 1541, he painted the *Last Judgment* on the altar wall.

Figure **16.16** is a view of the frescoed ceiling from below. Figure **16.17** shows it in diagrammatic form. Although none of the figures or scenes on the Sistine ceiling is from the New Testament, they nevertheless have a typological intent. All refer in some way to the Christian future. The Old Testament prophets and the **sibyls** of antiquity, who appear between the window triangles, were specifically viewed as having foretold the coming of Christ. The inclusion of Christ's ancestors, in the triangular sections above the windows, serves to reinforce Adam's role as the Old Testament type for Christ.

In the *Creation of Adam* (fig. **16.18**), the monumental and patriarchal God extends dramatically across the picture plane. He is framed by a sweeping, dark red cloak containing a crowd of nude figures, including a woman (possibly Eve), who looks expectantly over his left

16.18 Michelangelo, *Creation of Adam* (detail of fig. **16.16**, after cleaning 1989) © Nippon Television Network Corporation Tokyo 1991. In 1980 a controversial restoration of the Sistine Chapel frescoes was begun. The results have stirred up a vigorous debate among scholars about the practice of restoration in general and the effects on the Sistine ceiling in particular. The cleaning has revealed a range of **pastel** colors that have been described by its supporters as radiant and dazzling. Others — scholars, artists, and restorers — contend that the cleaning has been too radical, that a layer of size applied by Michelangelo himself has been removed, that untried solvents have been used, and that the treated frescoes will prove to have been damaged beyond repair.

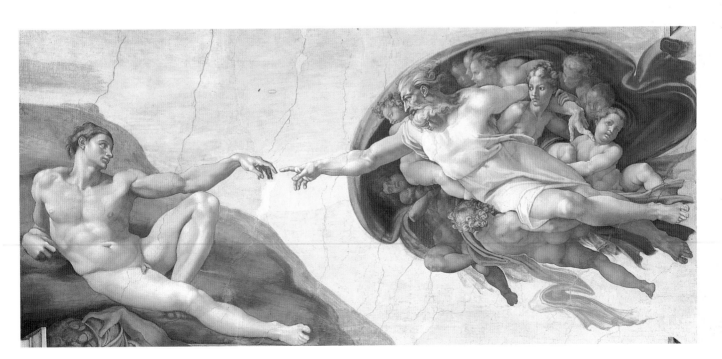

16.19 (above) Detail of fig. **16.20** showing St. Bartholomew and the flayed skin.

16.20 (opposite) Michelangelo, *The Last Judgment*, fresco on altar wall of Sistine Chapel. 1534–41. Vatican, Rome. Commissioned in 1534, the *Last Judgment* was completed in 1541, when Michelangelo was sixty-six. The effect on contemporary viewers was strong — and not always favorable (see p.281). During Michelangelo's lifetime Pope Paul IV wanted to erase it, and after Michelangelo's death loincloths and draperies were painted over the nude figures. Many of these have been removed in the recent cleaning.

shoulder. In contrast to the vibrant energy of God, Adam reclines languidly on the newly created earth. Michelangelo's interest in landscape was minimal in contrast to his emphasis on the power inherent in the human body, especially the torso. Whether clothed or nude, Michelangelo's muscular figures, rendered in exaggerated *contrapposto*, are among the most monumental images in western art.

Michelangelo's Late Style

When Michelangelo had completed the Sistine ceiling, he went back to Florence to resume work for the Medici family. In 1534, on the order of Pope Paul III, he returned to Rome and began the *Last Judgment*, covering the altar wall of the Sistine Chapel (fig. **16.20**). There has been a great deal of discussion of Michelangelo's late style. Some scholars consider that it marks the close of the Renaissance, while others prefer to see it as part of new Mannerist developments (see p.275). Both views contain some truth, since Mannerist trends (which share certain characteristics with late Michelangelo) were under way by the mid-sixteenth century. Nevertheless, the *Last Judgment* is considered here within the context of Michelangelo's style, which developed beyond the High Renaissance.

The picture is divided horizontally into three levels, which correspond roughly to three planes of existence. At the top is Heaven. In the lunettes, angels carry the instruments of Christ's Passion — the crown of thorns, the column of the Flagellation, and the cross. In the center, below the lunettes, Christ, surrounded by a glow of light, raises his hand and turns toward the damned. Mary is beneath his upraised right arm, and crowds of saints and martyrs twist and turn in space, exhibiting the instruments of their martyrdom. In the middle level, at the sound of the "Last Trump" (blown by angels in the lower center), saved souls ascend toward Heaven on Christ's right (our left), while the damned descend into Hell on Christ's left. At the lowest level, the saved climb from their graves and are separated from the scene of Hell, on the lower right, by a rocky riverbank.

Michelangelo's Hell is a new conception in Christian art. Unlike the medieval Hell of Giotto's Arena Chapel (see p.221), Michelangelo's is a Classical vision. The boatman of Greek mythology, Charon, ferries the damned across the River Styx into Hades. In the far right corner, the monstrous figure of Minos is entwined by a giant serpent. In contrast to Giotto's *Last Judgment* (fig. **14.6**), which, except for Hell, was orderly, restrained, and clear, Michelangelo's is filled with overlapping figures, whose twisted poses, radical *contrapposto*, and sharp foreshortening energize the surface of the wall. In Giotto's conception, tortures are confined to Hell. In Michelangelo's, torture pervades the whole work.

That this mood reflects the artist himself, as well as the troubled times, is evident in the detail of St. Bartholomew (fig. **16.19**), the Christian martyr who was flayed alive. He brandishes a knife and displays a flayed skin that bears Michelangelo's self-portrait.

Raphael

Raphael (Raffaello Sanzio) was born eight years after Michelangelo but died forty-four years before him. During his short life (1483–1520) Raphael came to embody the Classical character of High Renaissance style. He assimilated Classical antiquity and hired scholars to translate Greek and Roman texts. Prolific and influential, he was primarily a painter, although it is clear from figure **16.6** and his appointment as overseer of the new St. Peter's that his skills included architecture.

At the beginning of his career, Raphael worked in Florence, where he painted many versions of the Virgin with the Christ child. The *Madonna of the Meadows* of 1505 (fig. **16.21**) is a good example of his clear, straight-forward, classicizing style. Figures are arranged in the pyramidal form favored by Leonardo, though the landscape lacks the *sfumato* of Leonardo's mysterious backgrounds. Christ stands in the safety of Mary's embrace. John the Baptist, his second cousin and playmate, symbolically hands Christ the symbol of his earthly mission, which Christ accepts by receiving the cross. Mary observes this exchange from above, recognizing that it means the future sacrifice of her son. In contrast to the ambiguities of Leonardo's iconography and the contorted, anxious figures of Michelangelo, Raphael's style is calm, harmonious, and restrained.

16.22 (above, left) Raphael, *Drawing of Pope Julius II*. 1511. Red chalk drawing, 14³⁄₁₆ × 9⁷⁄₈ in (36 × 25 cm). Duke of Devonshire Collection, Chatsworth, Derbyshire.

16.23 (above, right) Raphael, *Portrait of Pope Julius II*. 1511–12. Oil on panel, 3 ft 6½ in × 2 ft 7½ in (1.08 × 0.80 m). Duke of Devonshire Collection, Chatsworth.

16.22 and **16.23** Julius II (1443–1513) was a forceful ruler and the greatest patron of his age. As pope, he restored the papal states as the leading power in Italy. A fearless military leader, he drove out the French forces of Louis XII. He led a worldly life (he was the father of three illegitimate daughters), and had a reputation for being hot-tempered and *terribile* (awe-inspiring). The acorn motif on the pope's chair was an emblem of his family, the della Rovere. X-ray analysis of the painting has revealed that Raphael originally included papal insignia in the background, but later painted them out. The rings on six of his fingers confirm the record that Julius liked to spend money on jewels.

16.21 (opposite) Raphael, *Madonna of the Meadows*. 1505. Oil on panel, 3 ft 8½ in × 2 ft 10¼ in (1.13 × 0.87 m). Kunsthistorisches Museum, Vienna.

16.24 (above) Raphael, *The School of Athens.* 1509–11. Fresco, 26 × 18 ft (7.92 × 5.49 m). Stanza della Segnatura, Vatican, Rome. This fresco covered one entire wall of the private library of Julius II. The room was known as the Stanza della Segnatura because it used to be the place where the *Signatura Curiae*, a division of the supreme papal tribunal, met. Raphael was commissioned by Julius II to decorate this vast room with frescoes of Classical and Christian subjects.

16.25 (left) Detail of fig. **16.24** showing Raphael's self-portrait. The proverbial contrast between Raphael's sociability and Michelangelo's brooding isolation is captured by a sixteenth-century anecdote. The two artists run into each other on a street in Rome. Michelangelo, noting the crowd around Raphael, asks "Where are you going, surrounded like a provost?" Raphael replies: "And you? Alone like the executioner?"

At the age of twenty-six, Raphael went to Rome, where, in addition to religious works, he painted portraits and mythological pictures. His patrons were among the political, social, and financial leaders of the High Renaissance. In 1511 Raphael drew Pope Julius II (fig. **16.22**) in preparation for painting his portrait (fig. **16.23**) a year or so later. The drawing illustrates Raphael's skillful use of line to evoke the pope's personality. He has emphasized with darker strokes the eye sockets and the right cheek, which, in the painting, will be shaded so that they appear recessed. The forehead, left blank in the drawing, is highlighted in the painting. The more textured drawing of the cap is rendered in paint as dark red felt. The final result — the first known portrait of an individual pope — shows a man of about seventy, dressed in everyday (rather than ceremonial) official garb. Raphael has captured a sense of Julius II's intellect and his capacity for deep introspection. The pope's portrait is a psychological portrayal rather than a conventional icon of power. The oblique position and three-quarter length view of the figure became typical for portraiture throughout the High Renaissance.

Raphael's monumental *School of Athens* (fig. **16.24**) is generally considered to represent the culmination of his Classical harmony. Philosophers representing the leading schools of ancient Greek philosophy are assembled in a single, unified compositional space. The figures are lined up horizontally at the top of the steps, with distinct groups on either side. On the left, Pythagoras demonstrates his system of proportions to students. Diogenes, who proverbially carried a lantern through the streets of ancient Athens in his search for an honest man, sprawls across the steps slightly to the right of center. On the right, the Greek mathematician Euclid discusses geometry. At the center of the top step, framed and accented by the round arches, are the two most famous Greek philosophers. On the left, Plato carries a text of his dialogue, the *Timaeus*, and on the right is Aristotle with his *Ethics*. The point at which the shoulders of these two giants of western thought touch corresponds to the vanishing point of the painting.

Not only has Raphael integrated different philosophical schools, he has also included portraits of his contemporaries among the philosophers. Euclid, for example, is a portrait of Bramante. The architecture of the painting, which is a tribute by Raphael to his mentor, is itself influenced by Bramante. Plato is a portrait of Leonardo, whose pointing finger is a characteristic gesture in Leonardo's own pictures — for example, the doubting Thomas in the *Last Supper* (fig. **16.12**). Here Raphael pays tribute to Leonardo's central role as a thinker and artist in establishing the High Renaissance style.

The brooding foreground figure to the left of center, presumed to be the philosopher Heraclitus, is a portrait of Michelangelo, who was working on the Sistine ceiling while Raphael was painting the papal apartments. On the far right, amidst the crowd of geographers, is a self-portrait of Raphael (fig. **16.25**), looking out from the picture plane. Raphael portrays Michelangelo and himself according to their respective personalities and styles. Michelangelo is brooding, isolated, and muscular. Raphael, who was known for his easy, sociable manner, relates freely to his companions and to the observer, and is painted in the soft, restrained style of his early works. By placing Leonardo at the top of the steps, Raphael sets him apart, as if above the competitive rivalry that existed between Michelangelo and himself.

Raphael's style became more complex after the *School of Athens*, expanding in scale, in the range of movement, and in the use of light and dark. But his early death cut short his remarkable career. He, more than any other High Renaissance artist, combined Classical purity with the Christian tradition in painting. In contrast to Leonardo, who had enormous difficulty completing his works, Raphael worked quickly and efficiently. Michelangelo's difficult personality often interfered with his relationships with patrons and affected his ability to finish and deliver a work. Raphael, on the other hand, was sociable and an adept diplomat. In a final tribute to the Classical past and its relevance to present and future, Raphael was, at his own request, buried in the Pantheon. His painting of Christ's Transfiguration hangs over his tomb.

Titian

Titian (Tiziano Vecellio), the leading painter of the High Renaissance in the wealthy republic of Venice, enjoyed a long, productive, and prosperous life (c. 1490–1576). His paintings cover a wide range of subject matter, including portraits, religious, mythological, and allegorical scenes. Particularly impressive are his warm colors, deepened by many layers of glaze, his insight into the character of his figures, and his daring compositional arrangements. In contrast to the sculptural quality of Michelangelo's paintings, Titian's are soft, textured, and richly material.

An important early commission was the *Pesaro Madonna* (fig. **16.26**), painted for Santa Maria Gloriosa, the church of the Frari family in Venice. Titian modified the pyramidal composition by placing Mary and Christ off-center, high up on a portico, and by setting the architecture asymmetrically, at an oblique angle. Only the members of the donor's family, kneeling in the foreground, are motionless. All the other figures are gesturing or moving, and are set on diagonals in relation to the picture plane. The steps, surmounted by large columns cut off at the top, are thrust diagonally back into space. Infant angels appear on the cloud above. One seen in rear view holds the cross. The back of this angel is juxtaposed with the infant Christ, who turns playfully on Mary's lap and looks out at the viewer. The fabrics are characteristically rich and textured, particularly the Pesaro flag and costumes. This attention to material textures is further enhanced by the variation of bright lights and dark accents in the sky. The light of Venice, sparkling in the waterways of that city, seems to illuminate this painting.

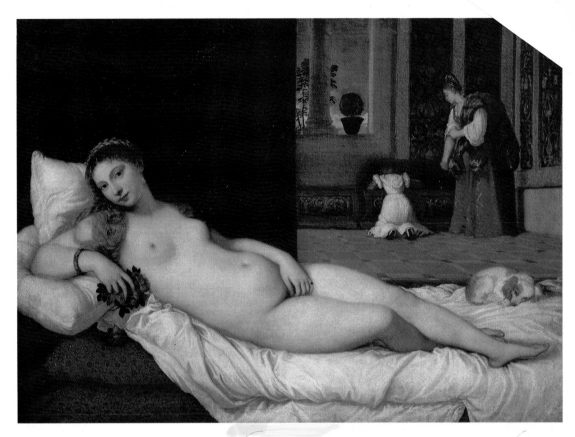

16.27 Titian, *Venus of Urbino*. c. 1538. Oil on canvas, 3 ft 11 in × 5 ft 5 in (1.19 × 1.65 m). Galleria degli Uffizi, Florence. The symbolism of this painting has been the subject of much discussion. Some claim that the Venus is a Venetian courtesan and that the theme of the work is illicit love. Others, while admitting its sensuality, see it as representing marital love and fidelity.

16.26 (opposite) Titian, *The Pesaro Madonna*. 1519–26. Oil on canvas, 16 ft × 8 ft 10 in (4.88 × 2.69 m). S. Maria Gloriosa dei Frari, Venice. Titian became the official painter of the Venetian republic in 1516 and raised the social position of the artist in Venice to the level achieved by Michelangelo and Raphael in Rome. He painted the *Pesaro Madonna* from 1519 to 1526 for Jacopo Pesaro, bishop of Paphos and a renowned admiral, who is the kneeling figure in the dark cloak at the lower left of the picture.

In the *Venus of Urbino* (fig. **16.27**) of c. 1538, Titian's spatial construction is more Classical. A sensual nude of unknown identity reclines on a bed parallel to the picture plane. A relatively symmetrical rectangular room, where two maids remove garments from a chest, occupies the background space. This Venus continues the tradition of the reclining nude female in western art. She is a descendant of the prehistoric Venus of Laussel (fig. **3.2**), whose gesture is remarkably similar to that of Titian's figure. The rich red of Venus's long flowing hair is characteristic of Titian, as are the yellow light and gradual shading that enhance the fleshy texture of her body. The roses, which drop languidly from her hand, and the myrtle in the flowerpot on the windowsill are attributes of Venus. The dog, as in the *Arnolfini Wedding Portrait* (fig. **15.31**), signifies both fidelity and erotic desire.

Titian's fame resulted in an invitation to the court of the Holy Roman Emperor Charles V at Augsburg, and he became the emperor's painter. In 1530, he attended Charles's coronation in the northern Italian city of Bologna, and three years later he was made a member of the nobility. In 1548 Titian painted an equestrian portrait of Charles V to commemorate the emperor's victory against the Protestants at Mühlberg in 1547 (fig. **16.28**). According to the western tradition of equestrian monuments, Titian renders the emperor as an assertive leader. Charles sits upright, armed for battle. His bearded chin juts out aggressively, and he thrusts his lance forward. The horse, nervously pawing the ground, seems to emerge from a dark forest on the left into an open space

16.28 Titian, *Charles V at Mühlberg*. 1548. Oil on canvas, 10 ft 11 in × 9 ft 2 in (3.32 × 2.79 m). Prado, Madrid. Although Titian's painting seems to be a faithful portrait, it actually idealizes Charles, who was short and had a deformity of the jaw that made it impossible to close his mouth. Titian has masterfully disguised these shortcomings, and portrays Charles as dignified and self-confident.

against a richly colored sky. In Titian's portrait, the emperor, defender of the Catholic faith, is at once a specific individual and a symbol of power.

Titian's long career, like Michelangelo's, chronologically overlapped styles such as Mannerism (see p.275), which developed after the High Renaissance. The late styles of both artists went beyond the High Renaissance Classicism

of Raphael — Titian in his loose brushwork and Michelangelo in his elongated forms. This demonstrates the difficulty of placing dynamic individual artists within neat categories of style. Nevertheless, by virtue of their training and their impact on the history of art, both Titian and Michelangelo are considered to epitomize the High Renaissance.

Mannerism and the Later Sixteenth Century in Italy

The sixteenth century was a period of intense political and military turmoil from which no artist could remain completely insulated. Charles I of Spain extended his empire to Austria, Germany, the Low Countries, and, finally, Italy. His aggression culminated in the sack of Rome in 1527. The 1500s were also a period of fundamental religious change. The power of the Catholic Church was challenged, and finally fractured, by the Protestant Reformation.

The counter-challenge, or Counter-Reformation, went far in the opposite direction. Humanism gave way to dogmatic religious orthodoxy, which was strictly enforced by the Inquisition. Love of naturalistic beauty was replaced by a much harsher view of nature. More emphasis was placed on God's role as judge and on the penalties of sin, rather than on the possibility of redemption. Besides splitting Europe into two religious camps, the Reformation and Counter-Reformation had fundamental effects on art, artists, and patrons.

Mannerism

After the death of Raphael in 1520, new developments began to emerge in Italian art. The most significant of these has been called Mannerism. It coexisted with the later styles of Michelangelo and Titian, and continued to be influential until the end of the sixteenth century. Some scholars see the late work of Michelangelo and Raphael as sharing certain qualities with the Mannerists.

The very term "Mannerism" is ambiguous and has potentially conflicting meanings. Among the several derivations that have been proposed for Mannerism are the Latin word *manus* (meaning "hand"), the French term *manière* (meaning a style or way of doing things), and the Italian *maniera* (an elegant, stylish refinement). In English, too, the term is fraught with possible interpretations. We speak of being "well-mannered" or "mannerly," when we mean that someone behaves according to social convention. "To the manner born" denotes that someone is suited by birth to a certain social status. Being "mannered," on the other hand, suggests a stilted, unnatural style of behavior. "Mannerisms," or seemingly uncontrolled gestures, are considered exaggerated or affected. In clinical psychology, to be "manneristic" means to have bizarre, stylized behavior of an individual nature.

All of these terms apply in some way to the sixteenth-century style called Mannerism. In contrast to the Renaissance interest in studying, imitating, and idealizing nature, the Mannerist artists took as their models other works of art. The main subject of Mannerism is the human body, which is often elongated, exaggerated, elegant, and arranged in complex, twisted poses. Classical Renaissance symmetry does not apply in Mannerism, which creates a sense of instability in figures and objects. Spaces tend to be compressed, and crowded with figures in unlikely or provocative positions. Finally, Classical proportions are rejected, and odd juxtapositions of size and space often occur.

In contrast to the dominance of papal patronage in the High Renaissance, Mannerism was a style engendered by the courts. It appealed to an elite, sophisticated audience. Mannerist subjects are often difficult to decipher, and their iconography can be highly complex, and obscure except to the initiated. They may also be self-consciously erotic.

Mannerist Painting

Parmigianino. The Mannerist taste for virtuosity and artifice is exemplified by the *Self-Portrait in a Convex Mirror* (fig. **17.1**) of Parmigianino (1503–40). He painted it in 1524 at the age of twenty-one, with the intention of dazzling the pope, Clement VII, with his skill. According to Vasari (see p.227), the artist got the idea from seeing his reflection in a barber shop mirror and decided to "counterfeit everything." The painting does indeed replicate the image in a convex mirror and is, in reality, convex. In the background Parmigianino's studio appears curved by the mirror's surface. The face itself is not distorted because of its distance from the picture plane, while the hand, being close to the picture plane, is enlarged. In these spatial arrangements, Parmigianino has emphasized the hand, making it as important a part of the

image as the face. The role of the artist's hand in the artifice is thus an integral part of the picture's iconography.

Parmigianino's *Madonna and Child with Angels* (fig. **17.2**), also called the *Madonna of the Long Neck*, illustrates the odd spatial juxtapositions and non-classical proportions that are typical of the Mannerist style. The foreground figures are short from the waist up, and long from the waist down. The Madonna, in particular, has an elongated neck and tilted head that flow into the spatial twist of her torso and legs. Her pose creates a typically Mannerist **figura serpentinata**, or serpentine figure. The man in the distance unrolling a scroll could be an Old Testament prophet. His position between the Madonna and the unfinished column creates a logical visual link between pagan antiquity and the Christian era. His improbably small size in relation to both the column and the Madonna, however, is illogical.

17.1 Parmigianino, *Self-Portrait in a Convex Mirror.* 1524. Oil on wood, diameter 9⅝ in (24.4 cm). Kunsthistorisches Museum, Vienna. Il Parmigianino ("The Little Fellow from Parma") was the nickname of Francesco Mazzola, who worked in Parma, Rome, and Bologna. His career was fraught with conflicts and lawsuits, and his interest in pictorial illusionism can be related to his preoccupation with counterfeiting. He was obsessed with alchemy (the science of converting base metal to gold) and eventually he abandoned painting altogether.

The Reformation

By the second decade of the sixteenth century, after more than a thousand years of religious unity under the Roman Catholic Church, western Christendom underwent a revolution known as the Reformation. This led to the emergence in large parts of Europe of the Protestant Church.

During the fifteenth century the Church had become increasingly materialistic and corrupt. Particularly offensive was the selling of "indulgences" (a kind of credit against one's sins), which allegedly enabled sinners to buy their way into Heaven. In 1517 a German Augustinian monk named Martin Luther protested. He nailed to a church in Wittenberg, Saxony, a manifesto listing ninety-five arguments against indulgences. Luther further criticized the basic tenets of the Roman Church. He advocated abolition of the monasteries and restoration of the Bible as the sole source of Christian truth. Luther believed that human salvation depended on individual faith and not on the mediation of the clergy. In 1520 he was excommunicated.

In 1529 Charles V tried to stamp out dissension among German Catholics. Those who protested were called Protestants. In the course of the next several years most of north and west Germany became Protestant. England, Scotland, Denmark, Norway, Sweden, the Netherlands, and Switzerland also espoused Protestantism. For the most part, Italy and Spain remained Catholic. By the end of the sixteenth century, about one-fourth of western Europe was Protestant.

King Henry VIII of England had been a steadfast Catholic, but his wish for a male heir led him to ask the pope to annul his marriage to Catherine of Aragon, the first of his six wives. The pope refused, and Henry broke with the Catholic Church. In 1534 the Act of Supremacy made Henry, and all future English kings, head of the Church of England. In 1536 the fundamental doctrines of Protestantism were codified in John Calvin's *Institutes of the Christian Religion*. His teachings became the basis of Presbyterianism.

The Reformation dealt a decisive blow to the authority of the Roman Catholic Church, and the balance of power in western Europe shifted from religious to secular authorities. As a result, the cultural and educational dominance of the Church waned, particularly in the sciences. In the visual arts, the Reformation had a far greater impact in northern Europe than in Italy or Spain. Throughout Europe, however, the Reformation marked the beginning of a progressive decline in Christian imagery.

17.2 (opposite) Parmigianino, *Madonna and Child with Angels* (*Madonna of the Long Neck*). c. 1535. Oil on panel, c. 7 ft 1 in x 4 ft 4 in (2.16 x 1.32m). Galleria degli Uffizi, Florence. Parmigianino's perverse nature is evident in this painting. Its undercurrent of sinister, lascivious eroticism is also consistent with Mannerist tastes. Vasari described him as "unkempt . . . , melancholy, and eccentric" at the time of his early death, and related that he was, at his own request, buried naked with a cypress cross standing upright on his breast — apparently an expression of his psychotic identification with Christ.

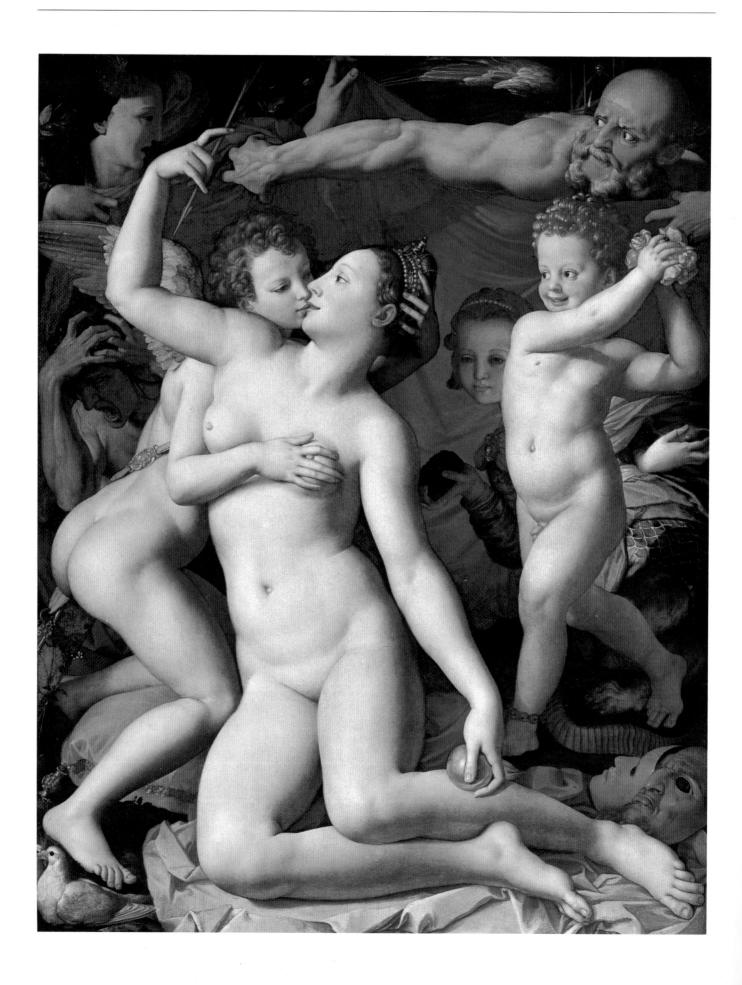

17.3 (opposite) Agnolo Bronzino, Allegory called *Venus, Cupid, Folly, and Time.* c. 1545. Oil on wood, 5 ft 1 in x 4 ft 8¾ in (1.55 x 1.44 m). National Gallery, London.

17.4 (right) Benvenuto Cellini, Saltcellar of Francis I. Finished 1543. Gold and enamel, 10¼ x 13⅛ in (26 x 33.3 cm). Kunsthistorisches Museum, Vienna. Benvenuto Cellini (1500–71), a versatile Mannerist artist, made this elaborate saltcellar while working in France as Francis I's court goldsmith.

Bronzino. The allegorical painting of about 1545 by Bronzino (1503–72), traditionally called *Venus, Cupid, Folly, and Time* (fig. **17.3**), illustrates the Mannerist taste for obscure imagery with erotic overtones. The attention to silky textures, jewels, and masks is consistent with Bronzino's courtly, aristocratic patronage. Crowded into a compressed foreground space are several figures whose identities and purpose have been the subject of extensive scholarly discussion. Venus and her son Cupid are easily recognizable as the two figures in the left foreground. Both are nude, and bathed in a white light that creates a porcelain skin texture. Cupid fondles his mother's breast and kisses her lips. To the right, a nude *putto* with a lascivious expression dances forward and scatters flowers.

All three twist in the Mannerist *figura serpentinata* pose. But only the *putto*'s pose seems required by his action. The undulating forms of Venus and Cupid are rendered for their own sake rather than to serve narrative logic. A more purposeful gesture is that of Time, the old man who angrily draws aside a curtain to reveal the incestuous transgressions of Venus and Cupid. The identity of the remaining figures is less certain. The hag tearing her own hair has been called Envy, and the creature behind the *putto*, with a serpent's tail and the rear legs of a lion, Fraud. There is, however, no consensus on their identification or even on the overall meaning of this painting. It was apparently commissioned by Cosimo de' Medici as a gift for Francis I of France. Despite the strictures of the Counter-Reformation, as codified by the Council of Trent, court patronage clearly delighted in playful and erotic, if somewhat obscure, imagery.

Cellini. Cellini's elaborate gold and enamel saltcellar (fig. **17.4**) illustrates the iconographic complexity and taste for mythological subject matter that appealed to Mannerist artists and their patrons. Cellini himself gave conflicting accounts of the saltcellar's meaning. Perhaps he simply forgot — but the ambiguity is nevertheless consistent with Cellini's ambivalent lifestyle. Cellini described his life in a celebrated autobiography, which he dictated while under house arrest for sodomy. He worked throughout Italy and in France, constantly on the move to avoid lawsuits for his violent behavior (including two murders in Rome). Bisexual in his tastes, in 1558 he took preliminary vows for the priesthood, but later renounced them and married the mother of his illegitimate children.

What is clear is that the two main nude figures of the saltcellar represent the bearded Neptune, holding a trident and surrounded by seahorses, and the Earth goddess, next to an Ionic temple. She holds a cornucopia. Neptune's ship was designed to contain the salt, and Earth's temple the pepper. Other figures include personifications of winds, seasons, and times of day. The style and poses of the figures are clearly Mannerist. They are elegantly proportioned and arranged to form spatial twists that result in impossible poses. Both Neptune and Earth, whose legs are intertwined, lean so far back that in reality they would topple over. The absence of any visible means of support reinforces their uneasy equilibrium and the movement inherent in their elaborate poses and surface patterns is enhanced by the high polish of the gold.

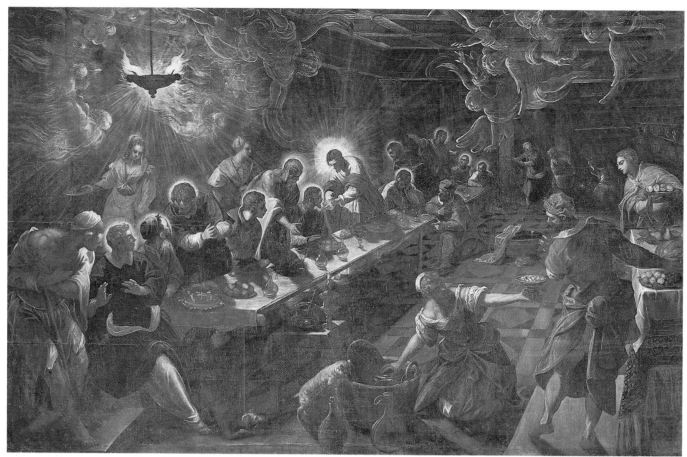

17.5 (above) Jacopo Tintoretto, *The Last Supper*. 1592–4. Oil on canvas, 12 ft × 18 ft 8 in (3.66 × 5.69 m). Chancel, S. Giorgio Maggiore, Venice. Jacopo Robusti (1518–94) was nicknamed Tintoretto ("Little Dyer" in Italian) because of his father's profession as a wool dyer. He worked for most of his life in Venice and succeeded Titian as official painter to the republic. He was very prolific and employed many assistants, including two sons and a daughter, Marietta (see p.281).

17.6 (below) Paolo Veronese, *The Last Supper*, renamed *Christ in the House of Levi*. 1573. Oil on canvas, 18 ft 3 in × 42 ft (5.56 × 12.8 m). Accademia, Venice. Paolo Caliari was born in Verona, hence his name, Il Veronese. In 1553 he moved to Venice, where, with Titian and Tintoretto, he dominated sixteenth-century Venetian painting. This picture illustrates his mastery of *di sotto in sù* (Italian for "looking up from below") perspective. Although Veronese liked to dress luxuriously — in keeping with the taste for pageantry evident in his paintings — he was known for his piety and financial acumen.

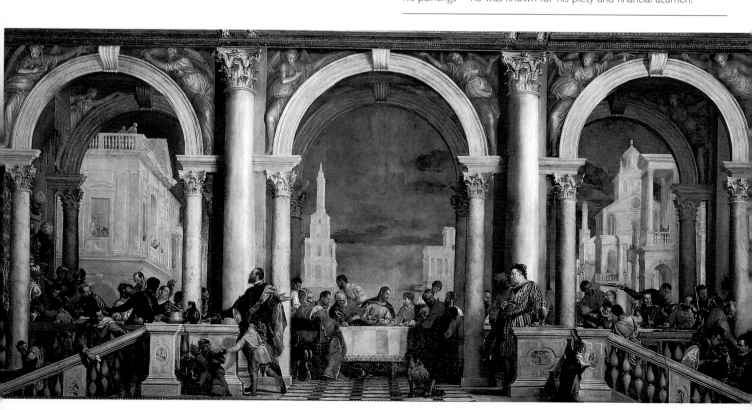

Counter-Reformation Painting

Tintoretto. The impact of the Council of Trent and the Counter-Reformation on the visual arts is most evident from the second half of the sixteenth century. Tintoretto, for example, a leading Venetian painter and a contemporary of Veronese, painted a *Last Supper* (fig. **17.5**) that conformed well to Counter-Reformation requirements. The choice of the moment represented, when Christ demonstrates the symbolic meaning of the bread as his body and the wine as his blood, lends itself to mystical interpretation.

In Tintoretto's *Last Supper*, in contrast to those of Veronese (fig. **17.6**) and Leonardo (fig. **16.12**), the picture space is divided diagonally. The table is no longer parallel to the picture plane, and the figures are not evenly lit from a single direction. Humanist interest in psychology and observation of nature has been subordinated to mystical melodrama. The table recedes into the background. To its right, in deep shadow, are servants who go about their business apparently unaware of the significant event taking place at the table. On its left are the apostles, some

The Painter's Daughter

In the seventeenth-century biography of Tintoretto by Carlo Ridolfi, the author includes an account of two of the artist's children, Domenico and Marietta, who were also painters. Both children assisted their father in completing commissions and were well thought of by their contemporaries. Ridolfi reports that Tintoretto trained Marietta and had her instructed in music. She accompanied her father everywhere and dressed as a boy. Because Tintoretto was so attached to her, he arranged for her to marry a local jeweler rather than leave Venice. Her special talent, according to Ridolfi, was portraiture, although he notes that her works have disappeared. Marietta died at age thirty.

Particularly striking, in the light of modern feminist approaches to art history, is Ridolfi's vigorous defense of women artists. Like Vasari, he cites examples of famous women in antiquity as well as in his own day. He condemns the discrimination that keeps women untrained and at home. Ridolfi concludes, however, that women will triumph because, in addition to natural talents, they are also armed with beauty.

The Counter-Reformation

In response to the Reformation, the Roman Catholic Church mounted the Counter-Reformation and tried to eliminate internal corruption. From 1546 to 1564 the Council of Trent was convened at Trento in northern Italy. It denounced Lutheranism and reaffirmed Catholic doctrine. Measures were initiated to improve the education of priests and reassert papal authority beyond Italy. To this end, the Council established an Inquisition in Rome to identify heretics and bring them to trial.

In its final session, the Council of Trent restated the Roman Church's view that art should be didactic, ethically correct, decent, and accurate in its treatment of religious subjects. Parallels between the Old and New Testaments were to be emphasized, rather than Classical events. The Council directed that art should appeal to emotion rather than reason — an implicitly anti-humanist stance, which resulted in an increase of miraculous themes. The Roman Inquisition was granted the power to censor works of art that failed to meet the requirements of the Council.

In 1573 the Venetian painter Veronese (1528–86) was summoned to appear before the Holy Tribunal to defend his monumental High Renaissance painting of the *Last Supper* (fig. **17.6**). The trial transcript, which has been preserved, makes it clear that the Inquisition objected to Veronese's naturalism. The Inquisitors asked Veronese to identify his profession and describe his painting.

"In this Supper," the prosecutor asked, "what is the significance of the man whose nose is bleeding?"

"I intended to represent a servant whose nose was bleeding because of some accident," the artist replied. Then the Inquisitor asked about the apostle next but one to St. Peter.

"He has a toothpick and cleans his teeth," said Veronese.

The Inquisitor also objected to German soldiers eating and drinking on the stairs, and to the jesters and other figures in the picture. Germany, he declared, no doubt thinking of Martin Luther, was "infected with heresy."

Veronese was suitably contrite, admitting that he had used some artistic license. He said that Christ's Last Supper had taken place in the house of a rich man who might be expected to have visitors, servants, and entertainment. The Inquisitor was not impressed.

"Does it seem fitting at the Last Supper of the Lord to paint buffoons, drunkards, Germans, dwarfs, and similar vulgarities?"

"No, milords."

The Inquisition gave Veronese three months to alter his picture. He did so by changing its title to *Christ in the House of Levi*.

In Catholic countries the zeal of the Counter-Reformation led to intolerance, moralizing, and a taste for exaggerated religiosity. Michelangelo, for example, came under particular attack. In 1549 a copy of his *Pietà* (fig. **16.14**) was unveiled in Florence. Because of Mary's depiction as an attractive figure, scarcely older than Christ himself, Michelangelo was called an "inventor of filth." In 1545 Pietro Aretino wrote to Michelangelo, criticizing his *Last Judgment* (fig. **16.20**) as suitable for a bathroom but not for a chapel.

It was against this background of political and religious turmoil that sixteenth-century art developed after 1520. One cannot necessarily show a cause and effect relationship with Mannerism. Nevertheless, there is, in that style, an undercurrent of anxiety and tension — beneath the refinement and elegance — that is not inconsistent with the times.

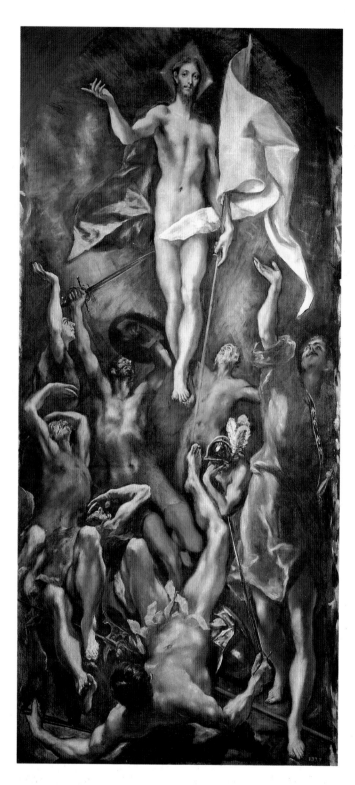

17.7 El Greco, *The Resurrection of Christ*. c. 1597–1604. Oil on canvas, 9 ft ¼ in x 4 ft 2 in (2.75 x 1.27 m). Prado, Madrid. Domenikos Theotokopoulos (1541–1614) was born in Crete and subsequently nicknamed El Greco (Spanish for "The Greek"). Most of his work was executed for the Church rather than the court, and has a strongly spiritual quality. Of all the leading Mannerist painters, El Greco was the most mystical, and was therefore well suited to the fervent religious atmosphere of Counter-Reformation Spain.

in exaggerated poses, illuminated by a mystical light that is consistent with official Counter-Reformation taste. Toward the center of the table, Christ distributes bread to the apostles. Light radiates from his head, so that he is depicted literally as "the light of the world." On the right of the table, brooding, isolated, and in relative darkness compared to the other apostles, sits Judas. In the upper right, outlined in glowing light, is a choir of angels.

El Greco. El Greco was even more directly a painter of the Counter-Reformation. He worked in Spain from 1577 onward when Counter-Reformation influence was at its strongest. In his paintings virtually all traces of High Renaissance style, humanist concerns, and Classical subject matter have disappeared. In his late *Resurrection* (fig. **17.7**), Mannerism has been placed squarely in the service of Christian mysticism—especially in the depiction of light. Christ rises in light against a dark background, his halo forming a diamond shape. The Roman soldiers reveal their agitation in their twisting, unstable poses. Some are blinded by the divine light of Christ. One unstable soldier falls backward, toward the picture plane. The surface is animated throughout by flickering flames of light, and three-dimensional space is radically decreased.

Architecture: Palladio

The greatest architect of late sixteenth-century Italy was Andrea Palladio (1508–80), who synthesized Mannerism with the ideals of the High Renaissance. He combined certain Mannerist tendencies with a humanist education that inspired his use of ancient sources, particularly Vitruvius (see p.254).

Between 1566 and 1570 Palladio built the Villa Rotonda (figs. **17.8** and **17.9**), near the northern Italian city of Vicenza, for a Venetian cleric. The façade replicates the Classical temple portico—Ionic columns supporting an entablature crowned by a pediment—in the context of domestic architecture. There are four porticos, all in the same style and one on each side of the square plan (fig. **17.8**). In Palladio's view, the Classical entrance endowed the building with an air of dignity and grandeur. The strict symmetry was both a Classical and a Renaissance characteristic. Such features recalled ancient Rome, where the villa had originated as an architectural type.

The square plan of the Villa Rotonda is typical of Palladio's villas. Passages radiate from the domed central chamber to each of the four exterior porticos. They, in turn, offer views of the surrounding landscape in four directions. At the sides, each portico is enclosed by a wall pierced by an arch, thereby providing shelter as well as ventilation.

In figure **17.9** some of the classically inspired statues at each angle of the pediments are visible. Others decorate the **postaments** flanking each side of the steps. Since the Villa Rotonda was a purely recreational building, used exclusively for entertaining, it did not have the functional additions found in Palladio's other villas.

17.8 Plan and section of the Villa Rotonda (from the *Quattro Libri dell'Architettura*, 1570). 18th-century engraving. Bibliothèque de l'Arsenal, Paris.

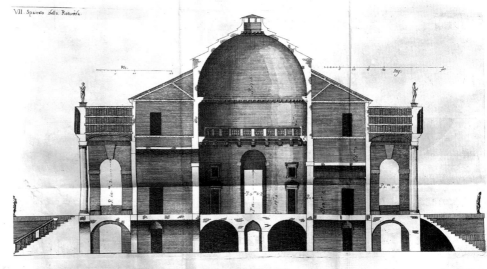

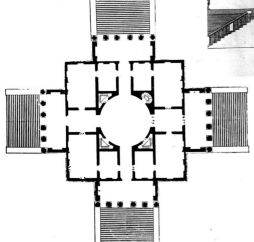

17.9 Andrea Palladio, Villa Rotonda, Vicenza. Begun 1567–9. Andrea di Pietro Gondola was renamed Palladio (after Pallas Athena) by Count Trissino, a humanist scholar and poet who supervised his education and career. Palladio is known to have been involved in over 140 building projects, of which no more than about thirty-five survive. He also published *L'Antichità di Roma*, the first Italian guidebook, in 1554 and the *Quattro Libri dell'Architettura* (*The Four Books of Architecture*) in 1570.

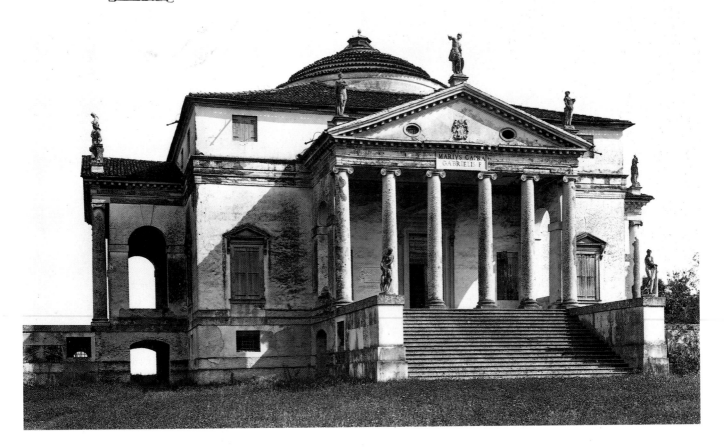

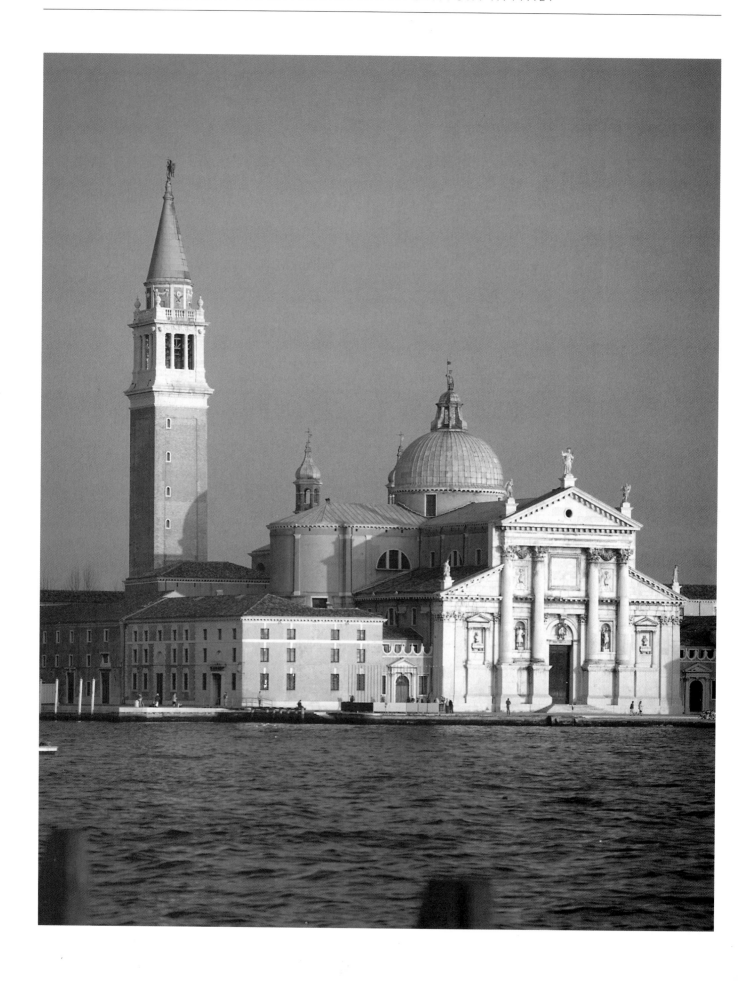

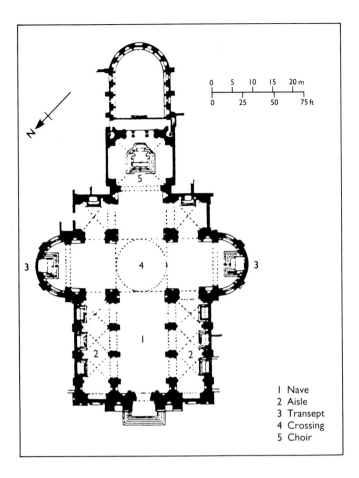

17.11 Plan of S. Giorgio Maggiore, Venice.

1 Nave
2 Aisle
3 Transept
4 Crossing
5 Choir

17.10 (opposite) Andrea Palladio, S. Giorgio Maggiore, Venice. Begun 1565.

From 1570 Palladio worked mainly in Venice, particularly on church design. His Church of San Giorgio Maggiore (figs. **17.10** and **17.11**), begun in 1565 but not completed until 1592, stands on an island facing the Grand Canal. In this building, Palladio solved the problem of relating the façade to an interior with a high central nave and lower side aisles. He did so by superimposing a tall Classical façade with engaged Corinthian columns and a high pediment on a shorter, wider façade with shorter columns and a low pediment. The former corresponded to the elevation of the nave, and the latter to that of the side aisles. This relationship between the façade and the nave and side aisles unified the exterior and interior of the church in a new way. They are further unified by the repetition of Corinthian columns along the nave and of shorter pilasters on the side aisles.

In these solutions, Palladio incorporates Classical elements into religious as well as domestic architecture. Nevertheless, the order and the relationship of the elements are not strictly Classical. It would be difficult to demonstrate that his works are Mannerist, but they share with Mannerism the tendency to juxtapose form and space in a way that is inconsistent with Classical arrangements. For example, Palladio breaks, or interrupts, one pediment in imposing another over it. This feature, called a **broken pediment**, becomes a characteristic aspect of Baroque architecture in the seventeenth century (see Chapter 19). In superimposing larger and smaller façades, as in San Giorgio Maggiore, and combining a temple portico with a domestic villa, Palladio recalls the unexpected juxtapositions found in Mannerist paintings.

Palladio was the single most important architect of his generation, and his influence on subsequent generations of western architecture was extensive. His style was revived in the eighteenth century by Colen Campbell and Lord Burlington in England, and in America by Thomas Jefferson. His palaces and villas are still imitated in western Europe and America.

Sixteenth-Century Painting in Northern Europe

As in the fifteenth century, northern Europe in the sixteenth century underwent many of the same developments as the south. The most important northern artists were the painters of Germany and the Netherlands, who traveled to Italy and studied the High Renaissance style. Many were influenced by Italian humanism, although the north was always less comfortable with the Classical tradition than Italy. The **linear** nature and crisp edges of Gothic forms persist in even the most innovative artists of Germany and the Netherlands. Northern artists were less interested than the Italians in the subtleties of *chiaroscuro* and modeling. The rich, painterly qualities of even the late Venetian Renaissance do not appear in the north.

Despite these differences, however, the north produced some of Europe's most distinguished humanists, including Erasmus of Rotterdam. Germany was the home of Martin Luther, the leading figure of the Protestant Reformation (see p.276). As a result, many of the conflicts between the humanists and the Inquisition that created tensions in southern Europe affected the north as well. Northern Europe also displayed the same interest in artists' biography as the Italian Renaissance humanists. In 1604, for example, Karel van Mander (1548–1606) of Haarlem, Holland, published *Het Schilderboeck*, or *The Painter's Book*, which describes the lives of northern artists. Like Vasari's *Lives* (see p.227), it has become an important source for the history of Renaissance art.

The Netherlands

Bosch

The most important Netherlandish artist was Hieronymus Bosch (c. 1450–1516). His *Seven Deadly Sins and the Four Last Things* (fig. **18.1**), painted on a tabletop, expresses the medieval view that life on earth is a mere reflection, or mirror, of heavenly perfection. God, according to this view, is both the creator and the "eye." He watches, remembers, and in the end punishes or rewards, according to one's merits while on earth.

The large central circle of Bosch's painting is a metaphor for the eye as a mirror. It is a variation on the convex mirror in van Eyck's fifteenth-century *Arnolfini Wedding Portrait* (fig. **15.31**), which reflected the artist and also symbolized God's presence. In the Bosch, the resurrected Christ occupies the center of a dark ring, with rays of light extending from it—a visual metaphor for the pupil in an eye. Inscribed in Gothic letters in Latin under Christ's sarcophagus is *Cave, cave, Dominus videt*, or "Beware, beware, the Lord sees."

On the outermost ring of the circle are seven scenes from daily life illustrating the Deadly Sins (see p.218). *Superbia* (Pride) is represented as a vain woman admiring herself in a mirror. Holding the mirror and half-hidden behind a chest is a devil. *Ira* (Anger) is a fight between neighbors. *Avaritia* (Avarice) is a rich man taking money from a poor man while bribing a judge. And *Gula* (Gluttony) is a scene of excessive eating and drinking. This combination of Christian moralizing with genre (see p.32), mixed with humor, is characteristic of Late Renaissance painting in the Netherlands.

Erasmus: Reform without Strife

Desiderius Erasmus (c. 1466–1536) was a Dutch Roman Catholic reformer and one of the greatest Renaissance humanists in northern Europe. The illegitimate son of a priest, Erasmus was ordained in 1492 and then studied the Classics in Paris. Among his most important works is *Moriae Encomium* (*The Praise of Folly*), in which he satirizes greed, superstition, and the corruption and ignorance of the sixteenth-century clergy. Erasmus nevertheless opposed the Reformation, fearing that partisan religious strife would prove destructive. Attacked by Catholics and Protestants alike, Erasmus remained committed to reconciliation and unity.

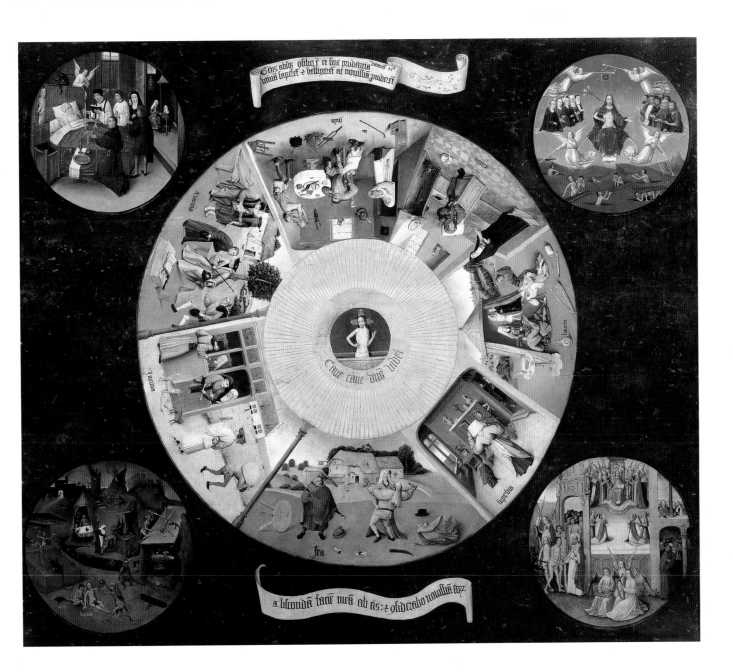

18.1 Hieronymus Bosch, *The Seven Deadly Sins and the Four Last Things*, painted tabletop. Oil on wood, 3 ft 11¼ in × 4 ft 11 in (1.20 × 1.50 m). Prado, Madrid. None of Bosch's pictures have documented dates. This painting is variously regarded as an early (c. 1475) or a late (1505–15) work. All that is known of Bosch is that he lived in the small Dutch town of Hertogenbosch (from which his name is derived) and was a member of a religious fraternity, the Brotherhood of Our Lady. He believed in the pervasiveness of sin, usually of a sensual nature, and his works illustrate the torments of Hell in vivid detail.

The four corners of Bosch's tabletop illustrate the "Four Last Things," a reminder of life's end on earth and the rewards or punishments that follow. In the deathbed scene at the upper left, a dying man, surrounded by his family, receives the last rites. At the upper right, Christ presides over the Last Judgment. In the lower right and left, respectively, are Heaven and Hell. Heaven is an orderly, harmonious court illuminated by divine light. Hell is dark, disordered, and fraught with torture and destruction.

The meaning of Bosch's huge altarpiece called *The Garden of Earthly Delights* (fig. **18.2**), generally dated c. 1505–10, is more obscure than the tabletop. In the foreground, God presents the newly created Eve to a reclining Adam in the Garden of Eden. Around Adam and Eve are smaller animals and an unusual tree. In the middle ground, a curious fountain stands in a pool of water. In

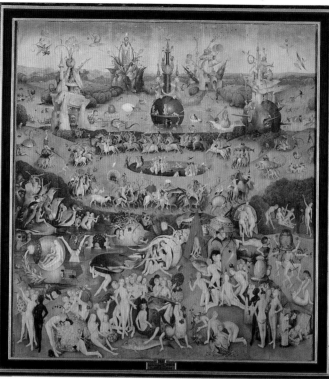

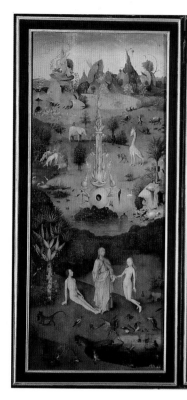

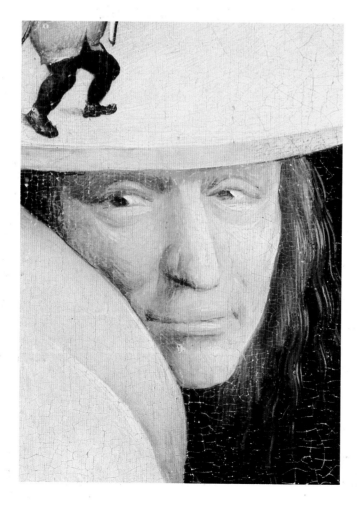

18.2 Hieronymus Bosch, *The Garden of Earthly Delights*, triptych: left panel *Garden of Eden*, center panel *The World before the Flood*, right panel *Hell*. c. 1505–10. Oil on wood, side panels 7 ft 2 in x 3 ft (2.18 x 0.91 m), center panel 7 ft 2 in x 6 ft 4 in (2.18 x 1.93 m). Prado, Madrid. The meaning of this triptych has been debated at length. It is not known who commissioned it or why. The left wing represents the Garden of Eden, and the central panel has been interpreted as an allegory of corruption through lust. On the right, Hell is a dark region of destruction and disaster.

18.3 (left) Head of the egg-monster, detail of fig. **18.2**.

the background, wild animals exist in a state of apparent tameness.

The human figures in the central panel seem engaged in sexual pursuits. They are small in relation to the odd plant and animal forms that populate the picture's space. Some are enclosed in transparent globular shapes. These illogical juxtapositions of size, together with the strange symbolic details, such as the enlarged strawberries, suggest that Bosch is depicting an inner, dreamlike world. At the same time, however, many of his images are within the context of Christian tradition — as is the conventional opposition of the era before the Fall on the left with Hell on the right. The slightly sinister aura of the central panel suggests moralizing on the artist's part — a tendency that is more clearly evident in the tabletop.

In Hell, buildings burn in the distance. Elaborate tortures and dismembered body parts take on a life of their own. A man is crucified on the strings of a harp, and a seated monster swallows one soul and expels another

through a transparent globe. A pair of ears is pierced by an arrow. At the center of this vision of Hell is a monster whose body resembles a broken egg (fig. **18.3**). He is supported by treetrunk legs, and on his head he balances a disk with a bagpipe, which is a traditional symbol of lust in western art. Peering out from under the disk, and seemingly weighed down by it, is an individualized face that could be Bosch's self-portrait. The specific nature of the face and its self-conscious appeal to the observer suggest the artist's identification with it. Like the fantastic complexity and tantalizing obscurity of Bosch's images in this work, however, the face remains unexplained.

Pieter Brueghel the Elder

The foremost sixteenth-century painter of the Netherlands, and a follower of Bosch, was Pieter Brueghel the Elder (c. 1525–69). In his *Landscape with the Fall of Icarus* (fig. **18.4**), Brueghel reveals his interest in landscape for its own sake — an interest that developed sooner in the north than in Italy. Brueghel's vision of humanity in nature is revealed by the intense relationship between the peasant pushing his plowshare and the land. The folds of the peasant's tunic repeat the furrows of the plowed earth beneath him, formally uniting him with the land. The most outstanding feature of this figure is his bright red sleeve, which contrasts with the subdued tone of the scene.

Below the peasant stands a shepherd tending his flock, while a third man leans over the edge of the sea. Much of the picture plane is dominated by a seascape of boats, rocks, and a distant horizon. So absorbed are the three figures in their tasks that they fail to observe the mythical event taking place in their very midst.

To the humanist integration of antiquity with contemporary concerns, Brueghel adds the Christian moralizing tradition of northern Europe. The *Fall of Icarus* implies that it is wiser to tend the land than to brave the skies. This was also the message of his *Tower of Babel* (fig. **1.4**). There, too, though in a biblical setting, Brueghel depicts the dangers of unrealistic ambition, as the tower crumbles and falls like Icarus. To avoid the fall, according to Brueghel's imagery, one is advised to concentrate on

18.4 Pieter Brueghel the Elder, *Landscape with the Fall of Icarus*. c. 1554–5. Oil on panel (transferred to canvas), 2 ft 5 in x 3 ft 8⅛ in (0.74 x 1.12 m). Musées Royaux des Beaux-Arts, Brussels. Although famous for his peasant scenes and known as "Peasant Brueghel," Brueghel was a townsman and humanist. Here he combines the theme of man's unity with landscape with the Classical myth of Icarus. Daedalus, the father of Icarus, fashioned a pair of wings out of wax and warned his son not to fly too near the sun. Icarus disobeyed, the sun melted his wings, and he drowned in the Aegean Sea. In the painting Icarus can be seen flailing around in the water just below the large ship on the right.

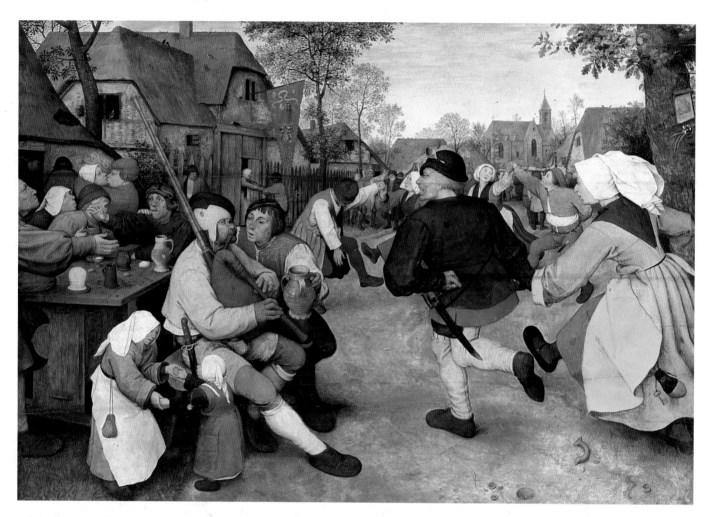

work. Even in our own age of air travel and space programs, popular wisdom considers it a virtue and a sign of mental stability to "have one's feet planted firmly on the ground." People who "fly too high" are considered overly ambitious and destined for a fall.

Entirely different in mood, but nevertheless moralizing in tone, is Brueghel's *Peasant Dance* (fig. **18.5**) of about 1567. In contrast to the peasants in the previous picture, these indulge in the enjoyments of dancing, eating, drinking, music-making, and lust. On the right, two peasants literally "kicking up their heels" seem to dance their way into the picture plane. The dancers in the background give way to even greater abandon. On the left, the bagpipe provides a formal echo of the rotund figures. The slow, deliberate peasants who occupy the landscape near Icarus's fall have become energetic, filled with vitality and rhythm.

Brueghel lived during the tense years between the Reformation and the Counter-Reformation, which coincided with Spanish rule of the Netherlands. Nothing is known for certain of his personal response to these events, although it has been speculated that he had Protestant sympathies. Nevertheless, it is clear that in his art Brueghel creates a synthesis of Christian, genre, Classical, and erotic imagery, which is at once moralizing and satirical.

18.5 Pieter Brueghel the Elder, *The Peasant Dance*. c. 1567. Oil on wood, c. 3 ft 9 in x 5 ft 5 in (1.14 x 1.65 m). Kunsthistorisches Museum, Vienna. Brueghel moralizes through a kind of visual irony. As in fig. **18.4**, the peasants are oblivious to the moral message that lies right before their eyes. They simply do not see, for example, the church in the distant background that overlooks the scene — an architectural version of the all-seeing God in the tabletop. Equally ignored, a little picture of the Madonna hangs on the tree at the far right.

18.6 (opposite, left) Albrecht Dürer, *Self-Portrait*. 1498. Oil on panel, 20½ x 16 in (52 x 40.6 cm). Prado, Madrid. Dürer was born in Nuremberg, Germany, to a family of goldsmiths. He was trained as a metalworker and painter and, at about age twenty, traveled to Italy. Young German artists traditionally spent a *Wanderjahr*, or year of travel, visiting different parts of Europe and studying art. From 1512, as court painter to the Holy Roman Emperor, Dürer became the most important figure in the transition from late Gothic to Renaissance style in northern Europe.

18.7 (opposite, right) Albrecht Dürer, *The Four Horsemen of the Apocalypse*. c. 1497–8. Woodcut, 15⅖ x 11 in (39.2 x 27.9 cm). Courtesy, Museum of Fine Arts, Boston (Bequest of Francis Bullard). This is one of a series of fifteen woodcuts from the late 1490s illustrating the Apocalypse. They are based on descriptions of the end of the world in the last book of the Bible.

Germany

Dürer

The German taste for linear qualities in painting is especially striking in the work of Albrecht Dürer. His *Self-Portrait* (fig. **18.6**) of 1498 reveals the influence of Leonardo, whom Dürer greatly admired, in the figure's three-quarter view and the distant landscape. Although set in a three-dimensional cubic space, according to the laws of fifteenth-century perspective, and consistently illuminated from the left, Dürer's figure is painted with a harshness and a crispness of edge that would be unusual in Italy. The attention to patterning in the long curls and in the details of costume also reveal Dürer's interest in line for its own sake. Particularly prominent in this and other works by the artist is his signature monogram — a "D" within an "A" — which is here accompanied by an inscription. The lettering, as well as expressing linearity, is the artist's statement of his own role in creating the image.

Dürer's interest in line is most apparent in his work as an engraver and woodcut artist. In the *Four Horsemen of the Apocalypse* (fig. **18.7**), the aged and withered figure of Death rides the skeletal foreground horse, trampling a bishop whose head is in the jaws of a monster. Cowering before the horse are figures awaiting destruction. Next to

Death, and the most prominent of the four horsemen, rides Famine, carrying a scale. War brandishes a sword, which is parallel to the angel above. Plague, riding the background horse, prepares to shoot his bow and arrow. (Arrow wounds were associated with the sores caused by the plague. St. Sebastian, who was shot with arrows, became the saint to whom one addressed prayers for protection from the plague.) Finally, the presence of God as the ultimate motivating force behind the four horsemen is implied by the rays of light that enter the picture plane from the upper left corner.

In this image, Dürer evidently delighted in the graphic and psychological expressiveness of line. The powerful left-to-right motion of the horses and their riders is created by their diagonal sweep across the picture space. The less forceful, zigzag lines of the cowering figures reveal their anxious ambivalence, in contrast to the unrelenting and inevitable advance of the horsemen.

Dürer's copper engraving of *Melencolia* (fig. **18.8**), or Melancholy, signed and dated 1515, is an early example of artists portrayed as saturnine, or melancholic, personalities. That the female winged genius is meant to be Dürer himself is suggested by his monogram underneath her bench. She leans on her elbow in a traditional pose of melancholic mourning or deep thought, similar to Raphael's portrait of Michelangelo in the *School of*

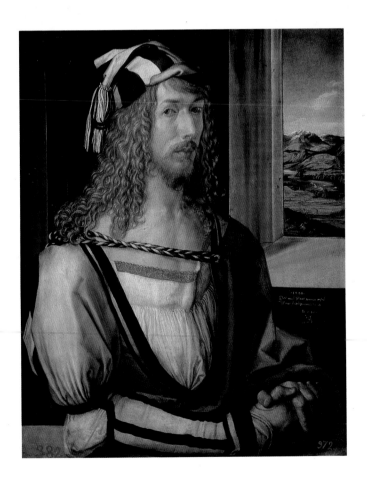

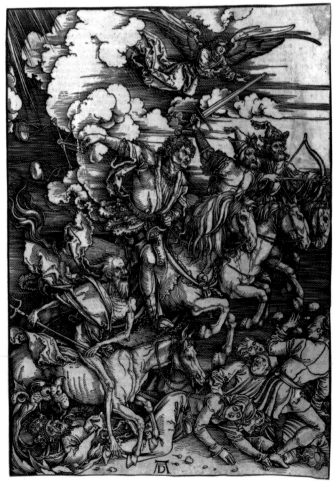

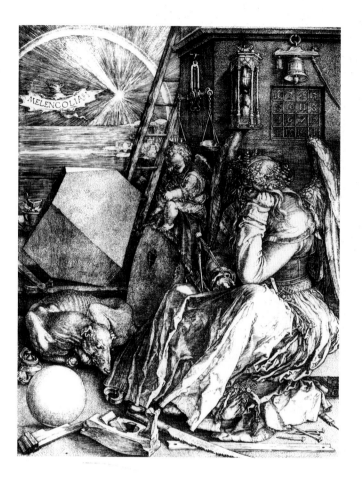

Athens (fig. **16.24**).

In Dürer's image, Melancholy is an idle, uninspired creator, an unemployed "genius," looking inward for inspiration and not finding it. She is surrounded by idle tools, including a bell that does not ring, empty scales, and a ladder leading nowhere. The restless winged child conveys a sense of anxiety that probably mirrors the anxiety felt by the uninspired artist. Other details, such as the hourglass above the genius, refer to the passing of time. In the upper left, a squeaking bat displays a banner with "MELENCOLIA I" written on it. The bat is associated with night, and, by combining it with the darkened sky pierced by rays of light, Dürer seems to be making a visual play on the contrasting mental states of black melancholy and the light of inspiration.

Grünewald

Nearly contemporary with Dürer's engraving is the *Isenheim Altarpiece* (fig. **18.9**), a monumental **polyptych**

18.8 Albrecht Dürer, *Melencolia I.* 1514. Engraving, c. 9⅜ × 6⅝ in (23.8 × 16.8 cm). The term "melancholic" is derived from two Greek words, *melas*, meaning "black" and *cholos*, meaning "bile" or "wrath." According to Renaissance medical theory, melancholic people were those whose black bile, considered to be one of the body's four main humors, or fluids, had made them angry and depressed. The concept of the "artist as genius," which is implicit in Dürer's iconography, probably originated in Italy.

The Development of Printmaking

Printmaking is the generic term for a number of processes, of which the **engraving** and **woodcut** are two prime examples. **Prints** are made by pressing a sheet of paper (or other material) against an image-bearing surface (the **print matrix**) to which ink has been applied. When the paper is removed, the image adheres to it, but in reverse.

The woodcut had been used in China from the fifth century A.D. for applying patterns to textiles. The process was not introduced into Europe until the fourteenth century, first for textile decoration and then for printing on paper. Woodcuts are created by a relief process. First, the artist takes a block of wood sawn parallel to the grain. He covers it with a white ground and draws the image in ink. The background is then carved away, leaving the design area slightly raised. The woodblock is inked, and the ink adheres to the raised image. It is then transferred to the damp paper either by hand or with a printing press.

Engraving, which grew out of the goldsmith's art, originated in Germany and northern Italy in the middle of the fifteenth century. It is an intaglio process (from the Italian *intagliare*, "to carve"). The image is incised into a highly polished metal

plate, usually of copper, with a cutting instrument, or **burin**. The artist then inks the plate and wipes it clean so that some of the ink remains in the incised grooves. An impression is made on damp paper in a printing press, with sufficient pressure being applied so that the paper picks up the ink.

Both woodcut and engraving have distinctive characteristics. Dürer's engraving in figure **18.8**, for example, shows how this technique lends itself to subtle modeling and shading through the use of fine lines. Hatching and cross-hatching (see p.24) determine the degree of light and shade in a print. Woodcuts, as in figure **18.7**, tend to be more linear, with sharper contrasts between light and dark, and hence more vigorous.

Printmaking is well suited to the production of multiple images. A set of multiples is called an **edition**. Both methods described here can yield several hundred good quality prints before the original block or plate begins to show signs of wear. Mass production of prints in the sixteenth century made images available, at a lower cost, to a much broader public than before. Printmaking played a vital role in northern Renaissance culture, particularly in disseminating knowledge and expanding the social consciousness of the population.

18.9 Matthias Grünewald, *Crucifixion*, view of the *Isenheim Altarpiece*, closed. c. 1510–15. Oil on panel (with frame), side panels 8 ft 2½ in × 3 ft ½ in (2.50 × 0.93 m), central panel 9 ft 9½ in × 10 ft 9 in (5.73 × 3.28 m), base 2 ft 5½ in × 11 ft 2 in (0.75 × 3.4 m). Musée d'Unterlinden, Colmar, France.

18.10 (below) Matthias Grünewald, *Annunciation*, *Virgin and Child with Angels*, and *Resurrection*, view of the *Isenheim Altarpiece*, opened.

by the German artist Matthias Grünewald (d. 1528). The altarpiece (or **retable**) was a form popular in Germany between 1450 and 1525. It typically consisted of a central *corpus*, or body, containing sculpted figures, and was enclosed by doors or wings painted on the outside and carved in low relief inside. The exterior of the doors depicts the Crucifixion, confronting the viewer with Christ's death. The strikingly graphic attention to physical suffering is enhanced by the German taste for linear detail. The cross is made of two logs tied together, its arms bowed from Christ's weight. In contrast to the idealized, relaxed Christ of Michelangelo's *Pietà* (fig. **16.14**), in Grünewald's Christ *rigor mortis* (the stiffening of the body that occurs after death) has already set in. His skin has a greenish pallor, the crown of thorns causes blood to drip from his scalp, and his loincloth is torn and ragged.

John the Baptist, on Christ's left, points to Christ. The Latin inscription, which John seems to be speaking, reads "He must increase and I must decrease." At John's feet, holding a small cross, is the sacrificial lamb, whose blood drips into a chalice. On Christ's right, Mary Magdalen extends her arms in a broad curve of prayer that continues backward toward the swooning Virgin and John the Evangelist, who supports her. The sky is black, recalling the biblical account of the darkening sky and nature's death at the time of Christ's death. On the base, Grünewald has depicted the Lamentation, or mourning over Christ after he has been taken down from the cross.

The broad curves and rugged edges of Grünewald's forms reflect contemporary German taste for crisp, linear quality, which in the *Isenheim Altarpiece* emphasizes pain and suffering. The commission of this painting and its location in Isenheim's Hospital of St. Anthony probably accounts for its focus on physical torture. St. Anthony, who was associated with healing the sick, appears on the left wing. St. Sebastian is on the right. His inclusion is related to his role as a plague saint and to the Hospital's specialty in leprosy and other skin diseases. It also explains Grünewald's emphasis on Christ's wounds.

The altarpiece was generally kept in the closed position. Patients prayed before it to atone for their sins. On Sundays and feast days, however, it was opened. In the interior (fig. **18.10**), the mood is changed by bright colors. In the right panel, Christ attains a new, spiritual plane of existence beyond the pull of gravity. His body, defined by curvilinear forms, floats upward into a fiery orb. Christ as the sun is opposed to the Roman soldiers, whose sinful ignorance causes them to stumble in a rocky darkness.

Hans Holbein the Younger

The last great German painter of the High Renaissance is Hans Holbein the Younger (c. 1497–1543). He synthesized German linear technique with the fifteenth-century Flemish taste for elaborately detailed surface textures and rich color patterns. Perhaps his greatest achievements were his portraits. In his portrait of Henry VIII (fig. **18.11**) of about 1540, Holbein evokes the overpowering force of the

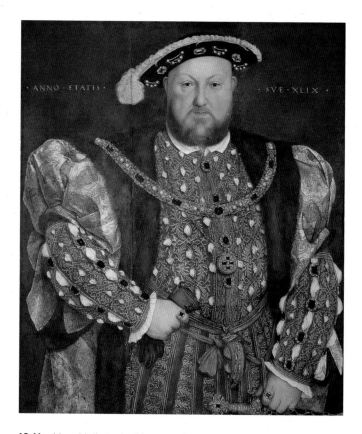

18.11 Hans Holbein the Younger, *Portrait of Henry VIII.* 1539–40. Oil on panel, 34¾ x 29½ in (88.3 x 74.9 cm). Galleria Nazionale d'Arte Antica, Rome.

king's personality. Henry's proverbial bulk dominates the picture plane as he stares directly out at the observer. The fine textures and minute patterns of his costume create a surface luster that is reminiscent of van Eyck. Henry's bent right arm is posed so that the elbow is thrust forward, emphasizing the elaborate sleeves. From the neck down, the king's body forms a rectangle filling the bottom two-thirds of the picture. His head seems placed directly on his shoulders, creating a small, almost cubic shape. The hat, by contrast, forms a slightly curved diagonal, echoing the curved chain across his chest and also softening the monumental force of Henry's body and gesture.

The main source of variety in this picture is the material quality of the surface patterns. Their richness reminds the viewer of Henry's wealth, just as his pose exudes power, self-confidence, and determination, while his face reflects his intelligence and political acumen. Thus, in this image, Holbein has fused formal character with the personality represented, creating a figure who is "every inch a king."

After Holbein's death, no major artists emerged in Germany during the sixteenth century. By 1600 the conflicts between Protestant and Catholic, Reformation and Counter-Reformation, though hardly at an end, had at least become familiar. Their effect on art would continue, though to a lesser degree, into the seventeenth century.

	Style/Period	Works of Art	Cultural/Historical Developments
1600	**BAROQUE** 17th century		
	Caravaggio	*Calling of St. Matthew* (p.312)	Cervantes, *Don Quixote* (1605)
	Bernini	*David* (p.309)	Puritans reach New England (1620)
	Rubens	*Venus and Adonis* (p.316)	Galileo recants *Dialogue on Copernicus* (1633)
	Rembrandt	*Belshazzar's Feast* (p.318)	René Descartes, *Discourse on Method* (1637)
	Bernini	*Ecstasy of St. Teresa* (p.311)	Charles I beheaded (1649)
		Piazza of St. Peter's (p.300)	England declared a Commonwealth (1649)
1650	Velázquez	*Las Meninas* (p.327)	Restoration of Charles II as King of England (1662)
	Steenwyck	*Vanitas* (p.324)	John Milton, *Paradise Lost* (1667)
	Vermeer	*View of Delft* (p.322)	Isaac Newton, *Philosophiae Naturalis Principia*
	Hardouin-Mansart & Lebrun	Versailles (p.304)	*Mathematica* (pub. 1687)
	Wren	St. Paul's Cathedral (p.306)	Peter I Tsar of Russia (1689)
1700	**ROCOCO** 18th century		
	Watteau	*The Dance* (p.331)	Defoe, *Robinson Crusoe* (1719)
	Hogarth	*Marriage à la Mode II* (p.333)	
	Walpole	Strawberry Hill (p.338)	Rousseau, *Social Contract* (1762)
	Fragonard	*The Swing* (p.332)	Winckelmann, *History of Art* (1764)
	NEOCLASSICISM		
	Late 18th to early 19th century		
	Jefferson	Monticello (p.348)	American Declaration of Independence (1776)
	West	*Death of General Wolfe* (p.341)	Adam Smith, *Wealth of Nations* (1776)
			Kant, *Critique of Pure Reason* (1781)
	Canova	*Cupid and Psyche* (p.343)	Mozart, *Marriage of Figaro* (1786)
1750	David	*Death of Marat* (p.345)	Fall of the Bastille (1789)
			Execution of Louis XVI (1793)
			Wordsworth and Coleridge, *Lyrical Ballads* (1798)
	Ingres	*Napoleon Enthroned* (p.346)	Bonaparte appointed First Consul (1799)
		Grande Odalisque (p.347)	
	Greenough	*George Washington* (p.349)	
1800	**ROMANTICISM**		
	Early to mid-19th century		
			Napoleon proclaimed emperor (1804)
	Goya	*Executions of the Third of May, 1808*	Beethoven, "Eroica" Symphony (1804)
		(p.358)	First working steam engine (1814)
	Nash	Royal Pavilion (p.350)	
	Géricault	*Raft of the "Medusa"* (p.354)	
	Delacroix	*Liberty Leading the People* (p.355)	July Revolution; Louis Philippe King of France (1830)
	Turner	*Burning of the Houses of Parliament* (p.361)	
	Cole	*The Oxbow* (p.362)	Victoria Queen of England (1837)
1825	**REALISM** Mid to late 19th century		
	Daumier	*Gargantua* (p.369)	
	Courbet	*The Interior of My Studio* (p.367)	J. S. Mill, *Principles of Political Economy* (1848)
	Paxton	Crystal Palace (p.378)	John Ruskin, *Seven Lamps of Architecture* (1849)
			Nathaniel Hawthorne, *The Scarlet Letter* (1850)
	Millet	*The Gleaners* (p.366)	Henry Thoreau, *Walden* (1854)
	Nadar	*Portrait of Sarah Bernhardt* (p.371)	Charles Darwin, *Origin of Species* (1859)
	Brady	*Lincoln "Cooper Union" Portrait* (p.373)	Charles Dickens, *Great Expectations* (1861)
	Manet	*Le Déjeuner sur l'Herbe* (p.375)	American Civil War (1861–5)
			Tolstoy, *War and Peace* (1864)
			Assassination of Lincoln (1865)
			Louisa M. Alcott, *Little Women* (1868)
1850	Eakins	*The Gross Clinic* (p.374)	Suez Canal opened (1869)
	Eiffel	Eiffel Tower (p.380)	
	IMPRESSIONISM		
	Late 19th to early 20th century		
	Monet	*Terrace at Sainte-Adresse* (p.387)	U.S. transcontinental railroad completed (1869)
			Wagner, *Die Walküre* (1870)
	Whistler	*Nocturne in Black and Gold* (p.394)	Schliemann begins to excavate Troy (1870)
	Degas	*Absinthe* (p.384)	Lewis Carroll, *Through the Looking Glass* (1871)
	Renoir	*Torso of a Woman in the Sun* (p.389)	First public telephones (1877)
	Manet	*Bar at the Folies-Bergère* (p.383)	Carnegie develops first large steel furnace (1880)
	Sargent	*Daughters of Edward D. Boit* (p.393)	Brooklyn Bridge opened to traffic (1883)
1875	Rodin	*Balzac* (p.391)	Karl Marx, *Das Kapital* published in English (1886)
	Pissarro	*Place du Théâtre Français, Pluie* (p.390)	Dunlop invents pneumatic tire (1888)
	POST-IMPRESSIONISM		
	Late 19th to early 20th century		
	Cézanne	*Still Life with Apples* (p.398)	
	Seurat	*La Grande Jatte* (p.400)	
	van Gogh	*Portrait of Père Tanguy* (p.401)	Diesel patents internal combustion engine (1892)
	Toulouse-Lautrec	*Quadrille at the Moulin Rouge* (p.397)	Henry Ford builds his first car (1893)
	Munch	*Anxiety* (p.406)	Cinematograph invented (1894)
	Gauguin	*Nevermore* (p.403)	Puccini, *La Bohème* (1896)
	Cézanne	*The Great Bathers* (p.399)	The Curies discover radium (1898)
1900	Rousseau	*The Dream* (p.407)	

The Baroque Style in Western Europe

The Baroque style corresponds roughly to the closing years of the sixteenth century, overlapping Mannerism and lasting, in some areas, as late as 1750. Religious and political conflicts, especially between Catholics and Protestants, continued in the seventeenth century. The Thirty Years' War (1618–48) sapped the power of the Holy Roman Emperor. Holland rebeled against the repressive Catholic domination of Philip II of Spain. As a result, what had previously been the Netherlands was separated into Protestant Holland and Catholic Flanders (modern Belgium). From 1620 the Puritans fled religious persecution in Europe and sailed to New England. In 1649 England beheaded King Charles I and introduced parliamentary rule.

Building on the explorations of the 1500s, the seventeenth century was an age of geographical colonization and scientific development. European powers competed for control of the Far East and the Americas. In science and philosophy, the seventeenth century made great strides—though not without controversy. In England, William Harvey established the system of blood circulation. Isaac Newton discovered the laws of gravity, which brought him into conflict with the Catholic King James II. René Descartes, the French thinker, based his philosophical system on a method of systematic doubt. He emphasized clear, rational thought, embodied by the humanist phrase "I think, therefore I am." Descartes avoided conflict with the Church only by acknowledging that God was the source of the original impulse to reason.

Perhaps the greatest threat to established theology came from the astronomers. The earth definitively lost its place as the center of the universe, and the sun, always a central image in the imagination, now became the demonstrable center of the solar system. The discoveries of Nicolas Copernicus, Johannes Kepler, and Galileo Galilei were vigorously opposed by the Church. In Rome, the Inquisition forced Galileo to recant and banned his book. These scientific advances were paradoxically accompanied by a rise in religious fundamentalism. Superstition and fear of the Devil and the Antichrist swept Europe. In America as well as in Europe, these fears led to the most devastating waves of witch hunts.

Baroque Style

The term "Baroque" is applied to diverse styles, which highlights the approximate character of art historical categories. Like "Gothic," Baroque was originally a pejorative term. It is a French form of the Portuguese *barocco*, meaning an irregular, and therefore imperfect, pearl. The Italians used the term *barocco* to describe an academic and convoluted medieval style of logic. Although Classical themes and subject matter continued to appeal to artists and their patrons, Baroque painting and sculpture tended to be relatively unrestrained, overtly emotional, and more energetic than earlier styles.

Baroque artists rejected Mannerist virtuosity and stylization in favor of the direct study of nature. A new taste for dramatic action and violent narrative scenes emerged in the visual arts of the seventeenth century. Inner emotions were given a wide range of expression—a departure from the Renaissance adherence to Classical restraint. Baroque color and light are dramatically contrasted and surfaces are richly textured. Baroque space is usually asymmetrical and lacks the appearance of controlled linear perspective. Landscape, genre, and still life, which had originated as separate, but minor, categories of painting within Mannerism, achieved a new status in Baroque.

Variety within the Baroque style is partly a function of national and cultural distinctions. Baroque art began in Italy, particularly Rome, whose position as the center of western European art had been established during the High Renaissance by papal patronage and Rome's links with antiquity. In the course of the Baroque period, however, Paris took over as the artistic center of Europe, a position it retained until World War II (1939–45). Two major Baroque architectural achievements, the completion of St. Peter's and the sumptuous court of the French monarch Louis XIV, characterize this shift from Rome to Paris.

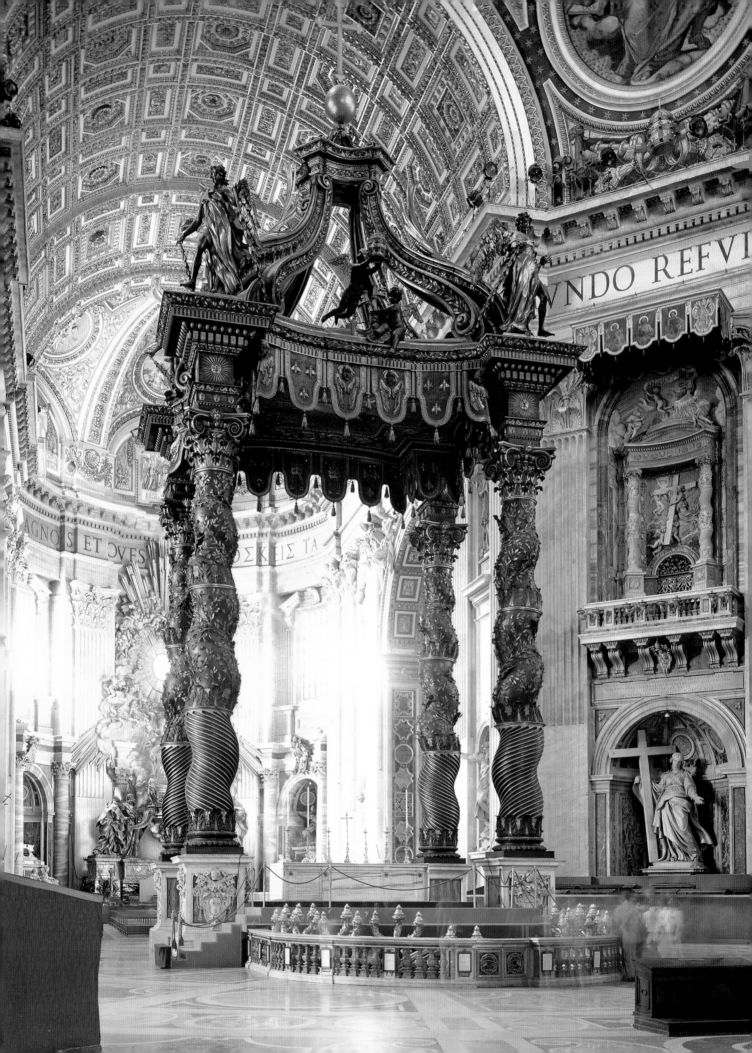

Architecture

Italy

The rebuilding of St. Peter's, which had begun when Julius II became pope in 1503 (see p.256), was finally completed during the Baroque period. Its interior decoration and spatial design, however, still required attention. The commission for these went to Gian Lorenzo Bernini (1589–1680), who was the official architect of St. Peter's until his death. One of his tasks was to reduce the space at the crossing to a more human scale, so that worshipers would be drawn to the altar. He did so by erecting the bronze **Baldacchino** (fig. 19.1), or canopy, over the high altar above St. Peter's tomb.

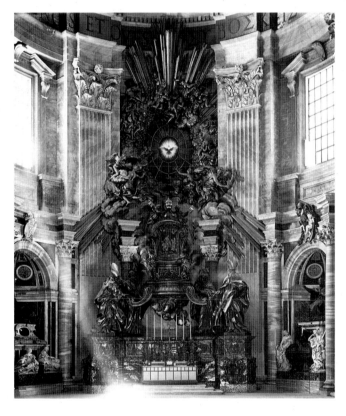

19.2 Gian Lorenzo Bernini, *Cathedra Petri* (Throne of St. Peter), St. Peter's, Rome. 1656–66. Gilded bronze, marble, stucco, and stained glass. The reliquary is surrounded at its base by the figures of four Doctors of the Church — Sts. Ambrose, Athanasius, Augustine, and John Chrysostom. Although it appears that the four Church Doctors are holding up the throne, it is actually cantilevered out from the wall. The illusory physical support is a metaphor for supporting the spiritual doctrine of the faith in the early days of Christianity.

19.1 (opposite) Gian Lorenzo Bernini, Baldacchino, St. Peter's, Rome. 1624–33. Gilded bronze, c. 95 ft (28.96 m) high. The Baldacchino's height of 95 feet (28.96 m) is about one-third the distance from the floor of St. Peter's to the base of its lantern. Although small in relation to the dome, it is the size of a modern nine-story building and its foundations reach deep into the floor of the old Constantine basilica.

Four twisted columns, decorated with vinescrolls and surmounted by angels, support a bronze valance resembling the tasseled cloth canopy used in religious processions. At the top, a gilded cross stands on an orb. The twisted column motif did not originate with Bernini. In the fourth century, Constantine was thought to have taken spiral columns from Solomon's temple in Jerusalem and used them at Old St. Peter's. Bernini's columns, however, seem to pulsate, as if in response to some internal pressure or tension. The dark bronze, accented with gilt, stands out against the lighter marble of the nave and apse. Such contrasts of light and dark, like the undulating columns, are characteristic Baroque expressions.

In the western apse of St. Peter's, framed by the columns of the Baldacchino, is Bernini's distinctive *Cathedra Petri*, or Throne of St. Peter (fig. 19.2). This structure is an elaborate **reliquary** (container for relics) built around an ivory and wooden chair, once believed to have been St. Peter's original papal throne, but actually an Early Medieval work. Above the throne, the Holy Spirit is framed by a stained glass window. Because the building is oriented to the west, the window catches the afternoon and evening sun, which reflects from the gilded rods, representing divine light.

In 1637 Bernini transformed the exterior of St. Peter's. His goal was to provide an impressive approach to the church and, in so doing, he defined the Piazza San Pietro. The Piazza, or public square (fig. 19.3), is the place where the faithful gather on Christian festivals to listen to the pope's message and receive his blessing.

Bernini conceived of the Piazza as a large, open space, organized into elliptical and trapezoidal shapes (in contrast to the Renaissance circle and square). He placed different orders within the same structure, and combined the Classical orders with statues of Christian saints. He divided the Piazza into two parts (fig. 19.4). The first section has the approximate shape of an oval or ellipse, and at its center is an obelisk 83 feet (25.3 m) high, imported from Egypt during the Roman Empire. Around the curved sides of the oval, Bernini designed two colonnades, consisting of 284 travertine columns in the Tuscan order, each one 39 feet (11.89 m) high. The columns are four deep, and the colonnades end in temple fronts on either side of a large opening. Crowds can thus convene and disperse easily. They are enclosed, but not confined. Bernini wrote that the curved colonnades were like the arms of St. Peter's, the Mother Church, spread out to welcome and embrace the faithful.

The second part of the Piazza is a trapezoidal area connecting the oval with the church façade. The trapezoid lies on an upward gradient and the visitor approaches the portals of St. Peter's by a series of steps. As a result, the walls defining the north and south sides of the trapezoid become shorter toward the façade. This enhances the verticality of the façade and offsets the horizontal emphasis produced by the incomplete flanking towers. The two sections of the Piazza are tied together by an Ionic entablature that extends all the way around the sides of both the

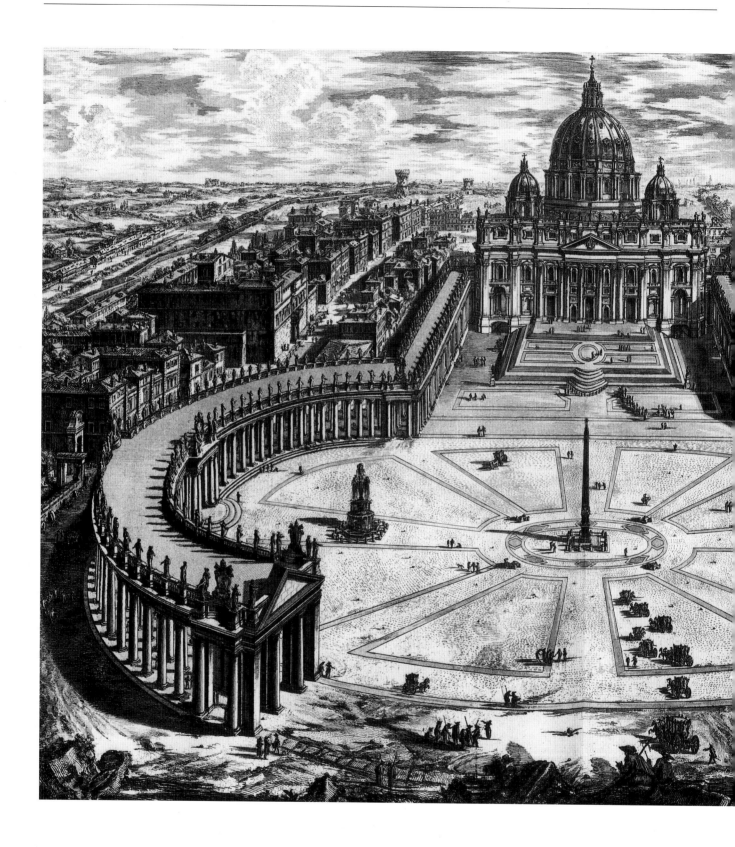

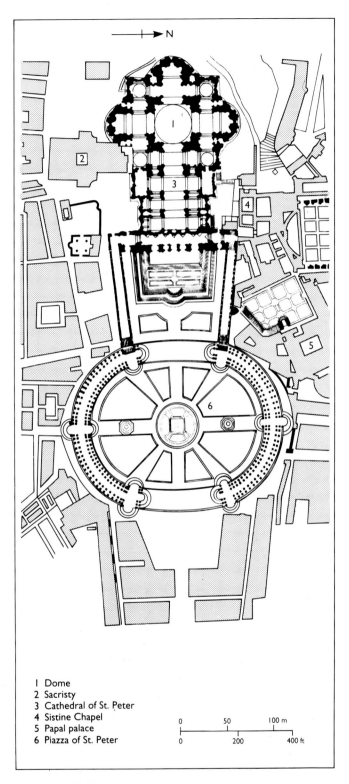

1 Dome
2 Sacristy
3 Cathedral of St. Peter
4 Sistine Chapel
5 Papal palace
6 Piazza of St. Peter

19.3 Gian Lorenzo Bernini, Aerial view of colonnade and east façade of St. Peter's, Rome. Begun 1656. Travertine, longitudinal axis c. 800 ft (243.84 m). Copper engraving by Giovanni Piranesi, 1750. Kunstbibliothek, Berlin. The enormous Piazza in front of the façade can accommodate over 250,000 people.

19.4 Plan of St. Peter's (see also figs. **16.8**, **16.9**, and **16.10**) and the Piazza, Rome. On the floor of the oval a radial pattern converges at the obelisk. The shape and width of the oval — approximately 800 feet (244 m) — and the location of a fountain within each of its semicircular sections help to establish a stronger north–south axis. That axis is perpendicular to the direction in which most visitors move, namely along the east–west axis of the nave and dome.

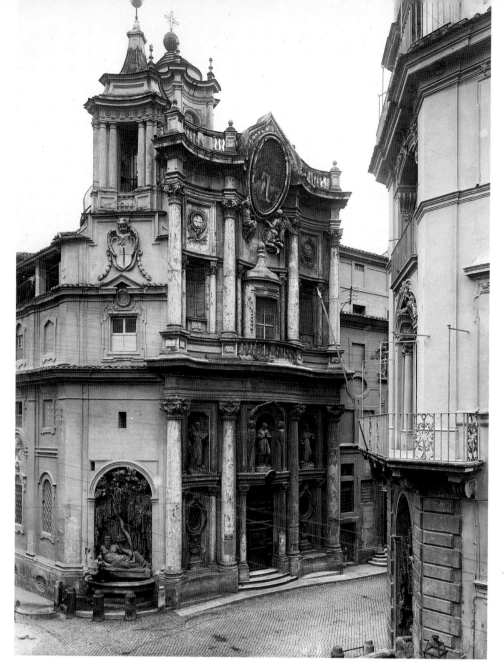

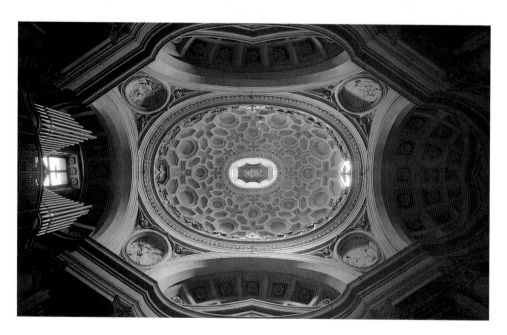

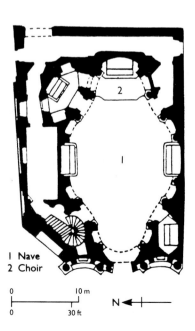

19.5 (left) Francesco Borromini, Façade of S. Carlo alle Quattro Fontane, Rome. 1665–7. Born in Lombardy, Borromini was the son of an architect. In 1621 he moved to Rome and worked under both Maderno and Bernini. Borromini and Bernini were intense rivals of very different temperaments. Borromini resented living and working in Bernini's shadow. Moody and constantly dissatisfied, he eventually committed suicide.

19.6 (bottom, left) Francesco Borromini, Interior dome of S. Carlo alle Quattro Fontane, Rome. The dome is illuminated on the interior by windows at its base, and contains coffers in the shape of hexagons, octagons, and crosses. At the center of the dome, an oval oculus contains a triangle, a geometric symbol of the Trinity and emblem of the Trinitarian Order that commissioned the church.

19.7 (below) Francesco Borromini, Plan of S. Carlo alle Quattro Fontane, Rome. 1638–41. The church plan is shaped like a pinched and distended oval. Its altars and entrance are set opposite each other on the short sides of the oval, and the walls are a series of convexities and concavities. Side chapels, which seem to be parts of smaller ovals, bulge out from the walls.

1 Nave
2 Choir

0 10 m
0 30 ft

N

England

Baroque was also the architectural style of seventeenth-century England. Its greatest exponent was Sir Christopher Wren (1632–1723). Following the Great Fire (1666), which destroyed over two-thirds of the old walled City of London, Wren was appointed the King's Surveyor of

19.12 (opposite) Christopher Wren, St. Paul's Cathedral, London. 1675–1710. The dome of St. Paul's is 112 feet (34.14 m) in diameter and 300 feet (91.44 m) high, second in size only to St. Peter's in Rome. Even today, the dome dominates the London skyline, though the lower façade is easily visible only from nearby.

19.13 Plan and longitudinal section of St. Paul's Cathedral, London. An invisible conical brick structure supports the lantern and the lead-faced, wooden framework of the outer dome. Extra support is supplied by flying buttresses which are masked by the upper parts of the side aisle walls.

Works. From 1670 to 1700 he took part in redesigning fifty-one of the churches that had burned down. Wren's priority during this period, however, was St. Paul's (fig. **19.12**), the first cathedral to be built for the Protestant Church of England.

The plan and longitudinal section (fig. **19.13**) blended elements from several styles. The formal arrangement (although not the style) of the nave, side aisles, and clerestory is medieval. The western façade (fig. **19.12**), with its paired columns and central pediment, is reminiscent of the Louvre. The two flanking towers, although similar in conception to Gothic cathedral towers, are more Baroque in their execution. The dome, which rises over the crossing and spans both nave and aisles, is in the tradition of Bramante's Tempietto (fig. **16.3**) and St. Peter's.

It took forty years to complete St. Paul's under Wren's supervision. Although the building is more restrained than Italian Baroque, it is a successful synthesis of various styles into what is now a traditional English cathedral.

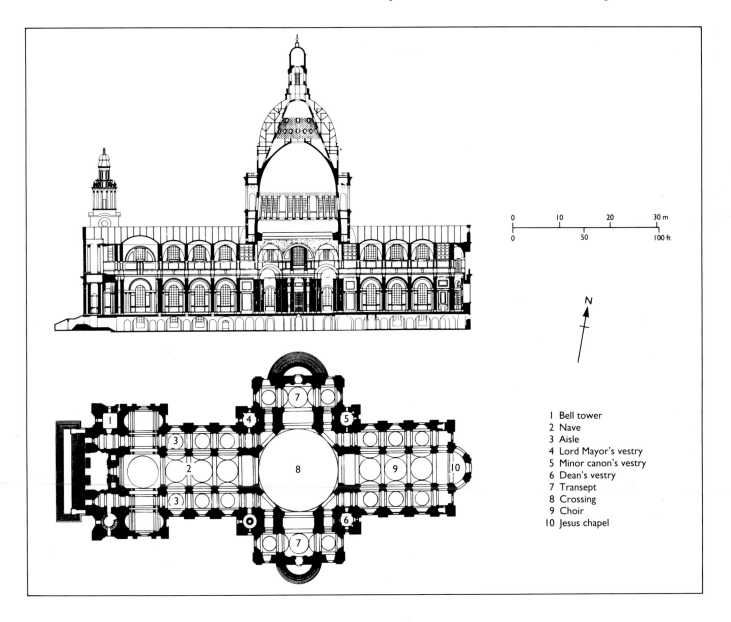

1 Bell tower
2 Nave
3 Aisle
4 Lord Mayor's vestry
5 Minor canon's vestry
6 Dean's vestry
7 Transept
8 Crossing
9 Choir
10 Jesus chapel

Sculpture

Bernini

By far the most important sculptor of the Baroque style in Rome was Bernini. His over-lifesize sculpture *Pluto and Proserpina* (fig. **19.14**) represents the most violent moment in the myth — the abduction of Proserpina. A muscular Pluto grabs hold of a struggling Proserpina, his fingers convincingly digging into her flesh. She, in turn, pushes his head away from her as she assumes a version of the Mannerist *figura serpentinata* (see p.276), squirming to escape Pluto's grasp. Here, however, the pose is in the service of a violent narrative moment, rather than being a virtuoso Mannerist exercise. Both figures are in *contrapposto*, leaning backward from the waist. Flowing hair and beard echo the rippling motion of the body surfaces and reinforce the sense of action. Seated next to Pluto is Cerberus, the three-headed dog who guards the Underworld. One head eyes the abduction intently, while another howls behind Proserpina's foot.

Bernini creates erotic tension between Pluto and Proserpina by a combination of pose and gesture that is characteristic of the Baroque style. Although Proserpina struggles against Pluto, she also turns toward him. In pushing away Pluto's head, her fingers curl around a peak of his crown. And, in protesting, she opens her mouth slightly and tilts her head back as if in ecstasy. Pluto, pulling back his head, eyes her amorously. The repeated formal back and forth planar motion of the figures echoes both their own psychological ambivalence and that of Cerberus's two visible heads. This ambivalence derives from the myth itself, for Proserpina is committed to Pluto for one half of the year and to her mother for the other half.

In the lifesize marble sculpture of *David* (fig. **19.15**) of 1623, all trace of Mannerism has disappeared. Once again Bernini has chosen to represent a narrative moment requiring action. David leans to his right and stretches the sling, while turning his head to look over his shoulder at Goliath. In contrast to Donatello's relaxed and self-satisfied bronze *David* (fig. **15.17**), who has already killed Goliath, and Michelangelo's (fig. **16.15**), who tensely sights his adversary, Bernini's is in the throes of the action.

19.14 Gian Lorenzo Bernini, *Pluto and Proserpina*, 1621–2. Marble, over-lifesize. Galleria Borghese, Rome. In Greek mythology, Pluto's abduction of Persephone (Proserpina in Latin) explained the seasonal changes. When Proserpina's mother, the Earth goddess Ceres, went in search of her daughter, vegetation ceased to grow and winter fell. Ceres found Proserpina in the Underworld. Because her daughter had eaten Pluto's pomegranate, she was doomed to spend half the year in his domain. During the six months of Fall and Winter, Ceres mourns and nature dies. Spring and Summer return when Proserpina rejoins her mother.

19.15 (opposite) Gian Lorenzo Bernini, *David*. 1623. Marble, lifesize. Galleria Borghese, Rome.

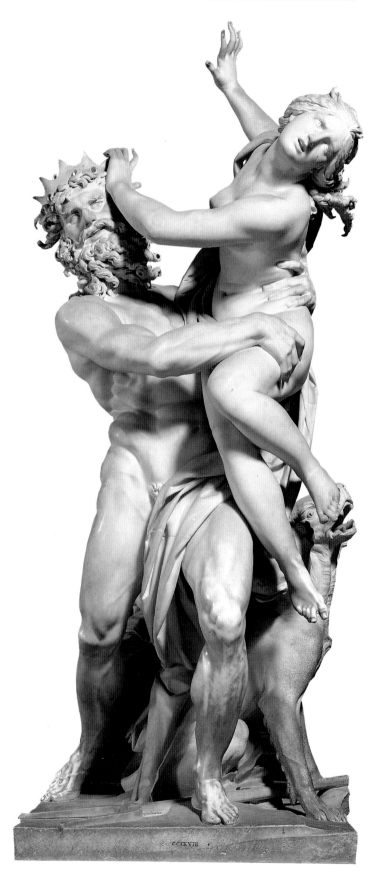

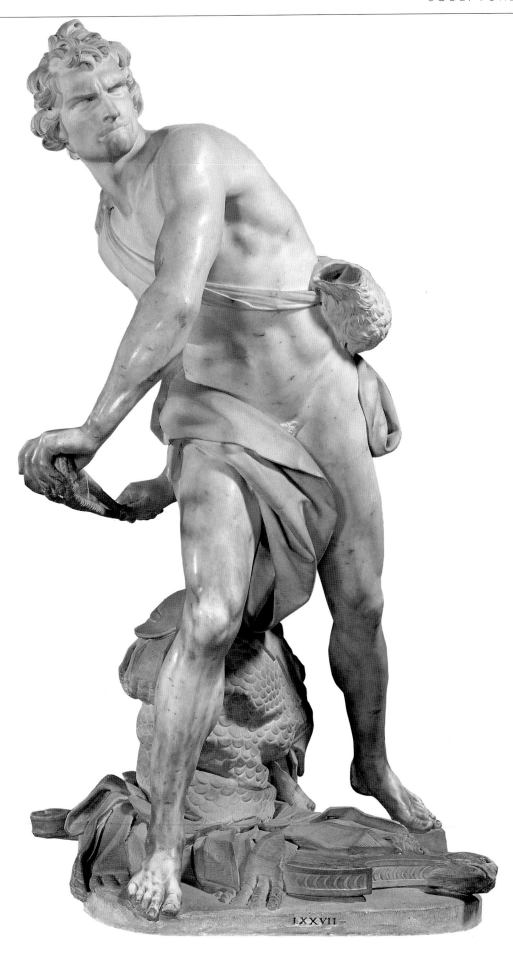

LXXVII

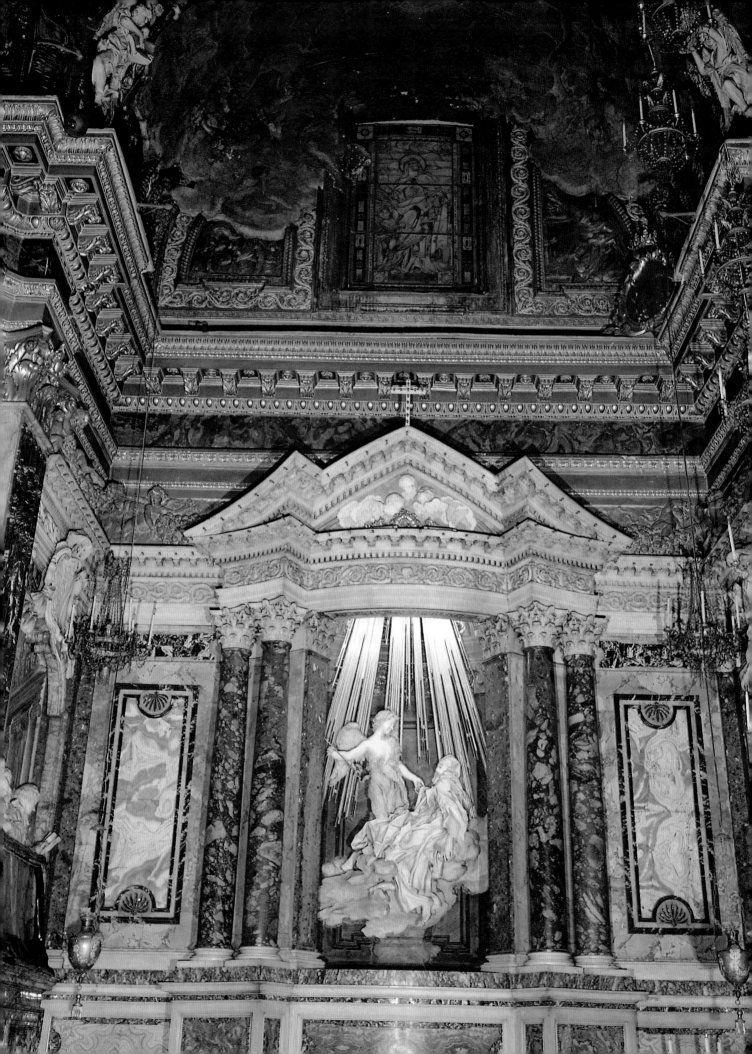

19.16 (opposite) Gian Lorenzo Bernini, Interior of the Cornaro Chapel, Church of S. Maria della Vittoria, Rome. 1645–52. The Cornaro Chapel illustrates Bernini's skill in integrating the arts in a single project. Here he uses the chapel as if it were a little theater. Directly opposite the worshiper, the altar wall opens onto the dramatic encounter of St. Teresa and the angel. Joining the worshiper in witnessing the miracle are members of the Cornaro family, who are sculpted in illusionistic balconies on the side walls.

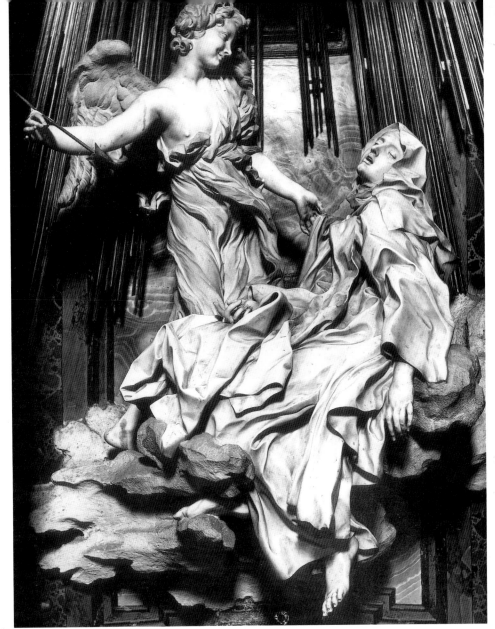

19.17 Gian Lorenzo Bernini, *Ecstasy of St. Teresa*, Cornaro Chapel, S. Maria della Vittoria, Rome. Marble, height of group 11 ft 6 in (3.51 m). St. Teresa was born in Avila, Spain, in 1515. She was a Carmelite nun who described the mystical experience depicted here. An angel from Heaven pierced her heart with a flaming golden spear. Pleasure and pain merged, and she felt as if God were "caressing her soul." She was canonized in 1622.

The vertical plane of the Renaissance Davids has become a dynamic diagonal extending from the head to the left foot. That diagonal is countered by the left arm, the twist of the head, and the drapery. Unlike the *Pluto and Proserpina*, Bernini's *David* is a single figure. Nevertheless, his portrayal assumes the presence of Goliath, thereby expanding the space — psychologically as well as formally — beyond the immediate boundaries of the sculpture. Such spatial extensions are a rather theatrical characteristic Baroque technique for involving the spectator in the work.

Even more theatrical is Bernini's "environmental" approach to the chapel of the Cornaro family (fig. **19.16**). The main event over the altar is the *Ecstasy of St. Teresa*. Lifesize figures are set in a typically Baroque niche with paired Corinthian columns and a broken pediment over a curved entablature. As in the *David* and *Pluto and Proserpina*, Bernini represents a moment of heightened emotion — the transport of ecstasy. The angel prepares to pierce St. Teresa as he gently pulls aside her drapery (fig. **19.17**). His own delicate drapery flutters slightly as if he has just arrived. Although Teresa appears elevated from

the ground, she is actually supported by a formation of billowing clouds. Leaning back in a long, slowly curving diagonal plane, she closes her eyes and opens her mouth slightly, as if in a trance. Her inner excitement contrasts with the relaxed state of her body, and is revealed by the elaborate, energetic drapery folds, which blend with the clouds. Behind St. Teresa and the angel are gilded rods, representing rays of divine light. They seem to descend from Heaven and enter the niche behind the altar.

This scene synthesizes the Baroque taste for inner emotion with Counter-Reformation mysticism. Only a sculptor as great as Bernini could combine the powerful religious content of this scene with its erotic implications in a way that would satisfy the Church. Also characteristic of the Baroque style is Bernini's ability to draw the observer into the event. This is further reinforced by the theatrical arrangement of the chapel. The sculptures of the Cornaro family on the side walls occupy an illusionistic architectural space, which combines the Ionic order with a barrel-vaulted ceiling and a broken pediment. The onlookers witness and discuss St. Teresa's mystical experience just like theater-goers watching a play.

Italian Baroque Painting

Caravaggio

The leading Baroque painter in Rome was Michelangelo Merisi da Caravaggio (1571–1610), who was born in the small northern Italian town of Caravaggio. When he was eleven, his father, a stonemason, apprenticed him to a painter in Milan. Caravaggio moved in about 1590 to Rome, where his propensity for violence landed him in repeated difficulty. During his relatively short life and despite the interruptions to his career caused by his brushes with the law, Caravaggio worked in an innovative style that influenced painters in Italy and northern Europe. He painted directly on the canvas, making no preliminary drawings. His depiction of religious themes was intended to appeal to the ordinary observer and was not aimed at a social or cultural elite. In his more private commissions, Caravaggio was equally direct in depicting subjects and themes of a homoerotic nature.

The *Calling of St. Matthew* (fig. **19.18**) is a good example of Caravaggio's innovative approach to Christian sub-jects. The scene is based on an account in the Gospel. Christ and an apostle approach a group of older men and youths who are gambling. They are seated at a table (whether indoors or outdoors is unclear), counting money. Among them is Matthew, the tax collector. Christ points to him with a gesture that is a visual quotation of Michelangelo's *Creation of Adam* (fig. **16.18**), as if to say "Follow me." This iconography implicitly parallels Adam's original creation with Matthew's *re*creation through Christ. The coin set in Matthew's hatband underlines his present preoccupation with money. His own gesture echoes that of Christ, however, and indicates that his future will be dedicated to Christ's service.

In the *Calling of St. Matthew*, Caravaggio's **tenebrism**, or use of sharply contrasting light and dark, enhances the Christian message. Christ enters the picture plane from the right, along with a diagonal shaft of light that penetrates the darkness of the street. Night-time and the illicit activities of night are suddenly illuminated by Christ's miraculous light. Light is ironically juxtaposed with sight in the two figures on the far left. The young man who does not see Christ because he is focusing intently on

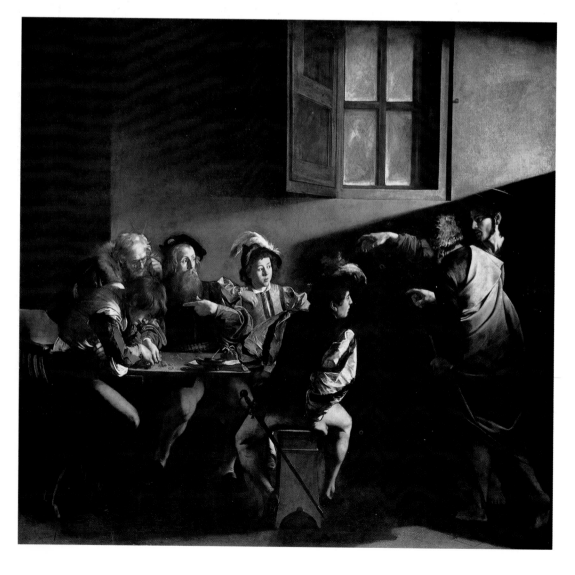

19.19 (above) Caravaggio, *Amor Vincit Omnia*. c. 1602. Oil on canvas, 5 ft ⅝ in × 3 ft 7⅜ in (1.54 × 1.1 m). Gemäldegalerie Staatliche Museen, Berlin. Caravaggio painted this picture for the Marchese Vincenzo Giustiniani, a wealthy Roman patron. Homosexual references pervade Caravaggio's religious pictures, but never so overtly as in his secular works. Soon after arriving in Rome, Caravaggio joined the homosexual household of Cardinal del Monte, a leading patron of the arts. Despite his personal proclivities and criminal record, Caravaggio's talent was recognized and fostered by ecclesiastical patronage.

19.18 (opposite) Caravaggio, *The Calling of St. Matthew*, Contarelli Chapel, S. Luigi dei Francesi, Rome. 1599–1600. Oil on canvas, 10 ft 6¾ in × 11 ft 1⅞ in (3.22 × 3.4 m). In 1608 Caravaggio fled Rome after killing a man in a dispute over a tennis match. Caravaggio's criminal behavior and his acquaintance with Roman street life clearly contributed to the character of this picture. He died of a fever in 1610 before news of the pope's pardon had reached him.

money is covered in shadow. The old man leaning over him peers through his spectacles, seeing the money but oblivious to the significance of the event taking place beside him.

Caravaggio's *Amor Vincit Omnia (Love Conquers All)* (fig. **19.19**) of about 1602 is a picture totally devoid of Christian content. It is perhaps his most overtly homosexual painting. Cupid slips from the edge of a rumpled bed, coquettishly mocking the world. His tilted head and the *contrapposto* of his torso create a series of Baroque diagonals that are accented by light. The wings appear alive, and the edges of the feathers catch the light. Records indicate that Caravaggio kept such wings in his studio in Rome in order to enhance the realism of his pictures. The anal erotic implications of the curved tip of the left wing are clear and direct. They simultaneously challenge and attempt to seduce the viewer.

In contrast to the darkened background of the *Calling of St. Matthew*, the *Amor* contains recognizable objects with a particular iconographic meaning. On the bed are a crown and scepter. Instruments of geometry and music, a manuscript and a quill pen, and a heap of armor are strewn about on the floor. Behind Cupid's right thigh is a starry globe, possibly representing astronomy. The message of this painting is that love, and specifically homosexual love, conquers all.

Artemisia Gentileschi

Caravaggio's lifestyle did not lend itself to the maintenance of a workshop or the employment of apprentices. Nevertheless, he had a major influence on western art. Among his followers, known as the *Caravaggisti*, was Artemisia Gentileschi (1593–1652/3), the first woman artist

Women as Artists: From Antiquity to the Seventeenth Century

Over the past twenty years, art historians have researched and reevaluated the role of women artists in western art. As a result, women's achievements in the visual arts, and the obstacles they have had to overcome, are much better understood.

Pliny's *Natural History* lists the names of five women in ancient Greece and Rome, together with their works, although nothing else is known of them. From the Roman period through the end of the fourteenth century, there are very few records of any individual artists, men or women. During the Middle Ages, women played a major role in the production of embroidery and tapestry — more so in northern Europe than in Italy. They were also active in the illumination of manuscripts, although this was largely confined to the daughters of wealthier families. Until the late thirteenth century, illumination was done by nuns, and a woman needed a dowry to enter a convent.

The bylaws of the Company of St. Luke, a confraternity of artists in Florence, founded in 1361, mentions dues to be paid by women members. However, no women's names are found in the Company's records. From the fifteenth century onward, beginning in Italy, women artists emerge from obscurity. There is evidence, for example, that a woman submitted a model for the lantern of Brunelleschi's dome over Florence Cathedral, though her name is unknown. Previously, women artists in Italy had usually been nuns, women of education and talent, but their work had been limited through their isolation from the wider artistic community. Artemisia Gentileschi was the first woman to join the Company's successor, the Accademia del Disegno (Academy of Design), in 1616.

The elevated status of the artist in the Renaissance was largely the result of a new humanist educational curriculum. For the first time, artists mixed socially with the princes of the Church and the nobility — as intellectual equals rather than as artisans and craftsmen. Gradually, the new educational standards were extended, especially among the ruling classes, to women. They were encouraged to engage in a wider range

of activities, including poetry, music, and art (in that order). The courts of fifteenth- and sixteenth-century Italy produced women who were outstanding cultural patrons, as well as having significant artistic accomplishments in their own right. By the sixteenth century it was generally agreed that the daughters of the middle classes should be educated. Women who wanted to become artists had to be trained in the workshops of established masters, and many were the daughters, sisters, or wives of artists. Nevertheless, attributions are always a problem with women, for works by women were likely to be delivered under the name of the male head of the workshop.

Vasari, writing in the sixteenth century, discussed the issue of women artists in his biography of Madonna Properzia de' Rossi. He begins her biography with typically humanist references to antiquity, in this case citing women of ancient Greece and Rome as models of female success. He points out that women were great warriors, poets, grammarians, and scientists. His own age, he observes, has produced women of distinction in Latin and Greek scholarship and in art. One Properzia, who was accomplished in playing and singing, set about carving peach stones. So impressive were her scenes that she was given monumental commissions in marble sculpture and painting. She was also praised as a copperplate engraver. Her draftsmanship was of the highest quality, and Vasari himself owned several of her drawings.

Despite the advances made by women in the Renaissance, however, practical obstacles remained. Marriage, usually followed by continuous childbearing, interfered with some promising careers. Women were barred from drawing live models, which prevented competition on equal terms with men. Artemisia Gentileschi drew from female models, but familiarity with the male nude was important for monumental works. It is thus no accident that, until recently, it was in the fields of portraiture and still life that women tended to achieve distinction.

19.20 Artemisia Gentileschi, *Judith Slaying Holofernes*. c. 1614–20. Oil on canvas, 6 ft 6⅓ in x 5 ft 4 in (1.99 x 1.63 m). Galleria degli Uffizi, Florence. Artemisia learned painting from her father Orazio. In 1611 Orazio hired Agostino Tassi to teach her drawing and perspective. Tassi raped Artemisia and then refused to marry her. When Orazio sued Tassi, Artemisia was tortured with thumbscrews to test her veracity before Tassi was convicted. Undoubtedly affected by this experience, Artemisia is especially known for her pictures of heroic women.

Northern Baroque Painting

As in the Renaissance, northern art of the seventeenth century was influenced by developments in the south, especially Italy. Italian patronage continued to be ecclesiastical, as well as private, while in France the state-sponsored Academy set the artistic style. In Flanders and Holland, however, the development of a free commercial art market and a bourgeois economy resulted in a significant change in the kind of art produced. For the first time artists were able to support themselves by specializing in a category such as portraiture, still life of various kinds, genre, or landscape. Art dealers set up businesses, selling works to middle-class citizens, who often purchased for investment and resale as much as for private enjoyment.

Rubens

The Flemish artist Peter Paul Rubens (1577–1640) was one of the most entrepreneurial of the seventeenth century. He left a wealth of paintings covering a wide range of subjects, and his patronage was as varied as his subject matter. He worked for the Church, for the nobility, for private citizens, and for himself. He ran a workshop with many apprentices, dealt shrewdly in the art market, and undertook important diplomatic missions for Flanders.

Rubens's mythological paintings, such as the *Venus and Adonis* (fig. **19.21**), celebrate the sensual side of life and seem unaffected by the Counter-Reformation. Venus tries to prevent her handsome young mortal lover Adonis from leaving. His hunting dogs wait impatiently as he tries to disengage himself from the goddess and her son Cupid. Cupid has placed his bow and arrow on the ground and tugs at Adonis's leg. Venus clings to his arm, as he turns and allows his right hand to linger seductively on her thigh. The ambivalence of Adonis's pose, forming a long spatial diagonal, reveals his inner struggle between staying and leaving.

Venus forms a counter-diagonal, her fleshy, highlighted body a variation on the traditional reclining nude. In contrast to Classical and Renaissance reclining nudes, Rubens's figure is actively, rather than passively, seductive. Venus's more active role in this scene is consistent both with the particular myth and with the moment represented, in which she attempts to control and dominate her lover. Her proportions have also ventured some distance from those of Classical antiquity. Rubens emphasizes her generous breasts and rippling, dimpled flesh in a way that is frankly voluptuous. It is possible that, for Rubens, such full figures reflected the Flemish equation of fleshiness with prosperity.

In contrast to the *Venus and Adonis*, the *Martyrdom of St. Lieven* (fig. **19.22**), which was destined for the high altar of the Jesuit church in Ghent, is very much affected by Counter-Reformation concerns. Rubens depicts the gruesome martyrdom of St. Lieven, following the

to emerge as a significant personality in Europe.

Artemisia's *Judith Slaying Holofernes* (fig. **19.20**), which shares the Baroque taste for violence, illustrates an event from the Book of Judith in the Old Testament Apocrypha (see p.17). The Assyrian ruler Nebuchadnezzar has sent his general Holofernes to lay waste the land of Judah. A Hebrew widow, Judith, pretending to be a deserter, goes with a maidservant to the camp of Holofernes and flirts with him. Arranging to spend the evening alone with him, Judith gets him drunk, uses his own scimitar to cut off his head and escapes with it. Artemisia depicts the moment at which Judith plunges the blade through Holofernes's neck. The violence of the scene is enhanced by the dramatic, Caravaggesque shifts of light and dark and by the energetic draperies. A series of diagonals converges around the victim's head, which Judith pulls back so that the viewer confronts his horror directly.

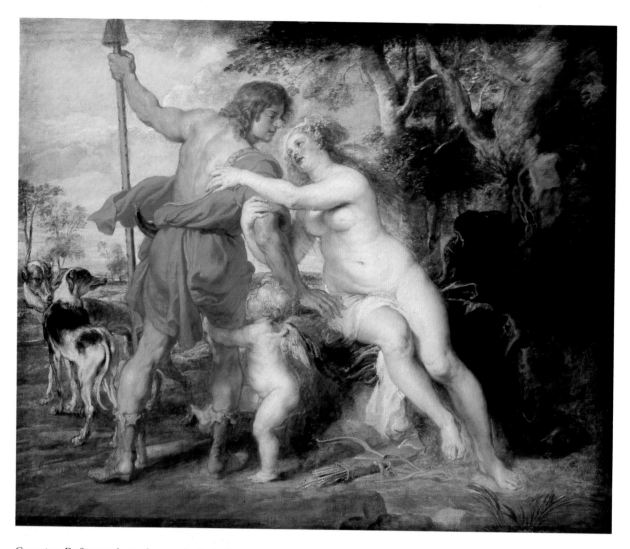

19.21 Peter Paul Rubens, *Venus and Adonis*. c. 1635. Oil on canvas, 6 ft 5½ in x 7 ft 11¼ in (1.97 x 2.42 m). Metropolitan Museum of Art, New York (Gift of Harry Payne Bingham, 1937).

Counter-Reformation demand that the viewer be encouraged to identify with Christian suffering and redemption. The combined violence and ecstasy of Rubens's interpretation is reflected in the formal excitement of the painting itself. Crowds of human figures in contorted poses either participate in the crime against St. Lieven or turn upward toward the light from Heaven. Horses rear, and angels appear in a swirl of cloud formations. On the lower right, a soldier turns in a dancelike motion, as if arrested by his recognition of light (and implicitly by enlightenment). The shifts from light to dark and from color to color enhance the motion of the poses and gestures, creating a feeling of intense urgency. It is the Baroque technique of involving the observer directly in the picture's space, and therefore in its narrative, that results in this sense of immediacy.

Although Rubens was influenced by Caravaggio, he painted with more textural variety and even stronger oppositions of light and dark. He used white light in contrast to Caravaggio's yellow light. The *St. Lieven* is a good example of Rubens's genius for synthesizing sensuous colors and textures with the most gruesome forms of torture and suffering.

19.22 (opposite) Peter Paul Rubens, *The Martyrdom of St. Lieven*. c. 1633. Oil on canvas, 14 ft 9⅛ in x 10 ft 11⅞ in (4.5 x 3.35 m). Musées royaux des Beaux-Arts de Belgique, Brussels. St. Lieven was a bishop of Ghent who was waylaid and murdered by robbers. They cut out his tongue and fed it to dogs. At the center of this picture, one of the robbers holds the tongue in a pair of tongs and offers it to an eager dog. Just below the robber and slightly to his left, the saint is depicted in a combination of suffering and ecstatic transport.

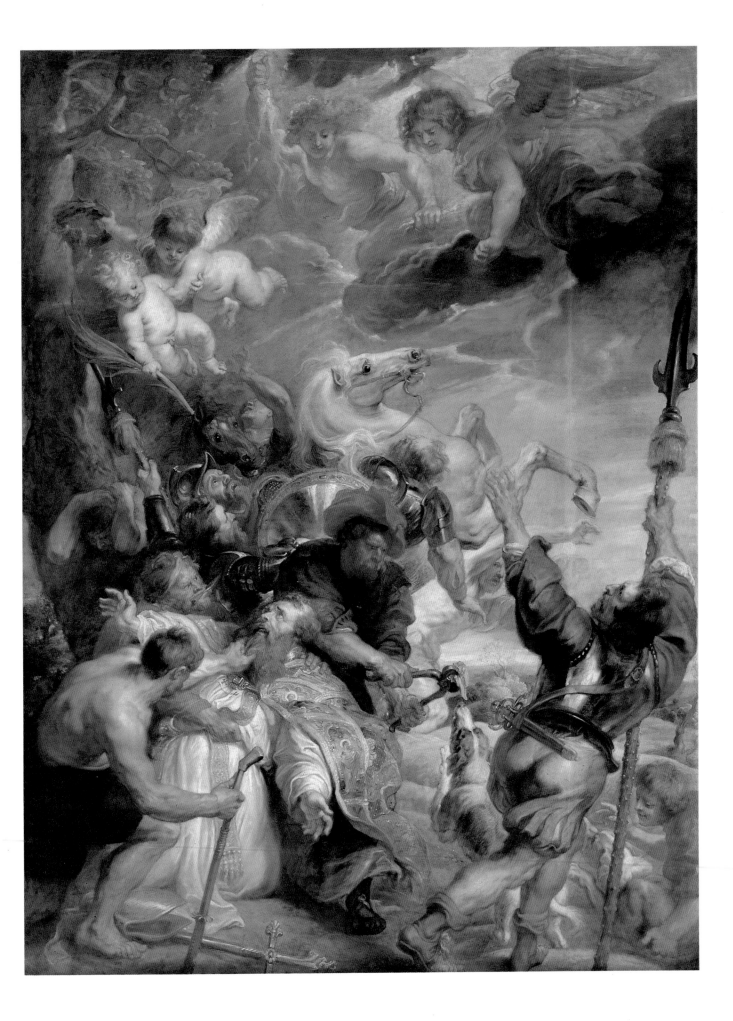

Rembrandt

Rembrandt van Rijn (1606–69) was born in Leiden in Protestant Holland. He quickly became a successful painter and moved to Amsterdam. Unlike Rubens, Rembrandt worked largely for Protestant patrons. Though his paintings include many religious subjects, they do not conform to any institutional orthodoxy. Stylistically, Rembrandt falls into the general category of Baroque. But his individuality within that category has placed him among the giants of western art. Rembrandt, more than any of his contemporaries, conveyed character and drama through his use of light and dark.

In the Old Testament scene of *Belshazzar's Feast* (fig. **19.23**), Rembrandt merges formal with symbolic light. Belshazzar, the son of the regent of Babylon in the sixth century B.C., sees a great light on the wall during a feast. Beside the light a hand appears with a cryptic message, which Daniel interprets as "You have been weighed in the balance and found wanting." The same night, Belshazzar is killed, fulfilling the sense of menace that is still popularly associated with the "writing on the wall."

In Rembrandt's image, Belshazzar rises from the table and turns to face the mysterious light. He spreads out his arms in a sweeping diagonal, displaying the elaborate gold embroidery of his cloak. Light is also concentrated on his face, jewelry, turban, and crown, contrasting these reflections of his material wealth with the illumination of inner fear and awe in the faces of the two figures on Belshazzar's right (our left), and with the light from

Heaven appearing on the wall. This painting is primarily rendered in warm brown tones, with a prominent color shift in the red-orange of the woman in the lower right corner. She withdraws from the light in fear and spills her drink. In so doing, she helps to draw the observer into the picture plane by virtue of her forceful diagonal movement.

Rembrandt painted more self-portraits than any other painter before the seventeenth century. They total over one hundred, and together constitute a visual autobiography. They chronicle Rembrandt's changing fortunes, moods, and, above all, his journey through life from youth to old age. If we compare two painted self-portraits, one from 1640 (fig. **19.24**) and one from 1661 (fig. **19.25**), we can see the differences in Rembrandt's self-image over a twenty-one-year period.

At age thirty-four (fig. **19.24**), Rembrandt is prosperous and self-confident. Dressed in velvet and fur, he rests his arm on a windowsill and looks out on the world. In the facial shading, he creates a sense of inner character that is visible through the "window" of the eyes, just as the picture itself is a "window" to the figure. By 1661 (fig. **19.25**), after several personal tragedies, Rembrandt is an older and sadder figure. His pose is less assertive, and he seems weighed down by his own body. He looks up from the rather worn pages he is reading, as if shrugging his shoulders at the twists of fate. The slight tilt of his head emphasizes the sagging cheeks. The raised eyebrows create a pattern of wrinkles on his forehead, and his hair has turned gray. As in the earlier pictures, Rembrandt has highlighted the face and hand, leaving a darkened sur-

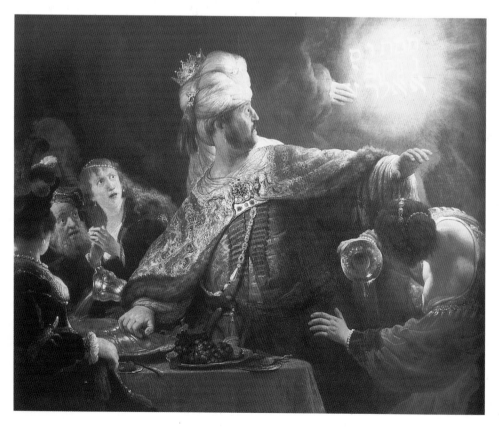

19.23 Rembrandt van Rijn, *Belshazzar's Feast*. c. 1635. Oil on canvas, 5 ft 5¾ in × 6 ft 9½ in (1.67 × 2.07 m). National Gallery, London. Rembrandt shared the Baroque interest in naturalism. For his Old Testament scenes, he liked to frequent the Jewish quarter of Amsterdam for inspiration and models. His broad subject matter included biblical and mythological scenes, landscapes, and portraits.

19.24 (opposite) Rembrandt van Rijn, *Self-Portrait Leaning on a Sill* (aged thirty-four). 1640. Oil on canvas, 3 ft 4⅛ in × 2 ft 7½ in (1.02 × 0.8 m). National Gallery, London.

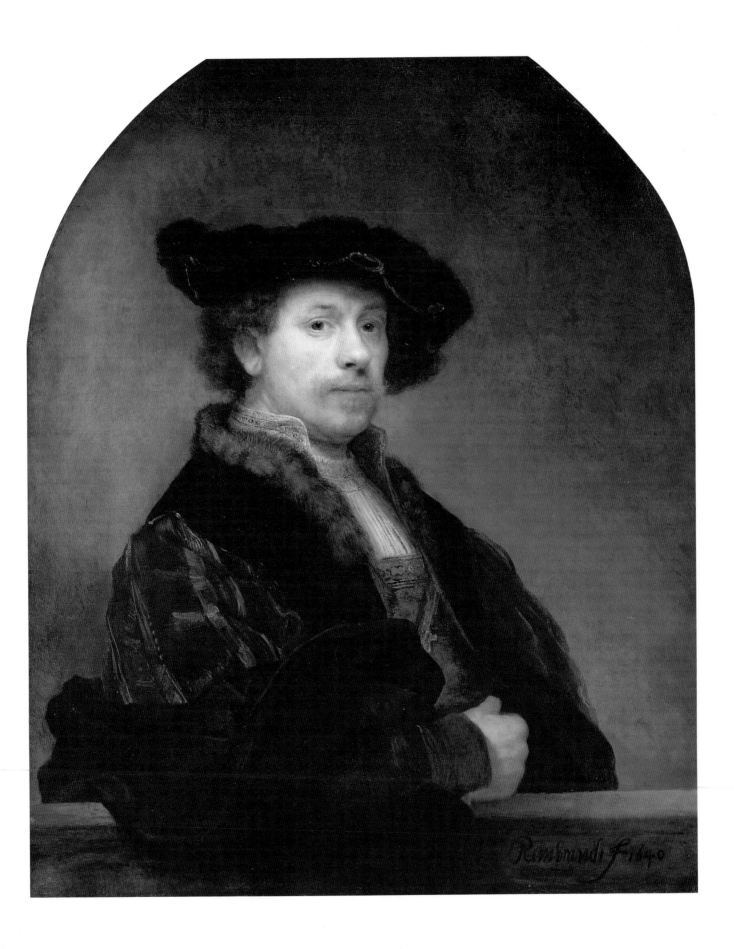

19.25 Rembrandt van Rijn, *Self-Portrait as St. Paul* (aged fifty-five). 1661. Oil on canvas, 35⅞ x 30⅜ in (91 x 77 cm). Rijksmuseum, Amsterdam.

rounding space from which the figure seems to emerge.

The medium of etching was particularly suited to Rembrandt's genius for the manipulation of light and dark. Although etching had been invented in the sixteenth century, it was Rembrandt who perfected the technique during the seventeenth century. The three little self-portrait etchings reproduced here illustrate his use of black and white, or pure dark and pure light, to convey character.

The earliest figure (fig. **19.26**) is the twenty-four-year-old Rembrandt in a cap. His youthful vigor is reflected in the short, wavy lines of his hair and the sharp twist of his head. Something seems suddenly to have caught his attention. His eyes are round with wonder and his mouth slightly open as if he is about to speak. The second etching

(fig. **19.27**), in which he is a few years older, shows the artist grimacing. Like Caravaggio and Bernini, Rembrandt studied his own facial expressions in a mirror. Such studies constituted a kind of visual research, which Rembrandt used later in creating painted figures. The third etching (fig. **19.28**), executed in 1639, is related to the painted self-portrait in figure **19.24**. A well-dressed Rembrandt, his hat perched rakishly on his head, exudes the self-confidence of success. His inner artistic energy seems to shine forth from the illumination of his face.

Etching

Etching, like engraving, is an intaglio method of producing multiple images from a metal (usually copper) plate. In etching, the artist covers the plate with a resinous, acid-resistant substance (the **etching ground**). A pointed metal instrument, or stylus, is then used to scratch through the ground and create an image on the plate. When the plate is dipped in acid, or some other corrosive chemical, the acid eats away the exposed metal. In so doing, it creates grooves where the ground was scratched through by the stylus. The ground is then wiped off. The plate is inked, and impressions are taken just as in engraving. The result, however, is different. Whereas in engraving the artist pushes the burin to cut into the metal surface, the etching stylus moves more easily through the ground, allowing for more delicate marks and greater freedom of action. The result is a more convincing sense of spontaneity in the image and a blurred, atmospheric quality (see, for example, the sleeves of fig. **19.28**).

Rembrandt also used the intaglio **drypoint** method, in which the image is scratched directly onto the plate. "Dry" signifies that acid is not used. The incisions on the plate make metal grooves with raised edges, called the **burr**. When the drypoint plate is inked, the burr collects the ink and produces a soft, rich quality in the darker areas of the image.

In both etching and drypoint, the burin can also be used for emphasis. It is possible to combine the two techniques in one image, as Rembrandt did. It is also possible to make alterations to an engraved plate and then produce additional prints. One can see the artist's changes by studying in order the different **states**, or subsequent versions, of the same image.

19.26 (above, left) Rembrandt van Rijn, *Self-Portrait in a Cap, Openmouthed and Staring.* 1630. Etching, 2 x 1⅞ in (51. x 4.6 cm). Rijksmuseum, Amsterdam.
19.27 (left) Rembrandt van Rijn, *Self-Portrait Grimacing.* 1630s. Etching, 3¼ x 2⅞ in (8.3 x 7.2 cm). Rijksmuseum, Amsterdam.
19.28 (above, right) Rembrandt van Rijn, *Self-Portrait, Leaning on a Stone Sill.* 1639. Etching and drypoint, state 2, 8⅛ x 6½ in (20.5 x 16.4 cm). Rembrandt House Museum, Amsterdam.

Vermeer

A contemporary of Rembrandt and Rubens, Jan Vermeer (1632–75) left a very small number of pictures — no more than thirty-five in all. Like Rembrandt, Vermeer was a master of light — though in a completely different way. His largest canvas, the *View of Delft* (fig. **19.29**), is a particularly striking example of the Dutch taste for landscape with panoramic vistas. Vermeer has combined an atmospheric sky with houses and water in a way that illustrates his genius for conveying a jewel-like light. Despite the large size of the canvas, Vermeer's attention to meticulous detail creates a feeling of intimacy.

The shifting lights and darks of the clouds and the delicately colored buildings are reflected in the water. Standing on the shore in the foreground are a few small human figures, who seem insignificant compared with the vast sky and the implied continuation of the scene beyond the

19.30 (opposite) Jan Vermeer, *A Woman Weighing Pearls.* c. 1664. Oil on canvas, 16¾ x 15 in (42.5 x 38 cm). National Gallery of Art, Washington (Widener Collection). The "picture in the picture" reveals the allegorical message of Vermeer's image. In the slightly blurred Last Judgment hanging on the wall, Christ is "weighing" the fate of human souls. The irony of Vermeer's picture lies in the parallel between the imperfect worldly judge of monetary value and the heavenly judge of spiritual value.

19.29 Jan Vermeer, *View of Delft.* c. 1662. Oil on canvas, 3 ft 2½ in x 4 ft ¼ in (0.98 x 1.23 m). Mauritshuis, The Hague. Vermeer lived and worked in Delft, Holland. Little is known of his life and career, but it appears that he earned most of his income as an art dealer. There is no record of the sale of any of his own pictures, which were not highly regarded during his lifetime. After Vermeer's death his works were neglected by critics and collectors until the late nineteenth century. Today they are among the most highly valued in the world.

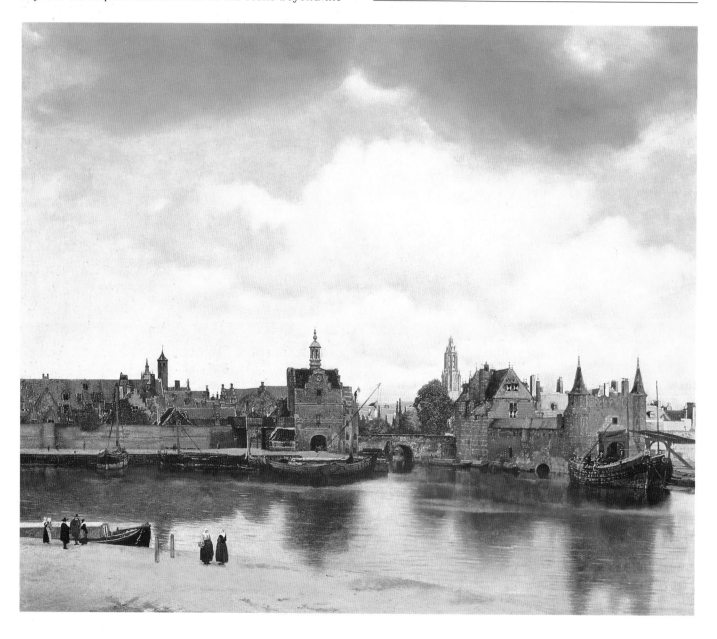

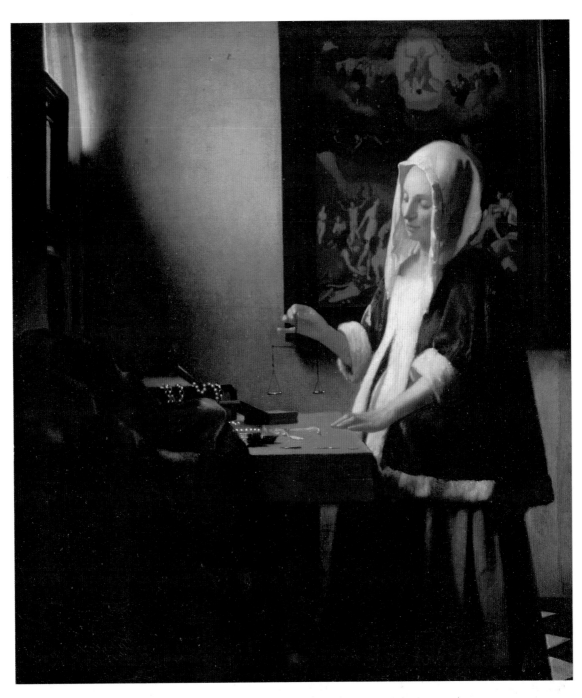

picture's frame. Their staunch vertical forms anchor the church spires, the towers of the drawbridge, and the reflections of these shapes in the water. Silvers, blues, and grays alternate in the sky and the yellow sunlight filters through the clouds. The sparkle of the sunlight, as it catches details of the houses or glimmers on the water, creates a glowing, textured surface motion that was entirely new in western European art.

The *View of Delft* is unique among Vermeer's known works. Most of his paintings are interior genre scenes, many of which have allegorical meanings. His canvases are generally small, and his subjects, as well as their treatment, are intimate. His *Woman Weighing Pearls* (fig.

19.30) combines genre with allegory. At first glance, the scene appears to be a typical domestic interior, conveyed with Vermeer's characteristically subtle effects of light. The room is illuminated by the morning glow, which filters through the window and highlights the white borders of the woman's jacket and head covering. The light catches the edge of the delicate scale she is holding, and reflects off each individual stringed pearl. Her meditative gaze matches the stillness of the interior and seems to have arrested the action of weighing the pearls. In contrast to the variations of light, the large area in the lower left of the picture is darkened. Its obscured forms are consistent with Baroque pictorial organization.

Vanitas

The moralizing trends in Dutch art are perhaps clearest in the Baroque *Vanitas* still lifes of the seventeenth century. In Harmen Steenwyck's *Vanitas* of 1660 (fig. **19.31**), a typical Baroque diagonal of light illuminates some of the objects on the table, leaving others in obscurity. Every object, however, has a double meaning. On the one hand, the convincing portrayal of their material textures appeals to the senses, while on the other it signifies the deceptions of materialism. Contrasted with these sensual pleasures are the references to time — a standard feature of Baroque *Vanitas* iconography. A watch, for example, reminds the viewer that time passes. The results of the passage of time are indicated by the smoke that lingers around the shiny metal oil lamp, as if its flame has just been blown out. The extinguished flame, like the skull, symbolizes death. The hard, curved, highlighted surface of Steenwyck's skull echoes the shell, lamp, and jug, all of which are now empty containers. The direct confrontation between observer and skull combines the Baroque taste for dramatic involvement in the picture with a reflection of what lies in store for the observer.

19.31 Harmen Steenwyck, *Vanitas*. 1660. Oil on canvas, 15½ × 20 in (39.2 × 50.7 cm). National Gallery, London. *Vanitas* is the Latin word for "emptiness," or "untruth," from which comes the English word "vanity." Such pictures appear to show random objects, but in fact have an underlying moral message — usually about the fleeting nature of physical reality. The open book, for example, may stand for human learning, as opposed to higher "moral" truth. A sword implies strength and power, a rare shell stands for earthly values and wealth, and the recorder and horn represent music and the arts.

Spanish Baroque Painting

Velázquez

The leading Baroque artist in seventeenth-century Counter-Reformation Spain, Diego Velázquez (1599–1660), was able to cover a broad spectrum of subject matter. His genius was nurtured by his Classical education, stimulated by his admiration for Titian (see p.271), and spurred by his emulation of Rubens.

For Philip IV, his most constant patron, Velázquez painted numerous pictures. The equestrian portrait *Philip IV on Horseback* (fig. **19.32**) illustrates Philip's exalted position in a Baroque version of the mounted Roman emperor. Philip controls the horse with apparent ease as he executes a *levade* — a difficult Spanish Riding School maneuver, in which the rider uses one hand to control a rearing horse. Despite the skill required for this exercise, Philip remains calm and in control. His upright posture contrasts with the diagonal plane of the horse, the slanting ground below, and the horizontal expanse of the sky. The blues and yellows spreading across the sky, the metal sheen of Philip's armor, and the rendering of the horse are all testimony to Velázquez's remarkable command of color and texture.

His *Venus and Cupid* (fig. **19.33**) of the 1640s, also known as the *Rokeby Venus,* was designed to suit the taste of a specific patron. This was probably the Marquis of Eliche, who was well known as both a libertine and a collector of Velázquez's works. The painting itself obscures the identity of the model by turning her away from the viewer and blurring her features in the mirror. Cupid's presence hints at, but does not specifically identify, the amorous content of the scene, which is enhanced by the **painterly** textures and rich colors. Seen in rear view, the nude is a long series of curves, which are repeated in the grand sweep of the silky curtain. Likewise, the reds and pinks in the curtain recur in the nude's cheeks and Cupid's cloth. The rarity of the female nude in seventeenth-century Spain makes this painting all the more unusual. It clearly reflects the influence of Titian's reclining Venus (fig. **16.27**).

Velázquez's unqualified masterpiece is the monumental *Las Meninas* of 1656 (fig. **19.34**). This work is not only a tribute to the artist's talent as a painter, but is about the very art of painting. The setting is a vast room in Philip's palace. The five-year-old infanta, or princess, Margarita is the visual focus of the picture. She is attended by her

19.32 (opposite) Diego Velázquez, *Philip IV on Horseback*. 1629–30. Oil on canvas, 9 ft 10½ in × 10 ft 5¼ in (3.01 × 3.18 m). Prado, Madrid. Velázquez became court painter to Philip IV early in his career. He followed the humanist leanings of his teacher, Francisco Pacheco, who later became his father-in-law. Like Titian, he worked for the elevation of painting to the status of a Liberal Art, alongside music and astronomy. In Spain, painting and sculpture were still considered mere crafts because artists worked with their hands.

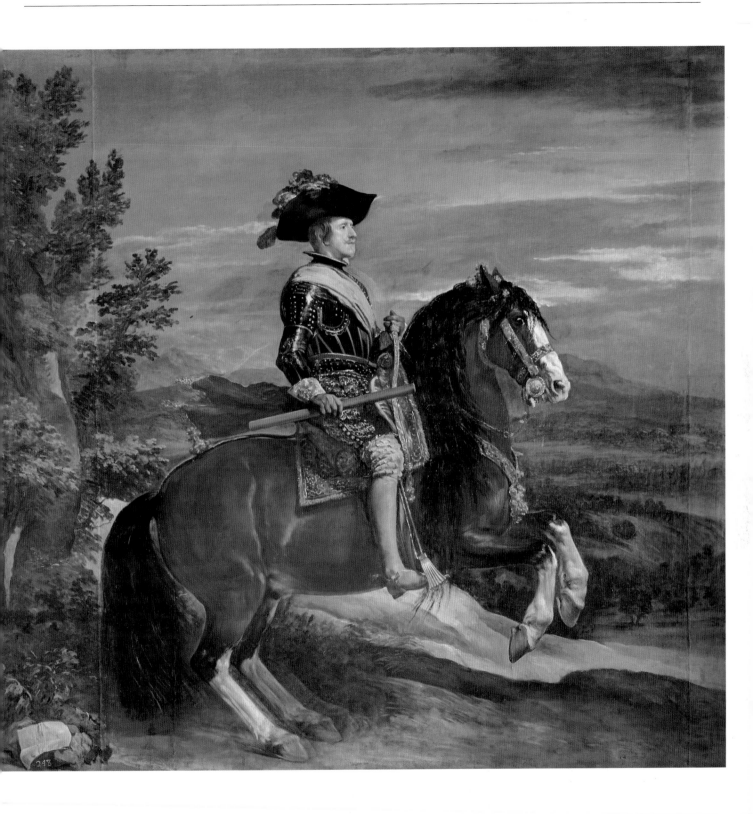

maids (*meninas*), and accompanied by dwarfs and a dog. The elaborate costumes of the Spanish court are painted in such a way that the brushstrokes themselves highlight the textures depicted.

Certain forms, such as the infanta and the doorway, are emphasized by light. Other areas of the picture—the paintings on the side wall, for example—are unclear. Most obscure of all is the large canvas at the left, on which Velázquez himself is working. It is seen, like the *Rokeby Venus,* from the back. Velázquez's variations of light and dark, which combine clarity and obscurity, are characteristic of the Baroque style.

Below the mythological scenes on the back wall, which depict contests between gods and mortals (which the gods inevitably win), is a mirror. This has been the subject of extensive discussion. The king and queen of Spain, the parents of the infanta, are visible in the mirror. Does their image mean that they are actually standing in front of their daughter, that they are the subjects of Velázquez's canvas? Or is this perhaps not a reflection at all, but rather a painted portrait? These are the questions most often posed about the unusual image. We have seen that mirror images occur in paintings for a variety of reasons (figs. **15.31** and **17.1**). The mirror in *Las Meninas* may have an intentional ambiguity, which, judging from the *Rokeby Venus,* would probably correspond to Velázquez's personal taste, possibly to that of his patrons, and certainly to the Baroque style as a whole.

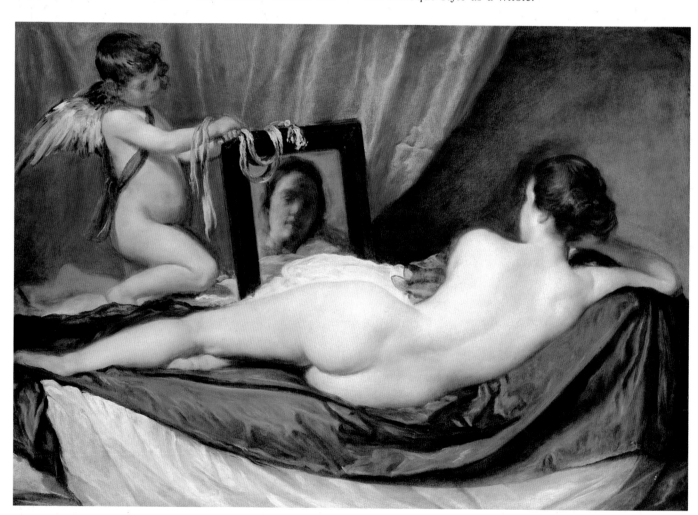

19.33 Diego Velázquez, *Venus and Cupid* (*The Rokeby Venus*). c. 1648. Oil on canvas, 4 ft ⅜ in x 5 ft 9⅝ in (1.23 x 1.77 m). National Gallery, London. The existence of this painting demonstrates that it was acceptable, even in Counter-Reformation Spain, to paint the female nude — provided it was for a private patron. Even so, Velázquez has erred on the side of modesty by showing only the face of the model in the mirror. A stricter application of the laws of physics might have shown another part of her body.

19.34 (opposite) Diego Velázquez, *Las Meninas.* 1656. Oil on canvas, 10 ft 7 in x 9 ft ½ in (3.23 x 2.76 m). Prado, Madrid. Velázquez's personal pride in his own status — as a "divine" artist and member of the royal circle — is evident in his self-confident stance and raised paintbrush. The red cross on his black tunic is the emblem of the Order of Santiago, of which Velázquez became a knight in 1659. Since the painting was completed in 1656, the cross must have been a later addition.

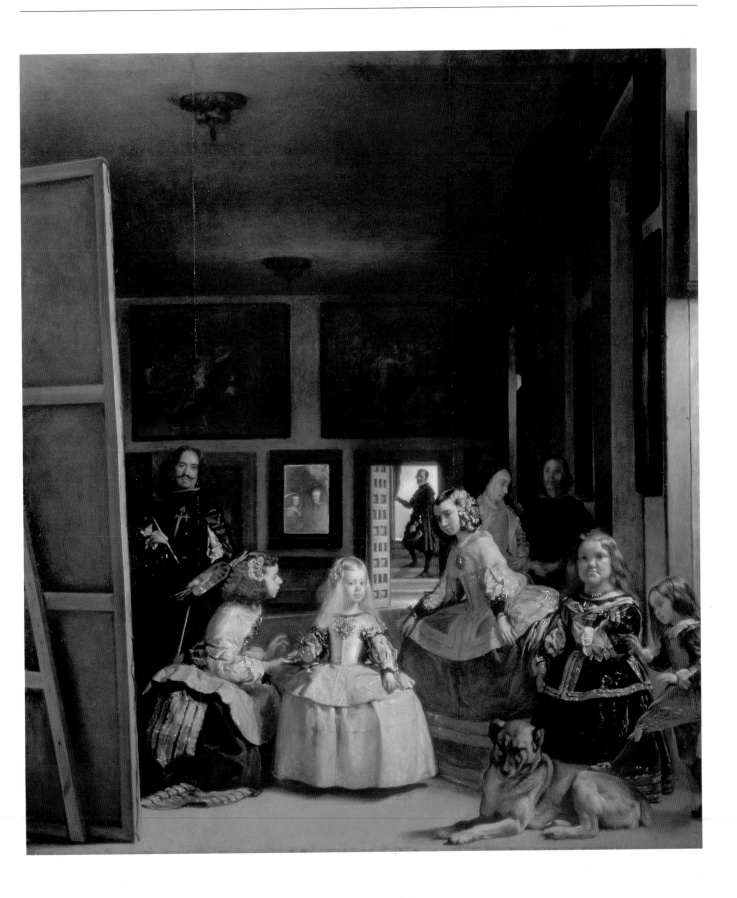

French Baroque Painting

Poussin

Although Nicolas Poussin (1594–1665) was a French painter, born in Normandy, he lived most of his adult life in Rome. He studied the Italian Renaissance and was drawn to Classical as well as biblical subjects. Poussin represents the most Classical phase of the Baroque style, particularly in those of his works that depict antique subject matter.

In *The Dance of Human Life,* also called *Dance to the Music of Time* (fig. **19.35**), Poussin uses mythology in the service of Christian allegory and in the context of a scene symbolizing *Vanitas.* Four women in Classical dress dance in a circle. They represent Luxury, Wealth, Poverty, and Labor — four states of human existence — locked in a

never-ending circular movement. Time himself, the old winged man on the right, is the musician. Apollo drives his chariot across the sky, symbolizing the passage from day to night. The two heads of Janus — the god of gateways who sees past and future simultaneously — adorn the top of an antique stone pedestal. Two children, one with an hourglass and the other blowing bubbles, remind the viewer that life is transient and insubstantial.

19.35 Nicolas Poussin, *The Dance of Human Life.* c. 1638–40. Oil on canvas, 2 ft 8⅝ in × 3 ft 5⅜ in (0.83 × 1.05 m). Wallace Collection, London. By 1624 Poussin was in Rome, working for influential patrons. Ironically, his reputation was at its highest with the French Academy, but he preferred to live in Rome, where his restrained classicizing style was out of tune with the more exuberant Roman Baroque. This painting was executed for Pope Clement IX (then still a cardinal), who suggested the subject to Poussin.

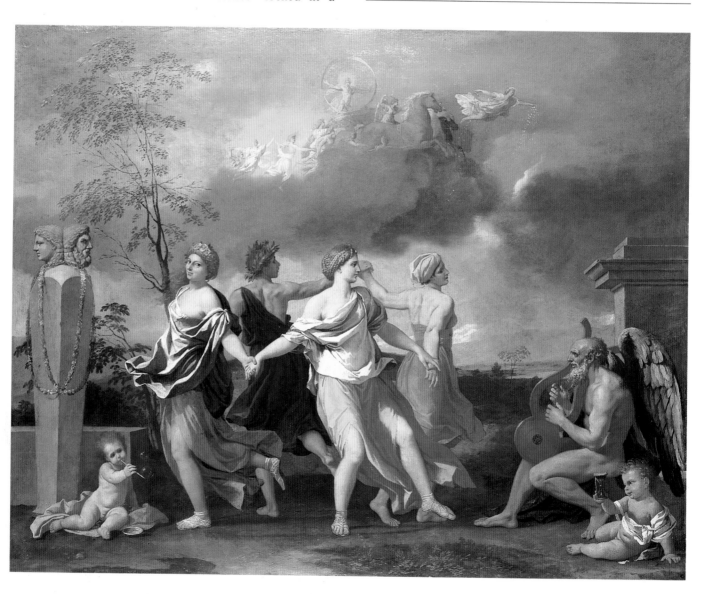

Rococo and the Eighteenth Century

The eighteenth century, particularly its latter half, was a complex patchwork of different artistic trends. The most distinctive eighteenth-century style is called Rococo, a term apparently coined from the French words *rocaille* and *coquille* (meaning, respectively, "rock" and "shell" — the formations used to decorate Baroque gardens). Scholars are divided over whether Rococo was an independent style or merely the decadent conclusion of the Baroque.

Rococo is above all an expression of stylish wit and frivolous charm. Elegant figures gather in parks and gardens. Cupids frolic around would-be lovers. Classical gods and goddesses engage in amorous pursuits. The world of Rococo is a world of fantasy and grace. At its best, it contains undercurrents of irony and satire, which remind viewers that there is a darker reality beneath the surface levity.

Rococo began at the turn of the century in the courtly atmosphere of Versailles. After the death of Louis XIV in 1715, and a subsequent decline in royal patronage, the center of taste shifted from the court to the Paris *hôtel* (or elegant private house). The source of patronage also shifted, from being the exclusive province of French royalty, to the upper middle class and the bourgeoisie. In the other capitals of Europe, especially in Germany, the Rococo style was quickly taken up by rulers and their courts.

In contrast to the apparent frivolity of Rococo, serious advances were taking place in other fields. The world of music could boast Antonio Vivaldi, Johann Sebastian Bach, Franz Joseph Haydn, and Wolfgang Amadeus Mozart. In science, Gottfried Leibniz developed calculus, Joseph Priestley discovered oxygen, and Edmond Halley identified the comet that bears his name. Technological developments, such as mechanized spinning and James Watt's steam engine, laid the foundations for the Industrial Revolution (see p.364). Satire, which is a feature of certain Rococo artists, had as its leading literary exponents Jonathan Swift in England and François de Voltaire in France.

Important political changes also occurred in eighteenth-century Europe. The Prussian king, Frederick the Great, built up a military establishment, and France and Austria united in opposition against him. This new alignment resulted in the Seven Years' War (1756–63), which was won by the Prussians. England, whose international influence was based largely on the strength of its navy, consolidated its position in the eighteenth century. It also took the lead in European industrialization.

Developments in America mirrored the shifts in European power. England's position of economic and naval leadership extended to the New World. The North American colonies belonged primarily to England. The main exceptions were in the south, in the Louisiana territory, and in Canada, where the English did not dislodge the French until 1763. The Spanish controlled the whole of Central and South America (with the exception of Brazil), Mexico, Texas, and most of Florida (which they ceded to England in 1763).

The Enlightenment

The eighteenth century has been called the "Age of Enlightenment." This complex concept derives from certain philosophical ideas, which were translated into political movements. The rationalism of Descartes — *Cogito, ergo sum* ("I think, therefore I am") — in the previous century continued to appeal to European and American thinkers. In England, John Locke advanced the notion of "empiricism," the belief that something exists only when it can be seen and experienced. Improvements in microscopes and telescopes lent credence to Locke's ideas. And in France, Denis Diderot and the "Encyclopedists" classified the various branches of knowledge on a scientific basis.

In political philosophy, the concept of a secular "social contract" developed. It was based on the principle that governments ruled only by the consent of the people. This "contract" could be broken if a government abused its powers. The practical effect of this reasoning can be seen in Thomas Jefferson's Bill of Rights and the American Constitution. The American Revolution (1776–83) ended the oppression of the colonies by the English King George III. It was followed a few years later by the French Revolution (1789–99). These two revolutions essentially broke

the time-honored belief in the divine right of kings throughout most of western Europe.

Traditionally, the image of light, associated with the sun, had been used for political ends. In ancient Egypt the pharaoh was thought of as the sun god Ra on earth (see p.73), while the entire court of Louis XIV (see p.303) revolved around his self-image as the Sun King. Likewise, throughout the history of Christian art, Christ himself is paralleled with the sun as the "light of the world." With the inroads made by non-Christian philosophies, and the consequent decline in the influence of the Church, the notion of "light" became increasingly secular. It now became associated with a "rational," empirical outlook. The light in En*light*enment referred to the primacy of reason and intellect, in contrast to the unquestioning acceptance of divine power. This bias was profoundly optimistic. It encouraged a spirit of inquiry, a belief in progress and in the human ability to control nature.

While these were the most dominant eighteenth-century views, however, countercurrents persisted. The prevalence of satire, for example, implies an awareness that darker forces underlie the optimistic view of human nature. In Germany, the reaction was even more pronounced, particularly in the esthetic of the so-called *Sturm und Drang* (or "Storm and Stress"). According to that more pessimistic outlook, nature had ultimate power over reason. As in Johann Wolfgang von Goethe's play *Faust*, human life was seen as a constant — and losing — battle for control over the evil forces of nature.

Although Rococo was the primary artistic style of the eighteenth century, Classicism remained a potent force. Excitement over the discovery of the buried Roman cities of Herculaneum (in 1738) and Pompeii (in 1748) fueled the interest in antiquity. In Germany, Johann Winckelmann introduced a historical approach to the study of ancient Greek and Roman art. His classification into four periods — Archaic, Phidian, the fourth century B.C., and the remainder of antiquity through the fall of the Roman Empire — became a model for subsequent art historical divisions. At the same time, Gothic (see p.189) and Palladian (see p.282) revivals took place — the former especially in England, the latter in both England and America. Toward the end of the century, newer movements, such as Romanticism, were to arise in opposition to the Classical esthetic of the European Academies.

Rococo Painting

The leading Rococo painter, Antoine Watteau (1684–1721), was born in Flanders, but spent most of his professional life in France. He is best known for his "Fêtes Galantes," paintings of festive gatherings, in which elegant men and women relax in outdoor settings. *The Dance* (fig. **20.1**) depicts a semicircular group of figures talking, flirting, and playing music by a garden wall. The wall creates an enclosure, so that the figures are at once distinct from, and yet related to, their natural surroundings. One couple

has detached itself from the group. They point their toes to begin a dance. The theme of courtship predominates, but it is kept on a frivolous plane. The lighthearted effect is enhanced by the colorful, silky, shimmering textures of the costumes.

The irony that often underlies Watteau's playful surfaces is suggested here by the more serious tone of the large, Classical *krater* on the edge of the garden wall (see p.94). Carved in relief under its lip, and staring down at the assembled figures, is a ram's head — a traditional symbol of lust. Also classically inspired is the reclining nude, who seems to be watching the group at leisure. She raises her arm languidly over her head in a gesture frequently associated with seduction. Both the nude and the *krater* are of stone, and are thus, like the Classical tradition itself, enduring. Their juxtaposition with the themes of courtship, music, and dance — all of which are transitory pleasures — is the ultimate source of Watteau's irony in this picture.

The last great Rococo painter was Jean-Honoré Fragonard (1732–1806). In *The Swing* (fig. **20.2**), he enlivens nearly the entire picture plane with frilly patterns. The lacy ruffles in the dress of the girl swinging are repeated in the illuminated leaves, the twisting branches, and the scalloped edges of the fluffy clouds. It is as if the entire design were animated by the erotic playfulness of the scene itself.

The Academy

The idea of an Academy of the arts had originated in late sixteenth-century Italy. It was based on the Platonic Academy (*akademia* in Greek) in Athens, where young men gathered to discuss philosophical issues.

In western Europe the Academy replaced the older apprentice system of artistic training, providing intellectual discussion as well as technical training. This change reflected the improved social status and increasingly humanist education of the artist. Eventually, the European Academies became more formalized and established rigid sets of rules, or canons of taste. Herein lay the seeds of subsequent rebellion. The French Academy, for example, founded in 1648, was at the center of a seventeenth-century disagreement between the "Rubenists" and the "Poussinists." The "Rubenists" followed Rubens in advocating the primacy of color and natural exuberance, while the "Poussinists" preferred reason, control, and order. Academic taste, which was more on the side of Poussin's classicizing style, persisted through most of the nineteenth century (see p.342).

20.1 (opposite) Antoine Watteau, *The Dance* (*Les Fêtes Vénitiennes*). c. 1718. Oil on canvas, 21½ x 17¾ in (54.6 x 45.1 cm). National Gallery of Scotland, Edinburgh. The figure on the right playing the bapgipes is Watteau's self-portrait. Watteau was acquainted with the dancing couple. The woman was an actress, while the man (who exchanges a glance with Watteau) was a fellow painter and friend.

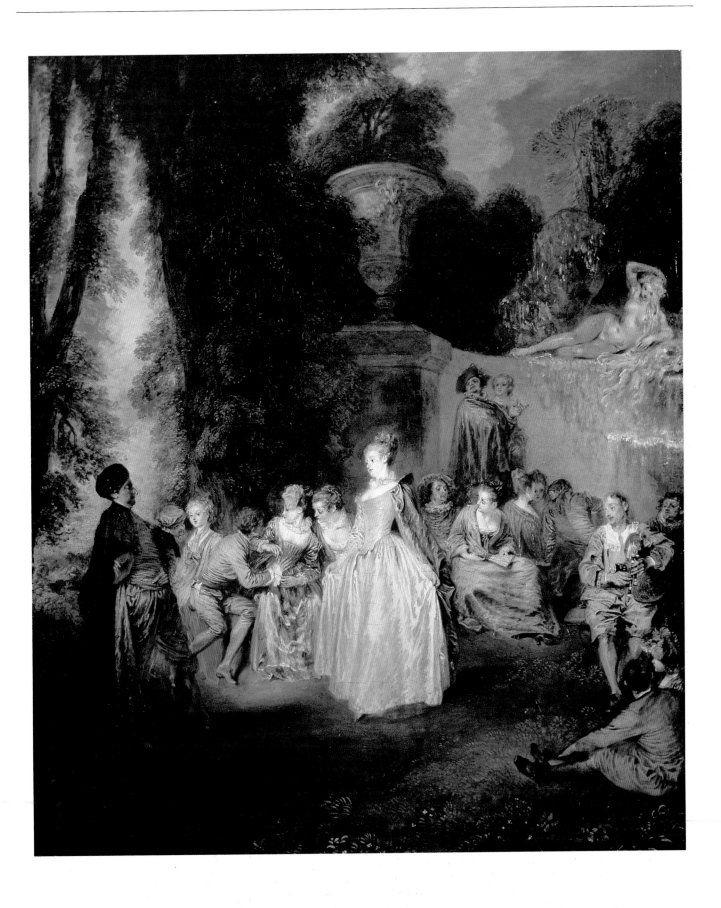

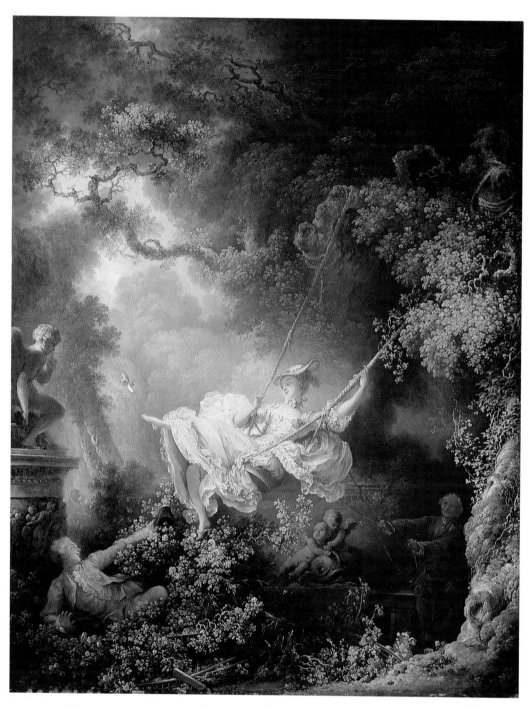

20.2 Jean-Honoré Fragonard, *The Swing.* 1766. Oil on canvas, 35 x 32 in (88.9 x 81.3 cm). Wallace Collection, London. *The Swing* was commissioned by the Baron de Saint-Julien, who specified that Fragonard should paint his (the baron's) mistress on the swing, with himself as her observer. Fragonard emphasizes the erotic associations of "swinging" by highlighting the shimmering texture and swirling curves of the dress. Swinging has some of the same connotations today — the "swinging sixties."

At the right of the painting, an elderly churchman pushes the swing, while a voyeuristic suitor hides in the bushes and gazes up under the girl's skirts. His hat and her shoe — both symbolic sexual references in this context — echo the setting: an enclosed yet open garden, where amorous games are played. The stone statues also echo the erotic implications of the scene. On the left, a winged god calls for secrecy by putting his finger to his lips. Between the swing and the old man, two Cupids cling to a shell. Like Watteau, therefore, Fragonard calls on Classical imagery to provide a more serious underpinning for frivolous erotic themes.

Nature, which predominated in French Rococo, was also an important aspect of the style in England. Thomas Gainsborough (1727–88), who is best known for his full-length portraits, liked to set his figures in a landscape. In his portrait of *Mrs. Richard Brinsley Sheridan* (fig. **20.4**), the sitter assumes a slightly self-conscious pose, and gazes out of the picture plane. The shiny, silky textures of her dress and the light filtering through the background trees evoke the materials and garden settings of French Rococo. Here, however, the amorous frivolity has been subdued. Mrs. Sheridan is at once enclosed by nature and distinct from it. She is sedate, aristocratic, and

20.3 William Hogarth, *Marriage à la Mode II*. 1745. Engraving by B. Baron after an oil painting of 1743. British Museum, London.

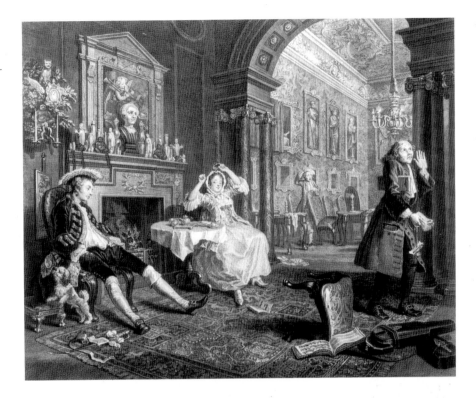

surrounded by a landscape as orderly and controlled as herself.

A very different expression of English Rococo is found in the witty, biting commentary of William Hogarth (1697–1764). Hogarth took contemporary manners and social conventions as the subjects of his satire. In a series of six works entitled *Marriage à la Mode* from the 1740s, Hogarth made fun of the hypocritical commitment to the marriage contract. In the second scene of the series (fig. **20.3**), the husband, a young aristocrat, has returned home exhausted from carousing. The little dog beside him is excited by the smell of a woman's hat in his pocket, thus drawing the viewer's attention to his master's sexual exploits. A black mark on the side of the man's neck indicates that he has already contracted syphilis.

The man's father-in-law is a merchant disturbed by the growing stack of bills. The wife, meanwhile, has engaged in illicit behavior of her own. She leans back in a sexually receptive pose, while the fallen chair in the foreground suggests that someone, perhaps the wife's music teacher, has just made a speedy exit. While the architecture reflects the Palladian style of eighteenth-century England (see p.336), Rococo details fill the interior. The costume frills, for example, echo the French version of the style. Elegant little statues on the mantelpiece, the elaborate

20.4 Thomas Gainsborough, *Mrs. Richard Brinsley Sheridan*. 1785–7. Oil on canvas, 7 ft 2½ in x 5 ft ½ in (2.2 x 1.54 m). National Gallery of Art, Washington (Andrew W. Mellon Collection). Gainsborough's patrons included the English royalty and aristocracy, but he also painted portraits of his musical and theatrical friends and their families. Mrs. Sheridan was the wife of Richard Brinsley Sheridan, author of the satirical comedies *The Rivals* and *School for Scandal*.

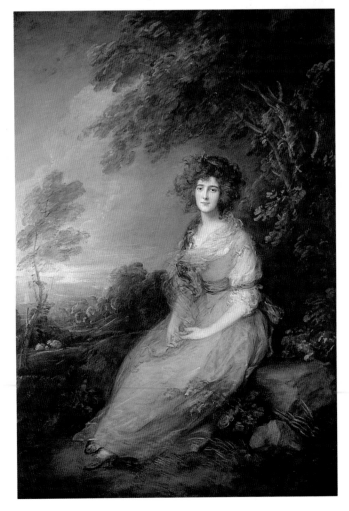

chandelier, and the wall designs are all characteristic of Rococo fussiness.

The device of the picture within the picture — over ·the fireplace — performs the same function as the stone statues in the Watteau and Fragonard discussed above. It depicts Cupid blowing the bagpipes, which, as in Brueghel's *Peasant Dance* (fig. **18.5**), signify lust. The dangers of phallic excess, which Hogarth satirizes, are underlined by locating Cupid among ruins. The "ruined" setting in which Cupid plays echoes the inevitable ruin of the couple's marriage. As in French Rococo, Hogarth calls on traditional figures from Classical antiquity for the purposes of playful, but telling, satirical warning. In contradistinction to French Rococo, however, Hogarth's pictures deal with identifiable social and professional classes. They lack the air of theatrical fantasy that pervades French examples of the style.

Rococo Architecture

Several divergent architectural trends can be identified in the eighteenth century, but the most original new style was Rococo. In architecture, as in painting, Rococo emerged from Late Baroque.

In northern Italy and central Europe, Baroque had been the preferred style for palaces and hunting lodges. Particularly in the countries along the Danube — Austria, Bohemia, and southern Germany — a distinct regional style developed, which was a blend of Italian Baroque and French Rococo. A leading exponent of this movement was the German architect Balthasar Neumann (1687–1753). Neumann created one of the most ornate Rococo buildings — the Residenz (fig. **20.5**), or Episcopal Palace, in Würzburg, Bavaria, in southwest Germany.

The Residenz, begun in 1719 and not finished until 1753, was an enormous edifice built for the hereditary prince-bishops of the Schönborn family. It was designed around a large entrance court, and the side wings had interior courtyards of their own. Although elements of the

Classical orders remain in the columns and pilasters on the façade of the Würzburg Residenz, the spaces once reserved for pediments are largely taken up by elaborate curvilinear designs.

The Kaisersaal, or Imperial Room, of the Residenz (fig. **20.6**) is a two-story octagonal chamber. Painted in white, gold, and pastel colors, it rises to a vaulted oval ceiling pierced by oval windows. The frescoes are by the Italian Rococo artist Giovanni Tiepolo (1696–1770). Engaged Corinthian columns with gilt capitals and bases and the entablature above them are made of **stucco**, or fine plaster, painted to resemble marble. The edges of the windows and other architectural features are traced with delicate **moldings** — like spun sugar decorating a wedding cake. The white surfaces of the vault are covered with ornamental designs. Most striking of all are the giant, illusionistic gilded curtains that are drawn apart by a pair of white Cupids to reveal the investiture of Bishop Harold. Other *trompe l'oeil* devices make the viewer wonder where the ceiling ends and exterior space begins. A dog, for example, sits on top of a column, and other figures appear to be half-in and half-out of the picture frame. Such playful illusions, combined with the ornate decorations, are characteristic of the painted spaces of Rococo architecture.

20.6 (opposite) Giovanni Battista Tiepolo, *The Investiture of Bishop Harold*, part of the ceiling frescoes of the Kaisersaal, Würzburg Residenz. 1751–2. Born and trained in Venice, by the 1730s Tiepolo had established himself throughout northern Italy as a master of monumental fresco decoration. He was known for his technical skill, command of perspective, and fondness for illusionistic architecture. He spent three years in Würzburg decorating the Residenz, and in 1762 he was invited to Spain by Charles II to work on the royal palace.

20.5 Balthasar Neumann, The Residenz, Würzburg, Germany. 1719–53.

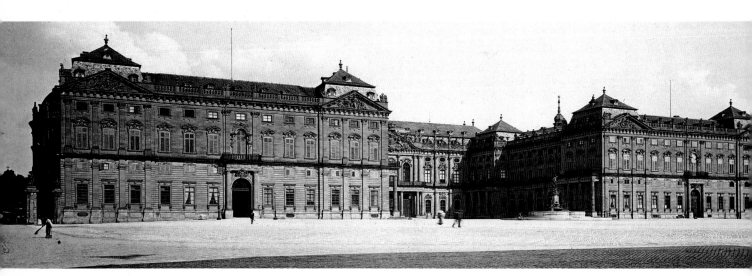

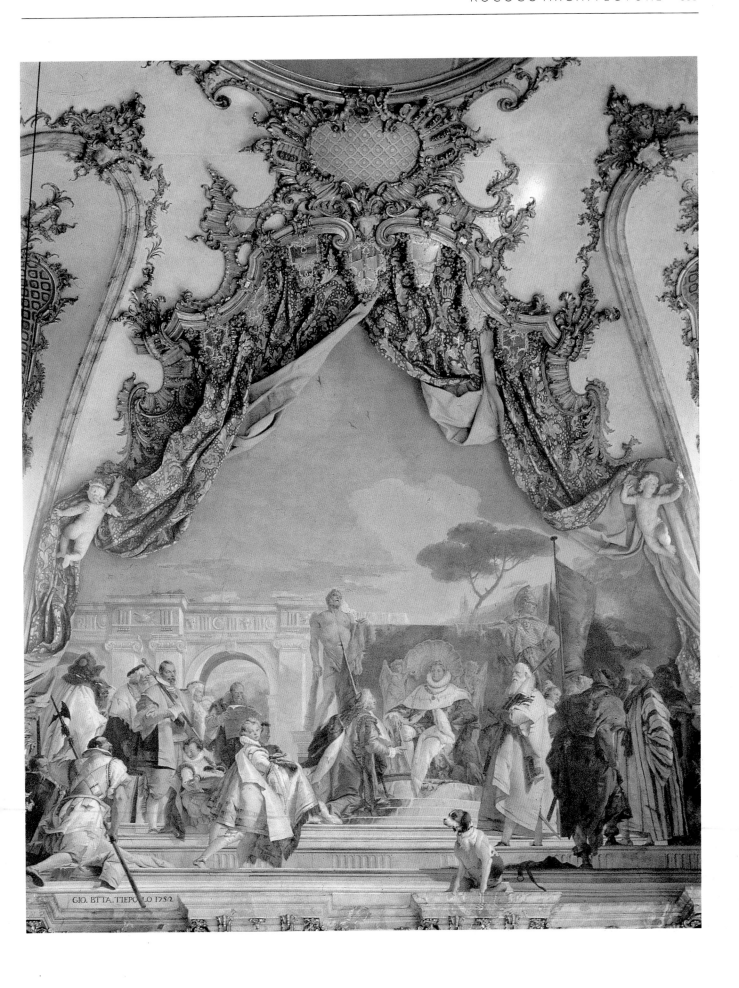

GIO. BTTA. TIEPOLO 1752

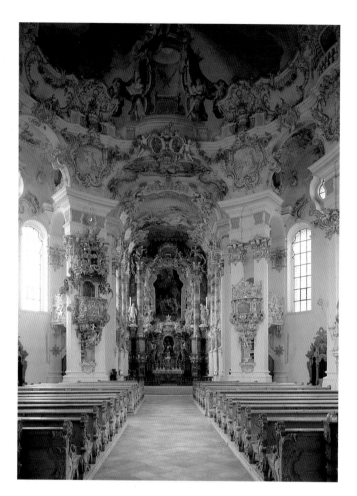

20.7 Dominikus Zimmermann, Wieskirche, Bavaria. 1745–54. The oval nave, built between 1745 and 1754, is a Rococo development of Borromini's oval church plans in Baroque Rome (see p.303). The Wieskirche's longitudinal axis is emphasized by the deep, oblong **chancel**. Eight freestanding pairs of columns with shadow edges (square corners or ridges that accentuate light and shadow) support the ceiling. The ambulatory, which continues the side aisles, lies outside the columns.

Rococo church architecture is well illustrated by Dominikus Zimmermann's Wieskirche, or "Church of the Meadow." The Wieskirche is a pilgrimage church, located in open country, as its name implies. It stands near Oberammergau in the foothills of the Bavarian Alps. Its exterior is relatively plain, but the interior (fig. **20.7**) is typical of German Rococo church interiors, which were designed to give visitors a sense of spiritual loftiness and a glimpse of Heaven. The nave is mainly white, and the decoration (including the elaborate pulpit on the left) is largely gold, though there are accents of pink throughout. As one approaches the chancel, the colors deepen. Gilt and brown predominate, but the columns flanking the altar are of pink marble, while the statues and other decorations are white. The decoration of the ceiling is entirely Rococo in that it unites the painted with the architectural surfaces through ornate illusionism.

Architectural Revivals

Palladian Style

In England, the Baroque style — especially Rococo, with all its frills — was rejected in favor of renewed interest in the ordered, classicizing appearance of Palladian architecture (see p.282). One of the most influential examples of this style is Chiswick House (fig. **20.8**) on the southwestern outskirts of London. Lord Burlington (1694–1753) began to build it in 1725 as a library and place of entertainment.

Burlington based Chiswick House loosely on Palladio's Villa Rotonda (fig. **17.9**), although it is on a smaller scale. Unlike the Villa Rotonda, Chiswick House did not need four porticos. Instead, it has one, which is approached by lateral double staircases on each side. The columns are Corinthian. There are no gable sculptures, and the dome is shallower than that of the Villa Rotonda. Despite such differences, however, the proportions and spirit of Chiswick are unmistakably Palladian.

Another leader of the Classical revival in England, particularly in the field of interior design, was Robert Adam (1728–92). Interest in Classical antiquity had been heightened by the excavations at Herculaneum and Pompeii. Discoveries on these sites provided the first concrete examples of imperial Roman domestic architecture. They had lain untouched since the volcanic eruption of Mount Vesuvius in A.D. 79. Publications on Classical archeology followed. Not only was Adam influenced by these, but he was himself an enthusiastic amateur archeologist. In a fireplace niche in the entrance hall of Osterley Park House near London (fig. **20.9**), which Adam began to remodel in 1761, he recreates the atmosphere of a Roman villa. Although there is still an element of Rococo delicacy, it is now in a much more austere setting, the principal characteristics of which are axial symmetry and geometrical regularity.

Gothic Revival

Contemporary with German Rococo architecture and the Palladian movement in England, a renewed interest in Gothic was under way. The revival of Gothic — which had never completely died out in England — began around 1750. It must be seen in relation to the late eighteenth-century Romantic movement, which is discussed in Chapter 22.

In its most general form, Romanticism involved the rejection of established beliefs, styles, and tastes — particularly the Classical ideals of clarity and perfection of form. It fostered the dominance of imagination over reason. The term comes from the highly-colored medieval literature, which became popular in the later eighteenth century, about heroes such as Charlemagne and King Arthur, or Classical themes such as the fall of Troy. These works — part fiction, part history — were called "romances," not because of their subject matter, but because they were

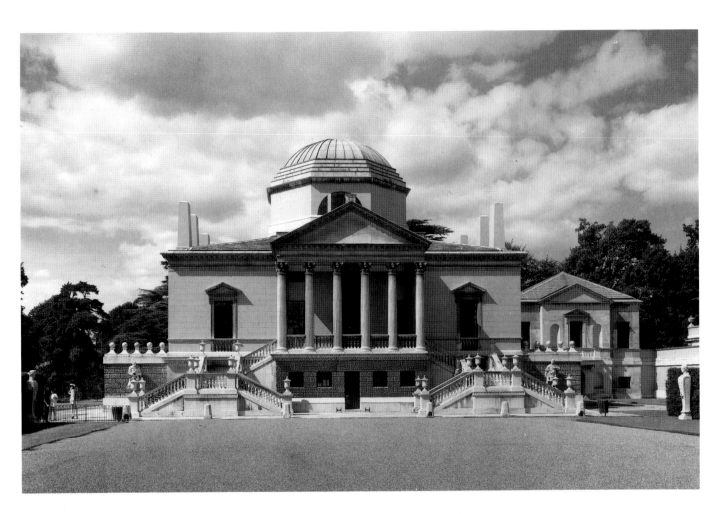

20.8 Richard Boyle (Earl of Burlington), Chiswick House, near London. Begun 1725. Lord Burlington was one of a powerful coterie of Whigs and supporters of the House of Hanover (George I and his family). As befitted his rank, he took a Grand Tour of Europe in 1714 to 1715 and returned to Italy in 1719 to revisit Palladio's buildings. On his return, he became an accomplished architect in the tradition of Palladio.

20.9 Robert Adam, Fireplace niche, Osterley Park House, Middlesex, England. Begun 1761. By courtesy of the Board of Trustees of the Victoria and Albert Museum, London. The ornamentation — including pilasters, entablature, moldings, relief over the fireplace, coffered semi-dome, and sculptures in the smaller niches — was all based on Classical precedent.

originally written in one of the Romance languages (French, Italian, Spanish). In the context of eighteenth-century architecture, Romanticism was a reaction against Neoclassical trends (see p.342), with their emphasis on order and symmetry. It involved the rediscovery of styles that had fallen into disuse or neglect.

One of the earliest manifestations of Romanticism in England was the use (starting in the 1740s) of imitation Gothic ruins and other medievally inspired objects in garden design. This was followed in 1749 by the more radical activity of Horace Walpole (1717–97), a prominent figure in politics and the arts. From 1747 Walpole and a group of friends spent over twenty-five years enlarging and "gothicizing" a small villa (fig. **20.10**) in Twickenham, just outside London. The result, renamed Strawberry Hill, was widely admired at the time. It is a large, sprawling structure that has none of the soaring grandeur of traditional Gothic buildings. Nevertheless, Strawberry Hill contains an interesting jumble of Gothic features, including battlements, buttresses, and tracery. There are turrets on the outside and vaulting in the interior. We have no reason to doubt the seriousness with which Walpole undertook the project, but it is difficult to resist the thought that the revived Gothic — or Gothick, as it was sometimes called — had a somewhat tongue-in-cheek quality.

20.10 Horace Walpole, Strawberry Hill, Twickenham, near London. 1749–77. Like his father, Sir Robert Walpole, a Whig prime minister of England, Horace Walpole also sat in Parliament as a Whig. His novel *The Castle of Otranto* started a fashion for Gothic tales of terror. Walpole's prolific correspondence is a valuable record of eighteenth-century manners and tastes, and, through it, he elevated letterwriting to an art form.

20.11 (opposite) Jean-Baptiste Siméon Chardin, *La Fontaine*. First exhibited 1733. Oil on canvas, 15 × 16½ in (38.1 × 41.9 cm). National Museum, Stockholm. Chardin's painterly attention to the character of inanimate objects gives them a life of their own. In this respect, he anticipates the nineteenth-century still lifes of artists such as Manet and Cézanne (see pp.382 and 397).

European Painting

Bourgeois Realism

The French Enlightenment encyclopedist Diderot praised Jean-Baptiste Chardin (1699–1779) as a realist painter. In contrast to the fashionable, aristocratic elegance of his Rococo contemporaries, Chardin painted down-to-earth genre scenes and still life.

Chardin's *La Fontaine* (fig. **20.11**) illustrates the artist's interest in household activities. Simple tasks are raised above the level of the ordinary by the conviction and intense concentration of the figures. Work, rather than play — as in Rococo — is Chardin's subject. In the very application of paint to canvas, Chardin conveys his own focus and intensity. The large copper vat in the center of *La Fontaine*, for example, is painted with thick, almost **impasto**, brushstrokes, to create the impression of a shiny metal surface. The wooden bucket, the tiled floor, and the draperies hanging at the left reflect Chardin's attention to the rustic textures of the kitchen. The woman herself, who carries out her chores with determination, is dressed in daily household attire, in contrast to the usual Rococo silks and lace. In the background, another woman talks to a little girl, as if to instill in her the "bourgeois" values of work. These figures gaze neither at one another nor at the observer. For Chardin, time is related realistically to work, whereas for the Rococo painters, time is spent in

20.13 (opposite) John Singleton Copley, *Paul Revere*. c. 1768–70. Oil on canvas, 35 × 28½ in (88.9 × 72.3 cm). Courtesy, Museum of Fine Arts, Boston (Gift of Joseph W., William B., and Edward H. R. Revere). Copley grew up in Boston, the son of Irish emigrants. He was trained by his stepfather, an engraver of **mezzotint** portraits, and then became a portrait painter.

20.14 (opposite, below) Benjamin West, *Death of General Wolfe*. c. 1770. Oil on canvas, 4 ft 11½ in x 7ft ¼ in (1.51 x 2.13 m). National Gallery of Canada, Ottawa (Gift of the Duke of Westminster, 1918). James Wolfe, the subject of this painting, was the young general who led the British troops to victory over a much larger French force in Quebec in 1759. His success obliged France to concede Canada to England. At the decisive moment of battle, Wolfe was wounded and died in the arms of his officers.

20.12 Angelica Kauffmann, *Pliny the Younger and his Mother at Misenum, A.D. 79.* 1785. The Art Museum, Princeton University (Museum Purchase, Gift of Franklin H. Kissner). Oil on canvas, 3 ft 4½ × 4 ft 2½ in (1.03 × 1.28 m). Kauffmann was a member of the Accademia di San Luca in Rome from 1765, but, as a woman, was excluded from figure drawing classes. In 1766 she went to England, where she helped found the Royal Academy of Art.

frivolity. Unlike the flirtatious character and fanciful settings of Rococo, Chardin's scenes extol the moral virtues of work and study in "realistic," everyday surroundings.

Neoclassicism

Angelica Kauffmann (1741–1807) was a child prodigy who became one of the most important and prolific Neoclassical painters. Her *Pliny the Younger and his Mother at Misenum, A.D. 79* (fig. **20.12**) illustrates the late eighteenth-century interest in Classical form and content. Figures in Classical dress observe the eruption of Mount Vesuvius from across the Bay of Naples. Pliny the Younger, who wrote a description of the eruption, sits with a scroll on his lap and his pen poised. He listens to an excited eyewitness, who gesticulates toward Pompeii. His mother turns away in fear, pulling her veil as if to shield her eyes. The architectural setting, with its round arch, triangular pediment, pilasters, and columns, conforms to the antique subject matter. Clarity, order, simplicity, and the elimination of Rococo frills characterize this return to Classical taste.

American Painting

Across the Atlantic, on the North American continent, artists of the late eighteenth century were inevitably influenced by European styles. A leading painter of the Colonial period was John Singleton Copley (1738–1815). He did not sympathize with the American Revolution, and in 1775 emigrated to England, where, under the influence of European Rococo, his work became more ornate.

Before his departure, Copley painted a portrait of *Paul Revere* (fig. **20.13**), which is typical of his earlier, more direct style. Despite the apparent simplicity of this picture, there are unmistakable elements of Baroque and Rococo. The figure looks directly out of the picture plane, inviting the viewer into its space, as many Baroque figures do. The way in which the illuminated figure is set against a dark background is also reminiscent of Baroque portraiture. Likewise, the attention to surface shine (for example, the silver teapot and highly polished tabletop with engraving tools) occurs frequently in both Baroque and Rococo. In contrast to those styles, however — and particularly to the latter — Copley's sitter wears a simple shirt and a plain vest. His solid, squarish bulk is emphasized, and the weight of his head is indicated by his stern expression and the thumb pushing up against his jaw.

Benjamin West (1738–1820), another important late eighteenth-century American artist, came from a Pennsylvania Quaker family, and began painting at the age of six. Like Copley, West settled in England, where he became known for his pictures of Classical and historical subjects.

In 1772 he was appointed historical painter to King George III. He was president of the Royal Academy from 1792 to 1805 and from 1807 to 1820. Many young American artists visiting London, including Copley, trained at his studio.

In his *Death of General Wolfe* (fig. **20.14**), West caused consternation among conservative elements by his choice of contemporary, rather than Classical, dress. King George III was not alone in feeling that modern dress was vulgar. It was considered that the figures should wear togas, so that the picture would convey a universal message. Despite this criticism, the work was enormously popular. Its appeal to the past, with a suggestion of nostalgia, became characteristic of nineteenth-century Romanticism. Although West rejected Classical costume, his training in the Classical tradition is clearly evident. The Indian in the foreground kneels in a pose that is found in scenes of death and mourning as early as ancient Greek art. But at the same time, the use of light and the melodramatic gestures are reminiscent of the Baroque style.

In eighteenth-century America as well as Europe, various trends in artistic style persisted alongside the Palladian movement, the Gothic revival, and the beginnings of Romantic and Realist developments. By the nineteenth century, Rococo was a style of the past. The Neoclassical, Romantic, and Realist movements would at various times emerge to dominate nineteenth-century taste.

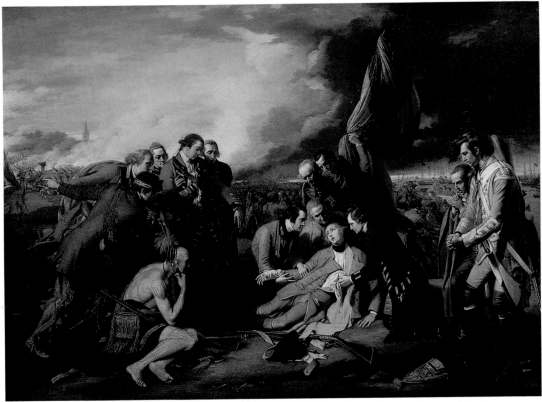

Neoclassicism: The Late Eighteenth and Early Nineteenth Centuries

During the late eighteenth and early nineteenth centuries in western Europe, several styles competed for primacy. Paris had become the undisputed center of the western art world, although Rome was still influential. Artistically, the "True Style," later called the Neoclassical style, was a reaction against the levity of Rococo. Although Neoclassicism originated under Louis XIV, it was later adopted by the leaders of the French Revolution. It became the style most closely associated with the revolutionary movements of the period.

Chronology of the French Revolution and the Reign of Napoleon

1789	The storming of the Bastille prison in Paris, followed by the Reign of Terror. Anyone associated with the *ancien régime* ("old regime") or the hereditary monarchy is killed.
1793	Louis XVI and his wife Marie-Antoinette are beheaded by the guillotine.
1795–9	The *Directoire* period, or Directory — rule by the middle class.
1799	Napoleon becomes first consul.
1803	The Napoleonic Law Code is issued.
1804	Napoleon is crowned emperor.
1806	Napoleon begins a building campaign in Paris with the intention of creating a new Rome. He takes Julius Caesar — who was also a consul before becoming dictator — as his model. Like Caesar, Napoleon adopts the eagle for his military emblem and the laurel wreath for his crown.
1812	Napoleon attacks Russia, but is forced to retreat.
1814	Napoleon abdicates. The monarchy is restored under Louis XVII.
1815	Napoleon is defeated in the Battle of Waterloo. The Congress of Vienna establishes the borders of European countries, which last until World War I (1914–18).
1821	Napoleon dies in exile.

The Neoclassical Style in France

The stylistic contrast between Rococo and Neoclassical can be illustrated by comparing two sculptures of a similar subject — an embrace — taken from different scenes in Classical mythology. The terra cotta *Intoxication of Wine* (fig. **21.1**) by Clodion (1738–1814) embodies the amorous frivolity of Rococo. The *Cupid and Psyche* (fig. **21.2**) of Antonio Canova (1757–1822), on the other hand, displays the sweeping grandeur and idealization of the Neoclassical style.

In the Clodion, a lusty satyr leans backward, drawing a nude bacchante toward him. She pours wine into his mouth while embracing him and straddling his thigh. The satyr's excitement is revealed by his raised right leg, which echoes the bacchante's left leg. The figures seem prevented from toppling over only by the satyr's hand resting on the rock. Their twisted poses animate the space and, together with the surface motion created by the satyr's rippling muscles, underline the orgiastic nature of the encounter.

Canova's *Cupid and Psyche* portrays an embrace of another kind. Its subject is the ill-fated romance between Cupid and Psyche (also the Greek word for "soul"). It is a tale that contains the seeds of tragedy, and so this sculpture rises above the frivolous anonymity of the Clodion. The Canova is more reminiscent of a classical ballet. Broad poses and gestures encompass a space beyond the embrace itself. Cupid leans over, his wings spreading out in an eloquent V-shape. Their formal upward motion suggests the rising of the soul and the lofty nature of true love. Psyche lies back — a pose that recalls the traditional reclining nude — and curves her arms about Cupid's head in a gesture that is at once open and closed. It is the lofty, tragic dimension of Canova's sculpture that allies it with the Neoclassical style, in contrast to the "satirical" Rococo revelry of Clodion.

Satyrs and Bacchantes

In Greek mythology, **satyrs** are woodland creatures, part man and part goat, that symbolize male lust. Satyr plays, in which satyrs made fun of human tragedies, were performed in Classical Greece and became the basis of satire in western literature. The *Bacchantes* were priestesses of Dionysus, the Greek god of wine. The term "bacchante" is related to the Roman wine god, Bacchus, and a "bacchanal" is an orgiastic, drunken party.

The tragic character of the myth of Cupid and Psyche is more suited to the Neoclassical esthetic. Their romance was fated to end if Psyche should see Cupid. Unable to restrain her curiosity, Psyche did look at her lover, and so lost him.

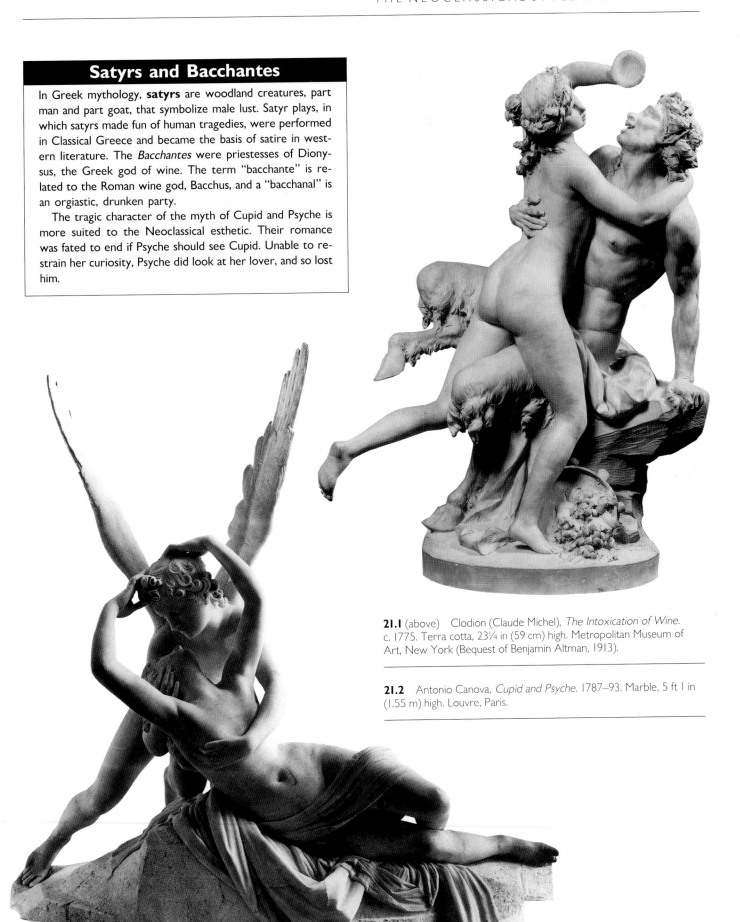

21.1 (above) Clodion (Claude Michel), *The Intoxication of Wine*. c. 1775. Terra cotta, 23¼ in (59 cm) high. Metropolitan Museum of Art, New York (Bequest of Benjamin Altman, 1913).

21.2 Antonio Canova, *Cupid and Psyche*. 1787–93. Marble, 5 ft 1 in (1.55 m) high. Louvre, Paris.

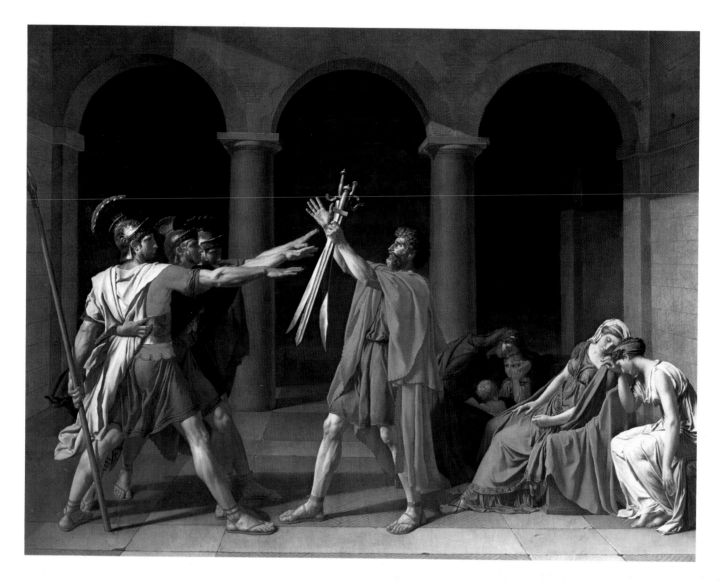

Art in the Service of the State

The political dimensions of the Neoclassical style derived from its associations with heroic subject matter, formal clarity, and its impression of stability and solidity. It also contained implicit references to Athenian democracy and the Roman Republic. In artistic terms, the Neoclassical style was a reaction against Rococo. However, the political preoccupations of the Neoclassical style arose directly from the questioning stance that had so strongly characterized the eighteenth century. Increasing popular resentment of the abuses of monarchy was a logical outcome of Enlightenment philosophy, which championed the rights of the individual within the state. After the French Revolution, Napoleon Bonaparte adopted the Neoclassical style to create and sustain his desired political image as general, consul, and finally emperor.

The leading Neoclassical painter, Jacques-Louis David (1748–1825), appealed to the republican sentiments that derived from ancient Rome. His *Oath of the Horatii* (fig. **21.3**), first exhibited in 1785, illustrates an event from

21.3 Jacques-Louis David, *The Oath of the Horatii*. 1784–5. Oil on canvas, c. 14 ft × 11 ft (4.27 × 3.35 m). Louvre, Paris. Although this event is not described in Classical sources, the story of the Horatii was known from a tragedy by Pierre Corneille, the seventeenth-century French dramatist. Rome and Alba Longa had agreed to settle their differences by "triple" combat between two sets of triplets — the Horatii of Rome and the Curiatii of Alba Longa — rather than by all-out war.

21.4 (opposite) Jacques-Louis David, *The Death of Marat*. 1793. Oil on canvas, c. 5 ft 3 in × 4 ft 1 in (1.6 × 1.25 m). Musées Royaux des Beaux-Arts de Belgique, Brussels. On 13 July 1793 Marat was stabbed in his bathtub by Charlotte Corday, a supporter of the conservative Girondin group. Inscribed on the crate supporting Marat's inkwell, pen, and papers is a combined personal and political message. David dedicates the painting "*A Marat, David*" ("To Marat, from David") and dates it "*L'An Deux*" ("The Year Two"), the second year of the French revolutionary calendar.

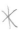

Roman history in which honor and self-sacrifice prevail. The figures wear Roman dress, and the scene takes place before three Roman arches resting on a form of Doric column. Framed by the center arch, Horatius Proclus raises his sons' three swords, on which they swear an oath of allegiance to Rome. Their gestures are vigorous, determined, and somewhat theatrical. The women and children, on the other hand, collapse on the right in a series of fluid, rhythmic curves, which reflect their more emotional nature. They include the sisters of the Horatii, one of whom is engaged to an enemy combatant and is overcome by her tragic destiny.

The clarity of David's style, and his use of ancient history and heroic content, made *The Oath of the Horatii* an exemplary image for a France on the verge of revolution. The painting was commissioned by Louis XVI as part of a program aimed at the moral improvement of France. Although the modern viewer tends to see it as a piece of overtly revolutionary propaganda, the ideals embodied in Neoclassical painting were in fact appealing to both the monarchical establishment and its republican opponents. The irony of the political subtext was apparently lost on Louis's minister for the arts, who approved the painting.

In the *Death of Marat* (fig. **21.4**), commissioned during the Reign of Terror, David used the principles of the Neoclassical style explicitly in the service of contemporary political events. Both David and Marat were members of the Jacobin movement, a group of revolutionary extremists. David was elected to the National Convention and voted to send Louis XVI to the guillotine. When Robespierre fell, David was imprisoned twice but regained favor under Napoleon. After Napoleon's exile, David left France and died in Brussels in 1825.

The painting, which is set in a clear cubic space, like the *Horatii*, depicts a recent, rather than a Classical, event. David has idealized Marat in Classical fashion, for his body was in fact ravaged by a skin disease. He found relief from this by soaking in the bath. At the same time, however, the stab wound is clearly visible, and the red bath water has stained the sheet. Marat has set a writing surface over the tub, and he holds the letter sent by his killer: "*Il suffit que je sois bien malheureuse pour avoir droit à votre bienveillance,*" meaning "I just have to be unhappy to merit your goodwill."

Marat was the victim of a deceitful woman, and David displays her deceit for all the world to see as political propaganda. Ironically, Charlotte Corday has dropped her knife on the floor beside the tub. It is contrasted with the quill pen still in Marat's limp hand. The instrument of violence and death is thus opposed to the pen, which is associated in this picture with revolutionary political writing. That Marat the revolutionary was stabbed by a member of a more conservative party enhances the tragic irony of David's picture.

Ingres: The Transition to Romanticism

The career of David's student, Jean-Auguste-Dominique Ingres (1780–1867), marks the end of the Neoclassical style and the beginning of the transition to Romanticism (see p.350). Ingres's work also retains traces of Mannerist elegance. His portrait of 1806 depicts Napoleon as a deified Roman emperor (fig. **21.5**) in all his imperial splendor. Napoleon exhibits the accoutrements of kingship and deity. His scepter and staff point heavenward, forming a large V. The grand, halo-like golden arc of the throne echoes the arc of his laurel wreath, and mirrors the curves of his collar, necklace, and ermine. Also denoting his imperial status are the eagles that adorn the columns forming the sides of his throne. The high degree of opulence reveals Ingres's taste for Mannerism, despite his training with David. Ingres's fondness for rich textures is expressed in the red velvet (red was the color of Roman emperors), ermine, and gold. Everywhere, the brushstrokes are submerged to enhance the illusion of texture. His smooth, highly finished surfaces were characteristic of Academic painting in contrast to those of the Romantic painters (see Chapter 22), who stressed the material quality of their media.

It was in his "Odalisques" that Ingres achieved the most

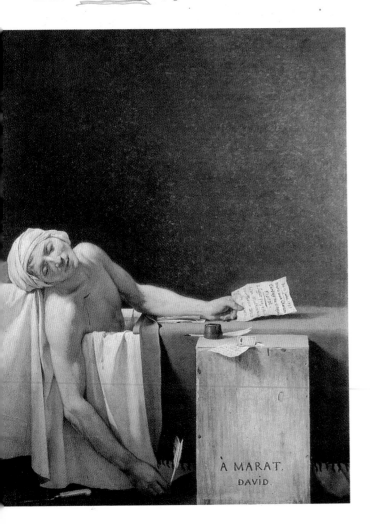

À MARAT.
DAVID.

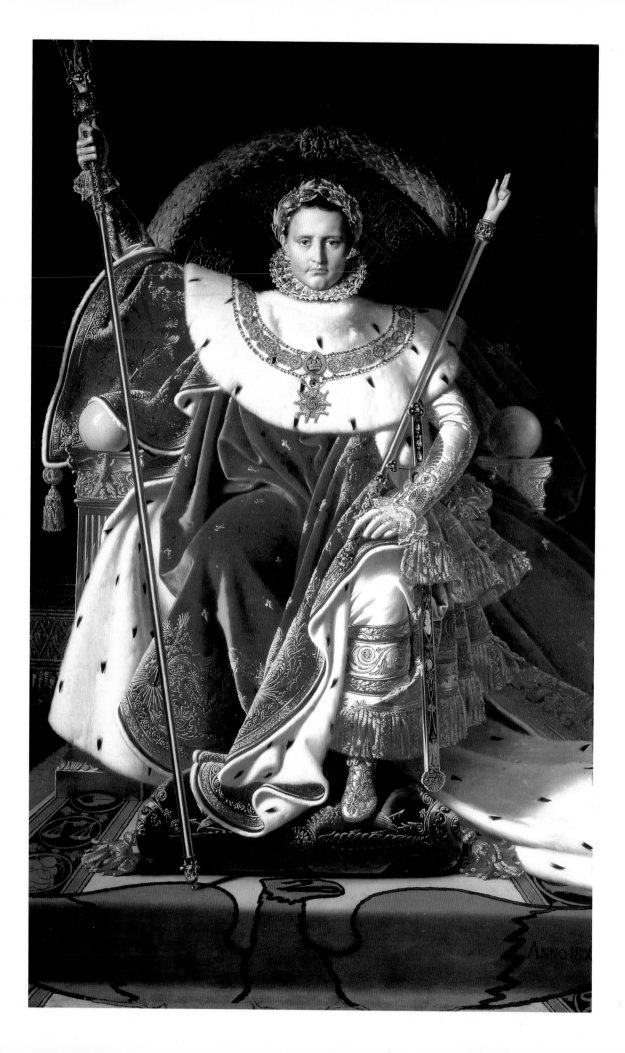

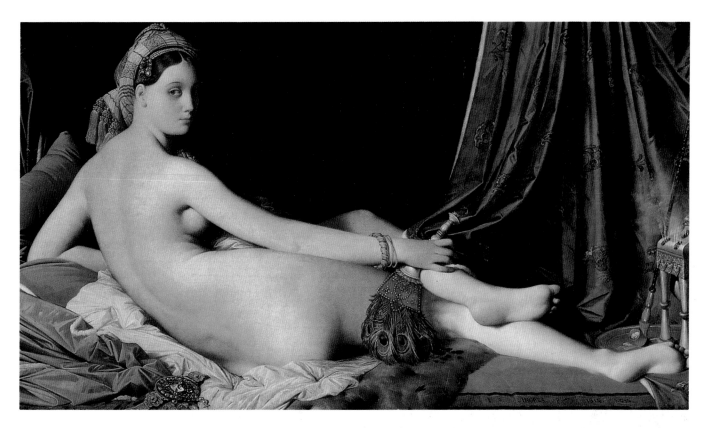

21.6 Jean-Auguste-Dominique Ingres, *Grande Odalisque*. 1814. Oil on canvas, c. 2 ft 11¼ in × 5 ft 4¾ in (0.89 × 1.65 m). Louvre, Paris.

21.5 (opposite) Jean-Auguste-Dominique Ingres, *Napoleon Enthroned*. 1806. Oil on canvas, 8 ft 8 in × 5 ft 5¼ in (2.59 × 1.66 m). © Musée de l'Armée, Paris. After being crowned emperor in 1804, Napoleon commissioned monuments throughout Paris intended to recreate the grandeur of ancient Rome. Among them, a huge Doric column in the Place Vendôme, inspired by Trajan's Column (fig. **9.21**), illustrated Napoleon's 1805 campaign in bronze relief. Napoleon also commissioned the Arc de Triomphe (Arch of Triumph), the largest arch ever built, which was modeled on Roman triumphal arches.

successful synthesis of Neoclassical clarity, rich, aristocratic textures, and a Romantic taste for the exotic. (An **odalisque** is a harem girl, from *oda*, a room in a Turkish harem.) Ingres's *Grande Odalisque* (fig. **21.6**), exhibited in 1814 (the year of Napoleon's abdication), is the best example. The idealized, reclining nude is seen from the back, as is Velázquez's *Rokeby Venus* (fig. **19.33**). But here the figure turns to gaze at the observer. In contrast to the painterly obscurity of the Velázquez, Ingres's nude has precise edges and a clear form. At the same time, however, the odalisque remains aloof and somewhat distant by comparison with the Baroque Venus. She is removed from everyday contemporary French experience by an exotic setting filled with illusionistic textures — the silk curtain and sheets, the peacock feathers of the fan, the fur bed covering, the headdress, and the hookah (a Turkish pipe in which the smoke is cooled by passing through water). The *Grande Odalisque* well illustrates Ingres's love of line, and his academic motto that "drawing is probity." Nevertheless, he, more than the purely Neoclassical David, was also attracted to the sensual, coloristic aspects of painting.

Developments in America

Events and taste in late eighteenth- and early nineteenth-century Europe were paralleled by developments in America. The American Revolution preceded the French Revolution by only a few years. As in France, the intent of the American Revolution was liberation from monarchy. But the additional factor of throwing off the yoke of a foreign ruler made the revolution in America somewhat different from its French counterpart. Once liberated from the English throne, then occupied by King George III, America finally abandoned monarchy completely. The system designed by Thomas Jefferson and the framers of the Constitution resulted in a smoother transition of power than in France and a more stable form of government.

In America the revolution signified a political break with its colonial origins. It also marked a departure from the dominant pre-revolutionary style of architecture. This was the so-called "Colonial Georgian" style, named after the English king. Just as republican Rome had been the political model to which the newly independent colonies aspired, so Roman architecture was more closely imitated in the early years of American independence. Since this period (c. 1780–1810) coincided with the establishment of many United States government institutions, the style is referred to as the Federal Style.

The Architecture of Jefferson

No single American embodied the principles of Neoclassicism more than Thomas Jefferson (1743–1826). Jefferson was a native of Virginia, which was then the wealthiest and most populous of the states. Jefferson's views on contemporary architecture reflect his Classical education and

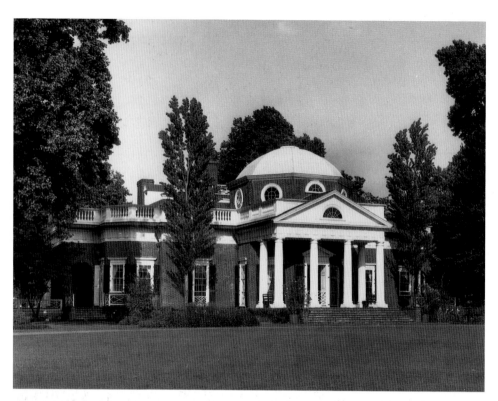

21.7 (left) Thomas Jefferson, Monticello, Charlottesville, Virginia. 1768–84 (rebuilt 1796–1809). Jefferson was a member of the Continental Congresses of 1775–6 and was principally responsible for drafting the Declaration of Independence. He was governor of Virginia 1779–81, U.S. minister in France 1785–9, secretary of state under George Washington 1789–93, vice-president 1796–1801, and president 1801–9.

21.8 (below) Thomas Jefferson, Rotunda of the University of Virginia, Charlottesville. 1817–26. The University of Virginia was built between 1817 and 1825. Jefferson was its first rector and described himself on his tombstone as "Father of the University." Both the curriculum and the architectural conception were a tribute to Jeffersonian humanist principles. In the quality of its individual parts and the harmony of the whole environment, Jefferson's "academical village," as he called it, is a masterpiece of the Federal Style.

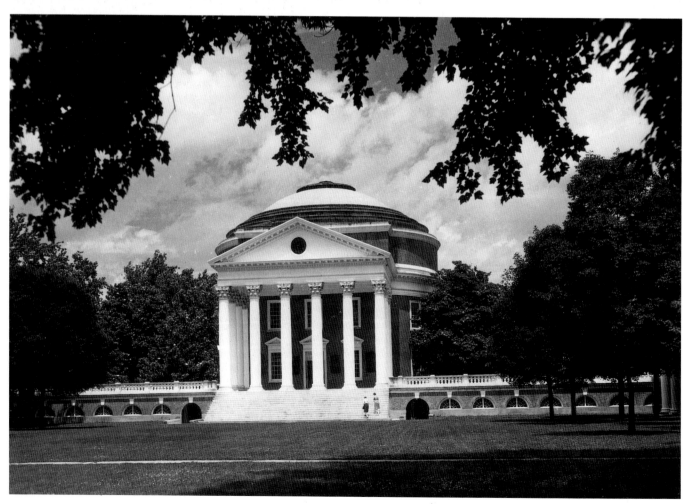

humanist outlook. His own home, Monticello (Italian for "Little Mountain"), set on a hilltop outside Charlottesville, Virginia (fig. **21.7**), is a good example of his classicizing style. He built Monticello in two distinct stages over a fifty-year period, from 1789 to 1823. The final result was a building that seemed to have only one, high-ceilinged floor. In fact, however, the entablature and balustrade conceal a **mezzanine** and an attic floor, both containing bedrooms. The house itself is connected to two small pavilions, whose symmetry reflects the influence of Palladio. The dome and the east portico, which is colonnaded in the Doric order, indicate Jefferson's absorption of Classical antiquity.

The pride and joy of Jefferson's later years was the University of Virginia, the first state-supported educational establishment, located just a few miles from Monticello. Its centerpiece is the Rotunda (fig. **21.8**), which was the original university library. Although its proportions are somewhat taller, its inspiration is clearly the Pantheon in Rome (fig. **9.15**). Among the purely Jeffersonian features are an entablature encircling the building and two layers of windows (pedimented on the ground floor, plain on the second).

On either side of the Rotunda, and framing the central lawn, are two symmetrical rows of low, colonnaded buildings, which were (and still are) student quarters. These link a series of pavilions, built in the form of Roman temples. Each pavilion faithfully reproduces an architectural order according to a Classical prototype. The pavilions also housed the academic departments, with classrooms on the ground floor and living quarters for the professors on the upper floor.

Shortly after the University of Virginia was completed, the U.S. Congress decided to erect a statue to commemorate George Washington in a grand manner. In 1832 the commission was given to Horatio Greenough (1805–52), an American sculptor living in Italy. The colossal marble sculpture that he produced (fig. **21.9**) was inspired by Phidias's Early Classical sculpture of Zeus in the

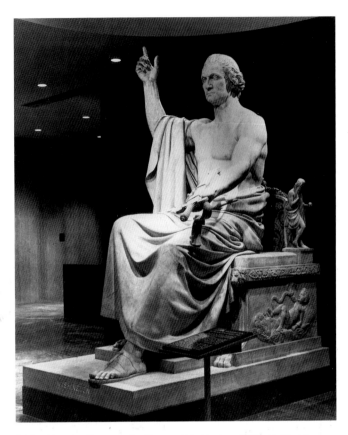

21.9 Horatio Greenough, *George Washington*. 1832–41. Marble, 11 ft 4 in × 8 ft 6 in × 6 ft 10 in (3.45 × 2.59 × 2.1 m). National Museum of American Art, Smithsonian Institution, Washington. Greenough was America's first professional sculptor. Although installed originally in the Capitol rotunda in Washington, D.C., the statue was too heavy for its site and was moved to the Smithsonian Institution.

temple at Olympia. Though now lost, the Olympian work had been one of the Seven Wonders of the ancient world. Nude from the waist up, Greenough's Washington points upward in the manner of Raphael's Plato (fig. **16.24**). The left hand, extending forward and holding a sword, repeats the movement of the left leg. Washington is represented as a man of action, a political philosopher, and ruler. A frontal pose and imposing presence, combined with a lion throne, create the impression of a powerful leader. Unfortunately, the statue did not reach America until 1841, by which time tastes had changed. The Neoclassical style was no longer in fashion, and the statue was criticized for its partial nudity.

In the United States, as in western Europe, the purity of Neoclassicism gave way to Romanticism. In its own way, the Romantic movement, like the Neoclassical, would have political, cultural, and literary significance, much of which is reflected in the visual arts.

Romanticism: The Late Eighteenth and Early Nineteenth Centuries

The Romantic movement, like Neoclassicism, encompassed both western Europe and the United States. The term "Romantic" is derived from the Romance languages (French, Italian, Spanish, and Portuguese), and more particularly from the medieval tales of chivalry and adventure written in those languages, such as the *Chanson de Roland* (Song of Roland). Romantic literature shares with the so-called "Gothic" novels and poems by English writers of the late eighteenth and early nineteenth centuries a yearning for the past, which contributes to its haunting, nostalgic character. The Romantic esthetic of "long ago" and "far away" is conveyed in works with locales and settings that indicate the passage of time (for example, ruined buildings or dilapidated sculptures). To the extent that Neoclassicism expresses a nostalgia for the Classical past, it too may be said to have "Romantic" quality.

Romanticism was not only an artistic style. It was a movement with a relatively wide range of subject matter, which offered more thematic possibilities than Neoclassicism. The origins of Romanticism are found in the eighteenth century, especially in the work of the French philosopher Jean-Jacques Rousseau. In contrast to the Neoclassical virtues of order and clarity, the Romantics believed in emotional expression and sentiment. And instead of encouraging heroism on behalf of an abstract ideal, in the Neoclassical manner, the Romantics were often partisan supporters of contemporary causes, such as the individual's struggle against the state.

In addition to their nostalgia for the past and willingness to become active participants in current events, the Romantics developed an interest in the mind as the site of mysterious, unexplained, and possibly dangerous phenomena. For the first time in western art, dreams and nightmares were depicted as internal events, with their source in the individual, rather than as external, supernatural happenings. States of mind, including insanity, began to interest artists, whose studies anticipated Freud's theories of psychoanalysis at the end of the nineteenth century and the development of modern psychology.

Rousseau and the Return to Nature

Jean-Jacques Rousseau (1712–78) was the leading eighteenth-century French philosopher. His writings inspired the French Revolution, and also provided the philosophical underpinning of the Romantic movement. The artists and writers who subscribed to Rousseau's views are known as the "Romantics." Rousseau advocated a "return to nature." He believed in the concept of the "noble savage" — that humanity was born to live harmoniously with nature, free from vice, but had been corrupted by civilization and progress. Such ideas led to the political belief that the people themselves should rule. In his fiction, Rousseau created elaborate descriptions of natural beauty which were consistent with the Romantic esthetic.

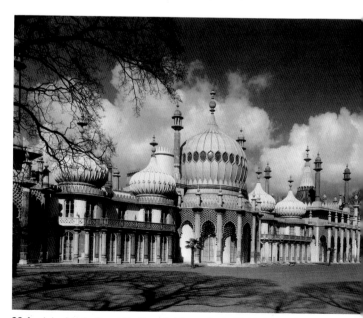

22.1 John Nash, Royal Pavilion, Brighton, England, 1815–18.

Romanticism in Music and Poetry

The various strains of Romanticism that are evident in the visual arts are also found in nineteenth-century music and poetry. In romantic music, the expression of mood and feeling takes precedence over form and structure. Its antithesis is classical music, in which classical form and proportion predominate over emotional expression.

Romantic music was often based on literary themes, and literary or geographical references evoked various moods. Hector Berlioz's overtures, for example, are based on Sir Walter Scott's historical novels, which are set in the Middle Ages. Felix Mendelssohn's "Italian" and "Scottish" Symphonies are based on the composer's travels in Italy and Scotland. The Polish mazurkas of Frédéric Chopin and Hungarian rhapsodies of Franz Liszt reflect the strong nationalistic strains of Romanticism. In opera, the emotional and nationalistic intensity of the Romantic movement found its fullest expression in the works of Richard Wagner.

In English poetry, the leaders of Romanticism were William Wordsworth (1770–1850) and Samuel Taylor Coleridge (1772–1834). In 1798 they jointly published a collection of poems, *Lyrical Ballads*, the introduction to which served as a manifesto for the English Romantics.

Wordsworth's *The Solitary Reaper* conveys a sense of the melancholy oneness of humanity with an all-encompassing nature. The reaper is alone in a vast expanse of land when seen by the poet:

> Behold her, single in the field,
> Yon solitary Highland Lass!
> Reaping and singing by herself;
> Stop here, or gently pass!
> Alone she cuts and binds the grain,
> And sings a melancholy strain;
> O listen! for the Vale profound
> Is overflowing with the sound. (stanza I)

Other English poets of the Romantic Movement included Lord Byron (1788–1824), Percy Bysshe Shelley (1792–1822), and John Keats (1795–1821). Byron's nostalgic yearning for ancient Greece is evident in much of his poetry:

> The isles of Greece, the isles of Greece!
> Where burning Sappho loved and sung,
> Where grew the arts of war and peace,
> Where Delos rose, and Phoebus sprung!
> Eternal summer gilds them yet,
> But all, except their sun, is set. (*Don Juan* III, lxxxvi)

Shelley's *Ozymandias* evokes the attraction of exotic locales and explores our ability to communicate with the past through time-worn artifacts:

> I met a traveler from an antique land
> Who said: "Two vast and trunkless legs of stone
> Stand in the desert. . . . "
> And on the pedestal these words appear:
> "My name is Ozymandias, king of kings:
> Look on my works, ye Mighty, and despair!"
> Nothing beside remains. Round the decay
> Of that colossal wreck, boundless and bare
> The lone and level sands stretch far away.

In 1819 Shelley visited the Uffizi Gallery in Florence, where he saw a painting of Medusa's head, then attributed to Leonardo. The head lies on the ground, crawling with lizards, insects, and snakes. Shelley's poem expresses the Romantic taste for the macabre, the appeal of death, and the theme of the aloof, unattainable woman:

> It lieth, gazing on the midnight sky,
> Upon the cloudy mountain-peak supine;
> Below, far lands are seen tremblingly;
> Its horror and its beauty are divine.
> (*On the Medusa of Leonardo da Vinci in the Florentine Gallery*, lines 1–4)

The aloof and unattainable woman, seen by the Romantics as cold and deathlike but nevertheless fascinating, is celebrated with a medieval flavor in Keats's *La Belle Dame sans Merci*:

> I saw pale kings and princes too,
> Pale warriors, death-pale were they all;
> They cried — "La Belle Dame sans Merci
> Hath thee in thrall!" (lines 38–41)

Romantic Trends in Architecture

In architecture, the Romantic movement was marked by revivals of historical styles. The Gothic revival had begun in the late eighteenth century, with such buildings as Horace Walpole's Strawberry Hill (fig. 20.10) evoking a spiritual past. Likewise, the Neoclassicism of Jefferson was really a revival of ancient Greek and Roman forms, which were ideologically appropriate for a newly founded democracy.

The Romantic vision of the orient as a distant, exotic locale also became a source for nineteenth-century developments in architecture. John Nash's Royal Pavilion (fig. 22.1) in Brighton, a fashionable English seaside resort, is constructed in the Indian Gothic style. A mixture of minarets and onion domes, borrowed from Islamic architecture, cover a cast-iron framework. The Royal Pavilion echoes the eastern forms that attracted Coleridge. His *Kubla Khan*, for example, incorporated the exotic sounds of faraway places, and suggested the typically Romantic taste for endless time and infinite spaces:

> In Xanadu did Kubla Khan
> A stately pleasure-dome decree;
> Where Alph, the sacred river, ran
> Through caverns measureless to man
> Down to a sunless sea. (lines 1–5)

Romantic Painting

Blake

There was a strong Christian strain in Romanticism. This was associated with the longing for a form of religious mysticism, which, from the Reformation (see p.276) onward, had been on the wane in western Europe. This can be seen in the work of the visionary English artist and poet William Blake (1757–1827). Though trained in the Neoclassical style, he was more of a Romantic by temperament.

From 1793 to 1796 Blake illuminated a group of so-called *Prophetic Books* dealing with visionary biblical themes. His watercolor and gouache design of *God Creating the Universe* (fig. 22.2), also called the *Ancient of Days*, shows God organizing the world with a compass (see the related image in fig. 1.3). Blake's nostalgic combination of medieval iconography and a Michelangelo-style God with a revival of mysticism is characteristic of the Romantic movement. His yearning for a past (and largely imaginary) form of Christianity appears in his poems as well as in his pictures. It is exemplified by the opening lines of his *Jerusalem*:

> And did those feet in ancient time
>> Walk upon England's mountains green?
> And was the holy Lamb of God
>> On England's pleasant pastures seen?

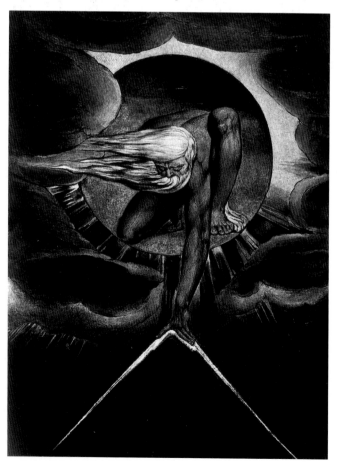

Géricault

Théodore Géricault (1791–1824) died at the age of only thirty-three, but his work was crucial to the development of Romantic painting, especially in France. His paintings reveal an interest in human psychology and a sense of revolt against political and social injustice which are typical of certain nineteenth-century trends. In the *Mad Woman* (fig. 22.3), for example, the figure hunches forward and stares suspiciously off to the left, as if aware of some potential menace. The raising of one eyebrow and the lowering of the other, combined with the slight shift in the planes of her face, indicate the wariness of paranoia.

Géricault's loose brushstrokes create the textures of the woman's face, which is accentuated by light and framed by the ruffle of her cap. Through the conscious organization of light, color, and the visibility of his brushwork, Géricault unifies the composition both formally and psychologically. The sweeping, light brown curve below the collar echoes the more tightly drawn curve of the mouth. Reds around the eyes and mouth are repeated in the collar, and the white of the cap ruffle recurs in the small triangle of the madwoman's white undergarment. The untied cap laces and the few disheveled strands of

Watercolor

In **watercolor**, powdered pigments are mixed with water, often with gum arabic used as a binder and **drying agent**. Watercolor is transparent, and so one color overlaid on another can create a **wash** effect. The most common **ground** for watercolor is paper. Because the medium is transparent, the natural color of the paper also contributes to the image.

Watercolor had been known in China as early as the third century A.D., but was only occasionally used in Europe before the late eighteenth and early nineteenth centuries. At that point it became popular, particularly with English artists such as Constable and Turner, for landscape paintings on a small scale. In the second half of the nineteenth century, watercolor became popular among American artists. It was favored by those who preferred to paint directly from nature rather than in a studio, and needed a more portable, quickly drying medium.

Gouache is a watercolor paint which, when dry, becomes opaque. It is commonly used on its own or in combination with transparent watercolor.

22.2 William Blake, *God Creating the Universe* (*Ancient of Days*), frontispiece of *Europe: A Prophecy*. 1794. Metal relief etching, hand-colored with watercolor and gouache, 12¼ × 9½ in (31.1 × 24.1 cm). Whitworth Art Gallery, University of Manchester. Blake was an engraver, painter, and poet, whose work was little known until about a century after his death. In this image Blake's God is almost entirely enclosed in a circle. The light extending from each side of his hand forms the arms of a compass. The precision of the circle and triangle contrasts with the looser painting of clouds and light, and the frenetic quality of God's long, white hair, blown sideways by an unseen wind.

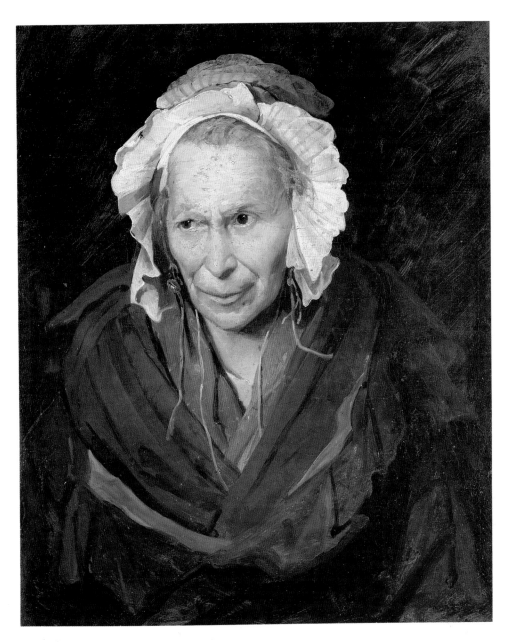

22.3 Théodore Géricault, *Mad Woman with a Mania of Envy*. 1822–3. Oil on canvas, 28⅜ × 22⅘ in (72 × 58 cm). Musée des Beaux-Arts, Lyons. Géricault was an avid rider, and his death in 1824 was due to a fall from his horse. He was a man of paradoxes — a fashionable society figure, but a political and social liberal, who was active in exposing injustice. In 1822 to 1823 he did a series of paintings of the insane which captured the nature of their conditions through pose and physiognomy. The subject of this portrait was a child-murderess. This picture is also known as *L'Hyène de la Salpêtrière*. La Salpêtrière was a mental hospital in Paris where Freud studied under the celebrated neuropathologist Jean-Martin Charcot and learned that hypnosis could temporarily relieve the symptoms of hysteria.

hair are a subtle metaphor for the woman's emotional state, as if she were "coming apart" and "unraveling" physically as well as mentally.

Géricault's commitment to social justice is reflected in his acknowledged masterpiece, *The Raft of the "Medusa"* (fig. **22.4**). He began the work in 1818, and it was exhibited at the Salon the following year. This picture commemorates a contemporary disaster at sea, rather than a heroic example of Neoclassical patriotism. On 2 July 1816 the French frigate *Medusa* hit a reef off the west coast of Africa. The captain and senior officers boarded six lifeboats, saving themselves and some of the passengers. The 149 remaining passengers and crew were crammed onto a wooden raft, which the captain cut loose from a lifeboat. During the thirteen-day voyage that followed, the raft became a floating hell of death, disease, mutiny, starvation, and cannibalism. Only fifteen people survived.

The episode became a national scandal when it was dis-

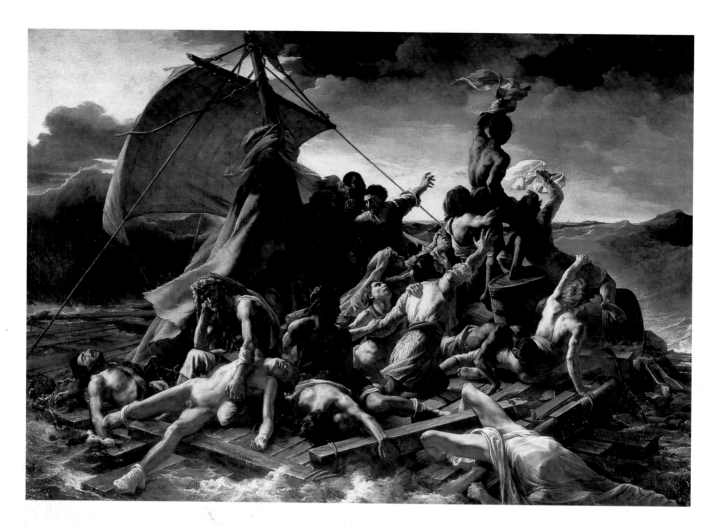

22.4 Théodore Géricault, *The Raft of the "Medusa."* 1819. Oil on canvas, 16 ft x 23 ft 6 in (4.88 x 7.16 m). Louvre, Paris.
The mood of this painting is evoked by lines from *The Rime of the Ancient Mariner* by Coleridge, the English Romantic poet: "I looked upon the rotting deck and there the dead men lay." To ensure authenticity, Géricault spoke with survivors and did many studies before executing the final painting, including drawings of the dead and dying in morgues and hospitals.

covered that the ship's captain owed his appointment to monarchist sympathies rather than to merit. Furthermore, the French government had tried to cover up the worst of the incident. It was not until the ship's surgeon, one of the survivors from the raft, published his account of the disaster that the full details of the tragedy became known. Géricault took up the cause of the individual against social oppression and translated it into a struggle of humanity against the elements.

The writhing forms, which are reminiscent of Michelangelo's Sistine Chapel figures (see p.266), echo the turbulence of sea and sky. In the foreground a father mourns his dead son. Other corpses hang over the edge of the raft, while in the background, to the right, frantic survivors wave hopefully at a distant ship. The raft itself tilts upward on the swell of a wave, and the sail billows in the wind. As a result, the viewer looks down on the raft, directly confronting the corpses. The gaze gradually moves upward, following the diagonals of the central figures, and finally reaches the waving drapery of the man standing upright. In this painting Géricault incorporates the Romantic taste for adventure and individual freedom into a real event, in which people are the victims of injustice and have to fight the primal forces of nature to survive.

Delacroix

The mainstay of French Romantic painting during his lifetime was Eugène Delacroix (1798–1863), a younger compatriot of Géricault. Delacroix was rumored to be the illegitimate son of the French statesman Charles Talleyrand (whom he resembled physically), but was brought up in the family of a French government official. His celebrated *Journal*, which reveals his talent for writing, is a useful source of information on his life, art, and philosophy.

In his art, Delacroix stood for color, just as Ingres (see p.345), his contemporary and rival, championed line. Delacroix's paintings are characterized by broad sweeps of color, lively patterns, and energetic figure groups. His thick brushstrokes, like Géricault's, contribute to the

The Salon

The **Salon** refers to the official art exhibitions sponsored by the French authorities. The term is derived from the Salon d'Apollon in the Louvre Palace. It was here, in 1667, that Louis XIV sponsored an exhibition of works by members of the Académie Royale de Peinture et de Sculpture (Royal Academy of Painting and Sculpture). From 1737 the Salon was an annual event, and in 1748 selection by jury was introduced. Throughout the eighteenth century, the Salons were the only important exhibitions at which works of art could be shown. This made acceptance by the Salon jury crucial to an artist's career.

During the eighteenth century the influence of the Salon was largely beneficial and progressive. By the nineteenth century, however, despite the fact that during the Revolution the Salon was officially opened to all French artists, it was in effect controlled by Academicians whose conservative taste resisted innovation of any sort.

character of the image as well as to the actual surface of the canvas. They are in direct contrast to the precise edges and smooth surfaces of Neoclassical painting.

In his mature work of 1830, *Liberty Leading the People* (fig. **22.5**), Delacroix applies Romantic principles to the revolutionary ideal. Delacroix "romanticizes" the uprising by implying that the populace has spontaneously taken up arms, united in yearning for liberty. The figures emerge from a haze of smoke — a symbol of France's political emergence from the shackles of tyranny to enlightened republicanism. Visible in the distance is the Paris skyline with the towers of Notre Dame Cathedral. From here the rebels will fly the tricolor, the red, white, and blue French flag.

22.5 Eugène Delacroix, *Liberty Leading the People.* 1830. Oil on canvas, 8 ft 6 in x 10 ft 7 in (2.59 x 3.23 m). Louvre, Paris.
This painting refers to the July 1830 uprising against the Bourbon King Charles X, which led to his abdication. Louis-Philippe, the Citizen King, was installed in his place, though his powers were strictly limited.

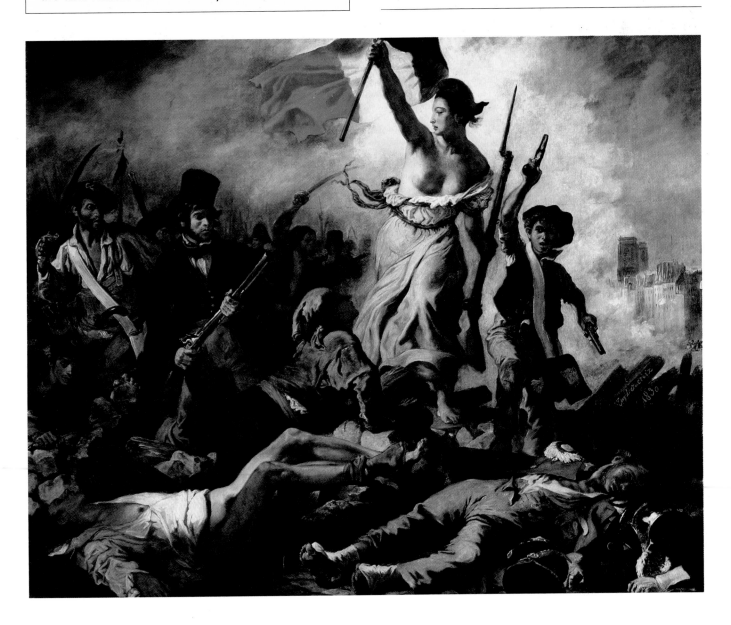

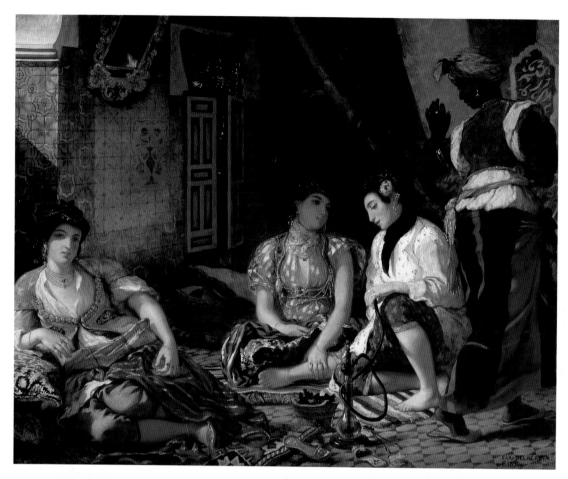

22.6 Eugène Delacroix, *Women of Algiers*, 1834. Oil on canvas, 5 ft 10⅞ in x 7 ft 6⅛ in (1.8 x 2.29 m). Louvre, Paris. After a visit to a harem, Delacroix became fascinated by the lively patterns of Moorish costume and interior decor. Here he combines the relaxed, langorous poses of the harem women with the formal motion of surface design. Throughout the picture plane, the arabesques of Islamic lettering are · reflected in pose and gesture, as well as in the designs themselves.

Delacroix's rebels confront the viewer directly. As in *The Raft of the "Medusa,"* Delacroix's corpses lie in contorted poses in the foreground. The diagonal of the kneeling boy leads upward to Liberty, whose raised hand, holding the flag aloft, forms the apex of a pyramidal composition. Her Greek profile and bare breasts recall ancient statuary, while her towering form, as well as her costume, confirms her allegorical role. By incorporating antiquity into his figure of Liberty, Delacroix makes a nostalgic, "romantic" appeal to Roman republican sentiment. Among Liberty's followers are representatives of different social classes, who are united by their common cause. In their determined march forward, they trample the corpses beneath them. They are willing to die themselves, secure in the knowledge that others will arise to take their place.

A colorist in the tradition of Rubens, Delacroix integrates color with the painting's message. In an image that is primarily composed of brown tones and blacks, the colors that appear most vividly on the flag itself are repeated with more or less intensity throughout the picture plane. Whites are the most freely distributed. In the sky, reds and blues are muted. Denser blues are repeated in the blue stocking of the fallen man on the left and the shirt of the kneeling boy. His scarf and belt, like the small ribbon of the corpse on the right, are accents of red. In echoing the colors of the flag, which is at once a symbol of Liberty and of French republicanism, Delacroix paints a political manifesto.

In 1832 Delacroix traveled to North Africa. The exotic character of the area appealed to his Romantic taste. Although he continued to paint scenes of violence, including battles and animal hunts, he was also attracted by more tranquil scenes. A comparison of the *Women of Algiers* (fig. **22.6**) of 1834 with Ingres's *Grande Odalisque* (fig. **21.6**) highlights Delacroix's rejection of the precise edges and smooth surface texture of Neoclassicism. His figures are redolent of the exotic, perfumed, and drugged harem atmosphere, whereas Ingres's odalisque is alert and clear. In contrast to the three seated harem girls, the Moorish woman on the right of the Delacroix seems in full possession of her faculties. She turns in a dancelike motion, as if something has caught her attention. The figure on the far left leaning against a large pillow is an exotic, Moorish version of the traditional reclining nude. It is quite at odds with the pictorial principles of Ingres's odalisque.

Goya

The leading Spanish painter of the late eighteenth and early nineteenth century, Francisco de Goya (1746–1828), was attracted by several Romantic themes. His compelling images reflect his remarkable psychological insights. Many also display his support for the causes of intellectual and political freedom. In 1799 Goya published *Los Caprichos* (The Caprices), a series of etchings combined with the new medium of aquatint. In this series, he depicts internal, psychological phenomena, often combining them with an educational or social message.

In *Los Caprichos, Plate 3* (fig. **22.7**), for example, the title of which can be translated as *The Bogeyman is Coming*, Goya illustrates the night-time fears of childhood. The mother's gaze is riveted on the unseen face of the Bogeyman, while her children cringe in fear. The terrified faces of the children, contrasted with the anonymity of the apparition, accentuate the uncanny character of the

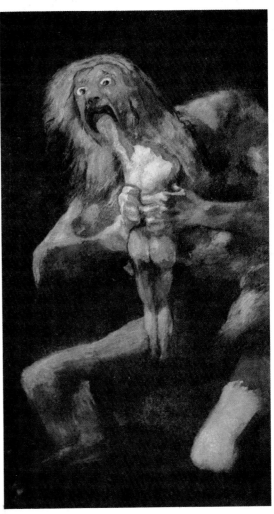

22.8 Francisco de Goya y Lucientes, *Chronos Devouring one of his Children*. c. 1820–2. Wall painting in oil detached on canvas, 4 ft 9⅞ in x 2 ft 8⅝ in (1.47 x 0.83 m). Prado, Madrid. According to Greek myth, Chronos devoured his children to thwart the prophecy that they would overthrow him. But the children were gods and therefore immortal. They survived to fulfill their destiny, and became the twelve Olympians. Goya's Chronos, on the other hand, destroys the child, crushing its torso like a flimsy doll and tearing away its arms and head. His savagery is accented by the red highlight outlining the upper torso and flowing across his hands.

Aquatint

Although etching (see p.321) was not new to the nineteenth century, its use in combination with **aquatint** was. In aquatint, the artist covers the spaces between etched lines with a layer of **rosin** (a form of powdered resin). This partially protects against the effects of the acid bath. Since the rosin is porous, the acid can penetrate to the metal, but the artist controls the acid's effect on the plate by treating the plate with varnish. This technique expands the range of grainy tones in finished prints. Aquatint thus combines the principles of engraving with the effects of a watercolor or wash drawing.

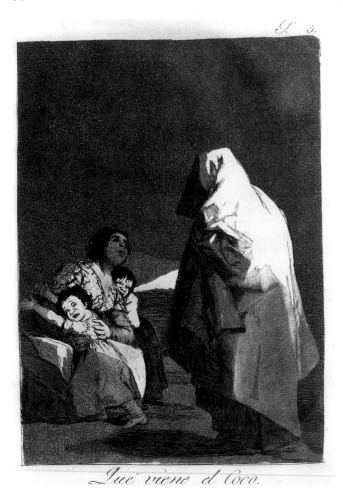

Que viene el Coco.

22.7 Francisco de Goya y Lucientes, *Los Caprichos, Plate 3*. Etching and aquatint. Metropolitan Museum of Art, New York (Gift of M. Knoedler and Co., 1918). Inscribed on the plate is Goya's warning against instilling needless fears in children: "Bad education. To bring up a child to fear a Bogeyman more than his own father is to make him afraid of something that does not exist."

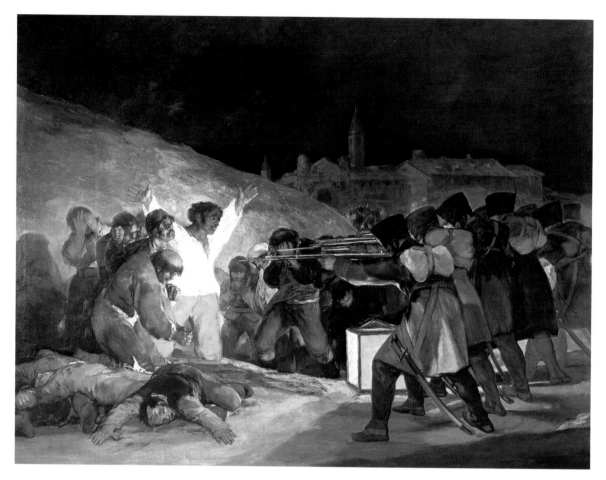

22.9 Francisco de Goya y Lucientes, *The Executions of the Third of May, 1808.* 1814. Oil on canvas, 8 ft 9 in x 11 ft 4 in (2.67 x 3.45 m). Prado, Madrid. This painting depicts the aftermath of events that occurred on 2 and 3 May 1808. Two Spanish rebels had fired on fifteen French soldiers from Napoleon's army. In response, the French troops rounded up and executed 15,000 inhabitants of Madrid (*Madrileños*) and other Spanish towns. Six years later, after the French had been ousted, the liberal government of Spain commissioned a pair of paintings, of which this is one, to commemorate the atrocity.

Bogeyman. An inscription on the plate confirms Goya's enlightened view of child development, which was unusual in a country still haunted by memories of the Inquisition.

In his images of war Goya extends his Enlightenment views to individual rights and state oppression. The dramatic juxtaposition of visible and covered faces is given monumental expression in *The Executions of the Third of May, 1808* (fig. **22.9**). Here the firing squad is an anonymous, but deadly, force. Its regular, repeated rhythms and dark mass contrast with the highlighted, disorderly victims. The emotional poses and gestures, accentuated by thick brushstrokes, and the stress on individual reactions to the "blind," brute force of the firing squad, are characteristic of Goya's Romanticism. The raised arms of the central, illuminated victim about to be shot recall Christ's

Crucifixion. His pose and gesture, in turn, are repeated by the foremost corpse. The lessons of Christ's death, Goya seems to be saying, are still unlearned. By mingling reds and browns in this section of the picture, Goya creates the color of blood flowing into the earth. Somewhat muted by the night sky, a church rises in the background and towers over the scene.

When Goya was in his seventies, he painted a series of so-called "black paintings." Since they were not commissioned, and were therefore painted for Goya's personal satisfaction, these late pictures reveal some of the artist's most intimate preoccupations. *Chronos Devouring one of his Children* (fig. **22.8**) of c. 1820–2 is a disturbing indictment of man's bestial nature. Goya depicts the Titan Chronos as a crazed, wide-eyed cannibal, who is barely contained by the picture space. Chronos stares wildly out of the picture plane, as his gaping mouth tears off a piece of the child's body. The loose brushstrokes, especially in the long hair and body, reinforce his bestial nature. In this frenzied, unclassical image of a father devouring his child, Goya combines several themes that preoccupied him throughout his life. He confronts humanity with an example of its "blackest," most primitive forms of behavior—infanticide and cannibalism. It is ironic that Goya's most anti-Classical image should ultimately project a humanistic message.

Romantic Landscape Painting

Romanticism focused on people's longing to return to nature, and on the insignificance of humanity in relation to nature's vastness. The varying moods of nature were often seen as a reflection of human states of mind. Such themes led to an expansion of landscape painting in the nineteenth century.

In Germany, which otherwise lacked major artists during this period, the poetic landscapes of Caspar David Friedrich (1774–1840) express these Romantic themes. His *Moonrise over the Sea* (fig. **22.10**) exemplifies the Romantic merging of human form and mood with nature. The barren scene echoes the mood of the two figures. The vastness of the landscape is suggested by its implied continuation beyond the borders of the picture. As a result, the men seem transitory in contrast to the permanence of nature. They are vertical silhouettes, accenting the horizontal strips of sky, and possess no individual identity beyond their relationship to the landscape. Their medieval dress evokes Romantic nostalgia for a past era.

In England, the two greatest Romantic landscape painters, John Constable (1776–1837) and Joseph Mallord William Turner (1775–1851), approached their subjects quite differently. Whereas Constable's images are clear and tend to focus on details of English country life, Turner's are apt to become swept up in the paint itself.

In Constable's *Salisbury Cathedral* (fig. **22.11**), for example, cows graze peacefully in the foreground, while couples stroll calmly along pathways. The cathedral is framed by trees that echo its vertical spire. Nostalgia for the past is evident in the juxtaposition of the day-to-day activities of the present with the Gothic cathedral. Humanity, like the cathedral, is at one with nature, and there is no hint of the industrialization that in reality was encroaching on the pastoral landscape of England. The atmosphere of this painting is echoed in the poems of Wordsworth, who wanted to break away from eighteenth-century literary forms and return to nature—to a "humble and rustic life." In *Tintern Abbey*, Wordsworth evokes the Romantic sense of the sublime that is achieved by oneness with nature:

> . . . And I have felt
> A presence that disturbs me with the joy
> Of elevated thoughts; a sense sublime
> Of something far more deeply interfused,
> Whose dwelling is the light of setting suns,
> And the round ocean and the living air,
> And the blue sky, and in the mind of man . . .
>
> (lines 93–9)

The ruined and mysterious character of Stonehenge (see p.41) was ideally suited to the Romantic imagination. In Constable's watercolor of *Stonehenge* (fig. **22.12**), tiny figures walk quietly among the monoliths. The clouds are streaked with light, emphasizing the connection between stones, earth, and sky. Thin, almost transparent waterpaint textures create a veil, which enhances the impression of looking back in time to a Neolithic past.

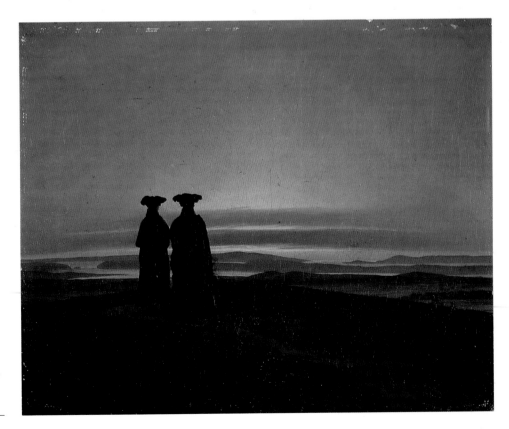

22.10 Caspar David Friedrich, *Moonrise over the Sea.* c. 1830–5. Oil on canvas, 9⅞ × 12¼ in (25.1 × 31.1 cm). State Hermitage Museum, St. Petersburg.

22.11 John Constable, *Salisbury Cathedral from the Bishop's Garden.* 1820. Oil on canvas, 2 ft 10⅝ in × 3 ft 8 in (0.91 × 1.12 m). Metropolitan Museum of Art, New York (Bequest of Mary Stillman Harkness, 1950). (See also figs. **13.23** and **13.24**).

22.12 (opposite, top) John Constable, *Stonehenge.* 1835. Watercolor. Victoria and Albert Museum, London. (See also figs. **3.8**, **3.9**, and **3.12**.)

22.13 (opposite) Joseph Mallord William Turner, *The Burning of the Houses of Parliament.* 1835. Oil on canvas, 3 ft ¼ in × 4 ft ½ in (0.92 × 1.23 m). Cleveland Museum of Art (Bequest of John L. Severance, 42.647). The painting is based on an actual London fire of 1834. Turner spent the entire night sketching the scene. After the fire, the new Houses of Parliament (still standing today) were built in the Gothic revival style, which was inspired by Romantic nostalgia for a medieval Christian past.

Turner's approach to Romanticism is characterized by dynamic, sweeping brushstrokes, and vivid colors that blur the forms. His *Burning of the Houses of Parliament* (fig. **22.13**) is a whirlwind of flame, water, and sky, structured mainly by the dark diagonal pier at the lower right, the distant bridge, and the barely visible towers of Parliament across the Thames. The luminous reds, yellows, and oranges of the fire dominate the sky and reflect in the water below. In this work, architectural structure is in the process of dissolution, enveloped by the blazing lights and colors of the fire. The forces of nature let loose and their destruction of manmade structures are the primary theme of this painting. In Constable's work, on the other hand, nature is under control, and in harmony with human creations.

In America as well as Europe, the Romantic movement infiltrated both art and literature. The landscape of different parts of the country inspired artists, individually and in groups, to produce works that were often monumental in size and breathtaking in their effect. Thomas Cole (1801–48) reportedly painted *The Oxbow* (fig. **22.14**) from memory, but it depicts an actual scene: a bend in the Connecticut River, near Northampton. A huge expanse of land, deserted except for a single figure in the foreground, is seen from a hill. The viewer is drawn into the picture by its sheer size, and then thrust downward into the valley below. The storm in the middle distance creates a sense of nature's dramatic, changing moods, which is characteristic of the Romantic esthetic.

Another, more direct, view of nature in nineteenth-century American painting can be found in folk art. Folk artists are typically not academically trained; their forms are usually unsophisticated, their proportions unrealistic, and their imagery lacks the traditional concern for a relationship with history. One example of this genre that

22.14 Thomas Cole, *The Oxbow* (*The Connecticut River near Northampton*). 1836. Oil on canvas, 6 ft 4 in × 4 ft 3½ in (1.93 × 1.31 m). Metropolitan Museum of Art, New York (Gift of Mrs. Russell Sage, 1908). Cole was a member of the Hudson River School which, although deriving its name from the Hudson River Valley in upstate New York, included artists working throughout the U.S.A. "Oxbow" is the term used to describe the crescent-shaped, almost circular, course of a river caused by its meandering.

22.15 Edward Hicks, *The Peaceable Kingdom*. c. 1850. Oil on canvas, 17⅞ x 28⅞ in (45.4 x 73.3 cm). Metropolitan Museum of Art, New York (Gift of Edgar William and Bernice Chrysler Garbisch, 1970). Hicks was influenced by the landscape of his native Pennsylvania, and this work, as in the case of most American Romantic landscape painting, conveys the sense of a specific place. This was Hicks's favorite image and he painted many versions of it from 1820 until his death — about forty examples are extant.

embodies the Romantic ideal of a return to nature is *The Peaceable Kingdom* (fig. **22.15**) of Edward Hicks (1780–1849). Rather than being drawn into a vast space, the viewer experiences an immediate confrontation with the image. Its impact is enhanced by the close-up view of wild animals coexisting peacefully with humans. Their careful, almost staged, arrangement and immobile frontality lend them an inanimate quality that is consistent with the folk art taste for objects. Based on the biblical prophecy of peace on earth (Isaiah 11:6–9), *The Peaceable Kingdom* merges the real landscape with a Utopian ideal related to the notion of a Garden of Eden. In contrast to the capricious, changing, and dangerous eruptions of nature that are captured in the work of Turner and Cole, Hicks's conception is still, almost static, as if frozen in time.

American Romantic Writers

Nineteenth-century America produced many important Romantic works of literature. The historical adventures of James Fenimore Cooper (1789–1851), particularly *The Last of the Mohicans* (1826), extol the American Indian as an example of the "noble savage." The supernatural poems and tales of Edgar Allan Poe (1809–49) contain uncanny portrayals of death and terror. Likewise, the Gothic novels and short stories of Nathaniel Hawthorne (1804–64) create a haunted, medieval atmosphere in which supernatural phenomena abound.

A characteristic American Romantic philosophy emerged in the Transcendentalism of Ralph Waldo Emerson (1803–82) and Henry David Thoreau (1817–62), a mystical doctrine which stressed the presence of God within the human soul as a source of truth and a moral guide. After a trip to England (where he met Coleridge and Wordsworth), Emerson became a spokesman for Romantic individualism, which he expressed in poems and essays. A more personal form of natural philosophy can be seen in Thoreau's experimental return to nature. He lived alone for two years in a hut at the edge of Walden Pond in Massachusetts, and recorded his experience in *Walden; or Life in the Woods* (1854).

Nineteenth-Century Realism

The nineteenth century was an age of revolution. Contemporary ideas about human rights can be traced to the late eighteenth-century Enlightenment. These led inevitably to conflicts which were often depicted or reflected by painters — usually from the viewpoint of those rebelling against government oppression.

England led the way in the Industrial Revolution, which transformed the economies, first of western Europe, then of America and other parts of the world, from an agricultural to a primarily industrial base. Once started, the process continued at a breakneck pace. Inventions such as the steam engine, and new materials such as iron and steel, made mechanized manufacturing possible. Factories, the organs of mass production, were set up, mainly in urban areas, and people moved from the country to the cities in search of work. New social class divisions arose — between factory owners and workers, for example. Demands for individual freedom and citizens' rights were accompanied in many European countries by social and political movements for workers' rights. The first convention for women's rights was held in New York in 1848. The same year witnessed the publication of the most influential of all political tracts written on behalf of workers — the Communist Manifesto of Karl Marx and Friedrich Engels.

French and English literature of the nineteenth century is imbued with the currents of reform that stemmed from this new social consciousness. Novelists described the broad panorama of society, as well as the psychological motivation of their characters. In science, too, the observation of nature led to new theories about the human species and its origin. Newspapers and magazines reported scientific discoveries, and also carried **cartoons** and **caricatures** satirizing political leaders.

The proliferation of newspapers reflected the expanding communications technology that resulted from the Industrial Revolution. Advances in printing and photography made articles and images ever more accessible to a wider public. Inventions such as the telegraph (1837) and telephone (1876) increased the speed with which messages could be delivered, and thus the efficiency of organized activity. Travel also accelerated. The first passenger railroad, powered by steam, went into service in 1830.

Paralleling the more general social changes in the nineteenth century was a change in the social and economic structure of the art world itself. Crafts were replaced by manufactured goods. Guilds were no longer important to an artist's training, status, or economic wellbeing. A new figure on the art scene was the critic, whose opinions, published in newspapers and journals, influenced buyers. Patronage became mainly the province of dealers, museums, and private collectors. Both the art gallery and the museum as they exist today originated in the nineteenth century.

In the visual arts, the style that corresponded best to the new social awareness is called Realism. The term was coined in 1840, although the style itself appeared well before that date. Direct observation of society and nature and political social satire are the primary concerns of the Realist movement in painting.

The Communist Manifesto

The political theory of Communism was set out by Karl Marx and Friedrich Engels in the *Communist Manifesto*, published in England in 1848.

Marxism views history as a struggle to master the laws of nature and apply them to humanity. The *Manifesto* outlines the stages of human evolution, from primitive society to feudalism and to capitalism, each phase being superseded by a higher one.

Marxists believed that bourgeois society had reached a period of decline. It was now time for the working class (or "proletariat") to seize power from the capitalist class and organize society in the interests of the majority. The next stage would be socialism under the rule of the working class majority ("dictatorship of the proletariat"). This, in turn, would be followed by true communism, in which the guiding principle "from each according to his ability, to each according to his needs" would be finally realized.

Part-analysis, part-rhetoric, the *Manifesto* ends: "The proletarians have nothing to lose but their chains. They have a world to win. Working men of all countries, unite!"

Realism in Literature

The current of Realism and its related "-ism," Naturalism, flows through nineteenth-century literature, science, and arts. In England, Charles Dickens (1812–70) described the dismal conditions of lower class life. He drew on direct observation and personal experience, for as a boy he had worked in a factory while his father was in debtors' prison. His opening sentence of *A Tale of Two Cities* reflects the ambivalence with which the new industrial society was viewed: "It was the best of times, it was the worst of times, it was the age of wisdom, it was the age of foolishness, it was the epoch of belief, it was the epoch of incredulity, it was the season of Light, it was the season of Darkness. . . . "

Dickens's compatriot Charles Darwin (1809–82) pursued the study of humanity as a species in much the same way that novelists studied society and Marx studied economics. In 1859 he published the *Origin of Species by Means of Natural Selection*, which he wrote after a five-year sea-voyage as a naturalist on the *Beagle*.

In France, Honoré de Balzac (1799–1850) wrote eighty novels, comprising the *Comédie Humaine* (Human Comedy) — a sweeping panorama of nineteenth-century French life. The novelists Gustave Flaubert (1821–80) and Emile Zola (1840–92) also focused on society and personality. In 1857 Flaubert published *Madame Bovary*, the story of the unfaithful wife of a French country doctor. The description of her suicide by arsenic poisoning is a classic example of naturalistic observation transformed into literature. Zola's *Thérèse Raquin* (1871) details a particular state of mind — namely remorse — while his *Nana*, the story of a prostitute, has broader social connotations. Zola not only championed a Realist approach to the arts; he was also a staunch defender of political and social justice.

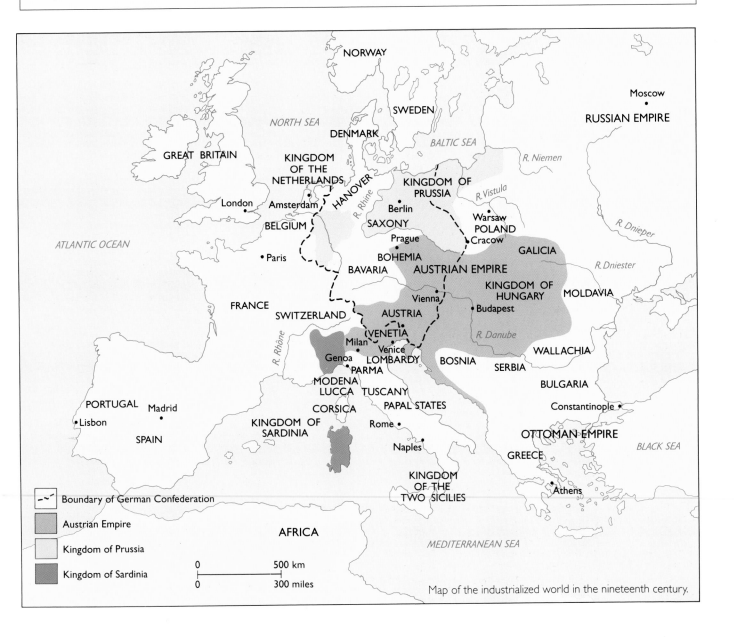

Map of the industrialized world in the nineteenth century.

French Realist Painting

Millet

The Gleaners (fig. **23.1**), by Jean-François Millet (1814-75), illustrates the transition between Romanticism and Realism in painting. The dramatic, heroic depiction of the three peasants in the foreground and their focus on their tasks recall the Romantic sense of "oneness with nature." Two peasants in particular are monumentalized by their foreshortened forms, which convey a sense of powerful energy. Contrasted with the laborers gleaning the remains of the harvest are the prosperous farmers in the background. The emphasis on class distinctions — the hard, physical labor of the poor as opposed to the comfortable lifestyle of the more economically fortunate — is characteristic of Realism.

Courbet

The painter most directly associated with Realism was Gustave Courbet (1819–77), who believed that artists could accurately represent only their own experience. He rejected Neoclassical historical painting, as well as the Romantic depiction of exotic locales and revivals of the past. Although he had studied the history of art, he claimed to have drawn from it only a greater sense of himself and his own experience in the present. In 1861 he wrote that art could not be taught. One had to draw upon individual inspiration, fueled by study and observation.

Courbet's complex *The Interior of My Studio: A Real Allegory Summing up Seven Years of My Life as an Artist* (fig. **23.2**) must be considered as a "manifesto" in its own right. It reflects his broad view of society on the one hand, and his relationship to the art of painting on the other.

23.1 Jean-François Millet, *The Gleaners*. 1857. Oil on canvas, c. 2 ft 9 in × 3 ft 8 in (0.84 × 1.12 m). Louvre, Paris. Because of their powerful paintings of rural labor, Millet and his contemporary Courbet were suspected of harboring anarchist views. Both were members of the Barbizon School, a group of French artists who settled in the village of that name in the Fontainebleau Forest. There they painted directly from nature, producing landscapes that are tinged with nostalgia for the countryside, which was receding before the Industrial Revolution.

Mirroring his committed "socialist" principles is the separation of the working class figures on the left from those on the right, who belonged to Courbet's artistic and literary coterie. Those on the left are types rather than individuals, reflecting the humdrum anonymity of working class life. They consist mainly of country folk, including laborers, a Jew, and a clown, and are in shadow. On the right, and more brightly illuminated, are portraits of Courbet's contemporaries, most of whom are recognizable as individuals. They include Courbet's patron, J. L. Alfred Bruyas, who financed the exhibit, and the poet Charles Baudelaire, who is seen reading at the far right.

The central group illustrates Courbet's conception of himself as an artist, and his place in the history of western European painting. Having come from a rural background himself, Courbet identifies the group on the left with his past. Those on the right refer to his present and future role in the sophisticated world of Parisian society. He himself is at work on a rural landscape, characteristically building up the paint with brushes and a **palette knife** to recreate the material textures of "reality." He displays the unformed paint by tilting his palette toward the observer, while also extending his arm to place a daub of paint on the landscape.

In planning the *Studio*, Courbet clearly had in mind Velázquez's *Las Meninas* (fig. **19.34**), in which the artist also paints in company. Whereas Velázquez places himself among the royal family, however, Courbet is set within the spectrum of "society" as a whole, midway between

23.2 Gustave Courbet, *The Interior of My Studio: A Real Allegory Summing up Seven Years of My Life as an Artist.* 1849–50. Oil on canvas, 11 ft 10 in × 19 ft 7¾ in (3.61 × 5.99 m). Louvre, Paris. In 1855 Courbet's entries were rejected by the Paris Universal Exposition. He rented a separate exhibition space, which was privately financed, and called it the "Pavilion of Realism." The exhibition has been called the first one-man show in western European art, and Courbet took advantage of it to disseminate his artistic principles. His introduction to the catalogue amounted to a "Realist Manifesto." This vast painting was the star of the show.

the workers and the intellectual elite. Velázquez stands to one side, facing the viewer, and works on a canvas seen only from the back. Courbet occupies the center of the composition, and his painting is visible to the observer. Courbet the artist has usurped the king's central role and is "enthroned" before his canvas. A nude woman, whose pink drapery has dropped to the floor, inspires the painter-king — she is a kind of artistic "power behind the throne." In this role, she fulfills Courbet's stated relationship to earlier art. That is, he studies and absorbs it, but then transforms it according to his inspiration in the "real," present world. There is further significance in the woman's placement behind Courbet. The artist, in effect, "turns his back" on her, rejecting the Academic tradition in the form of a Classical nude. The link between woman and landscape is conveyed by the drapery above the canvas, which has been pulled back to reveal the view, just as the nude reveals herself.

Lithography

A lithograph, literally a "stone (*lith*) writing or drawing (*graph*)," is a print technique first used at the end of the eighteenth century in France. In the nineteenth century, **lithography** became the most widely used print medium for illustrating books, periodicals, and newspapers, and for reproducing posters.

To create a lithograph, the artist makes a picture with a grease crayon on a limestone surface. Alternatively, a pen or brush is used to apply ink to the stone. Since limestone is porous, it "holds" the image. The artist then adds water, which adheres only to the non-greased areas of the stone, because the greasy texture of the image repels the moisture. The entire stone is rolled with a greasy ink, which sticks only to the image. When a layer of damp paper is placed over the stone and both are pressed together, the image is transferred from the stone to the paper, thereby creating the lithograph. This original print can then be reproduced relatively cheaply and quickly, making it suitable for mass distribution. Since the stone does not wear out in the printing process, an almost unlimited number of impressions can be taken from it.

In transfer lithography, a variant used particularly by Daumier, the artist draws the image on paper, and it is fixed to the stone before printing. This method retains the texture of the paper in the print and is more convenient for mass production.

Daumier

Honoré Daumier (1808–79), one of the most direct portrayers of social injustice, has been called both a Romantic and a Realist. In this chapter, he is discussed in the context of Realism. A juxtaposition of his *Third-Class Carriage* (fig. **23.5**) and *Interior of a First-Class Carriage* (fig. **23.6**) illustrates his attention to Realist concerns. In both works, Daumier's characteristically dark, sketchy outlines and textured surfaces remind the viewer of the media. In both, a section of society seems to have been framed unawares. Strong contrasts of light and dark, notably in the silhouetted top hats, create clear edges, in opposition to the looser brushwork elsewhere. The very setting, the interior of a railroad car, exemplifies the new industrial subject matter of nineteenth-century painting.

Although Daumier had painted for much of his life, he was not recognized as a painter before his first one-man show at the age of seventy. For most of his career, he was known for his satirical drawings and cartoons, which were sold to the Paris press and reproduced in large numbers by lithography. His works usually appeared in *La Caricature*, a weekly paper founded in 1830 and suppressed by the government in 1835, and *Le Charivari*, a daily paper started in 1832. Both had been established by Charles Philipon, a liberal republican. Daumier satirized the corruption of political life, the legal system, judges, lawyers, doctors, businessmen, actors, bourgeois hypocrisy, and even the king himself.

Gargantua

Gargantua, a good-natured giant in French folklore, became the main character in the classic work by Rabelais (c. 1494–1553) on monastic and educational reform, *La Vie très Horrifique du Grand Gargantua* (The Very Horrific Life of the Great Gargantua). Rabelais's Gargantua is a gigantic prince with an equally enormous appetite.

In Daumier's print (fig. **23.4**), a gigantic Louis-Philippe, the French king (1773–1850), is seated on a throne before a starving crowd. A poverty-striken woman tries to feed her infant, while a man in rags is forced to drop his last few coins into a basket. The coins are then carried up a ramp and fed to the king. Underneath the ramp, a crowd of greedy but well-dressed figures grasps at falling coins. A group in front of the Chamber of Deputies, the French parliament, applauds Louis-Philippe. The message of this caricature is clear. A never-satisfied king exploits his subjects and grows fat at their expense. Daumier explicitly identified Louis-Philippe as Gargantua in the title of the print. In 1832 Daumier, along with his publisher and printer, was charged with inciting contempt and hatred for the French government and with insulting the person of the king. He was sentenced to six months in jail and ordered to pay a fine of one hundred francs.

The derivation of the word "gargantuan" is consistent with the intended character of Louis-Philippe in this print. The root word "garg" is related to "gargle" and "gorge," which is also French for "throat." In Greek, the word *gargar* means "a lot" or "heaps," and in English one who loves to eat is sometimes referred to as having a "gargantuan" appetite.

23.4 Honoré Daumier, *Gargantua.* 1831. Lithograph, 8⅜ × 12 in (21.4 × 30.5 cm). Private collection, Paris.

23.3 (opposite) Honoré Daumier, *The Freedom of the Press: Don't Meddle with It (Ne Vous y Frottez Pas).* 1834. Lithograph, 12 × 17 in (30.5 × 43.2 cm). Private collection, France. The implication of this image is that the power of the press is ultimately greater than that of a king. Daumier's depiction of dress according to class distinctions is characteristic of nineteenth-century Realist social observation.

In 1834 *La Caricature* published Daumier's protest against censorship, entitled *The Freedom of the Press: Don't Meddle with It* (fig. **23.3**). The foreground figure in working class dress is Daumier's hero. He stands firm, with clenched fists and a set, determined jaw. Behind him "Freedom of the Press" is inscribed like raised print type on a rocky terrain. He is flanked in the background by two

groups of three social and political types, who are the targets of Daumier's caricature. On the left, members of the bourgeoisie feebly brandish an umbrella. On the right, the dethroned and crownless figure of Charles X receives ineffectual aid from two other monarchs in a configuration that recalls West's *Death of General Wolfe* (fig. **20.14**).

The impact of Daumier's caricatures was so great that in 1835 France passed a law limiting freedom of the press to verbal rather than pictorial expression. The French authorities apparently felt that drawings were more apt to incite rebellion than words. Such laws, which are reminiscent of the ninth-century Iconoclastic Controversy (see p.165), are another reflection of the power of images on the human mind. Clearly, the nineteenth-century French censors felt more threatened by the proverbial "single picture" than by a "thousand words."

Nineteenth-Century Photography

Another method of creating multiple images that underwent enormous development in the nineteenth century was photography. It achieved great popularity, and its potential for both portraiture and journalism was widely recognized. Many painters were also photographers and, from the nineteenth century to the present, the mutual influence of photography and painting has grown steadily.

In France, the photographic portraits of the novelist and caricaturist known as Nadar (1820–1910) were particularly insightful. His *Portrait of Sarah Bernhardt* (fig. **23.7**), the most renowned French actress of her generation, illustrates the subtle gradations of light and dark that are possible in the photographic medium. Nadar has captured Bernhardt in a pensive mood. Her dark, piercing eyes stare at nothing in particular, but seem capable of deep penetration.

23.7 Gaspard-Félix Tournachon (Nadar), *Portrait of Sarah Bernhardt*. 1859. Photograph from a collodion negative. Bibliothèque Nationale, Paris. Nadar was a French caricaturist, journalist, and portrait photographer. In 1854 he published *Le Panthéon Nadar*, a collection of his best works. The portrait of Bernhardt emphasizes her delicate features and quiet pose, in contrast to the large, voluminous, tasseled drapery folds. This contrast suggests the distinction between her private self and her reputation as a great dramatic actress.

23.5 (opposite, top) Honoré Daumier, *Third-Class Carriage*. c. 1862. Oil on canvas, 25¾ x 35½ in (65.4 x 90.2 cm). Metropolitan Museum of Art, New York (Bequest of Mrs. H. O. Havemeyer, 1929). Lower class figures crowd together in a dark, claustrophobic space. The three drably dressed passengers in the foreground slump slightly on a hard, wooden bench. They seem resigned to their status, and turn inward, as if to retreat from harsh economic reality. Their psychological isolation defends them from the crowded conditions in which they live.

23.6 (opposite) Honoré Daumier, *Interior of a First-Class Carriage*. Crayon and watercolor, 8¹⁄₁₆ x 11¾ in (20.5 x 30 cm). Walters Art Gallery, Baltimore. Four well-dressed and comfortably seated passengers occupy the first class car. One woman looks out of the window, as if alert to the landscape and not destined for a life of crowded confinement. The elegant dress and upright, neatly arranged poses of all of these figures reveal their higher social position, compared with the rough dress and peasant-like proportions of their counterparts in third class.

In America, the photographs of Mathew Brady (c. 1822–96) combine portraiture with on-the-spot journalistic reportage. In his *"Cooper Union" Portrait* of Lincoln (fig. **23.9**), Brady depicts the president as a thoughtful, determined man. His straightforward stare, as if gazing firmly down on the viewer, creates a very different impression from the dreamy, introverted character of Nadar's Sarah Bernhardt. Differing from the subtly varied tones that characterize the Lincoln portrait are the sharp contrasts of the *Ruins of the Gallego Flour Mills, Richmond* (fig. **23.10**). The remains of the flour mills, burned when the Union army drove Confederate troops from Richmond, Virginia, stand as testimony to a vanishing civilization. The dark architectural skeleton, arranged as a stark horizontal, is silhouetted against a light sky with only a few intervening grays.

Photography

Photography means literally "drawing with light" (from the Greek *phos*, meaning "light" and *graphe*, meaning "drawing" or "writing"). The basic principles may have been known in China as early as the fifth century B.C. The first recorded account of the **camera obscura** (fig. **23.8**), literally a "dark room," is that of Leonardo da Vinci. He described how, when light is admitted through a small hole into a darkened room, an inverted image appears on the opposite wall or on any surface (for example, a piece of paper) interposed between the wall and the opening. In the early seventeenth century, the astronomer Johannes Kepler devised a portable camera obscura, resembling a tent. It has since been refined and reduced to create the modern camera, the operation of which matches the principles of the original "dark room."

From the eighteenth century, discoveries in photochemistry accelerated the development of modern photography. It was found that silver salts, for example, were sensitive to light, and that an image could therefore be made with light on a surface coated with silver. In the 1820s a Frenchman, Joseph-Nicéphore Niepce (1765–1833), discovered a way to make the image remain on the surface. This process was called **fixing** the image. But the need for a long exposure time (eight hours) made it impractical.

In the late 1830s another Frenchman, Louis Daguerre (1789–1851), discovered a procedure that reduced the exposure time to fifteen minutes. He inserted a copper plate coated with silver and chemicals into a camera obscura and focused through a lens onto a subject. The plate was then placed in a chemical solution (or "bath"), which "fixed" the image. Daguerre's photographs, called **daguerreotypes**, could not be reproduced, and each one was therefore unique. The final image reversed the real subject, however, and also contained a glare from the reflected light. In 1839 the French state purchased Daguerre's process and made the technical details public.

Improvements and refinements quickly followed. Contemporaneous with the development of the daguerreotype, the English photographer William Henry Fox Talbot (1800–77) invented "negative" film, which permitted multiple prints. The negative also solved the problem of Daguerre's reversed print image. Since the negative was reversed, reprinting the negative onto light-sensitive paper reversed the image back again. By 1858 a shortened exposure time made it possible to capture motion in a still picture.

During the twentieth century, color photography developed. Still photography inspired the invention of "movies," first in black and white and then in color. Today, photography has achieved the status of an art form in its own right.

From its inception, photography has influenced artists. Italian Renaissance artists used the camera obscura to study perspective. Later artists, including Vermeer (see p.322), are thought to have used it to enhance their treatment of light. In the midnineteenth century, artists such as Ingres and Delacroix (see pp.345 and 354) used photographs to reduce the sitting time for portraits. Eakins (see p.375) was an expert photographer. He used photographic experiments to clarify the nature of locomotion.

As an artistic medium, black-and-white photography has an abstract character quite distinct from painting, which, like nature itself, usually has color. The black-and-white photograph creates an image with tonal ranges of gray rather than line or color. Certain photographic genres, such as the close-up, the candid shot, and the aerial view, have influenced painting considerably.

23.8 Diagram of a camera obscura. Here the camera obscura has been reduced to a large box. Light reflected from the object (1) enters the camera through the lens (2) and is reflected by the mirror (3) onto the glass ground (4), where it is traced onto paper by the artist/photographer.

23.9 Mathew B. Brady, *Lincoln "Cooper Union" Portrait*. 1860. Photograph. Lincoln stands before a column, which is both a standard studio "prop" and a reference to his sense of history. To foster the "union" of North and South, Lincoln cited the biblical metaphor "A house divided against itself cannot stand." His hand rests on a pile of books, evoking his profound commitment to literature and intellectual truth. Of the one hundred or so known photographs of Lincoln, more than one third were taken by Brady.

23.10 Studio of Mathew B. Brady, *Ruins of the Gallego Flour Mills, Richmond*. 1863–5. Albumen-silver print from a glass negative, 6 × 8³⁄₁₆ in (15.2 × 20.8 cm). Collection, The Museum of Modern Art, New York (Purchase). When the Civil War broke out in 1861, Brady organized a group of cameramen into a "photographic corps" to record the events of the war. The project was a great artistic and historical success — but proved a financial disaster for Brady.

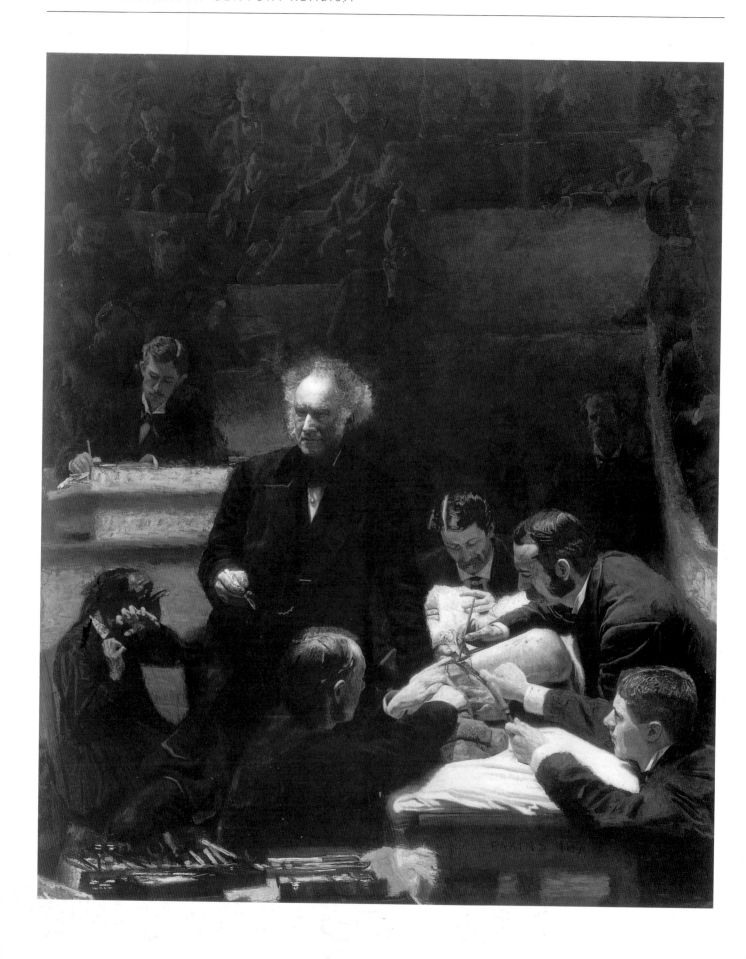

American Realism

Eakins's *Gross Clinic*

One of the landmarks of Realist painting in America was *The Gross Clinic* (fig. **23.11**) by Thomas Eakins (1844–1916). It depicts a team of doctors, led by an eminent surgeon, Dr. Gross. They are performing an operation dressed in street clothes, as was the practice in the nineteenth century. Like Courbet, Eakins builds up the paint to a thick, rich texture. On the right, the incision is brightly illuminated. Surgical instruments occupying the foreground are in shadow, as is the patient's mother on the left. Eakins uses atmospheric perspective to give an illusion of depth, and illumination to accentuate the details of the surgery. Eakins's treatment of light also shows the influence of Rembrandt (see p.318). The symbolic meaning of the light merges with its formal arrangement. By highlighting Dr. Gross's head and hand, Eakins draws attention to both the "enlightenment" of his mind and his manual skill.

23.11 (opposite) Thomas Cowperthwait Eakins, *The Gross Clinic*. 1875. Oil on canvas, 8 ft × 6 ft 6 in (2.44 × 1.98 m). Jefferson Medical College, Philadelphia. As an art teacher, Eakins emphasized the study of anatomy, dissection, and scientific perspective. He clashed with the authorities of the Pennsylvania Academy over his policy that women art students draw from the nude. *The Gross Clinic* was rejected by the 1876 Philadelphia Centennial Exhibition and was finally shown in the medical wing — a status that did not do justice to its importance.

French Realism of the 1860s

Manet's *Déjeuner sur l'Herbe*

The work of Edouard Manet (1832–83) in Paris formed a transition from Realism to Impressionism (which is the subject of the next chapter). By and large, Manet's paintings of the 1860s are consistent with the principles of Realism, whereas in the 1870s and early 1880s he adopted a more Impressionist style.

In 1863 Manet scandalized the French public by exhibiting his *Déjeuner sur l'Herbe* (or *Luncheon on the Grass*) (fig. **23.12**). It is not a Realist painting in the social or political sense of Daumier, nor does it have the explicitness of Eakins. But it is a statement in favor of the artist's individual freedom. The shock value of the *Luncheon* clearly resulted from the fact that the foreground group of figures is located in a public setting. A painting of a nude alone in a landscape would probably not have raised a single

23.12 Edouard Manet, *Déjeuner sur l'Herbe*. 1863. Oil on canvas, 7 × 9 ft (2.13 × 2.69 m). Musée d'Orsay, Paris. The visual impact of the *Luncheon* is partly the result of the shallow perspective. Rather than creating the illusion of a distant space, Manet, like Courbet and Eakins, builds up areas of color, so that the forms seem to advance toward the viewer. The final effect of this technique is a direct confrontation between viewer and image, allowing little of the relief, or "breathing space," that comes with distance.

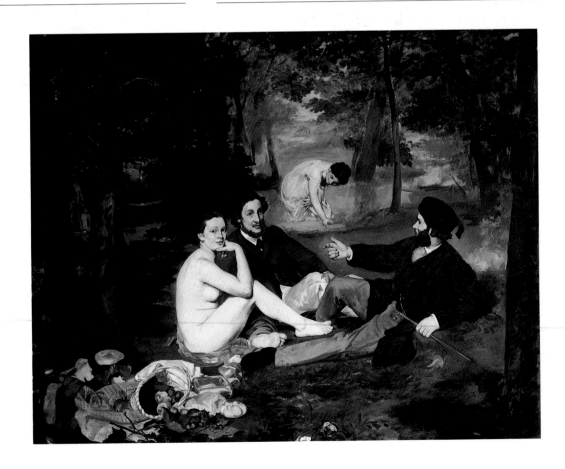

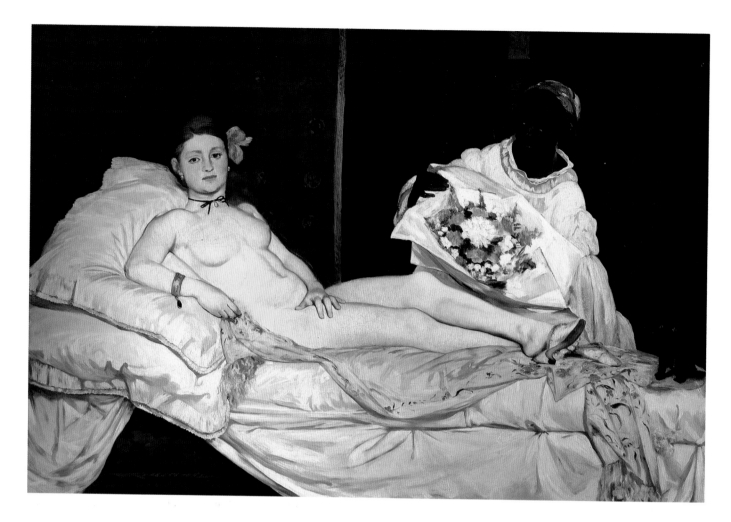

eyebrow in nineteenth-century Paris. The depiction of a recognizable contemporary figure (a model known as Victoire), however, rendered without Classical proportions or mythological guise, in a familiar Paris park and in the company of fully dressed men, was more than viewers were prepared to accept. Although Manet's *Luncheon* contains several historical echoes in references to well-known paintings of the past, it embodies the artist's belief that a good painting is first and foremost true to itself. In accordance with Courbet's "Realist Manifesto," Manet has assimilated the past and transformed it into his own contemporary idiom.

Manet's *Olympia*

Manet created an even more direct visual impact in the *Olympia* (fig. **23.13**). This painting caused a scandal when it was first exhibited in 1865. Here again, Manet is inspired by the past—most obviously by Titian's *Venus of Urbino* (fig. **16.27**). But whereas Titian's nude is psychologically "distanced" from the viewer's everyday experience by her designation as a Classical deity, Manet's figure was widely assumed to be a contemporary French prostitute. The reference to "Olympia" in this context only serves to accentuate the contrast between "reality" and the

23.13 Edouard Manet, *Olympia*. 1865. Oil on canvas, 4 ft 3 in × 6 ft 3 in (1.3 × 1.9 m). Musée d'Orsay, Paris. Olympia is naked rather than nude, an impression emphasized by her bony, unclassical proportions. The sheets are slightly rumpled, suggesting sexual activity. The flowers that her maid delivers have clearly been sent by a client. Olympia's shoes may refer to "streetwalking," and the alert black cat is a symbol of sexuality, no doubt because of the popular reputation of the alley cat. The term "cat house" is commonly used for a brothel.

Classical ideal. Titian had relieved the viewer's confrontation with his Venus by constructing space that receded into depth. In the *Olympia*, however, the back wall of the room is close to the picture plane, separated from it only by the bed and the black servant. Furthermore, Olympia is harshly illuminated, in contrast to the soft light and gradual, sensual shading of Titian's Venus.

The Salon (see p.355), biased as it was toward Academic art, had always been uncomfortable with "modern" works. It did not know what to make of Manet. In 1863 it rejected his *Luncheon*, but two years later accepted the *Olympia*. It is impossible to overestimate not only the depth of feeling that surrounded the decisions of the Salon juries, but also the hostile criticism that generally greeted **avant-garde**, or modern, works. In 1863 there was an outcry following the rejection of over 4000

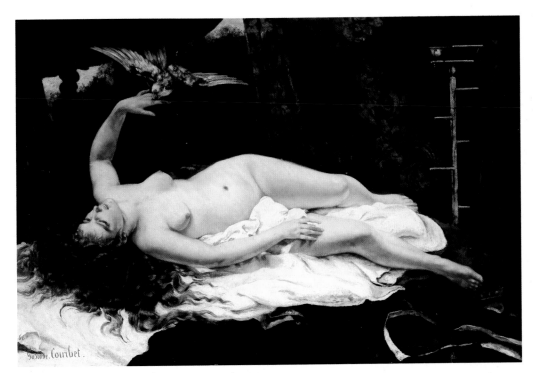

23.14 Gustave Courbet, *Woman with a Parrot*, 1866. Oil on canvas, 4 ft 3 in x 6 ft 5 in (1.3 x 1.96 m). Metropolitan Museum of Art, New York (Bequest of Mrs. H. O. Havemeyer, 1929). In response to Courbet's criticism of his *Olympia*, Manet accused Courbet of "billiard ball esthetics," a reference to the voluptuous proportions of the *Woman with a Parrot*. Other critics described the figure as "ungainly" and her hair as "disheveled." Napoleon III's Superintendent of Fine Arts reneged on a contract to purchase the picture.

canvases by the Salon jury. This prompted Napoleon III to authorize a special exhibition, the "Salon des Refusés," for the rejected works. Among the "rejected" were Manet, Camille Pissarro, Paul Cézanne (only one of whose works was ever shown in an official Salon during his lifetime), and James Abbott McNeill Whistler — all of whom subsequently gained international recognition. It is interesting that Manet's *Olympia* caused dissension even among the ranks of the so-called Realists. Not only was it considered an affront by the Academic artists and the bourgeois public, it also offended Courbet, author of the "Realist Manifesto," who declared it to be "as flat as a playing card."

In 1866, a year after Manet exhibited *Olympia*, Courbet exhibited his *Woman with a Parrot* (fig. **23.14**). Courbet's woman is set in a deeper space than Olympia, and does not confront the viewer as directly. Her head falls back on the bed, and her self-consciously wavy hair corresponds to the ripples of the bedcover. Courbet softens her impact on the viewer by turning her face toward the parrot that perches on her hand. Her sexuality is more muted than Olympia's because of an element of idealization and her indirect placement in relation to the viewer. The woman with the parrot is voluptuous, her shading more gradual than Olympia's. She is nude rather than naked.

Architecture

By and large, nineteenth-century architects were not quick to adopt iron and steel, both of which had been recently developed, as building materials. Indeed, at first they did not regard them as suitable for such use. Accordingly, the first major project making extensive use of iron was regarded as a utilitarian structure rather than a work of architecture.

Crystal Palace

In 1851 the "Great Exhibition of the Works of Industry of All Nations" was held in London. This was the first in a series of Universal, or International, Expositions ("Expos") and World's Fairs, which continue to this day. Architects were invited to submit designs for a building in Hyde Park to house the exhibition.

When Joseph Paxton submitted his proposal (fig. **23.15**), 245 designs had been received and rejected. Paxton had started his career as a landscape gardener. He had built large conservatories and greenhouses from iron and glass. Not only was his proposal less expensive than the other designs, but it could be completed within the nine-month deadline. The design could be subdivided into a limited number of separate components, so the work could be subcontracted out. The individual components were thus "prefabricated," or made in advance of final construction, and then assembled on the actual site. Because of its extensive use of glass, the structure was dubbed the "Crystal Palace."

There were many advantages to this construction method. Above all, prefabrication meant that the structure could be treated as a temporary one. After the exhibition

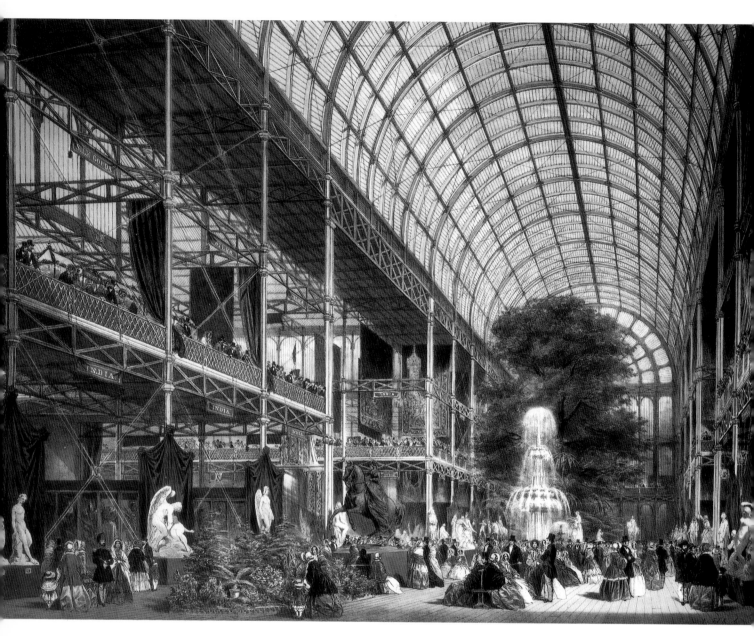

23.15 Joseph Paxton, Crystal Palace, London. 1850–1. Cast iron, wrought iron, and glass. Engraving (R. P. Cuff after W. B. Brounger). Drawings Collection, Royal Institute of British Architects, London. The Crystal Palace was 1850 feet (563.88 m) long (perhaps an architect's pun on the year in which it was built) and 400 feet (121.92 m) wide. It covered an area of 18 acres (7.3 hectares), enclosed 33 million cubic feet (934,000 m^3) of space (the largest enclosed space up to that time), and contained more than 10,000 exhibits of technology and handicrafts from all over the world.

had ended, the building was taken apart and reassembled on a site in the south of London. But one perceived advantage of iron and glass — that they were fireproof — proved to be illusory. In 1936 the Crystal Palace was destroyed in a fire. The intense heat caused the framework to buckle and collapse.

Bridges

The industrializing countries, particularly America, with its great distances, urgently needed better systems of transportation to keep up with advances in communication. Rivers and ravines had to be crossed by roads and railroads, and this led to new developments in nineteenth-century bridge construction. Until the 1850s bridges had been designed according to the **truss** method of construction (i.e. short components were joined together to form a

23.16 John A. and W. A. Roebling, Brooklyn Bridge, New York. Stone piers with steel cables, span 1595 ft (486 m). Built between 1869 and 1883, this suspension bridge spanned the East River — a distance of nearly 1600 feet (485 m) — to connect Manhattan (New York City) and Brooklyn. Like the Crystal Palace, the Brooklyn Bridge was regarded as a work of engineering rather than of architecture. Nevertheless, in deference to architectural tradition, the arches in the towers of the bridge were pierced by pointed Gothic arches.

longer, rigid framework). Wooden truss bridges used by the Romans to cross the River Danube, for example, are illustrated on Trajan's Column (fig. **9.22**). By the 1840s, metal had begun to replace wood as the preferred material for such bridges.

The principle of the **suspension bridge** had been known for centuries, from the bridges of twisted ropes or vines that had been used to cross ravines in Asia and South America. The superior span and height of the suspension bridge were appropriate for deep chasms or wide stretches of navigable water. Modern suspension bridges were built from the early 1800s using iron chains, but by the middle of the century engineers had begun to see the advantages of using flexible cable made of steel wire.

The greatest American bridgebuilders of the nineteenth century were J. A. Roebling (1806–69) and his son, W. A. Roebling (1837–1926), who were responsible for the

Brooklyn Bridge (fig. **23.16**). Two massive towers of granite were constructed at either end of the bridge. They were linked by four huge parallel cables, each containing over 5000 strands of steel wire. The steel wire, which was spun on site, supported the roadways and pedestrian walkways. It was the first time that steel had been used for this purpose.

23.17 Gustave Eiffel, Eiffel Tower, Paris. 1887–9. Wrought iron superstructure on a reinforced concrete base, 984 ft (300 m) high; 1052 ft (320 m) including television mast. The Eiffel Tower was so controversial that a petition demanding its demolition was circulated. When the Exposition ended in 1909, the tower was saved because of its value as a radio antenna. Its original height was twice that of the dome of St. Peter's or the Great Pyramid at Giza, and has since been increased by the addition of a television mast. Until the Empire State Building was built in New York in 1932, the Eiffel Tower was the highest human structure in the world.

Eiffel Tower

Like the Crystal Palace, the Eiffel Tower in Paris (fig. **23.17**) was built as a temporary structure. It was designed as a landmark for the Universal Exposition of 1889, celebrating the centenary of the French Revolution. From the third and highest platform of the tower, visitors could enjoy a spectacular panorama of Paris covering a radius of some 50 miles (80 km).

Named for its designer, Gustave Eiffel (1832–1923), the tower was a metal truss construction on a base of reinforced concrete. Through the curves of the elevation and the four semicircular curves of the base — all executed in open lattice wrought iron — Eiffel transformed an engineering feat into an elegant architectural monument. An unusual feature of the tower was the design of its elevators (by the American Elisha Otis), which at the lowest level had to ascend in a curve. In 1889 elevators were still something of a novelty, although they were to become a staple of commercial and residential architecture within the next generation.

Origins of the Skyscraper

By the second half of the nineteenth century, a new type of construction was needed to make more economical use of land. One of the drawbacks of masonry or brick construction is that, the higher the building, the thicker the supporting walls have to be at the base. This increases the cost of materials, the overall weight of the structure, and the area that it occupies. The new materials of structural steel, and concrete reinforced with steel wire or mesh, were stronger than the traditional materials. Their **tensile strength** (ability to withstand longitudinal stress) was also much greater, allowing flexibility in reaction to wind and other pressures. The powerdriven elevator, another necessity for highrise construction, had also made its appearance in the latter half of the century. All of the ingredients for the skyscraper were now in place. Skyscrapers could be used as apartment houses, office buildings, multi-story factories, department stores, auditoriums, and other facilities for mass entertainment.

The Wainwright Building in St. Louis (fig. **23.18**), a

23.18 Louis Sullivan, Wainwright Building, St. Louis. 1890–1.

nine-story office building dating from 1890–1, is one of the finest examples of early highrise building. It is based on the **steel frame** method of construction. Steel girders are joined horizontally and vertically, to form a grid. The framework is strong enough for the outer and inner walls to be suspended from it, without themselves performing any supporting function. Architectural features used since the Gothic period and earlier — post and lintel, arch, vault, buttress — were now functionally superfluous.

The architect, Louis Sullivan, used a Classical motif to stress the verticality of the building and to disguise the fact that it was basically a rectangular block with nine similar horizontals superimposed on one another. The almost Renaissance impression of the building is heightened by the brick, red granite, and terra cotta facing. Although the Wainwright Building is not high by contemporary standards, Sullivan's use of the Classical order makes it seem higher than it actually is.

CHAPTER TWENTY-FOUR

Nineteenth-Century Impressionism

The Impressionist style evolved in Paris in the 1860s and continued into the early twentieth century. Unlike Realism (see Chapter 23), Impressionism responded rarely, if ever, to political events. For example, the devastating effects of France's loss of the Franco-Prussian War in 1871 had virtually no impact on Impressionist imagery. The Impressionist painters preferred genre subjects, especially scenes of leisure activities and entertainment, and landscape. Finally, Impressionism was more influenced by imported Japanese prints and new developments in photography than by politics.

Despite the changing focus of its content, Impressionism was in some ways a logical development of Realism. In their concern with political commentary, the Realists had emphasized social observation. The Impressionists were also concerned with direct observation — especially of the natural properties of light. They studied changes in light and color caused by weather conditions, times of day, and seasons. Reflections and shadows became important Impressionist subjects. For the first time in western painting, artists depicted shadows as darker tones of their surface colors, rather than as grays, blacks, or browns. Impressionists also studied the effects of interior, artificial lighting, such as theater spotlights and café lanterns.

To a large extent, the Impressionist painters formed a distinct community. Although many were from bourgeois families, they liked to exchange ideas in more bohemian surroundings, notably the Café Guerbois in Paris. Because their paintings were initially, and vociferously, rejected by the French Academy, as well as by the French public, they became a group apart. They held eight exhibitions of their work between 1847 and 1886. Ironically, despite the contemporary rejection of Impressionism, it had a greater international impact in the long run than previous styles that had been readily accepted in France.

Painting

Manet: From the 1860s to the 1880s

At first Manet remained separate from the core of Impressionist painters. He did not adopt their interest in bright color and the study of light until the 1870s. His *Bar at the Folies-Bergère* (fig. 24.2) of 1881–2 keeps the figure close to the picture plane, as in the *Olympia* (fig. 23.13), but reveals his adoption of Impressionist color. By the device of the mirror in the background, Manet simultaneously maintains a narrow space and also expands it. The mirror reflects the back of the barmaid, her customer, and the interior of the music hall, which is both in front of her and behind the viewer.

The bright oranges in the glass bowl provide the strongest color accent in the picture. The bowl, like the green and brown bottles, is a surface that reflects light. Daubs of white paint on all these objects create the impression of sparkling light on three-dimensional surfaces. In contrast, the round lightbulbs on the reflected pilasters seem flat, because there is no tonal variation. Absorbing the light, on the other hand, is the smoke that rises from the audience, blocking out part of the pilaster's edge and obstructing our view. This detail exemplifies the Impressionist observation of the effect of atmospheric pollution — a characteristic of the modern, industrial age — on light, color, and form.

A third kind of light can be seen in the chandeliers, the blurred outlines of which create a sensation of movement. The depiction of blurring is one aspect of Impressionism that can be related to photography. When a photographic subject moves, a blur results. In Manet's painting, the figures reflected in the mirror are blurred, indicating that

24.2 (opposite) Edouard Manet, *A Bar at the Folies-Bergère.* 1881–2. Oil on canvas, 3 ft 1½ in x 4 ft 3 in (0.95 x 1.3 m). Courtauld Institute Galleries, University of London. The Folies-Bergère is a Paris music hall, which opened in 1869. Today it is a tourist attraction offering lavish spectacles featuring a great deal of nudity. In Manet's day its program consisted of light opera, pantomime, and similar forms of entertainment.

Japonisme

In 1853 to 1854 Commodore Matthew Perry, an American naval officer, led the expedition that forced Japan to end its policy of isolation. In the Paris Universal Exposition of 1867, many Japanese woodblock prints were on view. As a result, so-called *japonisme*, the French term for the Japanese esthetic, became popular in fashionable Parisian circles. Japanese prints had considerable influence on Impressionist painters in France, America, and elsewhere.

Figure **24.1** exemplifies the flat, colorful patterns of Japanese prints. The red maple leaves, repeated against the landscape greens, create particularly strong contrasts because red and green are opposites on the color wheel (see p.26). The minimal shading and black outlines around the forms, also typical of woodblock prints, create an abstract flatness, which is juxtaposed with an illusion of depth in the landscape. The tiny figures, arranged as vertical accents of dark and light, are typical of Hiroshige.

The technique of color prints was perfected in eighteenth-century Japan. In order to create a woodblock print in color, the artist makes a separate block for each color and prints each block separately. The raised portions differ in each block and correspond to a different color in the final print. It is important, therefore, that the outlines of each block correlate exactly, so that there is no unplanned overlapping or empty space between forms.

24.1 Ando Hiroshige, *Maple Leaves at the Tekona Shrine, Mamma*, from *One Hundred Views of Edo*. 1887. **Polychrome** woodblock print, 13¾ × 9¾ in (34.9 × 24.8 cm). Private Collection. Hiroshige (1797–1858), the son of a fire warden, was born in Edo (now Tokyo). He was trained in the *Ukiyo-e* ("Pictures of the Floating World") School and became a master of the color woodblock print.

the members of the audience are milling around.

The opposite of blurred edges — the silhouette — is also an important feature of the Impressionist style. In its purest form, a silhouette is a flat, precisely outlined image, black on white or vice versa, as in the black ribbon around the barmaid's neck. Other, more muted silhouettes occur in the contrast of the round lightbulbs and the brown pilasters, the gold champagne foil against the dark green bottles, or the woman with the white blouse and yellow gloves in the audience on the left. Such juxtapositions, whether of pure black and white or of less contrasting colors, occur in certain Realist pictures, notably those by Daumier (see p.368). They reflect the strong contrasts that are possible in black-and-white photography.

The impression that the image is one section of a larger scene — a "slice of life," or cropped view — is another characteristic of Impressionism that was borrowed from photography. In Manet's painting, the customer is cut by the frame, as is the trapeze artist, whose legs and feet are visible in the upper left corner of the picture plane. The marble surface of the bar is also cut, and appears to continue indefinitely to the right and left of the observer.

24.3 Hilaire Germain Edgar Degas, *Absinthe*. 1876. Oil on canvas, 36¼ x 26¾ in (92.1 x 67.9cm). Musée d'Orsay, Paris. Degas, the son of a wealthy Parisian banker, joined the Impressionist circle around 1865 and exhibited in seven of their eight exhibitions between 1874 and 1886.

Degas

Absinthe (fig. **24.3**), painted by Edgar Degas (1834–1917) in 1876, also represents a "slice of life," the boundaries of which are determined by the apparently arbitrary placing of the frame. The zigzag construction of the composition creates a slanted viewpoint, rather like that of a candid photograph. It is as if a photographer had taken the picture without aligning the camera with the space being photographed. The two figures are "stoned" on absinthe, the aniseed liqueur in their glasses, and stare fixedly at nothing in particular. Their poses and gestures define their psychological isolation and physical inertia.

In his ballet pictures, Degas depicts a wide range of movement. His dancers rest, stretch, exercise, and perform. The *Dancing Lesson* (fig. **24.4**) of 1883–5, which, like *Absinthe*, is set at an oblique angle, shows a series of ballerinas in various poses and stages of motion or rest. Illuminating the interior is outdoor light, which enters the rehearsal room through three windows. The figures are unified by the repeated blue of their costumes, each accented by a sash of a different color. Blue, yellow, and reddish orange—the three main colors of the costumes—are assembled in the open fan held by the central girl. The repetition of colors throughout the composition creates a chromatic unity that is a characteristic innovation of the Impressionist style.

Degas's passion for depicting forms moving in space was matched by the interest of nineteenth-century photographers in exploring the nature of motion. In 1878, for example, the photographer Eadweard Muybridge (1830–1904) recorded for the first time the actual movements of a galloping horse (fig. **24.5**). To do so, he set up twelve cameras along the side of a racetrack and

24.5 (right) Eadweard Muybridge, *Galloping Horse*. 1878. Albumen print. George Eastman House, Rochester, New York.

24.4 (below) Hilaire Germain Edgar Degas, *The Dancing Lesson*. 1883–5. Oil on canvas, 15½ × 34¾ in (39.4 × 88.4 cm). Sterling and Francine Clark Art Institute, Williamstown, Massachusetts. Degas is best known for his ballet pictures. He sketched ballerinas from the wings of the theater and in ballet studios such as this one. His interest in depicting forms moving through space led him to paint horseraces, acrobats, and other entertainers.

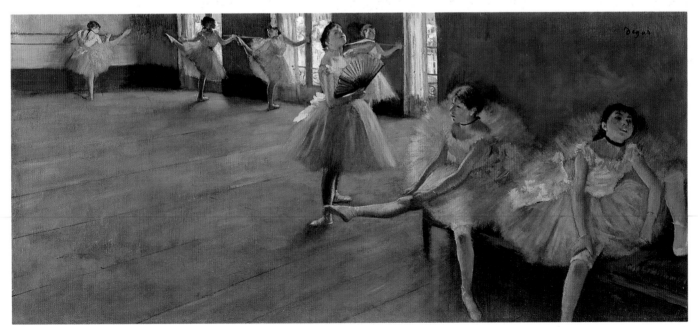

photographed the horses as they passed. One of his discoveries was that all four feet are off the ground only when they are underneath the horse (as in the second and third frames), and not when they are stretched out, as had previously been thought (see, for example, the running bulls from Lascaux, fig. **3.4**).

24.6 Mary Cassatt, *The Boating Party*. 1893–4. Oil on canvas, 2 ft 11½ in × 3 ft 10⅛ in (0.9 × 1.17 m). National Gallery of Art, Washington (Chester Dale Collection). Cassatt was from a well-to-do Pennsylvania family. For most of her career she lived in France, and in 1879, at Degas's invitation, she became the only American to exhibit with the Impressionist group. She fostered American interest in the Impressionists by urging her friends and relatives to buy their works at a time when they were still unpopular.

Cassatt

In the *Boating Party* (fig. **24.6**) of 1893–4, Mary Cassatt (1845–1926) uses the Impressionist "close-up," another pictorial technique derived from photography. She combines it with a slanting viewpoint to emphasize the intimacy between mother and child. The rower, on the other hand, is depicted in back view as a strong silhouette. More individualized are the mother and child, who gaze at the rower, and are contrasted with his anonymity. Cassatt intensifies the tension between the three figures by flattening the space and foreshortening both child and rower. The compacted forms create an image of powerful monumentality. Cassatt's bold planes of color, sharp outlines, and compressed spaces exemplify the influence of Japanese woodblock prints on the Impressionist artists.

Monet

The work of Claude Monet (1840–1926), more than that of any other nineteenth-century artist, embodied the formal principles of Impressionism. A critic who disapproved of one of Monet's landscapes declared in 1874 that his work was "Impressionistic." By that he meant that Monet had not carefully thought out his painting. Its edges were not clear, its subject was insignificant, and its technique was sloppy. In response, evidently rejecting the criticism implied in the term, Monet entitled one. of his landscapes *Impression: Sunrise.*

Monet was above all a painter of landscape who studied light and color with great intensity. Unlike the Academic artists, Monet did much of his painting outdoors, in the presence of natural landscape, rather than in the studio. As a result, he and the other Impressionists were sometimes called *plein-air*, or "open-air," painters.

From the 1860s, early in his career, Monet worked with a wide range of color. A comparison of an early and a late work by Monet illustrates the development of Impressionist style. The *Terrace at Sainte-Adresse* (fig. **24.7**) of about 1866–7 is a leisure genre scene. In the distance, sailboats and steamships hint subtly at the Industrial Revolution. The *Bassin des Nymphéas*, or *Waterlily Pond*, of 1904 (fig. **24.8**) illustrates Monet's style nearly forty years later.

Both pictures reflect Monet's concern with the direct observation of nature. Both are the result of outdoor painting, and nature itself is the "model." The water is painted by the Impressionist technique of broken color. Instead of using a solid, "unbroken" color for the water, Monet "breaks it up" into different hues and values. In the *Terrace*, light and dark blue-green brushstrokes alternate to create the illusion that the water is moving slowly. In the *Waterlily Pond*, the lack of motion in the water is indicated by the more vertical arrangement of the broken

24.7 Claude Monet, *Terrace at Sainte-Adresse*. c. 1866–7. Oil on canvas, 3 ft 2⅜ in × 4 ft 3⅛ in (0.98 × 1.3 m). Metropolitan Museum of Art, New York. In his youth Monet lived at Le Havre, a port town on the Normandy coast. It was here that he first became familiar with rapid changes in light and weather. In 1874 he exhibited in the show that launched the Impressionist movement. Until the 1880s his work was poorly received and he lived in extreme poverty.

colors—greens, blues, yellows, and purples—that comprise the water's surface. Here, though the observer's point of view is the same as in the *Terrace*, more of the canvas is devoted to the portrayal of water and its reflections.

These paintings illustrate Monet's typically Impressionist interest in the representation of colored shadows and reflections. In the *Terrace*, the shadows on the pavement are dark gray. The creases in the flags are darker tones of their actual colors—red, yellow, and blue. Likewise, the reflection in the water of the large, dark gray sailboat is composed of more densely distributed dark green brushstrokes than the rest of the water. In the *Waterlily Pond*, the reflected foliage is transformed into relatively formless patches of color. Without the lily pads and the shore, there would be no recognizable objects at all, and no way for viewers to orient themselves in relation to nature.

Although even in late Impressionism there is never a complete absence of recognizable subject and form, the comparison of these two pictures indicates a progressive dissolution of painted edges. The brushstrokes and the paint begin to assume an unprecedented prominence. As a result, instead of accepting a canvas as a convincing reflection of reality, the viewer is forced to take account of the technique and medium in experiencing the picture. This is consistent with Monet's recommendation that artists focus on the color, form, and light of an object rather than its "verbal" content, or meaning. In that suggestion, Monet emphasized the essence of a painted object as an abstract form, and not as a replica of the thing itself. In other words, a painted "tree" is not a tree at all, but a vertical accent on a flat surface. The direct confrontation with the material of painting, which Monet articulated, was one of the most revolutionary aspects of Impressionism. It is one that has had a lasting impact on western art.

Renoir

The *Torso of a Woman in the Sun* (fig. **24.9**) of about 1875–6, by Auguste Renoir (1841–1919), is composed of patches of broken color and reflections of light. The softness of the brushstrokes creates a silky texture on the flesh as well as in the surrounding foliage. The woman seems to emerge from the landscape like a Classical Venus rising from the sea (see Botticelli's *Birth of Venus*, fig. **15.27**). Although her proportions are not quite Classical, the gesture of her right hand evokes the traditional Venus Pudica gesture of the *Medici Venus* (fig. **15.14**) and the Venuses of Botticelli and Titian (fig. **16.27**).

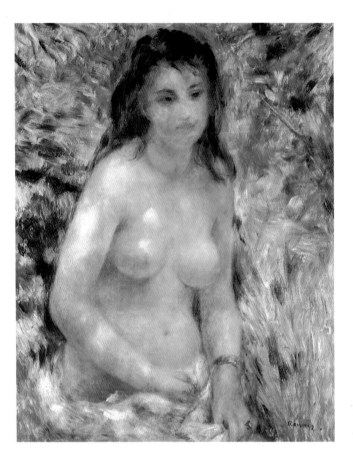

24.9 Pierre-Auguste Renoir, *Torso of a Woman in the Sun*. c. 1875–6. Oil on canvas, 31½ x 24 in (80 x 61 cm). Musée d'Orsay, Paris. Renoir survived years of financial hardship before gaining critical recognition. When he exhibited this painting in 1876, one conservative critic (Albert Wolff) called the figure a "head of decomposing flesh covered with green and purple patches, which are the sign of advanced putrefaction in a corpse."[1]

Renoir evokes a type of Classical and Renaissance Venus in the anonymous torso. But like Manet, with his *Olympia* (fig. **23.13**), Renoir has combined traditional thematic content with a new formal idiom. Although the figure is part of a continuing theme in western art, the style in which she is painted corresponds to Impressionist interest in the effects of outdoor light and color on different kinds of surfaces.

Like the *Olympia* and Titian's *Venus*, Renoir's figure is not completely nude. Her bracelet and ring accentuate the absence of clothing. The identity of the model is known (her name was Anna Leboeuf), but this is not a portrait. Her facial features seem to dissolve into the paint itself, conveying a general idea rather than portraying a specific individual.

24.8 (opposite) Claude Monet, *Bassin des Nymphéas (Waterlily Pond)*. 1904. Oil on canvas, 34½ x 35¾ in (87.6 x 90.8 cm). Denver Art Museum. In 1883 Monet moved to Giverny, a village about 50 miles (80 km) west of Paris, where he spent his later years. He built a water garden that inspired numerous "waterscape" paintings, including this one and a series of large *Waterlily* murals.

Pissarro

In contrast to the oblique, close-up views of Cassatt and Degas, Camille Pissarro's *Place du Théâtre Français* of 1898 (fig. **24.10**) is an aerial view of a Paris street. This is another innovative viewpoint that emerged during the Impressionist period. It is very likely that Pissarro (1830–1903) was influenced by photography, and by the photographer's characteristic experimentation with different viewpoints. The blurred figures walking or riding along the street, together with the asymmetry of the buildings, also suggest the eye of a camera.

Although Pissarro does not dissolve the surface details of the buildings, his figures are rendered as dark patches against a lighter pavement. The effect of the gray sky is to drain color from the street and dull it. At the same time, however, the street surface is enlivened by visible brushstrokes and reflective shadows, indicating rain, which are cast by human figures, horses, and carriages. Impressionist cityscapes offered artists an opportunity to explore the effects of outdoor light on the color and textures of the city.

24.10 Camille Pissarro, *Place du Théâtre Français, Pluie.* 1898. Oil on canvas, 29 × 36 in (73.7 × 91.4 cm). Minneapolis Institute of Arts (William Hood Dunwoody Fund).

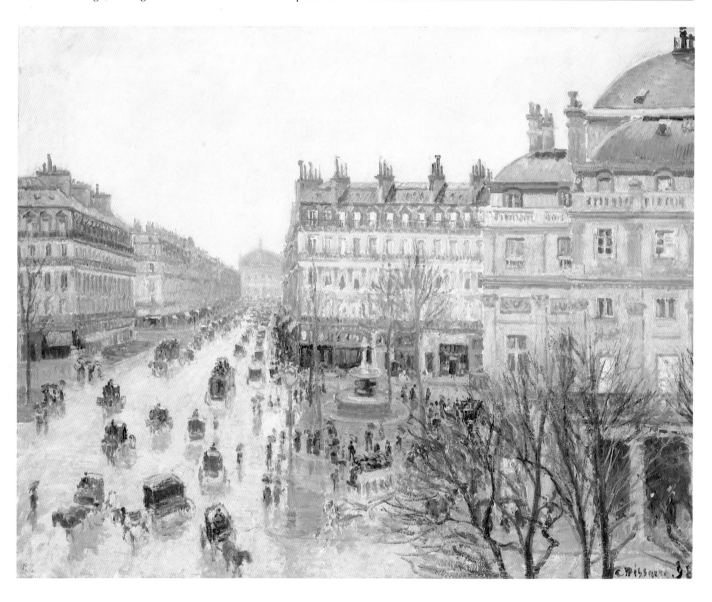

Sculpture

Rodin

The acknowledged giant of nineteenth-century sculpture was Auguste Rodin (1840–1917). His stylistic influence on twentieth-century sculpture parallels the impact of the Impressionists on the development of painting.

Rodin built up his forms in clay or wax before casting them in plaster or bronze, which was his preferred medium. A comparison of the plaster and bronze versions of Rodin's *Balzac* (figs. **24.11** and **24.12**) demonstrates his interest in conveying the dynamic, experimental process of making monumental sculpture, rather than in the finished work itself. In the plaster statue, the great French novelist looms upward like a ghostly specter wrapped in a white robe. The bronze is less spectral, but more reflective. In both versions, the material itself characterizes the surface texture of the work. The rough, unfinished surface of the plaster is reminiscent of the unpolished, often incomplete marble sculptures of Michelangelo. In the bronze, the reflecting light activates the surface and energizes it.

Both statues have the Impressionist quality of retaining the surface texture of the medium. The surface motion creates a blurred effect that recalls the prominence of Impressionist brushwork and mirrors Balzac's own dynamic spirit. The figure seems to be in an unfinished state — a not-quite-human character in transition between the unformed and the formed. Since Balzac's literary output was prodigious, his representation as a monumental, creative power evokes the raw energy of his work.

24.11 Auguste Rodin, *Balzac*. 1892–7. Plaster, 9 ft 10 in (3 m) high. Musée Rodin, Paris.

24.12 Auguste Rodin, *Balzac*. 1893–7. Bronze, 9 ft 3 in (2.82 m) high. Boulevard Raspail, Paris.

24.11 and **24.12** Rodin's revolutionary methods of working included the use of nonprofessional models in nontraditional poses. Rodin was the first major sculptor to create work consisting of less than the whole body — a headless torso, for example.

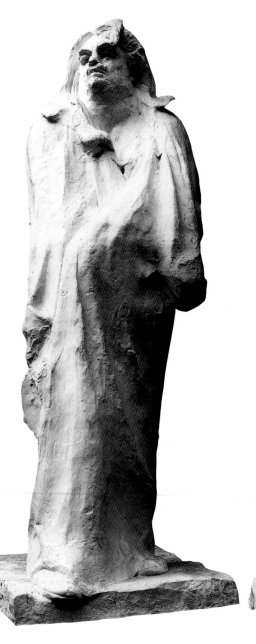
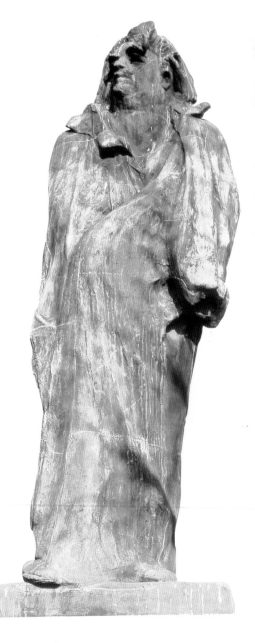

America at the Turn of the Century

Several important late nineteenth-century American artists correspond chronologically with French Impressionism. Some, such as Cassatt, lived as expatriates in Europe and worked in the Impressionist style. Others stayed in America and continued in a more Realist vein.

Winslow Homer (1836–1910), for example, visited Paris before the heyday of Impressionism. His work can be regarded as transitional between Realism and Impressionism. In *Breezing Up* (fig. **24.13**) of 1876, Homer's interest in revealing the American identity of his subjects and their place in society is evident. At the same time, however, he has clearly been influenced by the Impressionist interest in weather conditions and their effect on light and color. The sea, churned up by the wind, is rendered as broken color with visible brushstrokes. By tilting the foreground boat, Homer creates a slanted "floor" that is related to Degas's compositional technique. The interruption of the diagonal sail by the frame, together with the oblique viewpoint, suggests a fleeting moment captured by the camera.

John Singer Sargent (1856–1925), who lived in Paris in the early 1880s, espoused Impressionism wholeheartedly. But even though Sargent is considered an Impressionist painter, he and the other American Impressionists did not allow form to dissolve into paint, as did the French Impressionists. After his death, and with the advent of Modernism, Sargent was dismissed as a painter of elegant, superficial portraits, which emphasized the rich materials worn by his society patrons. But the *Daughters of Edward D. Boit* (fig. **24.14**), which he exhibited in the Salon of 1883, reveals the inner tensions of four young sisters despite their comfortable lifestyle.

The girls occupy a fashionable room decorated with elements of *japonisme*, notably the large vases and the rug. The mirror, which recalls Velázquez's *Las Meninas* (fig. **19.34**), complicates the spatial relationships within the picture, while the oblique view sets the figures above the observer. The cut-off rug and vase evoke the Impressionist "slice of life," or cropped view, and the subjects seem frozen in time. Three stare at the observer, and one leans introspectively against a vase. Two are close together and two, echoing the vases, are apart. The spaces between the figures convey psychological tension and create the impression of an internal subtext.

The style of another important American painter, Maurice Prendergast (1859–1924), clearly evolved from Impressionism. Prendergast, who was active in the late 1800s and during the first two decades of the twentieth century, was far in advance of his American contemporaries. In his *Bathers* (fig. **24.15**), he creates a mosaic effect with short, patchy brushstrokes. Despite the prominence of the brushwork, the dynamic color patterns maintain their distinctive character.

24.14 John Singer Sargent, *The Daughters of Edward D. Boit.* 1882. Oil on canvas, 7 ft 3 in x 7 ft 3in (2.21 x 2.21 m). Courtesy, Museum of Fine Arts, Boston (Gift of Mary Louisa Boit, Florence D. Boit, Jane Hubbard Boit, and Julia Overing Boit, in memory of their father, Edward Darley Boit).

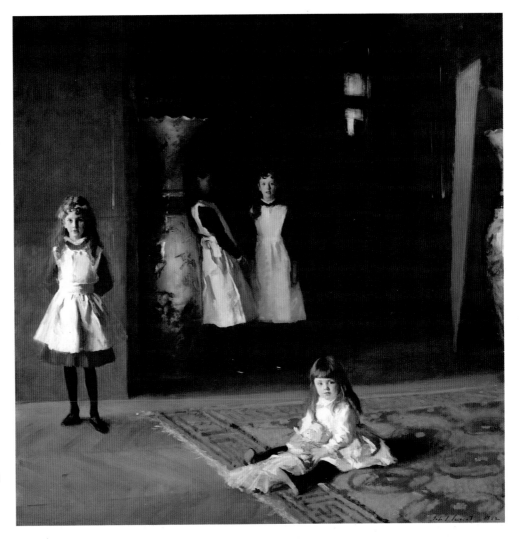

24.13 (opposite) Winslow Homer, *Breezing Up* (*A Fair Wind*). 1876. Oil on canvas, 24⅛ x 38⅛ in (61.5 x 97 cm). National Gallery of Art, Washington (Gift of the W. L. and May T. Mellon Foundation). Homer, a largely self-taught artist from Boston, worked as a magazine illustrator. At the outbreak of the Civil War, he was sent by *Harper's Weekly* to do drawings at the front. After the war, he spent a year in France. From 1873 he worked in watercolor, which became as important a medium for him as oil.

24.15 Maurice Prendergast, *Bathers.* c. 1912. Oil on canvas, 22 x 34 in (55.9 x 86.4 cm). Photo courtesy of Adelson Galleries, New York. This canvas was painted in 1912, the year in which the artist returned from Europe. He was asked in that same year to be on both the foreign and the American selection committees for the forthcoming Armory Show (see p.429).

"Art for Art's Sake"

In Paris, widespread public and critical condemnation made it difficult for the Impressionists to sell their work. In London, the celebrated libel trial between the American painter James Abbott McNeill Whistler (1834–1903) and the English art critic John Ruskin brought the esthetic conflict into the courtroom. In 1877 Ruskin wrote a scathing review of Whistler's *Nocturne in Black and Gold (The Falling Rocket)*, painted some four years earlier (fig. **24.16**). He accused Whistler of flinging "a pot of paint . . . in the public's face." Whistler himself, Ruskin implied, was a "coxcomb," guilty of "Cockney impudence" and "willful imposture."

Whistler sued Ruskin for libel, and the case went to trial in November 1878. Ruskin, who was in the throes of a psychotic breakdown, could not appear in court, but his views were presented by his attorney. According to Ruskin, Whistler's picture was outrageously overpriced at 200 guineas, quickly and sloppily executed, technically "unfinished," and devoid of recognizable form. Several of Whistler's other paintings were introduced as exhibits and declared equally "unfinished." Ruskin also objected to Whistler's musical titles (in this case "Nocturne") as pandering to the contemporary fad for the incomprehensible. The paintings themselves were not, he insisted, serious works of art.

Ironically, Ruskin had once used his critical genius to further the public reception of Turner (see p.362), himself a rather "impressionistic" artist. And in fact, Whistler was quite capable of painting clear and precise images. The famous portrait of Whistler's mother (fig. **1.5**), which also has a musical title — *Arrangement in Black and Gray* — is a remarkable psychological portrait. It conveys her dour,

24.16 (opposite) James Abbott McNeill Whistler, *Nocturne in Black and Gold (The Falling Rocket)*. c. 1875. Oil on oak panel, 23⅝ × 18½ in (60 × 47 cm). © Detroit Institute of Arts (Gift of Dexter M. Ferry, Jr.). Whistler, born in Lowell, Massachusetts, moved with his family to Russia, where his father designed the Moscow–St. Petersburg railroad. He set up art studios in Paris and London, finally settling in Chelsea. The author of *The Gentle Art of Making Enemies*, Whistler was known for his distinctive personality and biting wit. He dressed as a dandy, wearing pink ribbons on his tight, patent leather shoes and carrying two umbrellas in defiance of the inclement London weather.

puritanical character, reflected in the assertion that she lived on the top floor of her son's London house in order to be closer to God. In addition to the clarity of certain paintings, many of Whistler's etchings reveal his talent for rendering forms in a linear medium.

Whistler countered Ruskin's position by stating what was essentially the Impressionist view of art. Art was "for its own sake." It did not necessarily serve a utilitarian purpose. Although designated as a painting of fireworks on the Thames, Whistler's *Nocturne* was actually a study in light, color, and form. The atmospheric effects of the cloudy night sky are contrasted with the gold spots of light from the exploded rocket. When asked about the identity of the black patch in the lower right corner, Whistler replied that it was a vertical, placed there for purely formal reasons. He refused to define the beauty of the painting on the grounds that to do so would be like trying to explain the beauty of musical harmony to one who had no ear for music. On the subject of money, Whistler testified that he had spent only a day and a half painting the *Nocturne*, but was charging for the experience of a lifetime.

The jury followed the judge's instructions and decided in Whistler's favor, but awarded him only a farthing in damages. The historical significance of this absurd trial is its function as a window on esthetic conflict in a cultural context. Whistler later referred to the trial as a conflict between the "brush" and the "pen." It exemplified the rise of the critic as a potent force in the nineteenth-century art world. Although Ruskin had shown foresight when dealing with his own contemporaries, he did not have the same vision when it came to the younger generation of Impressionists. He was not alone. The French public also failed to recognize the merits of Impressionism. As a result, many important nineteenth-century French paintings were bought by foreigners and are now in important collections outside France.

The history of western art is fraught with esthetic "quarrels," but passions rose to new heights in the Impressionist period. For the first time, the material of art became the subject of art, and content gave way to style. More than anything else, it is this dissolution of form that seems to have been the cause of the critical outrage. It is this very development, however, that proved to have the most lasting impact on western art.

Post-Impressionism and the Late Nineteenth Century

The term Post-Impressionism, meaning "After-Impressionism," is used to designate the work of a group of important late nineteenth-century painters. Although their styles are quite diverse, they are united by the fact that nearly all were influenced in one way or another by the Impressionist style. Like the Impressionists, the Post-Impressionists were drawn to bright color and visible, distinctive brushstrokes. Despite the prominent brushwork, however, Post-Impressionist forms do not dissolve into the medium as completely as they do, for example, in the late works of Monet. The edges in Post-Impressionist works, whether outlined or defined by sharp color separations, are relatively clear.

Certain Post-Impressionist artists were also affected by the late nineteenth-century Symbolist movement. Symbolists rejected both the social consciousness of Realism (see Chapter 23) and the Impressionist interest in nature and the outdoors. They were attracted instead by the internal world of the imagination. Their interest has affinities with Goya's Romantic preoccupation with dreams, and possibly even with Géricault's studies of the insane (see p.352).

Post-Impressionist Painters

Toulouse-Lautrec

Henri de Toulouse-Lautrec (1864–1901) based his most characteristic work on the nightlife of Paris. He frequented dance halls, nightclubs, cafés, and bordellos in search of subject matter. The loose, sketchy brushwork, which is contained within clearly defined color areas, contributes to the sense of dynamic motion in his paintings. He enlivens the surface by creating an illusion of the textures depicted. In the *Quadrille at the Moulin Rouge* (fig. **25.1**), the woman facing the viewer exudes an air of determined, barely contained, energy about to erupt in dance. As well as being the opening position for a quadrille, her stance is a challenge to the other dancers. Like Degas,

Toulouse-Lautrec favored partial, oblique views, which suggest photographic cropping. He also employed strong silhouettes, which offset the more textured areas of the painting surface.

In contrast to the textured surfaces of his paintings, Toulouse-Lautrec's lithograph posters consist of flat, unmodeled blocks of color. The poster — which Lautrec popularized at the end of the nineteenth century — was not only an art form. Like the print techniques used by the

The Symbolist Movement

Symbolism was particularly strong in France and Belgium in the late nineteenth century. It began as a literary movement, emphasizing internal, psychological phenomena rather than objective descriptions of nature.

The English word "symbol" comes from the Greek *sumbolon*, or "token." It originally referred to a sign that had been divided in two, and could therefore be identified by virtue of the fact that the two halves fitted together. A symbol thus signifies the matching part, or other half. It is something that stands for something else. Symbols derive from myth, folklore, allegory, dreams, and other unconscious phenomena. The Symbolists believed that, by focusing on the internal world of dreams, it was possible to rise above the here and now of a specific time and place, and arrive at the universal. It is no coincidence that the Symbolist movement in art and literature was contemporary with developments in modern psychology, most notably psychoanalysis.

In literature, the poets' "Symbolist Manifesto" of 1886 rejected Zola's Naturalism (see p.365) in favor of the Idea and the Self. The French poets Charles Baudelaire, Stéphane Mallarmé, and Paul Verlaine became cult figures for the Symbolists, as did the American writer Edgar Allen Poe and the Swedish philsopher Emanuel Swedenborg. Their literature of decadence, disintegration, and the macabre shares many qualities with Symbolist painting. An erotic subtext, often containing perverse overtones, pervades and haunts the imagery.

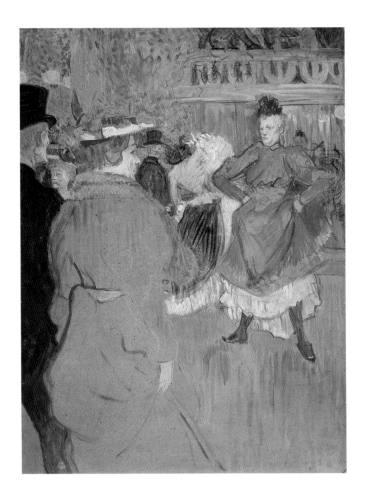

25.1 Henri de Toulouse-Lautrec, *Quadrille at the Moulin Rouge*. 1892. Gouache on cardboard, 31½ x 23¾ in (80 x 60.5 cm). National Gallery of Art, Washington (Chester Dale Collection). The Moulin Rouge was (and still is) a popular music hall in Montmartre. It was here, in the artistic and entertainment center of Paris, that Toulouse-Lautrec lived and worked. He was descended from the counts of Toulouse and, although his family disapproved of his lifestyle, his wealth saved him from the poverty suffered by many artists of his generation. He died at age thirty-seven from the effects of alcoholism.

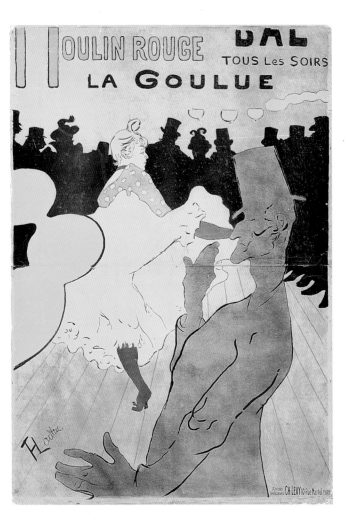

25.2 Henri de Toulouse-Lautrec, *La Goulue at the Moulin Rouge*. 1891. Lithograph, 5 ft 5 in x 3 ft 10 in (1.65 x 1.17 m). Philadelphia Museum of Art (Gift of Mr. and Mrs. R. Sturgis Ingersoll). At fifteen, two accidents left Toulouse-Lautrec with permanently stunted legs. Perhaps because of his own disability, dancers had a particular attraction for him. La Goulue was one of the professional dancers who, along with singers, circus performers, and prostitutes, were among his favorite subjects.

Realists for social and political purposes, posters made information available on a broad scale. *La Goulue at the Moulin Rouge* (fig. **25.2**) is a good example of this combination. Because the purpose of a poster is to advertise an event, words necessarily form part of the message. In *La Goulue*, the letters are integrated with the composition by repetition of the lines and colors of the printed text within the image. The blacks of "BAL" ("Dance") and "LA GOULUE" recur in the silhouetted background crowd and the stockings of the dancer. The flat bright color of "MOULIN ROUGE" is echoed in the dress. And the thin, dark lines of "TOUS Les SOIRS" ("Every Evening") are repeated in the floorboards and the outlines of the figures.

Cézanne

The Post-Impressionist who was to have the most powerful impact on the development of western painting was Paul Cézanne (1839–1906). He, more than any artist before him, transformed paint into a visible structure. Cézanne's early pictures were predominantly black and obsessed with erotic or violent themes. He exhibited with the Impressionists and, under the influence of Pissarro (see p.390), his palette became brighter, and his subject matter more restricted.

In the *Still Life with Apples* (fig. **25.3**) of c. 1875–7, painted at the height of his Impressionist period, Cézanne subordinates narrative to form. He combines the rich thematic associations of the apple in western imagery with a new, architectural abstraction. Cézanne's punning

assertion that he wanted to "astonish Paris with an apple" is nowhere more evident than in this work. Seven brightly colored apples are set in a slightly darker surface. Each is a sphere, outlined in black and built up with patches of color — reds, greens, yellows, and oranges — like the many facets of a crystal. Light and dark, as well as color, are created by the arrangement of the brushstrokes in rectangular shapes.

The apples are endowed with a life of their own. Each seems to be jockeying for position, as if it has not quite settled in relation to its neighbors. The shifting, animated quality of these apples creates dynamic tension, just as the crystalline structure of the brushstrokes does. Nor is it entirely clear what the apples are resting on, for the unidentified surface beneath them also shifts. As a result, the very space of the picture is ambiguous, and the image has abstract, iconic power.

25.3 Paul Cézanne, *Still Life with Apples.* c. 1875–7. Oil on canvas, 7½ × 10¾ in (19.1 × 27.3 cm). By kind permission of the Provost and Fellows of King's College, Cambridge, England (Keynes Collection). Cézanne was born and lived most of his life in Provence, in the south of France. He studied law before becoming a painter. In 1869 he began living with Hortense Fiquet, by whom he had a son in 1872. They married in 1886, the year his father died.

An Apple a Day . . .

Since its portrayal as the "forbidden fruit" in the Garden of Eden, the apple has had a prominent place in the western imagination. The traditional associations of the apple with health ("an apple a day keeps the doctor away") and love ("the apple of one's eye") are still apparent in current popular expressions.

In Greek mythology, Heracles (whose Roman name was Hercules) had to steal the golden apples of the Hesperides. The apple is also central to the legends of Troy. The Trojan prince Paris judged a beauty contest between three goddesses — Athena, Hera, and Aphrodite. He awarded the prize of an apple to Aphrodite, who had promised him the most beautiful woman in the world. The fact that the woman was Helen of Troy was the cause of the Trojan War.

Cézanne's pun condenses the Paris of Greek myth with Paris, the capital city of France. In astonishing "Paris" (in the latter sense), Cézanne wins the mythical beauty contest and becomes a Hercules among painters.

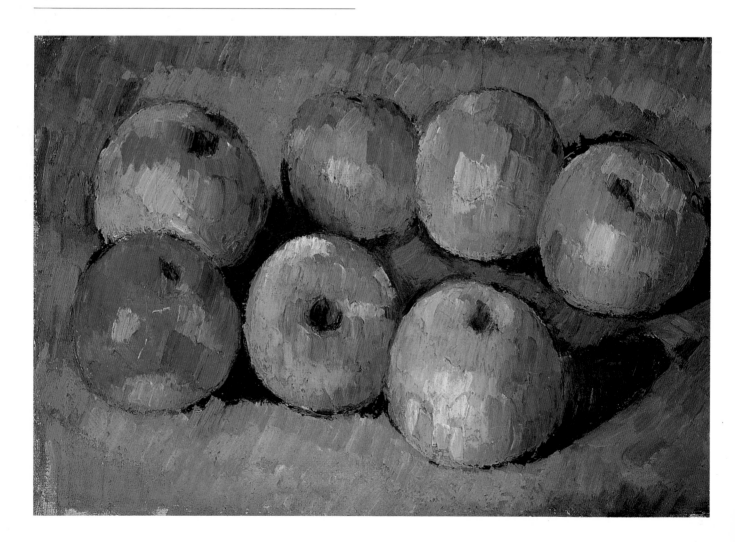

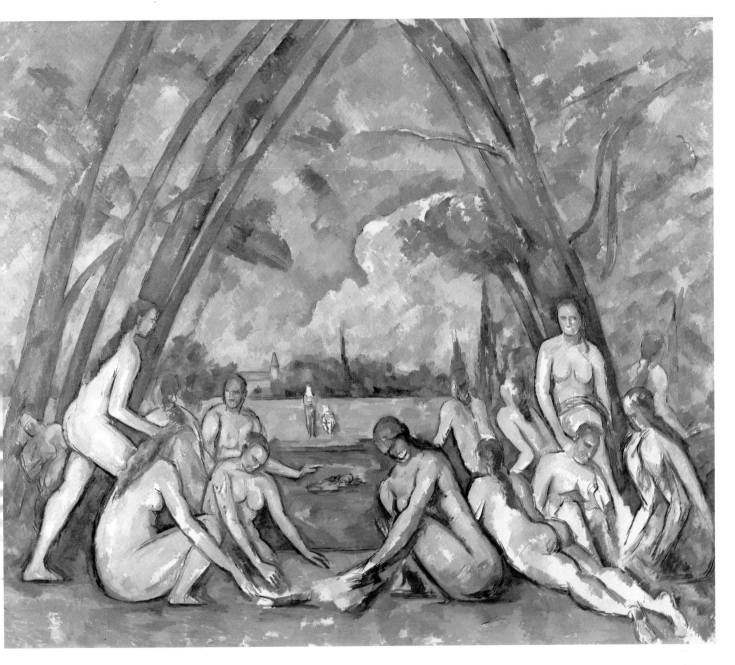

In 1887 Cézanne's active involvement with the Impressionists in Paris ended and he returned to his native Provence. Having integrated Impressionism with his own objectives, he now focused most of his energy on the pursuit of a new pictorial approach. In *The Great Bathers* (fig. 25.4), painted toward the end of his life, Cézanne achieved a remarkable synthesis of a traditional subject with his innovative technique of spatial construction.

As in the *Still Life with Apples*, there is no readily identifiable narrative in *The Great Bathers*. A group of nude women occupy the foreground. They blend with the landscape through pose and similarity of construction, rather than through Impressionist dissolution of form. They form the base of a towering pyramidal arrangement, which is carried upward by the arching trees. Two smaller figures visible across a river repeat the distant verticals.

Cézanne's new conception of space is evident in the relationship of the sky and trees. He depicts air and space,

25.4 Paul Cézanne, *The Great Bathers*. 1898–1905. Oil on canvas, 6 ft 10 in x 8 ft 3 in (2.08 x 2.52 m). Philadelphia Museum of Art (W. P. Wilstach Collection).

as well as solid form, as a "construction." Through his technique of organizing the brushstrokes into rectangular shapes, his surfaces, such as the sky, become multifaceted patchworks of shifting color. In certain areas — the tree on the left, for example — patches of sky overlap the solid forms. This results in spatial ambiguity, and traditional distinctions between foreground and background no longer apply. In this breakdown of the spatial conventions of western art, Cézanne created a revolution in the painter's approach to the picture plane. It was a revolution made possible by the Post-Impressionist synthesis of the prominent brushstroke and the clear outline.

Seurat

In his own brand of Post-Impressionism, shortlived though it was, Georges Seurat (1859–91) combined Cézanne's interest in volume with Impressionist subject matter. His most famous painting, *Sunday Afternoon on the Island of La Grande Jatte* (fig. 25.5), monumentalizes a scene of leisure by filling the space with volumetric, rigid, iconic forms. Human figures, animals, and trees are frozen in time and space. Motion is created formally, by contrasts of color, silhouettes, and repetition, rather than by the figures themselves.

Seurat called himself a "divisionist." He has also been called a Neo-impressionist and a Pointillist, after his process of building up forms through dots, or points, of pure color. In contrast to Cézanne's outlined forms, Seurat's are separated from each other by the grouping of dots according to their color. In the detail of the girl holding the spray of flowers (fig. 25.6), the individual dots are quite clear.

Seurat's Pointillism was based on two relatively new theories of color. The first was that placing two colors side by side intensified the hues of each. There is in *La Grande Jatte* a shimmering quality, in the areas of light and bright color, which tends to support this theory. The other theory, which is only partly confirmed by experience,

asserted that the eye causes contiguous dots to merge into their combined color. Blue dots next to yellow dots, according to this theory, would merge and be perceived as green. If the painting is viewed from a distance or through half-closed eyes, this may be true. It is certainly not true if the viewer examines the picture closely, as the illustration of the detail confirms. True or not, such theories are characteristic of the search by nineteenth-century artists for new approaches to light and color, based on scientific analysis.

Van Gogh

Vincent van Gogh (1853–90), the greatest Dutch artist since the Baroque period (see p.315), devoted only the last ten years of his short life to painting. He began with a dark palette and subjects that reflected a social consciousness reminiscent of nineteenth-century Realism.

When van Gogh arrived in France and met the Impressionists, however, his palette expanded. In 1887 he painted the *Portrait of Père Tanguy* (fig. **25.7**), in which vibrant color has supplanted the somber tones of his early pictures. The brushstrokes are thick, clear, and separated from each other, creating the surface animation that characterizes van Gogh's work after 1886. The Japanese

25.6 (opposite) Detail of fig. **25.5**.

25.5 (opposite, below) Georges Seurat, *Sunday Afternoon on the Island of La Grande Jatte*. 1884–6. Oil on canvas, 6 ft 9 in x 10 ft ⅜ in (2.08 x 3.08 m). Art Institute of Chicago (Helen Birch Bartlett Memorial Collection). Seurat's painstaking and systematic technique reflected his scientific approach to painting. For two years he made many small outdoor studies, before painting the large final canvas of *La Grande Jatte* in his studio. In 1886 it was unveiled for the last Impressionist Exhibition.

25.7 (right) Vincent van Gogh, *Portrait of Père Tanguy*. 1887. Oil on canvas, 25½ x 20 in (64.8 x 50.8 cm). Private Collection. Unable to sell his works, van Gogh relied on his brother Theo, an art dealer in Paris, for most of his financial support. Père Tanguy was a Paris dealer in art supplies who helped the artist by showing his canvases in his shop window. In a letter to Theo, Vincent compared Tanguy with Socrates, and expressed the wish to be like him. Tanguy's frontal pose, hands crossed in front of him, is reminiscent of Buddha, who was also one of van Gogh's ideal figures.

25.8 (above) Vincent van Gogh, *Wheatfield with Reaper.* 1889. Oil on canvas, 29¼ x 36¼ in (74.3 x 92.1 cm). Vincent van Gogh Foundation/van Gogh Museum, Amsterdam. Van Gogh described the "all yellow, terribly thickly painted" figure as Death, who reaps humanity like a wheat field. The yellow symbolically derives its power from the sun, which is the painting's source of light. Here it determines the color of the entire picture, and its intensity seems to "heat" the scene.

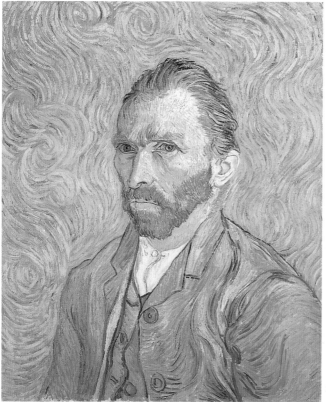

25.9 Vincent van Gogh, *Self-Portrait.* 1889. Oil on canvas, 25½ x 21¼ in (64.8 x 54 cm). Musée d'Orsay, Paris. Van Gogh's mental instability, no doubt aggravated by overwork and excessive drinking, led to his cutting off part of his ear in a fit of rage. He committed himself to an asylum, and died in 1890 from a self-inflicted gunshot wound.

prints in the background reflect the artist's attraction to their colorful patterns and bold contrasts of light and dark. Their partial character — each is cut by the painting's frame — reflects the Impressionist preference for works of art that represent a "slice of life." Here, however, the cropping also serves to intensify the contrast between the colorful background movement and Père Tanguy's static, iconic character.

Van Gogh shared the Impressionist passion for landscape. *Wheatfield with Reaper* (fig. 25.8) illustrates his genius for intense, expressive color. The frenzied curves in the wheat — actually formed with individual brush-

strokes — repeat the curve of the reaper's scythe. But despite the unforgettable power of van Gogh's brushwork, his forms never dissolve completely. The areas of color are maintained as distinct shapes, and the power of the color, by virtue of its containment, exceeds that of Impressionism.

Like Rembrandt (see p.318), whom he had surely studied in his native Holland, van Gogh painted many self-portraits. Whereas Rembrandt created physiognomy and character primarily by variations in lightness and darkness, van Gogh did so with color. Aside from the yellows and oranges of the face and hair, the *Self-Portrait* (fig. **25.9**) is very nearly monochromatic. The main color is a pale blue-green, varying from light to dark in accordance with the individual brushstrokes. The jacket remains distinct from the background by its darkened color and outline.

Although the figure itself is immobile, the pronounced spiraling, wavy brushstrokes undulate over the surface of the picture plane. Van Gogh's personal relationship to the color is indicated by the yellow, which is a component of both the orange and the blue-green. His intense gaze is also achieved through color. The whites of his eyes are not white at all, but the same blue-green as the background. As a result, the observer has the impression of looking through van Gogh's skull at eyes set far back inside his head.

25.10 Paul Gauguin, *Nevermore*. 1897. Oil on canvas, 1 ft 11⅞ x 3 ft 9⅝ in (0.61 x 1.16 m). Courtauld Institute Galleries, London. Although Gauguin's style changed little after he left France, Polynesian life and culture became the subjects of his work. Gradually, poverty and syphilis undermined his health, and he died at the age of fifty-five, after at least one suicide attempt.

Gauguin

Compared to the dynamic character of van Gogh's pictorial surfaces, Paul Gauguin (1848–1903) applied his paint smoothly. Although Gauguin's colors are bright, they are arranged in flat, unmodeled shapes, usually outlined in black. The surfaces of his pictures seem soft, even silky, in contrast to the energetic rhythms of van Gogh's brushstrokes.

Gauguin began his career under the aegis of the Impressionists — he exhibited with them from 1879 to 1886 — and then went on to explore new approaches to style. In *The Yellow Christ* (fig. **25.11**) of 1889, Gauguin identifies with the new Symbolist movement. He sets the Crucifixion in a Breton landscape and depicts Christ in flattened yellows. Three women in local costume encircle the cross — a reference to traditional Christian symbolism, in which the circle signifies the Church. This juxtaposition of the Crucifixion with the late nineteenth-century landscape of northern France is a temporal and spatial condensation that is characteristic of the dream world depicted by Symbolist writers and artists.

In 1891 Gauguin sold thirty paintings to finance a trip to Tahiti. Apart from a brief return to France in 1895, he spent the rest of his life in the South Sea islands. In his Tahiti paintings, Gauguin synthesized the Symbolist taste for dreams and myth with native subjects and traditional western themes. *Nevermore* (fig. **25.10**), for example, depicts a Tahitian version of the reclining nude. The brightly colored forms suggest the influence both of Japanese prints and of native designs. The formal patterns enliven the composition and contrast with the immobility of the nude.

Gauguin has infused the traditional reclining nude with a new sense of danger and suspicion. She evidently knows of the danger, since she rolls her eyes, as if aware of the two women talking in the background. The title of the picture, spelled out in the upper left corner, echoes the refrain of Edgar Allan Poe's poem *The Raven*. The same bird stands on a shelf, between the title and the whispering women, and stares at the nude. This juxtaposition of raven, nude, and talking women hints at a silent, but sinister, communication. In this combination of Tahitian imagery and western themes, self-consciously imbued with a psychic dimension, Gauguin merges his personal brand of Post-Impressionism with a Symbolist quality.

Artists on Art

Gauguin's later attraction to the brown tones of his Polynesian subjects is foreshadowed by his symbolist use of color in the *Yellow Christ*. An interesting twentieth-century echo of this painting is the *Crucifixion* (fig. **25.12**) by the American artist Bob Thompson (1937–66), whose early death from a drug overdose cut short a promising career. Thompson was born in Louisville, Kentucky. One of his ancestors was an American Indian; others were slaves. During his training he was influenced by Renaissance painters, particularly Masaccio and Piero della Francesca.

Thompson's combination of his self-image as an African-American with the psychology of color merges contemporary concerns with nineteenth-century Symbolism. The foreshortened crucified figure in red on the right (Christ's left) is the artist's self-portrait and possibly, therefore, his self-image as a sinner. The yellow Christ, on the other hand, is clearly borrowed from Gauguin.

25.11 Paul Gauguin, *The Yellow Christ*. 1889. Oil on canvas, 36¼ × 28⅞ in (92.1 × 73.3 cm). Albright-Knox Art Gallery, Buffalo, New York. In 1873 Gauguin married a Danish piano teacher, with whom he led a stable middle-class life and had five children. In 1882 he became a full-time painter and deserted his family. After a turbulent year with van Gogh in Arles in the south of France, Gauguin returned to Brittany in 1889. During this period, he was influenced by the Symbolists and his work assumed a spiritual, self-consciously symbolic quality.

25.12 Bob Thompson, *Crucifixion*. 1963–4. Oil on canvas, 5 × 4 ft (1.52 × 1.22 m). Private collection. Photo Maggie Nimkin. The blue Mary has red hair, similar to that of Thompson's Caucasian wife, with whom she can be identified. The painting not only reflects Thompson's concern over racial issues, but also shows the correlation between his personal and artistic identity as a "man of color." It further reveals his familiarity with Italian Renaissance art, in which the Virgin is typically depicted in blue and red draperies.

Symbolism

The Symbolists gave imagination precedence over nature. They were drawn to mythological subject matter because of its affinity with dreaming. Their rendition of myth was neither heroic in character nor Classical in style. Rather, it was disturbed and poetic, and contained more than a hint of perversity.

Moreau

Gustave Moreau (1826–98) was the leader of the Symbolist movement in France. His *Orpheus* (fig. **25.13**) is an imaginary scene from Greek myth. Orpheus was a musician who was killed and torn limb from limb by the maenads, or frenzied female followers of Dionysus. A young woman dressed in rich fabrics gazes down at the head of Orpheus

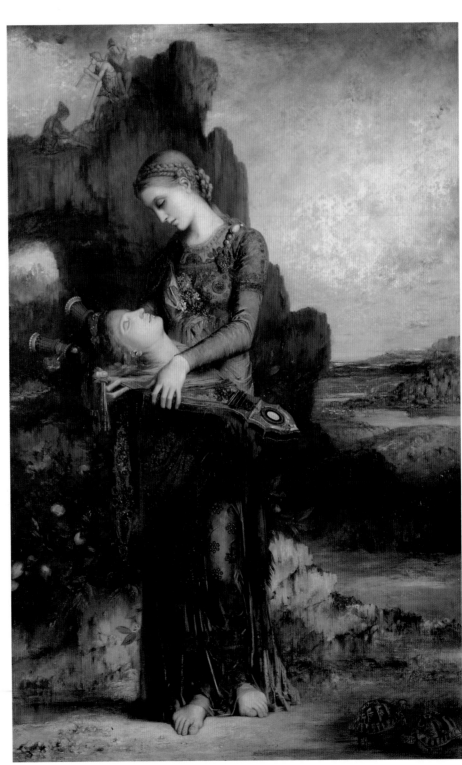

25.13 Gustave Moreau, *Orpheus.* 1865. Oil on canvas, 5 ft 1 in x 3 ft 3½ in (1.55 x 1 m). Louvre, Paris. This painting was shown in the Paris Universal Exposition of 1867. The two turtles in the lower right corner, an apparently anomalous feature, may refer to the legend that Orpheus made his lyre by stringing a hollow tortoiseshell. To a public that knew the story of Orpheus, this painting must have seemed macabre indeed.

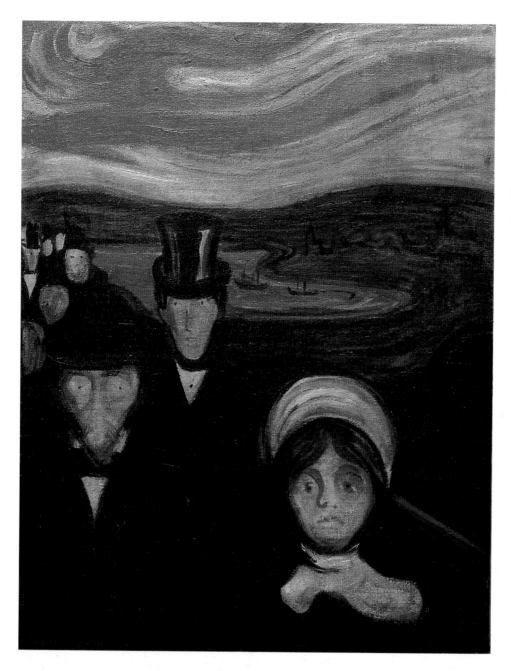

25.14 Edvard Munch, *Anxiety*. 1894. Oil on canvas, 37 × 28¾ in (94 × 73 cm). © Munch Museum, Oslo. In 1892 Munch received electric shock treatment for depression and lived thereafter in almost total seclusion. *Anxiety* is one of Munch's favorite themes, along with death, illness, despair, and other forms of personal suffering. The woman in the painting is possibly Mrs. Heiberg, Munch's first love, with whom he was obsessed. According to his notes, he saw her in every woman he passed on the street.

as it lies across his lyre. Both she and the head are somewhat idealized, and there is a sense of languid passivity in their expressions, enhanced by the soft, unreal yellow light. The idyllic episode at the top of the craggy mountain on the left, together with the peaceful quality of Orpheus and the woman, belie the violence that has preceded the present moment.

Munch

A comparison of Moreau's *Orpheus* with other works discussed in this chapter makes it clear that, while the ideas of the Symbolists influenced certain Post-Impressionists, the Symbolist style, or form, did not. The Norwegian artist Edvard Munch (1863–1944) went in 1889 to Paris, where he came into contact with both Impressionism and Post-Impressionism. The combination of Symbolist content with Post-Impressionist form was particularly well suited to Munch's character.

Munch's mental suffering, like van Gogh's, is so openly acknowledged in his imagery and statements that it is unavoidable in considering his work. His pictures conform to Symbolist theory in that they depict a state of mind, an emotion, or an idea, rather than a physical reality that can be externally observed. The style in which his mental states are expressed, however, is Post-Impressionist.

In *Anxiety* (fig. **25.14**), painted in 1894, the state of mind is specified in the title. The vivid, swirling colors of sky and water echo the artist's fear of internal disintegration. A woman, who is about to walk out of the picture and

thus out of Munch's sight, is followed by a relentless crowd of skeletal men in black coats and top hats. Like retribution itself, they are inevitable and endless. Munch wrote as follows about *Anxiety*: "I saw all the people behind their masks—smiling, phlegmatic—composed faces—I saw through them and there was suffering—in them all—pale corpses—who without rest ran around—along a twisted road—at the end of which was the grave."[1]

The remainder of this text surveys the major styles of twentieth-century art, which derive from certain nineteenth-century developments. Realism had introduced a new social consciousness into the visual arts, and Impressionism had made artists and viewers alike aware of the potentially expressive power of the medium itself. Post-Impressionists explored various ways in which the individual brushstrokes could enhance images, even to the point where the paint intruded on the subject. At the same time, Symbolism took up the Romantic interest in giving visual form to states of mind. The nineteenth century ended with an artist in whose work both the medium and the imagination were combined as new subjects in western art.

Rousseau

Although Henri Rousseau (1844–1910) worked largely during the latter part of the nineteenth century, his impact on western art history must be seen in the context of the first half of the twentieth century. He has been called a "**naive**" painter because he had no formal training. Rousseau spent most of his early life working as a customs inspector near Paris—hence his nickname *Le Douanier* ("customs man"). He painted in his spare time and exhibited at the Salon des Indépendants, before retiring in 1885 to become a fulltime painter. At first mocked by critics, Rousseau was later much admired. In 1908 Pablo Picasso gave a banquet in his honor at his Montmartre studio.

Rousseau's last great painting, *The Dream* (fig. **25.15**), was painted in 1910, shortly before his death, and eleven years after the publication of Sigmund Freud's *The Interpretation of Dreams*. The painting shows a nude, reclining but alert, who has been transported on a Victorian couch

25.15 Henri Rousseau, *The Dream*. 1910. Oil on canvas, 6 ft 8½ in x 9 ft 9½ in (2.05 x 2.99 m). The Museum of Modern Art, New York (Gift of Nelson A. Rockefeller).

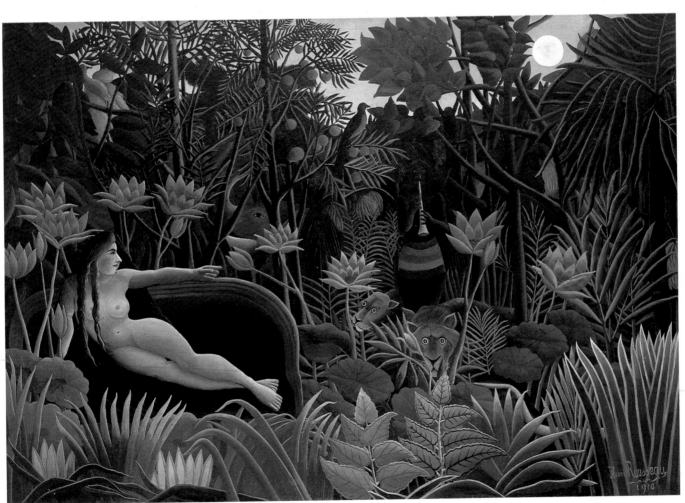

The Mechanisms of Dreaming

In 1899 Sigmund Freud published *The Interpretation of Dreams*. Although initially only a few copies were sold, its impact on western thought has been enormous. The mechanisms of dreaming as defined by Freud are four in number:

1 *Representability*—also a condition of painting or any form of image-making—means that an idea or feeling can be changed into a picture. The dream picture is an automatic and unconscious regression from words to images, whereas works of art are products of the conscious mind.

2 *Condensation* merges more than one element into a new, disguised form. In Rousseau's *The Dream*, for example, the jungle is condensed with a European sitting room, and day is condensed with night.

3 *Displacement* involves moving an element from its usual setting to another place. The dark musician is an example of displacement, for the features of a non-human creature have been displaced onto him. Displacement can result in condensation. Thus, it is by displacing the couch into the jungle that the geographical condensation is achieved.

4 *Symbolization* is the process of symbol-making. A symbol is something that stands for something else. In *The Dream*, the flowers, fruit, and serpent may be interpreted as symbols of the dreamer's sexual fantasies. The same can be said of the musician and the jungle setting, and even of the reclining nude herself, who is a conventional representation of female sexuality in western art.

to a jungle setting, complete with wild animals, and abundant flowers and foliage. Despite their slightly sinister cast, the animals are tame. Emerging from the jungle depths is a dark, gray creature. Clothed and upright, simultaneously animal and human, he plays a musical instrument. The bizarre gray of his face and skin is at odds with the bright jungle colors. The daytime sky is at odds with the normal time for dreaming, which is night.

When asked about the unlikely juxtaposition of the couch with the jungle in *The Dream*, Rousseau gave two answers. In the first, he said that the woman is the dreamer. She is sleeping on the couch, and both have been transported to the jungle. In the second, he said that the couch was there simply because of its red color. In the French journal *Soirées de Paris* (15 January 1914), Rousseau published the following inscription for the painting:

> In a beautiful dream
> Yadwigha gently sleeps
> Heard the sounds of a pipe
> Played by a sympathetic charmer
> While the moon reflects
> On the rivers and the verdant trees
> The serpents attend
> The gay tunes of the instrument.

In one sense *The Dream* can be regarded as a synthesis of the two main trends in western European art at the turn of the century. For lack of better terminology, these trends may be described as "subjectivity" (one of the primary characteristics of Romanticism and Symbolism) and "objectivity" (the ideal aspired to by the Realists and Impressionists). In *The Dream*, Rousseau merges the visionary world of dream and imagination with a detailed depiction of reality. To this end, he made a careful study of leaves and flowers before painting them, although their very "reality" in this painting has an eery quality. However, *The Dream* is remarkably consistent with Freud's account of the mechanisms of dreaming. Rousseau's image merges dream (the picture) and dreamer (the nude). Its precise, clear edges serve to contain the wild character of the jungle, which represents the primitive forces revealed in dreams.

PART SIX
THE TWENTIETH CENTURY

	Style	Artist	Works of Art	Cultural/Historical Developments
1900	BLUE PERIOD	Picasso	*The Old Guitarist* (p.412)	Freud, *Interpretation of Dreams* (1900)
	EXPRESSIONISM	Kollwitz	*Whetting the Scythe* (p.414)	Max Planck formulates quantum theory (1900)
	EARLY CUBISM	Picasso	*Gertrude Stein* (p.420) *Les Demoiselles d'Avignon* (p.421)	Radioactivity first postulated (1904) Edith Wharton, *House of Mirth* (1905)
	FAUVISM	Matisse	*Madame Matisse (The Green Line)* (p.413) *Harmony in Red* (p.417)	Albert Einstein, *Special Theory of Relativity* (1905) Upton Sinclair, *The Jungle* (1906)
	PRAIRIE STYLE	Wright	Robie House (p.432)	Ford Motor Company produces first Model T (1908) E. M. Forster, *A Room with a View* (1908)
1910	ANALYTIC CUBISM	Picasso Braque	*Head of a Woman* (p.423) *Violin and Pitcher* (p.422)	Stravinsky, *The Firebird* (1910) Armory Show (1913)
	THE BRIDGE	Kirchner	*Five Women in the Street* (p.415)	Thomas Mann, *Death in Venice* (1913)
	DEVELOPMENTS OF CUBISM	Brancusi	*Mlle. Pogany* (p.429)	Niels Bohr formulates theory of atomic structures (1913)
	THE BLUE RIDER	Kandinsky	*Painting Number 201* (p.416)	World War I (1914–18) Margaret Sanger jailed for views on birth control (1915)
	FUTURISM	Boccioni Léger	*Unique Forms of Continuity in Space* (p.426) *The City* (p.427)	Bolshevist Revolution in Russia (1917) Versailles Peace Conference (1919)
1920	DE STIJL	van Doesburg	*Composition (The Cow)* (p.30)	
	DADA	Duchamp	*L.H.O.O.Q.* (p.436)	League of Nations established (1920)
	SYNTHETIC CUBISM	Picasso	*Three Musicians* (p.425)	T. S. Eliot, *The Waste Land* (1922)
	BAUHAUS	Gropius	The Bauhaus (p.434)	Adolf Hitler, *Mein Kampf* (1925) F. Scott Fitzgerald, *The Great Gatsby* (1925)
	INTERNATIONAL STYLE	Rietveld Le Corbusier	Schroeder House (p.433) Villa Savoye (p.434)	Television invented (1926) Wall Street stock market crash (1929)
1930	SURREALISM	Man Ray Magritte	*Le Violon d'Ingres* (p.439) *Time Transfixed* (p.442)	Ernest Hemingway, *A Farewell to Arms* (1929)
	REGIONALISM	Wood	*American Gothic* (p.445)	Virginia Woolf, *A Room of One's Own* (1929) Eugene O'Neill, *Mourning Becomes Electra* (1931) Aldous Huxley, *Brave New World* (1932)
	CUBISM/SURREALISM	Picasso	*Guernica* (p.425)	Spanish Civil War begins (1936)
1940	SOCIAL REALISM	Lawrence	*Harriet Tubman Series, No. 7* (p.446)	Germany invades Poland; World War II (1939–45)
	NEO-PLASTICISM	Mondrian	*Broadway Boogie Woogie* (p.428)	Atomic bomb dropped on Hiroshima (1945)
	COLLAGE	Matisse	*Jazz* (p.419)	George Orwell, *Nineteen Eighty-Four* (1949)
1950	ABSTRACT EXPRESSIONISM	Pollock de Kooning	*Black and White* (p.452) *Woman and Bicycle* (p.453)	Korean War (1950–3) J. D. Salinger, *The Catcher in the Rye* (1951) Samuel Beckett, *Waiting for Godot* (1952)
	COLOR FIELD	Rothko	*Green on Blue* (p.455)	Tennessee Williams, *Cat on a Hot Tin Roof* (1954)
1960	POP ART	Hamilton Johns Warhol	*Just what is it that makes . . . ?* (p.461) *Three Flags* (p.462) *200 Campbell's Soup Cans* (p.464)	Leonard Bernstein, *West Side Story* (1957) Construction of Berlin Wall (1961) President John F. Kennedy assassinated (1963) The Beatles, *I Want to Hold Your Hand* (1964)
	MINIMALISM	Judd	*Untitled* (p.468)	Martin Luther King assassinated (1968)
1970	PHOTOREALISM	Close	*Self-Portrait* (p.470)	James D. Watson, *The Double Helix* (1968) Apollo 11 lands on moon (1969)
	PERFORMANCE ART	Gilbert & George	*Singing Sculptures* (p.471)	End of Vietnam War (1973)
	ENVIRONMENTAL ART	Smithson	*Spiral Jetty* (p.478)	Watergate investigation; resignation of Nixon (1974)
1980	OP ART	Riley	*Aubade* (p.468)	Solzhenitsyn, *The Gulag Archipelago: 1918–56* (1974)
	POST-MODERNISM	Moore & Hersey	Piazza d'Italia (p.475)	
1990	WEST COAST ABSTRACTION	Diebenkorn	*Ocean Park No. 129* (p.457)	Communist governments in eastern Europe fall (1989) Reunification of East and West Germany (1990)
	ENVIRONMENTAL ART	Christo	*The Umbrellas*, Japan–U.S.A. (p.479)	Dissolution of U.S.S.R. (1992)

Turn of the Century: Early Picasso, Fauvism, Expressionism, and Matisse

Western history is traditionally divided into centuries, and historians tend to see significance in the "turn of a century." Given the span of human history from the Paleolithic era, in which the first known works of art were produced, a century represents a small, almost infinitesimal, fragment of time. Nevertheless, as we consider historical events that are closer to our own era, their significance seems to increase, and time itself to expand. Although we measure the prehistoric era by millennia, and later periods by centuries, we tend to measure our own century by decades — or less. Our perception of time depends upon its relation to ourselves.

From the perspective of its last decade, the twentieth century has been a time of rapid change in many fields. Technological advances set in motion by the Industrial Revolution have speeded up communication and travel to an unprecedented degree. Electric lights were used from the 1890s, radios from 1895, cars from the early 1900s, televisions and computers from the 1950s. The Wright brothers flew the first airplane in 1903. Sixty-six years later, in 1969, America put the first man on the moon. Great strides were made in medicine, Albert Einstein conceived the theory of relativity, and Sigmund Freud established psychoanalysis as an internationally accepted science.

In politics, too, major changes have taken place. Lenin led the Russian Revolution of 1917. In 1991 the Soviet Union was dissolved. World War I (1914–18) claimed the lives of nearly an entire generation of European men. Following the Great Depression of 1929, Europe witnessed the rise of Hitler and Nazism, which led to World War II (1939–45). The end of that war ushered in the anxieties of the nuclear era, and new concerns about the future of our environment.

In the arts, too, rapid changes occurred, as styles came and went, often merging into one another. For the purposes of this text, the twentieth century is divided by the marker of World War II. Up to that point, Paris had been the undisputed center of the western art world. As Gertrude Stein (see p.420) said, "Paris was where the twentieth century was." It exerted a strong pull on artists, who studied in its art schools, and on collectors and critics, who toured its studios, galleries, and museums. After the war, and partly because of it, many artists — indeed entire schools of artists — were forced to flee Europe and settle in America. As a result, the significant innovations in western art in the second half of the twentieth century took place largely in America, particularly in New York.

In 1900 many works by Impressionist and Post-Impressionist artists were shown at the World's Fair, or International Exhibition, in Paris. These styles had emphasized the primacy of the medium. Building on this innovation, twentieth-century artists expanded into new areas, influenced in part by nonwestern cultures. The nineteenth century had already developed a taste for *japonisme*, as a result of the influence of Japanese woodblock prints (see p.383). In the early twentieth century, there was a growing interest in African art (fig. **27.3**), whose geometric abstraction appealed to artists, collectors, and critics.

Just as the Impressionists had expanded the range of subject matter in the nineteenth century, so twentieth-century artists turned to entirely new subjects, including everyday objects. They also began to use new materials, such as plastics, which resulted from advances in technology. New techniques for making art were developed, especially in the second half of the century. Technological developments also encouraged new directions in architecture.

The very idea of "newness" became the basis of Modernism. The so-called "avant-garde" (literally the "vanguard," or leaders, of artistic reform) became a prominent force in western art. Continual striving for avant-garde status contributed to the rapidity with which styles changed in the twentieth century.

Picasso and Matisse

In painting, two figures dominate the first half of the twentieth century, Pablo Picasso (1881–1973) and Henri Matisse (1869–1954). Both made sculptures, but were primarily painters. In contrast to that of the Impressionists and Post-Impressionists, the genius of Picasso and Matisse was recognized early in their careers. Their paths crossed at the Paris apartment of Gertrude Stein, who held regular gatherings of European and American intellectuals.

Picasso and Matisse began their careers in the nineteenth century under the influence of Impressionism, Post-Impressionism, and Symbolism. They soon branched out — Picasso earlier than Matisse — and spearheaded the avant-garde. As artists, however, they were quite distinct. Matisse's career seems to have followed a more direct line than Picasso's. He began and ended as a colorist, although his style underwent important evolutions along the way. Picasso, on the other hand, shifted from one style to another, often working in more than one mode at the same time (see Chapters 27 and 28). His first individual style was actually Symbolist, and is referred to as the "Blue Period."

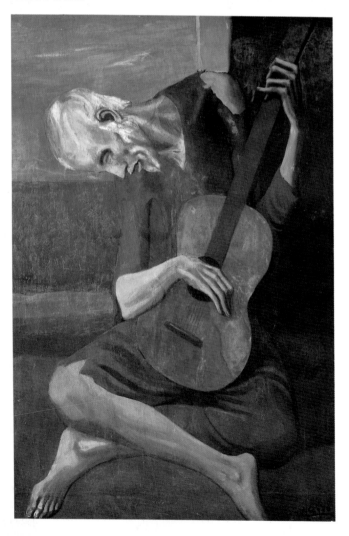

Picasso's "Blue Period"

Picasso's Blue Period lasted from approximately 1901 to 1904. Consistent with the Symbolist esthetic, his "Blue" paintings depict a mood or state of mind, in this case melancholy and pessimism (think, for example, of the expressions "to be in a blue mood," "Blue Monday," "to have the blues"). The predominance of blue as the mood-creating element reflects the liberation of color that had been effected by nineteenth-century Post-Impressionism.

Picasso emphasizes the somber quality of *The Old Guitarist* (fig. 26.1) by the all-pervasive blue color and the shimmering, silver light. The elongated, bony form, tattered clothes, and repeated downward curves create a sense of dejection. The guitarist's inward focus enhances the impression that he is listening intently, absorbed in his music.

Fauvism

In 1905 a new generation of artists exhibited their paintings in Paris. Bright, vivid colors seemed to burst from their canvases and dominate the exhibition space. Forms were built purely from color. Vigorous patterns and unusual color combinations created a startling effect on viewers. One critic, who noticed a single traditional sculpture in the room, exclaimed *"Donatello parmi les fauves!"* ("Donatello among the wild beasts!"), because the color and movement of the paintings reminded him of the jungle. His term stuck, and the style of those pictures is still referred to as "Fauve."

The critic's contrast between the traditional sculpture and the works of the young artists exhibiting in 1905 represented the latest skirmish in the conflict between line and color. Although there was plenty of "line" in Fauve painting, it was the brilliant color and emotional exuberance that struck viewers. Classical restraint and harmony, which were associated with line, appeared more controlled and, by implication, more civilized.

26.I Pablo Picasso, *The Old Guitarist.* 1903. Oil on panel, 4 ft ⅖ in × 2 ft 8½ in (1.23 × 0.83 m). Art Institute of Chicago (Helen Birch Bartlett Memorial Collection). Picasso was born in Málaga on the south coast of Spain. His father, José Ruíz Blasco, was an art teacher devoted to furthering his son's career. (Picasso followed the Spanish custom of taking his mother's family name.) From 1901 to 1904 Picasso moved restlessly between Paris, Barcelona, and Madrid, settling permanently in Paris in 1904. The subjects of Picasso's Blue Period were primarily the poor and unfortunate.

Matisse: *The Green Line*

The leading Fauve artist in France was Henri Matisse. *Madame Matisse (The Green Line)* of 1905 (fig. **26.2**) exemplifies the new style. It represents the artist's wife as a construction in color — a concept that Matisse had learned from Cézanne (see p.397). Shading, modeling, and perspective are now subordinate to color.

The left side of the face is pink, while the right is a subdued ocher. A green line at the top of the forehead continues down the nose, dividing the face. Strong accents of line and color create the features. The dark blue hair, which lacks organic quality, seems to perch on the head. This inorganic relation of head to hair, like the absence of modeling — for example, in the flat planes of the ears — reveals the influence of African masks (fig. **27.3**) on Matisse's style. He himself acknowledged his attraction to African sculpture, saying that it inspired his interest in "invented planes and proportions."

The background of *The Green Line* is identified only as patches of color. To the right of Madame Matisse (our left) are two tones of red, clearly separated above her ear. On the opposite side, the background is green. Variations on these reds and greens recur in the face itself, creating a chromatic unity between figure and background.

26.2 Henri Matisse, *Madame Matisse* (*The Green Line*). 1905. Oil on canvas, 16 × 12¾ in (40.6 × 32.4 cm). Statens Museum for Kunst, Copenhagen. Matisse was born in northern France. He reportedly decided to become a painter when his mother gave him a set of **crayons** while he was recuperating from surgery.

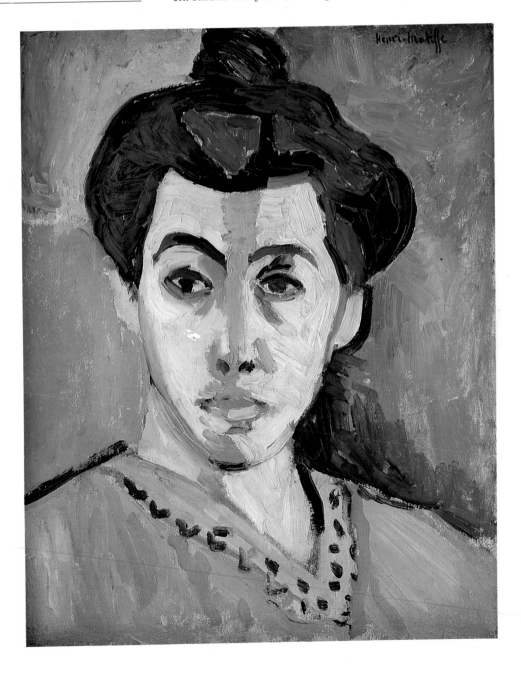

Expressionism

In Germany, the artists who, like the Fauves, were most interested in the expressive possibilities of color — as derived from Post-Impressionism — were called Expressionists. They formed groups that outlasted the Fauves in France, and styles that persisted until the outbreak of World War I in 1914. Expressionism, like Fauvism, used color to create mood and emotion.

Whetting the Scythe (fig. **26.3**), of 1905 by Käthe Kollwitz (1867–1945), conveys the direct emotional confrontation that is another characteristic of Expressionism — even though the artist herself was not a formal member of any artistic group. Her hard textures and the preponderance of rich blacks enhance her typically depressive themes. The gnarled figure concentrating intently on her task is rendered in close-up. This viewpoint accentuates the detailed depiction of the woman's wrinkled hands and aged, slightly suspicious face. In the background, the cruciform arrangement of blacks around her form reinforces the morbid associations of the image. The presence of the scythe, an attribute of the Grim Reaper, or Death, conforms to the woman's rather sinister quality. She is an Expressionist version of van Gogh's Post-Impressionist *Wheatfield with Reaper* (fig. **25.8**) and Wordsworth's Romantic "Solitary Reaper" (see p.351).

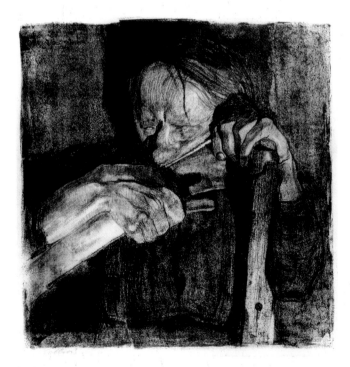

26.3 Käthe Kollwitz, *Whetting the Scythe*. 1905. Soft-ground 8th state etching, 11¹¹⁄₁₆ × 11¹¹⁄₁₆ in (29.7 × 29.7 cm). British Museum, London. Despite being financially comfortable herself, Kollwitz's imagery brings the viewer into contact with the emotional and material struggles of the working classes. This print is from a series published in 1904 to commemorate Germany's sixteenth-century peasant rebellion.

The Bridge *(Die Brücke)*

In 1905, the year of the Fauve exhibition in Paris, German artists in Dresden formed *Die Brücke* (The Bridge), a group that continued until 1913. The name was inspired by the artists' intention to create a "bridge," or link, between their own art and modern revolutionary ideas, between past spirituality and modern abstraction. They modernized both the spiritual abstraction of medieval art and the geometric esthetic of African and Oceanic art by integrating them with mechanistic abstractions of the city.

The leading artist of The Bridge was Ernst Ludwig Kirchner (1880–1938), who had trained as an architect before becoming a painter. His *Five Women in the Street* of 1913 (fig. **26.4**) captures the anxious, frenetic pace of urban life. Angular, elongated figures occupy a shifting perspective. They seem somewhat harsh and mechanized. The predominant greens create a uniformity that accentuates their impersonal character.

Kirchner's training in architecture is reflected in the tectonic forms of the women. Their high-heeled shoes, for example, create two-dimensional geometric silhouettes against a lighter space, and their fur ruffs form perfect crescents. The distinctions between light and dark in the dresses are crisply defined, creating a sense of solid, blocklike structure rather than of soft material.

The Blue Rider *(Der blaue Reiter)*

In 1911 another German Expressionist group, *Der blaue Reiter* (The Blue Rider), was established in Munich. Unlike the artists of The Bridge, those of the Blue Rider were drawn to pure abstraction and nonobjective **formalism**. This is particularly true of Vassily Kandinsky (1866–1944), the Russian artist who was among the first to eliminate recognizable objects from his paintings. For Kandinsky, art was a matter of rhythmic lines, colors, and shapes, rather than the depiction of a particular object or narrative.

Like Whistler (see p.395), Kandinsky gave his works musical titles to express their abstract qualities. By avoiding references to material reality, Kandinsky followed The Blue Rider's pursuit of the spiritual in art. Titles such as *Improvisation* evoked the dynamic spontaneity of creative activity, while Kandinsky's *Compositions* emphasized the abstract nature of lines, shapes, and colors.

In his *Painting Number 201* of 1914 (fig. **26.5**), Kandinsky creates a swirling, curvilinear motion, within which there are varied lines and shapes. Lines range from thick to thin, color patches from plain to spotty, and hues from solid to blended. The most striking color is red, which is set off against yellows and softer blues and greens. The strongest accents are blacks. Winter is suggested primarily by the whites, which occur in pure form and also blend with certain colors. Blues become light blues, and reds become pinks, creating an illusion of coldness that is readily associated with winter.

The Blue Rider, in contrast to The Bridge, was international in scope and had a greater influence on western

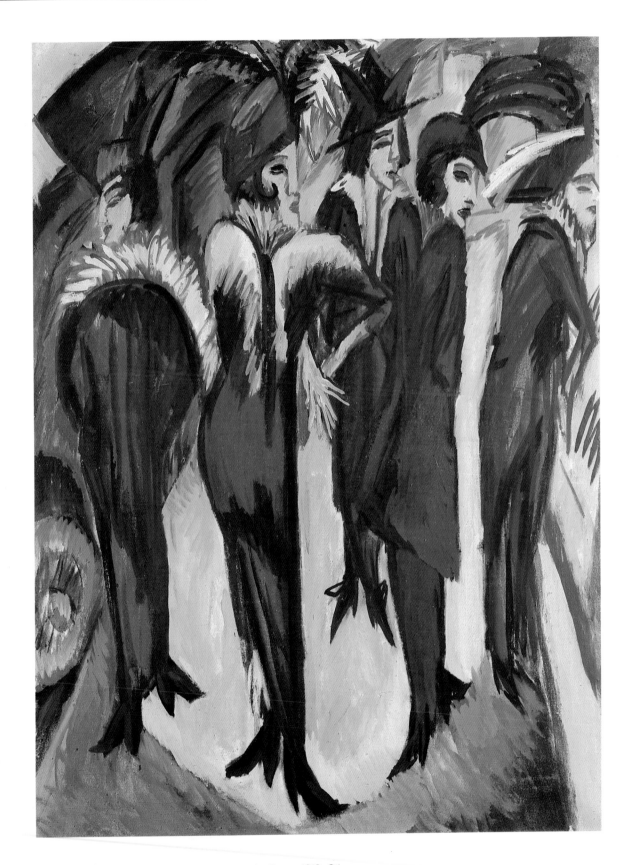

26.4 Ernst Ludwig Kirchner, *Five Women in the Street.* 1913. Oil on canvas, 3 ft 10½ in × 2 ft 11½ in (1.18 × 0.9 m). Museum Ludwig, Cologne (Courtesy, Rheinisches Bildarchiv, Cologne).

26.5 Vassily Kandinsky, *Painting Number 201*. 1914. Oil on canvas,
5 ft 4¼ in x 4 ft ¼ in (1.63 x 1.24m). The Museum of Modern Art, New
York (Nelson A. Rockefeller Fund, by exchange).

European art. In particular, Kandinsky's nonobjective imagery, whether or not it was the first of its kind, was part of a revolutionary development that would remain an important current in twentieth-century art. Neither Matisse nor Picasso, for all their innovations, ever completely eliminated recognizable objects from their imagery.

Matisse after Fauvism

Although Fauvism was shortlived, its impact, and that of Expressionism, laid the foundations of twentieth-century abstraction. Matisse reportedly said that "Fauvism is not everything, but it is the beginning of everything."

As Matisse developed, he was influenced by abstraction without embracing it completely. His sense of musical rhythm translated into line becomes energetic, curvilinear form. On the other hand, the shapes and spaces of Matisse that are determined primarily by color, and only secondarily by line, are more static and geometric. These

two tendencies — fluid line and flat color — create a dynamic tension that persists throughout his career.

In *Harmony in Red* of 1908–9 (fig. **26.6**), Matisse has already gone beyond the thick, constructive brushstrokes and unusual color juxtapositions of his Fauve period. The actual subject of the painting, a woman arranging a bowl of fruit on a table, seems secondary to its formal arrangement. Within the room, the sense of perspective has been minimized, because the table and wall are of the same red. The demarcation between them is indicated not by a constructed illusion of space, but by a dark outline, and by the bright still life arrangements that lie on the table surface. The effect is reinforced by the tilting plates and bowls. Linear perspective is confined to the chair at the left and the window frame behind it. Despite the flattening of the

26.6 Henri Matisse, *Harmony in Red.* 1908–9. Oil on canvas, 5 ft 11 in x 8 ft 1 in (1.8 x 2.46 m). State Hermitage Museum, St. Petersburg.

26.7 Henri Matisse, *Piano Lesson*, Issy-les-Moulineaux. Late summer 1916. Oil on canvas, 8 ft ½ in x 6 ft 11¾ in (2.45 x 2.13 m). Collection, The Museum of Modern Art, New York (Mrs. Simon Guggenheim Fund).

forms by minimal modeling, Matisse does endow the woman and the still life objects with a sense of volume.

The landscape relieves the tension of the close-up, interior view. It is related to the interior by the repetition of energetic black curves, which Matisse referred to as his **"arabesques."** The inside curves create branchlike forms that animate the table and wall, while those outside form branches and treetrunks. Smaller arabesques define the flower stems and the outline of the woman's hair.

The title *Harmony in Red* evokes the musical abstraction of Matisse's picture. It refers to the predominant color, whose flat planes "harmonize" the wall and table into a shared space. Matisse builds a second, more animated "movement" in the fluid arabesques harmonizing interior with exterior. Finally, the bright patches on the woman, the still life objects, and the floral designs create a more staccato beat composed of individual accented forms. Matisse's ability to harmonize these different formal

modes within a set pictorial space represents a synthesis of three artistic currents: the Post-Impressionist liberation of color, the Symbolist association of mood, and the twentieth-century move toward abstraction.

Another painting with a musical subject indicates the change that occurred in Matisse's style over the next decade. The *Piano Lesson* (fig. **26.7**) of 1916 has an auto-biographical subtext. It is about the conflict between musical discipline and ambition on the one hand, and erotic pleasure on the other. In contrast to the two earlier paintings, the *Piano Lesson* is constructed geometrically from rectangular and trapezoidal shapes that suggest Matisse's willingness to experiment with Cubist form (see p.420). The seated woman on the right, for example, who could be the boy's mother or teacher, is a rectangular structure with ovals defining her blank face. She is raised up, as if on a throne, implicitly commanding the boy to practice. The boy stares fixedly at his music. His right eye

is blocked out by a gray trapezoid that echoes the shape in the window and the metronome.

To the left of the gray window section is a rich green trapezoid in reverse. In the lower left corner, a figurine lounges in the seductive pose of Titian's *Venus of Urbino* (fig. **16.27**). Her outlines echo the arabesques in the music stand and the grillwork in the window. Although the boy is boxed in by the rectangle, which he shares with the "enthroned" woman, he is also related to the figurine through their shared tones of orange-brown. Though prevented from "seeing" her by the gray shape over his right eye, he seems to have her literally "on his mind" by virtue of the color of his hair. The same orange-brown is repeated in the illuminated candle, which is positioned between the boy and the figurine. The candle, which has erotic implications and also denotes the passage of time, can be allied with the sexuality of music.

The opposition of the woman as either disciplinarian or seductress is evident in the formal structure of the painting, as well as in its iconographic details. The rectilinear organization of the space, like the metronome, corresponds to the "lofty" woman in its sense of ordered logic and measured time. (She is based on an earlier portrait of

the wife of a Cubist critic, and can thus be linked with the geometry of Cubism.)

Inscribed across the center bar of the music stand is the word "PLEYEL" in reverse. This is a reference to the manufacturer of the piano, as well as to the Salle Pleyel, the most distinguished concert hall of Paris. It therefore combines the present practice of the ambitious young musician with his wished-for future. The *Piano Lesson* can be read as a metaphor for Matisse's relationship to the art of painting. It combines the rules of practice, technique, order, and logic with controlled sexual energy. The role of female inspiration, echoed by the separate implications of metronome and candle, is divided between two women. In a way, therefore, this picture is to Matisse what the *Studio* (fig. **23.2**) was to Courbet—a psychological "manifesto" of the painter's art.

During the last decade of his life, Matisse gave up painting, partly because of crippling arthritis. Instead, he grappled directly with the problem of creating a three-dimensional illusion from absolutely flat forms. His medium was the so-called *découpé*, or "cut-out," an image "built" by pasting pieces of colored paper onto a flat, colored surface. An early series of cut-outs, entitled *Jazz*, indicates Matisse's continuing interest in synthesizing musical with pictorial elements. His cut-out of *Icarus* of 1947 (fig. **26.8**), from the *Jazz* series, combines a subject from Greek mythology with modern style and technique. By curving the edges and expanding or narrowing the forms, Matisse gives the silhouetted Icarus (see Brueghel's *Landscape with the Fall of Icarus*, fig. **18.4**) the illusion of three-dimensional volume. His outstretched, winglike arms and tilting head create the impression that, though he is falling through space, he is not plummeting down to the sea, but floating gracefully in slow motion.

Entirely different in character are the zigzagging, bright yellow stars that surround Icarus. Their points shoot off in various directions, and their vivid color is far more energetic than the languid figure of Icarus. There are thus two musical "movements" in this cut-out—the slower, curvilinear motion of Icarus, and the rapid, angular motion of the stars. Staccato and adagio are combined against the deep, resonant blue sky. The drive toward new techniques and media for image-making, which is evident in Matisse's cut-outs, will be seen to characterize many of the innovations of twentieth-century art.

26.8 Henri Matisse, *Icarus*, plate 8 from *Jazz*, Paris, Tériade. 1947. Pochoir, printed in color, composition 16¼ × 10¾ in (41.3 × 27.3 cm). Collection, The Museum of Modern Art, New York (Louis E. Stern Collection). The *Jazz* series is composed of individual booksize cut-outs printed in book form to accompany Matisse's own text.

Cubism, Futurism, and Related Twentieth-Century Developments

The most influential style of the early twentieth century was Cubism. Like Fauvism, it developed in Paris. Cubism was essentially a revolution in the artist's approach to space, both on the picture's flat surface and in sculpture. The colorism of the Fauves (see p.412) can be seen as synthesizing nineteenth-century Impressionism, Post-Impressionism, and Symbolism. Cubism, however, together with the nonobjective innovations of Expressionism (see p.414), soon became the wave of the artistic future.

The main European impetus for Cubism came from Cézanne's new spatial organization: building up an image from constructions of color. Other decisive currents of influence came from so-called "primitive" and Iberian art.

Collectors and artists alike, including Matisse and Picasso, bought African and Oceanic art. These works suggested to European artists unfamiliar, anti-Classical ways to represent the human face and figure.

Early Cubism

Precursors

Picasso's 1906 portrait of *Gertrude Stein* (fig. **27.1**) is executed in the red hues of his Rose Period, which followed the Blue Period discussed in Chapter 26 (see p.412).

Gertrude Stein

Gertrude Stein (1874–1946) was an eccentric expatriate American art collector and writer. She had moved to Paris in 1903, after studying psychology at Radcliffe and medicine at Johns Hopkins. There, her apartment became a salon for the leading intellectuals of the post-World War I era, whom she dubbed the "lost generation." Her most popular book, *The Autobiography of Alice B. Toklas* (Stein's lifelong companion), is actually her own autobiography.

Stein and her two brothers were among the earliest collectors of paintings by avant-garde artists. History has vindicated her judgment, for she left an art collection worth several million dollars. Ernest Hemingway, in *A Movable Feast*, wrote that he had been mistaken not to heed Stein's advice to buy Picassos instead of clothes.

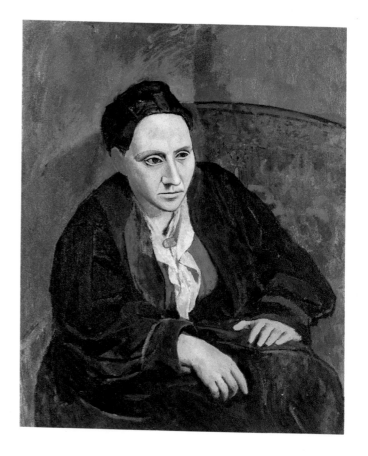

27.1 Pablo Picasso, *Gertrude Stein*. 1906. Oil on canvas, 3 ft 3⅜ in × 2 ft 8 in (1 × 0.81 m). Metropolitan Museum of Art, New York. (Bequest of Gertrude Stein, 1946). In 1909 Gertrude Stein wrote *Prose Portraits*, the literary parallel of Analytic Cubism. Her unpunctuated cinematic repetition reads like free association. The following is from her *Portrait* of Picasso: "One whom some were certainly following was one working and certain was one bringing something out of himself then and was one who had been all his living had been one having something coming out of him This one was one who was working."[1]

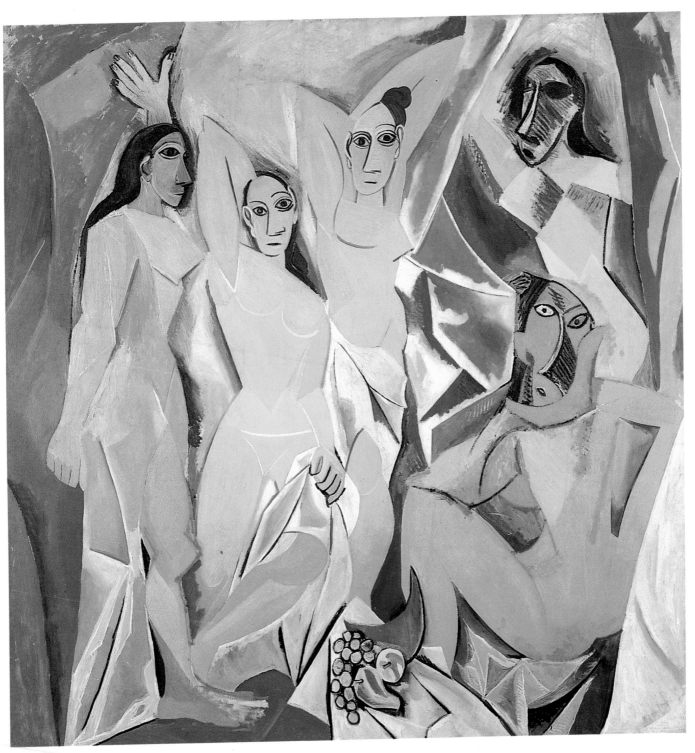

27.2 Pablo Picasso, *Les Demoiselles d'Avignon*, Paris. June to July 1907. Oil on canvas, 8 ft × 7 ft 8 in (2.44 × 2.34 m). Collection, The Museum of Modern Art, New York (Acquired through the Lillie P. Bliss Bequest). This painting was named for a bordello in the Carrer d'Avinyo (Avignon Street), Barcelona's red light district. Earlier versions contained a seated sailor and a medical student carrying a skull. Both were aspects of Picasso himself. By removing them from the final painting, Picasso shifted from a personal narrative to a more powerful mythic image.

The emphasis on color is consistent with contemporary Fauve interests, but a comparison with the *Old Guitarist* of the Blue Period (fig. **26.1**) indicates that more than color has changed. In the *Gertrude Stein,* new spatial and planar shifts occur which herald the development of Cubism.

Gertrude Stein's right arm and hand, for example, are organically shaded and contoured. Her left hand, however, seems flatter, and her arm looks as if it were constructed of cardboard. Picasso reportedly needed over eighty sittings to finish the picture, the main stumbling block being the face. In the final result, Gertrude Stein seems to be staring impassively from behind a mask. The hair does not grow organically from the scalp, and the ears are flat. The sharp separations between light and dark at the eyebrows, the black outlines around the eyes, and the disparity in the size of the eyes detract from the impression of a flesh-and-blood face.

Even more like masks are the faces in Picasso's pivotal picture, *Les Demoiselles d'Avignon* (*The Women of Avignon*) of 1907 (fig. **27.2**). With this representation of five nudes and a still life, Picasso launched a spatial revolution. The subject itself is hardly new, and Picasso has adapted traditional poses from earlier periods of western art. On the far left, for example, the standing figure nearly replicates the pose of ancient Egyptian kings (see p.63). The left leg is forward, the right arm is extended straight down, and the fist is clenched. Also borrowed from Egypt is the pictorial convention of rendering the face in profile and the eye in front view. Picasso's two central figures, whose arms stretch behind their heads, are based on traditional poses of Venus. Of all the figures, the faces of the seated and standing nudes on the far right are most obviously based on African prototypes. The wooden mask from the Congo in figure **27.3**, for example, shares an elongated, geometric quality with the face of the standing

figure. Here Picasso has abandoned *chiaroscuro* shading in favor of the Fauve preference for bold strokes of color. The nose, for instance, is so forcefully modeled that it resembles the long, curved, solid wedge of the mask's nose.

Like the mask, Picasso's faces disrupt nature and defy the Classical ideal. In the two central nudes, one eye is slightly above another, the nose is no longer directly above the mouth, and the ears are out of alignment. Still more radical is the depiction of the seated woman, the so-called "squatter." She looks toward the picture plane, while simultaneously turning her body in the opposite direction, so that her face and back are visible at the same

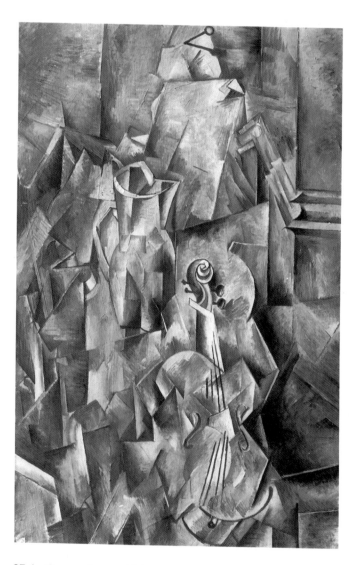

27.4 Georges Braque, *Violin and Pitcher.* 1909. Oil on canvas, 3 ft 10 in x 2 ft 4¾ in (1.17 x 0.73 m). Öffentliche Kunstsammlung, Kunstmuseum Basel. Braque was born in Argenteuil, France and moved to Paris in 1900. There he joined the Fauves, and established a collaborative friendship with Picasso. They worked closely together until World War I and were jointly responsible for the development of Cubism. In 1908, on seeing a painting by Braque, Matisse reportedly remarked that it had been painted "with little cubes." This is credited with being the origin of the term "Cubism."

27.3 Mask from the Etoumbi region, People's Republic of the Congo. Wood, 14 in (35.6 cm) high. Musée Barbier-Müller, Geneva.

time. In this figure, Picasso has broken away from tradition by abandoning the single vantage point of the observer.

The figures in the *Demoiselles* are fragmented into solid geometric constructions, with sharp edges and angles. They interact spatially with the background shapes, blurring the distinction between foreground and background, just as Cézanne had done (see p.399). Such distortion of the human figure is particularly startling because it assaults our very identity. Light, as well as form, is fragmented into multiple sources, so that the observer's point of view is constantly shifting. Because of its revolutionary approach to space and its psychological power, the *Demoiselles* represented the greatest expressive challenge to the traditional, Classical ideal of beauty and harmony since the Middle Ages.

Although neither the *Gertrude Stein* nor the *Demoiselles* are strictly speaking Cubist pictures, their planar dislocations revolutionized traditional conceptions of picture space.

Analytic Cubism

In 1907 Picasso met the French painter Georges Braque (1881–1963), who had studied Cézanne and been overwhelmed by the *Demoiselles*. Braque is reported to have declared, when he first saw the painting, that looking at it was like drinking kerosene. For several years Braque worked so closely with Picasso that it can be difficult to distinguish between their output during the period known as Analytic Cubism. Braque's *Violin and Pitcher* (fig. **27.4**) of 1909 is very much like Picasso's works of that time, and will serve as an example of Analytic Cubism.

Both the subject matter and the expressive possibilities of color—here limited to dark greens and browns—are subordinated to a geometric exploration of three-dimensional space. The only reminders of space, as we experience it, and of the objects that occupy it are the violin and pitcher, a brief reference to the horizontal surface of a table, and a vertical architectural support on the right. Most of the picture plane, including parts of these objects, is rendered as a jumble of fragmented cubes and other solid geometric shapes. What would, in reality, be empty space is filled up, in Cubism, with multiple lines, planes, and geometric solids. The sense of three-dimensional form is achieved by combining shading with bold strokes of color. Despite the crisp edges of the individual shapes in Analytic Cubist pictures such as this one, the painted images nevertheless lose parts of their outlines. Whereas in Impressionism (see p.387) edges dissolved into prominent brushstrokes, in Cubism they dissolve into shared geometric shapes. No matter how closely the forms approach dissolution, however, they never completely disappear. An important visual effect of the new Cubist approach to space is the so-called **simultaneous view**, resulting in a **spatial condensation**. For example, the back and front of an object may be depicted at the same time—as in the "squatter" of the *Demoiselles*.

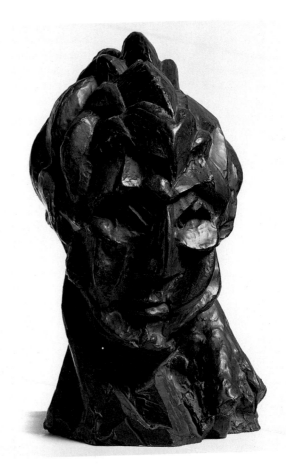

27.5 Pablo Picasso, *Head of a Woman*. 1909. Bronze (cast), 16³⁄₁₆ × 9⁵⁄₈ × 10½ in (41.1 × 24.5 × 26.7 cm). Collection of the Modern Art Museum of Fort Worth (Acquired with a Donation from Mr. and Mrs. J. Lee Johnson III).

In 1909 Picasso produced the first Cubist sculpture, a bronze *Head of a Woman* (fig. **27.5**). He shifted the natural relationship between head and neck, creating two diagonal planes. The hair, as in Analytic Cubist paintings, is multifaceted, and the facial features are geometric rather than organic.

In 1911 two Cubist exhibitions held in Paris brought the work of avant-garde artists to the attention of the general public. 1911 also marked the culmination of Analytic Cubism. Although this phase of Cubism was brief, its impact on western art was enormous. It stimulated the emergence of new and related styles, along with original techniques of image-making.

Collage

Picasso's Cubist *Man with a Hat* (fig. **27.6**) of 1912 is an early example of **collage**, which was a logical outgrowth of Analytic Cubism. Pieces of colored paper and newspaper are pasted onto paper to form geometric sections of a head and neck. The remainder of the image is drawn in charcoal. The use of newspaper, which appeared textured

because of the newsprint, was a common feature of early collages. Words and letters, which are themselves abstract signs, often formed part of the overall design. Collage, like Cubism itself, involved disassembling aspects of the environment—just as one might take apart a machine, break up a piece of writing, or even divide a single word into letters—and then rearrange (or reassemble) the parts to form a new image.

Synthetic Cubism

Synthetic Cubism marked a return to bright colors. Whereas Analytic Cubism fragmented objects into abstract geometric forms, Synthetic Cubism arranged flat shapes of color to form objects. Picasso's *Three Musicians* (fig. **27.8**)—a clarinetist on the left, a Harlequin playing a guitar in the center, and a monk—is built up from unmodeled shapes of color and arranged into tilted planes. In addition, the flat shapes—such as the dog lying under the table—occupy a more traditional space than those of Analytic Cubism, in which space is filled with solid geometry. Simultaneity of viewpoint is preserved—for example, in the sheet of music. It is held by the monk and turned toward the viewer, who sees both the musician and what he is reading at the same time.

In his monumental work of 1937, *Guernica* (fig. **27.9**), Picasso combined both Analytic and Synthetic Cubist forms with several traditional motifs, which he juxtaposed in a new way. Here Cubism serves the political message of the painting—namely, Picasso's powerful protest against the brutality of war and tyranny. Consistent with its theme of death and dying, the painting is nearly devoid of color, though there is considerable tonal variation within the range of black to white.

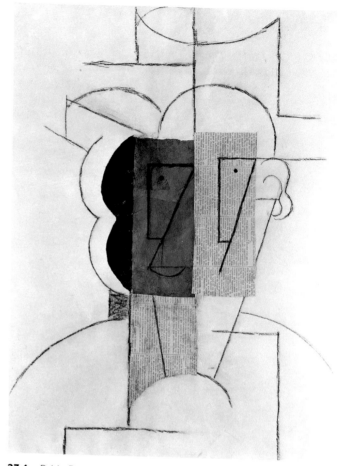

27.6 Pablo Picasso, *Man with a Hat*, Paris. After 3 December 1912. Pasted paper, charcoal, and ink on paper, 24½ × 18⅝ in (62.2 × 47.3 cm). Collection, The Museum of Modern Art, New York (Purchase).

Collage and Assemblage

Collage (from the French *coller*, meaning "to paste" or "to glue") developed in France from 1912. It is a technique that involves pasting lightweight materials or objects, such as newspaper and string, onto a flat surface. A technique related to collage, which developed slightly later, is **assemblage**. Heavier objects are brought together and arranged, or assembled, to form a three-dimensional image. Both techniques make use of "**found objects**" (*objets trouvés*), which are taken from everyday sources and incorporated into works of art.

Picasso's witty 1943 assemblage entitled *Bull's Head* (fig. **27.7**) is a remarkable example of his genius for synthesis. He has fused the ancient motif of the bull and the traditional medium of bronze with modern steel and plastic. He has also conflated the bull's head with African masks, and effected a new spatial juxtaposition, by reversing the direction of the bicycle seat and eliminating the usual space between it and the handlebars. In this work, Picasso simultaneously explores the possibilities of new media, of conflated imagery, and of the spatial shifts introduced by Cubism.

27.7 Pablo Picasso, *Bull's Head*. 1943. Assemblage of bicycle saddle and handlebars, 13¼ × 17⅛ × 7½ in (33.7 × 43.5 × 19 cm). Musée Picasso, Paris. Picasso detached the seat and handlebars of a bicycle, turned the seat around, and attached it to the handlebars. The object was then cast in bronze and hung on a wall. Although the image of a bull's head is clear and convincing, the influence of African masks is also evident.

27.8 Pablo Picasso, *Three Musicians*. 1921. Oil on canvas, c. 6 ft 7 in x 7 ft 3¾ in (2.01 x 2.23 m). The Museum of Modern Art, New York (Gift of Mrs. Simon Guggenheim).

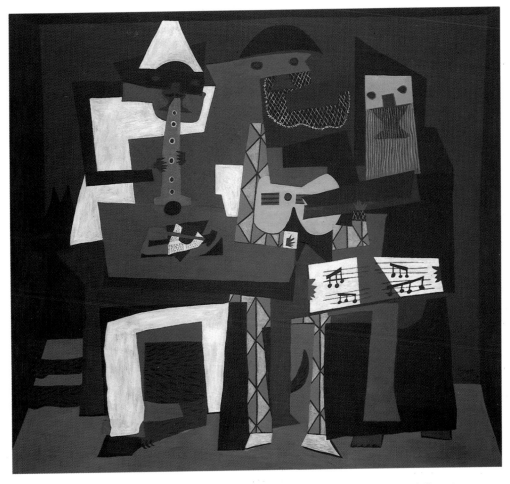

27.9 Pablo Picasso, *Guernica*. 1937. Oil on canvas, 11 ft 5½ in x 25 ft 5¾ in (3.49 x 7.77 m). Prado, Madrid. From 1936 to 1939 there was a civil war between Spanish Republicans and the Fascist army of General Franco. In April 1937 Franco's Nazi allies carried out saturation bombing over the town of Guernica. Picasso painted *Guernica* to protest this atrocity. He loaned it to New York's Museum of Modern Art, stipulating that it remain there until democratic government had been restored in Spain. In 1981 *Guernica* was returned.

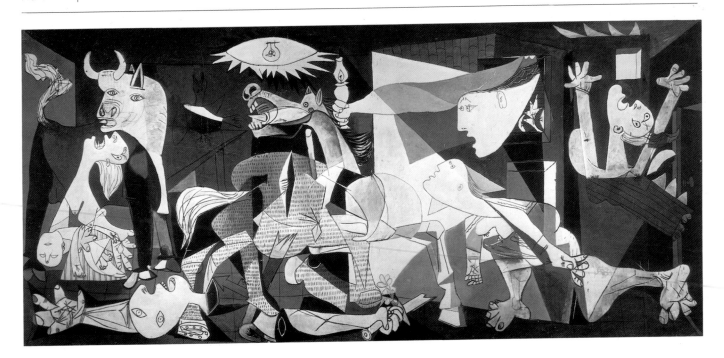

Guernica is divided into three sections. There is a central triangle with an approximate rectangle on either side. The base of the triangle extends from the arm of the dismembered and decapitated soldier at the left to the foot of the running woman at the right. The dying horse represents the death of civilization, though it may be rescued by the woman with a lamp (Liberty) rushing toward it. Another expression of hope appears in the motif combining the shape of an eye with the sun's rays and a lightbulb just above the horse's head. On the right, the pose and gesture of a falling woman suggest Christ's Crucifixion. On the left, a woman holds a dead baby on her lap in a pose reminiscent of Mary supporting the dead Christ in the traditional *Pietà* scene (fig. **16.14**). Behind the woman looms the specter of the Minotaur (see p.80), the monstrous tyrant of ancient Crete, whose only human quality is the flattened face and the eyes. For Picasso, the Minotaur came to represent modern tyranny, as embodied by General Francisco Franco, who collaborated with Adolf Hitler and Benito Mussolini.

These apparently disparate motifs are related by form and gesture, by their shared distortions, and by the power of their message. Cubist geometric shapes and sharp angles pervade the painting. Picasso's characteristic distortions of body and face emphasize the physical destruction of war. Eyes twist around, ears and noses are slightly out of place, tongues are shaped like daggers, palms and feet are slashed. Although the integrity of the human form is maintained throughout, it is an object of attack and mutilation.

Early Twentieth-Century Developments

The City

Cubism and other early twentieth-century movements were well suited to the new artistic awareness of the modern urban landscape. Kirchner's Expressionist *Five Women in the Street* (fig. **26.4**) captured the mechanistic character of a city street. Related to Expressionism was the contemporary movement called Futurism, which originated in Italy. The Futurists were inspired by the dynamic energy of industry and the new machine age. They argued for a complete break with the past.

27.10 Umberto Boccioni, *Unique Forms of Continuity in Space*. 1913. Bronze (cast 1931), 43⅞ × 34⅞ × 15¾ in (111 × 88.5 × 40 cm). Collection, The Museum of Modern Art, New York (Acquired through the Lillie P. Bliss Bequest). In 1910 Boccioni wrote the *Manifesto of the Futurist Painters*, which encouraged artists to portray the speed and dynamism of contemporary life, as he himself has done in this sculpture. He fought for Italy in World War I and was killed by a fall from a horse in 1916.

Futurism

In February 1909 a Futurist Manifesto appeared on the front page of the French newspaper *Le Figaro*. The Manifesto sought to inspire in the masses an enthusiasm for a new artistic language. All of the arts — the visual arts, music, literature, theater, and film — would abandon old Academic traditions, abolish libraries and museums, and focus creative energy on the present and future. Speed, travel, technology, and dynamism would be the subjects of Futurist art.

This philosophy is expressed in a 1913 sculpture by Umberto Boccioni (1882–1916) entitled *Unique Forms of Continuity in Space* (fig. **27.10**). It represents a man striding vigorously, with a definite goal in mind. The long diagonal from head to foot is thrust foward by the determined angle of the bent knee. The layered surface planes convey the impression of material flapping behind the man's forward motion. Organic flesh and blood is subjugated to a mechanical, robotlike appearance — a vision that corresponds to Futurist philosophy.

Léger's *City*

The work of Fernand Léger (1881–1955) is more directly derived from Cubism than Boccioni's sculpture. In *The City* of 1919 (fig. **27.11**), Léger captures the cold, steel surfaces of the urban landscape. Harsh forms, especially cubes and cylinders, evoke the metallic textures of industry. The jumbled girders, poles, high walls, and steps, together with the human silhouettes, create a sense of the anonymous, mechanical movement associated with the

27.11 Fernand Léger, *The City*. 1919. Oil on canvas, 7 ft 7 in × 9 ft 8½ in (2.31 × 2.96 m). Philadelphia Museum of Art (A. E. Gallatin Collection). Léger described the kinship between modern art and the city as follows: "The thing that is imaged does not stay as still . . . as it formerly did A modern man registers a hundred times more sensory impressions than an eighteenth-century artist The condensation of the modern picture, . . . its breaking up of forms, are the result of all this. It is certain that the evolution of means of locomotion, and their speed, have something to do with the new way of seeing."[2]

fast pace of city life. In this painting, Léger has taken from Analytic Cubism the multiple viewpoint and super-imposed solid geometry. His shapes, however, are colorful and recognizable, and there is a greater illusion of distance within the picture plane.

Mondrian

In 1911, the year of the two Cubist exhibitions, Piet Mondrian (1872–1944) came to Paris from Holland. He had begun as a painter of nature, but under the influence of Cubism he transformed his imagery to flat rectangles of color. His delicate *Amaryllis* (fig. **27.12**) is a superb example of his sensitivity to nature and his attention to the subtleties of surface texture. Mondrian gradually

abstracted from nature to create flat rectangles bordered by thick, black lines. In these pictures, he plays on the tension, as well as the harmony, between vertical and horizontal. He rejected curves and diagonals altogether, and believed in the purity of the primary colors. According to Mondrian, chromatic purity, like the simplicity of the rectangle, contributed to a universal character. He wrote that, since paintings are made of line and color, they must be liberated from the slavish imitation of nature (see the **installation** photograph in fig. **27.17**).

Later, in the early 1940s, Mondrian painted *Broadway Boogie Woogie* (fig. **27.13**). This was one of a series of pictures that he executed in small squares and rectangles of color, which replaced the large rectangles outlined in black. The title evokes a busy city street and dance music. The grid pattern of the New York streets, the flashing lights of Broadway, and the vertical and horizontal motion of cars and pedestrians are conveyed as flat, colorful shapes. Fast shifts of color and their repetition recall the strong, accented rhythms of Boogie-Woogie, a popular form of dance music of the period. In combining musical references with the beat of city life and suggesting these qualities through color and shape, Mondrian synthesized Expressionist exuberance with Cubist order and control.

27.12 (below) Piet Mondrian, *Amaryllis*. Watercolor on paper, 18½ × 13½ in (47 × 34.3 cm). Sidney Janis Family Collection, New York. Mondrian was an Impressionist and Symbolist painter before helping to found the *De Stijl* movement in 1917. His spiritual attitude toward art was reflected in his belief that perfect esthetic harmony and balance in art are derived from ethical purity and world harmony. The dating of Mondrian's nature studies is controversial. This one has been variously dated from 1909 to the 1920s.

27.13 (right) Piet Mondrian. *Broadway Boogie Woogie*. 1942–3. Oil on canvas, 4 ft 2 in × 4 ft 2 in (1.27 × 1.27 m). Collection, The Museum of Modern Art, New York (Given anonymously).

The Armory Show

The burgeoning styles of the early twentieth century in western Europe did not reach the general American public until 1913. In February of that year, the armory of the Sixty-ninth Regiment, National Guard, on Lexington Avenue at 25th Street in New York was the site of an international exhibition of modern art. A total of 1200 exhibits, including works by Post-Impressionists, Fauves, and Cubists, as well as by American artists, filled eighteen rooms. This event marked the first widespread American exposure to the European avant-garde.

The Armory Show caused an uproar. Marcel Duchamp (1887–1968; see p.437) submitted *Nude Descending a Staircase, No. 2* (fig. **27.14**), which was the most scanda-

lous work of all. It was a humorous attack on Futurist proscriptions against traditional, Academic nudity. The image has a kinetic quality consistent with the Futurist interest in speed and motion. At the same time, the figure is a combination of Cubist form and multiple images, which indicate the influence of photography. She is shown at each point in her descent, so the painting resembles a series of consecutive movie stills, unframed and superimposed.

Various accounts published at the time ridiculed the *Nude*'s début in the United States. Descriptions by outraged viewers included the following: "disused golf clubs and bags," "elevated railroad stairway in ruins after an earthquake," "a dynamited suit of Japanese armor," an "orderly heap of broken violins," an "explosion in a shingle factory," and "Rude Descending a Staircase (Rush Hour in the Subway)." Duchamp recorded his own version of the *Nude*'s place in the history of art, describing her as follows: "My aim was a static representation of movement — a static composition of indications of various positions taken by a form in movement — with no attempt to give cinema effects through painting."[3]

The influence of Futurism, Cubism, and African sculpture is evident in the style of the Romanian sculptor Constantin Brancusi (1876–1957), who was also represented in the Armory Show. A version of his *Mlle. Pogany* (fig. **27.15**), listed for sale at $540, created a stir of its own. She was described as a "hard-boiled egg balanced on a cube of sugar." The last stanza of *Lines to a Lady Egg*, which appeared in the New York *Evening Sun*, went as follows:

27.14 Marcel Duchamp, *Nude Descending a Staircase, No. 2.* 1912. Oil on canvas, 4 ft 10 in × 2 ft 11 in (1.47 × 0.89 m). Philadelphia Museum of Art (Louise and Walter Arensberg Collection).

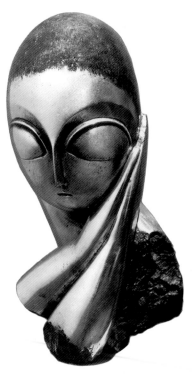

27.15 Constantin Brancusi, *Mlle. Pogany.* Version I (1913) after a marble of 1912. Bronze, 17¼ in (43.8 cm) high. Collection, the Museum of Modern Art, New York (Acquired through the Lillie P. Bliss Bequest).

27.16 Stuart Davis, *Lucky Strike*. 1921. Oil on canvas, 33¼ x 18 in (84.5 x 45.7 cm). The Museum of Modern Art, New York (Gift of The American Tobacco Company, Inc.). Davis designed the first abstract postage stamp for the United States in 1964. He gravitated to abstract forms from objects such as eggbeaters and electric fans. As a lifelong smoker, Davis had a particular fondness for the imagery of smoking.

27.17 Installation view, "Brancusi + Mondrian" exhibition, December 1982–January 1983. Photo courtesy of Sidney Janis Gallery, New York. The art critic Sidney Geist wrote of this show that "If the century's Modernist struggle seems to have been called in question by recent developments, 'Brancusi + Mondrian' banished all doubt. . . . We have to do here with two saintly figures — for whom art was a devotion. Their lives and art evolved under the sign of inevitability."[5]

Ladies builded like a bottle,
Carrot, beet, or sweet potato —
Quaint designs that Aristotle
Idly drew to tickle Plato —
Ladies sculptured thus, I beg
You will save your tense emotion;
I am constant in devotion,
O my egg![4]

In Chapter 1, we discussed Brancusi's bronze *Bird in Space* (fig. **1.1**), which achieved notoriety in the legal debate over whether it was a work of art or a "lump of manufactured metal." In *Mlle. Pogany*, the emphasis on rationalized, or quasi-geometrical, form allies the work with Cubism and related styles. Brancusi's high degree of polish conveys the increased prominence of the medium itself as artistic "subject." The roughness of the unpolished bronze at the top of the head, on the other hand, which contrasts with the polish of the face, creates an impression of hair. In the detachment of *Mlle. Pogany*'s hands (and head) from her torso, she becomes a partial body image that is characteristic of Brancusi's human figures and reflects the influence of Rodin (see p.391). This partial aspect of his sculptures is related to his search for a truthful, Platonic "essence" of nature, rather than a literal and objective depiction of it.

Despite — or perhaps because of — the sensation caused by the Armory Show, which traveled to Chicago and Boston, its impact on American art was permanent. The American artist Stuart Davis (1894–1964), for example, had exhibited several watercolors in the Armory Show while still an art student. Later, in 1921, he painted *Lucky Strike* (fig. **27.16**), whose flattened cigarette box is clearly influenced by collage. The colorful, unmodeled shapes are reminiscent of Synthetic Cubism, while the words and numbers recall early newspaper collages. The subject itself reflects American consumerism, which advertises a product by its package.

Postscript

The installation photograph in figure **27.17** illustrates the main room of the Sidney Janis Gallery in New York during a landmark exhibition of Brancusi and Mondrian in the early 1980s. Mounted nearly seventy years after the Armory Show, the Janis exhibition conveyed the importance of both artists, and emphasized their formal and historical relationship to each other. In the left corner, a group of highly polished bronzes by Brancusi includes two versions of *Mlle. Pogany*. Flanked by Mondrians are a marble and a bronze version of Brancusi's *Bird in Space*. Brancusi's "essences," here composed of graceful curves and rounded, volumetric shapes, are contrasted with Mondrian's pure verticals and horizontals on a flat surface. In this juxtaposition, the viewer confronts the work of two major early twentieth-century artists. Despite their apparent differences, these artists have a remarkable affinity in their pursuit of an "idea," which they render in abstract form.

Early Twentieth-Century Architecture

In the late nineteenth and early twentieth centuries, the most innovative developments in architecture took place in the United States. Following Louis Sullivan, who developed the skyscraper (see p.380), the next major American architect was Frank Lloyd Wright (1869–1959). Wright had worked in Chicago as Sullivan's assistant before building private houses, mainly in Illinois, in the 1890s and early 1900s. But, whereas Sullivan's skyscrapers addressed the urban need to provide many offices or apartments on a relatively small area of land, Wright created the Prairie Style, which sought to integrate architecture with the natural landscape.

Wright and the Prairie Style

In 1908 Wright wrote that "the Prairie has a beauty of its own and we should recognize and accentuate this natural beauty, its quiet level. Hence . . . sheltering overhangs, low terraces, and out-reaching walls, sequestering private gardens." In his philosophy, Wright found affinities with Japanese architecture and its tradition of open internal spaces. He incorporated this tradition into a series of early twentieth-century, midwestern Prairie Style houses.

The best-known example of Wright's early Prairie Style is the Robie House of 1909 (fig. **27.18**), in south Chicago. Its low, horizontal emphasis, low-pitched roofs with large overhangs, and low boundary walls are related to the flat prairie landscape of the American West and Middle West. At the same time, the predominance of rectangular shapes and shifting, asymmetrically arranged horizontal planes is reminiscent of the Cubist esthetic.

The ground floor of the Robie House contained a playroom, garage, and other service areas. The main living area was on the second floor, and the bedrooms were on the third. The second-floor plan (fig. **27.20**) illustrates the massive central core, which doubles as a fireplace and staircase, and which is the focal point of the living quarters. Around the central core the living and dining rooms are arranged in an open plan. Verandas extend from the two main rooms. The huge cantilevered roof on the second floor shields the windows from sunlight.

Cantilever

The system of **cantilever construction** is one in which a horizontal architectural element, projected in space, has vertical support at one end only. Equilibrium is maintained by a support and counterbalancing weight inside the building. The cantilever requires materials with considerable tensile strength. Wright pioneered the use of reinforced concrete and steel girders for cantilever construction in large buildings. In a small house, wooden beams provide adequate support.

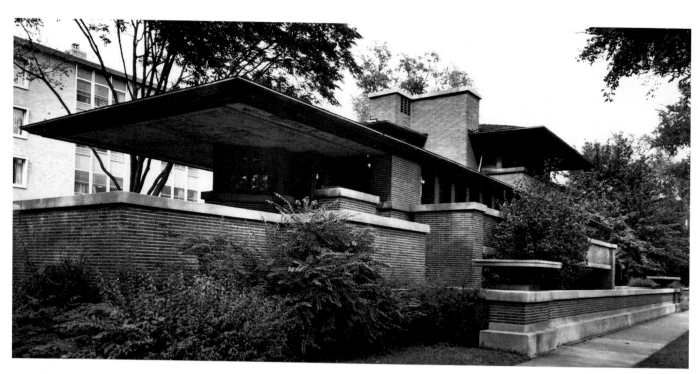

27.18 (above) Frank Lloyd Wright, Robie House, Chicago. 1909. Wright's insistence on creating a total environment inspired him, sometimes against the wishes of his clients, to design the furniture and interior fixtures of his houses. In the case of the Robie House, Wright even designed outfits for Mrs. Robie to wear on formal occasions so that she would blend with his architecture.

27.19 (below) Frank Lloyd Wright, Fallingwater, Bear Run, Pennsylvania. 1936.

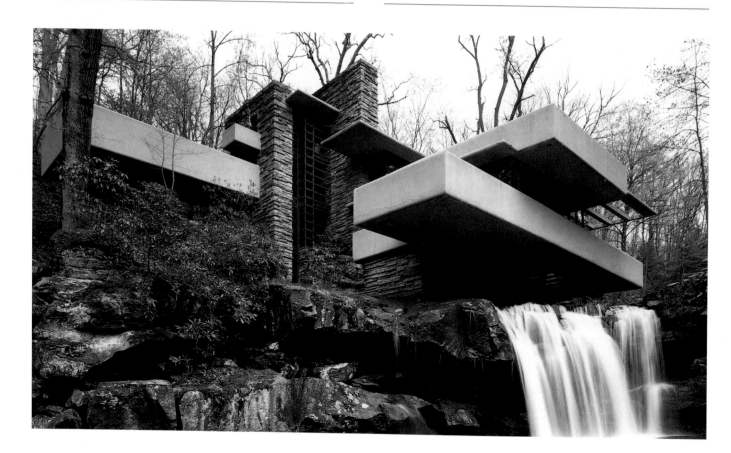

and the schools. They were linked by an elevated bridge containing offices. This conception differed radically from previous academic institutions, which were monumental and had a clearly marked entrance within a distinctive façade. Formal affinities with Cubism are inescapable, although Gropius, like the members of the Dutch *De Stijl*, was motivated primarily by a philosophy of simplicity and harmony intended to integrate art and architecture into society. The Bauhaus exteriors, devoid of any regional identity, were an international concept translated into architectural form.

France. The best-known exponent of the International Style in France during the 1920s and early 1930s was the Swiss-born architect Charles-Edouard Jeanneret, known as Le Corbusier (1887–1969). The Villa Savoye (fig. **27.23**), a weekend residence built from 1928 to 1930 at Poissy, near Paris, is the last in a series of International Style houses by Le Corbusier. It is regarded as his masterpiece.

The Villa Savoye is a grand version of what Le Corbusier described as a "machine for living." It rests on slender reinforced concrete pillars, which divide the second-floor windows. The second floor contains the main living area. It is connected to the ground floor and the open terrace on the third floor by a staircase and a ramp. The driveway extends under the house and ends in a three-car carport. This part of the ground floor is deeply recessed under the second-floor overhang, and contains an entrance hall and servants' quarters. All four elevations of the house are virtually identical, each having the same ribbon windows running the length of the wall.

America. The architectural principles of the International Style were brought to the United States by Bauhaus artists who were forced to leave Germany in the late 1930s. Mies van der Rohe (1886–1969), the director of the Bauhaus from 1930, designed the glass and steel Lake Shore Drive Apartment Houses in Chicago (fig. **27.24**) with the principles of **functionalism** in mind. The influence of Cubism in their geometric repetitions is inescapable. These vertical, cubic structures, which are reminiscent of Mondrian's late paintings, inspired many similar skyscrapers throughout America's large cities.

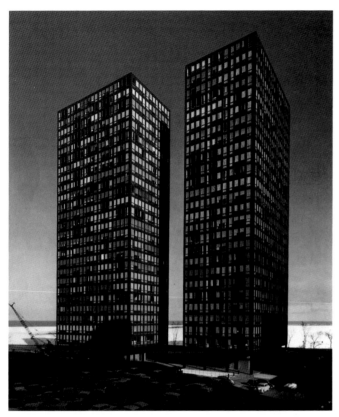

27.24 Mies van der Rohe, Lake Shore Drive Apartment Houses, Chicago. 1950–2.

Bauhaus, in Weimar. The Bauhaus (from the German *Bau*, meaning "structure" or "building" and *Haus*, meaning "house") combined an arts and crafts college with a school of fine arts. Gropius believed in the integration of art and industry. With that in mind, he set out to create a new institution that would offer courses in design, architecture, and industry.

In 1926 Gropius relocated the Bauhaus in Dessau, and planned its new quarters (fig. **27.22**) according to his International Style philosophy of architecture. Three blocklike buildings contained living and working areas,

Dada, Surrealism, Fantasy, and America Between the Wars

The devastation of World War I affected the arts as well as other aspects of western civilization. For the first time in western history, armies used trench warfare, barbed wire, machine guns firing along fixed lines, chemical weapons, and poison gas. After treating the victims of gassing and shell shock in World War I, Freud and other medical researchers published accounts of the long-term psychological traumas of the new warfare. Gertrude Stein's phrase "the lost generation" (see p.420) captured the overwhelming sense of desolation experienced by the post-World War I intellectuals. In the visual arts of that era, the same pessimism and despair emerged as Dada.

Dada

The term "Dada" refers to an international intellectual movement that began during the war in the relative safety of neutral Switzerland. Artists, writers, and performers gathered at a Zürich café, the Cabaret Voltaire, for discussion, entertainment, and creative exploration. Dada was thus not an artistic style in the sense of shared formal qualities that are easily recognized. Rather, it was an idea, a kind of "anti-art," based on a Nihilist (from the Latin *nihil*, meaning "nothing") philosophy of negation. By 1916 the term Dada had appeared in print — a new addition to the parade of artistic "manifestos" that had developed in the nineteenth century. Dada lasted as a cohesive European movement until about 1920. It also achieved a foothold in New York, where it flourished from about 1915 to 1923.

According to the 1916 manifesto, "Dada" is French for a child's wooden horse. "Da-da" are also the first two syllables spoken by children learning to talk, and thus suggest a regression to early childhood. The implication was that these artists wished to "start life over." Likewise Dada's iconoclastic force challenged traditional assumptions about art, and had an enormous impact on later twentieth-century Conceptualism (see p.479). Despite the despair that gave rise to Dada, however, a taste for the playful and the experimental was an important creative, and ultimately optimistic, aspect of the movement.

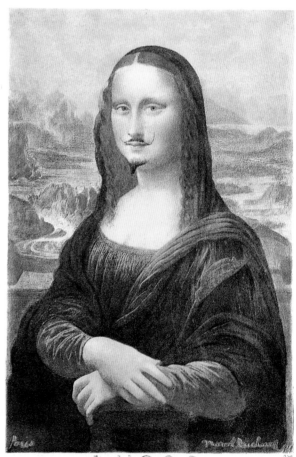

L.H.O.O.Q.

28.1 Marcel Duchamp, Replica of *L.H.O.O.Q.*, Paris. 1919, from "Boîte-en-Valise." Color reproduction of the *Mona Lisa* altered with a pencil, 7¾ x 5 in (19.7 x 12.7 cm). Philadelphia Museum of Art (Louise and Walter Arensberg Collection). Duchamp was born in Blainville, France, the third of three sons who were artists. In 1915 he moved to New York and in 1955 became an American citizen. After painting only twenty works, Duchamp announced his retirement in 1923 and devoted the rest of his life to chess.

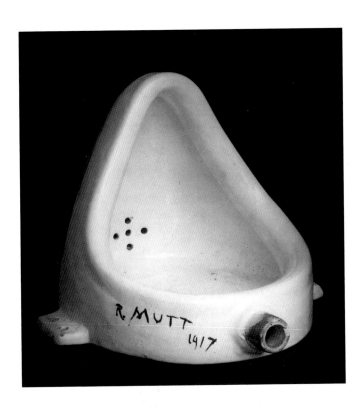

28.2 Marcel Duchamp, *Fountain (Urinal)*. 1917. Ready-made, 24 in (61 cm) high. Photo courtesy of Sidney Janis Gallery, New York. Duchamp declared that it was the artist's conscious choice that made a "Ready-made" into art. In 1915 he bought a shovel in a New York hardware store and wrote on it "In advance of a broken arm." "It was around that time," he said, "that the word 'ready-made' came to my mind. . . . Since the tubes of paint used by an artist are manufactured and ready-made products, we must conclude that all the paintings in the world are ready-made aided."[1]

28.3 Marcel Duchamp, *To Be Looked At (From the Other Side of the Glass) with One Eye, Close To, for Almost an Hour*, Buenos Aires. 1918. Oil paint, silver leaf, lead wire, and magnifying lens on glass (cracked), 19½ × 15⅝ in (49.5 × 39.7 cm), mounted between two panes of glass in a standing metal frame, 20⅛ × 16¼ × 1½ in (51 × 41.2 × 3.7 cm), on painted wood base, 1⅞ × 17⅞ × 4½ in (4.8 × 45.3 × 11.4 cm); overall height 22 in (55.8 cm). Collection, The Museum of Modern Art, New York (Katherine S. Dreier Bequest).

One of the major proponents of Dada was Marcel Duchamp, whose *Nude Descending a Staircase* (fig. **27.14**) had already caused a sensation in the 1913 Armory Show. He shared the Dada taste for wordplay and punning, which he combined with visual images. Delighting in the pleasure children derive from nonsensical verbal repetition, for example, Duchamp entitled his art magazine *Wrong Wrong*. The most famous instance of combined visual and verbal punning in Duchamp's work is *L.H.O.O.Q.* (fig. **28.1**), the very title of which is a bilingual pun. Read phonetically in English, the title sounds like "LOOK," which, on one level, is the artist's command to the viewer. If each letter is pronounced according to its individual sound in French, the title reads "Elle (*L*) a ch (*H*) aud (*O*) au (*O*) cul (*Q*)," meaning in English "She has a hot ass." Read backward, on the other hand, "LOOK" spells "KOOL," which counters the forward message.

When viewers do, in fact, "look," they see that Duchamp has penciled a beard and mustache onto a reproduction of Leonardo's *Mona Lisa* (fig. **16.13**), turning her into a bearded lady. One might ask whether Duchamp has "defaced" the *Mona Lisa* — perhaps in a prefiguration of graffiti art (see p.479) — or merely "touched her up."

This dilemma plays with the sometimes fine line between creation and destruction. (The modern expression "You have to break eggs to make an omelet" illustrates the connection between creating and destroying that is made explicit by the Dada movement.)

Duchamp called the kind of work exemplified by *L.H.O.O.Q.* a "Ready-made Aided." When he merely added a title to an object, he called the result a "Ready-made." Duchamp's most outrageous Ready-made was a urinal 24 inches (61cm) high that he submitted as a sculpture to a New York exhibition mounted by the Society of Independent Artists in 1917 (fig. **28.2**). He turned it upside-down, signed it "R. Mutt" and called it a *Fountain*. The work was rejected by the Society, and Duchamp resigned his membership.

Despite the iconoclastic qualities of his Ready-mades and his Ready-mades Aided, it must be said that both *L.H.O.O.Q.* and *Fountain* have a basis in traditional art history. In the former, the connection with the past is obvious, for the work is a reproduction of a classic icon. It comments on Leonardo's homosexuality and also on the sexual ambiguity of the *Mona Lisa* herself. In the latter, the urinal makes a connection between the idea of a fountain

and a urinating male, which in fact has been the subject of actual and painted fountains in many works of western art.

A good example of Dada principles in a Duchamp assemblage is his work of 1918 entitled *To Be Looked At (From the Other Side of the Glass) with One Eye, Close To, for Almost an Hour* (fig. **28.3**). A pyramidal shape is painted on a glass surface above a balance, which is tilted slightly by the weight of a circle. As in *L.H.O.O.Q.*, the title of the assemblage is about the viewer's relationship to the work of art, and the potential for shock in looking and seeing. Whereas in the Renaissance, artists controlled the direction of sight with linear perspective, Duchamp "instructs" the observer verbally via the title. Duchamp also plays with the point of view by using glass as the work's surface, which makes it two-sided. This can be seen as a development of the Cubist multiple viewpoint.

The glass surface of *To Be Looked At* cracked while it was being shipped, and the cracks were allowed to remain as part of the design. This accident and Duchamp's decision to let it stand are characteristic of the Dada artists' incorporation of the effects of chance into their works. For the Dada artists, chance became a subject of art, just as the medium itself became a subject in the late nineteenth century. In collage and assemblage, too, the medium is as prominent a feature of the image as brushstrokes were for Impressionists and Post-Impressionists. Art based on the "found object" relies on the conscious exploitation of chance in finding the medium for the work. Accepting chance and using what it offers requires a degree of flexibility that is a necessary aspect of creativity.

Surrealism

Many members of the Dada movement also became interested in the Surrealist style that supplanted it. It was the writer André Breton who bridged the gap between Dada and Surrealism with his first Surrealist Manifesto of 1924. He advocated an art and literature based on Freud's psychoanalytic technique of free association, an exploration into the imagination, and a reentry into the world of myth, fear, fantasy, and dream. The very term "surreal," meaning "above the real," connotes a higher reality—a state of being that is more real than mere appearance.

Breton had studied medicine and, like Freud, had encountered the traumas experienced by World War I shell-shock victims. He defined Surrealism as "pure psychic automatism, by which it is intended to express, either verbally or in writing, the true function of thought. Thought dictated in the absence of all control exerted by reason, and outside all esthetic or moral preoccupations."[2] Breton recommended that writers try to write in a state of free floating associations, in order to achieve spontaneous, unedited expression. This was referred to as "automatic writing" and had a significant impact on the Abstract Expressionists (see p.450). The Surrealists' interest in gaining access to unconscious phenomena led to images that seem unreal or unlikely, as dream images are, and to odd juxtapositions of time, place, and symbols.

Breton cited the Greek artist Giorgio de Chirico (1888–1978) as the paradigm of Surrealism. De Chirico had signed the 1916 Dada Manifesto and then developed an individual Surrealist style, which he termed *pittura*

28.4 Giorgio de Chirico, *Place d'Italie*. 1912. Oil on canvas, 18½ x 22½ in (47 x 57.2 cm). Collection, Dr. Emilio Jesi, Milan.

metafisica, or "metaphysical painting." His *Place d'Italie* (fig. **28.4**) of 1912 combines a perspective construction and architectural setting reminiscent of the Italian Renaissance with an unlikely marble reclining figure in the foreground and a train in the background. Strong diagonal shadows are cast by the buildings, the statue, and a standing couple in the distance. One shadow, entering the picture from the left, belongs to an unseen person.

In this painting, de Chirico combines anachronistic time and place within a deceptively rational space. The reclining figure is derived from Classical sculpture and thus denotes the Greek and Roman past. The moving train, on the other hand, refers to the industrial present and the passage of time. There is an eerie quality to this scene that is typical of de Chirico. Isolation and a sense of foreboding pervade the picture space. The viewer is uneasy, as if aware of a mystery that can never be solved.

Among the Surrealists who had also been part of the Dada movement was the American Man Ray. In 1921 he moved to Paris, where he showed his paintings in the first Surrealist exhibition of 1925. He worked as a fashion and portrait photographer and avant-garde filmmaker. His experiments with photographic techniques included the **Rayograph**, made without a camera, by placing objects directly on light-sensitive paper. His most famous photograph, *Le Violon d'Ingres* (fig. **28.5**), combines Dada

28.5 Man Ray, *Le Violon d'Ingres.* 1924. Photograph. Savage Collection, Princeton, New Jersey. The artist's real name was Emanuel Rudnitsky. His choice of the name Man Ray, although derived from his real name, illustrates the fondness for punning and word games that he shared with other Dada artists. He reportedly chose "Man" because he was male and "Ray" because of his interest in light.

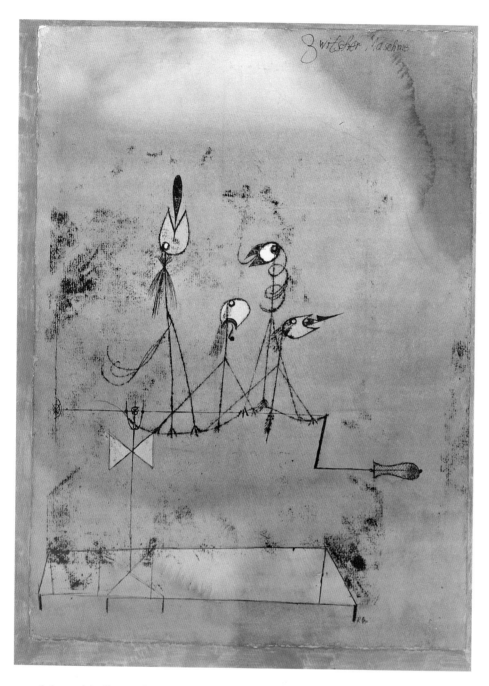

28.6 Paul Klee, *Twittering Machine (Zwitscher-Maschine)*. 1922. Watercolor, pen, and ink on oil transfer drawing on paper, mounted on cardboard, 25¼ × 19 in (63.8 × 48.1 cm). Collection, The Museum of Modern Art, New York (Purchase). Klee described the creative process as follows: "Art does not reproduce the visible; rather, it makes visible."[4] Klee himself was enormously productive. He recorded a total of nearly 9000 works.

wordplay with Surrealist imagery. The nude recalls the odalisques of Ingres (fig. **21.6**), while the title refers to Ingres's hobby — playing the violin (which led to the French phrase *violon d'Ingres*, meaning "hobby"). Man Ray also puns on the formal similarity between the nude's back and the shape of a violin, by adding sound holes to the former. The unlikely combination of the nude and the holes exemplifies the dreamlike imagery of Surrealism.

Man Ray strongly defended the art of photography and argued against those who were unwilling to treat it as an art form. In "Photography Can Be Art," he wrote that "when the automobile arrived, there were those that declared the horse to be the most perfect form of locomotion. All these attitudes result from a fear that the one will replace the other. Nothing of the kind has happened. We have simply increased our vocabulary. I see no one trying to abolish the automobile because we have the airplane."[3]

Fantasy characterizes the Surrealism of the Swiss artist Paul Klee (1879–1949). He made many pencil drawings that reveal his attraction to linear, childlike imagery, as well as the influence of Surrealist "automatic writing." In his *Twittering Machine* of 1922 (fig. **28.6**), Klee combines natural creatures with the Futurist and Cubist affinity for mechanical forms. The birds "twitter" in a language that has no meaning for human ears, just as the machine cranks out its repeated, industrial sounds. The linear quality of this picture makes the stick-figure birds into wiry, noisy, and mindless beings.

28.7 Joan Miró, *Dog Barking at the Moon*. 1926. Oil on canvas, 28¾ × 36¼ in (73 × 92.1 cm). Philadelphia Museum of Art (A. E. Gallatin Collection).

The Surrealist pictures of Joan Miró (1893–1983) are also composed of imaginary motifs, which are often reminiscent of childhood. His *Dog Barking at the Moon* of 1926 (fig. **28.7**) depicts a colorful, toylike dog standing alone on a hill. The night sky contains a fanciful moon and another shape, which might be a bird. The most surreal form in this picture is the unsupported ladder that seems to go nowhere. As the ladder rises, its reach becomes vast, while the space between earth and sky is condensed.

The Belgian artist René Magritte (1897–1967) painted Surrealist images of a more veristic kind. Individually they are realistic, often to the point of creating an illusion. However, their context, their size, or the juxtaposition of their objects is unrealistic, or possible only in a world of dreams. Magritte sometimes used language as part of his

images, a feature we have noted in Cubist collages (fig. **27.6**) and which we shall see again in the works of artists of the 1960s — Larry Rivers (fig. **30.3**) and Roy Lichtenstein (fig. **30.6**), for example. In *The Betrayal of Images* (fig. **1.2**), the pipe is convincingly real; however, the legend "This is Not a Pipe" contradicts the illusionistic quality of the image. Magritte is saying that this picture is not actually the object which it depicts so faithfully.

In *Time Transfixed (La Durée poignardée* in French) of 1938 (fig. **28.8**), Magritte juxtaposed two "immediately familiar" objects in order to evoke a mysterious unfamiliarity. The power of the artist's mind, according to Magritte, would be revealed by virtue of the mystery image. Various motifs in this work are clearly depicted and easily identifiable, and yet they have an odd quality of immobility and timelessness. The clock indicates a specific hour, but the candlesticks are without candles, whose burning typically denotes the passage of time. The room, empty of figures and composed entirely of rectangular elements, seems formal and cold. A steam engine has

Sculpture Derived from Surrealism

Surrealism influenced sculptors as well as painters and photographers in Europe and America. The Surrealist interest in the literal depiction of unconscious, chance, and dream images contributed to the twentieth-century break with many traditional forms and techniques. *The King Playing with the Queen* (fig. **28.9**) by Max Ernst (1891–1976) combines the influence of Surrealism, Cubism, and the playful qualities of Picasso and Duchamp. A geometric king looms up from a chessboard, which is also a table. His horns are related to the role of the bull as a traditional symbol of male fertility and kingship. He dominates the board by his large size and extended arms. The king is a player sitting at the table, as well as a chesspiece on the board. He literally "plays" with the queen, who is represented as a smaller geometric construction at the left. On the right, a few tiny chesspieces seem uninvolved in whatever "game" is taking place between the king and queen.

28.8 René Magritte, *Time Transfixed* (*La Durée poignardée*). 1938. Oil on canvas, 4 ft 9⅝ in x 3 ft 2⅜ in (1.46 x 0.98 m). Art Institute of Chicago (Joseph Winterbotham Collection). Freud's discovery that time does not exist in the unconscious accounts for certain unlikely condensations in dreams. The uncanniness of temporal condensation contributes to the eerie quality of this painting, as does the impossible juxtaposition of realistic objects.

burst through the fireplace, but without disturbing the wall. A shadow cast by the train against the wall is unexplained, because there is no light source to account for it. The smoke, which indicates that the train is moving as well as standing still, disappears up the chimney. *Poignardée*, literally meaning "stabbed" with a dagger or sword, expresses the "fixed," frozen quality of both the train and time.

28.9 Max Ernst, *The King Playing with the Queen*. 1944. Bronze (cast 1954, from original plaster), 38½ in (97.8 cm) high, at the base 18¾ × 20½ in (47.7 × 52.1 cm). Collection, The Museum of Modern Art, New York (Gift of D. and J. de Menil).

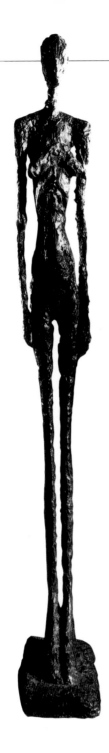

Large Standing Woman III of 1960 (fig. **28.10**), by Alberto Giacometti (1901–66), is one of his most imposing works. Its tall, thin, anti-Classical proportions hark back to the rigid, standing royal figures of ancient Egypt (fig. **5.13**). In figures such as this, whether large or small, Giacometti plays with the idea of extinction. His obsession with existence and nonexistence is evident in the fact that he has made these sculptures as thin as they can be without collapsing. Ironically, the thinner they become, the greater their presence and power to evoke anxiety. By confronting the observer with the potential for disappearance, Giacometti seems to take the viewer to the very threshold of being.

In contrast to Giacometti, the British sculptor Henry Moore (1898–1986) was drawn to massive forms. The traditional motif of the reclining figure was one of his favorite subjects. He himself related the image to the Mother Earth theme and to his fascination for the mysterious holes of nature. From the 1930s he began making sculptures with hollowed-out spaces and openings, thereby playing with the transition between inside and outside, interior and exterior. Many of his reclining figures are intended as outdoor landscape sculptures. As such, their holes permit observers to see through the work, as well as around it, and thus to include the surrounding landscape in their experience of the sculpture.

28.10 (above) Alberto Giacometti, *Large Standing Woman III.* 1960. Bronze, 7 ft 8½ in (2.35 m) high. Photo courtesy of Sidney Janis Gallery. Born in Switzerland, Giacometti spent a formative period in the 1930s as a Surrealist. He met the Futurists in Italy and the Cubists in Paris, and finally developed a distinctive way of representing the human figure that has become his trademark.

28.11 Henry Moore, *Reclining Figure,* Lincoln Center for the Performing Arts, New York. 1963–5. Bronze, 16 ft (4.88 m) high. Moore's habit of collecting the chance objects of nature, such as dried wood, bone, and the smooth stones from beaches recalls the use of "found objects" in collage and assemblage. Unlike the Dada and Surrealist artists, however, he used found objects as his inspiration rather than his medium, preferring the more traditional media of stone, wood, and bronze.

28.12 Alexander Calder, *Mobile in Red and Black*. Metal, 2 ft 8 in × 6 ft 10 in (0.81 × 2.08 m). Perls Gallery, New York. The playfulness of Calder's mobiles has not been lost on the toy industry. Mobiles composed of various kinds of figures, often activated by a wind-up motor attached to a music box, have been suspended over the cribs of generations of babies.

The Lincoln Center *Reclining Figure* (fig. **28.11**) illustrates a reclining figure in an architectural setting. The imposing, monumental forms are separated into two sections, relating the figure to the surrounding architecture. Softening the angular, urban quality of the image is the reflection in the pool, which includes the sky in the experience of the sculpture. In this figure, Moore achieves a formal and psychological synthesis of the woman with architecture and landscape.

From the 1930s, the American artist Alexander Calder (1886–1976) developed **mobiles**, or hanging sculptures that are set in motion by air currents. *Mobile in Red and Black* (fig. **28.12**) is made from a series of curved wires set in a sequence of horizontal planes. Flat, colorful metal shapes are attached to the wires. Because they hang from the ceiling, mobiles challenge the traditional viewpoint of sculpture. Their playful quality and the chance nature of air currents are reminiscent of Dada and Surrealism, although Calder is more abstract (in the non-figurative sense) than many Dada and Surrealist artists.

America Between the Wars

Regionalism and Social Realism

American painting of the 1920s and 1930s was affected by economic and political events, particularly the Depression and the rise of Fascism in Europe. Two types of response to the times which had political overtones of their own can be seen in the work of American Regionalists and Social Realists.

American Gothic (fig. **28.13**) by Grant Wood (1892–1942) reflects the Regionalists' interest in provincial America, and their isolation from the European avant-garde. Although the influence of Gothic is evident in the vertical planes and the pointed arch of the farmhouse window, the figures and their environment are unmistakably those of the American Middle West. Wood's meticulous attention to detail and the linear quality of his forms recall the early fifteenth-century Flemish painters. All such European references, however, are subordinated to a regional American character.

The African-American artist Jacob Lawrence (b. 1917) dealt with issues of racial inequality and social injustice. Figure **28.14** reveals the influence of European Expressionist and Cubist trends, although the subject and theme are purely American. Lawrence creates a powerful image of the abolitionist Harriet Tubman sawing a log by a combination of flattened planes and abrupt foreshortening. Tubman's singleminded concentration, as she fills the picture plane and focuses her energies on the task at hand, engages the observer directly in her activity. The geometric abstraction of certain forms, such as the raised right

28.13 Grant Wood, *American Gothic*. 1930. Oil on **beaverboard**, 29⅞ x 24⅞ in (75.9 x 63.2 cm). Art Institute of Chicago (Friends of American Art Collection). Wood studied in Europe, but returned to his native Iowa to paint the region with which he was most familiar. In this work, the two sober paragons of the American work ethic depicted as Iowa farmers are the artist's sister and dentist.

shoulder, contrasts with three-dimensional forms — the shaded left sleeve, for example — to produce a shifting tension. The result of such shifts is a formal instability that is stabilized psychologically by Tubman's determination.

Edward Hopper (1882–1967), also a painter of the American scene, cannot be identified strictly as either a Regionalist or a Social Realist. His work combines aspects of both styles, to which he adds a sense of psychological isolation and loneliness. His settings, whether urban or rural, are uniquely American, often containing self-

absorbed human figures whose interior focus matches the still, timeless quality of their surroundings. In *Gas* of 1940 (fig. **28.15**), a lone figure stands by a gas pump, the form of which echoes his own. The road, for Hopper a symbol of travel and time, seems to continue beyond the frame. Juxtaposed with the road are the figure and station that "go nowhere," as if frozen within the space of the picture plane.

Toward American Abstraction

Countering the Regional and Social Realist currents of American art between the wars was the influence of the European avant-garde. The 1913 Armory Show (see p.429) had brought examples of avant-garde European art to America, and Duchamp had lived in New York since 1915. A few private New York galleries, run by dealers who understood the importance of the new styles, began to exhibit "modern" art. As early as 1905, the American photographer Alfred Stieglitz (1864–1946) had opened the 291 Art Gallery at 291 Fifth Avenue in New York, where he exhibited Cézanne, the Cubists, and Brancusi, along with more progressive American artists. The Museum of

28.14 (left) Jacob Lawrence, *Harriet Tubman Series, No. 7.* 1939–40. **Casein tempera** on hardboard, 17⅛ × 12 in (43.5 × 30.5 cm). Hampton University Museum, Hampton, Virginia. From the age of ten, Lawrence lived in Harlem, and in 1990 he was awarded the National Medal of Arts. This painting is from his 1939 to 1940 series celebrating Harriet Tubman (c. 1820–1913). She was an active abolitionist and champion of women's rights, who helped southern slaves to escape. From 1850 to 1860, as a "conductor" on the Underground Railroad, she freed more than 300 slaves.

28.15 (left) Edward Hopper, *Gas.* 1940. Oil on canvas, 2 ft 2 ¼ in × 3 ft 4¼ in (0.67 × 1.02 m). Collection, The Museum of Modern Art, New York (Mrs. Simon Guggenheim Fund).

28.16 Alfred Stieglitz, *Equivalent.* 1923. Chloride print, 3⅘ x 4½ in (9.6 x 11.3 cm). Art Institute of Chicago (Alfred Stieglitz Collection). Stieglitz was born in Hoboken, New Jersey. He organized the 1902 exhibition that led to Photo-Secession, an informal group that held exhibitions all over the world and whose objective was to gain the status of a fine art for pictorial photography. In 1903 he founded the quarterly *Camera Work*, which encouraged modern esthetic principles in photography.

28.17 Georgia O'Keeffe, *Black and White*. 1930. Oil on canvas, 36 x 24 in (91.4 x 61 cm). Collection, Whitney Museum of American Art, New York (Gift of Mr. and Mrs. R. Crosby Kemper). O'Keeffe was born in Sun Prairie, Wisconsin. In 1917 Stieglitz gave her her first one-woman show at "291." She married Stieglitz in 1924, and after his death moved permanently to New Mexico, where desert objects — animal bones, rocks, flowers — became favorite motifs in her work.

Modern Art, under the direction of Alfred Barr Jr., opened in 1929, the year of the stock market crash. A year later Stieglitz opened the American Place Gallery to exhibit abstract art. Also during this period, government support for the arts was provided by the Federal Arts Project, operating under the aegis of Franklin Roosevelt's social programs. The Project provided employment for thousands of artists and, in doing so, granted some measure of official status to abstract art.

Stieglitz's photographs straddle the gulf between the concerns of American Social Realism and avant-garde abstraction. Many of his pictures document contemporary society, while others are formal studies in abstraction. In 1922 he began a series of abstract photographs entitled *Equivalent* (fig. **28.16**), in which cloud formations create various moods and textures. Stieglitz believed in what is called "straight photography," as opposed to achieving unusual visual effects by the manipulation of negatives.

Georgia O'Keeffe (1887–1986), who was married to Stieglitz, also became a major American painter. She is

difficult to place within a specific stylistic category, but it is clear that she was influenced by photography and early twentieth-century abstraction. Her *Black and White* of 1930 (fig. **28.17**) is an abstract depiction of various textures, motion, and form, without any reference to recognizable objects. By eliminating color, O'Keeffe makes use of the same tonal range that is available to the black-and-white photographer.

Stieglitz and O'Keeffe were among the most avant-garde artists of the early twentieth century in America. At that time, despite the Armory Show and other inroads made by the new European styles, art in the United States was still primarily conservative. It was not until the 1950s that American art finally emerged as the most innovative on an international scale.

Abstract Expressionism and Color Field Painting

The Teachers: Hofmann and Albers

American abstraction emerged from the contradictory and paradoxical background of conservative Regionalism and Social Realism inspired by Marxism. Equally influential in its development, however, was the influx of avant-garde artists from Europe. Two of the most important, Hans Hofmann (1880–1966) and Josef Albers (1888–1976), emigrated to America from Germany. They taught at the Art Students' League in New York and at Black Mountain College in North Carolina, respectively. From 1950 to 1960 Albers chaired the Department of Architecture and Design at Yale. Both Hofmann and Albers influenced a generation of American painters as much through their teaching as their work.

Hofmann's *Gate* (fig. **29.2**) is, as the title implies, an architectural construction in paint. The intense, thickly applied color is arranged in squares and rectangles. It ranges from relatively pure hues, such as the yellow and red, to more muted greens and blues. For Hofmann, it was the color in a picture that created light. In nature, the reverse is true. Light creates the sense of color. In *The Gate*, edges vary from precise to textured. Everywhere, the paint is structured, combining bold Fauve color with the tectonic qualities of Cubism and related styles.

Albers's series of paintings entitled *Homage to the Square* (fig. **29.1**) also explores color and geometry. But his surfaces are smooth, and the medium is subordinate to the color relationships between the squares. In his investigation of light and color perception, Albers concentrated on the square because he believed that it was the shape furthest removed from nature. "Art," he said, "should not represent, but present."

By the middle of the 1930s, the New York avant-garde was clearly identified with abstraction. In 1939 Peggy Guggenheim, an important dealer and collector, opened the Museum of Nonobjective Painting (later to become the Guggenheim Museum). Fascist authorities in Europe prevented artists from pursuing Modernism on the grounds that it was "decadent." The waves of refugees who fled

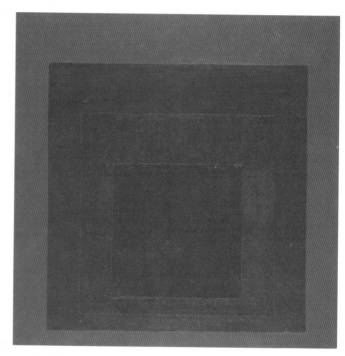

29.1 Josef Albers, *Homage to the Square*. 1968. Oil on **masonite**, 32 × 32 in (81.3 × 81.3 cm). Photo courtesy of Sidney Janis Gallery, New York.

oppression and war in the late 1930s therefore included many avant-garde architects, artists, musicians, and writers. By 1940, when Paris fell to the Nazis, the center of the art world had shifted to New York, whose cultural life was enriched by these émigré artists.

29.2 (opposite) Hans Hofmann, *The Gate*. 1959–60. Oil on canvas, 6 ft 3⅛ in × 4 ft ½ in (1.9 × 1.23 m). Solomon R. Guggenheim Museum, New York. For Hofmann, nature was the source of inspiration, and the artist's mind transformed nature into a new creation. "To me," he said, "a work is finished when all parts involved communicate themselves, so that they don't need me."[1]

Abstract Expressionism and the New York School

Abstract Expressionism was a term used in 1929 by Alfred Barr, Jr. to refer to the nonobjective paintings of Kandinsky (see p.414). The style was to put America on the map of the international art world. In the 1950s it was generally used to categorize the New York School of painters, which, despite its name, actually comprised artists from many different parts of America and Europe.

Nearly all the Abstract Expressionists had passed through a Surrealist phase. From this they had absorbed an interest in myths and dreams, and in the effect of the unconscious on creativity. From Expressionism they inherited an affinity for the expressive qualities of paint. This aspect emerged particularly in the so-called "action" or "gesture" painters of Abstract Expressionism.

Gorky

The Abstract Expressionist painter who was most instrumental in creating a transition from the European to the American avant-garde was the Armenian Arshile Gorky (1904–48). After absorbing several European styles, including Impressionism and Surrealism, he developed his own pictorial "voice" in the 1940s.

Some time between about 1926 and 1936, Gorky painted his famous work *The Artist and his Mother* (fig. **29.3**). The slightly geometric character of the faces suggests the influence of early Cubism. Flattened planes of color—the mother's lap, for example—and visible brushstrokes reveal affinities with Fauvism and Expressionism. On the left stands a rather wistful Gorky. His more dominant mother recalls the mythic enthroned mother goddesses of antiquity (see the Etruscan *Mater Matuta*, fig. **8.3**).

Entirely different in form, though it shares the nostalgic

29.3 Arshile Gorky, *The Artist and his Mother*. c. 1926–36. Oil on canvas, 5 ft x 4 ft 2 in (1.52 x 1.27 m). Collection, Whitney Museum of American Art, New York. Gorky was born Vosdanig Manoog Adoian in Turkish Armenia and emigrated to the United States in 1920. At the height of his career, a series of misfortunes — a fire that burnt most of his recent work, a cancer operation, a car crash that fractured his neck — led to his suicide in 1948. This painting is based on an old photograph.

quality of *The Artist and his Mother*, is the *Garden in Sochi* (fig. **29.4**) of 1943. The third of a series depicting child-hood recollections, this painting exemplifies Gorky's most characteristic innovations. Paint is applied thinly, and the colorful shapes are bounded by delicate curvilinear out-lines, which create a sense of fluid motion. Both the title and the biomorphic shapes suggest references to natural, organic protozoan or vegetable life. Gorky did, in fact, study nature closely, sketching flowers, leaves, and grass from life before transforming the drawings into abstract forms. The suggestive but elusive identity of Gorky's shapes is somewhat reminiscent of Miró (see p.441), who had influenced Gorky's Surrealist phase.

Action Painting

Just as brushstrokes are a significant aspect of Impres-sionism and Post-Impressionism, so new methods of applying paint are characteristic of the action painters. They dripped, splattered, sprayed, rolled, and threw paint

29.4 Arshile Gorky, *Garden in Sochi* . 1943. Oil on canvas, 31 × 39 in (78.7 × 99 cm). Collection, The Museum of Modern Art, New York (Acquired through the Lillie P. Bliss Bequest). Gorky related this series to a garden at Sochi on the Black Sea. He recalled porcupines and carrots and a blue rock buried in black earth with moss patches resembling fallen clouds. Long shadows reminded him of the lancers in Uccello's battle scenes (see p.228). In Sochi, the village women rubbed their breasts on the rock in the garden. Passers-by tied colorful strips of clothing to a leafless tree. They blew in the wind like banners and rustled like leaves.

on to their canvases, with the result that the final image reflects the artist's role in the creative process itself.

Of the "action" or "gesture" painters who were part of the New York School, the best known is Jackson Pollock (1912–56). He began as a Regionalist, and turned to Sur-realism in the late 1930s and early 1940s. *Guardians of the Secret* (fig. **29.5**) is from his period of Surrealist abstrac-tion. A series of thickly painted rectangles enlivened by energetic curves and zigzags evokes the spontaneous

29.5 Jackson Pollock, *Guardians of the Secret.* 1943. Oil on canvas, 4 ft ⅜ in x 6 ft 3⅜ (1.23 x 1.91 m). San Francisco Museum of Modern Art, California (Albert M. Bender Collection and Bequest Fund Purchase). Pollock, born in Wyoming, moved to New York in 1929. He worked for the Federal Arts Project and had his first one-man show in 1943 at Peggy Guggenheim's *Art of This Century* Gallery. In 1956 he died in a car accident in East Hampton, Long Island, where he had a studio. Pollock's interest in Surrealism, unconscious processes, and myth, which is apparent in this painting, led him to undertake a Jungian psychoanalysis.

29.6 (left) Jackson Pollock, *Black and White.* 1948. Oil, enamel, and aluminum paint on canvas, mounted on wood. Private Collection. Pollock first exhibited paintings such as this in 1948 to a shocked public. A critic for *Time* magazine dubbed him "Jack the Dripper," but avant-garde critics came to his defense. Within a few years of his death, he was the most widely exhibited of all the artists of the New York School.

29.7 (opposite) Willem de Kooning, *Woman and Bicycle.* 1952–3. Oil on canvas, 6 ft 4½ in x 4 ft 1 in (1.94 x 1.25 m). Collection, Whitney Museum of American Art, New York (Purchase). De Kooning was born in Rotterdam and emigrated to the United States in 1926, but did not have his first one-man show until 1948. He described his relationship to twentieth-century art as follows: "Of all movements, I like Cubism most. It had that wonderful unsure atmosphere of reflection . . . and then there is that one-man movement: Marcel Duchamp — for me a truly modern movement because it implies that each artist can do what he thinks he ought to — a movement for each person and open for everybody."[3]

reminiscent of graffiti. It suggests the signs of a hidden and unintelligible language. The apparent spontaneity of Pollock's painted "signs" can be related to the Surrealist interest in gaining creative access to the unconscious.

From 1947 onward, Pollock worked with the **drip technique**, which he used to produce his most celebrated pictures. In these, he used his whole body energetically in the act of painting. From cans of commercial housepainter's paint, enamel, and aluminum rather than tubes of oil paint, Pollock dripped the paint from the end of a stick or brush directly onto a canvas spread on the ground. In so doing, he achieved some of the chance effects sought by the Dada and Surrealist artists. At the same time, however, he did control the placement of the drips and splatters through the motion of his arm and body. He described this process as follows: "On the floor I am more at ease. I feel nearer, more a part of the painting, since this way I can walk around it, work from the four sides and literally be *in* the painting. This is akin to the Indian sand painters of the West." Pollock also declared that, when actually painting, he was unaware of his actions:

Acrylic

One of the most popular of the modern **synt**
is **acrylic**, a water-based paint. Acrylic co
colors, dries quickly, and does not fade. It can
paper, canvas, and board with either traditio
airbrushes. It can be poured, dripped, a
When thick, acrylic approaches the texture
thinned, it is fluid like water paint. In cont
paint, however, which mixes when more t
color is applied, acrylic can be applied in lay
not blend even when wet. It is possible to bu
layers of paint, which retain their individual
to create a structure of pure color — as Frank
in *Flood* (fig. **29.8**).

29.8 Helen Frankenthaler, *Flood*. 1967. Synthetic p
10 ft 4 in x 11 ft 8 in (3.15 x 3.56 m). Collection, Whit
American Art, New York (Purchase). Like Pollock, F
places canvases on the floor to prevent the paint fro
downward. Her pouring technique creates a thin, wa

"When I am 'in' my painting, I'm not aware of what I'm doing . . . because the painting has a life of its own."[2]

Pollock's *Black and White* of 1948 (fig. **29.6**) eliminates all reference to recognizable objects. It is a celebration of dynamic line. Set against a yellow and white background is an elaborate build-up of interwoven dripped black lines. At certain points the paint has spread out, thereby varying the width and texture of the lines. Pollock's habit of trimming his finished canvases enhances their dynamic quality. The lines swirl rhythmically in and out of the picture plane, unbounded by any edge or frame, as if self-propelled.

The dynamic energy of Pollock's monumental drip paintings is virtually unmatched, even among the other Abstract Expressionist action painters. In the work of Willem de Kooning (b. 1904), action painting is used in the service of explicit aggression and violence. This is particularly true of a series of pictures of women that de Kooning painted in the early 1950s. Unlike Pollock, de Kooning only partially eliminated recognizable form from his iconography. His *Woman and Bicycle* of 1952–3 (fig. **29.7**) combines the frontal image of a large, frightening woman with aggressive brushstrokes which literally tear through the figure's outline. The anxiety created by the woman's appearance — her huge, staring eyes, double set of menacing teeth, and platformlike breasts, which reveal the influence of Cubist geometry — matches the frenzied violence of the brushstrokes. The assault on the figure, which seems to disintegrate into unformed paint, is also an attack on the idealized Classical image of female beauty.

Helen Frankenthaler (b. 1928), another action painter, used synthetic media to "stain" her canvas, by pouring paint directly onto it. To create *Flood* of 1967 (fig. **29.8**), she poured thinned paint onto the canvas in layers of color, which engulf the picture plane. The colors are delicate and, for the most part, pastel. They swell across the canvas, creating a sense of relentless flood waters.

Color Field Painting

At the opposite pole of Abstract Expressionism are artists who applied paint in a more traditional way than the action painters. This has been variously referred to as "Chromatic Abstraction" and "color field painting." The latter term refers to the preference for expanses of color applied to a flat surface in contrast to the domination of line in action painting. The imagery of action painting is more in tune with Picasso and Expressionism. Color field painters, by contrast, were influenced by Matisse's broad planes of color. Compared with action paintings, color field imagery is typically calm and inwardly directed. It tends to evoke a meditative, even spiritual, response.

One of these artists was Mark Rothko (1903–70). Like Pollock, he had gone through a Surrealist period, and was engaged in the search for universal symbols, which he believed were accessible through myths and dreams. By the 1950s he had developed his most original style. Totally nonobjective, Rothko's paintings are images of large rectangles hovering in fields of color. In *Green on Blue* of 1956 (fig. **29.9**), two rectangles — one green, the other white — occupy a field of blue. By muting the colors and blurring the edges of the rectangles, Rothko softens the potential contrast between them. He likewise mutes the observer's attention to the "process" of painting by subduing the presence of the medium.

29.9 Mark Rothko, *Green on Blue.* 1956. Oil on canvas, 7 ft 5¾ in × 5 ft 3¼ in (2.28 × 1.61 m). University of Arizona Museum of Art (Gift of Edward J. Gallagher Jr.). Rothko was born in Latvia. In 1913 his family emigrated to Portland, Oregon, and in 1923 he moved to New York. Rothko suffered from depression, and committed suicide in 1970. He expressed his alienation from society as follows: "The unfriendliness of society to his [the artist's] activity is difficult . . . to accept. Yet this very hostility can act as a lever for true liberation Both the sense of community and of security depend on the familiar. Free of them, transcendental experiences become possible."[4] Rothko's striving for freedom from the familiar is evident in the absence of recognizable forms in paintings such as this one.

29.10 Adolph (Ad) Reinhardt, *Abstract Painting (Black)*. 1965. Oil on canvas, 5 ft × 5 ft (1.52 × 1.52 m). Photo Bill Jacobson, courtesy of the Pace Gallery, New York.

29.11 Frank Stella, *Tahkt-i-Sulayman I*. 1967. Polymer and fluorescent paint on canvas, 10 ft ¼ in × 20 ft 2¼ in (3.05 × 6.15 m). Pasadena Art Museum, California (Gift of Mr. and Mrs. Robert A. Rowan). Stella has lived and worked in New York since 1958. The Near Eastern title of this painting indicates his interest in colorful Islamic patterns (which also influenced Matisse). The interlaced color strips reflect his study of Hiberno-Saxon designs (see p.171).

In eliminating references to the natural world, as well as to the creative process, Rothko attempted to transcend material reality. His pictures seem to have no context in time or space. The weightless, spiritual quality of his rectangles is enhanced by their blurred edges and thin textures, which allow the underlying blue to filter through them. Whereas Pollock's light moves exuberantly across the picture plane, weaving in and out of the colors in the form of white drips, Rothko's light is luminescent. It flickers at the edges of the rectangles and shifts mysteriously from behind and in front of them.

Even more luminous are the late color field paintings of Ad (Adolph) Reinhardt (1913–67). The longer one stares at these pictures, the stronger is the sense of light shimmering and glowing behind the paint. Reinhardt's stated intention was to avoid all association with nature. He wanted the observer to focus on the painting as an experience in itself—distinct from other, more familiar experiences. In his series of black paintings dating from the 1960s (fig. **29.10**), Reinhardt comes close to his desired aim. Color is eliminated, and nine squares of dark gray and black fill the picture plane.

Frank Stella (b. 1936) was trained in art during the heyday of the New York School of Abstract Expressionism, but he paints with a new vision of color and form. His early somber, largely monochrome pictures departed from the traditional square, rectangular, or circular shapes. They are fitted into triangular, starshaped, zigzag, and open rectangular frames (see p.24). By varying the shape of the canvas, Stella focused on the quality of the picture as an object-in-itself. Within the picture, he painted stripes of flat color, separated from each other and bordered by a precise edge. This technique is sometimes referred to as "Hard Edge Painting."

Tahkt-i-Sulayman I of 1967 (fig. **29.11**) belongs to Stella's

"Protractor Series," in which arcs intersect as if drawn with a compass. Here, a central circle is divided into two semicircles, which are repeated symmetrically on either side by flanking semicircles. These forms are related by sweeping curves, which interlace with all three sections in a continuous, interlocking motion. The intense, bright color strips in Stella's paintings of the 1960s combine dynamic exuberance with geometric control.

West Coast Abstraction

A related group of West Coast abstract painters includes Richard Diebenkorn (1922–93). Among his earlier pictures were landscapes, often based on the San Francisco Bay area, and anonymous, isolated figures reminiscent of Hopper (see p.445) in mysterious, rectangular settings. By the end of the 1960s, however, Diebenkorn had replaced figuration with abstraction, building up layers of textured geometric shapes defined by straight lines. His

monumental *Ocean Park* series (1970s–1980s) evokes the open spaces of the American West and the vast expanse of the Pacific Ocean. Most of his paintings contain a dominant horizontal, suggestive of landscape. *Ocean Park No. 129* of 1984 (fig. **29.12**), for example, suggests a blue sea. Above the horizon is a narrow strip of abstract colored patches bounded by horizontals and diagonals. Despite the obvious influence of Matisse and Cubism on Diebenkorn's vision, the strict geometry of the forms is relieved by the drips and emphasis on the paint texture, which relate his work to Abstract Expressionism.

29.12 Richard Diebenkorn, *Ocean Park No. 129.* 1984. Oil on canvas, 5 ft 6 in x 6 ft 9 in (1.68 x 2.06 m). Private Collection. Courtesy, M. Knoedler & Co., Inc.

Sculpture

Contemporary with the above developments in American painting were several sculptors whose work conveys a dynamic abstraction akin to Abstract Expressionism. Isamu Noguchi's *Kouros* (fig. **29.13**), for example, contains biomorphic shapes that evoke those of Miró and Gorky. Flat, protozoan forms are arranged in interlocking horizontal and vertical planes. They create a configuration which, the artist claimed, "defies gravity." Although it conforms to the principles of twentieth-century abstraction, Noguchi's figure shares a vertical stance — softened by curvilinear stylization — with the Archaic Greek *kouros* (fig. **7.7**).

Shapes and lines combine with open space in the sculpture of David Smith (1906–65). Smith welded iron and steel to produce a dynamic form of sculptural abstraction. His last great series of work, entitled *Cubi* (fig. **29.14**), is composed of cylinders, cubes, and solid rectangles. As both the title and the shapes indicate, Smith was influenced by Cubism. The works were intended to be installed outdoors (as in the illustration). Their open spaces make it possible to experience the landscape through and around them. The surface, enlivened by variations of

29.13 Isamu Noguchi, *Kouros*. 1944–5. Pink marble, slate base, 9 ft 9 in (2.97 m) high. Metropolitan Museum of Art, New York (Fletcher Fund, 1953). Noguchi was born in Los Angeles in 1904 to an American mother and a Japanese father. He grew up in Japan and was a pre-medical student at Columbia University (1921–4). He decided to become a sculptor and worked with Brancusi, whose influence can be seen in the smooth surfaces and elegant forms of the *Kouros*. In addition to sculpture, Noguchi has produced furniture and stage designs, public sculptural gardens, and playgrounds.

29.14 David Smith, *Cubi XVIII and Cubi XVII*. 1963–4. Stainless steel, 9 ft 8 in and 9 ft (2.95 and 2.74 m) high. Courtesy, Museum of Fine Arts, Boston, and Dallas Museum of Fine Arts.

texture, contributes to the sense of planar motion in the individual shapes. Each sculpture is set against another, and often at an angle to it, so that they seem to move and stretch, though still firmly anchored by their pedestals.

Louise Nevelson (1900–88) made assemblages (see p.424) consisting of "found objects" — especially furniture parts and carpentry tools — set inside open boxes. The boxes were piled on top of each other and arranged along a wall, much like bookshelves, so that they could be seen, as paintings, from only one side. Nevelson used a wide range of media, and in the 1970s and 1980s she created a number of monumental outdoor sculptures. Her *Night Presence* of 1972 (fig. **29.15**) dominates the junction of Park Avenue and 92nd Street in New York. Like the earlier "box" sculptures, this is an open wall composed of abstract shapes, and it is made to be seen primarily from one viewpoint. The two shapes at the front suggest chess-pieces, which recall Max Ernst's Surrealist *King Playing with the Queen* (fig. **28.9**).

Although many American Abstract Expressionists worked beyond the 1950s, the novelty and excitement of that style had diminished a decade later. In painting, Abstract Expressionism can be seen as the ultimate, logical development of the Impressionist attention to the medium of paint itself. Brushstrokes became part of the critical vocabulary of Impressionism, Post-Impressionism, Fauvism, and then Expressionism. With the gestural Abstract Expressionists, paint and the way it behaved took over the content entirely, emerging finally as the very "subject" of painting. In sculpture as well, the texture of the medium became an increasingly significant feature of the work.

29.15 Louise Nevelson, *Night Presence 4*, Park Avenue and 92nd Street, New York. 1972. Cor-ten steel, 22 ft (6.71 m) high.

The 1960s: Pop, Op, and Minimalism

In the late 1950s and 1960s, a reaction against the non-objective character of Abstract Expressionism took the form of a return to the object. The most significant style to emerge in America in the 1960s was "Pop," whose popular imagery was derived from commercial sources, the mass media, and everyday life. In contrast to Abstract Expressionist subjectivity—which viewed the work of art as a revelation of the artist's inner, unconscious mind—the Pop artists strove for an "objectivity" embodied by the imagery of objects. What contributed to the special impact of Pop Art was the mundane character of the objects selected. As a result, Pop Art was regarded by many as an assault on accepted conventions and esthetic standards.

Despite the 1960s emphasis on the objective "here-and-now," however, the artists of that period were not completely detached from historical influences or psychological expression. The elevation of everyday objects to the status of artistic imagery, for example, can be traced to the early twentieth-century taste for "found objects" and assemblages. Likewise, the widespread incorporation of letters and numbers into the new iconography of Pop Art reflects the influence of the newspaper collages produced by Picasso and Braque.

Another artistic product of the 1960s, the so-called **Happenings**, probably derived from the Dada performances at the Cabaret Voltaire in Zürich during World War I (see p.436). Happenings, in which many Pop artists participated, were multimedia events that took place in specially created environments. They included painting, assemblage, television, radio, music, film, and artificial lighting. Improvisation and audience participation encouraged a spontaneous, ahistorical atmosphere that called for self-expression in the "here-and-now."

The small collage *Just what is it that makes today's homes so different, so appealing?* (fig. **30.1**), by Richard Hamilton (b. 1922), was originally produced for reproduction on a poster. It can be considered a visual manifesto of what was to become the Pop Art movement. First exhibited in London in a 1956 show entitled "This is Tomorrow," Hamilton's collage inspired an English critic to coin the term "Pop."

The muscle man in the middle of the modern living room is a cross between the Classical *Spearbearer* (fig. 7.11) by Polyclitus and the *Medici Venus* (fig. **15.14**). The giant Tootsie Pop directed toward the woman on the couch is at once a sexual, visual, and verbal pun. Advertising references occur in the sign pointing to the vacuum hose, the Ford car emblem, and the label on the tin of ham. Mass media imagery is explicit in the tape recorder, television set, newspaper, and movie theater. The framed cover of *Young Romance* magazine refers to popular teenage reading matter of the 1950s.

Despite the iconographic insistence on the contemporary, however, Hamilton's collage contains clear historical references. The image of a white-gloved Al Jolson, above the marquee advertising *The Jazz Singer*, recalls an earlier era of American entertainment. The oldfashioned portrait on the wall evokes an artistic past, and the silicon pin-up on the couch is a plasticized version of the traditional reclining nude. Hamilton's detailed attention to the depiction of objects, especially those associated with the domestic interior, reveals his respect for fifteenth-century Flemish painters, as well as his stated admiration for Duchamp.

New York Pop Art

Painting

Although Pop Art made its début in London in 1956 and continued in England throughout the 1960s, it reached its fullest development in New York. In 1962 an exhibition of the "New Realists" at the Sidney Janis Gallery gave Pop artists official status in the New York art world. Pop Art, however, was never a homogeneous style, and within this classification are many artists whose imagery and technique differ significantly.

In *Three Flags* of 1958 (fig. **30.2**) Jasper Johns (b. 1930) depicts a popular image that is also a national emblem. It is an abstract image insofar as it consists of pure geometric shapes (for example, stars and rectangles), but it is also instantly recognizable. The American flag has its own history, and the encaustic medium that Johns used to paint it dates back to antiquity (see p.95). Johns's return to the object, however, did not cause him to reject the

30.1 Richard Hamilton, *Just what is it that makes today's homes so different, so appealing?* 1956. Collage on paper, 10¼ × 9¼ in (26 × 23.5 cm). Kunsthalle, Tübingen (Collection, Professor Dr. Georg Zundel). Hamilton compiled a checklist of Pop Art subject matter: "Popular (designed for a mass audience), transient (short-term solution), expendable (easily forgotten), low-cost, mass-produced, young (aimed at youth), witty, sexy, gimmicky, glamorous, big business."

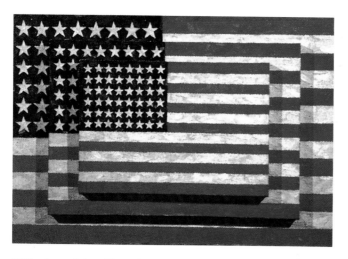

30.2 Jasper Johns, *Three Flags*. 1958. Encaustic on canvas, 30⅞ × 45½ × 5in (78.4 × 115.6 × 12.7 cm). Collection, Whitney Museum of American Art, New York.

painterly qualities of Abstract Expressionism. The flags are built up with superimposed canvas strips covered with encaustic — a combination that creates a pronounced sense of surface texture.

Two other Pop artists who maintained a sense of painterly texture are Larry Rivers (b. 1923) and Robert Rauschenberg (b. 1925). Rivers's *Portrait of Frank O'Hara* (fig. **30.3**) combines words with the poet's image. "O'Hara" is stenciled over the poet's head, and individual words are written on the left. The picture is co-signed "Rivers" above "O'Hara" near the figure's shoulder on the right, signifying that the work is a collaborative effort of both painter and poet. As such, the portrait recalls Dada combinations of words and pictures, and other forms of multimedia experimentation.

Rauschenberg's **silkscreen** print of 1964, *Retroactive I* (fig. **30.4**), is an arrangement of cut-outs resembling a collage. It illustrates the artist's expressed wish to "unfocus" the mind of the viewer, by presenting simultaneous images that are open to multiple interpretations. The newspaper imagery emphasizes current events, reflecting the contemporary focus of Pop Art. A returning astronaut parachutes to earth in the upper left frame, while in the center President Kennedy, who had been assassinated the

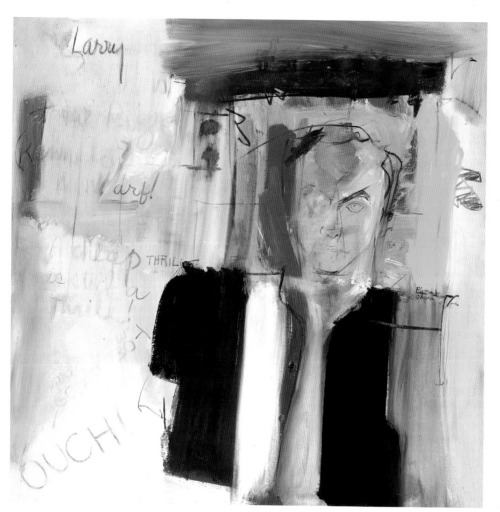

30.3 Larry Rivers, *Portrait of Frank O'Hara*. 1961. Oil on canvas, 36 × 36 in (91.4 × 91.4 cm). Private collection. Photo Maggie Nimkin. Rivers worked as a professional saxophonist before taking up painting in 1945. His portrait of Frank O'Hara (1926–66), a post-World War II poet, playwright, and art critic, reveals his interest in diverse expressive media. O'Hara himself worked as a curator at The Museum of Modern Art, New York, and his poems depict mental states of consciousness in a style reminiscent of Abstract Expressionism.

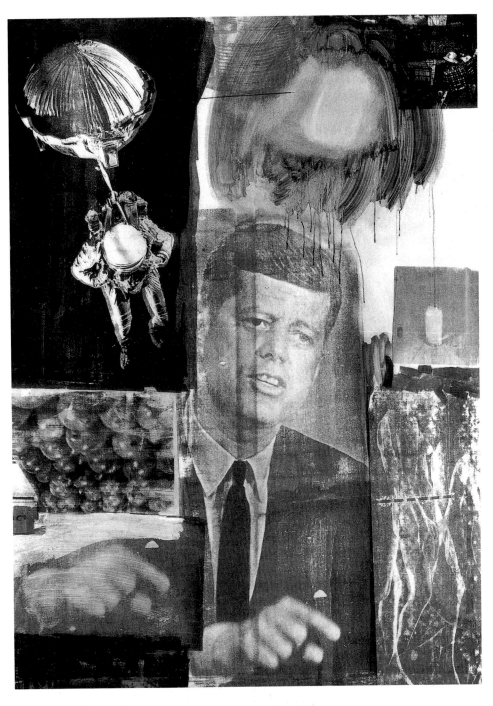

30.4 Robert Rauschenberg, *Retroactive I*. 1964. Silkscreen print. Wadsworth Atheneum, Hartford, Connecticut.

previous year, extends his finger as if to underline a point. The frame at the lower right reveals a historical sense lurking behind Rauschenberg's "current events" iconography. It contains a blow-up of a stroboscopic photograph of a take-off on Duchamp's *Nude Descending a Staircase* (fig. **27.14**). At the same time, it is strongly reminiscent of Masaccio's *Expulsion* (fig. **15.15**) of 1425.

Despite the presence of media images in this print, Rauschenberg seems to have covered it with a thin veil of paint. Brushstrokes and drips running down the picture's surface are particularly apparent at the top. The dripping motion parallels the fall of the astronaut, and one drip

lands humorously in a glass of liquid embedded in the green patch on the right. More hidden, or "veiled," is the iconographic parallel between the falling paint, the astronaut, and the "Fall of Man," which resulted in the expulsion from Paradise. Kennedy's "mythic" character is implied by his formal similarity to the Christ of Michelangelo's *Last Judgment* (fig. **16.20**) and to God in his *Creation of Adam* (fig. **16.18**).

Andy Warhol (1928–87) was a protagonist of the Pop Art lifestyle, as well as the creator of highly individual works of art. With his flair for multimedia events and self-promotion, Warhol turned himself into a work of Pop Art,

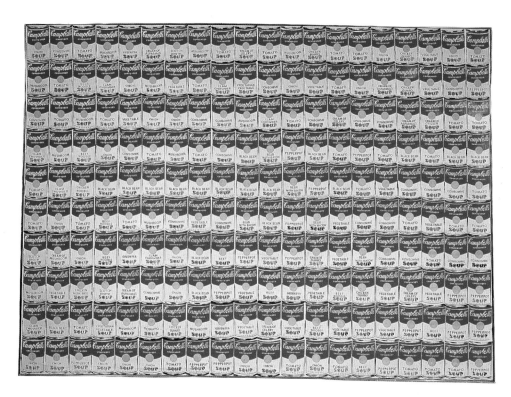

30.5 (above) Andy Warhol, *200 Campbell's Soup Cans*. 1962. Oil on canvas, 6 ft x 8 ft 4 in (1.83 x 2.54 m). Private Collection. Courtesy, Leo Castelli Gallery, New York. The smooth surface of Warhol's canvas replicates the illusion of paper labels stretched over metal cans.

30.6 (below) Roy Lichtenstein, "*Torpedo . . . Los!*" 1963. Oil on canvas, 5 ft 8 in x 6 ft 8 in (1.73 x 2.03 m). Courtesy, Roy Lichtenstein. In addition to comic-book imagery, Lichtenstein produced his own versions of paintings by Cézanne, Picasso, Matisse, Mondrian, and others.

30.7 (opposite) Tom Wesselmann, *Great American Nude No. 48.* 1963. Mixed media, 7 ft x 9 ft (2.13 x 2.74 m). Private collection. Photo courtesy of Sidney Janis Gallery, New York.

and became the central figure of a controversial cult. One of his most characteristic works, *200 Campbell's Soup Cans* of 1962 (fig. **30.5**), illustrates his taste for repeated commercial images. Since a label is, in effect, an advertisement for a product, Warhol's painting forces the viewer to confront the sameness and repetition inherent in advertising. The clear precision of Warhol's forms and the absence of any visible reference to paint texture intensify the viewer's confrontation with the object represented — with the object as object. Warhol's famous statement "I want to be a machine" expresses his obsession with mass production and his personal identification with the inhuman, mindless, and repetitive qualities of mass consumption.

The popular reading matter of the 1940s and 1950s included comic books. These provided the source for some of the best-known images of Roy Lichtenstein (b. 1923). He monumentalized the flat, clear comic-book drawings with their "balloons" containing dialogue. *Torpedo . . . Los!* (fig. **30.6**) is a blow-up made from a war comic, illustrating a U-boat captain launching a torpedo. The impression of violence is enhanced by the close-up of the figure's open mouth and scarred cheek. The absence of shading, except for some rudimentary hatching, and the clear, outlined forms replicate the character of comic-book imagery.

The *Great American Nude* series of Tom Wesselmann (b. 1931) combines Hollywood pin-ups with the traditional reclining nude. In *No. 48* (fig. **30.7**), the nude is placed in a contemporary setting with real as well as painted objects. The exterior urban skyline contrasts with the more intimate interior bedroom. The nude is faceless except for her voluptuous red lips, which are visual echoes of the tulips and the apple and tomato on the windowsill. Her pose is clearly derived from such figures as Titian's *Venus of Urbino* (fig. **16.27**). Wesselmann's play with flat, unmodeled painted shapes and literal three-dimensional space is echoed by the reproduction of a Matisse woman with flowers, which hangs over the bed. In this work, therefore, Wesselmann juxtaposes the three-dimensional "object" with flattened geometric abstractions, interior with exterior, intimate and personal with general and anonymous. He sets hard metallic or wooden surfaces against soft, floral textures, and creates a "Modernism" with historical echoes.

Sculpture

Generally included among New York Pop artists are the sculptors Claes Oldenburg (b. 1929) and George Segal (b. 1924). Although both can be considered Pop artists in the sense that their subjects are derived from everyday objects and the media, their work is distinctive in maintaining a sense of the textural reality of their materials.

Oldenburg has produced an enormous, innovative body of imagery, ranging from clothing, lightswitches, food displays, and furniture sets to tea bags. The *Giant Soft Drum Set (Ghost Version)* of 1972 (fig. **30.8**) is one of his "soft sculptures." In these works, which are composed of materials such as vinyl and canvas, he typically represents a hard, solid object in soft form. The effect on the observer can be startling, because tactile expectations are reversed. Drums, for example, require a degree of tautness in order to create sound. Soft drums are impotent and without sound. In this sculpture, Oldenburg's drums and batons have collapsed on their pedestal, as if worn out from overwork. The drums sag, and the metal stays and batons are splayed and flat, assuming an almost human quality despite their inanimate nature.

Oldenburg takes a different approach with other popular objects. His giant *Clothespin* of 1976 in Philadelphia (fig. **30.9**) illustrates his enlargement of objects that are small in everyday experience. Like the soft drums, the *Clothespin* has an anthropomorphic quality. It resembles a tall man standing with his legs apart, as if striding

forward. The wire spring suggests an arm, and the curved top with its two circular openings, a head and face. Despite the hard texture of this work, Oldenburg manages to arouse a tactile response by association with actual clothespins. Pressing together the "legs," for example, would cause the spring to open up the spaces at the center of the "head." The "tactile" urge aroused by the clothespin, together with its anthropomorphic character, reflects Oldenburg's genius for paradox and metaphor. The clothespin thus assumes the quality of a visual pun, which is reminiscent of Picasso's *Bull's Head* (fig. **27.7**) and the Dada esthetic.

The sculptures of George Segal differ from Oldenburg's in that they are literally "figurative." Segal creates environments in which he sets figures, single or in groups, who convey a sense of isolation or self-absorption. In *Chance Meeting* (fig. **30.10**), three lifesize pedestrians encounter each other by a one-way street sign. Their anonymity is emphasized by Segal's "mummification" of living figures and the impression that they do not communicate. Their light, textured surfaces create a paradoxical impression for, although they have been molded from specific people, they seem ghostly and alien.

30.9 Claes Oldenburg, *Clothespin*, Centre Square, Philadelphia. 1976. Cor-ten and stainless steel, 45 ft × 6 ft 3¾ in × 4 ft ⅓ in (13.7 × 1.92 × 1.32 m). This is one of several "projects for colossal monuments," based on everyday objects, which Oldenburg proposed for various cities. Others include a giant *Teddy Bear* for New York, a *Drainpipe* for Toronto, and a *Lipstick* for London (presented to Yale in 1969). Oldenburg says that he has always been "fascinated by the values attached to size."

30.8 Claes Oldenburg, *Giant Soft Drum Set* (*Ghost Version*). 1972. Canvas painted with latex, nine instruments (125 pieces), 7 × 6 × 4 ft (2.13 × 1.83 × 1.22 m). Private Collection. For many of his soft sculptures made mainly of vinyl, which has a shiny texture, Oldenburg created a "ghost" version, which was drained of color and made of canvas. This is the ghost version of his soft drum set.

Marisol's (b. 1930) brand of Pop Art combines Cubist-inspired blocks of wood with figuration. In her monumental sculptural installation of the *Last Supper* (fig. **30.11**), she recreates Leonardo's fresco (fig. **16.12**) in a modern idiom. The architectural setting replicates the Leonardo, with four rectangular panels on either side, which recede toward a back wall, a triple window, and a curved pediment. The apostles, like Leonardo's, are arranged in four groups of three, with corresponding poses. An image of Marisol herself sits opposite the scene, playing the role of viewer as well as artist. As viewer, Marisol contemplates the past, which she appropriates and integrates with her own contemporary style. Art history itself is thus an implied subject of this installation, as the modern artist communicates with a great predecessor by participating in the work.

30.10 George Segal, *Chance Meeting*. 1989. Plaster, paint, aluminum post, and metal sign, 10 ft 3 in x 3 ft 5 in x 4 ft 7 in (3.12 x 1.04 x 1.4 m). Photo courtesy of Sidney Janis Gallery, New York. Segal wraps the subject's body in gauze bandages dipped in wet plaster. Once the plaster has hardened, he cuts it off in sections which he then reassembles. His effigies, the descendants of Egyptian mummies and Roman death masks, are usually in unpainted white plaster, but sometimes in gray or color. Segal's subjects, however, are alive when the cast is made, and are often depicted in the course of some activity.

30.11 Marisol, *The Last Supper* (installed at the Sidney Janis Gallery). 1982. Wood, brownstone, plaster, paint, charcoal, 10 ft 1 in x 29 ft 10 in x 5 ft 7 in (3.07 x 9.09 x 1.7 m). Photo courtesy of Sidney Janis Gallery, New York.

Op Art

Another artistic movement that flourished during the 1960s has been called Optical, or Op Art. In 1965 the Museum of Modern Art contributed to the vogue for the style by including it in an exhibit entitled "The Responsive Eye." However, Op Art is akin to Pop Art in rhyme only, for the recognizable object is totally eliminated from Op Art in favor of geometric abstraction. The Op artists produced kinetic effects (that is, illusions of movement), using arrangements of color, lines, and shapes, or some combination of these elements.

In *Aubade* (*Dawn*) of 1975 (fig. **30.12**), by the British painter Bridget Riley (b. 1931), there are evident affinities with Albers, the Abstract Expressionist color field painters, and Frank Stella. Riley has arranged pinks, greens, and blues in undulating vertical curves of varying widths, evoking the vibrancy of dawn itself. The changing width of each line, combined with the changing hues, makes her picture plane appear to pulsate with movement.

Minimal Sculpture

Sculptures of the 1960s "objectless" movement were called Minimal, or Primary, Structures, because they were direct statements of solid geometric form. In contrast to the personalized process of Abstract Expressionism,

Minimalism eliminates all sense of the artist's role. There is no reference to narrative or to nature and no content beyond the medium itself. The impersonal character of Minimal sculptures is intended to convey the idea that an artwork is a pure object having only shape and texture in relation to space.

Untitled (fig. **30.13**), by Donald Judd (b. 1928), is a set of rectangular "boxes" derived from the solid geometric shapes of David Smith's *Cubi* series (fig. **29.14**) and the "minimal" simplicity of Ad Reinhardt (fig. **29.10**). Judd's "boxes," however, do not stand on a pedestal. Instead, they hang from the wall or rest directly on the floor,

30.12 Bridget Riley, *Aubade* (*Dawn*). 1975. Acrylic on linen, 6 ft 10 in × 8 ft 11½ in (2.08 × 2.73 m). Private collection. Photo courtesy of Sidney Janis Gallery, New York. Riley's work generally relies on two effects — producing a hallucinatory illusion of movement (as here), or encouraging the viewer to focus on a particular area before using secondary shapes and patterns to intrude and disturb the original perception. Riley's early Op Art pictures were in black and white and shades of gray. In the mid-1960s, she turned to color compositions such as this one.

30.13 Donald Judd, *Untitled*. 1967. Green lacquer on galvanized iron, each unit 9 in × 3 ft 4 in × 2 ft 7 in (0.23 × 1.02 × 0.79 m). Photo courtesy the Helman Collection, New York.

30.14 Dan Flavin, *Untitled* (*In Honor of Harold Joachim*). 1977. Fluorescent light fixtures with pink, blue, green, and yellow tubes. 8 ft (2.44 m) square across the corner. Courtesy, Dia Center of the Arts, New York. Flavin described this work as a "corner installation . . . intended to be beautiful, to produce the color mix of a lovely illusion. . . . [He] did not expect the change from the slightly blue daylight tint on the red rose pink near the paired tubes to the light yellow midway between tubes and the wall juncture to yellow amber over the corner itself."[1]

thereby involving the immediate environment in the viewer's experience of them. They are made of galvanized iron and painted with green lacquer, reflecting the Minimalist preference for industrial materials. Judd has arranged the boxes vertically, with each one placed exactly above another at regular intervals, to create a harmonious balance. The shadows cast on the wall, which vary according to the interior lighting, participate in the design. They break the monotony of the repeated modules by forming trapezoids between each "box," and between the lowest "box" and the floor. The shadows also emphasize the vertical character of the boxes by linking them visually, and creating the impression of a modern, nonstructural pilaster.

Light is the primary medium of the Minimal fluorescent sculptures of Dan Flavin (b. 1933). They can be related to Duchamp's Ready-mades — store-bought objects transformed into "art" by virtue of the artist's intervention. Flavin defines interior architectural spaces with tubes of fluorescent lights arranged in geometric patterns or shapes. Light spreads from the tubes and infiltrates the environment, creating an installation within an available space. The technological character of the medium and its impersonal geometry is typical of the Minimal esthetic. Sometimes, as in *Untitled (In Honor of Harold Joachim)* (fig. **30.14**), the color combinations are quite unexpected. Flavin's merging of light and color, dependent as it is on technology and twentieth-century abstraction, nevertheless has a spiritual quality that allies his work with stained glass windows and the play of light and color inside Gothic cathedrals.

After 1965

As we respond to contemporary art, our sense of historical perspective inevitably diminishes. The more recent the development or style, the more necessary is the passage of time before one can properly evaluate a work of art and assess whether or not it will last. Accordingly, of all the chapters in this survey, this is the most subject to later revision.

Even in recent works of art, however, age-old themes are expressed in new ways, through modern as well as traditional media. Portraits and self-portraits, for example, have claimed the attention of artists from the Neolithic era to the present. The belief in the power of portraiture, which inspired people to reconstitute skulls (see p.46) and create death masks to keep alive a likeness (see pp.89 and 122), persists today. Political and social subtexts, and environmental concerns, which have informed works of art throughout western history, also persist in contemporary art, although they are often expressed in new ways.

Return to Realism

With the development of photography in the nineteenth century, artists found a new medium for capturing a likeness. Many painters and sculptors used photographs to decrease the amount of time their subjects were required to pose. In the late 1960s, the popularity of photography, its relationship to Pop Art, and the notion that it permits an objective record of reality, led to the development of the Photorealist Style.

In his 1968 study for a *Self-Portrait* (fig. **31.1**), Chuck Close (b. 1940) uses a grid to convert a photographic image — in this case a black-and-white passport-style close-up of his own head — into a painting. The final picture conveys a sense of rugged monumentality. Because the face is frontal and seen from slightly below the chin, the nose and cigarette are foreshortened. At the same time, there is an interplay between the curvilinear strands of the hair and the textures of the flesh. Up to 1970 it was Close's habit to paint mainly in black and white, as here, and to use an airbrush to create a smooth surface. The

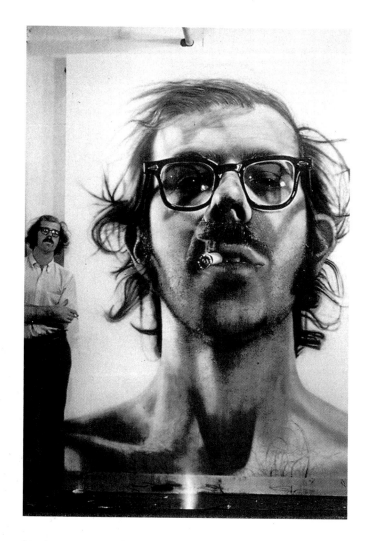

31.1 Chuck Close, *Self-Portrait*. 1968. Acrylic on canvas, 9 x 7 ft (2.74 x 2.13 m). Photo Kenny Lester, courtesy of the Pace Gallery, New York. The grid used to transfer this image from a photograph to a painting consisted of 567 squares ruled on a piece of paper measuring 14 by 11 inches (35.6 x 27.9 cm). The photographic data in each small square were enlarged to fill squares of approximately 16 square inches (103 cm^2).

31.2 Gilbert Proesch and George Passmore, *Singing Sculptures.* 1969.

31.3 Laurie Anderson in her movie *Home of the Brave.* 1985. Photo Les Fincher. Courtesy, Original Artists, New York.

result is a work that resembles a photographic enlargement and, in a sense, forms a transition between painting and photography.

Transitional elements of another kind can be seen in the work of two English performing artists, Gilbert (Proesch, b. 1943) and George (Passmore, b. 1942). In a series of performances related to the "Happenings" of the 1960s (see p.460), Gilbert and George became their own works of art. Figure **31.2** illustrates a 1969 performance of their much-repeated piece, *Singing Sculptures*, in which they mimed in slow motion to a recording of an old English music hall song while standing on a low platform. Both wore business suits and had gilded faces and hands. Their only props were Gilbert's cane and George's gloves. This and similar performances raised the issue of the boundary between artists and their work. By describing themselves as "living sculptures," Gilbert and George explored the transitional ambiguity between living and nonliving, between illusion and reality.

The more recent multimedia Performance Art of Laurie Anderson (b. 1947) uses photography, video, film, and music. Her message, which is typically delivered in spoken narrative, is political and social. Figure **31.3** is a movie still from *Home of the Brave*, shown in July 1985 at the Park Theater in Union City, New Jersey. Anderson describes her performances as being "about a collaboration between people and technology." Like Gilbert and George, she participates as an actor in her own work of art. In so doing, she explores the boundary between artist and art, subject and object, and the natural and the technological worlds.

No less transitional is the Photorealist style of the American artist Duane Hanson (b. 1925). Whereas no one would mistake Gilbert and George for actual sculptures, Hanson's sculptures are often taken for real people. As in the case of the more abstract plaster figures of George

Segal (see p.466), Hanson's sculptures are created directly from the models themselves. His convincing *trompe-l'oeil* illusionism is reminiscent of ancient Greek legends about the artist Daedalus, who reportedly rivaled the gods by making living sculptures. In clothing his figures, Hanson also evokes Ovid's tale of Pygmalion, the sculptor who dressed his statue of Galatea as if she were a real woman.

Despite its contemporary esthetic and dependence on modern materials, Hanson's *Artist with Ladder* (fig. **31.4**) replicates the relaxed *contrapposto* pose of Polyclitus's *Spearbearer* (fig. **7.11**). The artist's bent left arm, which in the Polyclitus originally held a spear, rests casually on the ladder. A comparison of these two statues reveals the relationship between artists of very different times and places. It also emphasizes the striking distinction between the Classical idealization of fifth-century-B.C. Athens and modern Photorealism.

One of the most prominent painters of the Photorealist style is Richard Estes (b. 1936). His oil paintings resemble color photographs, although they are on a larger scale and are more crisply defined than a photograph of similar size would be. His *Williamsburg Bridge* of 1987 (fig. **31.5**) combines an urban landscape with the reflections of steel, chrome, and glass. Divided by the strong vertical accent of the red subway car, the painting is an optical play between the interior on the left and the exterior, visible through the window of the car, on the right. The self-absorption of the subway riders contrasts with the moving cars and distant city skyline on the right. As in the Renaissance (see p.228), Estes's illusionistic effects are enhanced by his use of linear perspective.

31.4 Duane Hanson, *Artist with Ladder*. 1972. Polyester resin polychromed in oil, lifesize. Courtesy, ACA Galleries, New York. Hanson molds each section of the model's body and then assembles the sections. Flesh-colored polyester resin is then poured into the mold and reinforced with fiberglass. When the mold is broken, the figure is painted and dressed in actual clothing, and real accessories such as hair and glasses are added.

31.5 Richard Estes, *Williamsburg Bridge*. 1987. Oil on canvas, 3 ft x 5 ft 6 in (0.91 x 1.68 m). Courtesy Allan Stone Gallery, New York. Estes assembles color photographs into a studio model and then recreates it with brushes and oil on canvas. "The incorporation of the photograph into the means of painting," he wrote, "is the direct way in which the media have affected the type of painting. That's what makes New Realism new."[1]

Developments in Architecture

Estes's Photorealist painting of the *Guggenheim Museum* (fig. **31.6**) is an urban landscape of another kind. It will serve to illustrate the exterior of Frank Lloyd Wright's unusual structure in New York City. Its purpose was to house the Guggenheim Collection and to provide space for exhibitions of twentieth-century art.

Built between 1956 and 1959, somewhat earlier than the other works in this chapter, the Guggenheim embodies the climax of Wright's interest in curvilinear form. Its most imposing feature is the large inverted cone, which encloses a six-story ramp coiling around a hollow interior. Natural light enters from a flat skylight. Viewers inside the Guggenheim Museum look at paintings and sculptures as they walk down the ramp, so that they are always slightly tilted in relation to the works of art.

Despite a design that is frankly inconvenient for the purpose of viewing art, the Guggenheim is a monumental work of art in its own right. Unlike Wright's Prairie Style architecture (see p.431), it cannot be said to blend into its surroundings. Located on Fifth Avenue, right across from Central Park, the spiral cone can be conceived of as growing organically upward and outward, toward the sky, like the trees opposite. Most observers, however, experience the museum in relation to the neighboring rectangular buildings, which generally become smaller toward the top. These apparent formal anomalies between the Guggenheim and its environment were, for a while, a source of considerable controversy.

Less than a mile away from the Guggenheim Museum is the Whitney Museum of American Art (fig. **31.7**). This was designed by Marcel Breuer (1902–81) in a style inspired by the stark rectangularity of the Bauhaus (see p.433). The floors are cantilevered out toward Madison Avenue like a chest with its drawers pulled out at increasing distances. The only features that interrupt the wall surfaces are the slightly projecting trapezoidal windows. Inside and out, the museum is constructed of concrete and dark gray granite blocks, which correspond to its stark, angular character.

Unlike the Guggenheim, the Whitney is well conceived for viewing works of art. Its floors are horizontal rather than slanted. Its galleries are ample and flexible, with ceilings that can support mobile wall partitions. Both buildings, however, have thick, massive walls, in contrast to more recent twentieth-century architecture, in which glass and steel predominate.

Geodesic Domes

One of the more interesting personalities of twentieth-century design was R. Buckminster Fuller (1895–1983), philosopher, poet, architect, and engineer, as well as a cult figure among American college students. His architecture expresses his belief that the world's problems can be solved through technology. One of his first designs (1927–8) was a house that he called Dymaxion, a name combining the words "dynamic" and "maximum." These reflect key concepts for Fuller, who aimed at achieving the maximum output from the minimum energy consumption. The Dymaxion house was a prefabricated, factory-assembled structure which hung from a central mast and cost no more than a car to build. A later invention was the three-wheeled Dymaxion car (1933), but, like the house, it was never produced commercially.

Buckminster Fuller is best known for the principle of structural design that led to the invention of the **geodesic dome** (fig. **31.8**). It is composed of polyhedral units (from the Greek *poly*, meaning "many" and *hedron*, meaning

31.6 Richard Estes, *The Solomon R. Guggenheim Museum*. 1979. Oil on canvas, 2 ft 7⅛ in x 4 ft 7⅛ in (0.79 x 1.4 m). Solomon R. Guggenheim Museum, New York.

31.7 Marcel Breuer, Whitney Museum of American Art, New York. 1966.

"side") — usually either tetrahedrons (four-sided figures) or octahedrons (eight-sided figures). The units are assembled in the shape of a sphere. This structure offers four main advantages. First, because it is a sphere, it encloses the maximum volume per unit of surface area. Second, the strength of the framework increases logarithmically in proportion to its size. This fulfills Fuller's aim of combining units to create a greater strength than the units would have individually. Third, it can be constructed of any material at very low cost. And fourth, it is easy to build. Apart from purely functional structures like greenhouses and hangars, however, the geodesic dome has been used very little. Fuller's design for the American Pavilion at the

Montreal Expo of 1967 gives us an idea of both its utility and its curious esthetic attraction. (The architectural principle underlying the geodesic dome is shared by a class of carbon molecules named fullerenes, which were discovered in the late 1980s. They possess unique qualities of stability and symmetry.)

Post-Modernism: The Piazza d'Italia

Fuller's architectural ideas remained isolated from the stylistic mainstream of the late twentieth century. Post-Modernism, on the other hand, has developed into a widespread movement. Post-Modern architecture is eclectic. It combines different styles from the past to produce a new vision, which is enhanced, but not determined, by modern technology.

A good example of Post-Modernism is the Piazza d'Italia (fig. 31.9), or Italy Square, in New Orleans. In this illustration, the Piazza is shown at night, illuminated by colored neon lights. The lights define space and accentuate

31.8 R. Buckminster Fuller, American Pavilion, Expo '67, Montreal. 1967. R. Buckminster Fuller was descended from eight generations of New England lawyers and ministers. He was expelled from Harvard twice, served in the U.S. Navy in World War I, and worked in the construction business. In 1959 he became a professor of design science at Southern Illinois University. Fuller's abiding interest in education is revealed by his belief that all children are born geniuses. "It is my conviction from having watched a great many babies grow up," as he was quoted in the *New York Times* (3 July 1983), "that all of humanity is born a genius and then becomes de-geniused very rapidly by unfavorable circumstances and by the frustration of all their extraordinary built-in capabilities."

31.9 (opposite) Charles W. Moore and William Hersey, Piazza d'Italia, New Orleans. 1978–9. The Piazza was built to celebrate the contributions made to New Orleans by Italian immigrants. Its eclecticism is characteristic of the Post-Modern style.

architectural form—an effect that allies the Piazza with Flavin's sculptures (see p.469). Color conforms to each particular architectural element. The central entablature and its round arch, for example, are green, and the supporting Corinthian columns are red. Curved colonnades on either side are alternately red and yellow, while the inner Corinthian capitals are predominantly blue. The shiny pavement reflects the interplay of colored neon lights and shadows.

The Piazza d'Italia is a modern rearrangement of Classical, Renaissance, and Baroque architectural forms, enlivened by the light and color possibilities of twentieth-century technology. Whereas Flavin's light sculptures are used for interior display and are intimate in scale, those in the Piazza contribute to its expansive relationship with the surrounding buildings and open sky.

The Louvre Pyramid

In contrast to the Post-Modern amalgam of past styles, glass and steel form the prevailing esthetic in I. M. Pei's Louvre Pyramid (fig. **31.10**). In 1983 the French government commissioned Pei to redesign parts of the Louvre in Paris. Completed in 1988, the pyramid includes an underground complex of reception areas, stores, conference rooms, information desks, and other facilities, all located below the vast courtyard. To serve as a shelter, skylight, and museum entrance for the underground area, Pei built a large glass pyramid between the wings of the sixteenth-century building.

Paris had not witnessed such controversy since the construction of the Eiffel Tower (fig. **23.17**) in 1889. Not only was the architect not a Frenchman, but the imposing façade of the Louvre, former residence of French kings, was to be blocked by a pyramid—and a glass one at that. Although Pei's pyramid has an undeniable presence, its glass walls are transparent and, depending on the position of the sun, they allow a fairly clear view of the buildings beyond. The night view in figure **31.10** illustrates the dramatic possibilities of the pyramid as a pure geometric form juxtaposed with a Baroque environment.

31.10 I. M. Pei, Louvre Pyramid, Paris. 1988. The pyramid is 65 feet (19.8 m) high at its apex, 108 feet (32.9 m) wide, and contains 105 tons (107,000 kg) of glass.

"High Tech" Architecture: The 1986 Lloyd's Building

By 1977 Lloyd's of London, the international insurance market, needed new quarters. In addition to housing the more than 5000 people who use the building every day, Lloyd's had to adapt to the technological changes, principally in communications, that were revolutionizing the insurance and other financial markets. Unlike the Neolithic structures (see p.40), the Egyptian pyramids (see p.65), and the Gothic cathedrals (see p.194), the technology on which modern structures are based may be obsolete within five or ten years of their construction.

The commission for the new Lloyd's building went to the firm of Richard Rogers, an English architect who had been jointly responsible for the Pompidou Center in Paris in the 1970s. The irregular, triangular space that Rogers had to work with in London was large, but not large enough to accommodate all of the underwriting staff on one floor. Rogers solved the problem, first, by creating an *atrium* — the original central court of Etruscan (see p.122) and Roman (see p.129) houses — and wrapping all the floors around it. The *atrium* is a rectangle rising the entire height of the building (twelve floors) and culminating in a barrel-vaulted, glass and steel roof (fig. **31.11**). The three lower floors form galleries around the *atrium*. Together, they make up the approximately 115,000 square feet (10,700 m²) where underwriters sit and negotiate terms with brokers. This solution visually unified the working areas of the building and illuminated them from above.

Second, Rogers left the *atrium* space as flexible and open as possible, by housing all the ancillary services —

31.12 Schematic section of the Lloyd's Building.

31.11 Richard Rogers, Lloyd's Building, London. 1986. Rogers wrote that "esthetically one can do what one likes with technology . . . , but we ignore it at our peril. To our practice, its natural functionalism has an intrinsic beauty." In the Lloyd's Building, Rogers has fulfilled his philosophical view of uniting technology with esthetic appeal.

airconditioning ducts, elevators, staircases, toilet facilities, and so forth — in satellite towers built apart from the main structure. At the top of the towers are boxlike "plant rooms," which dominate distant views of the building. Each room is three stories high and contains elevator motors, tanks, and an airhandling plant. On the roofs, bright yellow cradles for carrying maintenance crews are suspended from blue cranes.

Rogers's system (see the diagram in fig. **31.12**) has the advantage of ensuring the greatest flexibility of space on each floor. On the ground floor, the only structural elements that interrupt the working space are eight concrete columns supporting the galleries, and the escalator block, which links the basement and the four underwriting floors. Since the mechanical services are located in the towers, they can be replaced or upgraded in the future without disturbing the main floors.

31.13 Robert Smithson, *Spiral Jetty*, Great Salt Lake, Utah. 1970. Rock, salt crystals, earth, algae; coil length 1500 ft (457 m). Financed by two art galleries, Smithson took a twenty-year lease on 10 acres (4 hectares) of land. He hired a contractor to bulldoze some 6000 tons (61,000,000 kg) of earth. The resulting spiral consists of black rock, earth, and salt crystals. The algae inside the spiral change the water's color to red. Smithson wrote an essay on this work, and photographed and filmed it from a helicopter. The *Jetty* itself is now underwater and no longer visible.

Environmental Art

All works of art affect the environment in some way. In its broadest sense, the environment encompasses any indoor or outdoor space. Today, the term tends to refer more to the outdoors — the rural and urban landscape, for example — than to indoor spaces. Two recent artists whose work has had a startling, though usually temporary, impact on the natural environment are Robert Smithson (1938–73) and Christo (Jachareff, b. 1935).

Smithson: *Spiral Jetty*

Smithson's *Spiral Jetty* (fig. **31.13**) — a huge single spiral that jutted out into the Great Salt Lake of Utah — is his best-known **earthwork**. As an isolated form, set against a background — in this case, water — *Spiral Jetty* was rooted in 1960s Minimalism (see p.468). The philosophy of Smithson's earthworks, however, has many levels of meaning. In some of his gallery exhibits, he placed rocks and earth — reflecting his interest in the natural landscape — in boxes and bins indoors (the "non-site," in Smithson's terminology). Crystals, in particular, appealed to him as examples of the earth's geometry, and he used them, along with earth, as an artistic medium.

Ecology, as one might expect, was one of Smithson's primary concerns. *Spiral Jetty* and his other earthworks are all degradable and will eventually succumb to the natural elements. Smithson's interest in the earth has a

primeval character. He was inspired by the Neolithic stone structures of Great Britain (see p.40) and their mythic association with the land. Although he created his own earthworks with modern construction equipment, his affinity for the prehistoric earth mounds of America also influenced the shape of his monuments and their integration with the landscape.

Christo: *The Umbrellas,* Japan–U.S.A.

Another approach to shaping the environment can be seen in the work of Christo. He evokes a sense of mystery by "wrapping" buildings or sections of landscape, paradoxically covering something from view while accentuating its external contour. Among the structures he has "wrapped" are the Kunsthalle in Berne (1968) and the Pont Neuf, a bridge in Paris (1985). He has surrounded eleven islands in Biscayne Bay, Florida, with over six million square feet (560,000 m²) of pink nylon, and has run a white fabric fence 24½ miles (39 km) long through two California counties.

Christo's work is sometimes referred to as Conceptual Art, which emphasizes its relation to an idea, or concept. This is not, however, the case, because Christo actually realizes the concept and gives it concrete form. Unlike

31.14 and **31.15** *The Umbrellas,* Japan–U.S.A., 1984–91. **31.14** (left) Detail of 1340 blue umbrellas in Ibraki, Japan. Nylon and aluminum. Photo Wolfgang Volz. © Christo. **31.15** (right) Detail of 1760 yellow umbrellas in California, U.S.A. Nylon and aluminum. Photo Wolfgang Volz. © Christo. *Umbrellas* ran 12 miles (19 km) in length in Japan and 18 miles (29 km) in California. Height of each umbrella, including the base, was 19 feet 8¼ inches (6 m), diameter was 28 feet 5 inches (8.66 m), weight without base was 448 pounds (203 kg). The fabric area was about 638 square feet (59.3 m²). Christo, born in Bulgaria, has lived in New York since 1964 and works around the world. At sunrise on 9 October 1991, 1880 workers opened 3100 umbrellas in Ibraki, Japan and in California. The project, which cost the artist $20 million, was dismantled eighteen days after the umbrellas were opened. The aluminum was recycled.

artists who intend their works to last, Christo always removes his projects from their sites, leaving the environment intact. The temporary nature of his large-scale works is part of their esthetic identity. The continued existence of his work depends on film, photographs, lithographs, and models. It endures as a series of visual concepts, only temporarily realized on a monumental scale. Another feature distinguishes Christo from many artists—a unique view of patronage. He accepts no financial sponsorship or commissions for his large-scale projects and personally provides the funding for construction.

Figures **31.14** and **31.15** illustrate sections of the blue and yellow *Umbrellas* in Japan and California, respectively. Their placement is related to their environment. The blue *Umbrellas* are close together, reflecting the limited space of Japan, and the yellow *Umbrellas* are farther apart, whimsically spread out in harmony with the vast California landscape. Blue is consistent with the water that fertilizes the Japanese rice fields, while the yellow echoes the blond grass and brown hills of the dry valley in which the California *Umbrellas* are located. As free-standing, dynamic forms, *The Umbrellas* have a sculptural quality. They define space and interact with it, casting shadows and swaying with the wind.

Urban Environment

The urban environment has also been influenced by artistic "projects." *Long Division* of 1988 (fig. **31.16**), by Valerie Jaudon (b. 1945), is a painted steel barrier commissioned by the Metropolitan Transportation Authority in New York City. Located in a subway station, *Long Division* is an "open wall" enlivened by curves and diagonals that seem to dance across the vertical bars. The surrounding neon lights and broad areas of color form a sharp contrast with the dark accents of the barrier.

A recent development in painting that was inspired by an aspect of the modern urban environment is the iconography of graffiti. Graffiti, and reactions to them, call into question the boundary between the creative and

31.16 (above) Valerie Jaudon, *Long Division*, 23rd Street Station, IRT Subway Line, New York. 1988. Painted steel, 12 x 60 ft (3.66 x 18.29 m). Photo courtesy of Sidney Janis Gallery, New York.

destructive impulses. In the case of graffiti, which in any event are a visual statement and often a personal affirmation, the arguments go both ways.

CARBON/OXYGEN of 1984 (fig. **31.17**) by Jean-Michel Basquiat (1960–88) conveys the frenetic pace and mortal dangers of the city in a harsh, linear style derived from graffiti. The childlike drawing of the buildings is ironically contrasted with scenes of explosion and death. Various methods of transportation—cars, planes, and rocketships—create a sense of speed and technology that pollute the environment. The black face at the center of the picture plane stares blankly at the viewer as if warning of threatened destruction. The words of the title implicitly pose the question of whether we are going to poison the air we breathe or ensure that it remains clean.

31.17 (below) Jean-Michel Basquiat, CARBON/OXYGEN. 1984. Acrylic on canvas, 7 ft 4 in x 6 ft 5 in (2.24 x 1.96 m). Private Collection, Switzerland. Courtesy, Robert Miller Gallery, New York.

Feminist Iconography

Chicago: *The Dinner Party*

Although women artists have made significant contributions to the history of western art, the iconography of feminism *per se* is a twentieth-century phenomenon. In 1979 Judy Chicago (b. 1939) created her monumental installation *The Dinner Party* (fig. **31.18**), a triangular feminist version of the *Last Supper*. We saw in Marisol's *Last Supper* (fig. **30.11**) that the artist introduced herself as both viewer and participant in the work. Here, on the other hand, Christ and his apostles have been replaced by a group of thirty-nine distinguished women, such as Queen Hatshepsut of Egypt (see p.62), Georgia O'Keeffe (see p.447), and the author Virginia Woolf. Thirty-nine is three times the number of Christ and his twelve apostles. The tiled floor contains 999 names of other famous women. Traditional female crafts, such as embroidery, appliqué, needlepoint, painting on china, and so forth, are used for details. The artist, born Judy Cohen, established a foundation to send *The Dinner Party* on tour and later published a monograph on it that included the biographies of the women it celebrated.

Despite the originality of Chicago's conception and the new iconographic content of her piece, the work would have less impact without its historical relevance. For although the triangle can be read as a female symbol, it also refers to the Trinity, and is thus rooted in Christian art and culture. Likewise, the numerical regularity and symmetry of design allies the formal arrangement of *The Dinner Party* with Leonardo's *Last Supper* (fig. **16.12**).

Innovation and Continuity

At times, history seems to repeat itself. The French expression *"Plus ça change, plus c'est la même chose"* ("The more things change, the more they remain the same") well describes this historical paradox. In the visual arts, it is possible to witness this phenomenon unfolding before our very eyes. Themes persist, styles change and are revived. New themes appear, old themes reappear. The media of art also persist. Artists still use bronze and marble, oil paint and encaustic. Nevertheless, modern technology is constantly expanding the media available to artists, as well as introducing new subjects and inspiring stylistic developments.

This can be illustrated by three significant trends of the early twentieth century that continue to emerge in contemporary art—Expressionism, the preeminence of the object, and Surrealism. The American Neo-expressionist painter Julian Schnabel (b. 1951) engages the viewer in large canvases, which are powerfully enlivened with thick

31.18 Judy Chicago, *The Dinner Party.* 1979. Multimedia, 48 × 48 × 48 ft (14.63 × 14.63 × 14.63 m).

31.19 Julian Schnabel, *Portrait of William Gaddis*. 1987. Oil, plates, bondo/wood, 5 × 4 ft (1.52 × 1.22 m). Photo Phillips/Schwab. Reproduced courtesy of William Gaddis. Schnabel's admiration for the work of William Gaddis (b. 1922), one of America's most distinguished contemporary authors, prompted this portrait. Gaddis's first novel, *The Recognitions*, deals with themes of forgery in the art world as a metaphor for the fraudulence of life.

paint and unusual combinations of media. In his 1987 portrait of the novelist William Gaddis (fig. **31.19**), he creates a mosaic effect using broken plates instead of *tesserae* (see p.158). The very use of plates, which are everyday manufactured objects, is in part a consequence of Duchamp and the primacy of the "object." In breaking the plates, Schnabel introduces an element of Dada "chance" (see p.438).

Echoing Schnabel's juxtaposition of media is the combination of styles. For example, the Byzantine character of the outlined forms and the mosaic effect contrast with the illusion of shading in the face and the sense of a distinctive personality. In this work, Schnabel incorporates Byzantine frontality, and the principles of collage and assemblage, with Expressionist exuberance, in representing Gaddis as an icon of American literature.

The "objects" of Jeff Koons (b. 1955), sometimes dismissed as "kitsch," are clearly derived from Duchamp's "Ready-mades." They are also related to Oldenburg's Pop Art ichhonography of everyday household objects (see p. 466) and Flavin's neon lights (see p.469). They lack the Expressionist attraction to the material textures of paint and the traditional media of sculpture. His *New Hoover Convertibles, Green, Blue; New Hoover Convertibles, Green, Blue; Double-decker* of 1981 to 1987 (fig. **31.20**), for example, consists of four vacuum cleaners in plexiglass cases illuminated by fluorescent lights. Koons enshrines the vacuums, revealing them as icons of our technological society. His alliterative title is a kind of verbal collage, juxtaposing the brand (Hoover) of vacuum with the formality of color (blue and green) and references to modern transportation (convertible — as in cars — and double-decker — buses).

The continuing influence of Dada and Surrealism can be

31.21 (above) Nancy Graves, *Morphose*. 1986. Bronze and copper with polychrome patina and baked enamel, 4 ft 6 in x 3 ft 3 in x 3 ft 3 in (1.37 x 0.99 x 0.99 m). Courtesy, M. Knoedler & Co., Inc.

31.20 (left) Jeff Koons, *New Hoover Convertibles, Green, Blue; New Hoover Convertibles, Green, Blue; Double-decker*. 1981–7. Vacuum cleaners, plexiglass, fluorescent lights; 22 units overall, 9 ft 8 in x 3 ft 5 in x 2 ft 4 in (2.95 x 1.04 x 0.71 m). Collection, Whitney Museum of American Art, New York (Purchase).

seen in *Morphose* (fig. **31.21**) by Nancy Graves (b. 1940). Her linear abstractions of natural form are reminiscent of Calder's witty mobiles (see p.444). The central part is the actual turbine rotor of a ship, which integrates the "object" into a sculptural assemblage, as Picasso did in his *Bull's Head* of 1943 (fig. **27.7**). Anthropomorphic quality is created by Graves in a series of visual metaphors — ball for head, sardines for hair, bronze bananas for fingers. At the same time, however, the sculpture as a whole resembles a sea animal rotating slowly in space. Graves's title is itself a kind of Surrealist pun, suggesting metamorphosis, anthropomorphism, and metaphor. All are related to the Greek word *morphe*, meaning "shape" or "form."

Conclusion

Recalling that one of the primary impulses to make art is the wish to keep memory alive, we conclude this text with two memorial works. Both have political, social, and artistic significance. Anselm Kiefer (b. 1945), a prominent German Neo-expressionist, creates powerful canvases using aggressive lines and harsh textures. His *To the Unknown Painter* of 1983 (fig. **31.22**) protests the Fascist persecution of artists in Europe and tyranny of all kinds. The somber colors and jagged surface evoke the devastation of war. From beneath the scorched picture plane a large, rectangular structure comes into focus, looming forward to memorialize those who stand for the forces of creativity.

The Vietnam Veterans Memorial (fig. **31.23**) of Maya Ying Lin (b. 1960) is a more understated form of protest than Kiefer's. The names of all Americans killed in the Vietnam War (a total of 58,183) are inscribed in the order of their deaths on the polished granite wall. Viewers are engaged in reading the names as the reflective nature of the wall mirrors the world of the living. In this work, it is the name of the deceased, rather than the image or likeness, that conveys immortality.

As we approach the twenty-first century, we are presented with a proliferation of artistic styles and expanding definitions of what actually constitutes art. The pace of technological change, particularly in communications and the media, spawns new concepts and styles at an increasing rate. Taste as well as style changes, and it will be for future generations to look back on our era and to separate the permanent from the impermanent. How long a work of art must endure for it to claim a place in the artistic pantheon is a matter of dispute. The Venus of Willendorf has existed for over 25,000 years, the Sistine Chapel ceiling for over 450. And yet some of the modern art discussed in this chapter is intentionally transitory. Performance art, for example, lasts no longer than the performance itself, except when captured in memory or on film.

In this survey we have considered some of the artists whose works have stood the test of time. Artists, the "children" of preceding generations of artists, are influenced by their predecessors. This text will have served its purpose if its readers are influenced by some of the best of what has survived.

31.22 Anselm Kiefer, *To the Unknown Painter*. 1983. Oil, emulsion, woodcut, shellac, latex, and straw on canvas, 9 ft 2 in x 9 ft 2 in (2.79 x 2.79 m). Carnegie Museum of Art, Pittsburgh.

31.23 Maya Ying Lin, Vietnam Veterans Memorial, The Mall, Washington, D.C. 1981–3. Lin designed this monument while attending the Yale School of Architecture. It consists of seventy slabs of polished granite comprising two wings, each 246 feet (74.98 m) long.

Glossary

Abacus: the flat slab that forms the topmost unit of a Doric column and on which the **architrave** rests (see p.108).

Abstract: in painting and sculpture, having a generalized or essential form with only a symbolic resemblance to natural objects.

Abutment: the part of a building intended to receive and counteract the thrust, or pressure, exerted by vaults and arches.

Academy: (a) the gymnasium near Athens where Plato taught; (b) from the eighteenth century, the cultural and artistic establishment and the standards that they represent.

Acanthus: a Mediterranean plant with prickly leaves, supposedly the source of foliage-like ornamentation on Corinthian columns.

Achromatic: free of color.

Acrylic: a fast-drying, water-based synthetic paint medium.

Aedicule: (a) a small building used as a shrine; (b) a niche designed to hold a statue, both formed by two columns or **pilasters** supporting a **gable** or **pediment**.

Aerial (or atmospheric) perspective: a technique for creating the illusion of distance by the use of less distinct contours and a reduction in color intensity (see p.237).

Agora: the open space in an ancient Greek town used as a marketplace or for general meetings.

Airbrush: a device for applying a fine spray of paint or other substance by means of compressed air.

Aisle: a passageway flanking a central area (e.g. the corridors flanking the **nave** of a **basilica** or cathedral).

Alabaster: a dense variety of fine-textured gypsum, usually white and translucent, but sometimes gray, red, yellow, or banded, used for carving on a small scale.

Allegory: the expression (artistic, oral, or written) of a generalized moral statement or truth by means of symbolic actions or figures.

Altar: (a) any structure used as a place of sacrifice or worship; (b) a tablelike structure used in a Christian church to celebrate the Eucharist.

Altarpiece: a painted or sculptured work of art designed to stand above and behind an altar.

Ambulatory: a vaulted passageway, usually surrounding the **apse** or **choir** of a church (fig. **12.3**).

Amphitheater: an oval or circular space surrounded by rising tiers of seats, as used by the ancient Greeks and Romans for plays and other spectacles (fig. **7.32**).

Amphora: an ancient Greek two-handled vessel for storing grain, honey, oil, or wine (fig. **7.2**).

Analogous hues: hues containing a common color, though in different proportions.

Annular: ring-shaped, as in an annular barrel vault.

Anthropomorphism: ascribing human characteristics to nonhuman objects.

Apocalypse: (a) the last book of the New Testament, containing revelations of the future by St. John the Divine; (b) a prophetic revelation.

Apocrypha: certain books of the Bible, the authority and authenticity of which are in doubt.

Apostle: in Christian terminology, one of the twelve followers, or disciples, chosen by Christ to spread his Gospel; also used more loosely to include early missionaries such as St. Paul.

Apse: a projecting part of a building (especially a church), usually semicircular and topped by a half-dome or vault.

Aquatint: a print from a metal plate on which certain areas have been "stopped out" to prevent the action of the acid (see p.357).

Aqueduct: a manmade conduit for transporting water (fig. **9.13**).

Arabesque: literally meaning "in the Arabian fashion"; an intricate pattern of interlaced or knotted lines consisting of stylized floral, foliage, and other motifs.

Arcade: a gallery formed by a series of arches with supporting columns or **piers** (fig. **13.4**), either freestanding or blind (i.e. attached to a wall).

Arch: a curved architectural member, generally consisting of wedge-shaped blocks (**voussoirs**), which is used to span an opening; it transmits the downward pressure laterally (see p.130).

Architrave: the lowest unit of an **entablature**, resting directly on the **capital** of a column.

Archivolt: the ornamental band or molding surrounding the **tympanum** of a Romanesque or Gothic church.

Arena: the central area in a Roman amphitheater where gladiatorial and other spectacles took place.

Armature: (a) a metal framework for a stained glass window; (b) a fixed, inner framework supporting a sculpture made of a more flexible material.

Arriccio: the rough first coat of plaster in a **fresco**.

Assemblage: a group of three-dimensional objects brought together to form a work of art.

Asymmetrical: characterized by asymmetry, or lack of balance, in the arrangement of parts or components.

Atmospheric perspective: see **aerial perspective**.

Atrium: (a) an open courtyard leading to, or within, a house or other building, usually surrounded on three or four sides by a **colonnade**; (b) in a modern house, a rectangular space off which other rooms open.

Attic: in Classical architecture, a low story placed above the main **entablature**.

Avant-garde: literally the "advanced guard"; a term used to denote innovators or nontraditionalists in a particular field.

Axis: an imaginary straight line

passing through the center of a figure, form, or structure and about which that figure is imagined to rotate.

Axonometric projection: the depiction on a single plane of a three-dimensional object by placing it at an angle to the picture plane so that three faces are visible (fig. **15.4**).

Balance: an esthetically pleasing equilibrium in the combination or arrangement of elements.

Baldacchino: a canopy or canopylike structure above an altar or throne (fig. **19.1**).

Balustrade: a series of balusters, or upright pillars, supporting a rail (as along the edge of a balcony or bridge).

Baptistery: a building, usually round or polygonal, used for Christian baptismal services.

Barrel (or tunnel) vault: a semicylindrical vault, with parallel **abutments** and an identical cross section throughout, covering an oblong space (see p.130).

Base: (a) that on which something rests; (b) the lowest part of a wall or column considered as a separate architectural feature.

Basilica: (a) in Roman architecture, an oblong building used for tribunals and other public functions (see p.132); (b) in Christian architecture, an early church with similar features to the Roman prototype (fig. **10.2**).

Bas-relief: see **low relief.**

Bay: a unit of space in a building, usually defined by **piers**, vaults or other elements in a structural system (fig. **15.9**).

Beaverboard: a type of fiberboard used for partitions and ceilings.

Belfry: a bell tower.

Binder, binding medium: a substance used in paint and other media to bind particles of pigment together and enable them to adhere to the support.

Biomorphic: derived from or representing the forms of living things rather than abstract shapes.

Bistre (or bister): a brown artistic medium made from the soot of burnt wood.

Black-figure: describing a style of pottery painting found in sixth-century-B.C. Greece, in which the decoration is black on a red background.

Book of Hours: a prayer book, intended for lay use, containing the devotions, or acts of worship, for the hours of the Roman Catholic Church (i.e. the times appointed for prayer, such as Matins and Vespers).

Broken pediment: a pediment in which the **cornice** is discontinuous or interrupted by another element.

Buon fresco: see **fresco.**

Burin: a metal tool with a sharp point used to incise designs on pottery and **etching** plates, for example.

Burr: in **etching**, the rough ridge left projecting above the surface of an engraved plate where the design has been incised (see p.292).

Bust: a sculptural or pictorial representation of the upper part of the human figure, including the head and neck (and sometimes part of the shoulders and chest).

Buttress: an external architectural support that counteracts the lateral thrust of an arch or wall.

Calligraphy: the art of fine (literally "beautiful") handwriting.

Camera obscura: a dark enclosure or box into which light is admitted through a small hole, enabling images to be projected on to a wall or screen placed opposite that hole; the forerunner of the photographic camera (see p.372).

Campanile: Italian for bell tower, usually freestanding, but built near a church.

Canon: a set of rules, principles, or standards used to establish scales or proportions.

Cantilever construction: an architectural system in which a beam or member, supported at only one end, projects horizontally from a wall or pier to which it is fixed (fig. **27.19**).

Capital: the decorated top of a column or **pilaster**, providing a transition from the shaft to the **entablature**.

Caricature: a representation in art or literature that distorts, exaggerates, or oversimplifies certain features.

Cartoon: (a) a full-scale preparatory drawing for a painting, which is transferred to the support before the final work is executed; (b) a comical or satirical drawing.

Cartouche: an oval or scroll-shaped design or ornament, usually containing an inscription, a heraldic device, or (as in Egypt) a ruler's name.

Caryatid: a supporting column in **post and lintel** construction carved to represent a human (generally female) figure.

Casting: a sculptural process in which liquid metal or plaster is poured into a mold to create a copy of the original model.

Catacomb: an underground complex of passageways and vaults, such as those used by Jews and early Christians to bury their dead.

Cathedral: the principal church of a diocese (the ecclesiastical district supervised by a bishop).

Cella: the main inner room of a temple, often containing the cult

image of the deity.

Centering: the temporary wooden framework used in the construction of arches, vaults, and domes.

Centrally planned: radiating from a central point.

Ceramics: (a) the art of making objects from clay or other substances (such as enamel and porcelain) that require **firing** at high temperatures; (b) the objects themselves.

Chancel: that part of a Christian church, reserved for the clergy and choir, in which the altar is placed.

Chapter house: a meeting place for the discussion of business in a monastery.

Château: French word for a castle or large country house.

Chevet: French term for the eastern end of a Gothic church, comprising the **choir, ambulatory**, and **radiating chapels**.

Chiaroscuro: the subtle gradation of light and shadow used to create the effect of three-dimensionality.

Choir: part of a Christian church, near the altar, set aside for those chanting the services (fig. **12.3**); usually part of the **chancel**.

Chroma: see **intensity.**

Chromatic: colored.

Chryselephantine: consisting of, or decorated with, gold and ivory.

Circus: in ancient Rome, an oblong space, surrounded by seats, used for chariot races, games, and other spectacles.

Cire-perdue: see **lost-wax bronze casting.**

Clerestory: the upper part of the main outer wall of a building (especially a church), located above an adjoining roof and admitting light through a row of windows (fig. **10.3**).

Cloisonné: a multicolored surface made by pouring enamels into compartments outlined by bent wire fillets, or strips.

Cloister: in a monastery, a covered passage or **ambulatory**, usually with one side walled and the other open to a courtyard.

Close: an enclosed space, or precinct, usually next to a building such as a cathedral or castle.

Cluster (or compound) pier: a **pier** composed of a group, or cluster, of **engaged column** shafts, often used in Gothic architecture (fig. **13.4**).

Codex: sheets of **parchment** or **vellum** bound together—the precursor of the modern book.

Coffer, coffering: a recessed geometrical panel in a ceiling (fig. **9.17**).

Collage: a work of art formed by pasting fragments of printed matter, cloth, and other materials (occasionally three-dimensional) to a

flat surface.

Colonnade: a series of columns set at regular intervals, usually supporting arches or an **entablature**.

Colonnette: a small, slender column, usually grouped with others to form **cluster piers**.

Color wheel: a circular, two-dimensional model illustrating the relationships of the various hues (fig. **2.7**).

Colossal (or giant) order: an architectural **order** with the columns or **pilasters** extending in height above one story (fig. **19.3**).

Column: a cylindrical support, usually with three parts—**base**, **shaft**, and **capital** (see p.108).

Complementary colors: hues that lie directly opposite each other on the **color wheel**.

Composition: the arrangement of formal elements in a work of art.

Compound pier: see **cluster pier**.

Conceptual art: art in which the idea is more important than the form or style.

Content: the themes or ideas in a work of art, as distinct from its form.

Contour: a line representing the outline of a figure or form.

Contrapposto **(or counterpoise):** a stance of the human body in which one leg bears the weight, while the other is relaxed, creating an asymmetry in the hip–shoulder axis (fig. **7.11**).

Contrast: an abrupt change, such as that created by the juxtaposition of dissimilar colors, objects, etc.

Convention: a custom, practice, or principle that is generally recognized and accepted.

Corbelling: brick or masonry courses, each projecting beyond, and supported by, the one below it; the meeting of two corbels would create an arch or vault.

Corinthian: see **order**.

Cornice: the projecting horizontal unit, usually molded, that surmounts an arch or wall; the topmost member of a classical **entablature** (see p.108).

Cornucopia (or horn of plenty): a curved horn overflowing with fruit and produce, symbolic of abundance.

Counterpoise: see *contrapposto*.

Crayon: a stick for drawing formed from powdered pigment mixed with wax.

Cromlech: a prehistoric monument consisting of a circle of **monoliths**.

Cross-hatching: pattern of superimposed parallel lines (**hatching**) on a two-dimensional surface used to create shadows and suggest three-dimensionality (fig. **2.4**).

Cross section: a diagram showing a building cut by a vertical plane, usually at right angles to an axis (fig. **9.16**).

Cross vault: see **groin vault**.

Crossing: the area in a Christian church where the **transepts** intersect the **nave**.

Cruciform: shaped or arranged like a cross (fig. **10.2**).

Crypt: a chamber or vault beneath the main body of a church.

Cuneiform: a form of writing, consisting of wedge-shaped characters, used in ancient Mesopotamia.

Cupola: a small, domed structure crowning a roof or dome, usually added to provide interior lighting.

Curvilinear: composed of, or bounded by, curved lines.

Cyclopean masonry: stone construction using large, irregular blocks without mortar.

Daguerreotype: mid-nineteenth-century photographic process for fixing positive images on silver-coated metal plates (see p.372).

Deësis: a tripartite **icon** in the Byzantine tradition, usually showing Christ enthroned between the Virgin Mary and St. John the Baptist.

Diorite: a type of dark (black or gray) crystalline rock.

Diptych: a writing tablet or work of art consisting of two panels side by side and connected by hinges.

Dolmen: a prehistoric structure consisting of two or more **megaliths** capped with a horizontal slab.

Dome: a vaulted (frequently hemispherical) roof or ceiling, erected on a circular base, which may be envisaged as the result of rotating an arch through 180 degrees about a central axis.

Doric: see **order**.

Dressed stone: blocks of stone that have been cut and shaped to fit in a particular place for a particular purpose.

Drip technique: a painting technique in which paint is dripped from a brush or stick on to a horizontal canvas or other ground.

Drum: (a) one of the cylindrical blocks of stone from which the shaft of a column is made; (b) the circular or polygonal wall of a building surmounted by a dome or **cupola**.

Drypoint: an **engraving** in which the image is scratched directly into the surface of a metal plate with a pointed instrument.

Earthwork: a construction made of earth, such as an embankment.

Easel: a frame for supporting a canvas or wooden panel.

Easel painting: a moveable painting, as opposed to one executed on a wall or other architectural surface.

Echinus: in the Doric order, the

rounded molding between the **necking** and the *abacus* (see p.108).

Edition: a batch of prints made from a single **plate** or print form.

Elevation: an architectural diagram showing the exterior (or, less often, interior) surface of a building as if projected on to a vertical plane.

Emulsion: a light-sensitive, chemical coating used to transfer photographic images on to metal plates or other surfaces.

Enamel: a vitreous coating applied by heat-fusion to the surface of metal, glass, or pottery. See also **cloisonné**.

Encaustic: a painting technique in which pigment is mixed with a binder of hot wax and fixed by heat after application (see p.95).

Engaged (half) column: a column, decorative in purpose, which is attached to a supporting wall.

Engraving: (a) the process of incising an image on a hard material, such as wood, stone, or a copper plate; (b) a print or impression made by such a process (see p.292).

Entablature: the portion of a Classical architectural order above the **capital** of a column (see p.108).

Entasis: the slight bulging of a Doric column, which is at its greatest about one third of the distance from the base.

Esthetic: the theory and vocabulary of an individual artistic style.

Esthetics: the philosophy and science of art and artistic phenomena.

Etching: (a) a printmaking process in which an impression is taken from a metal plate on which the image has been etched, or eaten away by acid (see p.321); (b) a print produced by such a process.

Etching ground: a resinous, acid-resistant substance used to cover a copper plate before an image is etched on it.

Eucharist: (a) the Christian sacrament of Holy Communion, commemorating the Last Supper; (b) the consecrated bread and wine used at the sacrament.

Expressive content: the emotions and feelings communicated by a work of art.

Façade: the front or "face" of a building.

Facing: an outer covering or sheathing.

Faïence: earthenware or pottery decorated with brightly colored glazes (originally from Faenza, a city in northern Italy).

Fantasy: imagery that is derived solely from the imagination.

Fenestration: the arrangement of windows and doors in a building.

Figura serpentinata: a snakelike twisting of the body, typical of

Mannerist art.

Figurative: representing the likeness of a recognizable human (or animal) figure.

Fire (verb): to prepare (especially ceramics) by baking in a kiln or otherwise applying heat.

Fixing: the use of a chemical process to make an image (a photograph, for example) more permanent.

Fleur-de-lys: (a) a white iris, the royal emblem of France; (b) a stylized representation of an iris, common in artistic design and heraldry.

Flutes, fluting: a series of vertical grooves used to decorate the shafts of columns in Classical architecture.

Flying buttress: a **buttress** in the form of a strut or open half-arch.

Focal point: the point or area of a work of art to which the viewer's eye is most compellingly drawn.

Foreground: the area of a picture, usually at the bottom of the picture plane, that appears nearest to the viewer.

Foreshortening: the use of **perspective** to represent a single object extending back in space at an angle to the picture plane.

Form: the overall plan or structure of a work of art (see p.22).

Formal analysis: analysis of a work of art to determine how its integral parts, or formal elements, are combined to produce the overall style and effect (see p.22).

Formal elements: the elements of style (line, shape, and color) used by an artist in the composition of a work of art.

Formalism: the doctrine or practice of strict adherence to stylized shapes or other external forms.

Forum: the civic center of an ancient Roman city, containing temple, marketplace, and official buildings.

Found object (or *objet trouvé):* an object not originally intended as a work of art, but presented as one.

Fresco: a technique (also known as *buon fresco*) of painting on the plaster surface of a wall or ceiling while it is still damp, so that the pigments become fused with the plaster as it dries.

Fresco secco: a variant technique of fresco painting in which the paint is applied to dry plaster; this is often combined with *buon fresco*, or "true" fresco painting.

Frieze: (a) the central section of the **entablature** in the Classical orders; (b) any horizontal decorative band.

Functionalism: a philosophy of design (in architecture, for example) holding that form should be consistent with material, structure, and use.

Gable (or **pitched) roof:** a roof formed by the intersection of two planes sloping down from a central beam.

Gallery: the second story of a church, placed over the side **aisles** and below the **clerestory**.

Gargoyle: a waterspout, often in the form of a grotesque figure or animal.

Genre: a category of art representing scenes of everyday life.

Geodesic dome: a dome-shaped framework consisting of small, interlocking polygonal units (fig. **31.8**).

Geometric: (a) based on mathematical shapes such as the circle, square, or rectangle; (b) a style of Greek pottery made between c. 900 and 700 B.C., characterized by geometric decoration.

Gesso: a white coating made of chalk, plaster, and size that is spread over a surface to make it more receptive to paint.

Giant order: see **colossal order**.

Gilding: the covering of all or part of a work of art with gold leaf or some other gold-colored substance.

Giornata: a day's work (in Italian); a term used particularly in the context of **fresco** painting.

Glaze: (a) in oil painting, a layer of translucent paint or varnish, sometimes applied over another color or ground, so that light passing through it is reflected back by the lower surface and modified by the glaze; (b) in pottery, a material applied in a thin layer that, when fired, fuses with the surface to produce a glossy, non-porous effect (see p.56).

Glyptic art: the art of carving or engraving, especially on small objects such as seals or precious stones.

Golden section, mean, ratio, rectangle: a proportion formed by dividing a line so that the ratio of the shorter part to the longer is equal to the ratio of the longer to the whole (see p.106).

Gospel: one of the first four books of the New Testament, which recount the life of Christ.

Gouache: an opaque, water-soluble painting **medium**.

Greek cross: a cross in which all four arms are of equal length.

Grisaille: a monochromatic painting (usually in shades of black and gray, to simulate stone sculpture).

Groin (or **cross) vault:** the ceiling configuration formed by the intersection of two barrel vaults.

Ground: in painting, the prepared surface of the support to which the paint is applied.

Ground plan: a plan of the ground floor of a building, seen from above (as distinguished from an **elevation**).

Guild: an organization of craftsmen, such as those that flourished in the Middle Ages and Renaissance (see p.194).

Half column: see **engaged column**.

Halo: a circle or disc of golden light surrounding the head of a holy figure.

Happening: an event in which artists give an unrehearsed performance, sometimes with the participation of the audience.

Hatching: close parallel lines used in drawings and prints to create the effect of shadow on three-dimensional forms. See also **cross-hatching**.

Hierarchical scale: the representation of more important figures as larger than less important ones.

Hieroglyph: a picture or symbol of an object standing for a word or syllable, developed by the ancient Egyptians into a form of writing.

Highlight: in painting, an area of high **value** color.

High relief: relief sculpture in which the figures project substantially (e.g. more than half of their natural depth) from the background surface.

Horn of plenty: see **cornucopia**.

Hôtel: in the eighteenth century, a city mansion belonging to a person of rank.

Hue: a pure color with a specific wavelength (see p.26).

Hydria: an ancient Greek or Roman water jar.

Hypostyle: a hall with a roof supported by rows of columns.

Icon: a sacred image representing Christ, the Virgin Mary, or some other holy person.

Iconography: the analysis of works of art through the study of the meanings of symbols and images in the context of the contemporary culture.

Idealized, idealization: the representation of objects and figures according to ideal standards of beauty rather than to real life.

Ignudi (pl.): nude figures (in Italian).

Illuminated manuscript: see **manuscript**.

Illusionism, illusionistic: a type of art in which the objects are intended to appear real.

Impasto: the thick application of paint, usually oil or **acrylic**, to a canvas or panel.

Incised relief: see **sunken relief**.

Installation: a three-dimensional environment or ensemble of objects, presented as a work of art.

Insula: an ancient Roman building, up to five stories high, forming an apartment block.

Intaglio: a printmaking process in which lines are incised into the surface of a plate or print form (e.g. **engraving** and **etching**).

Intensity: the degree of purity of a color; also known as **chroma** or **saturation**.

Interlace: a form of decoration composed of strips or ribbons that are intertwined, usually symmetrically about a longitudinal axis.

Intermediate colors: see **tertiary colors**.

Intonaco: in fresco painting, the top coat of fine plaster, to which the final design is applied.

Ionic: see **order**.

Isocephaly, isocephalic: the horizontal alignment of the heads of all the figures in a composition.

Isometric projection: an architectural diagram combining a ground plan of a building with a view from an exterior point above and slightly to one side (fig. **13.9**).

Jambs: the upright surfaces forming the sides of a doorway or window, often decorated with sculptures in Romanesque and Gothic churches (fig. **13.15**).

Japonisme: the adoption of features characteristic of Japanese art and culture.

Keystone: the wedge-shaped stone at the center of an arch, rib, or vault, which is inserted last, locking the other stones into place.

Kore (pl. *korai*): Greek word for maiden; an Archaic Greek statue of a standing female, usually clothed (fig. **7.8**).

Kouros (pl. *kouroi*): Greek word for young man; an Archaic Greek statue of a standing nude youth (fig. **7.7**).

Krater: a wide-mouthed bowl for mixing wine and water in ancient Greece (fig. **7.2**).

Kylix: an ancient Greek drinking cup with a wide, shallow bowl (fig. **7.2**).

Lamassu (pl.): in Assyrian art, figures of bulls or lions with wings and human heads.

Lancet: a tall, narrow, arched window without tracery.

Lantern: the structure crowning a dome or tower, often used to admit light to the interior.

Lapis lazuli: a semiprecious blue stone; used to prepare the blue **pigment** known as ultramarine.

Latin cross: a cross in which the vertical arm is longer than the horizontal arm, through the midpoint of which it passes (fig. **10.4**).

Lekythos (or *lecythus*): an ancient Greek vessel with a long, narrow neck, used primarily for pouring oil (fig. **7.2**).

Linear: a style in which lines are used to depict figures with precise, fully indicated outlines.

Linear (or **scientific**) **perspective:** a mathematical system devised during the Renaissance to create the illusion of depth in a two-dimensional image, through the use of straight lines converging towards a **vanishing point** in the distance (see p.228).

Lintel: the horizontal cross-beam spanning an opening in the **post and lintel** system.

Lithography: a printmaking process (see p.368) in which the printing surface is a smooth stone or plate on which an image is drawn with a **crayon** or some other oily substance.

Load-bearing construction: a system of construction in which solid forms are superimposed on one another to form a tapering structure.

Loggia: a roofed gallery open on one or more sides, often with arches or columns.

Longitudinal section: an architectural diagram giving an inside view of a building intersected by a vertical plane from front to back.

Lost-wax bronze casting (also called *cire-perdue*): a technique for casting bronze and other metals (see p.100).

Low relief (also known as **bas-relief**): relief sculpture in which figures and forms project only slightly from the background plane.

Lunette: (a) a semicircular area formed by the intersection of a wall and a vault; (b) a painting, relief sculpture, or window of the same shape.

Maestà: the Italian word for "majesty"; the name given to pictures of the Madonna and Child enthroned in majesty (i.e. surrounded by saints and angels).

Magus (pl. **magi**): in the New Testament, one of the three Wise Men who traveled from the East to pay homage to the infant Christ.

Mandorla: an oval or almond-shaped aureola, or radiance, surrounding the body of a holy person.

Manuscript: a handwritten book produced in the Middle Ages or Renaissance. If it has painted illustrations, it is known as an **illuminated manuscript**.

Martyrium: a church or other structure built over the tomb or relics of a martyr.

Masonite: a type of fiberboard used in insulation and paneling.

Mastaba: a rectangular burial monument in ancient Egypt.

Mausoleum (pl. **mausolea**): an elaborate tomb (named for Mausolus, a fourth-century-B.C. ruler commemorated by a magnificent tomb at Halicarnassus).

Meander pattern: a fret or key pattern originating in the Greek Geometric period.

Medium (pl. **media**): (a) the material with which an artist works (e.g. watercolor on paper); (b) the liquid substance in which pigment is suspended, such as oil or water.

Megalith: a large, undressed stone used in the construction of prehistoric monuments (fig. **3.8**).

Megaron: Greek for "large room"; used principally to denote a rectangular hall, usually supported by columns and fronted by a porch, traditional in ancient Greece since Mycenaean times.

Memento mori: an image, often in the form of a skull, to remind the living of the inevitability of death.

Menhir: a prehistoric **monolith** standing alone or grouped with other stones.

Metope: the square area, often decorated with relief sculpture, between the **triglyphs** of a Doric **frieze** (see p.108).

Mezzanine: in architecture, an intermediate, low-ceilinged story between two main stories.

Mezzotint: a method of **engraving** by burnishing parts of a roughened surface to produce an effect of light and shade.

Mihrab: a niche or chamber in a **mosque** indicating the direction of Mecca, the holy city of Islam (fig. **11.5**).

Minaret: a tall, slender tower attached to a **mosque**, from which the *muezzin* calls the Moslem faithful to prayer (fig. **10.14**).

Miniature: a representation executed on a much smaller scale than the original object.

Mixed media: a term used to describe a single work of art executed in a variety of media or techniques.

Mobile: a delicately balanced sculpture with movable parts that are set in motion by air currents or mechanical propulsion.

Modeling: (a) in two-dimensional art, the use of value to suggest light and shadow, and thus create the effect of mass and weight; (b) in sculpture, the creation of form by manipulating a pliable material such as clay.

Module: a unit of measurement on which the proportions of a building or a work of art are based.

Molding: a continuous contoured surface, either recessed or projecting, used for decorative effect on an architectural surface.

Monastery: a religious establishment housing a community of people living in accordance with religious vows (see p.176).

Monochromatic: having a color scheme based on shades of black and white, or on values of a single hue (fig. **27.9**).

Monolith: a large block of stone that is all in one piece (i.e. not composed of smaller blocks), used in **megalithic** structures.

Montage: a pictorial technique in which cut-out illustrations (often from heterogeneous sources—prints, photographs, etc.) are combined to form a single, composite image.

Monumental: being, or appearing to be, larger than lifesize.

Mosaic: the use of small pieces of glass, stone, or tile (**tesserae**), or pebbles, to create an image on a flat surface such as a floor, wall, or ceiling (see p.158).

Mosque: an Islamic place of worship.

Motif: a recurrent element or theme in a work of art.

Mural: a painting on a wall, usually on a large scale and in **fresco**.

Naive art: art created by artists with no formal training.

Naos: the inner sanctuary of an ancient Greek temple.

Narthex: a porch or vestibule in early Christian churches (fig. **10.2**).

Naturalism, naturalistic: a style of art seeking to represent objects as they actually appear in nature.

Nave: in **basilicas** and churches, the long, narrow, central area used to house the congregation.

Necking: a groove or **molding** at the top of a column or **pilaster** forming the transition from shaft to **capital**.

Necropolis (pl. necropoleis): an ancient or prehistoric burial ground (literally, "City of the Dead").

Neutral: lacking color; white, gray, or black.

Nonobjective (or nonrepresentational): not representing any known object in nature.

Objet trouvé: see **found object**.

Oculus: a round opening in a wall or at the apex of a dome.

Odalisque: a concubine or woman working in a harem.

Oenochoe: an ancient Greek wine jug.

Oil paint: slow-drying and flexible paint formed by mixing pigments with the **medium** of oil.

Orchestra: in an ancient Greek theater, a circular space used by the chorus.

Order: one of the architectural systems (Corinthian, Ionic, Doric) used by the Greeks and Romans to decorate and define the **post and lintel** system of construction (see p.108).

Organic: having the quality of living matter.

Orthogonals: the converging lines that meet at the **vanishing point** in the system of **linear perspective**.

Painterly: in painting, using the qualities of color and texture, rather than line, to define form.

Palette: (a) the range of colors used by an artist; (b) an oval or rectangular tablet used to hold and mix the pigments.

Palette knife: a knife with a flat, flexible blade and no cutting edge, used to mix and spread paint.

Papyrus: (a) a plant found in ancient Egypt and neighboring countries; (b) a paperlike writing material made from the pith of the plant.

Parchment: a paperlike material made from bleached and stretched animal hides, used in the Middle Ages for manuscripts.

Pastel: a crayon made of ground pigments and a gum binder, used as a drawing **medium**.

Patina: (a) the colored surface, often green, that forms on bronze and copper either naturally (as a result of oxidation) or artificially (through treatment with acid); (b) in general, the surface appearance of old objects.

Patron: the person or group that commissions a work of art from an artist.

Pedestal: the base of a column, statue, vase, or other upright work of art.

Pediment: (a) in Classical architecture, the triangular section at the end of a gable roof, often decorated with sculpture; (b) a triangular feature placed as a decoration over doors and windows.

Pendentive: in a domed building, an inwardly curving triangular section of the vaulting that provides a transition from the round base of the dome to the supporting **piers** (fig. **9.3**).

Peplos: in ancient Greece, a woolen outer garment worn by women, wrapped in folds about the body (fig. **7.8**).

Peripteral: surrounded by a row of columns or **peristyle**.

Peristyle: a **colonnade** surrounding a structure (fig. **7.16**).

Perspective: the illusion of depth in a two-dimensional work of art.

Picture plane: the flat surface of a drawing or painting.

Pier: the vertical supports used to bear loads in an arched or vaulted structure (fig. **13.4**).

Pietà: an image of the Virgin Mary holding and mourning over the dead Christ (fig. **16.14**).

Pigment: a powdered substance that is used to give color to paints, inks, and dyes.

Pilaster: a flattened, rectangular version of a column, sometimes load-bearing, but often purely decorative.

Pitched roof: see **gable roof**.

Plane: a surface on which a straight line joining any two of its points lies on that surface; in general, a flat surface.

Plate: (a) in **engraving** and **etching**, a flat piece of metal into which the image to be printed is cut; (b) in photography, a sheet of glass, metal, etc., coated with a light-sensitive emulsion.

Podium: (a) the masonry forming the base of a temple; (b) a raised platform or pedestal.

Polychrome: consisting of several colors.

Polyptych: a painting or relief, usually an **altarpiece**, composed of more than three sections.

Portal: the doorway of a church and the architectural composition surrounding it.

Portico: (a) a **colonnade**; (b) a porch with a roof supported by columns, usually at the entrance to a building.

Post and lintel construction: an architectural system in which upright members, or posts, support horizontal members, or lintels (see p.43).

Postament: (a) a pedestal or base; (b) a frame or **molding** for a relief.

Primary color: the pure hues—blue, red, yellow—from which all other colors can in theory be mixed.

Print: a work of art produced by one of the printmaking processes—**engraving, etching, woodcut**.

Print matrix: an image-bearing surface to which ink is applied before a print is taken from it.

Pronaos: the vestibule of a Greek temple in front of the *cella* or *naos*.

Proportion: the relation of one part to another, and of parts to the whole, in respect of size, height, and width.

Propylaeum (pl. propylaea): (a) an entrance to a temple or other enclosure; (b) the entry gate at the western end of the Acropolis, in Athens.

Psalter: a copy of the Book of Psalms in the Old Testament, often illuminated.

Pseudo-peripteral: appearing to have a **peristyle**, though some of the columns may be engaged columns or **pilasters** (fig. **9.14**).

Pulpit: in church architecture, an elevated stand, surrounded by a parapet and often richly decorated, from which the preacher addresses the congregation.

Putto (pl. *putti*): a chubby male infant, often naked and sometimes depicted as a Cupid, popular in Renaissance art (fig. **15.26**).

Pylon: one of a pair of truncated, pyramidal towers flanking the entrance to an Egyptian temple.

Qibla: a wall in a **mosque** that indicates the direction of Mecca, the holy city of Islam.

Quatrefoil: an ornamental "four-leaf clover" shape, i.e. with four lobes radiating from a common center.

Radiating chapels: chapels placed around the **ambulatory** (and sometimes the **transepts**) of a medieval church.

Realism, realistic: attempting to portray objects from everyday life as they actually are; not to be confused with the nineteenth-century movement called Realism (see p.364).

Rebus: the representation of words or syllables by pictures or symbols, the names of which sound the same as the intended words or syllables.

Red-figure: describing a style of pottery painting in sixth- or fifth-century-B.C. Greece, in which the decoration is red on a black background.

Refectory: a dining hall in a monastery or other, similar institution.

Register: a range or row, especially when one of a series.

Reinforced concrete: concrete strengthened by embedding an internal structure of wire mesh or rods.

Relief: (a) a mode of sculpture in which an image is developed outward (**high** or **low relief**) or inward (**sunken relief**) from a basic plane; (b) a printmaking process in which the areas not to be printed are carved away, leaving the desired image projecting from the plate.

Reliquary: a casket or container for sacred relics.

Representational: representing natural objects in recognizable form.

Reredos: see **retable**.

Retable: the framework above and behind an altar (also called a **reredos**), usually containing painted or carved figures.

Rib: an arched diagonal element in a vault system that defines and supports a **ribbed vault**.

Ribbed vault: a vault constructed of arched diagonal ribs, with a **web** of lighter masonry in between.

Romanticize: to glamorize or portray in a romantic, as opposed to a realistic, manner.

Rose window: a large, circular window decorated with **stained glass** and **tracery** (fig. **13.19**).

Rosin: a crumbly resin used in making varnishes and lacquers.

Rotunda: a circular building, usually covered by a dome.

Rusticate: to give a rustic appearance to masonry blocks by roughening their surface and beveling their edges so that the joints are indented.

Sahn: an enclosed courtyard in a **mosque**.

Salon: (a) a large reception room in an elegant private house; (b) an officially sponsored exhibition of works of art (see p.355).

Sanctuary: (a) the most holy part of a place of worship, the inner sanctum; (b) the part of a Christian church containing the altar.

Sarcophagus: a stone coffin,

sometimes decorated with relief sculpture.

Sarsen: a large, sandstone block used in prehistoric monuments.

Saturation: see **intensity**.

Satyr: an ancient woodland deity with the legs, tail, and horns of a goat (or horse), and the head and torso of a man.

Scientific perspective: see **linear perspective**.

Screen wall: a nonsupporting wall, often pierced by windows.

Scriptorium: the room (or rooms) in a **monastery** in which manuscripts were produced.

Scroll: (a) a length of writing material, such as papyrus or parchment, rolled up into a cylinder; (b) a curved **molding** resembling a scroll (e.g. the **volute** of an Ionic or Corinthian **capital**).

Sculpture in the round: freestanding sculptural figures carved or modeled in three dimensions.

Sculptured wall motif: the conception of a building as a massive block of stone with openings and spaces carved out of it.

Secondary colors: hues produced by combining two **primary colors**.

Section: a diagrammatic representation of a building intersected by a vertical plane.

Sfumato: the definition of form by delicate gradations of light and shadow (see p.262).

Shading: decreases in the **value** or **intensity** of colors to imitate the fall of shadow when light strikes an object.

Shaft: the vertical, cylindrical part of a column that supports the **entablature** (see p.108).

Sibyl: a prophetess of the ancient, pre-Christian world.

Silhouette: the outline of an object, usually filled in with black or some other uniform color.

Silkscreen: a printmaking process in which pigment is forced through the mesh of a silkscreen, parts of which have been masked to make them impervious.

Sinopia (pl. *sinopie*): in **fresco** painting, a fullsized preliminary sketch executed in a red pigment on the first, rough coat of plaster.

Size, sizing: a mixture of glue or resin that is used to make a ground such as canvas less porous, so that paint will not be absorbed into it.

Skeletal (or steel-frame) construction: a method of construction in which the walls are supported at floor level by a steel frame consisting of vertical and horizontal members.

Skene: in a Greek theater, the stone structure behind the *orchestra* that

served as a backdrop or stage wall.

Slip: a mixture of clay and water used to decorate pottery (see p.94).

Spandrel: the triangular area between (a) the side of an arch and the right angle that encloses it, and (b) two adjacent arches.

Sphinx: in ancient Egypt, a creature with the body of a lion and the head of a human, an animal, or a bird (fig. **5.7**).

Spolia: materials taken from an earlier building for re-use in a new one.

Springing: (a) the architectural member of an arch that is the first to curve inward from the vertical; (b) the point at which this curvature begins.

Stained glass: windows composed of pieces of colored glass held in place by strips of lead (see p.193).

State: one of the successive printed stages of a print, distinguished from other stages by the greater or lesser amount of work carried out on the image (see p.321).

Steel-frame construction: see **skeletal construction**.

Stele: an upright stone slab or pillar, usually carved or inscribed for commemorative purposes.

Stereobate: a substructure or foundation of masonry visible above ground level (fig. **7.22**).

Stigmata (pl.): marks resembling the wounds on the crucified body of Christ (from "stigma," a mark or scar).

Still life: a picture consisting principally of inanimate objects such as fruit, flowers, or pottery.

Stucco: (a) a type of cement used to coat the walls of a building; (b) a fine plaster used for **moldings** and other architectural decorations.

Style: in the visual arts, a manner of execution that is characteristic of an individual, a school, a period, or some other identifiable group.

Stylization: the distortion of a **representational** image to conform to certain artistic conventions or to emphasize particular qualities.

Stylobate: the top step of a **stereobate**, forming a foundation for a column, **peristyle**, temple, or other structure (fig. **7.22**).

Stylus: a pointed instrument used in antiquity for writing on clay, wax, papyrus, and parchment.

Sunken (or incised) relief: a style of relief sculpture in which the image is recessed into the surface.

Support: in painting, the surface to which the pigment is applied.

Suspension bridge: a bridge in which the roadway is suspended from two or more steel cables, which usually pass over towers and are then anchored at their ends.

Symmetry: the esthetic balance that is achieved when parts of an object are arranged about a real or imaginary central line, or axis, so that the parts on one side correspond in some respect (shape, size, color) with those on the other.

Synthesis: the combination of parts or elements to form a coherent, more complex whole.

Tell: an archeological term for a mound composed of the remains of successive settlements in the Near East.

Tempera: a paint in which the pigments are mixed with egg yolk and water (see p.215).

Tenebrism: a style of painting used by Caravaggio and his followers, in which most objects are in shadow, while a few are brightly illuminated.

Tenon: a projecting member in a block of stone or other building material that fits into a groove or hole to form a joint.

Tensile strength: the internal strength of a material that enables it to support itself without rupturing.

Terra cotta: (a) an earthenware material, with or without a **glaze**; (b) an object made of this material.

Tertiary (or intermediate) colors: hues made from mixing **primary** and **secondary colors** that are adjacent to each other on the **color wheel**.

Tessera (pl. **tesserae**): a small piece of colored glass, marble, or stone used in a **mosaic**.

Texture: the visual or tactile surface quality of an object.

Tholos: (a) a circular tomb of beehive shape approached by a long, horizontal passage; (b) in Classical times, a round building modeled on ancient tombs.

Three-dimensional: having height, length, and width.

Thrust: the lateral force exerted by an arch, dome, or vault, which must be counteracted by some form of **buttressing**.

Tondo: (a) a circular painting; (b) a medallion with relief sculpture.

Trabeated: constructed according to the **post and lintel** method.

Tracery: a decorative, interlaced design (as in the stonework in Gothic windows).

Transept: a cross arm in a Christian church, placed at right angles to the **nave**.

Travertine: a hard limestone used as a building material by the Etruscans and Romans.

Tribune: (a) the **apse** of a **basilica** or basilican church; (b) a gallery in a Romanesque or Gothic church.

Triforium: in Gothic architecture, part of the **nave** wall above the **arcade** and below the **clerestory**.

Triglyph: in a Doric **frieze**, the rectangular area between the **metopes**, decorated with three vertical grooves (glyphs).

Trilithon: an ancient monument consisting of two vertical **megaliths** supporting a third as a **lintel**.

Triptych: an altarpiece or painting consisting of one central panel and two **wings**.

Trompe l'oeil: illusionistic painting that "deceives the eye" with its appearance of reality.

Trumeau: in Romanesque and Gothic architecture, the central post supporting the **lintel** in a double doorway.

Truss construction: a system of construction in which the architectural members (such as bars and beams) are combined, often in triangles, to form a rigid framework.

Tufa: a porous, volcanic rock that hardens on exposure to air, used as a building material.

Tumulus (pl. **tumuli**): an artificial mound, typically found over a grave.

Tunnel vault: see **barrel vault**.

Tympanum: a **lunette** over the doorway of a church, often decorated with sculpture (fig. **12.5**).

Typology: the Christian theory of types, in which characters and events in the New Testament (i.e. after the birth of Christ) are prefigured by counterparts in the Old Testament.

Underdrawing: a preparatory drawing applied directly to the **ground**, and over which the artist paints the final work.

Value: the degree of lightness (high value) or darkness (low value) in a **hue** (fig. 2.9).

Value scale: a graded scale of **value**.

Vanishing point: in the **linear perspective** system, the point at which the **orthogonals**, if extended, would converge (see p.228).

Vanitas: a category of painting, often a **still life**, the theme of which is the transitory nature of earthly things and the inevitability of death.

Vault, vaulting: a roof or ceiling of masonry, constructed on the **arch** principle (see p.130); see also **barrel vault, groin vault, ribbed vault**.

Vehicle: the liquid in which pigments are suspended and which, as it dries, binds the color to the surface of the painting.

Vellum: a cream-colored, smooth surface for painting or writing, prepared from calfskin.

Verisimilitude: the quality of appearing real or truthful.

Villa: (a) in antiquity and the Renaissance, a large country house; (b) in modern times, a detached house in the country or suburbs.

Visible spectrum: the colors, visible to the human eye, that are produced when white light is dispersed by a prism.

Volute: in the Ionic **order**, the spiral scroll motif decorating the **capital** (see p.108).

Voussoir: one of the individual, wedge-shaped blocks of stone that make up an **arch** (see p.130).

Wash: a thin, translucent coat of paint (e.g. in watercolor).

Watercolor: (a) paint made of **pigments** suspended in water; (b) a painting executed in this **medium**.

Web: in Gothic architecture, the portion of a **ribbed vault** between the ribs.

Westwork: from the German *Westwerk*, the western front of a church, containing an entrance and vestibule below, a chapel or **gallery** above, and flanked by two towers.

White-ground: describing a style of pottery painting found in fifth-century-B.C. Greece, in which the decoration is usually black on a white background.

Wing: a side panel of an **altarpiece** or screen.

Woodcut: a relief printmaking process (see p.292), in which an image is carved on the surface of a wooden block by cutting away those parts that are not to be printed.

Ziggurat: a stepped pyramid made of mud brick (fig. **4.5**).

Suggestions for Further Reading

General

Adams, Laurie. *Art on Trial*. New York: Walker & Co., 1976.

Baxandall, Michael. *Patterns of Intention: On the Historical Explanation of Pictures*. New Haven: Yale University Press, 1985.

Broude, Norma, and Mary D. Garrard, eds. *Feminism and Art History: Questioning the Litany*. New York: Harper & Row, 1982.

_____, eds. *The Expanding Discourse: Feminism and Art History*. New York: HarperCollins, 1992.

Bryson, Norman. *Vision and Painting*. New Haven: Yale University Press, 1987.

Eliade, Mircea. *A History of Religious Ideas*. 2 vols. Tr. W. R. Trask. Chicago: University of Chicago Press, 1978.

Elsen, Albert E. *The Purposes of Art*. New York: Holt, Rinehart & Winston, 1972.

Fichner-Rathus, Lois. *Understanding Art*. Englewood Cliffs, NJ: Prentice-Hall, 1989.

Fine, Elsa Honig. *Women and Art*. Montclair, NJ: Allanheld & Schram, 1978.

Freedberg, David. *The Power of Images*. Chicago: University of Chicago Press, 1989.

Gombrich, Ernst. *Art and Illusion*. New York: Pantheon, 1972.

Harris, Ann S., and Linda Nochlin. *Women Artists, 1550–1950*. Los Angeles: County Museum of Art; New York: Knopf, 1977.

Holt, Elizabeth G. *A Documentary History of Art*. 2 vols. Garden City: Doubleday, 1981.

Kemp, Martin. *The Science of Art: Optical Themes in Western Art from Brunelleschi to Seurat*. New Haven: Yale University Press, 1989.

Kostof, Spiro. *The Architect: Chapters in the History of the Profession*. New York: Oxford University Press, 1977.

_____. *A History of Architecture: Settings and Rituals*. New York: Oxford University Press, 1985.

Kris, Ernst, and Otto Kurz. *Legend, Myth, and Magic in the Image of the Artist*. New Haven: Yale University Press, 1979.

Nochlin, Linda. *Women, Art, and Power and Other Essays*. New York: Harper & Row, 1988.

Ocvirk, Otto G., Robert E. Stinson, Philip R. Wigg, and Robert O. Bone. *Art Fundamentals: Theory and Practice*. 7th ed. Madison: Wm. C. Brown, 1994.

Phipps, Richard, and Richard Wink. *Invitation to the Gallery: An Introduction to Art*. Madison: Wm. C. Brown, 1987.

Praz, Mario. *Mnemosyne*. Princeton: Princeton University Press, 1967.

Saxl, Fritz. *A Heritage of Images*. Harmondsworth: Penguin, 1970.

Schiller, Gertrud. *Iconography of Christian Art*. 2 vols. Greenwich: New York Graphic Society, 1971.

Sporre, Dennis J. *The Creative Impulse: An Introduction to the Arts*. 2nd ed. Englewood Cliffs, NJ: Prentice-Hall, 1990.

Stephenson, Jonathan. *The Materials and Techniques of Painting*. New York: Watson-Guptill, 1989.

Trachtenberg, Marvin, and Isabelle Hyman. *Architecture, from Pre-History to Post-Modernism*. New York: Abrams, 1986.

Verhelst, Wilbert. *Sculpture: Tools, Materials, and Techniques*. Englewood Cliffs: Prentice-Hall, 1973.

Wittkower, Rudolf, and Margot Wittkower. *Born Under Saturn*. New York: Norton, 1969.

Wodehouse, Lawrence, and Marian Moffett. *A History of Western Architecture*. Mountain View, CA: Mayfield Publishing, 1989.

Wölfflin, Heinrich. *Principles of Art History: The Problem of the Development of Style in Later Art*. 7th ed. New York: Dover, 1950.

_____. *The Sense of Form in Art*. New York: Chelsea, 1958.

Wollheim, Richard. *Painting as an Art*. Princeton: Princeton University Press, 1984.

Zelanski, Paul, and Mary P. Fisher. *The Art of Seeing*. 2nd ed. Englewood Cliffs, NJ: Prentice-Hall, 1990.

_____. *Color*. Englewood Cliffs, NJ: Prentice-Hall, 1989.

The Ancient World: Prehistoric Art, The Ancient Near East, and Egypt

Akurgal, Ekrem. *Art of the Hittites*. New York: Abrams, 1962.

Aldred, Cyril. *Akhenaten and Nefertiti*. New York: Viking Press, 1973.

_____. *Egyptian Art in the Days of the Pharaohs, 3100–320 B.C.* New York: Oxford University Press, 1980.

Amiet, Pierre, ed. *Art in the Ancient World: A Handbook of Styles and Forms*. New York: Rizzoli, 1981.

Bataille, Georges. *Lascaux: Prehistoric Painting, or the Birth of Art*. Lausanne: Skira, 1980.

Bottero, Jean. *Mesopotamia: Writing, Reasoning, and the Gods*. Tr. Z. Bahrani. Chicago: University of Chicago Press, 1992.

Chippindale, Christopher. *Stonehenge Complete*. London: Thames & Hudson, 1983.

Collon, Dominique. *First Impressions*. London: British Museum, 1987.

Finegan, Jack. *Light from the Ancient Past*. 2 vols. 2nd ed. Princeton: Princeton University Press, 1974.

Frankfort, Henri. *The Art and Architecture of the Ancient Orient*. Rev. ed. Pelican History of Art. Baltimore: Penguin, 1971.

Gardiner, Alan H. *Egypt of the Pharaohs*. Oxford: Oxford University Press, 1978.

Ghirshman, Roman. *The Arts of Ancient Iran from Its Origins to the Time of Alexander the Great*. Tr. S. Gilbert and J. Emmons. New York:

Golden Press, 1962.

Gilgamesh. Tr. J. Gardner and J. Maier. New York: Knopf, 1984.

Groenewegen-Frankfort, Henriette A. *Arrest and Movement: An Essay on Space and Time in Representational Art of the Ancient Near East.* Cambridge, MA: Belknap Press, 1987.

_____, and Bernard Ashmole. *Art of the Ancient World.* New York: Abrams, 1975.

Hayes, William C. *The Scepter of Egypt.* 2 vols. New York: Harper & Row, 1953–9.

James, Edwin O. *From Cave to Cathedral: Temples and Shrines of Prehistoric, Classical and Early Christian Times.* London: Thames & Hudson, 1965.

Kramer, Samuel N. *History Begins at Sumer.* New York: Doubleday, 1959.

_____. *The Sumerians: Their History, Culture, and Character.* Chicago: University of Chicago Press, 1963.

Lange, Curt, and Max Hirmer. *Egypt: Architecture, Sculpture, and Painting in Three Thousand Years.* 4th ed. London: Phaidon, 1968.

Leroi-Gourhan, André. *The Dawn of European Art: An Introduction to Paleolithic Cave Painting.* Cambridge: Cambridge University Press, 1982.

_____. *Treasures of Prehistoric Art.* New York: Abrams, 1967.

Lloyd, Seton. *The Archaeology of Mesopotamia: From the Old Stone Age to the Persian Conquest.* London: Thames & Hudson, 1978.

_____, and Hans W. Müller. *Ancient Architecture: Mesopotamia, Egypt, Crete.* New York: Electa/Rizzoli, 1986.

Lurker, Manfred. *The Gods and Symbols of Ancient Egypt.* Tr. Barbara Cummings. London: Thames & Hudson, 1982.

Mahdy, Christine, ed. *The World of the Pharaohs: A Complete Guide to Ancient Egypt.* London: Thames & Hudson, 1990.

Mellaart, James. *Çatal Hüyük: A Neolithic Town in Anatolia.* New York: McGraw-Hill, 1967.

_____. *The Earliest Civilizations of the Near East.* New York: McGraw-Hill, 1965.

Moortgat, Anton. *The Art of Ancient Mesopotamia.* New York: Phaidon, 1969.

Muscarella, Oscar W. *Bronze and Iron.* New York: Metropolitan Museum of Art, 1988.

Oppenheim, A. Leo. *Ancient Mesopotamia: Portrait of a Dead Civilization.* Rev. ed. Chicago: University of Chicago Press, 1977.

Porada, Edith, and Robert H. Dyson. *The Art of Ancient Iran: Pre-Islamic Cultures.* Rev. ed. New York: Greystone Press, 1967.

Powell, Thomas G. E. *Prehistoric Art.* New York: Praeger, 1966.

Redford, Donald B. *Akhenaten: The Heretic King.* Princeton: Princeton University Press, 1984.

Saggs, Henry W. F. *The Greatness That Was Babylon.* New York: Praeger, 1968.

Sieveking, Ann. *The Cave Artists.* London: Thames & Hudson, 1979.

Smith, William Stevenson, and W. Kelly Simpson. *The Art and Architecture of Ancient Egypt.* Rev. ed. New York: Viking, 1981.

Wainwright, Geoffrey. *The Henge Monuments: Ceremony and Society in Prehistoric Britain.* London: Thames & Hudson, 1990.

Woldering, Irmgard. *Gods, Men, and Pharaohs: The Glory of Egyptian Art.* New York: Abrams, 1967.

Woolley, Charles L. *The Art of the Middle East, including Persia, Mesopotamia, and Palestine.* New York: Crown, 1961.

_____. *The Development of Sumerian Art.* Westport, CT: Greenwood Press, 1981.

The Aegean and Ancient Greece

Ashmole, Bernard. *Architect and Sculptor in Classical Greece.* New York: New York University Press, 1972.

Beazley, John D. *Attic Red-Figure Vase-Painters.* 3 vols. First published 1963. Reprint. New York: Hacker, 1984.

_____. *The Development of the Attic Black-Figure.* Rev. ed. Berkeley: University of California Press, 1986.

Boardman, John. *Athenian Black-Figure Vases.* New York: Oxford University Press, 1974.

_____. *Greek Art.* Rev. ed. New York: Praeger, 1973.

_____. *The Parthenon and Its Sculptures.* Austin: University of Texas Press, 1985.

_____. *Pre-Classical: From Crete to Archaic Greece.* Baltimore: Penguin, 1967.

Brilliant, Richard. *Arts of the Ancient Greeks.* New York: McGraw-Hill, 1973.

Carpenter, Rhys. *The Architects of the Parthenon.* Baltimore: Penguin, 1970.

_____. *The Esthetic Basis of Greek Art.* Bloomington: Indiana University Press, 1959.

_____. *Greek Sculpture.* Chicago: University of Chicago Press, 1960.

Chadwick, John. *The Mycenaean World.* Cambridge: Cambridge University Press, 1976.

Cook, Robert M. *Greek Art: Its Development, Character, and Influence.* New York: Farrer, Straus & Giroux, 1973.

Dinsmoor, William B. *The Architecture of Ancient Greece.* 3rd ed. New York: Norton, 1975.

Havelock, Christine M. *Hellenistic Art.* Greenwich: New York Graphic Society, 1973.

Higgins, Reynold A. *Minoan and Mycenaean Art.* Rev. ed. Oxford: Oxford University Press, 1981.

Immerwahr, Sara A. *Aegean Painting in the Bronze Age.* University Park: Pennsylvania State University Press, 1990.

Marinatos, Spyridon N., and Max Hirmer. *Crete and Mycenae.* New York: Abrams, 1960.

Mylonas, George E. *Mycenae and the Mycenaean Age.* Princeton: Princeton University Press, 1966.

Nilsson, Martin P. *Minoan Mycenaean Religion.* 2nd rev. ed. Lund: Gleerup, 1968.

Onians, John. *Art and Thought in the Hellenistic Age.* London: Thames & Hudson, 1979.

_____. *Bearers of Meaning: The Classical Orders in Antiquity, the Middle Ages, and the Renaissance.* Princeton: Princeton University Press, 1988.

Palmer, Leonard R. *Mycenaeans and Minoans.* 2nd rev. ed. Westport, CT: Greenwood Press, 1980.

Papaionnou, Kostas. *The Art of Greece.* New York: Abrams, 1989.

Pollitt, Jerome J. *The Ancient View of Greek Art: Criticism, History, and Terminology.* New Haven: Yale University Press, 1974.

_____. *Art and Experience in Classical Greece.* Cambridge: Cambridge University Press, 1972.

_____. *Art in the Hellenistic Age.* Cambridge: Cambridge University Press, 1986.

_____. *The Art of Greece, 1400–31 B.C.: Sources and Documents.* Englewood Cliffs, NJ: Prentice-Hall, 1965.

Richter, Gisela M. A. *Archaic Greek Art Against Its Historical Background.* New York: Oxford University Press, 1949.

_____. *A Handbook of Greek Art.* 6th ed. London: Phaidon, 1969.

_____. *Kouroi.* 3rd ed. New York: Phaidon, 1970.

_____. *The Sculpture and Sculptors of the Greeks.* 4th ed., rev. New Haven: Yale University Press, 1970.

Ridgway, Brunilde Sismondo. *The Archaic Style in Greek Sculpture.* Princeton: Princeton University Press, 1977.

_____. *Fifth-Century Styles in Greek Sculpture.* Princeton: Princeton University Press, 1981.

_____. *The Severe Style in Greek Sculpture.* Princeton: Princeton University Press, 1970.

Robertson, Charles M. *A History of*

Greek Art. 2 vols. Cambridge: Cambridge University Press, 1975.

Scully, Vincent. *The Earth, the Temple, and the Gods: Greek Sacred Architecture.* Rev. ed. New Haven: Yale University Press, 1979.

Stobart, John C. *The Glory That Was Greece.* 4th ed. New York: Praeger, 1971.

Vermeule, Emily. *Aspects of Death in Ancient Greek Art and Poetry.* Berkeley: University of California Press, 1979.

_____. *Greece in the Bronze Age.* Chicago: University of Chicago Press, 1972.

Willetts, Ronald F. *The Civilization of Ancient Crete.* Berkeley: University of California Press, 1978.

Etruscan and Roman Art

Boethius, Axel, and John B. Ward-Perkins. *Etruscan and Roman Architecture.* Pelican History of Art. Baltimore: Penguin, 1970.

Bonfante, Larissa. *Etruscan: Reading the Past.* Berkeley: University of California Press/British Museum, 1990.

_____, ed. *Etruscan Life and Afterlife: A Handbook of Etruscan Studies.* Detroit: Wayne State University Press, 1986.

Brendel, Otto J. *Etruscan Art.* Ed. E. H. Richardson. Harmondsworth: Penguin, 1978.

_____. *Prolegomena to the Study of Roman Art.* New Haven: Yale University Press, 1979.

Brilliant, Richard. *Pompeii A.D. 79.* New York: Clarkson N. Potter Inc. (Museum of Natural History Publications), 1979.

Feder, Theodore. *Great Treasures of Pompeii and Herculaneum.* New York: Abbeville Press, 1978.

Goldscheider, Ludwig. *Roman Portraits.* London: Phaidon, 1940.

de Grummond, Nancy T., ed. *A Guide to Etruscan Mirrors.* Florida: Tallahassee, 1982.

Hanfmann, George M. A. *Roman Art.* Greenwich: New York Graphic Society, 1964.

Harris, William Vernon. *Rome in Etruria and Umbria.* Oxford: Clarendon Press, 1971.

MacDonald, William L. *The Architecture of the Roman Empire.* New Haven: Yale University Press, 1982.

Macnamara, Ellen. *Everyday Life of the Etruscans.* Cambridge: Harvard University Press, 1991.

Pollitt, Jerome J. *The Art of Rome c. 753 B.C.–A.D. 337: Sources and Documents.* New York: Cambridge University Press, 1983.

Ramage, Nancy H., and Andrew

Ramage. *Roman Art: Romulus to Constantine.* Englewood Cliffs, NJ: Prentice-Hall, 1991.

Richardson, Emeline H. *The Etruscans: Their Art and Civilization.* Chicago: University of Chicago Press, 1964.

Robertson, Donald S. *Greek and Roman Architecture.* 2nd ed. Cambridge: Cambridge University Press, 1969.

Sear, Frank. *Roman Architecture.* Ithaca: Cornell University Press, 1982.

Spivey, Nigel, and Simon Stoddart. *Etruscan Italy: An Archaeological History.* London: Batsford, 1992.

Sprenger, Maja, Gilda Bartoloni, and Max Hirmer. *The Etruscans: Their History, Art, and Architecture.* New York: Abrams, 1983.

Strong, Donald E. *Roman Imperial Sculptures: An Introduction to the Commemorative and Decorative Sculpture of the Roman Empire Down to the Death of Constantine.* London: Tiranti, 1961.

Vermeule, Cornelius. *European Art and the Classical Past.* Cambridge, MA: Harvard University Press, 1964.

Ward-Perkins, John B. *Roman Architecture.* New York: Abrams, 1977.

_____. *Roman Imperial Architecture.* Harmondsworth: Penguin, 1981.

_____, and Axel Boethius. *Etruscan and Roman Architecture.* Harmondsworth: Penguin, 1970.

Wells, Colin. *The Roman Empire.* Stanford: Stanford University Press, 1984.

Wheeler, Mortimer. *Roman Art and Architecture.* New York: Praeger, 1964.

Early Christian, Byzantine, and Medieval Art

Beckwith, John. *The Art of Constantinople: An Introduction to Byzantine Art (330–1453).* New York: Phaidon, 1968.

_____. *Early Medieval Art: Carolingian, Ottonian, Romanesque.* New York: Oxford University Press, 1974.

_____. *Early Christian and Byzantine Art.* Baltimore: Penguin, 1979.

Braunfels, Werner. *Monasteries of Western Europe.* London: Thames & Hudson, 1972.

Brown, Peter. *The Book of Kells.* New York: Knopf, 1980.

Demus, Otto. *Byzantine Art and the West.* New York: New York University Press, 1970.

Ettinghausen, Richard. *Arab Painting.* Geneva: Skira, 1962.

_____, and Oleg Grabar. *The Art and Architecture of Islam, 650–1250.* New York: Viking Penguin, 1987.

Finlay, Ian. *Celtic Art: An Introduction.* London: Faber & Faber, 1973.

Grabar, André. *The Beginnings of Christian Art, 200–395.* Tr. S. Gilbert and J. Emmons. London: Thames & Hudson, 1967.

_____. *Byzantium: Byzantine Art in the Middle Ages.* Tr. B. Forster. London: Methuen, 1969.

_____. *Christian Iconography: A Study of Its Origins.* Princeton: Princeton University Press, c. 1968.

_____. *The Golden Age of Justinian, from the Death of Theodosius to the Rise of Islam.* Tr. S. Gilbert and J. Emmons. New York: Braziller, 1971.

_____, and Carl Nordenfalk. *Early Medieval Painting.* Geneva: Skira, 1957.

Grabar, Oleg. *The Formation of Islamic Art.* New Haven: Yale University Press, 1973.

Grant, Michael. *The Dawn of the Middle Ages.* New York: Bonanza Books, 1981.

Hinks, Roger P. *Carolingian Art.* Ann Arbor: University of Michigan Press, 1962.

_____. *The Carolingian Renaissance.* New York: Braziller, 1970.

Kendrick, Thomas D. *Anglo-Saxon Art to A.D. 900.* New York: Barnes & Noble, 1972.

Kidson, Peter. *The Medieval World.* New York: McGraw-Hill, 1967.

Kitzinger, Ernst. *Byzantine Art in the Making: Main Lines of Stylistic Development in Mediterranean Art, 3rd–7th Century.* Cambridge, MA: Harvard University Press, 1978.

_____. *Early Medieval Art in the British Museum.* Bloomington: Indiana University Press, 1964.

Krautheimer, Richard. *Early Christian and Byzantine Architecture.* Pelican History of Art. Baltimore: Penguin, 1965.

_____. *Studies in Early Christian, Medieval, and Renaissance Art.* New York: New York University Press, 1969.

Lowrie, Walter. *Art in the Early Church.* New York: Norton, 1969.

Mainstone, Rowland J. *Hagia Sophia: Architecture, Structure and Liturgy of Justinian's Great Church.* London: Thames & Hudson, 1988.

Mango, Cyril. *Byzantine Architecture.* New York: Electa/Rizzoli, 1985.

Martindale, Andrew. *The Rise of the Artist in the Middle Ages and Early Renaissance.* New York: McGraw-Hill, 1972.

Megaw, Ruth, and Vincent Megaw. *Celtic Art: From Its Beginnings to the Book of Kells.* London: Thames & Hudson, 1989.

Morey, Charles Rufus. *Early Christian Art.* 2nd ed. Princeton: Princeton University Press, 1953.

Mütherich, Florentine, and Joachim E. Gaehde. *Carolingian Painting.* New

York: Braziller, 1976.

Nordenfalk, Carl. *Celtic and Anglo-Saxon Painting: Book Illumination in the British Isles 600–800.* New York: Braziller, 1977.

Panofsky, Erwin. *Tomb Sculpture.* New York: Abrams, c. 1954.

Pevsner, Nikolaus. *An Outline of European Architecture.* 6th ed. Baltimore: Penguin, 1960.

Rice, David T. *The Appreciation of Byzantine Art.* Oxford: Oxford University Press, 1972.

———. *Islamic Art.* London: Thames & Hudson, 1975.

Saalman, Howard. *Medieval Architecture.* New York: Braziller, 1962.

Skokstad, Marilyn. *Medieval Art.* New York: Harper & Row, 1986.

Snyder, James. *Medieval Art: Painting, Sculpture, Architecture, 4th–14th Century.* New York: Abrams, 1989.

Volbach, Wolfgang, and Max Hirmer. *Early Christian Art.* New York: Abrams, 1962.

Weitzmann, Kurt. *Art in the Medieval West and Its Contacts with Byzantium.* London: Variorum, 1982.

———. *Studies in Classical and Byzantine Manuscript Illumination.* Chicago: University of Chicago Press, 1971.

———, et al. *The Icon.* New York: Knopf, 1982.

Zarnecki, George. *Art of the Medieval World.* New York: Abrams, 1975.

Romanesque and Gothic Art

Aubert, Marcel. *The Art of the High Gothic Era.* New York: Crown, 1965.

———. *Gothic Cathedrals of France and Their Treasures.* New York: N. Kay, 1959.

Branner, Robert. *Chartres Cathedral.* New York: Norton, 1969.

Clapham, Alfred W. *Romanesque Architecture in Western Europe.* Oxford: Clarendon Press, 1959.

Demus, Otto. *Romanesque Mural Painting.* New York: Abrams, 1971.

Evans, Joan. *Art in Medieval France, 987–1498.* New York: Oxford University Press, 1952.

Focillon, Henri. *The Art of the West in the Middle Ages.* Ed. J. Bony. Tr. D. King. 2 vols. New York: Phaidon, 1963.

Gibbs-Smith, Charles H. *The Bayeux Tapestry.* London: Phaidon, 1973.

Grabar, André, and Carl Nordenfalk. *Romanesque Painting.* New York: Skira, 1958.

Grodecki, Louis. *Gothic Architecture.* New York: Abrams, 1977.

Hearn, Millard F. *Romanesque Sculpture in the 11th and 12th Centuries.* Ithaca: Cornell University Press, 1981.

Henderson, George D. S. *Chartres.* Baltimore: Penguin, 1968.

———. *Gothic.* Baltimore: Penguin, 1967.

Katzenellenbogen, Adolf. *The Sculptural Programs of Chartres Cathedral.* Baltimore: Johns Hopkins University Press, 1959.

Male, Emile. *Art and Artists of the Middle Ages.* Redding Ridge, CT: Black Swan Books, 1986.

———. *The Gothic Image: Religious Art in the 12th Century.* Rev. ed. Princeton: Princeton University Press, 1978.

———. *Religious Art in France: The 13th Century—A Study of Medieval Iconography and Its Sources.* Princeton: Princeton University Press, 1984.

———. *Religious Art in France: The Late Middle Ages—A Study of Medieval Iconography and Its Sources.* Princeton: Princeton University Press, 1986.

Marle, Raimond van. *The Development of the Italian Schools of Painting.* 19 vols. Reprint of 1923–38 ed. New York: Hacker, 1971.

Martindale, Andrew. *Gothic Art.* New York: Praeger, 1967.

Pacht, Otto. *The Rise of Pictorial Narrative in 12th-Century England.* Oxford: Clarendon Press, 1962.

Panofsky, Erwin, and Gerda Panofsky-Soergel, eds. *Abbot Suger on the Abbey Church of Saint-Denis and Its Art Treasures.* Princeton: Princeton University Press, 1979.

———. *Gothic Architecture and Scholasticism.* Latrobe, PA: Archabbey Press, 1951.

Pope-Hennessy, John. *Italian Gothic Sculpture.* 2nd ed. New York: Phaidon, 1970.

Radding, Charles M., and William W. Clark. *Medieval Architecture, Medieval Learning.* New Haven: Yale University Press, 1992.

Saxl, Fritz. *English Sculptures of the 12th Century.* Ed. Hanns Swarzenski. London: Faber & Faber, 1954.

Schapiro, Meyer. *Romanesque Art: Selected Papers.* New York: Braziller, 1976.

von Simson, Otto G. *The Gothic Cathedral: Origins of Gothic Architecture and the Medieval Concept of Order.* 2nd ed. Princeton: Princeton University Press, 1974.

Swann, Wim. *The Gothic Cathedral.* New York: Park Lane, 1969.

Swarzenski, Hanns. *Monuments of Romanesque Art: The Art of Church Treasures in North-Western Europe.* 2nd ed. Chicago: University of Chicago Press, 1967.

Thompson, Daniel V. *The Materials and Techniques of Medieval Painting.* New York: Dover, 1957.

Watson, Percy. *Building the Medieval Cathedrals.* Cambridge: Cambridge University Press, 1976.

Zarnecki, George. *Romanesque Art.* New York: Universe Books, 1971.

The Italian Renaissance

Ackerman, James S. *The Architecture of Michelangelo.* Rev. ed. New York: Viking Press, 1966.

Alazard, Jean. *The Florentine Portrait.* New York: Schocken Books, 1969.

Alberti, Leon Battista. *On Painting.* Tr. J. R. Spencer. Rev. ed. New Haven: Yale University Press, 1966.

———. *Ten Books on Architecture.* Ed. J. Rykwert. Tr. J. Leoni. London: Tiranti, 1955

Antal, Frederick. *Florentine Painting and Its Social Background.* Boston: Boston Book and Art Shop, 1965.

Barolsky, Paul. *Giotto's Father and the Family of Vasari's Lives.* University Park, PA: Pennsylvania State University Press, 1992.

———. *Infinite Jest: Wit and Humor in Italian Renaissance Art.* Columbia, MO: University of Missouri Press, 1978.

———. *Michelangelo's Nose: A Myth and Its Maker.* University Park, PA: Pennsylvania State University Press, 1990.

Baxandall, Michael. *Painting and Experience in 15th-Century Italy.* Oxford: Oxford University Press, 1972.

Beck, James. *Italian Renaissance Painting.* New York: HarperCollins, 1981.

Berenson, Bernard. *The Drawings of the Florentine Painters.* 3 vols. Reprint of 1938 ed. Chicago: University of Chicago Press, 1973.

———. *Italian Painters of the Renaissance.* Rev. ed. London: Phaidon, 1967.

———. *Italian Pictures of the Renaissance: Central and Northern Italian Schools.* 3 vols. London: Phaidon, 1968.

———. *Italian Pictures of the Renaissance: Florentine School.* 2 vols. London: Phaidon, 1963.

Blunt, Anthony. *Artistic Theory in Italy, 1450–1600.* New York: Oxford University Press, 1956.

Bober, Phyllis P., and Ruth O. Rubinstein. *Renaissance Artists and Antique Sculpture.* New York: Oxford University Press, 1986.

Borsook, Eve. *The Mural Painters of Tuscany.* London: Phaidon, 1960.

Burckhardt, Jakob C. *The Civilization of the Renaissance in Italy.* Tr. S. G. C. Middlemore. 3rd rev. ed. London: Phaidon, 1950.

Campbell, Lorne. *Renaissance Portraits:*

European Portrait-Painting in the 14th, 15th, and 16th Centuries. New Haven: Yale University Press, 1990.

Castiglione, Baldesar. *The Book of the Courtier* (1528). Tr. G. Bull. New York: Penguin, 1967.

Cennini, Cennino. *The Craftsman's Handbook (Il Libro dell'Arte).* Tr. Daniel V. Thompson, Jr. New York: Dover, 1954.

Chastel, André. *The Studios and Styles of Renaissance Italy, 1460–1500.* New York: Braziller, 1964.

Clark, Kenneth M. *Leonardo da Vinci.* Baltimore: Penguin, 1967.

Cole, Bruce. *The Renaissance Artist at Work.* New York: Harper & Row, 1983.

_____. *Sienese Painting: From Its Origins to the 15th Century.* Bloomington: Indiana University Press, 1985.

Davis, Howard McP. *Gravity in the Paintings of Giotto.* 1971. Reprinted in Schneider, *Giotto in Perspective.*

De Tolnay, Charles. *Michelangelo.* 2nd rev. ed. 5 vols. Princeton: Princeton University Press, 1969–71.

Edgerton, Samuel Y., Jr. *The Renaissance Rediscovery of Linear Perspective.* New York: Harper & Row, 1976.

Fischel, Oskar. *Raphael.* Tr. B. Rackham. 2 vols. London: Spring Books, 1964.

Freedberg, Sydney J. *Painting in Italy, 1500–1600.* Pelican History of Art. Baltimore: Penguin, 1971.

_____. *Painting of the High Renaissance in Rome and Florence.* 2 vols. Cambridge, MA: Harvard University Press, 1961.

Gilbert, Creighton E. *Italian Art, 1400–1500: Sources and Documents.* Englewood Cliffs, NJ: Prentice-Hall, 1980.

Gombrich, Ernst H. *Norm and Form: Studies in the Art of the Renaissance.* London: Phaidon, 1966.

Greenstein, Jack M. *Mantegna and Painting as Historical Narrative.* Chicago: University of Chicago Press, 1992.

Hartt, Frederick. *A History of Italian Renaissance Art.* 2nd rev. ed. New York: Thames & Hudson, 1987.

Hibbard, Howard. *Michelangelo.* 2nd ed. New York: HarperCollins, 1983.

Heydenreich, Ludwig H., and Wolfgang Lotz. *Architecture in Italy, 1400–1600.* Harmondsworth: Penguin, 1974.

Hind, Arthur M. *History of Engraving and Etching.* 3rd ed., rev. Boston: Houghton Mifflin, 1923.

Huse, Norbert, and Wolfgang Wolters. *The Art of Renaissance Venice.* Tr. E. Jephcott. Chicago: University of Chicago Press, 1990.

Janson, Horst W. *The Sculpture of Donatello.* 2 vols. Princeton:

Princeton University Press, 1957.

Kemp, Martin, ed. *Leonardo on Painting.* New Haven: Yale University Press, 1989.

Krautheimer, Richard, and Trude Krautheimer-Hess. *Lorenzo Ghiberti.* 2nd ed. Princeton: Princeton University Press, 1970.

Lee, Rensselaer W. *Ut Pictura Poesis: The Humanistic Theory of Painting.* New York: Norton, 1967.

Leonardo da Vinci. *The Notebooks.* Tr. E. MacCurdy. 2 vols. New York: Harcourt, Brace, 1938.

Levey, Michael. *High Renaissance.* Harmondsworth: Penguin, 1975.

Lowry, Bates. *Renaissance Architecture.* New York: Braziller, 1962.

Martindale, Andrew. *The Rise of the Artist.* New York: McGraw-Hill, 1972.

Meiss, Millard. *Painting in Florence and Siena after the Black Death.* New York: Harper & Row, 1951.

Murray, Peter. *Renaissance Architecture.* New York: Abrams, 1976.

Panofsky, Erwin. *Renaissance and Renascences in Western Art.* New York: Harper & Row, 1969.

Partridge, Loren, and Randolph Starn. *A Renaissance Likeness.* Berkeley: University of California Press, 1980.

Pater, Walter. *The Renaissance: Studies in Art and Poetry.* Ed. D. L. Hill. Berkeley: University of California Press, 1980.

Pope-Hennessy, John. *An Introduction to Italian Sculpture.* 3rd ed. 3 vols. New York: Phaidon, 1986.

_____. *The Portrait in the Renaissance.* Princeton: Princeton University Press, 1966.

_____. *Raphael.* New York: New York University Press, 1970.

Schneider, Laurie M., ed. *Giotto in Perspective.* Englewood Cliffs, NJ: Prentice-Hall, 1974.

Seznec, Jean. *The Survival of the Pagan Gods.* Tr. B. F. Sessions. First printed 1953. Reprint by Bollingen Foundation and Pantheon Books. Princeton: Princeton University Press, 1972.

Smart, Alastair. *The Dawn of Italian Painting, c. 1250–1400.* Ithaca: Cornell University Press, 1978.

Stubblebine, James H., ed. *Giotto: The Arena Chapel Frescoes.* New York: Norton, 1969.

Vasari, Giorgio. *The Lives of the Most Eminent Painters, Sculptors, and Architects.* Tr. Gaston Du C. de Vere. New York: Abrams, 1979.

Wethey, Harold E. *The Paintings of Titian.* 3 vols. London: Phaidon, 1969.

White, John. *Art and Architecture in Italy, 1250–1400.* Pelican History of Art. Baltimore: Penguin, 1966.

_____. *The Birth and Rebirth of Pictorial Space.* 2nd ed. Boston: Boston Book and Art Shop, 1967.

Wind, Edgar. *Pagan Mysteries in the*

Renaissance. Rev. ed. New York: Barnes & Noble, 1968.

Wittkower, Rudolf. *Architectural Principles in the Age of Humanism.* New York: Random House, 1965.

_____. *Idea and Image: Studies in the Italian Renaissance.* 3rd rev. ed. New York: Thames & Hudson, 1962.

Wölfflin, Heinrich. *Classic Art: An Introduction to the Italian Renaissance.* Tr. L. and P. Murray. 3rd ed. New York: Phaidon, 1968.

The Renaissance Outside Italy

Benesch, Otto. *The Art of the Renaissance in Northern Europe.* Rev. ed. London: Phaidon, 1965.

_____. *German Painting from Dürer to Holbein.* Tr. H. S. B. Harrison. Geneva: Skira, 1966.

Chastel, André. *The Age of Humanism: Europe, 1480–1530.* Tr. K. Delavenay and E. M. Gweyer. New York: McGraw-Hill, 1964.

Cuttler, Charles P. *Northern Painting from Pucelle to Bruegel.* New York: Holt, Rinehart & Winston, 1968.

Davies, Martin. *Rogier van der Weyden: An Essay with a Critical Catalogue of Paintings.* New York: Phaidon, 1972.

Friedländer, Max J. *Early Netherlandish Painting.* 14 vols. Tr. Heinz Norden. New York: Praeger, 1967–73.

_____. *From Van Eyck to Bruegel: Early Netherlandish Painting.* New York: Phaidon, 1969.

Fuchs, Rudolph H. *Dutch Painting.* London: Thames & Hudson, 1978.

Gilbert, Creighton E. *History of Renaissance Art Throughout Europe: Painting, Sculpture, Architecture.* New York: Abrams, 1973.

Hind, Arthur M. *A History of Engraving and Etching from the 15th Century to the Year 1914.* 3rd rev. ed. New York: Dover, 1963.

_____. *An Introduction to a History of Woodcut.* New York: Dover, 1963.

Meiss, Millard. *French Painting in the Time of Jean de Berry: The Late 14th Century and the Patronage of the Duke.* 2 vols. London: Phaidon, 1967.

Panofsky, Erwin. *Early Netherlandish Painting.* 2 vols. Cambridge, MA: Harvard University Press, 1958.

_____. *Life and Work of Albrecht Dürer.* 2 vols. 3rd ed. Princeton: Princeton University Press, 1948.

Pevsner, Nikolaus, and Michael Meier. *Grünewald.* New York: Abrams, 1958.

Snyder, James. *Northern Renaissance Art.* New York: Abrams, 1985.

Stechow, Wolfgang. *Northern Renaissance Art, 1400–1600: Sources and Documents.* Englewood Cliffs, NJ: Prentice-Hall, 1966.

Mannerism and the Baroque

Ackerman, James S. *Palladio*. New York: Penguin, 1978.

Alpers, Svetlana. *The Art of Describing: Dutch Art in the 17th Century*. Chicago: University of Chicago Press, 1983.

_____. *Rembrandt's Enterprise: The Studio and the Market*. Chicago: University of Chicago Press, 1988.

Bazin, Germain. *Baroque and Rococo Art*. New York: Praeger, 1974.

Blunt, Anthony. *Art and Architecture in France, 1500–1700*. Rev. ed. Harmondsworth: Penguin, 1973.

Brown, Jonathan. *The Golden Age of Painting in Spain*. New Haven: Yale University Press, 1991.

_____. *Velázquez, Painter and Courtier*. New Haven: Yale University Press, 1988.

Cellini, Benvenuto. *Autobiography*. Ed. John Pope-Hennessy. London: Phaidon, 1960.

Clark, Kenneth. *Rembrandt and the Italian Renaissance*. New York: New York University Press, 1966.

Enggass, Robert, and Jonathan Brown. *Italy and Spain, 1600–1750: Sources and Documents*. Englewood Cliffs, NJ: Prentice-Hall, 1970.

Freedberg, Sydney J. *Parmigianino*. Cambridge, MA: Harvard University Press, 1950.

Friedländer, Walter F. *Caravaggio Studies*. Princeton: Princeton University Press, 1955.

Garrard, Mary D. *Artemisia Gentileschi*. Princeton: Princeton University Press, 1989.

Goldscheider, Ludwig. *Vermeer: The Paintings: Complete Edition*. 2nd ed. London: Phaidon, 1967.

Haak, Bob. *The Golden Age: Dutch Painters of the 17th Century*. London: Thames & Hudson, 1984.

Haskell, Francis. *Patrons and Painters: A Study in the Relations between Italian Art and Society in the Age of the Baroque*. New Haven: Yale University Press, 1980.

Held, Julius, and Donald Posner. *17th- and 18th-Century Art*. New York: Abrams, 1974.

Hibbard, Howard. *Bernini*. Baltimore: Penguin, 1966.

_____. *Caravaggio*. New York: HarperCollins, 1983.

Holt, Elizabeth Gilmore, ed. *A Documentary History of Art*, vol. 2, *Michelangelo and the Mannerists: The Baroque and the 18th Century*. 2nd ed. Garden City: Doubleday, 1957.

Kahr, Madlyn M. *Dutch Painting in the 17th Century*. New York: Harper & Row, 1978.

Kemp, Martin, ed. *Leonardo on Painting*. New Haven: Yale University Press, 1989.

Kitson, Michael. *The Age of Baroque*. London: Hamlyn, 1976.

Levey, Michael. *Painting in 18th-Century Venice*. London: Phaidon, 1959.

Martin, John R. *Baroque*. New York: Harper & Row, 1977.

Moir, Alfred. *The Italian Followers of Caravaggio*. 2 vols. Cambridge, MA: Harvard University Press, 1967.

Montagu, Jennifer. *Roman Baroque Sculpture: The Industry of Art*. New Haven: Yale University Press, 1989.

Murray, Linda. *The High Renaissance and Mannerism*. New York: Oxford University Press, 1977.

Nicolson, Benedict. *The International Caravaggesque Movement*. London: Phaidon, 1979.

Norberg-Schulz, Christian. *Baroque Architecture*. New York: Abrams, 1985.

Pope-Hennessy, John. *Cellini*. London: Macmillan, 1985.

_____. *Italian High Renaissance and Baroque Sculpture*. 3rd ed. 3 vols. New York: Phaidon, 1986.

Rosenberg, Jakob. *Rembrandt: Life and Work*. 3rd ed. London: Phaidon, 1968.

Schama, Simon. *The Embarrassment of Riches: An Interpretation of Dutch Culture in the Golden Age*. New York: Knopf, 1986.

Shearman, John K. G. *Mannerism*. Baltimore: Penguin, 1967.

Slive, Seymour. *Rembrandt and His Critics, 1630–1730*. New York: Hacker, 1988.

Smyth, Craig H. *Mannerism and Maniera*. Locust Valley, NY: J. J. Augustin, 1963.

Stechow, Wolfgang. *Dutch Landscape Painting of the 17th Century*. London: Phaidon, 1966.

Varriano, John. *Italian Baroque and Rococo Architecture*. New York: Oxford University Press, 1986.

Waterhouse, Ellis K. *Baroque Painting in Rome*. London: Phaidon, 1976.

White, Christopher. *Peter Paul Rubens: Man and Artist*. New Haven: Yale University Press, 1987.

Wittkower, Rudolf. *Art and Architecture in Italy, 1600–1750*. 3rd ed. Pelican History of Art. Baltimore: Penguin, 1973.

_____. *Gian Lorenzo Bernini, The Sculptor of the Roman Baroque*. 2nd ed. London: Phaidon, 1966.

Wright, Christopher. *The French Painters of the 17th Century*. New York: New York Graphic Society, 1986.

Würtenberger, Franzsepp. *Mannerism: The European Style of the 16th Century*. New York: Holt, Rinehart & Winston, 1963.

The Eighteenth Century: Rococo and Neo-Classicism

Antal, Frederick. *Hogarth and His Place in European Art*. London: Routledge & Kegan Paul, 1962.

Arnason, Hjorvardur H. *The Sculptures of Houdon*. New York: Oxford University Press, 1975.

Blunt, Anthony, ed. *Baroque and Rococo: Architecture and Decoration*. New York: Harper & Row, 1982.

Burchard, John, and Albert Bush-Brown. *The Architecture of America: A Social and Cultural History*. Boston: Little, Brown, 1965.

Burke, Joseph. *English Art, 1714–1800*. New York: Oxford University Press, 1976.

Châtelet, Albert, and Jacques Thuillier. *French Painting from Le Nain to Fragonard*. Geneva: Skira, 1964.

Conisbee, Philip. *Painting in 18th-Century France*. Ithaca: Cornell University Press, 1981.

Eitner, Lorenz. *Neoclassicism and Romanticism, 1750–1850: Sources and Documents*. 2 vols. Englewood Cliffs, NJ: Prentice-Hall, 1970.

Friedländer, Walter F. *From David to Delacroix*. Cambridge, MA: Harvard University Press, 1952.

Gage, John. *J. M. W. Turner*. New Haven: Yale University Press, 1987.

Hitchcock, Henry R. *Rococo Architecture in Southern Germany*. London: Phaidon, 1968.

Honour, Hugh. *Neo-Classicism*. Harmondsworth: Penguin, 1987.

Irwin, David. *English Neoclassical Art*. London: Faber & Faber, 1966.

Kalnein, Karl W., and Michael Levey. *Art and Architecture of the 18th Century in France*. Harmondsworth: Penguin, 1972.

Kimball, Sidney F. *The Creation of the Rococo*. New York: Norton, 1964.

Levey, Michael. *Rococo to Revolution*. New York: Oxford University Press, 1977.

McLaughlin, Jack. *Jefferson and Monticello: The Biography of a Builder*. New York: Henry Holt & Co., 1988.

Norberg-Schulz, Christian. *Late Baroque and Rococo Architecture*. New York: Abrams, 1985.

Pignatti, Terisio. *The Age of Rococo*. New York: Hamlyn, 1969.

Powell, Nicolas. *From Baroque to Rococo: An Introduction to Austrian and German Architecture from 1580 to 1790*. London: Faber & Faber, 1959.

Raine, Kathleen. *William Blake*. New York: Oxford University Press, 1970.

Rosenblum, Robert. *Transformations in Late 18th-Century Art*. Princeton: Princeton University Press, 1970.

The Nineteenth Century: Romanticism and Realism

Athanassoglou-Kallmyer, Nina M. *Eugène Delacroix*. New Haven: Yale University Press, 1991.

Borsch-Supan, Helmut. *Caspar David Friedrich*. New York: Braziller, 1974.

Brion, Marcel. *Art of the Romantic Era: Romanticism, Classicism, Realism*. New York: Praeger, 1966.

Clark, Kenneth. *The Romantic Rebellion*. New York: Harper & Row, 1973.

Clay, Jean. *Romanticism*. New York: Phaidon, 1981.

Courthion, Pierre. *Romanticism*. Geneva: Skira, 1961.

Eitner, Lorenz. *Géricault's "Raft of the Medusa."* London: Phaidon, 1972.

Elsen, Albert. *Rodin*. New York: The Museum of Modern Art, 1963.

Fried, Michael. *Courbet's Realism*. Chicago: University of Chicago Press, 1990.

Hamilton, George H. *Manet and His Critics*. New Haven: Yale University Press, 1954.

Honour, Hugh. *Romanticism*. New York: Harper & Row, 1979.

Janson, Horst W. *19th-Century Sculpture*. New York: Abrams, 1985.

Meredith, Roy. *Mr Lincoln's Camera Man*. 2nd ed. New York: Dover, 1974.

Newhall, Beaumont. *The History of Photography from 1839 to the Present Day*. New York: The Museum of Modern Art, 1982.

Nicholson, Benedict. *Courbet: The Studio of the Painter*. London: Allen Lane, 1973.

Nochlin, Linda. *Gustave Courbet: A Study of Style and Society*. New York: Garland, 1976.

_____. *Realism*. Harmondsworth: Penguin, 1971.

_____. *Realism and Tradition in Art, 1848–1900: Sources and Documents*. Englewood Cliffs, NJ: Prentice-Hall, 1966.

Novak, Barbara. *American Painting of the 19th Century*. New York: Praeger, 1969.

Passeron, Roger. *Daumier*. Secaucus, NJ: Poplar Books, 1981.

Praz, Mario. *The Romantic Agony*. New York: Oxford University Press, 1983.

Reff, Theodore. *Manet: 'Olympia'*. London: Allen Lane, 1976.

Rosenblum, Robert. *Jean-Auguste-Dominique Ingres*. New York: Abrams, 1967.

_____, and Horst W. Janson. *19th-Century Art*. New York: Abrams, 1984.

Sullivan, Louis. *The Autobiography of an Idea*. New York: Dover, 1956.

The Nineteenth Century: Impressionism and Post-Impressionism

Andersen, Wayne. *Gauguin's Paradise Lost*. New York: Viking Press, 1971.

Badt, Kurt. *The Art of Cézanne*. Tr. S. A. Ogilvie. Berkeley: University of California Press, 1965.

Boggs, Jean Sutherland, et al. *Degas* (exhibition catalog). New York: Metropolitan Museum of Art, 1988.

Edvard Munch: Symbols and Images. Washington, D.C.: National Gallery of Art, 1978.

Elsen, Albert E. *Auguste Rodin: Readings on His Life and Work*. Englewood Cliffs, NJ: Prentice-Hall, 1965.

Geist, Sidney. *Interpreting Cézanne*. Cambridge, MA: Harvard University Press, 1988.

Gogh, Vincent van. *The Complete Letters of Vincent van Gogh*. Tr. J. van Gogh-Bonger and C. de Dood. 3 vols. Greenwich: New York Graphic Society, 1958.

Goldwater, Robert. *Paul Gauguin*. New York: Abrams, 1957.

Gowing, Lawrence, ed. *Cézanne: The Early Years, 1859–72*. New York: National Gallery of Art, Washington, D.C., in assoc. with Abrams, 1988.

Hanson, Anne C. *Manet and the Modern Tradition*. New Haven: Yale University Press, 1977.

Herbert, Robert L. *Impressionism*. New Haven: Yale University Press, 1988.

Jullian, Philippe. *The Symbolists*. New York: E. P. Dutton, 1973.

Nochlin, Linda. *Impressionism and Post-Impressionism, 1874–1904: Sources and Documents*. Englewood Cliffs, NJ: Prentice-Hall, 1966.

Pickvance, Ronald. *Van Gogh in Arles*. New York: Metropolitan Museum of Art in assoc. with Abrams, 1984.

_____. *Van Gogh in Saint-Remy and Auvers*. New York: Metropolitan Museum of Art in assoc. with Abrams, 1986.

Rewald, John. *The History of Impressionism*. 4th rev. ed. New York: New York Graphic Society for The Museum of Modern Art, 1973.

_____. *Post-Impressionism from Van Gogh to Gauguin*. 2nd ed. New York: The Museum of Modern Art, 1962.

_____. *Studies in Impressionism*. New York: Abrams, 1986.

_____. *Studies in Post-Impressionism*. New York: Abrams, 1986.

Russell, John. *Seurat*. New York: Praeger, 1965.

Schapiro, Meyer, *Paul Cézanne*. 3rd ed. New York: Abrams, 1962.

_____. *Vincent van Gogh*. New York: Abrams, 1950.

Stang, Ragna. *Edvard Munch*. Tr.

Geoffrey Culverwell. New York: Abbeville, 1988.

Thomson, Richard, et al. *Toulouse-Lautrec*. New Haven: Yale University Press, 1991.

Wood, Mara-Helen, ed. *Edvard Munch: The Frieze of Life*. London: National Gallery Publications, 1992.

The Twentieth Century

Albright, Thomas. *Art in the San Francisco Bay Area, 1945–80*. Berkeley: University of California Press, 1985.

Alloway, Lawrence. *American Pop Art*. New York: Whitney Museum, 1974.

_____. *Robert Rauschenberg*. Washington, D.C.: Smithsonian Institution, 1976.

Arnason, Hjorvardur H. *History of Modern Art*. New York: Abrams, 1986.

Arp, Hans. *Arp on Arp: Poems, Essays, Memories*. Ed. Marcel Jean. New York: Viking Press, 1972.

Ashton, Dore. *About Rothko*. New York: Oxford University Press, 1983.

_____. *20th-Century Artists on Art*. New York: Pantheon, 1985.

Barr, Alfred H., Jr., ed. *Cubism and Abstract Art*. Reprint of 1936 ed. by The Museum of Modern Art. New York: Arno Press, 1966.

_____, ed. *Fantastic Art, Dada, Surrealism*. Reprint of 1936 ed. by The Museum of Modern Art. New York: Arno Press, 1969.

_____. *Matisse, His Art, and His Public*. Reprint of 1951 ed. by The Museum of Modern Art. New York: Arno Press, 1966.

_____. *Picasso, Fifty Years of His Art*. Reprint of 1946 ed. by The Museum of Modern Art. New York: Arno Press, 1966.

Battcock, Gregory, ed. *Minimal Art: A Critical Anthology*. New York: Studio Vista, 1969.

_____. *Super Realism: A Critical Anthology*. New York: E. P. Dutton, 1975.

Bayer, Herbert, Walter Gropius and Ise Gropius, eds. *Bauhaus, 1919–28*. Boston: Chas. T. Branford, 1959.

Beardsley, Richard. *Earthworks and Beyond: Contemporary Art in the Landscape*. New York: Abbeville, 1984.

Blake, Peter. *Frank Lloyd Wright*. Harmondsworth: Penguin, 1960.

Boime, Albert. *A Social History of Modern Art*. Chicago: University of Chicago Press, 1987.

Bourdon, David. *Christo*. New York: Abrams, 1972.

Chipp, Herschel B. *Picasso's Guernica*. Berkeley: University of California Press, 1988.

_____. *Theories of Modern Art.* Berkeley: University of California Press, 1968.

Cooper, Douglas. *The Cubist Epoch.* New York: Phaidon, 1971.

Crichton, Michael. *Jasper Johns.* New York: Whitney Museum/Abrams, 1977.

Doesburg, Theo van. *Principles of Neo-Plastic Art.* Greenwich: New York Graphic Society, 1968.

Doss, Erika. *Benton, Pollock, and the Politics of Modernism: From Regionalism to Abstract Expressionism.* Chicago: University of Chicago Press, 1991.

Duthuit, Georges. *The Fauvist Painters.* New York: Wittenborn, Schultz, 1950.

Elderfield, John. *The Cut-Outs of Henri Matisse.* New York: Braziller, 1978.

Elsen, Albert. *Origins of Modern Sculpture.* New York: Braziller, 1974.

Flam, Jack D. *Matisse: The Man and His Art.* Ithaca: Cornell University Press, 1986.

_____. *Matisse on Art.* London: Phaidon, 1973.

Foucault, Michel. *This Is Not A Pipe.* Tr. J. Harkness. Berkeley: University of California Press, 1982.

Franciscono, Marcel. *Paul Klee: His Work and Thought.* Chicago: University of Chicago Press, 1991.

Fry, Edward E. *Cubism.* New York: Oxford University Press, 1978.

Geist, Sidney. *Brancusi: The Sculpture and Drawings.* New York: Abrams, 1975.

Goodyear, Frank H., Jr. *Contemporary American Realism Since 1960.* Boston: New York Graphic Society, 1981.

Gordon, John. *Louise Nevelson.* New York: Whitney Museum, 1967.

Gray, Cleve. *David Smith on David Smith: Sculpture and Writings.* London: Thames & Hudson, 1968.

Herbert, Robert L. *Modern Artists on Art.* Englewood Cliffs, NJ: Prentice-Hall, 1971.

Hertz, Richard, ed. *Theories of Contemporary Art.* Englewood Cliffs, NJ: Prentice-Hall, 1985.

Hess, Thomas B. *Willem de Kooning.* New York: The Museum of Modern Art, 1968.

Hughes, Robert. *The Shock of the New.* New York: Knopf, 1981.

Hunter, Sam, and John Jacobus. *American Art of the 20th Century: Painting, Sculpture, Architecture.* New York: Abrams, 1973.

Jaffé, Hans L. C. *De Stijl, 1917–31: The Dutch Contribution to Modern Art.* New York: Abrams, 1971.

Lippard, Lucy R. *Pop Art.* New York: Praeger, 1966.

_____. *Surrealists on Art.* Englewood Cliffs, NJ: Prentice-Hall, 1970.

Lucie-Smith, Edward. *Movements in Art Since 1945.* London: Thames & Hudson, 1984.

Lynes, Barbara B. *O'Keeffe, Stieglitz, and the Critics, 1916–29.* Chicago: University of Chicago Press, 1989.

Mashek, Joseph, ed. *Marcel Duchamp in Perspective.* Englewood Cliffs, NJ: Prentice-Hall, 1975.

McShine, Kynaston. *Andy Warhol: A Retrospective.* New York: The Museum of Modern Art, 1989.

Mendelowitz, Daniel M. *A History of American Art.* 2nd ed. New York: Holt, Rinehart & Winston, 1970.

Meyer, Ursula. *Conceptual Art.* New York: E. P. Dutton, 1972.

Mondrian, Piet C. *Plastic Art and Pure Plastic Art.* New York: Wittenborn, 1945.

Myers, Bernard. *The German Expressionists: A Generation in Revolt.* New York: Praeger, 1956.

O'Connor, Francis V. *Jackson Pollock.* New York: The Museum of Modern Art, 1967.

Prelinger, Elizabeth. *Käthe Kollwitz.* Washington, D.C.: Yale University Press/National Gallery of Art, 1992.

Read, Herbert. *A Concise History of Modern Painting.* New York: Oxford University Press, 1959.

Richter, Hans. *Dada: Art and Anti-Art.* New York: McGraw-Hill, 1965.

Rose, Barbara. *American Art Since 1960.* Rev. ed. New York: Praeger, 1975.

_____. *Claes Oldenberg.* New York: The Museum of Modern Art, 1970.

_____. *Frankenthaler.* New York: Abrams, 1975.

Rosenberg, Harold. *The Tradition of the New.* New York: Horizon, 1959.

Rosenblum, Robert. *Cubism and 20th-Century Art.* New York: Abrams, 1966.

Rubin, William, ed. *Cézanne: The Late Work.* New York: The Museum of Modern Art, 1977.

_____. *Dada and Surrealist Art.* New York: Abrams, 1968.

_____, ed. *Pablo Picasso: A Retrospective.* New York: The Museum of Modern Art, 1980.

_____, ed. *Primitivism in 20th-Century Art.* 2 vols. New York: The Museum of Modern Art, 1984.

Russell, John. *Max Ernst: Life and Work.* New York: Abrams, 1967.

_____, and Suzi Gablik. *Pop Art Redefined.* London: Thames & Hudson, 1969.

Sandler, Irving, *American Art of the 1960s.* New York: Harper & Row, 1989.

_____. *The Triumph of American Painting: A History of Abstract Expressionism.* New York: Harper & Row, 1970.

Schiff, Gert, ed. *Picasso in Perspective.* Englewood Cliffs, NJ: Prentice-Hall, 1976.

Schneider, Pierre. *Matisse.* Tr. M. Taylor and B. S. Romer. New York: Rizzoli, 1984.

Schwarz, Arturo. *The Complete Works of Marcel Duchamp.* London: Thames & Hudson, 1965.

_____. *Man Ray: The Rigors of Imagination.* New York: Rizzoli, 1967.

Selz, Peter. *Art in Our Times.* New York: Abrams, 1981.

Smithson, Robert. *The Writings of Robert Smithson.* Ed. N. Holt. New York: New York University Press, 1975.

Steinberg, Leo. *Other Criteria: Confrontations with 20th-Century Art.* New York: Oxford University Press, 1972.

Sylvester, David. *Magritte: The Silence of the World.* New York: The Menil Foundation/Abrams, 1992.

Taylor, Joshua C. *Futurism.* New York: The Museum of Modern Art, 1961.

Vaizey, Marina. *Christo.* New York: Rizzoli, 1990.

Vogt, Paul. *Expressionism: German Painting, 1905–20.* New York: Abrams, 1980.

Waldberg, Patrick. *Surrealism.* New York: Oxford University Press, 1965.

Waldman, Diane. *Mark Rothko, 1903–70: A Retrospective.* New York: Solomon R. Guggenheim Museum, 1978.

Wheat, Ellen Harkins. *Jacob Lawrence: American Painter.* Seattle: University of Washington Press, 1986.

Wright, Frank Lloyd. *American Architecture.* Ed. E. Kaufmann. New York: Horizon, 1955.

Notes

Chapter 1
1. Trans. from "Propos de Brancusi," collected by Claire Gilles Guilbert, in *Prisme des Arts* (Paris) No. 12, May 1957, p.6.

Chapter 4
1. Quotes from the *Epic of Gilgamesh* are from John Gardner and John Maier, *Gilgamesh*, Knopf, New York, 1984, p.57.

Chapter 24
1. From *Le Figaro*, 3 April 1876.

Chapter 25
1. From Munch catalog, National Gallery, London, 1992, p.98.

Chapter 27
1. From *Camera Work*, New York, August 1912, pp.29–30.
2. From Léger, *Contemporary Achievements in Painting*, cited in Edward Fry, *Cubism*, New York, 1978, pp.135–9.

3. From an interview with James Johnson Sweeney in "Eleven Europeans in America," *Bulletin of the Museum of Modern Art* (New York), XIII Nos. 4–5, 1946, pp.19–21.
4. From the New York *Evening Sun*, cited in Milton Brown, *The Story of the Armory Show*, New York, 1963.
5. From Sidney Geist, *Artforum*, Feb. 1983, p.69.

Chapter 28
1. Hans Richter, *Dada*, London, 1965.
2. A. Breton, *The Manifesto of Surrealism*, 1924.
3. From Man Ray, "Photography can be art," in *Man Ray Photographs*, New York, 1982.
4. Paul Klee, "Creative Credo," 1920, originally published as *Schöpferische Konfession*, ed. K. Edschmid, Berlin, 1920.

Chapter 29
1. Excerpt from a transcript of an artists' session held in New York,

1948, cited in Herschel B. Chipp, *Theories of Modern Art*, Berkeley, 1968.
2. Excerpt from "My Painting," *Possibilities I* (New York), Winter 1947/48, p.79.
3. From a symposium on "What Abstract Art Means to Me," held at The Museum of Modern Art, New York, 1951.
4. From Mark Rothko, "The Romantics were Prompted," 1947, from *Possibilities I*, p.84.

Chapter 30
1. Brydon Smith in *etc. from Dan Flavin*, exhibition catalog (The National Gallery of Canada, Ottawa, 1969), p.206.

Chapter 31
1. Linda Chase and Tom McBurnett, "Tom Blackwell," in "The Photo-Realists: Twelve Interviews," *Art in America*, Nov.–Dec. 1972, p.76.

Acknowledgements

Many of the line drawings in this book have been specially drawn by Taurus Graphics, Kidlington. Calmann & King are grateful to all who have allowed their plans and diagrams to be reproduced. Every effort has been made to contact the copyright holders, but should there be any errors or omissions, they would be pleased to insert the appropriate acknowledgement in any subsequent edition of this publication.

2.4, 3.10, 5.9 From Richard Phipps and Richard Wink, *Invitation to the Gallery*. Copyright © 1987 Wm. C. Brown Communications, Inc., Dubuque, Iowa. All Rights Reserved. Reprinted by permission.
3.11 From Christopher Chippindale, *Stonehenge Complete*. London: Thames & Hudson, 1983.
6.3 From Reynold A. Higgins, *The Archaeology of Minoan Crete*. Henry Z. Walck, 1973. © Random House, Inc.
6.11, 17.11 Fondazione Giorgio Cini, Istituto di Storia dell'Arte (Foto Rossi), Venice.
7.25 From B. F. Cook, *The Elgin Marbles*. London: British Museum Press, 1984. Copyright British Museum.
9.8 Fototeca Unione, Rome.
9.12 From Frank Sear, *Roman Architecture*. London: B. T. Batsford, 1982. © Frank Sear.

10.3, 13.3 From Lois Fichner-Rathus, *Understanding Art*. Englewood Cliffs, NJ: Prentice Hall, 1989.
13.2, 13.10 From David G. Wilkins and Bernard Schultz, *Art Past Art Present*. New York: Abrams, 1990. Reprinted by permission.
13.23 Paul Elek Productions Ltd.
15.4 From Peter Murray, *Renaissance Architecture*. New York: Abrams, 1976. © Electa Editrice.
19.4 From Lawrence Wodehouse and Marian Moffett, *A History of Western Architecture*. Mountain View, CA: Mayfield Publishing, 1989.
19.13 From Blaser and Hannaford, *Drawings of Great Buildings*. Basel: Birkhäuser Verlag.

Picture Credits

Calmann & King Ltd., the picture researcher, and the author wish to thank the institutions and individuals who have kindly provided photographic material or artwork for use in this book. Museums and galleries are given in the captions; other sources are listed below.

1.1 © DACS 1993
1.2 © DACS 1993, Giraudon/Bridgeman Art Library, London
1.5 Giraudon, Paris
1.6 Bildarchiv Preussischer Kulturbesitz, Berlin

2.3 © DACS 1993/Julian Bach Literary Agency, New York

3.3 Cliché des Musées Nationaux, Paris
3.4, 3.5 Archiv für Kunst und Geschichte, Berlin
3.6 Giraudon, Paris
3.7 Ancient Art and Architecture Collection, Harrow, UK
3.8 Aerofilms, Borehamwood, UK
3.12 Laurie Adams, New York

4.2 James Mellaart, London
4.6, 4.21 Roger-Viollet, Paris
4.10, 4.19 Cliché des Musées Nationaux, Paris
4.13 Gallimard, Paris
4.14, 4.15 Hirmer Fotoarchiv, Munich
4.18 Giraudon, Paris
4.20 Lee Boltin, Croton-on-Hudson, New York
4.22, 4.23 Photo Boudot-Lamotte

5.1 E. T. Archive, London
5.2a, 5.2b, 5.4, 5.5, 5.7, 5.12, 5.14, 5.19 Hirmer Fotoarchiv, Munich
5.8 1890 (90.35.1) neg.no.35716B, The Metropolitan Museum of Art, New York
5.10 Roger-Viollet, Paris
5.15 Peter Clayton, Hemel Hempstead, UK
5.16 Giraudon, Paris
5.18 C. M. Dixon, Kingston, Canterbury, UK
5.22a, 5.22b Scala, Florence

6.1, 6.9 Hannibal, Athens
6.2, 6.8, 6.12 Hirmer Fotoarchiv, Munich
6.4, 6.5 Sonia Halliday, Weston Turville, UK
6.6 Ancient Art and Architecture Collection, Harrow, UK

6.7, 6.10, 6.15 Scala, Florence
6.13 Laurie Adams, New York

7.4, 7.5, 7.8a, 7.9a, 7.9b, 7.10, 7.11, 7.12, 7.19a, 7.23, 7.26, 7.30, 7.35 Hirmer Fotoarchiv, Munich
7.6 Ekdotike Athenon, Athens
7.7a 1932 (32.11.1) neg.no.177694B, **7.17** 1890 (90.35.3) neg.no.167188B, **7.37** 1909 (09.39) neg.no.177688B, The Metropolitan Museum of Art, New York
7.7b Laurie Adams, New York
7.13, 7.15 Sonia Halliday, Weston Turville, UK
7.18a, 7.18b Giraudon, Paris
7.24 Hirmer Fotoarchiv, Munich
7.28, 7.29 Alison Frantz, Princeton, New Jersey
7.31 Mansell Collection, London
7.34 Alinari, Florence
7.36 Deutsches Archäologisches Institut, Rome
7.39 Bildarchiv Preussischer Kulturbesitz, Berlin

8.1 Deutsches Archäologisches Institut, Rome
8.2, 8.3, 8.4, 8.5a Hirmer Fotoarchiv, Munich
8.5a Soprintendenza Archeologica di Etruria Meridionale
8.7 Ancient Art and Architecture Collection, Harrow, UK

9.2, 9.20, 9.21, 9.23, 9.24, 9.29 Alinari, Florence
9.4, 9.19 Alinari/Art Resource, New York
9.6 Giancarlo Costa, Milan
9.9 Mary Evans Picture Library, London
9.10, 9.14, 9.22 Fototeca Unione, Accademia Americana, Rome
9.11, 9.27, 9.30, 9.31, 9.32 Scala, Florence
9.13 Roger-Viollet, Paris
9.15 Ralph Lieberman
9.17 1939.1.24.(135)/PA, © 1993 The National Gallery of Art, Washington, D.C.
9.18, 9.25 Deutsches Archäologisches Institut, Rome
9.26 E. T. Archive, London
9.28 Estate of Leonard von Matt, Buochs

p.149, 10.7, 10.8, 10.9, 10.10 Scala, Florence
10.1, 10.16 Hirmer Fotoarchiv, Munich
10.5 Alinari, Florence

10.11, 10.12, 10.13 Giancarlo Costa, Milan
10.14 G. E. Kidder Smith, New York
10.17 E. T. Archive, London

11.1, 11.3 Sonia Halliday, Weston Turville, UK
11.4 Raffaello Bencini, Florence
11.5 MAS, Barcelona
11.6 C. M. Dixon, Kingston, Canterbury, UK
11.7 Commissioners of Public Works, Dublin
11.12 Wim Cox, Cologne

12.1, 12.2, 12.5 James Austin, Cambridge, UK
12.4 Bulloz, Paris
12.7, 12.8 Lauros-Giraudon, Paris
12.9 Giraudon, Paris
12.10, 12.11 Hirmer Fotoarchiv, Munich
12.12 Scala, Florence

13.1 © Arch. Phot. Paris/SPADEM
13.4, 13.21, 13.22 Roger-Viollet, Paris
13.6, 13.7, 13.19 Sonia Halliday, Weston Turville, UK
13.11, 13.12, 13.14, 13.16 James Austin, Cambridge, UK
13.15a, 13.15b J. Feuille/© C.N.M.H.S./SPADEM
13.17, 13.18 Giraudon, Paris
13.24 British Tourist Authority, London

p.209, 14.1, 14.2, 14.3, 14.4, 14.6, 14.8a, 14.8b Scala, Florence
14.5 E. T. Archive, London
14.7 Alinari, Florence

15.1, 15.2, 15.5, 15.11, 15.17, 15.19, 15.20 Alinari, Florence
15.3 Michael Holford, Loughton, UK/Clyde
15.6, 15.7, 15.9, 15.12, 15.13, 15.15, 15.16, 15.21b, 15.22a, 15.23, 15.24, 15.25, 15.26, 15.27 Scala, Florence
15.10, 15.21a, 15.22b, 15.34 Bridgeman Art Library, London
15.14, 15.19 Alinari/Giraudon, Paris
15.28, 15.29 Photograph © 1981 (56.70), The Metropolitan Museum of Art, New York

16.1 Giraudon/Bibl. de l'Institut de France, Paris
16.3 A. F. Kersting, London
16.5, 16.13, 16.16, 16.19, 16.20, 16.26, 16.27 Scala, Florence
16.6 Giancarlo Costa, Milan

16.7, 16.15 Alinari, Florence
16.11 The Royal Collection © 1993 Her Majesty Queen Elizabeth II
16.12 Soprintendenza alle Gallerie di Milano
16.14 Anderson/Giraudon, Paris
16.22 Reproduced by permission of the Chatsworth Settlement Trustees
16.23 Bridgeman Art Library, London

17.2, 17.5, 17.6 Scala, Florence
17.3 Bridgeman Art Library, London
17.4 Meyer, Vienna
17.8b Lauros-Giraudon, Paris
17.9 Alinari, Florence
17.10 Angelo Hornak, London

18.1 Bridgeman Art Library, London
18.3, 18.11 Scala, Florence
18.4 Giraudon/Bridgeman Art Library, London
18.6 Archiv für Kunst und Geschichte, Berlin
18.9 Giraudon, Paris
18.10 Octave Zimmerman, Colmar

19.1, 19.10, 19.14, 19.15, 19.18, 19.20, 19.29 Scala, Florence
19.2, 19.5, 19.17 Alinari, Florence
19.3, 19.19 Bildarchiv Preussischer Kulturbesitz, Berlin
19.6, 19.12 Angelo Hornak, London
19.8 James Austin, Cambridge, UK
19.9 Fotomas Index, London
19.11 Cliché des Musées Nationaux, Paris
19.16 Robert Harding, London/Photo Walter Rawlings
19.21 1937 (37.162) neg.no.180617B, The Metropolitan Museum of Art, New York
19.22 Photo G. Cussac
19.23 Bridgeman Art Library, London
19.30 1942.9.97.(693)/PA, © 1993 The National Gallery of Art, Washington, D.C.
19.34 Oronoz, Madrid
19.35 Reproduced by Permission of the Trustees of the Wallace Collection

20.2 Reproduced by Permission of the Trustees of the Wallace Collection
20.4 © 1992 The National Gallery of Art, Washington, D.C.
20.5 Roger-Viollet, Paris
20.6 Archiv für Kunst und Geschichte, Berlin
20.7 Angelo Hornak, London
20.9, 20.10 A. F. Kersting, London

21.1 Topham, Edenbridge, UK/1913 (14.40.687) neg.no.148068B, The Metropolitan Museum of Art, New York
21.2 Cliché des Musées Nationaux, Paris
21.3, 21.4, 21.6 Bridgeman Art Library, London
21.7 Wayne Andrews, Chicago
21.8 University of Virginia Library
21.9 Art Resource, New York

22.1 A. F. Kersting, London
22.5, 22.6 Cliché des Musées Nationaux, Paris
22.7 1918 (18.643) neg.no.MM30563B, **22.11** © 1992 (50.145.8), **22.14** 1908 (08.228) neg.no.151425LSB, **22.15** © 1980 (1970.283.1) The Metropolitan Museum of Art, New York
22.8 MAS, Barcelona
22.9, 22.12 Bridgeman Art Library, London
22.10 Giraudon, Paris

23.1, 23.12 Cliché des Musées Nationaux, Paris
23.2, 23.3 Giraudon, Paris
23.5 The H. O. Havemeyer Collection (29.100.129), The Metropolitan Museum of Art, New York
23.9 Peter Newark's Western Americana, Bath, UK
23.11 Courtesy of Jefferson Medical College, Thomas Jefferson University
23.13 Archiv für Kunst und Geschichte, Berlin
23.16 Hulyon Deutsch, London
23.17 A. F. Kersting, London
23.18 Wayne Andrews, Chicago

24.1 Bridgeman Art Library, London
24.3, 24.9 Cliché des Musées Nationaux, Paris
24.5 George Eastman House, Rochester, New York
24.6, 24.13 © 1992, The National Gallery of Art, Washington, D.C.
24.7 Purchased with special contributions and purchase funds given or bequeathed by friends of the Museum, 1967 (67.241), © 1989, The Metropolitan Museum of Art, New York
24.11 Roger-Viollet, Paris
24.12 Giraudon/Bridgeman Art Library, London

25.1 © 1992, The National Gallery of Art, Washington, D.C.
25.4, 25.7 Bridgeman Art Library, London
25.5, 25.6 Photograph © 1993, The Art Institute of Chicago. All rights reserved
25.9, 25.13 Cliché des Musées Nationaux, Paris
25.11 Albright Knox Art Gallery, Buffalo, New York, General Purchase Fund, 1946

p.409 Arcaid, Kingston-upon-Thames, UK/ Photo Richard Bryant
26.1 Photograph © 1992, The Art Institute of Chicago. All rights reserved/© DACS 1993
26.2, 26.6, 26.7, 26.8 © Succession H. Matisse/DACS 1993
26.3, 26.5 © DACS 1993

27.1 Photograph © 1979 (47.106)/© DACS 1993, The Metropolitan Museum of Art, New York
27.2, 27.5, 27.6, 27.8, 27.9, 27.11, 27.12, 27.13, 27.17 © DACS 1993
27.4 © Succession H. Matisse/DACS 1993
27.7 Cliché des Musées Nationaux, Paris/© DACS 1993
27.14 Bridgeman Art Library, London/© DACS 1993
27.16 © Estate of Stuart Davis/DACS, London/VAGA, New York 1993
27.18 Library of Congress, Washington, D.C.
27.19 Ralph Lieberman
27.21 Amsterdam Historical Museum
27.24 Hedrich Blessing, New York

28.1 © DACS 1993
28.2, 28.3, 28.5, 28.10, 28.12 © DACS 1993
28.4 Scala, Florence/© DACS 1993
28.7 © ADAGP, Paris and DACS, London 1993
28.8 Photograph © 1992. All rights reserved. 1970.426/© DACS 1993, **28.13** 30.934/© DACS 1993, **28.16** Photograph © 1992. All rights reserved. 1949.795. The Art Institute of Chicago
28.9 © SPADEM/ADAGP, Paris and DACS, London 1993
28.11 Esto, Mamaroneck, New York/Photo Ezra Stoller
28.14 © Jacob Lawrence/DACS, London/ VAGA, New York 1993
28.17 50th anniversary gift, 81.9, Whitney Museum of American Art, New York

29.1 Courtesy of Sidney Janis Gallery, New York/Photo Allan Finkelman © 1988/ DACS 1993
29.2 Solomon R. Guggenheim Museum, New York/Photo David Heald ©
29.3 For Maro and Natasha Gorky in memory of their father, 50.17/© DACS 1993, **29.8** Funds from the Friends of the Whitney Museum of American Art, 68.12, Whitney Museum of American Art, New York
29.4 © DACS 1993
29.5, 29.9, 29.11 ARS, New York
29.6 Bridgeman Art Library, London/ARS, New York
29.7 © 1993 Willem de Kooning/ARS, New York
29.13 1953 (53.87 a–i) neg.no.156387 LSB, The Metropolitan Museum of Art, New York
29.14 © Estate of David Smith/DACS, London/VAGA, New York 1993
29.15 Courtesy of The Pace Gallery, New York/Photo Al Mozell

30.1 © Richard Hamilton 1993. All rights reserved DACS
30.2 © Jasper Johns/DACS, London/ VAGA, New York 1993
30.3 © Larry Rivers/DACS, London/ VAGA, New York 1993
30.4 Lucian Krukowski/© Robert Rauschenberg/DACS, London/VAGA, New York 1993
30.6 © Roy Lichtenstein/DACS 1993
30.7 © Tom Wesselmann/DACS, London/ VAGA, New York 1993
30.8, 30.9 © Courtesy of Claes Oldenburg
30.10 © George Segal/DACS, London/ VAGA, New York 1993
30.11 © Marisol Escobar/DACS, London/ VAGA, New York 1993
30.14 ARS, New York

31.2 Courtesy of the Sonnabend Gallery, New York
31.7 Esto, Mamaroneck, New York
31.8 Architectural Association, London/ Photo K. Parikh
31.9 Norman McGrath, New York
31.10 Deide von Schawen, Paris
31.11 Arcaid, Kingston-upon-Thames, UK/ Photo Richard Bryant
31.17 © 1984 The Estate of Jean-Michel Basquiat/© DACS 1993
31.20 Charles Gilman Jr. Foundation, Inc., and the Painting and Sculpture Committee (89.30 a–v), Whitney Museum of American Art, New York
31.21 © Nancy Graves/DACS, London/ VAGA, New York 1993
31.22 Richard M. Scaife Fund and A. W. Mellon Acquisition Endowment Fund, 83.53, The Carnegie Museum of Art, Pittsburgh
31.23 Esto, Mamaroneck, New York/Photo Peter Aaron

Index